50 YEARS OF
NEW YORK

Highbrow, Lowbrow, Brilliant, Despicable: 50 Years of

SIMON & SCHUSTER

NEW YORK | LONDON | TORONTO | SYDNEY | NEW DELHI

BY THE EDITORS OF

NEW YORK MAGAZINE

HAT KIND OF A MAGAZINE takes New York as its name? An ambitious one, obviously. At its founding, *New York* saw as its rivals two established publications that already had "New York" in their titles—the New York *Times* and *The New Yorker*—but viewed both of them as stuffed shirts. *New York* would take them on by being the unpretentious New York—unapologetic, funny, brash, even a bit crude. It would sound like the city itself. And that made it, when it launched in 1968, an unusual specimen: One of its most radical principles was that it would approach New York not simply as a subject to cover but as a point of view. And because the point of view was that of the most worldly city in the world, its purview would be far-flung. The White House and the studio back lot would be as interesting to it as City Hall.

Even so, with the arrogance of a New Yorker, it believed that New York was the capital of the world, where everything began, and that meant New York was its first preoccupation. The city in 1968 was undergoing some monumentally interesting change. It was beset with blight, as people were leaving in droves. At the same time, it was serving as the cradle for great movements—political movements, social movements, consumer movements—that would lift it out of its wreckage and ultimately invent a new kind of cosmopolitan creature that would reverberate throughout America and the world.

In a half century of episodic installments, *New York* told this dramatic story: the rebirth of a great city. This book is an attempt to put that story all in one place and to reconstruct how life in New York City changed, using the lens of *New York*'s writers, editors, photographers, and designers who, week to week, chronicled that transformation.

It is not a book of greatest hits (although we've tried to include many) but one that uses the magazine's material to trace the course of its namesake. The material did not always lend itself easily to that purpose. As we editors have made our way through five decades' worth of back issues, we found that the story (the city's and the magazine's) isn't exactly linear. Like all magazines, this one had its ups and downs. There have been times when the magazine caught the city's thrilling trajectory perfectly; there are also huge gaps in its coverage. *New York* was presciently early to many stories, right on time with others, embarrassingly late to some. And there are a few really strange turns: a 1970s obsession with houseplants, a cover story entirely devoted to Donald Trump's boat. A weekly magazine, putting out roughly 50 issues a year, made room for a substantial amount of variety, to say the least.

Because this book is coffee-table-size, with every page an overscale canvas, much of its narrative is visual, telling the story of the city through photographs and graphics and particularly magazine covers. (Also foldouts: We've tried to veer off the grid from time to time, just as the city's streets do.) But we have also excerpted many pieces of landmark writing that, in our opinion, evoke an especially vivid memory of New York City at a particular moment. Rather than dividing up the story by decade, we decided to organize this book around eight themes of city life. They develop chronologically, except for times when we thought it was worth busting up the timeline. Wherever we could, we revisited the people who posed for our photographers or spoke to our reporters or wrote for our editors. There are behind-the-scenes moments about the ways in which these stories and images came to be and the lives they took on after we published them. As an introduction to the book, we have compiled an oral history of the magazine itself, as told by staff and executives, as well as (in a couple of cases) our journalistic subjects. There is, of course, one glaring absence from that group: Clay Felker, the co-creator of *New York*, who died in 2008. Felker was a hungry journalist from Missouri who had already established himself as a kind of magazine genius when he became editor of *New York*, which was first a supplement to the dying New York *Herald Tribune*. After the paper finally drew its last breath, he and his equally iconoclastic design partner, Milton Glaser, snatched the title and launched the magazine into the city and the world on its own.

PRETTY MUCH FROM ISSUE ONE, the magazine that Felker and his colleagues made was magnetic, and, as it turned out, they had called the future. *New York* exalted and lampooned the city's revolutions, and found tumult in places people hadn't looked before. It was obsessed with power and striving and movement. It was fearless, almost free-form, giddy with change, infatuated with

the new. And the city gave it plenty of material. Starting in the late 1970s, after a near bankruptcy, New York City's fortunes started to turn upward. Young people, despite the crime and the filth, began to move in again. Through the subsequent decades, those young professional people—as a first approximation, they were what became yuppies—became emblematic of an urban revival. Movies and TV shows began to imagine New York not as a swamp of mayhem and corruption but as a fun, goofy place to live. *Panic in Needle Park* and *Dog Day Afternoon* gave way to *Friends* and *Sex and the City* and *Girls*. The half-imaginary city Felker sketched out in his magazine not only came to life but also became an actual place.

A city that at the magazine's founding had been unable to balance its books was soon awash in money—and, for a dozen years in the 21st century, was governed by its richest citizen. Wealth solved some problems and created others. "What Does It Take to Get a Decent Apartment?" the magazine asked in 1968, when the answer was $590 a month for a two-bedroom in the East 70s. Over the decades, as crime rates dropped and the cost of just about everything soared, the headaches of living in New York remained a preoccupation of the magazine. Neighborhoods were "discovered," celebrated, overrun, declared over. Nightlife was perpetually on the brink of obliteration, thanks to one sanitization project or another (the Disneyfication of Times Square, the smoking ban), even as it was reinvented again and again by new generations of weirdos. Raising children in New York remained a high-wire act, the universal anxiety of parenting intensified by the echo chambers of the playground and the mommy blog. The city could be extraordinarily hostile to making art—and yet, at the same time, devastatingly alluring. What Felker and his colleagues recognized in 1968 is that the difficulty of the city was also its charm. That is still true today.

So is New York's primacy as the place where things happen. Felker knew that a magazine grounded in the story of New York could also be a magazine about the whole world, and it is amazing how much history coursed through the city's streets. The 9/11 attacks, obviously. A few blocks west: the invention of collateralized mortgage obligations in 1983. A few blocks north: the Occupy Wall Street protests in 2012. *Ms.* magazine started in its pages in 1971. The city spurred multiple waves of feminism and celebrated the nomination of the first female major-party candidate for president. (It also saw its first Manhattan-developer president.) Soho artists invented a new way of living, something called the loft. Brooklyn became a lifestyle replicated the world over. The New York Police Department introduced two crime policies—"broken windows" and "stop and frisk"—that shaped the American justice system for better or worse. *Saturday Night Live* launched generations of comedians from 30 Rockefeller Plaza. One block away, Fox News revolutionized cable television and American politics. Martin Scorsese created a new language for movies. Dominique Ansel created the Cronut. And when *New York* did shift its focus elsewhere, it never had trouble writing about Washington or Hollywood or Silicon Valley because they traded in that common currency so central to the magazine's ethos: ambition.

Also central to that ethos: adaptation. *New York* was always an early adapter. Its sensibility has translated uncannily well to the internet, where its articles have found a vast new audience. In 2013, the magazine switched from weekly to biweekly publication. Meanwhile, its website, which launched in early 2001 with the magazine's content and listings, has become an immense news outlet, chronicling the changing universes of urbanites everywhere through its digital publications like Vulture (on entertainment), the Cut (on fashion), Daily Intelligencer (on politics), Select All (on technology), Grub Street (on food), Science of Us (on behavior), and the Strategist (on stuff you can buy; *New York,* one of the most expert trackers of consumer culture, is now its own store). The editors now "publish" on Snapchat and at live events and in words and images, and increasingly in moving pictures, in each case applying our particular way of seeing the world to whatever newfangled storytelling opportunity presents itself.

Still, this book is mostly preoccupied with the print magazine, tracing the course of the publication founded in 1968. For 50 years, New Yorkers have lived at the bleeding edge of the present, and the magazine's editors have done their best to capture it all. Or at least whatever felt most interesting as the Thursday-evening deadline approached and something or someone needed to land on the cover. What follows, then, is a patchwork history of both the magazine and the city, a story of what New York was, told by a bunch of people obsessed with what it was becoming. —*The Editors*

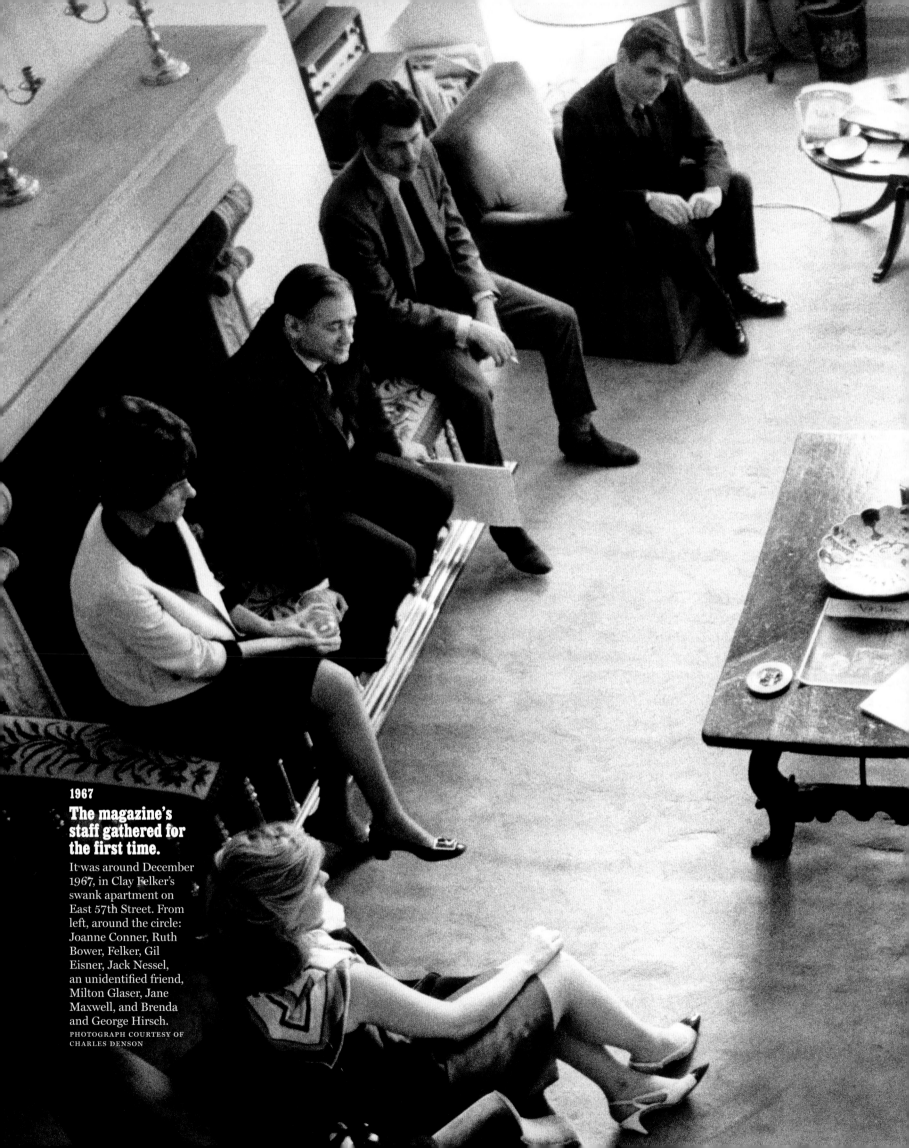

1967

The magazine's staff gathered for the first time.

It was around December 1967, in Clay Felker's swank apartment on East 57th Street. From left, around the circle: Joanne Conner, Ruth Bower, Felker, Gil Eisner, Jack Nessel, an unidentified friend, Milton Glaser, Jane Maxwell, and Brenda and George Hirsch.

PHOTOGRAPH COURTESY OF CHARLES DENSON

1968

The band got back together.

After the collapse of the *Herald Tribune* (and its short-lived successor, the *World Journal Tribune*), the relaunch of its Sunday supplement as a stand-alone magazine was announced with this ad showcasing the magazine's editorial team. Front and center: Tom Wolfe, Jimmy Breslin, Gloria Steinem.

x

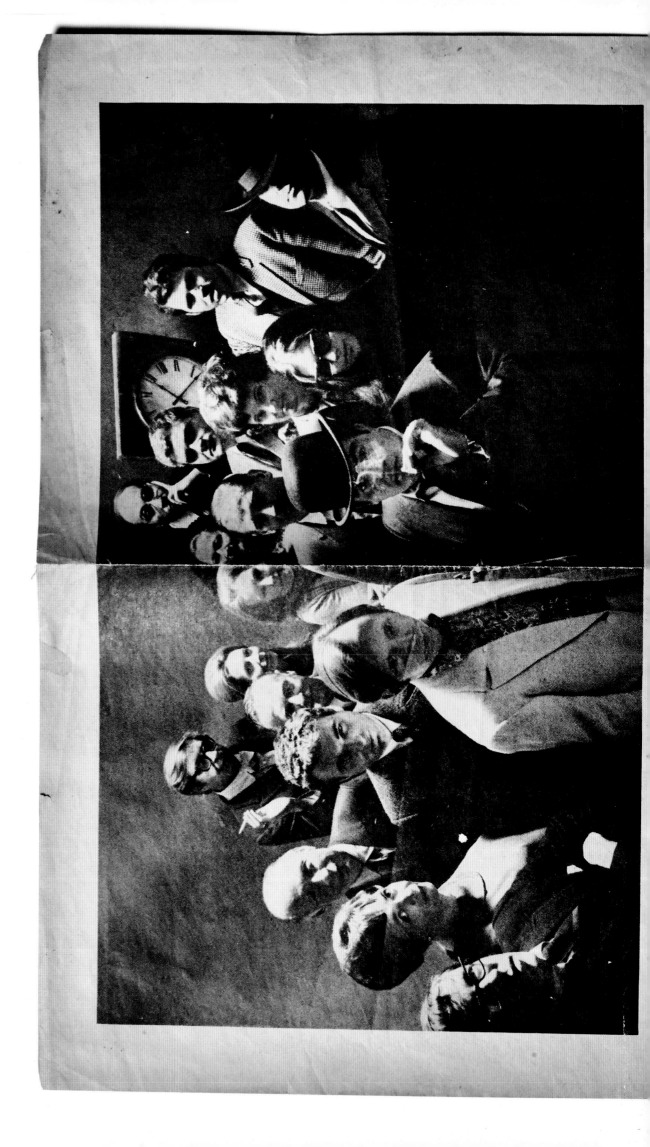

You used to spend Monday lunches swapping Breslin stories at Costello's.

You used to descend bravely on Bergdorf's armed with the latest news from Eugenia.

You even began to acquire a reputation as rather a wit simply by quoting Judith Crist and Tom Wolfe at the right moment.

And every Saturday night you'd run down to the corner, pull out our New York magazine supplement, and re-fuel for another week. Even after the Trib became the World Journal Tribune.

Then, one Saturday night, the WJT wasn't there.

And neither were we.

That was 9 months ago. And this city has been without its own magazine long enough.

We're coming back. April 8th.

Not all wrapped up in two pounds of Sunday newspaper. But on our own. Right in the middle of the week.

Breslin and Sheppard. Crist and Wolfe. Clay Felker, the guy with his feet up on the editor's desk. The pseudonymous "Adam Smith," phantom of Wall Street. Even the lady who made our TV listings more fun to read than the programs were to watch.

And we're coming back in style.

On classy, glossy paper. Designed from cover to cover by Milton Glaser. In a more traditional size, so we'll look like a real magazine and not a Sunday morning hybrid.

And at a respectable 40c price.

Harold Clurman will be at our drama desk. Richard Goldstein, the guy who took on Sergeant Pepper single-handed, will write on the pop scene. And Gloria Steinem, New York's most articulate beautiful person, on her not-always-beautiful friends.

But the chief contributor will still be this crazy city.

This bedlam, where eight million people holler if one stretch of ugly pavement is torn up, or one dowdy, lovable brownstone is torn down.

Well, we're going to be the guys who holler for you. And kick and yell and punch little holes in the big, pompous balloons that bug us all.

Because we've got the strongest weapon of all.

Good writing.

Things have been quiet around here long enough.

We're coming back.

NEW YORK MAGAZINE, 207 EAST 32nd ST., NEW YORK, N.Y. 10016

APRIL 8, 1968

40 CENTS

New York

The Story of *New York*, As Told By the People Who Made It

An Oral History

By Christopher Bonanos

1968

The first week was a big one.

New York's first issue, dated April 8, 1968, went on sale April 4. Martin Luther King Jr. was killed that evening, and Mayor Lindsay spent the night walking through Harlem, successfully quelling the riots that wrecked many other American cities.

THE CITY OF NEW YORK, in 1968, was going through the greatest existential crisis it had faced since the American Revolution. The factories of Manhattan were increasingly idle and dark, and the tenement dwellers who had worked in them were either moving into the projects or getting out of town. Abandoned buildings were everywhere. The snap-brim city of a generation earlier was looking dirty, dangerous, and generally beat-to-hell. Yet a certain type of moderately affluent, perpetually striving, in-the-know New Yorker was digging in. "I love New York even though…" was the prevailing spirit. People stayed for the arts, for the food, for the street life, for the mix of cultures, even for the brain-and-body-battering physicality of the place. As the author Fran Lebowitz put it a few years later, "When you leave New York, you are astonished at how clean the rest of the world is. Clean is not enough."

Clay Felker was one of those New Yorkers, here by choice rather than by birth. (He was from Webster Groves, Missouri.) He'd worked at *Life* and at *Esquire*, and in 1964 he had been hired to edit the Sunday magazine of a dying newspaper, the New York *Herald Tribune*. It was the other prestige broadsheet in town, the center-right competitor for the center-left *Times*, and in the early '60s the owners and editors were trying to save it with a push for editorial quality. With the relaunched and renamed *New York* supplement, Felker wanted to create a magazine with the New Journalism chops of *Esquire*, some of the sass of the prewar *New Yorker*, and the authority of the *Times* (without the deadly grayness it displayed back then), underlaid with great arts criticism and genuinely useful service journalism, and aimed at not suburban newspaper subscribers but upscale New Yorkers. He pulled together the talents of some of the best young writers on the paper—Tom Wolfe, Jimmy Breslin, Richard Reeves—and the editors Byron Dobell, Jack Nessel, and Sheldon Zalaznick, as well as the graphic designer Milton Glaser. In 1965, Felker deployed an old trick—to get noticed by the media, write about the media—and ran Tom Wolfe's "Tiny Mummies! The True Story of the Ruler of 43rd Street's Land of the Walking Dead," a gleeful strafing of the quiet conventions of William Shawn and *The New Yorker*. It appeared in two installments, and nobody in the press could talk about anything else for the week in between.

Despite the editorial efforts to save the *Herald Tribune*, it shut down in 1966, on the same day as two other dailies. Their scraps were gathered up into a merged entity called the *World Journal Tribune*, which continued to publish *New York* each Sunday for eight months until it too folded, on May 5, 1967. But Felker knew that *New York* had a loyal audience among those who loved their city and wouldn't live anywhere else. Eleven months later, the first issue of the new independent *New York* hit newsstands.

Jimmy Breslin on
Morning Drinking
Carolyn Gaiser on
Belly Dancing
Albee Vs. Albee
By Walter Kerr
Ads and Art
By Emily Genauer

NEW YORK

THE SUNDAY HERALD TRIBUNE MAGAZINE
JANUARY 30, 1966

THE LIVELY ARTS:
THEATER
MOVIES
MUSIC
RECORDS
DANCE
ART
TV/RADIO

SPECIAL PROBLEMS
OF NEW YORK WOMEN:
Beyond the
Feminine Mystique
By Betty Friedan
The Woman Who
Has Everything
By Tom Wolfe

NEW YORK

THE SUNDAY HERALD TRIBUNE MAGAZINE
FEBRUARY 21, 1965

THE LIVELY ARTS:
THEATER
MOVIES
MUSIC
RECORDS
DANCE
ART
TV/RADIO

Joseph Papp on
Lip Service to
Will Shakespeare
Lucius Beebe on
The Old El Morocco
John Molleson on
James Baldwin and
His "Mr. Charlie"

NEW YORK

THE SUNDAY HERALD TRIBUNE MAGAZINE
APRIL 19, 1964

THE LIVELY ARTS:
THEATER
MOVIES
MUSIC
RECORDS
DANCE
ART
TV/RADIO

'Adam Smith' on
The Urge to Merge
Why the City
Is So Noisy
Life With
Jackie the K
Professional New Yorkers
By Dan Greenburg

NEW YORK

THE WORLD JOURNAL TRIBUNE MAGAZINE
MAY 7, 1967

THE LIVELY ARTS:
THEATER
MOVIES
MUSIC
RECORDS
DANCE
ART
TELEVISION

The New York 'Times,' *May 8, 1967: "Hope for starting the* New York *magazine, which had been a Sunday supplement for* The World Journal Tribune, *as an independent publication, was disclosed yesterday by Clay Felker, who had been editor of that magazine and the Book Week supplement. Mr. Felker said he was trying to raise capital for a new enterprise, teaming up with Jimmy Breslin, columnist; Tom Wolfe, writer; and Milton Glaser, art director for Push Pin Studios…Mr. Felker said he had asked Matt Meyer, president of* The World Journal Tribune, *for the right to use the title."*

Milton Glaser (*design director and columnist, 1968–1977*): I must say how innocent we all were about what a magazine should be. But in some cases that kind of innocence is a benefit. You don't know what to do, so you invent something.

Gloria Steinem (*contributing editor, 1968–1971*): Clay and I had countless lunches that we referred to as "tap dancing for rich people." We were pitching the essence of New York—persuading New Yorkers that they were important enough and universal enough to have a magazine.

Tom Wolfe (*contributing editor, 1968–1977*): Jock Whitney [who had owned the *Herald Tribune*] had agreed to sell the name *New York* for $6,500, but Clay couldn't even come up with that. He finally borrowed it from a writer, Barbara Goldsmith.

Glaser: The prevailing spirit was, we're all in the same boat together. That means you could repair the leaks, it's going in the wrong direction, whatever—but it's never about tearing it down. Personally I've always felt optimistic about the city, because of this idea that it's a place where anything can happen, and that you can't anticipate what that will be. The city is too complex to ever be sort of epitomized by a single perception. I mean, it's the worst, it's the best, it's the least. It's the most terrible people, the best people. All of that at once.

Steinem: We had a lot of other names, some of them quite funny. Tom wanted to name it *The New York Moon*, because he had this vision of sending trucks to deliver it to newsstands, going too fast on purpose, with a big banner that said THE MOON IS OUT.

Gail Sheehy (*contributing editor, 1968–1977*): One of the unique aspects of this is the relationship between Clay and Milton. Clay was very much a kind of Upper East Side debonair man-about-town, living in a big duplex, and Milton was very much downtown, an artist in

turtlenecks and very long, wild hair. Clay had a more hair-trigger temper, and Milton was more the rabbi who worked things through. But their sensibilities were totally in sync. They both saw beyond the normal conventions of magazine journalism.

Glaser: We knew that we certainly couldn't beat *The New Yorker* at its game. We always thought of *New York* as being somewhat more working class. We tried to avoid issues of elitism or talking down to our audience, and wanted to be just one of the guys, the people who made it.

Charles Denson (*office assistant and staff photographer, 1968–1977*): Clay was obsessed with power and how things really worked in New York and what was going on behind the scenes, and that was the magazine's strong point.

Richard Reeves (*writer, 1971–1977*): The New York *Times* covered the city as government, and *New York* covered the city as millions of people.

Alan Patricof (*board member, 1968–1971; chairman, 1971–1977*): I really respected [Clay's] talent. His ability to catch trends—you look at the number of people he brought to the magazine, where all those people have gone—that's no accident.

The New York 'Times,' *February 1, 1968: "NEW YORK MAGAZINE TO APPEAR APRIL 8: New York magazine, the Sunday supplement of the defunct* World Journal Tribune, *will appear as an independent weekly on April 8, Clay Felker, its editor, announced yesterday. Mr. Felker said that production problems had set back the scheduled publication date of the first issue, which had been set for March 1. There is no plan to change the name of the magazine, he said, despite a protest by the* New Yorker, *the 43-year-old magazine of humor and commentary, which has threatened legal action against the forthcoming weekly."*

Steinem: The first issue of any magazine is, in my slender experience, a kind of heart attack, because systems are not in place yet, and there's been lots of questions about what should be in the issue, and everything's coming together at a fever point of inefficiency.

Sheehy: Gloria came up with the idea of writing about Ho Chi Minh's travels in New York and other parts of the United States as a young man. When she showed up late clutching her story, Clay grabbed the manuscript and without a glance handed it off to a messenger to take to the printer. She said, "How can you run a story without fact checking or something?" He said, "It's *here*."

"We were pitching the essence of New York—persuading New Yorkers that they were important enough and universal enough to have a magazine."

—GLORIA STEINEM

1963–1967

The earliest covers were gentle Sunday mornings.

Because the proto–*New York* Magazine was a supplement inside the Sunday paper, its covers did not have to entice newsstand buyers. They were often quiet city portraits, their images disengaged from the magazine's interior contents.

EXCERPT: APRIL 29, 1968

La Dolce Viva

By Barbara Goldsmith

Viva stretched, rubbed her eyes and yawned. "I'm tired out from that Tucson location trip… The first two nights I slept with John Chamberlain who is an old lover of mine. I slept with him for security reasons. Well, then, it was a different one every night. One night Allen Midgette and what's his name, Tom Hompertz, both made it with me. Andy looked in the window and said 'What are you doing in there? I told you not to. You're supposed to save it for the camera.' Then there was Little Joe [D'Alessandro] who was sweet and Eric [Emerson] who was just so rough." Viva looked up and said, "Don't look so skeptical. It's the truth I always tell the truth."

Steinem: That's almost true. I believe that that piece was at least three times as long. So he didn't change it, but it was drastically cut for space. But I have to say that Clay did not keep me from sending off Western Union telegrams to the leader of our enemy in a war, to try to fact-check Ho Chi Minh.

Glaser: I tell people this, and they say they don't believe me. But finally we put together an issue and we did everything that was required, and when we got it out of here none of us were ready for the fact that next week there was going to be another one. Suddenly we realized that the job wasn't done. *"Again?"*

Deborah Harkins *(editor, 1968–1995):* But it was collegial, and funny. We had a music editor, Alan Rich, and a switchboard person named Marion. Alan would always rush silently from his desk and come over to Marion and wrestle her to the floor. She kept going, "Oh, Alan. Oh, Alan." One day Clay came out of his office and stepped right over them and went down the stairs.

Glaser: The most difficult part was the transition from the old insert to a freestanding magazine. You can see, in the first year particularly, significant remnants of the old magazine. There was not accountability between the covers and the contents. You found a picture, it was about New York, and we were saying, "That's sufficient. We don't have to talk about what's inside or anything else."

Walter Bernard *(art director, 1968–1977):* A parking meter with a glove on it, the doorknob of the Plaza Hotel—all of those very beautiful things that were in the tradition of the *Herald Tribune*. Except people didn't want to pay 40 cents for that.

Glaser: We discovered that we had to be more aggressive, more visceral.

In the spring of 1968, Barbara Goldsmith filed a profile of Viva, a performer in Andy Warhol's circle, in which she talked about sex and drug use. The outrageousness of the story and the photographs by Diane Arbus sent the magazine into its first business crisis.

Wolfe: Clay said, "Take a look at this. The advertising department says if we run it, we'll lose every advertiser we have on Madison Avenue."

Steinem: There was a photograph of her kind of reclining, including the fact that she didn't shave the hair under her arms.

Denson: We had a full-page picture with her eyes rolling back into her head. I still can't believe that.

Wolfe: I looked up at Clay and said, "I don't see how you can *not* run it." "That's the way I feel," said Clay.

Viva *(actress and artist):* Barbara Goldsmith! That story is about 98 percent fiction. A lot of horrible things have happened to me, but I would consider that the worst. She had me having sex with every single cast member—who were all gay anyway! I ran into that miserable bitch years later. I can't believe I didn't sue those sons-of-bitches.

Wolfe: *New York* lost every high-end retailer on Madison Avenue and beyond.

Steinem: We lost some major department-store ads because of that. That's ridiculous, right? It was the hair.

Sheehy: He said "We're going to run it, never mind," and then suffered for a year—almost went out of business. But it brought everybody together. "We're going to save this thing because we're doing it the right way. We're going to run something even if it's shocking and the advertisers don't like it."

Steinem: Clay was absolutely on the writers' side.

Felker's unorthodox magazine-making extended even to the crossword.

Stephen Sondheim *(composer and lyricist; crossword constructor, 1968):* I'd known Gloria for a long time, and she asked me if I would do

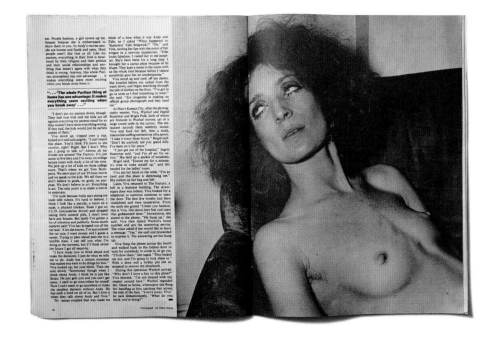

New York

Weather
Fresh mass of new information, driving out occluded front of old notions about what "journalism" does and doesn't do. Better reader insights likely today and tomorrow despite high winds and occasional storms of protest.

VOLUME V, NO. 7 FEBRUARY 14, 1972 40 CENTS

THE BIRTH OF 'THE NEW JOURNALISM'; EYEWITNESS REPORT BY TOM WOLFE

PARTICIPANT REVEALS MAIN FACTORS LEADING TO DEMISE OF THE NOVEL, RISE OF NEW STYLE COVERING EVENTS

[1] THE FEATURE GAME
By TOM WOLFE

I doubt if many of the aces I will be extolling in this story went into journalism with the faintest notion of creating a "new" journalism, a "higher" journalism, or even a mildly improved variety. I know they never dreamed that anything they were going to write for newspapers or magazines would wreak such evil havoc in the literary world . . . causing panic, dethroning the novel as the number one literary genre, starting the first new direction in American literature in half a century . . . Nevertheless, that is what has happened. Bellow, Barth, Updike—even the best of the lot, Philip Roth—the novelists are all out there ransacking the literary histories and sweating it out, wondering where they now stand. Damn it all, Saul, the *Huns* have arrived . . .

God knows I didn't have anything new in mind, much less anything literary, when I took my first newspaper job. I had a fierce and unnatural craving for something else entirely. Chicago, 1928, that was the general idea . . . Drunken reporters out on the ledge of the *News* peeing into the Chicago River at dawn . . . Nights down at the saloon listening to "Back of the Stockyards" being sung by a baritone who was only a lonely blind bulldyke with lumps of milk glass for eyes . . . Nights down at the detective bureau—it was always nighttime in my daydreams of the newspaper life. Reporters didn't work during the day. I wanted the whole movie, nothing left out . . .

I was aware of what had reduced me to this Student Prince Maudlin state of mind. All the same, I couldn't help it. I had just spent five years in graduate school, a statement that may mean nothing to people who never served such a stretch; it is the explanation, nonetheless. I'm not sure I can give you the remotest idea of what graduate school is like. Nobody ever has. Millions of Americans now go to graduate schools, but just say the phrase—"graduate school"—and what picture leaps into the brain? No picture, not even a blur. Half the people I knew in graduate school were going to write a novel about it. I thought about it myself. No one ever wrote such a book, as far as I know. Everyone used to sniff the air. How morbid! How poisonous! Nothing else like it in the world! But the subject always defeated them. It defied literary exploitation. Such a novel would be a study of frustration, but a form of frustration so exquisite, so ineffable, nobody could describe it. Try to imagine the worst part of the worst Antonioni movie you ever saw, or reading *Mr. Sammler's Planet* at one sitting, or just reading it, or being locked inside a Seaboard Railroad roomette, sixteen miles from Gainesville, Florida, heading north on the Miami-to-New York run, with no water and the radiator turning red in an amok psychotic overboil, and George McGovern sitting beside you telling you his philosophy of government. That will give you the general atmosphere.

In any case, by the time I received my doctorate in American

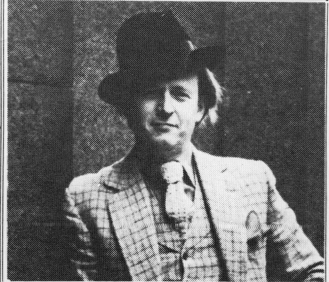

Tom Wolfe in 1968: Participant and observer in a time of change.

studies in 1957 I was in the twisted grip of a disease of our times in which the sufferer experiences an overwhelming urge to join the "real world." So I started working for newspapers. In 1962, after a cup of coffee here and there, I arrived at the *New York Herald Tribune* . . . This must be the place! . . . I looked out across the city room of the *Herald Tribune*, 100 moldering yards south of Times Square, with a feeling of amazed bohemian bliss . . . Either this is the real world, Tom, or there is no real world . . . The place looked like the receiving bin at the Good Will . . . a promiscuous heap of junk . . . Wreckage and exhaustion everywhere . . . If somebody such as the city editor had a swivel chair, the universal joint would be broken, so that every time he got up, the seat would keel over as if stricken by a lateral stroke. All the intestines of the building were left showing in diverticulitic loops and lines—electrical conduits, water pipes, steam pipes, effluvium ducts, sprinkler systems, all of it dangling and grunting from the ceiling, the walls, the columns. The whole mess, from top to bottom, was painted over in an industrial sludge, Lead Gray, Sub-

way Green, or that unbelievable dead red, that grim distemper of pigment and filth, that they paint the floor with in the tool and die works. On the ceiling were scalding banks of fluorescent lights, turning the atmosphere radium blue and burning bald spots in the crowns of the copy readers, who never moved. It was one big pie factory . . . A Landlord's Dream . . . There were no interior walls. The corporate hierarchy was not marked off into office spaces. The managing editor worked in a space that was as miserable and scabid as the lowest reporter's. Most newspapers were like that. This setup was instituted decades ago for practical reasons. But it was kept alive by a curious fact. On newspapers very few editorial employees at the bottom—namely, the reporters—had any ambition whatsoever to move up, to become city editors, managing editors, editors-in-chief, or any of the rest of it. Editors felt no threat from below. They needed no walls. Reporters didn't want much . . . merely to be *stars*! and of such minute wattage at that!

That was one thing they never wrote about in books on journalism or those comradely blind-

(continued on page 30)

40 CENTS

OCTOBER 26, 1970

NEW YORK

Notes on the Paralyzed Generation

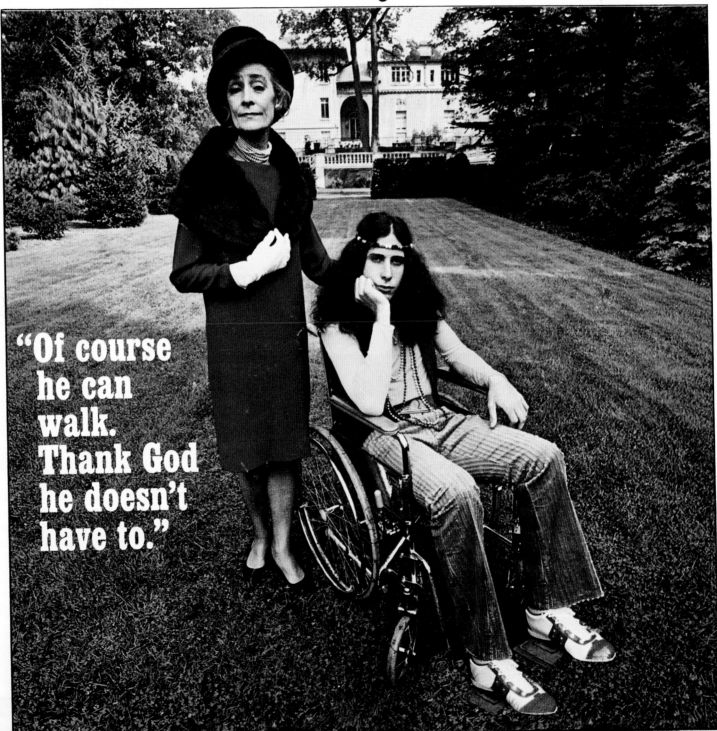

"Of course he can walk. Thank God he doesn't have to."

Family Outings: One-Day Trips Out of Town
The Underground Gourmet on Hand-Held Foods

40 CENTS

JUNE 9, 1969

NEW YORK

The (Liberated) Woman of the Year

You've Come a Long Way, Baby

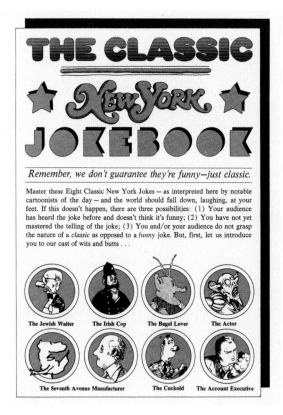

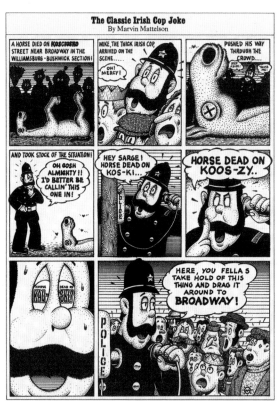

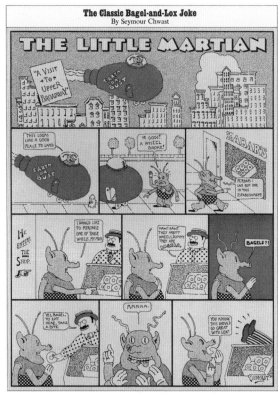

1973

Have you heard the one about the bankrupt city?

"We don't guarantee they're funny—just classic," read the copy. But "The Classic New York Jokebook" was also a chance for some of the cleverest illustrators in town to show their stuff, in a comic-book format that they'd pretty obviously admired as kids.

a puzzle page for her and Clay's new magazine. I was very interested in cryptic puzzles—Burt Shevelove had introduced me to the weekly one in *The Nation,* and then I got interested in British puzzles through the British papers. I used to do puzzles in a magazine called *The Listener* and in the *Sunday Observer,* and I thought it would be fun to spread the gospel in the United States.

Steinem: Obviously from his lyrics you can see that he is a champion wordsmith. He used to go every year to London to some banquet of Double-Crostic makers from around the world. The most arcane group of people!

Sondheim: I did it for about a year, and then I had to write *Company.* [Puzzle constructor] Dick Maltby had never done cryptics, and I said, "I bet he would do one for you, but I don't know if he could do one every week." And Burt suggested that maybe on alternate weeks, to give Dick a rest, the magazine do a literary competition. And Burt and I thought the perfect person to run it was Mary Ann Madden. [See page 413.] She was worried that nobody would send in any entries. So the first few weeks, we sent in a lot of entries under pseudonyms. Told her later.

The magazine ran on a shoestring budget, out of the fourth floor of Glaser's Push Pin Studios building on East 32nd Street.

Bernard: Do you know where our typesetter was, for the first six months? Philadelphia. We had messengers going back and forth.

Glaser: There'd be people replacing letters here, cutting in an *e* because there was a misprint.

Bernard: Because you couldn't send it back to Philadelphia to get an *e* fixed.

Glaser: It was the most perversely inappropriate way to put a magazine together you could imagine and yet somehow we did it every week.

Sheehy: You would arrive at the top of the stairs out of breath. The messengers, you always thought they were going to have a heart attack before they got into the newsroom. I had to borrow a desk. We had to wait until somebody went out to lunch.

Harkins: I sat under the skylight, which would drift snow down over us in the wintertime. We would sit there with gloves on to do our typing.

Bernard: We complained to the landlord, but he was ruthless.

Glaser: I wasn't going to give them a thing. [*Laughs*] Everybody, including Ruth Gilbert, who weighed 350 pounds, had to walk up those four flights every day, poor darling, and sit jammed up to somebody else.

Denson: She did "In and Around Town." Ruth was a tough customer. I was related to her, but boy, you got on her bad side, sometimes we didn't talk for a whole year.

Harkins: A woman from an art gallery called to say we'd not printed the name of her show, which was called something with "Excrement" in it. And Ruth told her, "Oh, go down on your grandmother!" I'd never heard anything like that—I was from Philadelphia, very proper. And then the woman called back, and told Marion, on the switchboard, "I want to speak to her supervisor," and Marion said, "I'm her supervisor."

Denson: There was a row of flat files in the center—Byron Dobell and Shelly Zalaznick and Milton and Clay would be standing around them discussing a story. It wasn't like an editorial meeting at a newspaper or something where you'd sit around the table.

Sheehy: Clay didn't really pencil-edit. I mean, his way of pencil editing—he'd say, "You'll need this on page three." He'd say, "This guy is the real story, is the lede."

Reeves: Clay was a great actor, when he was trying to push someone around—he'd be on the phone yelling at people as if he was totally out of control, and then he'd hang up the phone and turn and say, "Now, what were you saying?"

Patricof: People who were in my office then remember Clay calling me up and shouting at the top of his lungs. What I subsequently learned was that he was doing this, to a great extent, for the people sitting around him in the open office, so that they could hear him in this aggressive fashion, demonstrating his macho or whatever. I'd just put my hand over the speaker.

Harkins: The walls went only partway up, so we could hear everything. He would yell, mostly at Milton Glaser, and Glaser would boom back at him. We called them the Twin Towers.

In the fall of 1971, Steinem was planning a new magazine devoted to women and the women's movement. The 30-page preview issue of Ms. *was bound into the center of the December 20, 1971, issue of* New York.

Steinem: Clay, who had a great news sense, understood that there was something burgeoning out there that you might call the women's movement, and he had two answers to it. One was that he actually gathered together the women writers of *New York* and took a photograph of all of us, because he was thinking that he would do an issue or a magazine, or both, himself.

But his idea for the first cover story was the importation of more maids from Barbados and other places, because he was convinced that the problem was that women had two jobs. Which is not wrong! But he didn't get that it was a problem that could not be solved by the importation of maids, and that maids were part of the movement. So once he came up with that, I said, "Clay, you *cannot*. This is not something that can be done in this way. It has to happen autonomously."

And Clay, to his credit, said, "Okay, I need a theme for the year-end issue." There was always a big double issue in December. "So if I can pick 30 pages from your first preview issue, then I'll pay for the production as a sample."

Reeves: One of the things that made Clay successful was that he really liked and trusted women. People like [future literary agent] Binky Urban, Ruth Gilbert, and Gloria. I think a lot of men at that time, in that day and age, didn't want women around, or at least didn't want them around with power.

Steinem: He was thinking editorially and he well understood that this was news. He saw a solution for his year-end double issue, and also a way of testing whether or not this magazine could succeed on the newsstands. Had it not been for that test, we never could have raised money. And, to his credit, he never asked for a stake.

Wolfe: That was her start-up: a debut under the aegis of the most talked-about magazine in the country.

The magazine's ability to generate buzz also made writers eager to join up.

Sheehy: The fact that it was tiny and daring and on the edge is what made us believe in it. I mean, there wasn't anything else out there that was anything like it. The thing that you got back from people was not always *Oh, I loved your story*—it was, *How could you say that?*

Steinem: The initial group of writers had stock, a small amount—about $15,000. The reason I remember this is, I put it up for bail. You know the old women's prison that was in the Village? Well, there were friends in that prison that needed to get out for medical reasons—abortion reasons, actually. Clay got angry at me. He said, "You can't do that!" But he didn't keep me from doing it.

Sheehy: Jimmy Breslin and Tom Wolfe were constantly doing sociopolitical commentary on street life. With Breslin it was all about pimps and prostitutes and kneecappers and bail bondsmen, these great characters he created, and then Tom was constantly investigating status—such an important part of New York, with so many levels and sublevels. Tom's piece "The Me Decade"—he was such a master of language and satire, and that took up most of

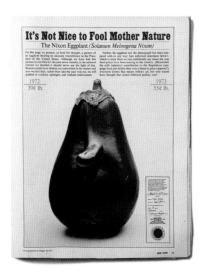

May 14, 1973:
The Nixon Eggplant.

the issue. I remember one of the biggest thrills of my life was to get a personal note from Tom Wolfe, typed, with his big flourishing signature, congratulating me for writing about "caste and class in the hustling trade." Because I was writing from the streetwalkers up to courtesans.

Reeves: I was doing pretty well at the *Times,* and Clay came up to me and said, "Why aren't you writing for *New York* Magazine?" I said, "Well, nobody ever asked me." I didn't take Clay seriously. I mean, *New York* was nice, but I wasn't about to move. Then, a few months later, I lived on West 11th Street, and there was a soup-and-sandwich café there, and Milton Glaser, who was then writing "The Underground Gourmet," did a piece on it saying this stuff was great. I looked out the window, and there was a line around the block, and I thought, "Oh, people are *really* reading this stuff."

Frank Rich *(writer, 2010–present):* I was in college, and I was captivated by it. The New York part of it was fascinating to me because I had always had a childhood fantasy of moving to New York, and Felker's *New York* brought home the glamour and the conflict and what we would now call the buzz of New York—the conversation about politics and culture—as nobody else did. It was so different from, at that time, the unbelievably dull and obligatory *New York Times Magazine.* It had ballsy critics—John Simon, Judith Crist. And a jazzy package that was so original and energizing in contrast to any conceivable competitor. And Nora [Ephron], who I'd later become friends with but who I was already reading when I was in college.

Corky Pollan *(writer and "Best Bets" editor, 1976–2000):* Binky Urban, who is now a big agent, hired me. I was responsible for getting Richard Reeves's column over the phone. He was in D.C. then, and he'd dictate it, and the errors were amazing because I had no idea what he was talking about.

Michael Wolff *(columnist, 1997–2004):* I had a story in the *Times Magazine* in 1974, and everybody called me, and I went to see Clay. I ultimately became very fond of Clay, but I had a bad reaction—he was intimidating, distracted, you could go through a list. So I didn't do it. I went to work for *New Times,* which was a kind of *New York* Magazine clone. Among the list of things you have to kick yourself for, that was certainly one.

John Ashbery *(poet; New York art critic, 1976–1980):* This was back in the typewriter days, when I was obliged to come in, personally, and wait around while the editorial changes were made. Once, I thought I was really going to have

a complete nervous breakdown. I'd typed my article up, at home, and grabbed a taxi on 23rd Street, and the driver had just had the aerial of his car ripped off and was in this insane rage. Then I somehow dropped my wallet in the street—there was snow on the ground—and I got to the office and I was just shaking and mildly hysterical.

Perhaps the most eccentric story of all walked through the door one day in late 1972.

Glaser: This woman walked in, huffing and puffing, having done the four flights. And she says, "Is Glaser here?" Someone pointed her in my direction. And she said, "I have a Nixon eggplant." I said, "I don't know what that is."

RitaSue Siegel *(subscriber):* I don't remember where I found it—it says Gristedes on the page, so I guess it was a Gristedes. I loved the magazine at that time. I had always admired Milton, and I thought this would be perfect and he'd appreciate it. Where else would I have taken it?

Glaser: She said, "Well, I have it with me." I said, "Okay, you want to show it to me?" And she took out a cardboard shoe box, and she opened it up. And there was this eggplant. And I said, "What's the big deal? It's just an eggplant." And she said, "Oh, yeah?" And she rotated it around, and there it was. The complete indication of art imitating life. I couldn't believe it, and I asked her if we could borrow it and photograph it, and she was very nice about it. Then we put it into the magazine with an authenticity stamp, saying that we didn't photo-retouch this thing. Mother Nature herself! It's still one of my very favorite things that we ever ran.

By 1976, the company had gone public. Felker had created a mini magazine empire, buying The Village Voice *and starting a California counterpart to* New York *called* New West. *The office had moved from the walk-up on 32nd Street to a much larger space on Second Avenue near 41st Street, behind the* Daily News *building.*

Reeves: Clay was always a big kid—a titan, but the truth is, he threw money away, and the problems he ran into were because he was spending too much.

Patricof: *New York* may have touched into the black for a quarter, then out of it, but it was never significantly profitable.

Reeves: Clay had utter contempt for the money people. He considered them lesser beings.

Joe Armstrong *(editor-in-chief and publisher, 1977–1980): New West* was [expected] to have lost I think $1.2 million its first year, and it lost

40 CENTS

JUNE 21, 1971

NEW YORK

OFFICIAL BALLOT

Fill out coupon below, put in envelope, and send to
The New York Magazine Poll, 207 East 32nd Street, New York, New York 10016

SHOULD NEW YORK CITY BECOME THE 51st STATE?

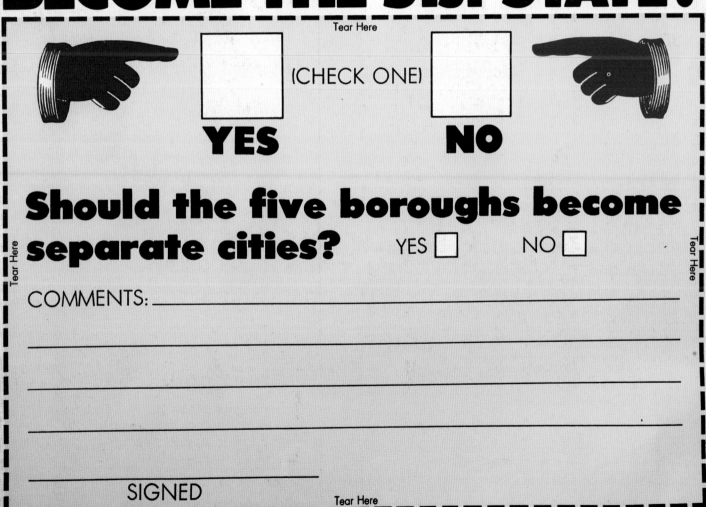

Tear Here

☐ (CHECK ONE) ☐

YES **NO**

Should the five boroughs become separate cities? YES ☐ NO ☐

COMMENTS: _____

SIGNED

Tear Here

January 17, 1977: After Felker's staff walked out, the next issue carried a note about "production difficulties."

four-something. Felker, spending just blank checks, bought the set of *All the President's Men,* and that became the furniture in the office. We were catty-corner with the Beverly Wilshire Hotel, the most expensive real estate in California, maybe the country. And that's why the shareholders wanted to sell.

John Berendt *(editor, 1977–1979):* The board of directors was really angry at him. Carter Burden, who was one of the major stockholders in the company—Clay antagonized him unnecessarily: "No one's going to give you a tin hat that says *publisher* written on it."

Patricof: I remember, like it was yesterday, having lunch or dinner with Clay and saying, Clay, you've got a board you don't like, you don't like the structure, you think you're being impeded by everyone—if I were you, I'd control my own destiny, and I would find someone that will buy the magazine at a reasonable price so you don't have to deal with all of us! That was a friendly gesture. I know, for a fact, that was 1975. And he floated the idea with Rupert Murdoch of buying the company. And it fell apart; Clay didn't like the terms.

At the end of 1976, Murdoch and Felker found themselves at Elaine's one night, talking. Murdoch let on that he was having trouble buying the Observer, *in London, because the paper's board was trying to block his bid. Felker, in turn, told Murdoch that he too was having a lot of trouble with his board. Over the next couple of weeks, as Felker tried to fight him off, Murdoch persuaded Burden and the rest of* New York's *large stockholders to sell in what amounted to a hostile takeover, and Felker knew he would lose his magazine.*

Patricof: I was friendly with a guy named Stanley Shuman, who was at Allen & Company—still is—and Stanley said that Rupert would really like to buy it. And I said, "Stanley, does he understand that if he buys it, he's buying Clay and has got to take on the responsibility of dealing with Clay, who will not be a happy person?" But I was worried that we were going to run out of money. Stanley talked to Rupert, and maybe I met with Rupert—I must have—and I told him the facts. "The financials are public; the board is just tired of dealing with Clay."

Denson: It was such a betrayal. It still seems so traumatic to see how Clay was treated.

Sheehy: We had the horrible meeting where we were brought in. "We'll have the writers now," and we were brought in like a bunch of scruffy dogs. Byron Dobell made an impassioned plea: "You people don't know what a talent package

April 26, 1976:
New West, *the California counterpart to* New York, *launched.*

is." Then Murdoch pitched Clay right on the spot to stay and be his editor, and Clay said, "I can't do that." He knew that he couldn't work for anybody, really.

Harkins: We were horrified that Clay had been bounced. We met in some restaurant and he explained what had just happened, and Byron Dobell and the other two top editors initiated a strike—which turned out to be a one-day strike.

Reeves: There was a bar across the street where we met in our revolt. Walter Bernard had hidden the pages for the next issue, and frankly I think we all knew where they were hidden. Win Maxwell [husband of Jane Maxwell, Felker's assistant], who felt that was committing a crime, went back into the building and got those things for Murdoch. I don't think he ever worked for Murdoch—I just think he thought it was dishonest and wrong. We all knew he did it. They would not have been able to come out for two issues.

After the walkout, James Brady, a former editor of New York's *"Intelligencer" column who had moved over to work for Murdoch, came back in to run the magazine for a few months before the reins were handed over to Joe Armstrong, hired from* Rolling Stone.

Armstrong: I remember one key thing that made me really want the job. In the summer of '77, there was the blackout, and *New York* Magazine, just after the blackout, had a cover: the chocolate-chip-cookie wars. And there was another one about plants. Plants! So I just thought, *I have to go have that job,* to make that magazine relevant again.

Berendt: Murdoch knew of Joe and asked him to be editor.

Armstrong: *New York*'s ad revenues were down 16 or 17 percent. And *New West* was another story: It was losing, I'd say, $4.6 million a year—a house on fire. The economy was terrible, inflation out of control. I really thought *New York* and *New West* deserved to be saved, and there was so much to do. What I did not know until I got the job is that they had taken every Rolodex. They had taken the index—we didn't even know what had run when! The files were all gone, and we still had to put out a weekly magazine.

Berendt: It was clear that Joe didn't have any background in editing the magazine, and that's when he brought me in. I felt terrible for Clay, and when I was offered the job of editor, I mentioned it to him. He said, "Do what you can—do it."

75 CENTS

MAY 3, 1976

New York

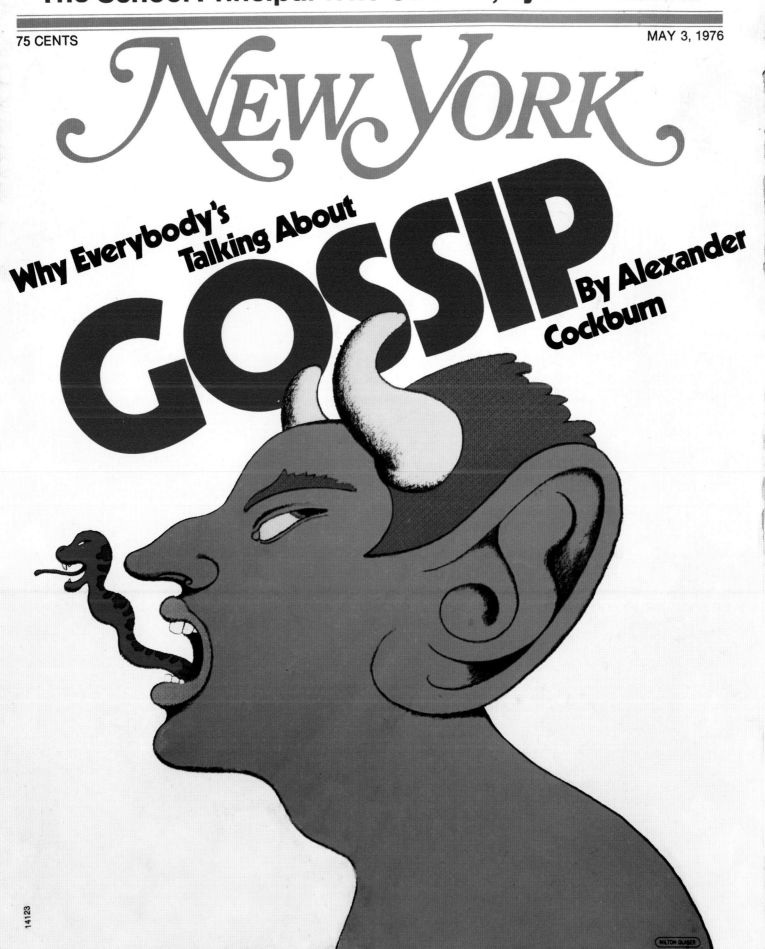

Why Everybody's Talking About **GOSSIP** By Alexander Cockburn

14123

Love in El Barrio: An Intimate Report by Oscar Lewis
Tom Wolfe's Latest Look at The New Life Out There

40 CENTS

DECEMBER 9, 1968

New York

Why Everybody
in New York
Feels Poor

I MAKE $80,000 A YEAR AND I'M BROKE

Marvelous Marv and Mario, by Jimmy Breslin
Uptight in Riverdale, by Fred Ferretti
Giants Coach Alex Webster: New Hope or No Hope?

40 CENTS

OCTOBER 6, 1969

NEW YORK

The New York Times

How the
New York Times
Covers the
Beautiful
People

Barry Goldwater Looks Back at Everything
Real Cowboy Gear: New Sexy Fashion
Where to Buy the First Prefab Solar Houses

75 CENTS

AUGUST 23, 1976

New York

Tom Wolfe

Reports on America's New Great Awakening:

THE "ME" DECADE

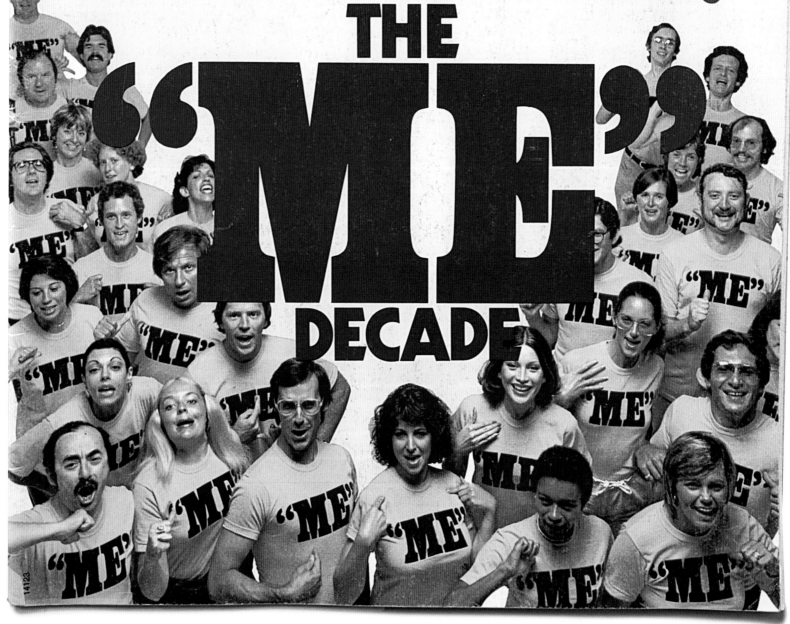

Armstrong: When Murdoch would want things put in, or taken out, I couldn't tell people on the staff some of the things that he would say or do. David Begelman was the head of Columbia Pictures. We came out with an article that showed that when he'd been an agent, he had forged Judy Garland's checks, all this other stuff. Well, I had the article off the printing press and flew back to New York and told Murdoch I had to come see him on Sunday night. His bankers were Allen & Company—they ran Columbia Pictures. Showed him the article. He threw it across the room. He said, *"This better be true,"* but he was so pissed off.

Berendt: On Studio 54, the writer, Henry Post—he was terrific. He got into the personalities involved. He was friendly with the owners, Steve Rubell and Ian Schrager. He knew what was all going on. I mean, he was back there snorting coke, I gather.

Armstrong: I'd run a picture in that story of Roy Cohn cuddling with Steve Rubell, with his arms all around him and everything, and that really set [Cohn] off because he was so homophobic.

Berendt: I was not interested in service journalism at all. But I had had a couple of Bloody Marys at Maxwell's Plum, and they didn't light my fire.

Armstrong: Maxwell's Plum, which was on First Avenue and 64th, was the biggest, hottest place in town. Warner LeRoy had started it.

Berendt: So I assigned some editors go out on a Sunday to all of the brunch places—like 20 of them—and order Bloody Marys and pour them into a specimen container and take it to a lab to see how much alcohol was in them. Maxwell's Plum had zero—the only one that had zero—so that was a story. Eventually, Maxwell's Plum served Bloody Mary mix in a big glass and a shot glass of vodka on the side, so that people knew what they were getting.

Armstrong: Warner LeRoy did send me a case of vodka—the strongest-proof vodka that you could have. I sent Warner LeRoy a case of Breathalyzers.

Armstrong and Berendt's relationship soured, and Berendt was fired in 1979. A few months later, Murdoch removed Armstrong as well, replacing him with Edward Kosner, who'd run Newsweek.

Edward Kosner *(editor-in-chief, 1980–1993):* One really cold, grim winter afternoon, the phone rang, and when I picked it up it was Murdoch. And without any foreplay he said, "Would you be interested in talking about being the editor of *New York*?" And I said, "Sure." And I went up to meet him. I came equipped with a mental list of the points I was going to make about what would be needed to revitalize *New York*—improving the service pieces, getting the real writers back, making the ideas better, the covers better, the captions better, the whole business. And the importance of having cover stories about subjects that people in New York were interested in. Before I took over, one cover was "New York's Windiest Corners." They'd lost the thread. Anyway, before I could open my mouth he gave me a three-minute recitation of what he thought needed to be done. Which was precisely what I had come to say, so I knew that it was not going to be a problem.

Armstrong: They bought *Cue* magazine, just a bunch of listings, the day after I left. I'm sure it improved the circulation numbers.

Kosner: In the best periods of *New York* Magazine, the service stuff is always great. You had to have the topical, interesting stuff, but you also had to have that undercarriage of useful service, which would be something that would bind people to the magazine, more so than the itinerant pleasures of what any particular cover story might be.

The other thing was the trend stories, some of which were frivolous but some of which were very good—like "Downward Mobility" and "Forever Single" and "Living in Tight Spaces." You don't want to be *too* serious; you don't want to be shallow. But you don't want to be too parochial either. Julie [Baumgold], my wife, did a two-part piece on Truman Capote, which was called "Unanswered Prayers," and the cover was a Warhol of Capote, or something that looked like a Warhol of Capote, and she uncovered all this stuff—Capote had actually not written anything, although the myth went around that he had this great masterpiece. And Michael Daly did a series of true-crime cover stories over the years that were just great. People loved them.

Pollan: Nancy McKeon was hired to do the first entertaining issues—and we had no idea what we were doing. I think we didn't know that most magazines doing those kinds of issues had a whole crew doing it. We would find people who were going to have a party; we would go with photographers and shoot the party.

Chris Smith *(writer, 1986-present):* Kosner's magazine was a place of definitive takes—you had Patricia Morrisroe on Mapplethorpe and Jeanie Kasindorf on Bess Myerson, for instance. It was a place that spotted trends and coined terms—Amy Virshup with "Club Kids" and David Blum with "The Brat Pack." It was

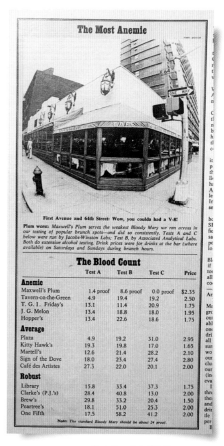

October 24, 1977: The bloodless Bloody Mary, unmasked.

April 24, 1978: An odd cover choice.

17

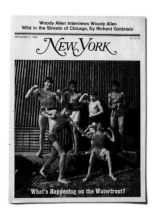

Woody Allen interviews Woody Allen
Wild in the Streets of Chicago, by Richard Goldstein
NEW YORK
What's Happening on the Waterfront?

A City Councilman's Life as a Cab Driver
Gentile's Guide to Jewish Food: Dairy Restaurants
NEW YORK
Wall Street's New Way To Make Money
The Hedge Fund

The Decision Not to Have Children, by Gail Sheehy
In Praise of Arrogant Athletes, by Heywood Hale Broun
NEW YORK
HARLEM ON MY MIND
A Preview of the Metropolitan Museum's Controversial New Show

Tom Wolfe on the Etiquette of Streetfights
'Adam Smith' on the Creation of Supercurrency
Gloria Steinem on the Women's Revolution
NEW YORK
Namath All Night Long By Jimmy Breslin

Why the City Doesn't Get Its Share of Federal Money
Planning the High School Revolt
NEW YORK
This is Occasioned Mutual Involvement: Desirable
This is Unsuitable Mutual Involvement: Undesirable
The Hidden Meanings of New York Parties.

The Amphetamine Explosion by Gail Sheehy
An Intimate Story of the "Magic Vitamin" and Its Consequences
NEW YORK
SPEED CITY

Notes on the Performance Game, by 'Adam Smith'
Wall Street Lawyers Reconsidered
Hoving After 'Harlem,' by Barbara Goldsmith
NEW YORK
Can Hypnosis Really Stop You From Smoking?

Joe Namath on Dumb Sportswriters
The Curse of Car-Owning in Manhattan
NEW YORK
How the Middle Class Turns On
New York's Secret Pot Smokers

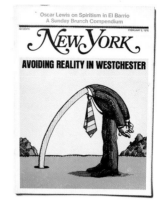

Oscar Lewis on Spiritism in El Barrio
A Sunday Brunch Compendium
NEW YORK
AVOIDING REALITY IN WESTCHESTER

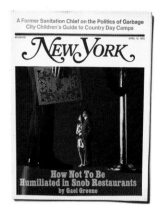

A Former Sanitation Chief on the Politics of Garbage
City Children's Guide to Country Day Camps
NEW YORK
How Not To Be Humiliated in Snob Restaurants
by Gael Greene

Political Love Styles, by Gloria Steinem
Wall Street's Broken Brokers
Bombing on the Mind, by Gail Sheehy
NEW YORK

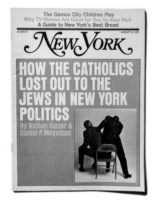

The Games City Children Play
Why TV Movies Are Good for You, by Alan Rich
A Guide to New York's Best Bread
NEW YORK
HOW THE CATHOLICS LOST OUT TO THE JEWS IN NEW YORK POLITICS
By Nathan Glazer & Daniel P. Moynihan

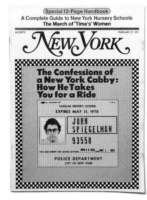

Special 12-Page Handbook
A Complete Guide to New York Nursery Schools
The March of 'Time's' Women
NEW YORK
The Confessions of a New York Cabby: How He Takes You for a Ride
TAXICAB DRIVER'S LICENSE
EXPIRES MAY 31, 1970
JOHN SPIEGELMAN
93558
POLICE DEPARTMENT
CITY OF NEW YORK

A New World Beckons to the City Chemical
NEW YORK
Fall Catalog
DRIVING OUT THE DEMONS
AND LETTING THE GOOD TIMES IN
The Rites of Fall

Special 8-Page Handbook:
A Critical Guide to New York Abortion Facilities
Mafia Maps: Where To Find Your Local Subtonsan
NEW YORK
Fire Island Behavior—Will It Spread To the Mainland?

And Now for the Good News at Time Inc.
Nights at The Rainbow Room with Gael Greene
What the Census Says About New York
NEW YORK
MALE CHAUVINISM IN THE OFFICE
An Hour-by-Hour Report on Men's Ingenious Last-Ditch Stand

The True Confessions of Thomas Hoving
The Underground Gourmet's 1973 Pastrami Olympics
Writers' Block: Why Words Fail Them
NEW YORK
IS THIS THE END OF WALL STREET'S FAT CATS?

How I invented the LP Record, by Peter Goldmark
The Rise and Fall of the New York Taxi, by Edward Sorel
Eating Well on Mail-Order Foods, by Mimi Sheraton
NEW YORK
Trouble With Jewish-Gentile Marriages

How Greenwich Village Got That Way, by Barbara Gelb
Remembering the Fun and Games of Babe Ruth
Golden Days of Barry Goldwater, by Nick Thimmesch
NEW YORK
Living with a Fussy Man
Match Your Home Decorating Taste With Top Art Directors

Jack Javits, a Burnt-out Case? by Richard Reeves
An Eater's Guide to Italian Street Festivals
The Most Powerful Black in Town, by Nicholas Pileggi
NEW YORK
What Are Your Chances of Surviving A High-Rise Fire?

Hard Partying at the New Discotheques
Smartest Man on Wall Street, by Dan Dorfman
Jim Bouton Tells the Yanks and Mets How to Win
NEW YORK
Answers to the Kissinger Riddle Is He Really Indispensable?

Why Killers Get Away with Murder, by Robert Daley
Cool Cafés Where You Can Linger
Is Samuels Selling Out the City? by Michael Kramer
NEW YORK
Dick Cavett Bares All
(And Talks About Sex, Celebrity Status, and Comic Genius)

How Ford Could Deal With Inflation, by Dan Dorfman
NEW YORK
The Burger That's Eating New York
Mimi Sheraton's Case Against McDonald's:
"...The meat is ground, kneaded, extruded, insulated in a soggy bun...the shakes are like aerated Kaopectate..."

Press Paranoia, by Katharine Graham
Restaurants for Romeos, by Gael Greene
New Music in Town: Jamaican Reggae
NEW YORK
Divorce Fever
Why Everybody's Splitting

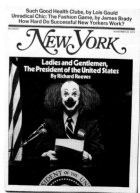

Such Good Health Clubs, by Lois Gould
Unradical Chic: The Fashion Game, by James Brady
How Hard Do Successful New Yorkers Work?
NEW YORK
Ladies and Gentlemen, The President of the United States
By Richard Reeves

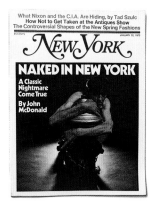

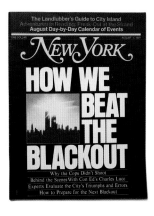

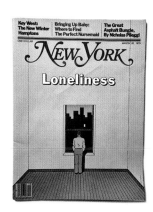
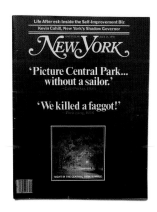

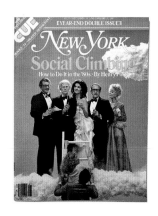
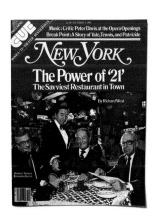
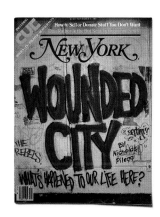
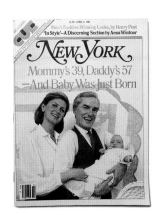
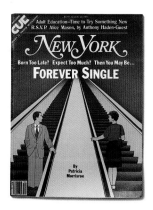

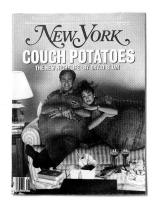

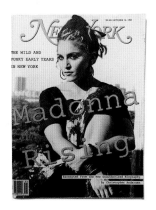
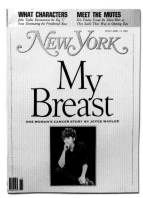

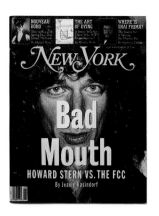

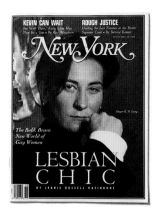

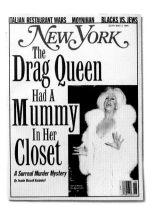

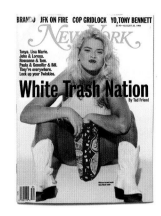

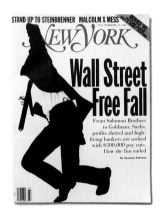

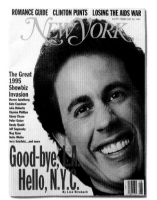

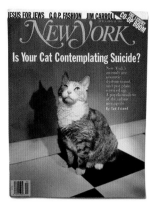

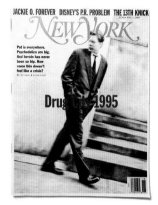

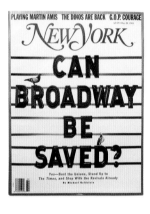

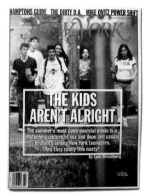

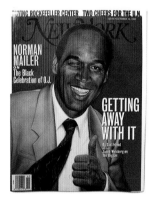

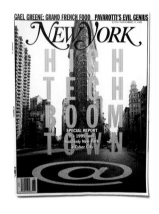

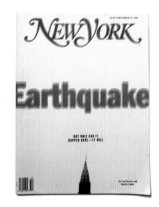

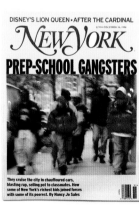

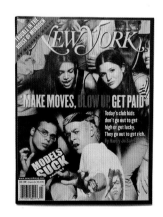

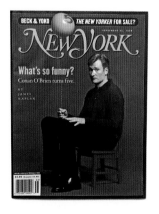

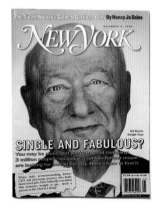

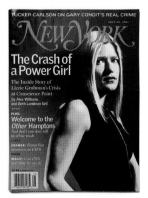

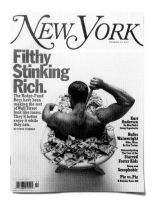

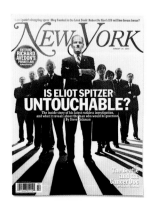

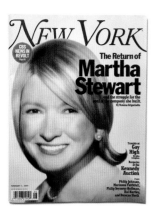

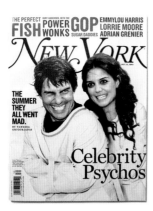

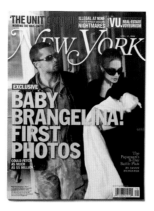

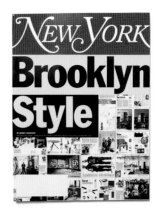

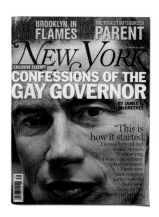

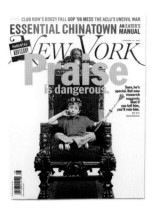

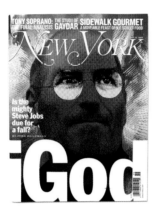

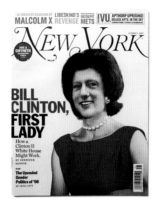

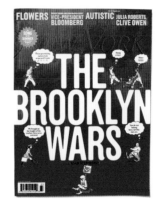

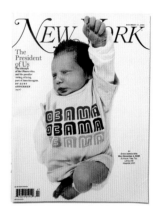

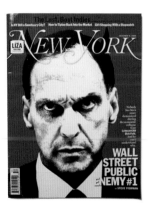

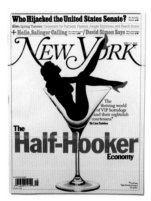

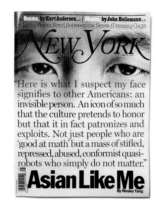

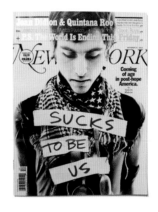

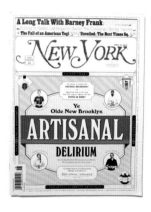

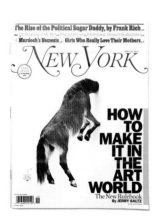

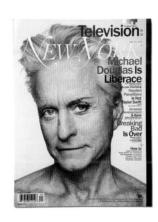

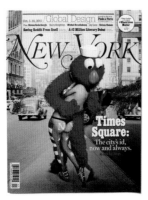

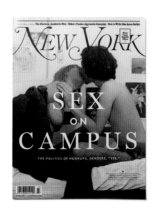

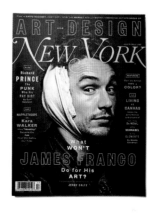

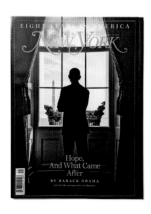

"It had a Jewish spine."

"There's no understanding New York without understanding that context—this Eastern European ironic stance coupled with this incredible desire for accomplishment."
—*Milton Glaser*

a place that had the power to make or break restaurants (with Gael Greene) and shows (with John Simon) and stores (with Corky Pollan).

Jean-Georges Vongerichten *(chef):* A Gael Greene review from 1986 changed my life. At the time she had a sharp pencil; it was not the most flattering. She made me understand New York. I had no idea what people were expecting. I thought people in New York had, like, three hours for lunch and five hours for dinner. In France, people go to a high-end restaurant for special occasions; they eat at home every day. I didn't realize that in New York people eat at home as an occasion and go to a restaurant every day. So the food has to be faster, lighter, healthier. I started to do the juices, the vegetable products. The first time [I offered] as a special a lentil soup like my mom would do at home, people were on their knees: "My God, do this again!" That review—it made me throw everything out and start from scratch.

Kosner: Murdoch understood that *New York* had to be an upscale magazine. The more upscale stuff we did, the happier he was. He never, ever wanted *New York* to have any tabloid dimension at all. In the periods when the magazine strayed from that, that's when it's gotten into trouble.

I worked for him for 13 years and he had one negative comment about a story. One! Marie Brenner did a piece about Cornelia Guest, the daughter of C. Z. Guest, kind of a satirical column—not nasty, but with an edge. And the phone rings and it's Murdoch, and he says, "You know, that Marie thing, she's really only a kid. She's 18. You think that was right?" I said, "Yeah, it was a little sharp." And that was the only editorial criticism I ever got from him in 13 years.

Armstrong: What Ed wants you to think is, Murdoch left him alone because he's so respected. No. He went off and bought the London *Times,* and then 20th Century Fox. He was onto other conquests. He wasn't interested anymore! Had nothing to do with "now we have a grown-up in the building."

Kosner: We were making money, he liked that his friends would tell him that they liked the magazine, and his real political interest then, before Fox News, was in newspapers. We were making $8 million, $9 million, on $50 million revenue. I mean, to be making a 20 percent margin on a weekly magazine was unheard of.

Anna Wintour *(fashion editor, 1981–1984):* There were incredible writers, people covering crime and politics—at that time very male-dominated areas—and they didn't really absolutely know what to do with me. They gave me a desk next to the ladies' room. I think that

they had had a somewhat bumpy run before me, so I think Ed was just relieved to have someone that loved fashion, and loved designers. But— and I learned this from him early on—once he understood that someone knew what they were doing, he would leave them alone. He was a great delegator. There's something that was so much fun about working on a weekly—if it was great it was out there, and if it was bad it was gone quite quickly. I miss it to this day.

Pollan: Well, Anna hated "Best Bets." Absolutely hated it. She was on vacation, and her very sweet assistant, Ginger, was told to please take a look at "Best Bets" because it always looks so horrible. And she left that memo in the copy machine, where someone found it.

Wintour: One of the shoots that I remember most clearly was of Basquiat and David Salle and all those artists coming out of the New York scene, and instead of just shooting the clothes, I asked all those different artists to paint them, and we shot the looks in front of the finished canvases. [See page 388.] Ed gave you so much creative freedom. He really taught me to be an editor.

Adam Moss *(editor-in-chief, 2004–present):* In 1988 I became the editor of a new magazine called *7 Days,* which was meant to sit in the market between *The Village Voice* and *New York.* My sense of *New York* then was that it seemed very Establishment, big, un-idiosyncratic, very much of the Upper East and Upper West Sides. It was the Man, and we saw ourselves as the little guerrilla operation against it. But it turned out that *New York* was a far more formidable competitor than we ever imagined. We wrote from the outside, they wrote from the inside, and the inside was a powerful place to occupy.

Wolff: Even with these disparate owners, *New York* manages to maintain a sense of itself. I might even argue that *New York* Magazine becomes the *New York* Magazine we know under Kosner, and not under Felker.

Smith: The magazine thrived commercially and journalistically by being at the center of an explosion in upper-middle-class mobility, in things like food and condominiums and travel. Nobody was better than Julie Baumgold at covering crazy Upper East Side rich people. And we covered a hell of a lot of Trump. Joe Klein—he put Bill Clinton on the national-media map in a way that was extraordinarily important at the time. He validated Clinton at a moment when people didn't really know who he was.

Kosner: The headline [see gatefold 2-H] was "Who Is This Guy?," which was exactly the question that everybody had in January of 1992, as the election year was really beginning. And if

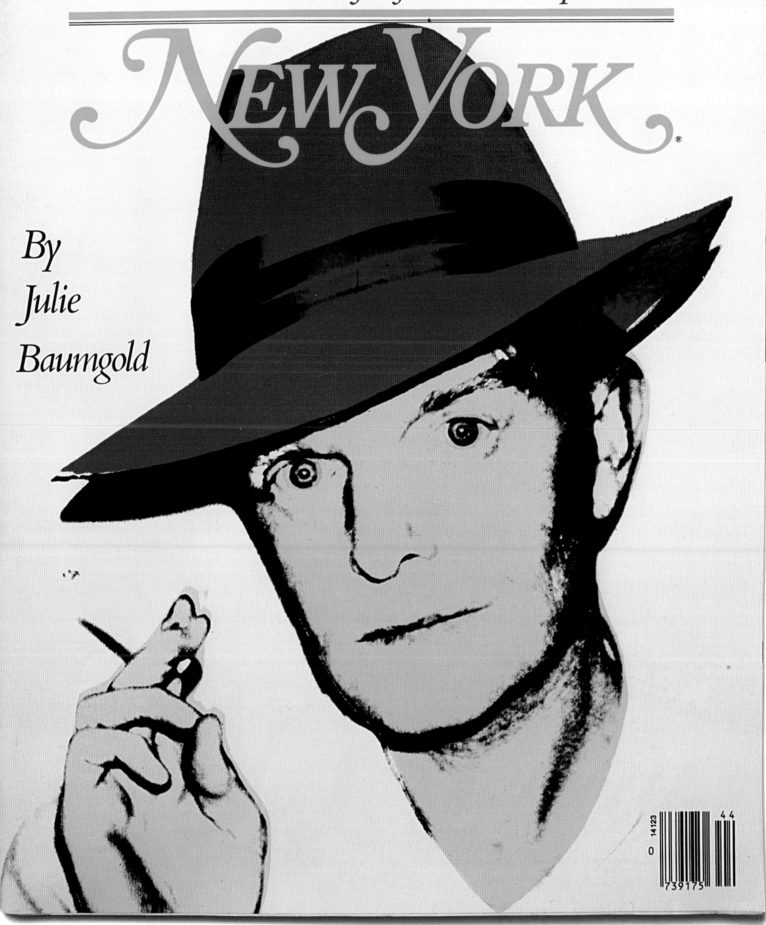

$1.75 • OCTOBER 29, 1984

Unanswered Prayers
The Death and Life of Truman Capote

NewYork

*By
Julie
Baumgold*

August 5, 1996: A story that may have pushed the magazine's owners too far.

October 14, 1996: Stainless-steel kitchens begat a stainless-steel cover.

you look at the story, it's pretty good! It captures a lot of Clinton—his grasp of the issues and his charm—and it took you into his world, and the world to come.

Smith: My first day as Joe Klein's assistant, I heard him yelling, long and loud, at someone on the phone. Joe hangs up and says, "Mario." Cuomo. The governor.

In 1991, Rupert Murdoch cashed out of most of his magazine holdings, selling New York *to K-III, a subsidiary of the investment firm Kohlberg Kravis Roberts that owned more than 200 hobbyist and trade magazines.*

Wolff: K-III—that was a weird company. Wackadoo stuff. They owned *National Hog Farmer*—hundreds of those magazines.

Kosner: Don't get me started on K-III. They thought that they were smarter than Murdoch. And they thought that they could come in and do the standard private-equity game, where they buy the thing, increase the profitability by running it more efficiently, and then cash out after five years. I told them, "You know, Murdoch ran a very, very frugal operation. There was no fat to cut." And they rapidly discovered that. So when the economy tanked and ad sales suffered, the profits began to melt like an ice cube on a stove.

The new owners began pressuring Kosner to economize, and three years later, he left to edit Esquire. *K-III then hired Kurt Andersen, the co-founder of* Spy, *to remake the magazine.*

Kurt Andersen *(editor-in-chief, 1994–1996):* They wanted to put some edge back in the magazine. *Edge* was what they wanted—they used that word, many times.

Michael Hirschorn *(executive editor, 1994–1996):* Spy altered the world of magazines in such a fundamental way that anything that lacked that bite and extra ten IQ points suddenly started feeling a bit bland.

Andersen: I felt like this was really an uptown magazine, for Upper West Siders and Upper East Siders, with the occasional editorial forays into my downtown world. I was 39 when I got the job and living in Brooklyn. And, well, that's a different person. Generationally, too. I thought it was this incredibly great thing—a franchise that could be updated and made interesting and exciting in new ways.

Hirschorn: To a shocking degree, the readers of *New York* Magazine lived between 60th and 96th Street on the East and West Sides.

It was astonishing—I think it was the case that 50 percent of all residents in those two areas were already subscribers. Spectacular market penetration, with an obvious ceiling. The Brooklynization of New York was just beginning to happen. So, in making it a little cooler and less bougie, we would start tapping into some of those transformations that were happening.

Andersen: One thing I remember was the pre-modern nature of the place. There were some computers, but the art department was putting layouts together with, like, wax.

Hirschorn: We were definitely understaffed—I don't think I ever worked harder. We were there regularly till two in the morning.

John Homans *(editor, 1994–2014):* Massive snafus. I do remember working till nine in the morning on one of those issues.

Hirschorn: But it sort of seemed cool somehow. Everybody was in their 20s or early 30s; everyone was kind of cute. Gwyneth Paltrow's entire Spence class, sans Gwyneth Paltrow, was working there. It was not a hugely diverse place, but we had a really deep roster of quirky people who brought an infusion of weirdo energy. I think Jerry Seinfeld was reading *New York* Magazine, so a number of the stories we did, they would then end up as a *Seinfeld* episode. Without ever talking to each other, we had a kind of symbiotic relationship.

Andersen: I remember trying to convince a few bossish people at the time that this online thing—we should really get in on this. We need to have a website. I remember thinking, *Wow, "Best Bets" on the web. What could* that *mean?*

Hirschorn: It was a different time in the sense that I don't think media properties were hyper-market-tested expressions of broader corporate strategy, in the way they are now, with the notable exception of *New York* Magazine. So the idea of the auteur-editor was one that people still believed in. I don't know that the magazine was overly downtown or young, but it was very Kurt. If you didn't like that, it was bad. If you liked that, it was good.

Andersen was abruptly fired in the summer of 1996, and Caroline Miller, from Seventeen *magazine, replaced him.*

Hirschorn: I've always struggled with the slight fear that I'd gotten Kurt fired accidentally. We did a package on the Hamptons that I think was awesome: a team of about 15 people spending 48 hours in the Hamptons to do a sociological critique of the hidden energies and economic power structure—the gardeners, contractors,

NEW YORK

DECEMBER 15, 1997

She met Alec Wildenstein on a safari. Twenty years later, he chased her out of their house with a gun.

THE LION QUEEN

A tale of love, divorce, and plastic surgery in the art world's richest family. By Eric Konigsberg

Facial attraction: Jocelyne Wildenstein and her husband, Alec.

$2.95 (Canada $3.95)

50>
18225
0 739175 0

bartenders. It ended up outraging [KKR partner] Henry Kravis, because he felt that it was mocking the world he inhabited and that he believed *New York* Magazine inhabited.

Andersen: The only shit I had ever gotten—and it wasn't even shit—was Henry Kravis inviting me to his house for breakfast and saying, "Don't cover Wall Street. It's inconvenient and awkward for me to have this magazine that I own covering Wall Street." I said, "Sir, it's *New York* Magazine. Occasionally, we're going to be covering Wall Street." When I was called up there to be fired, I really felt like, *What's this about? Maybe they want to give me a bigger job.*

Hirschorn: After Kurt was fired, I was put in charge of the magazine, and told that I was very likely to be the next editor, and it was obvious within a day or so that they were just lying to me to keep me around. I remember taking some really bold risks. The all-stainless-steel cover— that felt like a risk we could take without paying much of a penalty for it. The audience for *New York* Magazine was so attuned to what we were doing. It felt like a mind meld between us and the audience.

Wolff: The magazine had a moment of controversy when Kurt was pushed out, Kurt being a particular darling of a particular set.

Caroline Miller *(editor-in-chief, 1996–2004):* I had a conversation with Clay Felker at the beginning, and he said, "New York is a meritocracy, and the most recent incarnation of the magazine doesn't get that. It should be for people who are aspiring, to give them a road map to help them understand where they want to be going." My marching orders were really to make it more tuned into the sensibilities of New Yorkers in a broad way.

Homans: It was a fascinating but problematic era in New York City, that *Sex and the City* era, in which there was this enormous commercial social life. It was a kind of interesting subculture to some degree, but there was something corrupt about it. The magazine had to negotiate that, and we did a pretty good job.

Jared Hohlt *(editor, 2001–present):* I remember going through my training and seeing this totally strange array of magazines. Caroline was an editor who wanted big stories, and was up against a tight budget, and a corporate structure that was increasingly pushing forth things that they understood in the marketplace. She figured out a way to navigate through that.

Miller: There were quite a few people that I was dying to hire, but we had very little money, so our biggest successes were people who were younger and extremely talented: Ariel Levy and Vanessa

Grigoriadis and Jen Senior and Bob Kolker and Sue Dominus. We grew a lot of talent that *The New Yorker* later took advantage of, and the *Times*. Robin Raisfeld and Rob Patronite, speaking of homegrown talent—they're able to write about food in a way that was unpretentious but extremely colorful and appealing and not extreme.

Wolff: We were just at the verge of talking about digital media, in this moment of transformation.

Miller: Michael [Wolff] did a lot, added value. He really liked to try to express the mood and all the implications of the moment, psychically, and where we were.

Wolff: Almost from the first column, there was this response—I have never, ever, had the kind of response that I had in *New York*.

Miller: One of the things that we used to joke about at *New York* Magazine was that every New Yorker was an uninvited guest editor. *Everyone* had ideas about how they would do it.

Hohlt: My first real memory of working on an issue was in the Lizzie Grubman era. The magazine had a cast of characters that it covered, and it's hard to imagine any magazine devoting that energy level to it now, but at that time…

Homans: The dénouement of that era was when Lizzie Grubman crashed into a nightclub in Southampton. It was a crass time. And then 9/11 released the city—at a massive cost, much too high a cost—from a crass era.

Miller: I was having breakfast with Tim Zagat, and the manager tells us "a plane has flown into the World Trade Center," and we went downstairs and watched the first tower fall down on television. And I walked down to the office, and saw the second tower fall—they used to have a big TV screen on the Trump Building, the old GM Building.

Hohlt: I remember watching everybody's instincts kick in, especially Homans's.

Miller: Everyone knew what to do.

Homans: The magazine changed completely. For a couple of months, every single piece of it was news about the culture of 9/11, which was developing. You look at that culture now—the flags, all the emotion—and it's a little embarrassing, but that's what people felt.

Miller: And the other thing: My office was right above St. Patrick's. For *weeks* there were funerals there, and I could hear them. Twice a day, three times a day—first you'd hear the bagpipes, and then you'd hear "Amazing Grace."

In the new century, K-III—under its new name, Primedia—began to sell off its magazine business in chunks. In late 2003, New York *was put up for sale, and several groups bid. Michael Wolff assembled a group of several billionaires.*

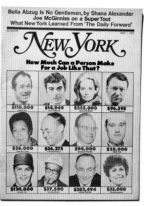

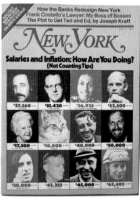

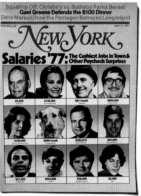

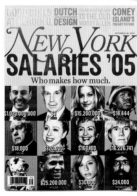

How much do you make? How about your neighbors?

"Every aspect of life was evaluated by so many of us—the caste, the class, the salaries. I remember the uproar when the magazine first published what New Yorkers made for a living. It was so shocking—it's one of the most sensitive secrets that we hold dear."
—*Gail Sheehy*

"The New York 'Times' covered the city as government, and 'New York' covered the city as millions of people."

—RICHARD REEVES

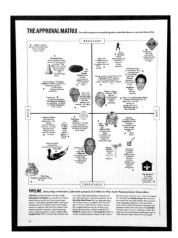

Summer 2004: One of the (many) prototypes for "The Approval Matrix." The lowbrow-to-highbrow axis goes left-to-right instead of bottom-to-top.

American Media, owners of The Star *and* The National Enquirer, *also put in an offer. So did Bruce Wasserstein, co-founder of the investment bank Wasserstein Perella & Co. and chairman of the investment bank Lazard Frères.*

Pam Wasserstein (*co-owner, 2003–present; CEO, 2016–present*): My father was always interested in journalism—he was the executive editor of *The Michigan Daily* when he was in college, and he named a child Scoop. And Wasserstein Perella owned *The Deal* and *The American Lawyer*. He had it in his bones.

Wolff: As a media columnist, I was this odd inside-outside figure. I knew everybody, and everybody was suspicious of me, attentive to me, currying favor with me. And so they put the magazine up for sale, and I thought, hell, why not? And I put together this group of monsters, billionaires, including Mort Zuckerman and Harvey Weinstein and Jeffrey Epstein. During this process, I began to think, *Oh, if this happens, I'm really screwed.*

Wasserstein: I do remember that, when there was a lot of talk about some of the other bidders, my father felt that his advantage was that he knows how to do a deal—does them all day long. I think he made it easy for Primedia to go with him. And I think he thought it was attractive as a business.

Wolff: These guys were having so much fun talking to each other that they took their eye off the ball, and then Bruce Wasserstein came in at the last minute. And then I had to fall on my sword. That dawning recognition: Oh. Oh! *Oooookay.* But it was a relief.

Wasserstein hired Adam Moss away from the Times, *where he had edited the Sunday magazine, and invested heavily in the digital part of the business. Moss commenced a redesign that rolled out over the course of three separate issues in the fall of 2004.*

Moss: Primedia saw *New York* very much as a provincial magazine of New York City, not dissimilar from other regional and city magazines. That's not how I understood it, and I made no secret of the fact that I wanted to rethink this thing from the beginning, and no one had any idea of what that would end up as, including me.

Homans: There was always a sense that concessions had to be made to these older commercial notions—that the magazine was one particular kind of thing—and Adam said, "Well, it doesn't." That was liberating.

Luke Hayman (*design director, 2004–2006*): It had been quite ornate, quite heavy with color. We immediately went to this transition period where we stripped everything out. And then the prototype was interesting—Adam had a series of meetings where people got together in groups and came up with ideas.

Moss: We had to still put out a weekly and at the same time we would stay till the wee hours of the night making and then ripping up and then remaking this other future magazine. We really didn't know what we were doing but we eventually figured something out.

Emily Nussbaum (*culture editor and writer, 2004–2011*): That whole spring was just so nuts. How were we doing this? I do have these weird, fond memories of this bizarre period of drafting, and talking about the name of this new section—"Should we call it 'The Culture Pages'?"

Hayman: Adam wanted every page to do as much as possible—so many captions and sidebars, so intricate. He had so many good ideas, and wanted to stuff in as many as possible.

"The Approval Matrix," the most wide-ranging and popular invention in the magazine's history, first appeared at the end of "The Culture Pages," and later moved to the magazine's last page.

Nussbaum: You know where I got the idea? In *Wired* magazine, they had a chart—I think it was "nerd to geek" and "hip to cool," or something like that. It didn't include jokes; it was only dots with names. I brought it in and said, "I think we should do something like this. We should put it at the end of the culture section every week; it should include all art forms." And we were in a group meeting I think, and I said, it should go something like highbrow to lowbrow, then great to terrible. And Adam said it should be more extreme than that, and I said, okay, "brilliant," and he said "despicable." I swear to God, the Matrix would not work without that "despicable," because it's such an inappropriate critical judgment. It really did have this amazing idea, which is that taste is not mathematical, but we are going to present it to you not only mathematically but with this intense, aggressively presumptuous position of taste and judgment.

Hayman: We did a ton of mockups, tons and tons, and I was never really happy with it. There was a lot of discussion around it, and we came up with the idea that people below 40 loved it, and people over 40 didn't like it. I was 40 at the time, so I was like, *I kinda get it...*But I didn't realize it was going to be the hit it became.

NEW YORK

SEPTEMBER 11, 2001

$2.99 (CANADA $3.99)

39>

0 74820 08183 9

NEWYORKMETRO.COM

August 30–September 2, 2004: New York *goes daily, for the Republican National Convention.*

Nussbaum: One of the most fun things was Adam Sternbergh and Chris Bonanos and me, on the night we closed the magazine, making the jokes better. It really was my only experience of being in a writers' room.

Adam Sternbergh *(writer-editor, 2004–2010, 2014–present):* It's the last great magazine charticle. And it's harder to do now—Carl Swanson, who does it, can tell you. Items you write on Tuesday, by the following Monday, have all been beaten to death on social media.

And, for not quite one week, the magazine also became a daily.

Lauren Kern *(editor, 2004–2010 and 2014–2017):* I had just started here, and in the middle of all the prototyping, we were also trying to prepare for the Republican National Convention, which was coming to New York for the first time in history. Adam brought Maer Roshan in to do a special issue of the magazine, but he also announced that we were going to produce a daily for the length of the convention. We had a special all-hands staff in the conference room, all just set up around the table with computers—a little newsroom.

Wasserstein: I had just moved back to New York that August, and I spent a week working at the daily. I did something from the floor, and then I remember I also went to a party at Elaine's and I accosted some TV personality and started asking questions.

Kern: It was college-newspaper-like in its late-night intensity, and very bloggy. It was a great crash course in the new *New York* Magazine.

Bruce Wasserstein died suddenly in 2009, just as the financial crash left many businesses— particularly in print journalism—in a precarious state. Control of New York *passed to his children, and although the economy was frail, the journalistic opportunities were rich. The magazine enthusiastically covered the irresistible characters of politics—Michael Bloomberg, Eliot Spitzer, Hillary Clinton, Barack Obama— and found some of its power brokers knocked back by the crisis.*

Smith: The mayor of New York City is obviously, always, a central figure in the life of *New York*. But Bloomberg was something entirely new. The richest man in the city had been elected to the most powerful political job in the city. It connected two things the magazine has cared most about in its life span: the exercise of financial and political power.

Jody Quon *(director of photography, 2004– present):* I really think it took us seven years to find our voice on the cover. The first one we did that stands the test of time was Eliot Spitzer. The news broke on Monday; we met about it on Tuesday morning, because we were going to press with a story about Horace Mann, and there was a decision to postpone that and instead do the Spitzer scandal. And I called the artist Barbara Kruger, and she said, "Can you believe that pig? Of course, I'd love to do it." And the next morning, she sends her work to us. We were blown away. And then: Tuesday's paper, Wednesday's paper, Thursday, Friday, Saturday, Sunday, "Week in Review": the public was so saturated with the Spitzer scandal that by the time we came out on Monday, you didn't need his name! "Brain" is almost the only word you see. [See page 80.]

Jessica Pressler *(writer, 2007–present):* I started right before the crash, as one of the first handful of writers blogging on the website. Somebody needed to cover Wall Street, and I volunteered to be that person, because I was new and it was necessary, even though I knew nothing about that. And it was all about these big glitzy parties, Christmas parties, Steve Schwarzman's birthday party—all this excess and craziness. Then the crash happened, this huge seismic event. It killed off a ton of dinosaurs, including the whole socialite scene. A new world grew out of that—the tea party came out of that, the artisanal movement. All of it happened because our foundations were so shook-up. Figuring out what was changing was my job, and I blogged it in real time.

In 2007, three years into the Wasserstein era and 39 years after its founding, New York *had its biggest night yet at the National Magazine Awards. Felker, who was in rehab recovering from a bad case of pneumonia, got the news from Tom Wolfe that evening.*

Sheehy: On May 1, Tom called Clay's room just before phone curfew. *New York* had won not one but five of the magazine industry's Oscars, and it was honored for General Excellence. That deeply pleased Clay, because it recognized his editorial mission—to work shoulder to shoulder with his genius art director and team of writers, editors, illustrators, photographers, and fact checkers to capture the attention of sophisticated readers. Clay had trouble speaking at that time—it was a little more than a year before his death. But a broad grin broke out on his face when Tom relayed the ultimate triumph. Their once indominable rival, *The New Yorker*, had won none.

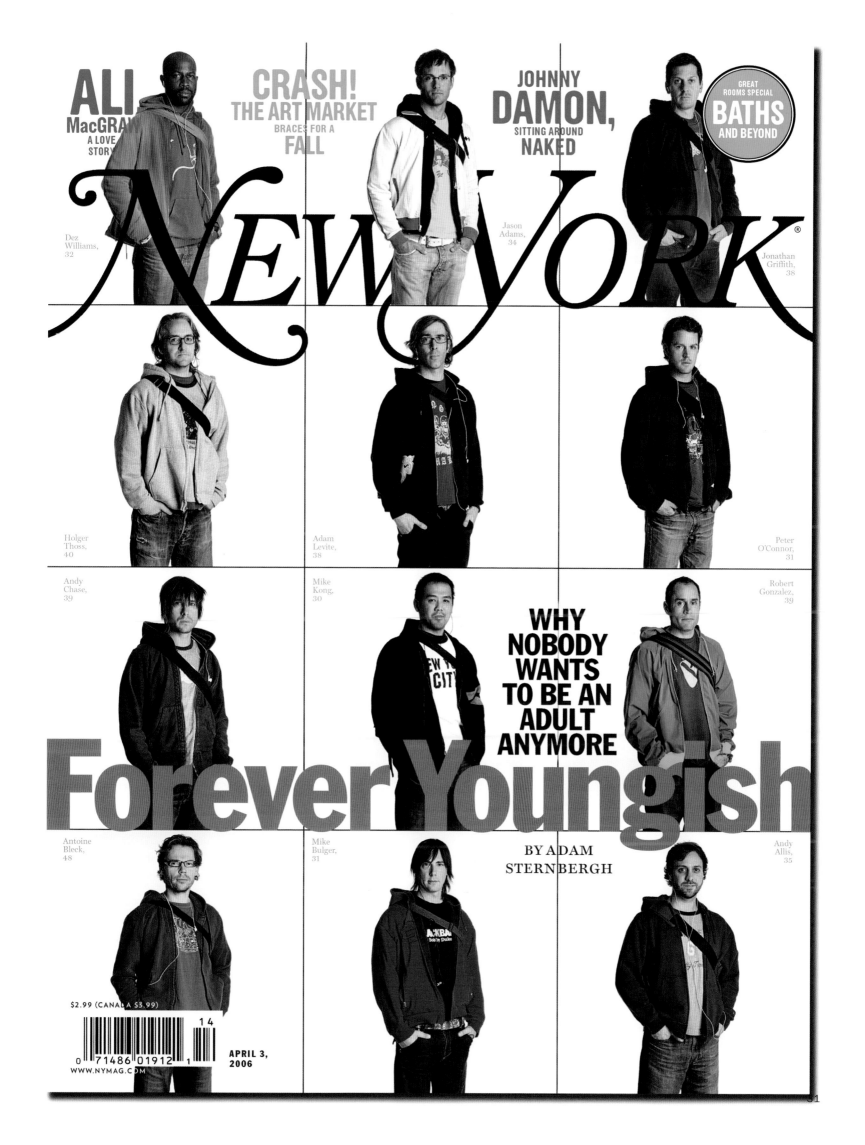

ALI MacGRAW
A LOVE STORY

CRASH!
THE ART MARKET
BRACES FOR A
FALL

JOHNNY DAMON,
SITTING AROUND
NAKED

GREAT
ROOMS SPECIAL
BATHS
AND BEYOND

New York

Dez
Williams,
32

Jason
Adams,
34

Jonathan
Griffith,
38

Holger
Thoss,
40

Adam
Levite,
38

Peter
O'Connor,
31

Andy
Chase,
39

Mike
Kong,
30

Robert
Gonzalez,
39

**WHY
NOBODY
WANTS
TO BE AN
ADULT
ANYMORE**

Antoine
Bleek,
48

Mike
Bulger,
31

Andy
Allis,
35

Forever Youngish

BY ADAM
STERNBERGH

$2.99 (CANADA $3.99)

APRIL 3,
2006

WWW.NYMAG.COM

0 71486 01912 1 14

Eric Cantor Is Killing It :

The House Majority Leader vs. the United States government. By Jason Zengerle **p.28**

Also: Wall St.'s Angry Youth / The Strategist Guide to Student Exploitation

+ **Michael Lewis** p.40 **Mayim Bialik** p.76 **Cults** p.70 **Mario Batali** p.22 **Laura Dern** p.65

Jesus Christie By John Heilemann p.24

New York

OCTOBER 10, 2011

twitter

#toobigtosucceed?
By Joe Hagan

$4.99 USA/CANADA

NYMAG.COM

0 74808 01912 0

42

The power of the city, culturally speaking, was drifting across the East River, to what had once been merely an outer borough. Soon "Brooklyn" would come to define a certain kind of look and feel that would permeate restaurants and lofts and bands and beers all over the country.

Rob Patronite *(writer and "The Underground Gourmet," 1989–present):* In 2006, we wrote about what was happening in Brooklyn and tried to coin something—we called it NBC, or New Brooklyn Cuisine—that kind of caught on a little bit. It came out of people who worked in Manhattan restaurants and wanted to open something and went to Brooklyn to find cheaper rent. It's become the dominant identity of a Brooklyn restaurant: mom-and-pop, shoestring budget, DIY, locavore, seasonal, sustainable. But this was before that became a horrible cliché. And it also kind of prompted what came to be known as the Brooklyn Twee movement.

Robin Raisfeld *(writer and "The Underground Gourmet," 1989–present):* You can even find New Brooklyn restaurants in Manhattan now—it's such a type. Even if it's in the Village, you'd say, "Oh, this is like a place in Brooklyn."

Moss: The new contours of New York were present almost from the first second I got there. The second issue I worked on, I think, was about the Manhattanization of Brooklyn, an idea suggested by John Homans that proved to be incredibly prescient and sold like crazy. Over the years, as New York itself became more expensive, what qualified as "the city" just kept growing and expanding into Brooklyn and Queens and points beyond—all of which was a constant and thrilling reminder of the city's morphability.

In 2011, the magazine produced the infographic reproduced on the following spread, which may be the most complicated six pages ever to appear in a weekly magazine.

Willa Paskin *(writer for Vulture, 2010–2012):* *All My Children* was being canceled after 40 years, and I wanted to write something. David Haskell came up with this idea of doing a visual history of the entire plot. I made, with graph paper and colored pencils, an enormous chart, by hand, using different colors for different relationships—red for marriages, blue when they get divorced, yellow when she has a baby. It was *A Beautiful Mind,* a crazy science-art project.

David Wallace-Wells *(editor, 2011–present):* She came back with a Kerouac roll that was more intricate than we possibly could have accommodated. We should've just published that scroll.

Paskin: The last couple of nights, there were multiple people working on it in the art department.

Wallace-Wells: Ann Clarke, the managing editor, was telling everybody that if we didn't abandon our hopes for the last spread that the magazine wasn't going to come out on Monday.

Ann Clarke *(managing editor, 2005–present):* It was the only time that really scared me—I was told that if we didn't close it in 20 minutes, we would not have an issue. And we were far from being done at that point.

Paskin: Given everything, there aren't many mistakes in it—one or two. So much effort for such a silly thing!

In the last week of October 2012, Hurricane Sandy left lower Manhattan without power for several days. The darkened zone included the magazine's offices, and the editors had to figure out how to cover the blackout from the blackout.

David Haskell *(editor, 2007–present):* Monday night, the city went dark. Tuesday morning, I'm biking around the wreckage near Wall Street, not particularly thinking about my job, and somehow my phone found service and started buzzing.

Homans: I was becoming horribly depressed, because you're a journalist—but also, you're just sitting in your apartment, and you can't make coffee, and you say—*Fuck, what am I gonna do?* And I had an actual landline in my house, and the phone rang, and it was Adam, saying that we're going to the Wasserstein office. And then we went and rallied the troops.

Haskell: And I thought, *Oh really? We're going to make a magazine?* But it turned out the Wassersteins had offices north of the blackout border, and they were willing to lend us some conference rooms.

Hohlt: I was in Brooklyn, so I was lucky: We had power. Adam called and said he was coming over, and I said okay.

Quon: I got blue painter's tape, because the conference rooms had that beautiful silk on the walls and we couldn't use tacks.

Adam Pasick *(digital editor, 2010–2013):* I was visiting Michigan to watch the Tigers play in the World Series, so I ran the website's live coverage of the storm as my colleagues in the city lost electricity and internet, one by one.

Hohlt: What I remember is that we were concerned about the city and its people, but also very, very eager to get down to work.

Quon: My husband picked me up in midtown, and we crossed 34th Street back downtown,

> ## "Though it might not have been obvious when the company first invested in digital journalism, politics turned out to have been a traffic monster. That was a relief."
> —DAVID HASKELL

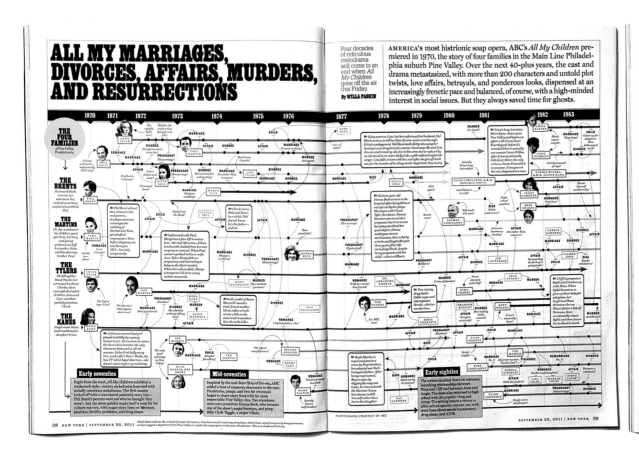
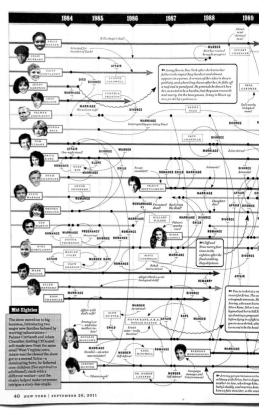

September 26, 2011:
The infographic that nearly broke the graphic-design department.

and suddenly all the traffic lights were out. And I said, that's the picture—this extraordinary divide—and we had to do it fast, because we don't know when the lights are coming back on. We called the photographer Iwan Baan, because we knew he had experience with helicopters, and he said, *Yes, I'd love to do the assignment.* The only marching order we gave him was that he had to do it from a vantage point where he could get the tip of the island in the frame. And he was off and running, and came in the next morning with the pictures. [See page 217.] And it was actually emotional for us, because we were overwhelmed with what we'd been seeing.

Hohlt: I remember watching that photo materialize, and having one of those moments.

Quon: And then he starts to tell us what happened. He'd anticipated the hurricane, so he'd reserved a car rental, and had gone to various bank machines and taken out cash, so he had upwards of $3,000 on him. He gets the helicopter; gets up in the air. On regular days, there's a ceiling because of all the other airline traffic—but on Wednesday night, La Guardia was still closed, and the pilot got permission to go much higher, which meant that he could get the angle from the tip of the island all the way up past the George Washington Bridge. And he had a new camera from Canon that would allow him, at that altitude, with the tremendous wind and shaking, to get pictures in focus. Out of 2,000 frames, he got maybe 50 that were in focus. That picture was meant to be.

Homans: It was a great *New York* Magazine week—the last great *weekly New York* Magazine week.

In 2013, the tough environment for print advertising led to a major shift: from weekly to biweekly publication. At the same time, its digital presence increased, with the expansion of the verticals—dedicated sites like Vulture, Science of Us, and the Cut.

Homans: I mean, even from 1999, you knew that the storm was coming. It had been considered in 2008, and I wrote Adam a memo saying, this is why you don't want to go biweekly, you're gonna cut off your nose to spite your face, and things are going to get better. This time, there was no argument, and the internet is now this incredibly vital thing, and you can transport some of what you're doing over there.

Wasserstein: We were nervous about the perception of weakness in a business built around being cutting-edge. But we did the numbers and it seemed to make sense. We invested more into the product so that it could become a deeper, more thoughtful version of itself. There were some advertisers who were initially skeptical,

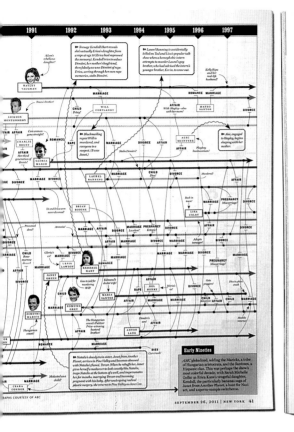

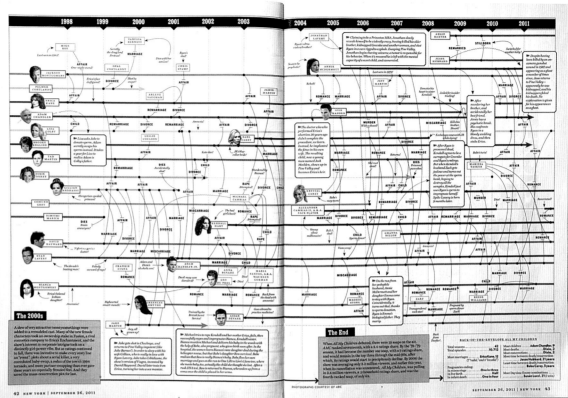

but once they actually saw the biweekly product, they said, "Oh, okay, you were being real about this—there's more of it and it's fuller and richer. A little more visual, just *more*."

Ben Williams *(print editor, 2004–2006; digital editor, 2006–present):* I don't think we knew at that time that these sites were going to become verticals per se. We decided we wanted to do blogs, and we started first with a pop-up around the 2008 Fashion Week called the Cut. Then Grub Street and Daily Intelligencer, which at that phase was a local city blog, then Vulture. And then we decided that actually, we were going to create new brands. One of the big debates was the feeling that the name *New York* Magazine had some limitations online because you think it's about the city.

Kelly Maloni *(digital editor and product-development director, 2000–present):* When we spun off Vulture as its own site, that was a moment. We were making bets about our digital properties. Can they stand on their own? Can a culture site? You know, there weren't that many then—there was *Entertainment Weekly*, and the arts section of the *Times*, but not many others.

Stella Bugbee *(editorial director of the Cut, 2011–present):* One of the things that *New York* has always done really, really well is being the first to give shape to a phenomenon that is clearly happening and everybody in New York is am-biently aware of. "Normcore"—about glorifying suburban plain mall style, not wanting to stand out, an anti-style style—was a trend forecaster's term, and we realized that it applied to this fashion trend that we were seeing and went about proving that it was real.

Haskell: The digital expansion effectively made us a newsroom, and politics was a natural area for us to jump on. The 2008 campaign was a soap opera that nobody covered more colorfully or irresistibly than John Heilemann. I'd guess that was the first time many people outside of New York started coming to our site, when attention-getting covers were splashed all over cable news. By 2012, Frank Rich had joined us from the *Times* and Jonathan Chait was writing constantly, and we were holding our own as one of the great resources for smart commentary and analysis. Andrew Sullivan wrote the most terrifying essay of 2016, imagining the Trump administration as an extinction-level event for democracy, and Rebecca Traister wrote an incredibly complex, intimate, prescient profile of Hillary Clinton.

Rebecca Traister *(writer, 2015–present):* I think I was among the very few women on the politics team at *New York*, which made a difference. I noticed it! But *New York* is also the magazine that produced *Ms.*, and where Gloria Steinem wrote. *New York* Magazine has a history of

2008

We Looked.

As New York Fashion Week became a global event, *New York* tried its hand at a twice-a-year oversize spinoff, *New York Look,* that covered it with verve.

Fifty Million Tourists!

Even in bad times, a record year for NYC. Which is ... good? By Michael Idov p.52

Also: Carey Mulligan p.90 / Gary Oldman p.83 / Miranda Kerr p.28 / Rex Ryan p.30

Elena Kagan and 'Obamacare' p.46 / Adventures of an Adderall Pusher p.20

New York

DECEMBER 5, 2011

TV: What the old, the rich, the young, etc., watch. **PLUS:** The return of the laugh track. *BY JOSEF ADALIAN*

Will it be 1968 all over again?

Occupy 2012

John Heilemann

New York

February 22–March 6, 2016

Single Women Are Now the Most Potent Political Force in America
By Rebecca Traister

"My first day as Joe Klein's assistant, I heard him yelling, long and loud, at someone on the phone. Joe hangs up and says, 'Mario.' Cuomo. The governor."

—CHRIS SMITH

producing feminist content and publishing feminist writers.

Haskell: And though it might not have been obvious when the company first invested in digital journalism, politics turned out to have been a traffic monster. That was a relief.

Gabriel Sherman *(writer, 2008–present):* As a reporter, I always felt that the notion of holding things for some unspecified publication date in the future was becoming incompatible with where and how people were consuming news and how my competitors were reporting it.

Kern: Gabe was the model for how to operate as a journalist across platforms, using both to his advantage. Take his coverage of the sexual-harassment scandal that took down Roger Ailes and threw Fox News into crisis. He would break news online as he was reporting, beating the competition the whole time, then synthesize it in a great, written-through cover story.

Sherman: We're all obsessed with serialized television these days, and the rolling dispatches kind of lead to the season finale—the story in the print magazine. We're all looking for the next episode, the next installment, with a satisfying payoff at the end.

Kern: *New York* has always gone after corruption and abuses of power. With Ailes, it was through investigative reporting. When it came to Bill Cosby, it was about convincing his victims to stand together. And be photographed.

Quon: In October 2014, the comedian Hannibal Burress made some comment about Bill Cosby in his act, and women started to come forward. Through the holidays, every other day there was someone else. I thought it would make a great portfolio, and I went through the internet and made a dossier of all the names and snapshots—18 women at the time—and you could see that the cases started as early as the '60s and up to modern-day. I cold-called six of the women, and all six jumped in. "*Yes.*" Nobody had listened to them. By the time we were ready to shoot, we had about 25 women.

Noreen Malone *(writer and editor, 2011–2012, 2014–present):* The photo department did the hard work of getting the women to commit. When I first started making the calls for interviews, all I had to do was ask them "Tell me how you met Bill Cosby." They just really wanted to talk about it.

Quon: Before the photo shoot, the women had never met each other. The only thing they had in common was having allegedly been assaulted by Bill Cosby. It went from very sober to laughing and crying.

Malone: There was a real shock to hearing just how much the stories had in common, the lines that he used, the situations that were set up. Eerily similar details.

Quon: The photographer Amanda Demme came up with the idea to shoot them sitting straight upright, hands on their laps, looking straight into the camera. And in some of those pictures she had an odd number, so we had them sitting next to an empty chair. One stayed on the cover, suggestive of all the other people out there who have been victims of sexual assault. And then it became a hashtag: #theemptychair.

Malone: The day it was published, our website got attacked. People wondered if it was some sort of retaliation for Cosby, but it was totally unrelated—more or less a coincidence. We came in the next day, and the interactive team, which had spent the whole weekend making it so beautiful for the site, had to build a whole new jury-rigged site on Tumblr.

As the city has changed in the decades since 1968, so has New York—*one not just reflecting but creating the other, in a cycle of reinvention.*

Wolff: It came to define, precipitate, predict the Manhattan that was to come. Clay basically created the yuppie—his proposition was a straightforward one, that you could buy yourself into the class you wanted to be in. And he created New York as a consumer city. There was a time when people didn't go out to restaurants here. And then *New York* Magazine came along and redefined what restaurants were, what public life was in New York, redefined who could be part of that life, and what the methods were to get there. The reconstruction of the urban environment which begins about then and comes to fruition in the '90s is a *New York* Magazine construct.

Hirschorn: There's something about *New York* Magazine that people really care about. It's still the case that *New York* Magazine has a unique impact that has not changed.

Moss: These days, as New York City continues to be a stunningly successful export of itself, *New York* has become more national and international, chronicling or reflecting the evolution of urban life in cities everywhere—which have come to look more and more like each other. *New York* has become a set of publications in every medium, including live performance, and its subject has become not just New York but cities everywhere, city life everywhere, the urban creature everywhere. And in America in the Trump years, which has really found itself very much divided between city and country, that turns out to be a huge and interesting and even important canvas. ■

Alleged assault: ca. 1960s In 1967 In 1969 In 1969 In 1969 In 1969 In 1969 Ca. 1970 Ca. 1970 Ca. 1970

In 1971 In 1973 In 1975 In 1975 In 1976 In 1977 In 1978 and 1980 In 1979 Ca. 1979 In 1981

In 1982 In 1982 In 1984 Ca. mid-1980s Ca. mid-1980s In 1985–87 In 1986 In 1986 In 1987 Ca. 1987

Ca. late 1980s Ca. late 1980s In 1989 Ca. early 1990s In 1996

Cosby:
The Women

An Unwelcome
Sisterhood

By Noreen Malone
A Portfolio by
Amanda Demme

2007

That's not Photoshop.

For the year-end "Reasons to Love New York" cover, *New York* applied a 90-foot temporary tattoo to Bryant Park's seasonal ice rink late one Saturday night, then photographed it from the roof of the Verizon Building across the street.
PHOTOGRAPHS BY VINCENT LAFORET; "LOVE" PAINTING BY MICHAEL DE FEO

POWER

"You play rough. And hopefully you don't get caught."

Eliot Spitzer
quoted in "The Governor and the Darkness," by Chris Smith, 2008

Everyone wanted to know who was in charge.

IF THERE'S ONE LENS THROUGH WHICH *New York* has seen the world, it is that of power. In politics and media and finance, the magazine has endlessly strived to satisfy a thirst to know not just about, say, the mayor but also about who has the mayor's ear. It's why a magazine ostensibly about New York City has spent so much energy on national politics: Washington power, and even international power, has mattered as much to our readers as the sometimes parochial doings at City Hall. ¶ To that end, *New York*'s first Power Issue appeared at the end of December 1968. Today, nearly every magazine produces a list like that, but at the time it was a revelation that you could rank powerful men (and they were all men) the way *Consumer Reports* ranked toasters, with a comparable note of skepticism. It quickly became an annual event, published in the first issue of each year, with a handy guide to those who had fallen off the list or were making their inaugural appearances. In 1972, the issue included a cheeky "Most Overrated People in New York" list, and George H.W. Bush—then ambassador to the UN—was near the top. He took it as a compliment and threw a party for the ten anointees. (Nine showed up. Senator Jacob Javits had no sense of humor.) ¶ The coverage of power—good, bad, and crooked—was hardly restricted to that annual issue. *New York* covered the Nixon administration so aggressively that the magazine was, for a time, reportedly banned from the White House. During the racial clashes of the '80s, when the city was roiled by one big conflict after another, *New York* began to take notice of a big, mouthy activist named Al Sharpton and a prosecutor named Rudolph Giuliani, both of whom would become regulars in our pages as their prominence grew: They were the kind of outsize figures the magazine depended upon. But other kinds of influence mattered as well. Power escort? Mark Jacobson profiled a call girl who charged $2,000 per hour (and who had once advertised in *New York*'s back pages). Power publicist? The very young Lizzie Grubman was made famous by a feature in our pages before she plowed her SUV into a Hamptons club and fled the scene. Power plastic surgeons? Yeah, those too. ¶ On the national stage, Barack Obama became one of the few true power crushes of the past 50 years, and the magazine doted on the first modern president who really seemed to understand city life. And no discussion of New York power is complete without the president who followed Obama. Donald Trump, noisy young real-estate developer, first appeared in the magazine in 1976 in a column about his fight with fellow developer Bob Tisch over the Grand Hyatt. Tisch's prescient words were "I don't think we ought to put up a convention center that someone is trying to build as a monument to himself." We probably helped inflate Trump's ego, as he has so far occasioned 19 covers of *New York* (13 of his increasingly colorful face, five of his various wives, and one entirely devoted to a profile of his yacht). But we'll also say that our coverage of him grew more skeptical over time, so much so that he has picked multiple Twitter fights with our editors. Sad!

1969
Well, was he?

For a generation, New York had been governed by stumpy little guys, most of them representatives of the city's white ethnic factions: Fiorello La Guardia, Jimmy Walker, William O'Dwyer. Then along came six-foot-four John Lindsay, inevitably described as handsome and patrician. By his fourth year in office, many New Yorkers were beginning to think that he was, despite honorable intentions, not nearly as capable of getting things done as his unhandsome, unpatrician predecessors had been. When Jimmy Breslin delivered one of the great stories of the age, with the perfect headline— "Is Lindsay Too Tall to Be Mayor?"—Milton Glaser capped it with a laugh-out-loud cover that chopped his head off.

How Shoplifters Are Cleaning Out the City
A Natatorial Guide to Public Pools

40 CENTS

JULY 28, 1969

New York

Is Lindsay Too Tall To Be Mayor? by Jimmy Breslin

When a joke turned semiserious, Jimmy Breslin the columnist became Jimmy Breslin the candidate, running on a mayoral slate with Norman Mailer.

I Run to Win

By Jimmy Breslin

THE FIRST PHONE CALL on Monday morning was at seven o'clock.

"He's asleep," I heard my wife mumble.

"Wake him up?" she mumbled.

She kicked me and I reached over for the phone.

"Somebody named Joe Ferris," she said. "He needs your correct voting registration for the petitions. *What* petitions?"

I sat up in bed, with the phone in one hand and my head against the wall and my eyes closed.

"*What* petitions?" my wife said again.

I knew what petitions Joe Ferris was talking about. I knew about them, but I never thought it would come to the point of an early morning phone call about them. You see, when it started, I was only in this thing for pleasant conversation with nice people. "Hello," I said to Joe Ferris. I was afraid he would send cold waves through the phone.

"I've got to be at the printer with the petitions this morning," Joe Ferris said. "So what I need is the exact way your name and address appears on the voting rolls. We don't want to have any petitions thrown out on a technicality. Because they're going to be looking for mistakes. Particularly when they see how much support you and Norman are going to get. That's all I've been hearing around town. You and Norman. I think you've got a tremendous chance."

"I'll get the information and call you back," I said to Joe Ferris. He gave me his phone number and I told him I was writing it down, but I wasn't. Maybe if I forgot his number and never called him back, he wouldn't bother to call me anymore.

"*What* petitions?" my wife said when I hung up.

"Nothing," I said. I put my face in the pillow. Well, to tell you what happened. I really don't know what happened, but I was in a place called the Abbey Tavern on Third Avenue and 26th Street at four o'clock one afternoon, when it was empty and I wouldn't have to talk to anybody I didn't know, and Jack Newfield came in. Jack Newfield is a political writer. He writes for the *Village Voice* and *Life* magazine and he does books and we got to know and like each other during the Bobby Kennedy campaigns last spring. Anyway, I'm having coffee with Jack Newfield and he says, "Did you hear me on the radio the other night? I endorsed you. I endorsed Norman Mailer for mayor and you for president of the City Council in the Democratic primary." I did two things. I laughed. Then I sipped the coffee. While I did it, I was saying to myself, "Why is Mailer on the top of the ticket?"

And a couple of days later, I had lunch in Limerick's, on Second Avenue and 32nd Street, and here was Newfield and Gloria Steinem, and she likes me and I like her, and Peter Maas, and he is all right with me, too, and we got to talking some more and they kept saying Norman Mailer and I should run in the Democratic primary and finally I said, "Has anybody talked to Norman?"

"No, not recently," Gloria said.

"Give me a dime," I said.

I went to the phone and called Norman. While I was dialing, I began to compromise myself. *Norman went to college,* I thought. *Maybe it's only right that he's the mayor and I'm the president of the City Council. But that's the only reason. He has a Harvard diploma. On ability, I should be mayor.*

"Norman?"

"Jimmy, how are you?"

"Norman, let's run."

"I know, they spoke to me. But I have to clean up some business first. I think we could make a great team. Now here's what I'm doing. I'm going to Provincetown for a week to think this over. Maybe we can get together for a night before I go. Then when I come back, we can make up our minds."

"All right," I said.

So two nights later there were about 40 people in the top floor of Mailer's house in Brooklyn Heights. They were talking about the terrible condition the city was in, and of the incredible group of candidates the Democrats had in the mayoralty primary, which is on June 17. He began to talk casually, as if everybody knew it and had been discussing it for weeks, about there being no such thing as integration and that the only way things could improve would be with a black community governing itself. "We need a black mayor," Mailer said. "I'll be the white mayor and they have to elect a black mayor for themselves. Just give them the money and the power and let them run themselves. We have no right to talk to these people anymore. We lost that a long time ago. They don't want us. The only thing white people have done for the blacks is betray them."

There hasn't been a person with the ability to say this in my time in this city. I began to think a little harder about the prospects of Mailer and me running the city.

We had another night at Mailer's, with a smaller group, and he brought up the idea of a "Sweet Sunday," one day a month in which everything in the city is brought to a halt so human beings can rest and talk to each other and the air can purify itself. When he got onto the idea of New York taking the steps to become a state, he had me all the way. The business of running this city is done by lobster peddlers from Montauk and old Republicans from Niagara Falls and some Midwesterners-come-to-Washington-with-great-old-Dick such as the preposterous George Romney. I didn't know what would come out of these couple of nights, but I knew we had talked about more things than most of these people running in the Democratic primary had thought of in their lives.

Mailer was leaving for Provincetown the next morning, and we agreed to talk on the phone in a few days.

I stayed around the city and somewhere in here I had a drink with Hugh Carey. He is a congressman from Brooklyn and he is listed as a candidate for mayor. I told Carey I was proud the way he turned down a chance to make a lot of headlines with an

investigation into the case of Willie Smith, a poverty worker in New York who had been convicted of great crimes in the newspapers. Carey announced that Willie Smith not only was clear, but also was doing a fine job for the poor. Endorsing the poor is not a very good way of getting votes these days. So I thanked Carey.

"What did you want me to do?" Hugh Carey said.

"Well, I just wanted you to know," I said.

"I wish to God I'd been right on the war when I should have been," he said. He had, from 1965 until only a short time ago, been a Brooklyn Irish Catholic Hawk, of which there are no talons sharper. But now he could look at you over a drink and tell you openly that he had been wrong. "It's the one thing in my life I'm ashamed of," he said. "And I'm going to go in and tell every mother in this city that I was wrong and that we're wasting their sons."

Pretty good, I thought. Let's have another drink.

"How's it look for you?" I asked.

"Well, it's up to The Wag," he said.

"The Wag?" I said.

"The Wag. Bob Wagner."

"What the hell has he got to do with it?"

"Look, if he comes back and runs and I can get on the ticket with him, then in a year he'll run for the Senate against Goodell and I can take over the city and we'll start putting the type of people in...."

Well, I told him then what I'm putting down here now. If Robert Wagner, who spent 12 years in City Hall as the representative of everybody in New York except the people who had to live in the city while he let it creak and sag, if this dumpy, narrow man named Robert Wagner, by merely considering stepping back into politics, could have a Hugh Carey thinking about running on the ticket below him, then there was something I didn't like about

Hugh Carey. Not as a guy, but as a politician who would run a city which is as wounded and tormented as New York.

You see, the condition of the City of New York at this time reminds me of the middleweight champion fight between the late Marcel Cerdan and Tony Zale. Zale was old and doing it from memory and Cerdan was a bustling, sort of classy alley fighter and Cerdan went to the body in the first round and never brought his punches up. At the start of each round, when you looked at Zale's face, you saw only this proud, fierce man. There were no marks to show what was happening. But Tony Zale was coming apart from the punches that did not leave any marks and at the end of the eleventh round Tony was along the ropes and Cerdan stepped back and Tony crumbled and he was on the floor, looking out into the night air, his face unmarked, his body dead, his career gone. In New York today, the face of the city, Manhattan, is proud and glittering. But Manhattan is not the city. New York really is a sprawl of neighborhoods, which pile into one another. And it is down in the neighborhoods, down in the schools that are in the neighborhoods, where this city is cut and slashed and bleeding from someplace deep inside. The South Bronx is gone. East New York and Brownsville are gone. Jamaica is up for grabs. The largest public education system in the world may be gone already. The air we breathe is so bad that on a warm day the city is a big Donora. In Manhattan, the lights seem brighter and the theatre crowds swirl through the streets and the girls swing in and out of office buildings in packs and it is all splendor and nobody sees the body punches that are going to make the city sag to its knees one day so very soon. The last thing, then, that New York can afford at this time is a politician thinking in normal politicians' terms. The city is beyond that. The City of New York either gets an imagination, or the city dies. ∎

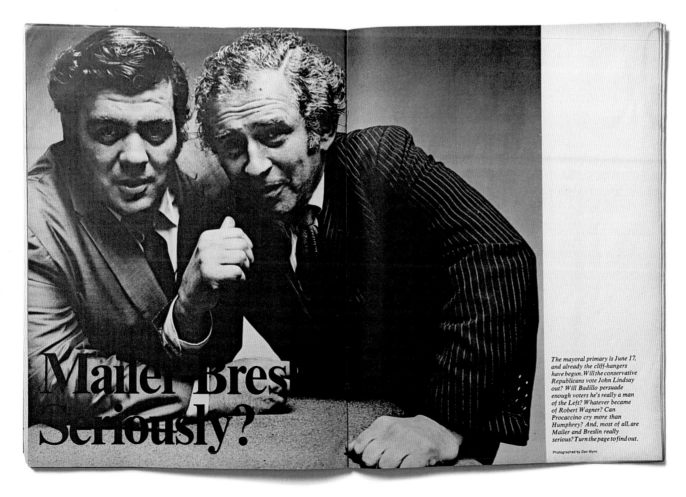

Maller-Bres seriously?

The mayoral primary is June 17, and already the cliff-hangers have begun. Will the conservative Republicans vote John Lindsay out? Will Badillo persuade enough voters he's really a man of the Left? Whatever became of Robert Wagner? Can Procaccino cry more than Humphrey? And, most of all, are Mailer and Breslin really serious? Turn the page to find out.

Photographed by Dan Wynn

1968–1978

"Who Really Runs New York City?"

The magazine never stopped asking that question, or studying power as if it were a 3-D chess game. A few nominees from the introduction to the 1972 edition: "'The goddamned Rockefellers.' 'The g.d. Mayor, Lindsay.' 'The g.d. unions.' 'The g.d. New York *Times*.' 'That g.d. Nixon and Mitchell'… The real power in New York City is the power to survive a year like 1971."

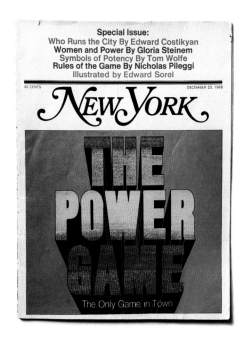

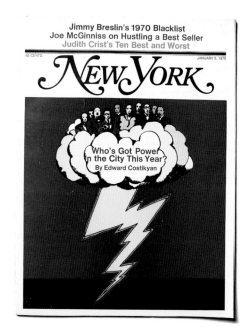

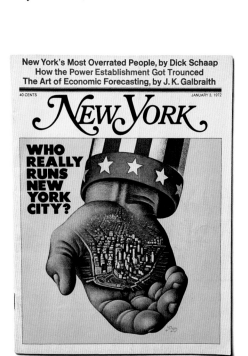

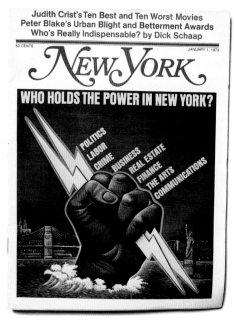

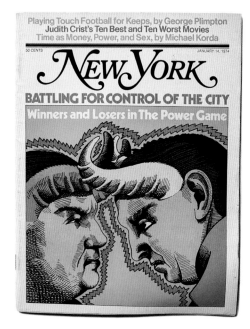

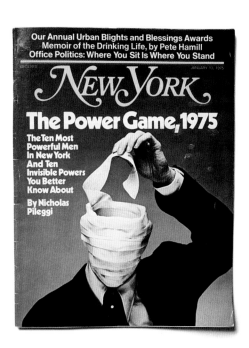

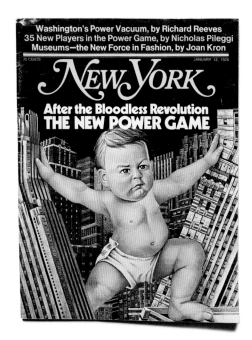

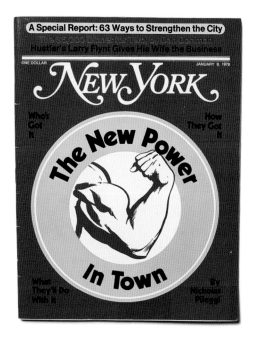

40 CENTS

JANUARY 4, 1971

New York

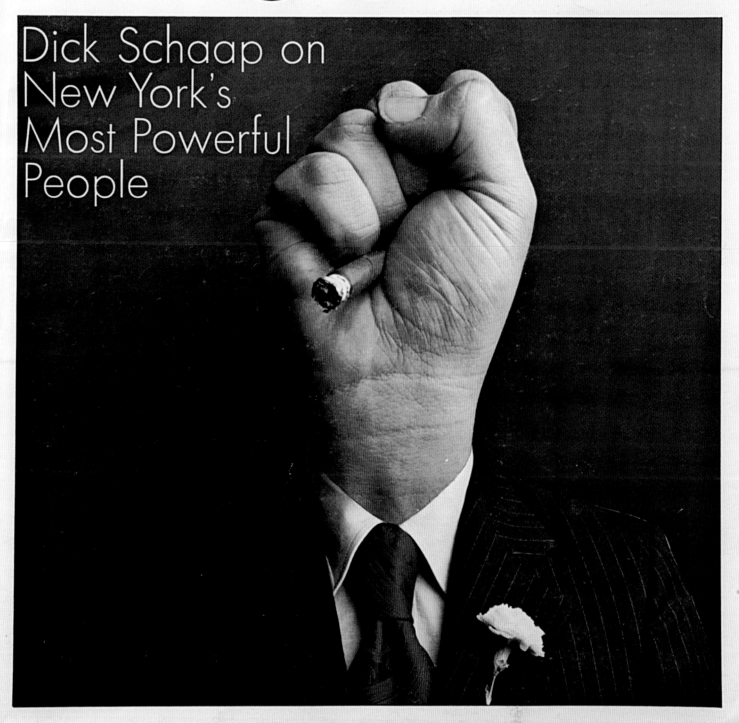

Dick Schaap on
New York's
Most Powerful
People

EXCERPT: JUNE 8, 1970

Tom Wolfe turned up at Leonard Bernstein's benefit for the Black Panthers, and caught the madness of the '60s in one 24,000-word yawp. If a single story established *New York* Magazine, this was it.

Radical Chic: That Party at Lenny's

By Tom Wolfe

MMMMMMMMMMMMMMM. These are nice. Little Roquefort cheese morsels rolled in crushed nuts. Very tasty. Very subtle. It's the way the dry sackiness of the nuts tiptoes up against the dour savor of the cheese that is so nice, so subtle. Wonder what the Black Panthers eat here on the hors d'oeuvre trail? Do the Panthers like little Roquefort cheese morsels wrapped in crushed nuts this way, and asparagus tips in mayonnaise dabs, and meatballs petites au Coq Hardi, all of which are at this very moment being offered to them on gadrooned silver platters by maids in black uniforms with hand-ironed white aprons…The butler will bring them their drinks…Deny it if you wish to, but such are the *pensées métaphysiques* that rush through one's head on these Radical Chic evenings just now in New York. For example, does that huge Black Panther there in the hallway, the one shaking hands with Felicia Bernstein herself, the one with the black leather coat and the dark glasses and the absolutely unbelievable Afro, Fuzzy Wuzzy–scale in fact—is he, a Black Panther, going on to pick up a Roquefort cheese morsel rolled in crushed nuts from off the tray, from a maid in uniform, and just pop it down the gullet without so much as missing a beat of Felicia's perfect Mary Astor voice….

Felicia is remarkable. She is beautiful, with that rare burnished beauty that lasts through the years. Her hair is pale blond and set just so. She has a voice that is "theatrical," to use a term from her youth. She greets the Black Panthers with the same bend of the wrist, the same tilt of the head, the same perfect Mary Astor voice with which she greets people like Jason, D.D., Adolph, Betty, Gian Carlo, Schuyler, and Goddard, during those *après*-concert suppers she and Lenny are so famous for. What evenings! She lights the candles over the dining room table, and in the Gotham gloaming the little tremulous tips of flame are reflected in the mirrored surface of the table, a bottomless blackness with a thousand stars, and it is that moment that Lenny loves. There seem to be a thousand stars above and a thousand stars below, a room full of stars, a penthouse duplex full of stars, a Manhattan tower full of stars, with marvelous people drifting through the heavens, Jason Robards, John and D. D. Ryan, Gian Carlo Menotti, Schuyler Chapin, Goddard Lieberson, Mike Nichols, Lillian Hellman, Larry Rivers, Aaron Copland, Richard Avedon, Milton and Amy Greene, Lukas Foss, Jennie Tourel, Samuel Barber, Jerome Robbins, Steve Sondheim, Adolph and Phyllis Green, Betty Comden, and the Patrick O'Neals…

…and now, in the season of Radical Chic, the Black Panthers. That huge Panther there, the one Felicia is smiling her tango smile at, is Robert Bay, who just 41 hours ago was arrested in an altercation with the police, supposedly over a .38-caliber revolver that someone had, in a parked car in Queens at Northern Boulevard and 104th Street or some such unbelievable place, and taken to jail on a most unusual charge called "criminal facilitation." And now he is out on bail and walking into Leonard and Felicia Bernstein's 13-room penthouse duplex on Park Avenue. Harassment & Hassles, Guns & Pigs, Jail & Bail—they're real, these Black Panthers. The very idea of them, these real revolutionaries, who actually put their lives on the line, runs through Lenny's duplex like a rogue hormone. Everyone casts a glance, or stares, or tries a smile, and then sizes up the house for the somehow delicious counterpoint…Deny it if you want to! But one does end up making such sweet furtive comparisons in this season of Radical Chic… There's Otto Preminger in the library and Jean vanden Heuvel in the hall, and Peter and Cheray Duchin in the living room, and Frank and Domna Stanton, Gail Lumet, Sheldon Harnick, Cynthia Phipps, Burton Lane, Mrs. August Heckscher, Roger Wilkins, Barbara Walters, Bob Silvers, Mrs. Richard Avedon, Mrs. Arthur Penn, Julie Belafonte, Harold Taylor, and scores more, including Charlotte Curtis, women's news editor of the New York *Times*, America's foremost chronicler of Society, a lean woman in black, with her notebook out, standing near Felicia and big Robert Bay, and talking to Cheray Duchin.

Cheray tells her: "I've never met a Panther—this is a first for me!"…never dreaming that within 48 hours her words will be on the desk of the President of the United States…

This is a first for me. But she is not alone in her thrill as the Black Panthers come trucking on in, into Lenny's house, Robert Bay, Don Cox the Panthers' Field Marshal from Oakland, Henry Miller the Harlem Panther defense captain, the Panther women— Christ, if the Panthers don't know how to get it all together, as they say, the tight pants, the tight black turtlenecks, the leather coats, Cuban shades, Afros. But real Afros, not the ones that have been shaped and trimmed like a topiary hedge and sprayed until they have a sheen like acrylic wall-to-wall—but like funky, natural, scraggly…wild…

These are no civil-rights Negroes wearing gray suits three sizes too big—

—no more interminable Urban League banquets in hotel ballrooms where they try to alternate the blacks and whites around the tables as if they were stringing Arapaho beads—

—these are real men!

Shootouts, revolutions, pictures in *Life* magazine of policemen grabbing Black Panthers like they were Viet Cong—somehow it all runs together in the head with the whole thing of how *beautiful* they are. *Sharp as a blade.* The Panther women—there are three or four of them on hand, wives of the Panther 21 defendants,

SPECIAL ISSUE
Tom Wolfe on Radical Chic

40 CENTS

JUNE 8, 1970

NEW YORK

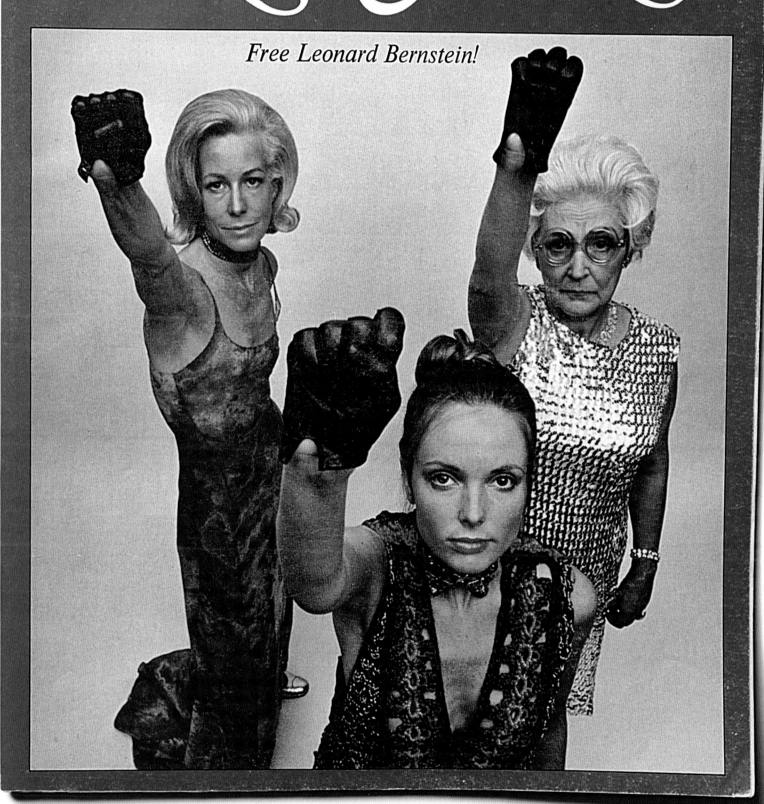

Free Leonard Bernstein!

and they are so lean, so *lithe,* as they say, with tight pants and Yoruba-style headdresses, almost like turbans, as if they'd stepped out of the pages of *Vogue,* although no doubt *Vogue* got it from them. All at once every woman in the room knows exactly what Amanda Burden meant when she said she was now anti-fashion because "the sophistication of the baby blacks made me re-think my attitudes." God knows the Panther women don't spend 30 minutes in front of the mirror in the morning shoring up their eye holes with contact lenses, eyeliner, eye shadow, eyebrow pencil, occipital rim brush, false eyelashes, mascara, Shadow-Ban for undereye and Eterna Creme for the corners...And here they are, right in front of you, trucking on into the Bernsteins' Chinese yellow duplex, amid the sconces, silver bowls full of white and lavender anemones, and uniformed servants serving drinks and Roquefort cheese morsels rolled in crushed nuts—

But it's all right. They're *white* servants, not Claude and Maude, but white South Americans. Lenny and Felicia are geniuses. After a while, it all comes down to servants. They are the cutting edge in Radical Chic. Obviously, if you are giving a party for the Black Panthers, as Lenny and Felicia are this evening, or as Sidney and Gail Lumet did last week, or as John Simon of Random House and Richard Baron, the publisher, did before that; or for the Chicago Eight, such as the party Jean vanden Heuvel gave; or for the grape workers or Bernadette Devlin, such as the parties Andrew Stein gave; or for the Young Lords, such as the party Ellie Guggenheimer is giving next week in *her* Park Avenue duplex; or for the Indians or the SDS or the G.I. Coffee Shops or even for the Friends of the Earth—well, then, obviously you can't have a Negro butler and maid, Claude and Maude, in uniform, circulating through the living room, the library and the main hall serving drinks and canapés. Plenty of people have tried to think it out. They try to picture the Panthers or whoever walking in bristling with electric hair and Cuban shades and leather pieces and the rest of it, and they try to pic-ture Claude and Maude with the black uniforms coming up and saying, "Would you care for a drink, sir?" They close their eyes and try to picture it *some way,* but there *is* no way. One simply cannot see that moment. So the current wave of Radical Chic has touched off the most desperate search for white servants. Carter and Amanda Burden have white servants. Sidney Lumet and his wife Gail, who is Lena Horne's daughter, have three white servants, including a Scottish nurse. Everybody has white servants. And Lenny and Felicia—they had it worked out before Radical Chic even started. Felicia grew up in Chile. Her father, Roy Elwood Cohn, an engineer from San Francisco, worked for the American Smelting and Refining Co. in Santiago. As Felicia Montealegre (her mother's maiden name), she became an actress in New York and won the *Motion Picture Daily* critics' award as the best new television actress of 1949. Anyway, they have a house staff of three white South American servants, including a Chilean cook, plus Lenny's English chauffeur and dresser, who is also white, of course. Can one comprehend how perfect that is, given...the times? Well, many of their friends can, and they ring up the Bernsteins and ask them to get South American servants for them, and the Bernsteins are so generous about it, so obliging, that people refer to them, good-naturedly and gratefully, as "the Spic and Span Employment Agency," with an easygoing ethnic humor, of course.

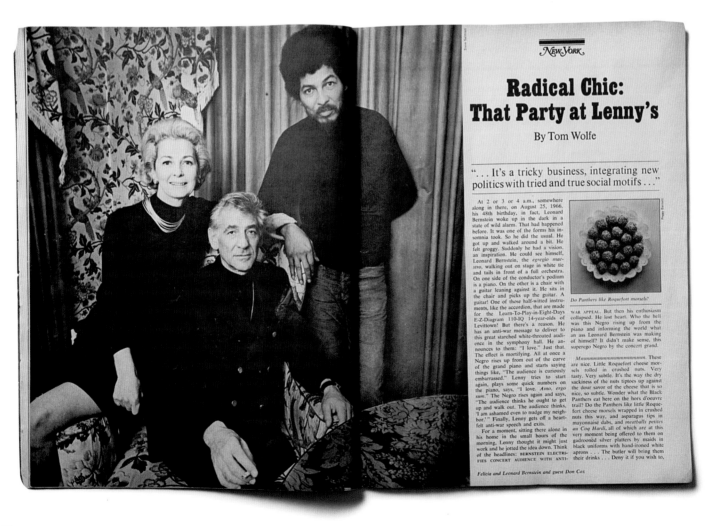

Felicia and Leonard Bernstein and guest Don Cox

NEW YORK

Radical Chic: That Party at Lenny's

By Tom Wolfe

"...It's a tricky business, integrating new politics with tried and true social motifs..."

At 2 or 3 or 4 a.m., somewhere along in there, on August 25, 1966, his 48th birthday, in fact, Leonard Bernstein woke up in the dark in a state of wild alarm. That had happened before. It was one of the forms his in-somnia took. So he did the usual. He got up and walked around a bit. He felt groggy. Suddenly he had a vision, an inspiration. He could see himself, Leonard Bernstein, the *egregio mae-stro,* walking out on stage in white tie and tails in front of a full orchestra. On one side of the conductor's podium is a piano. On the other is a chair with a guitar leaning against it. He sits in the chair and picks up the guitar. A guitar! One of those half-witted instru-ments, like the accordion, that are made for the Learn-To-Play-in-Eight-Days E-Z-Diagram 110-IQ 14-year-olds of Levittown! But there's a reason. He has an anti-war message to deliver to this great starched white-throated audi-ence in the symphony hall. He an-nounces to them: "I love." Just that. The effect is mortifying. All at once a Negro rises up from out of the curve of the grand piano and starts saying things like, "The audience is curiously embarrassed." Lenny tries to start again, plays some quick numbers on the piano, says, "I love. *Amo, ergo sum.*" The Negro rises again and says, "The audience thinks he ought to get up and walk out. The audience thinks, 'I am ashamed even to nudge my neigh-bor.'" Finally, Lenny gets off a heart-felt anti-war speech and exits.

For a moment, sitting there alone in his home in the small hours of the morning, Lenny thought it might just work and he jotted the idea down. Think of the headlines: BERNSTEIN ELECTRI-FIES CONCERT AUDIENCE WITH ANTI-

WAR APPEAL. But then his enthusiasm collapsed. He lost heart. Who the hell was this Negro rising up from the piano and informing the world what an ass Leonard Bernstein was making of himself? It didn't make sense, this superego Negro by the concert grand.

Mmmmmmmmmmmmmmmm. These are nice. Little Roquefort cheese mor-sels rolled in crushed nuts. Very tasty. Very subtle. It's the way the dry sackiness of the nuts tiptoes up against the sour savor of the cheese that is so nice, so subtle. Wonder what the Black Panthers eat here on the hors d'oeuvre trail? Do the Panthers like little Roque-fort cheese morsels wrapped in crushed nuts this way, and asparagus tips in mayonnaise dabs, and *meatballs petites au Coq Hardi,* all of which are at this very moment being offered to them on gadrooned silver platters by maids in black uniforms with hand-ironed white aprons . . . The butler will bring them their drinks . . . Deny it if you wish to,

Do Panthers like Roquefort morsels?

The only other thing to do is what Ellie Guggenheimer is doing next week with her party for the Young Lords in her duplex on Park Avenue at 89th Street, just ten blocks up from Lenny and Felicia. She is giving her party on a Sunday, which is the day off for the maid and the cleaning woman. "Two friends of mine"—she confides on the telephone—"two friends of mine who happen to be...not white—that's what I hate about the times we live in, the *terms*—well, they've agreed to be butler and maid...and I'm going to be a maid myself!"

Just at this point some well-meaning soul is going to say, Why not do without servants altogether if the matter creates such unbearable tension and one truly believes in equality? Well, even to raise the question is to reveal the most fundamental ignorance of life in the great co-ops and townhouses of the East Side in the age of Radical Chic. Why, my God! Servants are not a mere convenience, they're an absolute psychological necessity. Once one is into that life, truly into it, with the morning workout on the velvet swings at Kounovsky's and the late mornings on the telephone, and lunch at the Running Footman, which is now regarded as really better than La Grenouille, Lutèce, Lafayette, La Caravelle and the rest of the general Frog Pond, less ostentatious, more of the David Hicks feeling, less of the Parish-Hadley look, and then—well, then, the idea of not having servants is unthinkable. But even that does not say it all. It makes it sound like a matter of convenience, when actually it is a sheer and fundamental matter of—*having servants*. Does one comprehend?

God, what a flood of taboo thoughts runs through one's head at these Radical Chic events...But it's delicious. It is as if one's nerve-endings were on red alert to the most intimate nuances of status. Deny it if you want to! Nevertheless, it runs through every soul here. It is the matter of the marvelous contradictions on all sides. It is like the delicious shudder you get when you try to force the prongs of two horseshoe magnets together...*them* and *us*...

For example, one's own servants, although white, are generally no problem. The euphemisms are not always an easy matter, however. When talking to one's white servants, one doesn't really know whether to refer to blacks as *blacks, Negroes,* or *colored people.* When talking to other...well, *cultivated* persons, one says *blacks,* of course. It is the only word, currently, that implicitly shows one's awareness of the dignity of the black race. But somehow when you start to say the word to your own white servants, you hesitate. You can't get it out of your throat. Why? *Counter-guilt!* You realize that you are about to utter one of those touchstone words that divide the cultivated from the uncultivated, the attuned from the unattuned, the *hip* from the dreary. As soon as the word comes out of your mouth—you know it before the first vocable pops on your lips—your own servant is going to size you up as one of those *limousine liberals,* or whatever epithet they use, who are busy pouring white soul all over the black movement, and would you do as much for the white lower class, for the domestics of the East Side, for example, fat chance, sahib. Deny it if you want to! but such are the delicious little agonies of Radical Chic. So one settles for *Negro,* with the hope that the great god Culturatus has laid the ledger aside for the moment....In any case, if one is able to make that small compromise, one's own servants are no real problem. But the elevator man and the doorman—the death rays they begin projecting, the curt responses, as soon as they see it is going to be one of *those* parties! Of course, they're all from Queens, and so forth, and one has to allow for that. For some reason the elevator men tend to be worse about it than the doormen, even; less sense of *politesse,* perhaps.

Or—what does a woman wear? Obviously one does not want to wear something frivolously and pompously expensive, such as a Gerard Pipart party dress. On the other hand one does not want to arrive "poor-mouthing it" in some outrageous turtleneck and West Eighth Street bell-jean combination, as if one is "funky" and of "the people." Frankly, Jean vanden Heuvel—that's Jean there in the hallway giving everyone her famous smile, in which her eyes narrow down to f/16—frankly, Jean tends too much toward the funky fallacy. Jean, who is the daughter of Jules Stein, one of the wealthiest men in the country, is wearing some sort of rust-red snap-around suede skirt, the sort that English working girls pick up on Saturday afternoons in those absolutely *berserk* London boutiques like Bus Stop or Biba, where everything looks chic and yet skimpy and raw and vital. Felicia Bernstein seems to understand the whole thing better. Look at Felicia. She is wearing the simplest little black frock imaginable, with absolutely no ornamentation save for a plain gold necklace. It is perfect. It has dignity without any overt class symbolism.

Lenny? Lenny himself has been in the living room all this time, talking to old friends like the Duchins and the Stantons and the Lanes. Lenny is wearing a black turtleneck, navy blazer, Black Watch plaid trousers and a necklace with a pendant hanging down to his sternum. His tailor comes here to the apartment to take the measurements and do the fittings. Lenny is a short, trim man, and yet he always seems tall. It is his head. He has a noble head, with a face that is at once sensitive and rugged, and a full stand of iron-gray hair, with sideburns, all set off nicely by the Chinese yellow of the room. His success radiates from his eyes and his smile with a charm that illustrates Lord Jersey's adage that "contrary to what the Methodists tell us, money and success are good for the soul." Lenny may be 51, but he is still the *Wunderkind* of American music. Everyone says so. He is not only one of the world's outstanding conductors, but a more than competent composer and pianist as well. He is the man who more than any other has broken down the wall between elite music and popular tastes, with *West Side Story* and his children's concerts on television. How natural that he should stand here in his own home radiating the charm and grace that make him an easy host for leaders of the oppressed. How ironic that the next hour should prove so shattering for this *egregio maestro!*

A bell rang, a dinner table bell, by the sound of it, the sort one summons the maid out of the kitchen with, and the party shifted from out of the hall and into the living room. Felicia led the way, Felicia and a small gray man, with gray hair, a gray face, a gray suit, and a pair of Groovy but gray sideburns. A little gray man, in short, who would be popping up at key moments...to keep the freight train of history on the track, as it were...

Felicia was down at the far end of the living room trying to coax everybody in.

"Lenny!" she said. "Tell the fringes to come on in!" Lenny was still in the back of the living room, near the hall. "Fringes!" said Lenny. "Come on in!" ∎

The Power of 100 Black Men

By Jacob Wortham

It is a cold and windy afternoon, and West 125th Street is almost deserted. Only the junkies and a few street hustlers are to be seen on Harlem's busiest thoroughfare. Passing up an opportunity to buy a "$200 watch for 50 bills," I rush through the doors of Freedom National Bank for a four-o'clock appointment with J. Bruce Llewellyn, president of a little-known group called 100 Black Men.

Llewellyn appears within a half hour, his massive bulk spread over a six-foot, five-inch frame, and apologizes profusely for keeping me waiting. In Freedom National's boardroom he sprawls over a wobbly, tobacco-brown vinyl couch to reflect on his success as an entrepreneur. As the bank's former board chairman and the owner of a supermarket chain grossing $36 million a year, he has the articulate and self-confident manner of a man who has made it to the top and knows there is a 98 percent chance that he will remain there. "Sure, you might say I have arrived, and so have most of the guys in 100 Black Men," he muses. "Together we encompass the most accomplished group of blacks in this country, and we are—without a doubt—the most powerful black organization in this city.

Arthur Barne Eugene Callend of the New Yo tion a year and came to the job tute for Mediati Resolution, wh president he ha pute between versity and the Puerto Rican c surrounds the Heights campus planned to drop gram for minor 1972. Barnes s worked out a s lowed the progr

Earl G. Grav lisher of *Black* azine, Graves lucrative and c while gaining nition as an e economic intere ing a format tha best of *Money* has created a p has definite sno the black midd ministrative ai Robert Kenned he started *Blac* 1970, and turn first year. Toda has a circulati and advertising year totaled ne

Black Is Powerful:

Robert Carroll, 42, was a deputy administrator in the city's Human Resources Administration when he was tapped for a vice-presidency at City College three years ago. Educated at predominantly black Florida A & M, Columbia, and Yale, Carroll is head of communications and public affairs at CCNY. His appointment was generally applauded by the school's minority students, and he has worked hard to convince them he is not a high-ranking token. As a vice-president, he serves on all of the school's policymaking committees, and is not reluctant to make his presence felt.

Richard Clarke, 49, calls himself "the biggest black headhunter in the country." He is president of Richard Clarke Associates, a successful executive-search firm, serving a predominantly black clientele. With offices in New York and Chicago, Clarke claims to have placed more than 900 blacks in blue-chip positions last year. He roams the country in search of black talent for scores of Fortune 500 companies such as Exxon, Equitable Life, IBM, Xerox, CBS, Avon, and others. Between expeditions, he spends a lot of time at the Studio Museum in Harlem, where he is chairman of the board.

David Dinkins, 48, is a man with a tenacious sense of survival. He lost a chance to become a deputy mayor three years ago when it was revealed that he had not filed income-tax returns for several years. Believed politically dead, he eventually cleared up his tax problem and was appointed city clerk in 1975. As the hard-nosed, sometimes abrasive chairman of the Council of Black Elected Democrats in New York State, Dinkins wields considerable influence both in Albany and at City Hall. He is also a vice-president of 100 Black Men.

Hughlyn Fierce, 41, was a vice-president in the corporate banking department of Chase Manhattan when J. Bruce Llewellyn approached him three years ago about taking over the management of the then ailing Freedom National Bank. After eleven years at Chase, Fierce's star was just beginning to rise. Naturally, he was reluctant to leave. He had a change of heart, however, when the management of Chase agreed to grant him a three-to-five-year leave of absence, enabling him to retain his company affiliation while heading the rescue mission at Freedom National.

Gilroye Griffin Jr., 38. Educated at Dartmouth and Columbia University Law School, Griffin appears to have found a home at the "Black Rock." As vice-president of management planning for CBS, he oversees the activities of eight key departments and is probably the most influential black within the corporation. "He is definitely not just another chief deputy to the colored," says one longtime CBS executive. The affable young man from "magnolia land"— Columbia, South Carolina—came to CBS over two years ago from Kenyon & Eckhardt Advertising, where he'd been a vice-president.

John L. S. Holloman, 56, got his job with the help of 100 Black Men, Percy Sutton, and the *Amsterdam News*. The corporation's board of directors reviewed the credentials of more than 160 candidates before acceding to demands from the black community that a black be appointed president of the often unwieldy Health and Hospitals Corporation. After nearly three years on the job, Holloman—plagued by a perpetual financial crisis—has failed to convince most people that he is the right man for the job. And, ironically, some of his earlier supporters now say privately he was a bad choice.

Don King, 44, is the only member of 100 Black Men who has "done time." Normally this would preclude his acceptance into the group, but King is no ordinary ex-con. As a flamboyant impresario of Muhammad Ali spectacles, he made a bundle of cash and has emerged as the first black heavyweight promoter in the lucrative sport of boxing. King scored his biggest victory two years ago, when he wrested the Ali-Foreman fight out of the hands of Top Rank, Inc., a closed-circuit-television firm that had held a virtual monopoly on Ali's previous fights.

Edward Lewis, 36, publisher of *Essence* magazine. The odds were against Lewis—and a small group of friends—when the maiden issue of the now successful fashion magazine for black women rolled off the presses in May of 1970. Lewis and his associates, all novices in publishing, were offering yet another black publication, at a time when such magazines were going under at a rapid rate. Last year, under Lewis's tough and almost autocratic rule, *Essence* pulled in advertising revenues totaling more than $3 million, making it the strongest competitor to the ubiquitous *Ebony* and *Jet*.

A Harlot High and Low: Reconnoitering Through the Secret Government By Norman Mailer

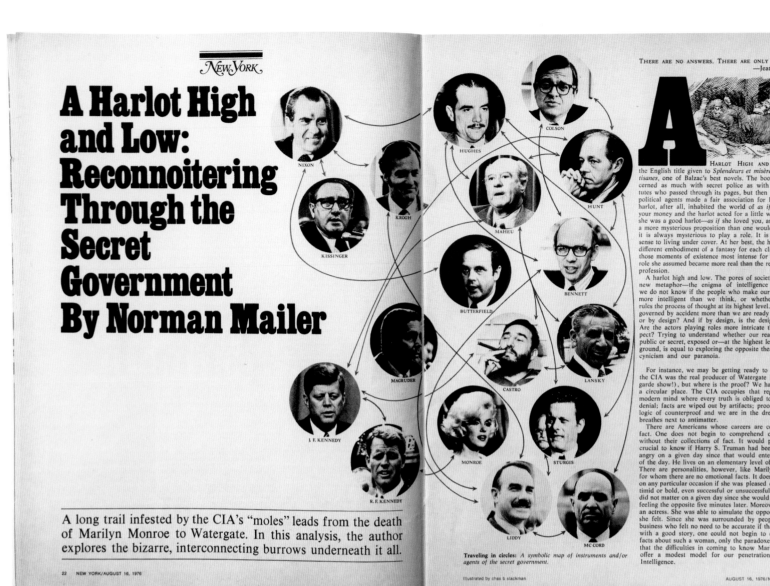

NIXON

KROGH

KISSINGER

HUGHES

COLSON

MAHEU

HUNT

BUTTERFIELD

BENNETT

MAGRUDER

CASTRO

LANSKY

J. F. KENNEDY

MONROE

STURGIS

R. F. KENNEDY

LIDDY

MC CORD

A long trail infested by the CIA's "moles" leads from the death of Marilyn Monroe to Watergate. In this analysis, the author explores the bizarre, interconnecting burrows underneath it all.

Traveling in circles: *A symbolic map of instruments and/or agents of the secret government.*

Illustrated by chas b slackman

THERE ARE NO ANSWERS. THERE ARE ONLY QUESTIONS.
—Jean Malaquais

A HARLOT HIGH AND LOW WAS the English title given to *Splendeurs et misères des courtisanes,* one of Balzac's best novels. The book was concerned as much with secret police as with the prostitutes who passed through its pages, but then whores and political agents made a fair association for Balzac. The harlot, after all, inhabited the world of *as if.* You paid your money and the harlot acted for a little while—when she was a good harlot—*as if* she loved you, and that was a more mysterious proposition than one would think, for it is always mysterious to play a role. It is equal in a sense to living under cover. At her best, the harlot was a different embodiment of a fantasy for each client, and at those moments of existence most intense for herself, the role she assumed became more real than the reality of her profession.

A harlot high and low. The pores of society breathe a new metaphor—the enigma of intelligence itself. For we do not know if the people who make our history are more intelligent than we think, or whether stupidity rules the process of thought at its highest level. Is America governed by accident more than we are ready to suppose, or by design? And if by design, is the design sinister? Are the actors playing roles more intricate than we expect? Trying to understand whether our real history is public or secret, exposed or—at the highest level—underground, is equal to exploring the opposite theaters of our cynicism and our paranoia.

For instance, we may be getting ready to decide that the CIA was the real producer of Watergate (that avant-garde show!), but where is the proof? We have come to a circular place. The CIA occupies that region in the modern mind where every truth is obliged to live in its denial; facts are wiped out by artifacts; proof enters the logic of counterproof and we are in the dream; matter breathes next to antimatter.

There are Americans whose careers are composed of fact. One does not begin to comprehend certain men without their collections of fact. It would probably be crucial to know if Harry S. Truman had been happy or angry on a given day since that would enter the event of the day. He lives on an elementary level of biography. There are personalities, however, like Marilyn Monroe, for whom there are no emotional facts. It does not matter on any particular occasion if she was pleased or annoyed, timid or bold, even successful or unsuccessful. Her mood did not matter on a given day since she would as easily be feeling the opposite five minutes later. Moreover, she was an actress. She was able to simulate the opposite of what she felt. Since she was surrounded by people in show business who felt no need to be accurate if that interfered with a good story, one could not begin to discover the facts about such a woman, only the paradoxes. It may be that the difficulties in coming to know Marilyn Monroe offer a modest model for our penetration of Central Intelligence.

1976

Mailer kept digging deep into the way power worked.

And in 1976, *New York* ran an extremely long, borderline-paranoid, pushing-the-boundaries-of-plausibility riff about the murderous doings of the Central Intelligence Agency. Even if you believed only a quarter of it, that was enough to make you sleep a little less soundly.

1977

But not all power rankings were so deeply disturbing.

For a year-end issue, Robert Grossman joined with Alan Rich to create short illustrated stanzas about 26 public belly flops, presented in alphabetical order. His choice for the "Z" was a deliberately misspelled New York Giant: "Larry Zonka (yes, I know)."

1976

Especially when they made fun of bad political theater.

During the 1976 Democratic National Convention, Grossman spent days on the floor of the Garden, catching in pen and ink the silly signs and bubble earrings of the delegates.

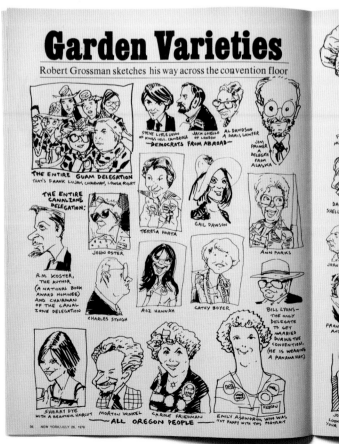

Before she went on to make news, Gloria Steinem covered it as a *New York* political columnist.

On office politics ➻ "An associate producer of a television talk show, who has now seen five not-very-well-qualified men promoted to be her producers, one by one, while her capabilities are ignored, complained to a station executive. 'He thought I was getting "women's rightsy,"' she said sorrowfully. 'Couldn't he at least say *human* rightsy?'" *—December 23, 1968*

On women and power ➻ "As Jacqueline Kennedy was quoted in a New York newspaper profile, 'There are two kinds of women: those who want power in the world and those who want power in bed.'" *—December 23, 1968*

On Gene McCarthy ➻ "Friends on the right said McCarthy didn't have a chance. Friends on the left said he was just another member of the Establishment; that no real reform could be made working through the system anyway. I grew more certain of my support just from those hours of arguing." *—August 5, 1968*

On "the Black John Wayne" ➻ "Jim Brown wasn't about to identify with the prop Negroes on the screen. They rarely won fights and they never got the girl: two things Jim always managed to do in real life." *—November 11, 1968*

On abortion ➻ "Florynce Kennedy, a lawyer and black militant at whose name strong white men shake, went into her specialty—creating a newsworthy sideshow to call attention to a good cause. 'Listen,' she said cheerfully. 'Why don't we shoot a New York State legislator for every woman who dies from an abortion?'" *—March 10, 1969*

On Republicans ➻ "One cure for New York depression: five minutes of thinking hard, very hard, about what would happen if Governor Rockefeller were supplanted by Governor Reagan." *—March 24, 1969*

On "liberation" ➻ "Once upon a time—say, ten or even five years ago—a liberated woman was somebody who had sex before marriage and a job afterward. Once upon the same time, a Liberated Zone was any foreign place lucky enough to have an American army in it. Both ideas seem antiquated now, and for pretty much the same reason: Liberation isn't exposure to the American values of Mom-and-apple-pie anymore (not even if Mom is allowed to work in an office and vote once in a while); it's the escape from them." *—April 7, 1969*

On the Nixon administration ➻ "What we have to worry about is applause. And, in the human vacuum left by the colorless Nixon administration, Agnew has been getting a lot. Nixon may be klutzy, manufactured like white bread, and not long on compassion, but Agnew is the cheerful, likeable Cossack who rides through the ghetto with a whip, or does whatever else is currently popular, and then goes home to eat a big meal and sleep like a top." *—December 15, 1969*

On bars that refused to serve women ➻ "Beginning on the date of this issue, Mayor Lindsay's signature will make effective a local law prohibiting such discrimination everywhere, McSorley's and the Oak Room of the Plaza included....Even the very resentful general manager at the Plaza says the Oak Room will conform. As one who has been turned away from business lunches and twice expelled from the Plaza's public lobby on the ground that I might be a prostitute (a strange combination of humiliation and flattery), I'm looking forward to seeing the new law enforced." *—August 10, 1970*

On journalism ➻ "After eight years of writing, I am happy to report the first occasion on which being a woman writer was a journalistic advantage. Author Caroline Bird and I, having been invited as explainers of the women's movement, found ourselves involved in a newsworthy meeting of the Harvard Business School Club of New York while the rest of the press were kept out." *—November 23, 1970*

On a new word ➻ "Since 'Mr.' doesn't indicate marital status, there's been a lot of resentment of 'Mrs.' and 'Miss' as required forms of address. Now, many politically sensitive organizations have started using 'Ms.' on letters and forms to indicate the addressee is female; a simple counterpart of 'Mr.'... Personally, I'm all in favor of the new form, and will put it on all letters and documents. But an airline clerk asked me 'Miss or Mrs.?' on the phone, and I was stumped. How the hell do you pronounce Ms.? *—August 24, 1970*

"How the hell do you pronounce Ms.?" A year later, Steinem and *New York* produced the premiere issue of a magazine for women with that very name.
(Turn the page to see it.)

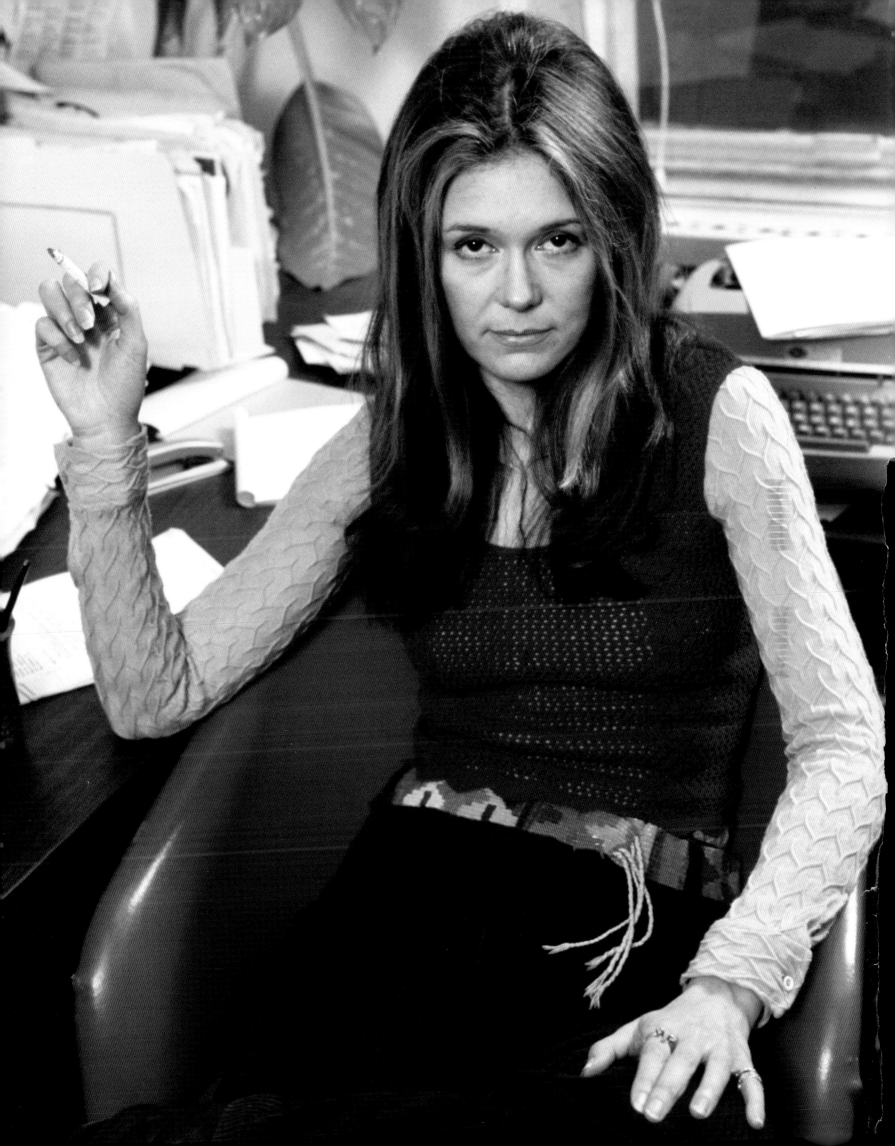

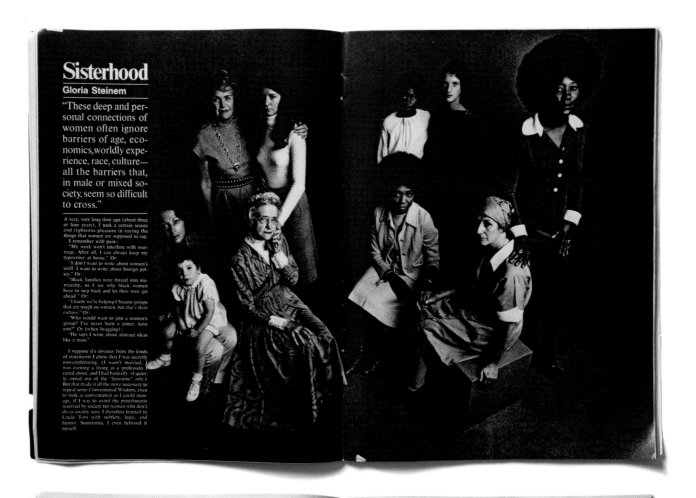

Sisterhood

Gloria Steinem

"These deep and personal connections of women often ignore barriers of age, economics, worldly experience, race, culture—all the barriers that, in male or mixed society, seem so difficult to cross."

A very, very long time ago (about three or four years), I took a certain secure and righteous pleasure in saying the things that women are supposed to say.

I remember with pain—

"My work won't interfere with marriage. After all, I can always keep my typewriter at home." Or:

"I don't want to write about women's stuff. I want to write about foreign policy." Or:

"Black families were forced into matriarchy, so I see why black women have to step back and let their men get ahead." Or:

"I know we're helping Chicano groups that are tough on women, but *that's their culture*." Or:

"Who would want to join a women's group? I've never been a joiner, have you?" Or (when bragging):

"He says I write about abstract ideas like a man."

I suppose it's obvious from the kinds of statements I chose that I was secretly non-conforming. (I wasn't married, I was earning a living at a profession I cared about, and I had basically—if quietly—opted out of the "feminine" role.) But that made it all the more necessary to repeat some Conventional Wisdom, even to look as conventional as I could manage, if I was to avoid the punishments reserved by society for women who don't do as society says. I therefore learned to Uncle Tom with subtlety, logic, and humor. Sometimes, I even believed it myself.

The Housewife's Moment of Truth

Jane O'Reilly

Last June, 40 people were lying on a floor in Aspen, Colorado, floating free and uneasy on the indoor/outdoor carpet, eyes closed, being led through the first phase of a "Workshop in Approaching Unisexuality." It would turn out later that the aim of the exercise was not to solve the problem of who does what and to whom, but to reveal to the participants that adjectives such as warm, violent, soft, timid, peaceful, and aggressive are not necessarily definitions for male or female.

We closed our eyes and cleared our minds. Slowly we perceived a lake in the distance, and as we walked toward it, the surface became smooth as a mirror into which we could look and see our reflection. There was no reflection. Infinitely slowly, we began to evolve into the animal that most expressed our own ideas of ourselves—of our sensual selves. Minutes passed and we became aware of the other animals around us. At last we opened our eyes and those animals that felt like it did whatever seemed natural. Most of the women twittered or purred. Most of the men growled, or attempted to wag tails. I was a cat, black, with a lovely long tail, sitting under a red geranium in a sunny window. We formed groups in our part of the conference-room forest, and told each other what we had become.

"I was a snake," said a beautiful young woman, a professional designer. "As I was moving through the grass, enjoying my slithering, curving progress, I realized I had no fangs. No bite. I couldn't even hiss. My only protection was that I could change color in reaction to the people that passed by. I started to go through my garden and I saw that there were panthers draped over all the lawn furniture. I went into my house, and there were panthers everywhere, filling every chair, curled up in groups in all the rooms. They were eating, rather elegantly, and no one paid any attention to me, even when I asked if they wanted anything more to eat. I was interested, but I was different, and finally I withdrew."

The women in the group looked at her, looked at each other, and . . . click! A moment of truth. The shock of recognition. Instant sisterhood. "You became a *housewife*," we said, excited, together, turning to the men to see if they understood. "She is describing a housewife. Do you know that?"

"Hmm, yes, well, uh . . ." they said, sensitized for the morning, but eager to recount their own stories of becoming spotted leopards in green forests, of turning to griffins with human heads who know and see all. The next time, or perhaps the time after that, they will recognize the click! of recognition, that parenthesis of truth around a little thing that completes the puzzle of reality in women's minds—the moment that brings a gleam to our eyes and means the revolution has begun.

Those clicks are coming faster and faster. They were nearly audible last summer, which was a very angry summer for American women. Not redneck-angry from screaming because we are so frustrated and unfulfilled-angry, but clicking-things-into-place-angry, because we have suddenly and shockingly perceived the basic disorder in what has been believed to be the natural order of things.

One little click turns on a thousand others. I had been sitting in that Aspen room, feeling a very liberated cat—alone on my window sill, self-sufficient and self-enclosed, able to purr or scratch as I chose. I was fooling myself. If my free-association had said something about my actual life, I would have evolved as a pig. But I followed the pattern of my socialization: cued by the word *sensual*, I became a nice, domestic cat, sitting under a healthy well-watered geranium, watching the sunlight fall through a clean window, over a dust-free window sill, across a polished floor. The room was cozy, with a tea tray by the fire. In another five minutes of meditating evolution, I would have jumped off the window sill and started curling around the leg of a dog.

In fact, parables are unnecessary for recognizing the blatant absurdity of everyday life. Reality is lesson enough. In Houston, Texas, a friend of mine stood and watched her husband step over a pile of toys on the stairs, put there to be carried up. "Why can't you get this stuff put away?" he mumbled. Click! "You have two hands," she said, turning away.

Last summer I got a letter, from a man who wrote: "I do not agree with your last article, and I am cancelling my wife's subscrip-

tion." The next day I got a letter from his wife saying, "I am not cancelling *my* subscription." Click!

On Fire Island my weekend hostess and I had just finished cooking breakfast, lunch, and washing dishes for both. A male guest came wandering into the kitchen just as the last dish was being put away and said, "How about something to eat?" He sat down, expectantly, and started to read the paper. Click! "You work all week," said the hostess, "and *I* work all week, and if you want something to eat, you can get it, and wash up after it yourself."

In New York last fall, my neighbors—named Jones—had a couple named Smith over for dinner. Mr. Smith kept telling his wife to get up and help Mrs. Jones. Click! Click! Two women radicalized at once.

A woman I know in St. Louis, who had begun to enjoy a little success writing a grain company's newsletter, came home to tell her husband about lunch in the executive dining room. She had planned a funny little anecdote about the deeply humorous pomposity of executives, when she noticed her husband rocking with laughter. "Ho ho, my little wife in an executive dining room." Click!

Last August, I was on a boat leaving an island in Maine. Two families were with me, and the mothers were discussing the troubles of cleaning up after a rental summer. "Bob cleaned up the bathroom for me, didn't you honey?" she confided, gratefully patting her husband's knee. "Well, what the hell, it's vacation," he said, fondly. The two women looked at each other, and the queerest change came over their faces. "I got up at six this morning to make the sandwiches for the trip home from this 'vacation,' " the first one said. "So I wonder why I've thanked him at least six times for cleaning the bathroom?" Click! Click!

Attitudes are expressed in semantic equations that simply turn out to be two languages; one for men and another for women. One morning a friend of mine told her husband she would like to hire a baby sitter so she could get back to her

painting. "Maybe when you start to make money from your pictures, then we could think about it," said her husband. My friend didn't stop to argue the inherent fallacy in his point—how could she make money if no one was willing to free her for work? She suggested that, instead of hiring someone, he could help with the housework a little more. "Well, I don't know, honey," he said, "I guess sharing the housework is all right if the wife is really contributing something, brings in a salary. . . ." For a terrible minute my friend thought she would kill her husband, right there at breakfast, in front of the children. For ten years, she had been covering furniture, hanging wallpaper, making curtains and refinishing floors so that they could afford the mortgage on their apartment. She had planned the money-saving menus so they could afford the little dinners for prospective clients. She had crossed town to save money on clothes so the family could have a new hi-fi. All the little advances in station—the vacations, the theater tickets, the new car—had been made possible by her crafty, endless, worried manipulation of the household expenses. "I was under the impression," she said, "that I was contributing something. Evidently my life's blood is simply a non-deductible expense."

In suburban Chicago, the party consisted of three couples. The women were a writer, a doctor and a teacher. The men were all lawyers. As the last couple arrived, the host said, jovially, "With a roomful of lawyers, we ought to have a good evening." Silence. Click! "What are we?" asked the teacher. "Invisible?"

In an office, a political columnist, male, was waiting to see the editor-in-chief. Leaning against a doorway, the columnist turned to the first woman he saw and said, "Listen, call Barry Brown and tell him I'll be late." Click! It wasn't because she happened to be an editor herself that she refused to make the call.

In the end, we are all housewives, the natural people to turn to when there is something unpleasant, inconvenient or inconclusive to be

54 NEW YORK

Illustrated by Miriam Wosk

1971

'Ms.' made its debut as a very different kind of centerfold.

Steinem's test issue was bound into the center of the December 20, 1971, issue of *New York*, in one of the most talked-about magazine launches ever. Jane O'Reilly's essay about the "click"—that moment of recognition when many women become enlightened about gender expectations—remains a watershed moment of second-wave feminism.

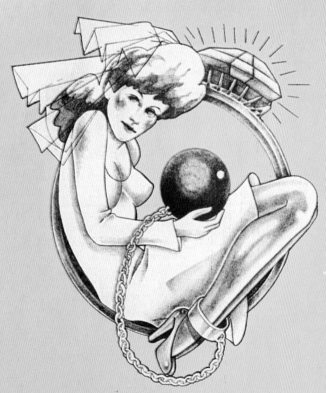

I WANT A WIFE

Judy Syfers

I belong to that classification of people known as wives. I am A Wife. And, not altogether incidentally, I am a mother.

Not too long ago a male friend of mine appeared on the scene fresh from a recent divorce. He had one child, who is, of course, with his ex-wife. He is obviously looking for another wife. As I thought about him while I was ironing one evening, it suddenly occurred to me that I, too, would like to have a wife. Why do I want a wife?

I would like to go back to school so that I can become economically independent, support myself, and, if need be, support those dependent upon me. I want a wife who will work and send me to school. And while I am going to school I want a wife to take care of my children. I want a wife to keep track of the children's doctor and dentist appointments. And to keep track of mine, too. I want a wife to make sure my children eat properly and are kept clean. I want a wife who will wash the children's clothes and keep them mended. I want a wife who is a good nurturant attendant to my children, who arranges for their schooling, makes sure that they have an adequate social life with their peers, takes them to the park, the zoo, etc. I want a wife who takes care of the children when they are sick, a wife who arranges to be around when the children need special care, because, of course, I cannot miss classes at school. My wife must arrange to lose time at work and not lose the job. It may mean a small cut in my wife's income from time to time, but I guess I can tolerate that. Needless to say, my wife will arrange and pay for the care of the children while my wife is working.

I want a wife who will take care of my physical needs. I want a wife who will keep my house clean. A wife who will pick up after me. I want a wife who will keep my clothes clean, ironed, mended, replaced when need be, and who will see to it that my personal things are kept in their proper place so that I can find what I need the minute I need it. I want a wife who cooks the meals, a wife who is a *good* cook. I want a wife who will plan the menus, do the necessary grocery shopping, prepare the meals, serve them pleasantly, and then do the cleaning up while I do my studying. I want a wife who will care for me when I am sick and sympathize with my pain and loss of time from school. I want a wife to go along when our family takes a vacation so that someone can continue to care for me and my children when I need a rest and change of scene.

I want a wife who will not bother me with rambling complaints about a wife's duties. But I want a wife who will listen to me when I feel the need to explain a rather difficult point I have come across in my course of studies. And I want a wife who will type my papers for me when I have written them.

I want a wife who will take care of the details of my social life. When my wife and I are invited out by my friends, I want a wife who will take care of the babysitting arrangements. When I meet people at school that I like and want to entertain, I want a wife who will have the house clean, will prepare a special meal, serve it to me and my friends, and not interrupt when I talk about the things that interest me and my friends. I want a wife who will have arranged that the children are fed and ready for bed before my guests arrive so that the children do not bother us.

And I want a wife who knows that sometimes I need a night out by myself.

I want a wife who is sensitive to my sexual needs, a wife who makes love passionately and eagerly when I feel like it, a wife who makes sure that I am satisfied. And, of course, I want a wife who will not demand sexual attention when I am not in the mood for it. I want a wife who assumes the complete responsibility for birth control, because I do not want more children. I want a wife who will remain sexually faithful to me so that I do not have to clutter up my intellectual life with jealousies. And I want a wife who understands that *my* sexual needs may entail more than strict adherence to monogamy. I must, after all, be able to relate to people as fully as possible.

If, by chance, I find another person more suitable as a wife than the wife I already have, I want the liberty to replace my present wife with another one. Naturally, I will expect a fresh, new life; my wife will take the children and be solely responsible for them so that I am left free.

When I am through with school and have a job, I want my wife to quit working and remain at home so that my wife can more fully and completely take care of a wife's duties.

My God, who *wouldn't* want a wife? ●

EDITOR'S LETTER

WHAT IS
Ms.
AND WHAT IS IT DOING IN
New York
?

In the almost-four years of *New York* Magazine's existence as an independent publication, we have witnessed a great upheaval in the publishing world. Magazines that were alive and strong at the time of our birth have since folded, victims to changing tastes, mailing costs, and the thousand other ills that print is heir to. Against all such trends, we have survived and continue to grow, as will other magazines that are designed to serve today's readers.

Partly out of the notion that success breeds success, and partly for reasons I'll come to later on, we are now giving our support to another new magazine. The central 40 pages of this issue of *New York*—a double issue, covering the two-week period from now to the first of the year—consist of a preview issue of *Ms.*, a national magazine edited totally by women, among them Gloria Steinem of our own staff. It is devoted to women—not as role players, but as full human beings.

Why *Ms.* (which, by the way, is pronounced *miz* or *miss*, depending on the pronouncer)? Certainly the publishing world offers a staggering array of magazines aimed at a women's readership, doing well for the most part. Invariably, however, these magazines see women in their traditional stereotypes as homemakers or clothes horses or mothers or hostesses. These days—as I don't have to tell you if you've been following our own editorial content over the past few years—that is hardly the entire story. Gloria Steinem, a contributor to *New York* since our earliest days, is a spokeswoman and leader of the Women's Movement, and it is inevitable that the combination of her deep personal convictions, her alliance with other women across the country,

and her skill as a writer and editor should result in a magazine.

We at *New York* owe Gloria a great deal. She helped enormously in getting our magazine started, and our staff members who have been with us since those uncertain days in early 1968 remember the forms her help took —from rewriting our direct mail pieces to promoting the magazine fiercely and turning out first-rate articles and columns under great pressure. Therefore, we must—out of love and gratitude, if for no other reasons (and there *are* others)—do what we can to help Gloria and her writing sisters get started on their own. Beyond that, we believe in the Women's Movement.

Until now, the Women's Movement has lacked an effective national publication to give voice to its ideas. We have placed our own knowledge and experience at Gloria's disposal to help shape such a magazine. *Ms.*, like *New York*, will concern itself with one of the most significant movements of our time.

Let me emphasize, however, that beyond playing godparent to *Ms.* for its first issue, we will have no further financial participation in the magazine. We want *Ms.* to be self-supporting and independent. With Elizabeth F. Harris in the role of publisher, *Ms.* is to be a magazine shaped by women. If we were to play the role of power-behind-the-scenes, that would only be a repetition of the traditional and already outmoded relationship between men and women.

The business arrangement is this: *New York* is paying production costs of the first issue, the *Ms.* staff is writing and editing it, and we are dividing the proceeds 50-50.

The Women's Movement will have impact on our lives. Such a force obviously needs its own voice. After having worked with Gloria for years, I know that she *is* the right woman at the right time. She will, of course, remain as a Contributing Editor of *New York*, continuing to write for our pages when she wants to comment on the local political scene.

Ms. will go on sale on January 25, in its first "solo" issue, after this *New York* Magazine "preview." The first solo issue will include more than twice as much material as is contained in our 40-page section. (Incidentally, two articles from our own portion of this double issue are also part of the editorial content of *Ms.*: the Urban Strategist pieces on "Desexing the English Language" and "Down With Sexist Upbringing."

There are more women than Gloria Steinem and Betty Harris involved. Some are on *New York*'s staff and worked to produce *Ms.* or to write for its first issue. Others have been working in the separate small office of *Ms.* and its female-controlled parent, Majority Enterprises. Naturally, all of us here in *New York*'s cramped East 32nd Street offices have been involved in one way or another, and it has been an exciting return for us to those days when our own Volume 1, Number 1 was taking shape. But special recognition should go to Bina Bernard, Joanne Edgar, Nina Finkelstein, Deborah Harkins, Betty Harris, Janet Lynch, Nancy Newhouse, Mary Peacock, Letty Pogrebin, Gloria Steinem, Joey Townsend, and Rochelle Udell.

For all of them, let me wish *Ms.* longevity and strength.

—Clay Felker

40 CENTS

DECEMBER 20, 1971

NEW YORK

Introduces

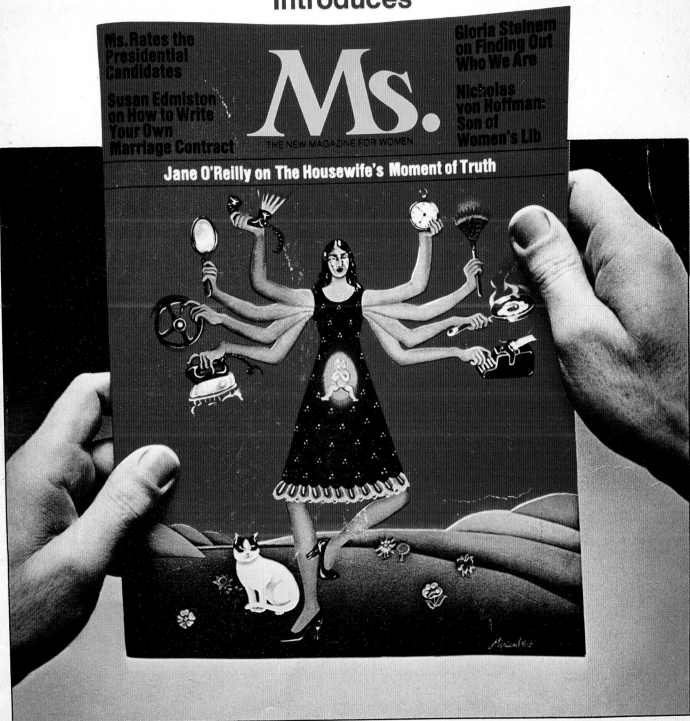

Ms. Rates the Presidential Candidates

Susan Edmiston on How to Write Your Own Marriage Contract

Ms.

THE NEW MAGAZINE FOR WOMEN

Gloria Steinem on Finding Out Who We Are

Nicholas von Hoffman: Son of Women's Lib

Jane O'Reilly on The Housewife's Moment of Truth

1977

Local politics was full of couldn't-make-'em-up characters.

"Stopping—even slowing down—is something Bella Abzug cannot allow herself to do," wrote Marie Brenner, "so she is running for mayor instead." Abzug's big hats and bus-driver honk did not quite reach the mayoralty or the Senate. But as a three-term representative, she was among the most powerful left-wingers in Congress and the dominant figure in women's-rights politics for a generation.

What Makes Bella Run?

By Marie Brenner

"...Bella is trying to prove that New York is ready for a municipal matriarchy..."

For anyone else, it would have been a moment of truth. Here she is: ex-congressperson, almost United States senator, now candidate for mayor of New York—probably the best-known female politician in America—sitting here in the airless Harvard room, allowing the arrogant eighteen-year-old photographer to compound the record-breaking heat with a battery of lights and the endless snapping of pictures, which he knows, and she knows, will never be published anywhere. Her perky little straw hat is beginning to wilt and she's perspiring, even though she's already traded in her early-morning long-sleeved Ultrasuede suit for a cooler short-sleeved model, and Bella is trying, really trying, to fire up these twenty undergrads who are simply not getting her at all.

All morning long, she's been hearing about John Connally, who preceded her at Harvard's Institute of Politics as visiting fellow. People have been telling Bella the Connally turnout was so astounding—so unexpectedly reverential—that one professor was heard to wonder if "the Harvards" imagined Watergate to be anything but the name of an apartment complex. But she doesn't seem to hear this. Earlier, Bella, Hunter-educated, was grousing in the car—but loving it too —about being "the visiting fireman" in this elitist territory. Perhaps her memories of Harvard are of the political strikes and rallies of the glorious war years. So she does not appear to get agitated that the twenty kids surrounding her at the Winthrop House

Marie Brenner is the author of the recently published novel Tell Me Everything. *Her new book,* Going Hollywood, *will be published in the fall.*

lunch do not have a single interesting question to ask. In fact, she seems oblivious to every indignity—until a soccer player announces there are no issues worth getting fired up about.

"You think we're living in calm times?" In a gesture I will see her repeat on a dozen occasions, Bella snaps into a different mental and physical state, as if she is most herself when she is on the attack. Her hand grabs the table for strength. Her voice shifts from basso Abzug-at-rest to a decibel level a colleague on the Public Works Committee once likened to sitting next to an airport. And Bella Abzug—the Bella Abzug you either love or hate but cannot, no matter how you try, ignore—starts yelling at the Harvard soccer player.

"Nothing for kids to be concerned about? You've got unemployment, you have got nuclear proliferation in technology that's crazy, you've got the cities decaying for a lack of funds all over this great country, you've got a failure of major programs in education, you have enormous energy problems— aren't these global problems?" She hesitates for a moment; in New York at this point she'd be getting an orgiastic response. Here? Nothing. She peers over her half-rimmed glasses, seeing, as if for the first time, that these faces are, if not bored, at least uncomprehending, but she cannot not press the point. *"Well, what do you kids think about that?"*

And still there is no cacophony of voices. Finally a blond Harvard female speaks up. "Well, frankly, Mrs. Abzug, here at Harvard, I don't think most of us worry about unemployment. Actually, most of us have summer jobs that are . . . quite good."

On the run: *Can Bella Abzug battle her way into Gracie Mansion?*

© DIANA MARA HENRY 1977

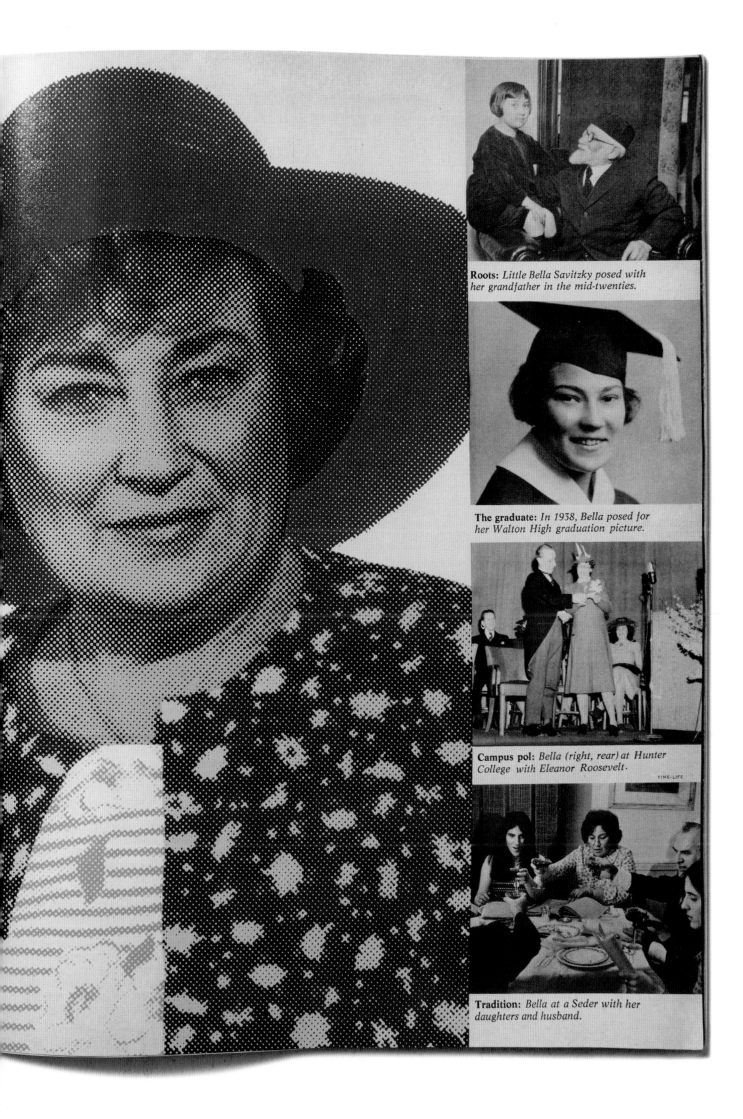

Roots: *Little Bella Savitzky posed with her grandfather in the mid-twenties.*

The graduate: *In 1938, Bella posed for her Walton High graduation picture.*

Campus pol: *Bella (right, rear) at Hunter College with Eleanor Roosevelt.*

TIME-LIFE

Tradition: *Bella at a Seder with her daughters and husband.*

1984

Power came in many forms: good, bad, and really bad.

"Just consider how much you already know about Leona Helmsley," wrote Bernice Kanner, going on to list the hotelier's perfectionism, imperiousness, relentless pushiness, and scorching treatment of her staff. (The caption on this photo noted that the fur coat was one of five she owned.) The Queen of Mean's conviction for tax evasion, and the 18 months she served, lay a few years in the future.

PHOTOGRAPH BY HARRY BENSON

Truly, the magazine spotted power everywhere.

Power Publicist: → 1998: "A bottle blonde with a tough New York accent that belies her Upper East Side roots, the 27-year-old **LIZZIE GRUBMAN** counts the trendiest of trendy nightspots as clients. Even Madonna is impressed. 'I don't know much about Lizzie's biz,' she admits, pushing up her cowboy hat. 'But she's had balls ever since she was a little kid.'" **Power Rabbi:** → 1979: "**RABBI ISAAC N. TRAININ:** 'I have dealt with more rabbis than any other Jew in history.'" **Power Drug Dealer:** → 1987: "The cops again began investigating the man they called the most powerful dealer in the area, **LORENZO 'FAT CAT' NICHOLS**."

Power Music Exec: → 1973: "**AHMET ERTEGÜN**, president of Atlantic Records, man of the world. The first Moslem to be given a testimonial dinner by the United Jewish Appeal; a white corporate executive who really does have some black best friends (can you think of another?);

a millionaire fat cat who, when the revolution comes, will probably be allowed to keep at least one of his chauffeurs." **Power Editor:** → 1996: "In a realm where the cult of personality reigns supreme—the more capricious, the better—**JOHN FAIRCHILD** manages to bring some of the biggest prima donnas this side of Coco Chanel to heel." **Power Real-Estate Broker:** → 2003: "Brokers love to hate **DOLLY LENZ**, mostly out of jealousy." **Power Drag Tupperware Salesperson:** → 2009: "**ROBERT SUCHAN**, nation's top seller: 'You can hardly speak to a woman on Long Island who doesn't know somebody who's been to one of my parties. I'm doing five a week, and I cannot keep up with the demand. These women, they clamor.'" **Power Gardener:** → 1974: "**MARY LASKER**, the lady who made Park Avenue bloom, is easily the city's most powerful local botanist." **Power Publisher:** → 2010: "Eight years into Gawker Media's existence, the standard line on **NICK DENTON** is still that he's an outsider of sorts, a rude alien come to torment—and supplant—media civilization as we know it. Thuggish is the reputation he wants." **Power Instagrammer:** → 2016: "'If there is one thing that Instagram does,' **DEREK BLASBERG** said, 'it provides a platform for hustlers.'"

Intelligencer

Who's the Most Important Living New Yorker?

We asked thirteen prominent New Yorkers that question, then we asked the people they nominated who they think is the most important... The result? A flow chart of regard.

BY KATHERINE WARD

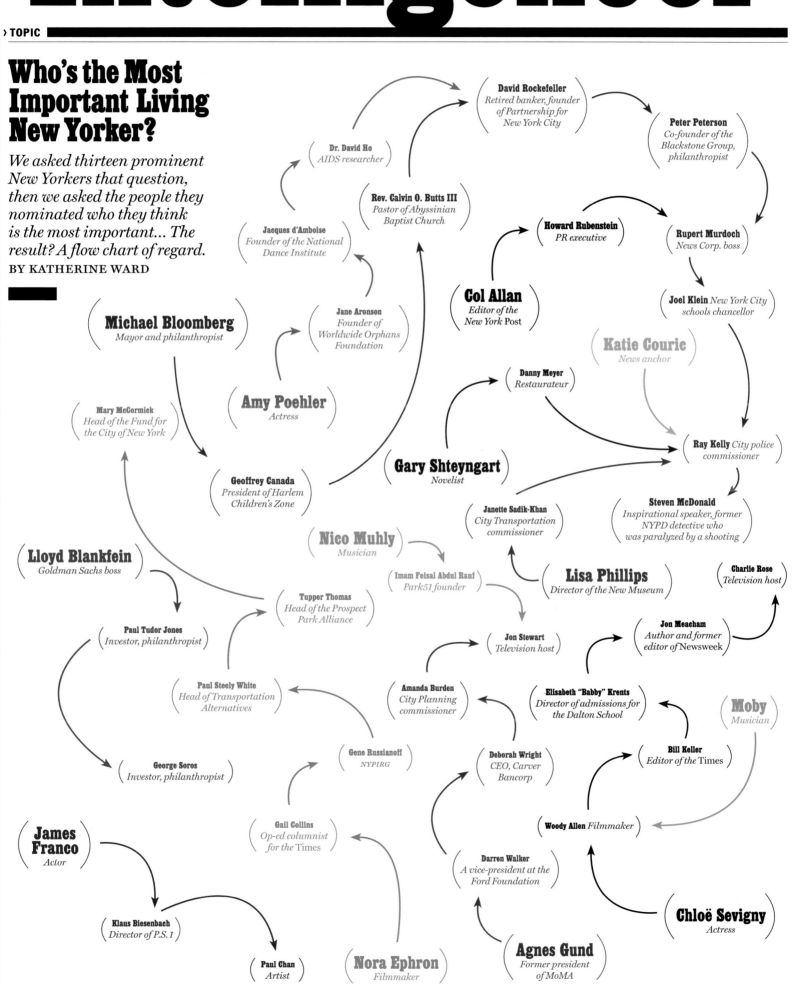

David Rockefeller *Retired banker, founder of Partnership for New York City*

Peter Peterson *Co-founder of the Blackstone Group, philanthropist*

Dr. David Ho *AIDS researcher*

Rev. Calvin O. Butts III *Pastor of Abyssinian Baptist Church*

Howard Rubenstein *PR executive*

Rupert Murdoch *News Corp. boss*

Jacques d'Amboise *Founder of the National Dance Institute*

Col Allan *Editor of the New York Post*

Joel Klein *New York City schools chancellor*

Michael Bloomberg *Mayor and philanthropist*

Jane Aronson *Founder of Worldwide Orphans Foundation*

Katie Couric *News anchor*

Amy Poehler *Actress*

Danny Meyer *Restaurateur*

Mary McCormick *Head of the Fund for the City of New York*

Gary Shteyngart *Novelist*

Ray Kelly *City police commissioner*

Geoffrey Canada *President of Harlem Children's Zone*

Steven McDonald *Inspirational speaker, former NYPD detective who was paralyzed by a shooting*

Janette Sadik-Khan *City Transportation commissioner*

Nico Muhly *Musician*

Lloyd Blankfein *Goldman Sachs boss*

Charlie Rose *Television host*

Imam Feisal Abdul Rauf *Park51 founder*

Lisa Phillips *Director of the New Museum*

Tupper Thomas *Head of the Prospect Park Alliance*

Jon Meacham *Author and former editor of Newsweek*

Paul Tudor Jones *Investor, philanthropist*

Jon Stewart *Television host*

Paul Steely White *Head of Transportation Alternatives*

Amanda Burden *City Planning commissioner*

Elisabeth "Babby" Krents *Director of admissions for the Dalton School*

Moby *Musician*

Bill Keller *Editor of the Times*

Gene Russianoff *NYPIRG*

Deborah Wright *CEO, Carver Bancorp*

George Soros *Investor, philanthropist*

James Franco *Actor*

Gail Collins *Op-ed columnist for the Times*

Woody Allen *Filmmaker*

Darren Walker *A vice-president at the Ford Foundation*

Klaus Biesenbach *Director of P.S. 1*

Chloë Sevigny *Actress*

Paul Chan *Artist*

Nora Ephron *Filmmaker*

Agnes Gund *Former president of MoMA*

In 50 years, organized crime went from ubiquitous to barely present. Nicholas Pileggi, *New York*'s man on the mob beat in the 1970s and 1980s, and Nicholas Gage, a *Times* reporter who wrote "Mafia at War" for *New York* in 1972, spoke about where all the gangsters have gone.

What Happened to the Mob?

It seems impossible for a reporter to infiltrate the Mafia. How did you each make your way in?

NICHOLAS GAGE: I had some luck. In a piece I did about bias in the Mafia for *The Wall Street Journal,* I wrote that one of the few people who were not prejudiced was Crazy Joe Gallo, who, when he was in Attica, would go to the black barbers to have his hair cut when no one else went. He desegregated the barbers in Attica. So when he came out, we had a connection. In fact, he moved into the apartment of the girl I later married, at 7 West 14th Street. So I went and rang the doorbell, and he was very friendly, and I said, you know, "Listen, I don't want to know what you're doing or what your friends are doing, but we all have enemies, you know?" Then he would call me periodically and tell me.

NICHOLAS PILEGGI: I spent all my time with cops at the police reporters' shack at 4 Centre Market Place. It's around the corner from Mulberry Street, and my father knew the owner of a restaurant called Paolucci's, and he'd said, "When my son comes in I want you to make sure he eats well." Well, if I was working the night shift, I'd get in there at about 2:30 a.m., and about 3 o'clock they would lock the door. Then suddenly men would show up, they would open the door for them, and the only people in there were mob bosses.

Did they look the part?

PILEGGI: No. You usually didn't know who they were. They were first-generation or immigrant Italian-Americans, all characters, and they were all funny. One of them would come in with paper bags filled with vegetables and dandelion greens that his wife had picked off the Belt Parkway—because you couldn't buy them at Zabar's in those days—and they would have to make that in salads for him. He would drink champagne and 7-Up. Big glass. And the way I got in was, my grandmother used to make a recipe which was sautéed pork chops, potatoes, peppers, onions, and hot vinegar peppers. It's just absolutely delicious. So I told the chefs, and that was the whole key. We were Calabrese, they were Calabrese—"Oh, we know that. That's wonderful." So they would make it for me. And these wiseguys are in there and they look over: *What the hell is he eating?* So before you know it all the wiseguys are eating my pork chops. They put me on the menu as Pork Chops Pileggi. True! And they got to know who I was, that I was safe.

GAGE: You had to maintain a professional distance, and I think they respected that. They did with me, anyway.

PILEGGI: You never said, "This Mafia guy is the worst, most loathsome person in the world." You didn't embarrass them. I know it's one of the reasons why you had the contacts you had.

GAGE: I mean, when they killed Joe Gallo, in a week or so I had on the front page of the *Times* who killed him, what guns they used, what cars they drove, where they went after the killing. I was really wired. But you have to stay on top of that.

How'd you do that? Regular check-ins? Do you call, or meet?

GAGE: You check in with everybody. You check in with law enforcement, you check in with people in the life, you check in with colleagues, you know, you share information, and you're there. One of the problems was, I only had one phone. So if I'm on the phone when somebody called…

PILEGGI: This is before the hold button.

GAGE: So I went to Abe [Rosenthal, executive editor of the *Times*] and I got three lines. All the other reporters were saying, "Why does he have three lines?"

Was it all centered in Little Italy then?

GAGE: And beyond. Brooklyn, certainly. The Bronx, Queens.

PILEGGI: I was born in Bensonhurst, Brooklyn, and I went to New Utrecht High School and a bunch of the Colombo people were there—Philly Dioguardi was in my class. All the pieces that I've done, in the magazine and the books and stuff, were all because I personally knew somebody, so I could get them to tell the story from their point of view.

GAGE: Joe Gallo's best friend and bodyguard was Pete "the Greek" Diapoulas. [*Laughs*]

PILEGGI: Did you know Pete?

GAGE: I got him on *60 Minutes* later, when he got into the federal witness program. You develop those sources.

PILEGGI: I became friendly with them before the Kefauver hearings, before they became famous, before the charts with their pictures. When those charts came out, I took them right to the joint. I showed them—and they go, "That's a pisser! That's full of shit. That guy is not a boss. He's over here." And they corrected the FBI's charts for me.

Those businesses they were in—concrete, linen supply—they're on the up-and-up now?

GAGE: Colombo was in real estate, wasn't he?

PILEGGI: A lot of them were in real estate. You know how that started, though? In 1933, Prohibition is over,

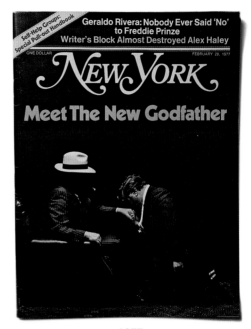

1972 1974 1977

now you can buy booze everywhere. There are no banks, you can't get a loan if you're a legitimate businessman. The only cash in the country were these guys, the old bootleggers. Joe Profaci, Longie Zwillman, Moe Dalitz, the Italian guys. They all had bootleg money. A real-estate deal comes up, you can't go to the bank to get it, so you wind up as a partner. "Let's go in on it, my son will work with your son." Peerless, Joe Profaci's liquor-distribution business—still the largest liquor-distribution business in the whole New York area.

But the next generation did it legally.

PILEGGI: Oh, yeah. Like, his grandchildren are running it, but it's all based out of Profaci's early wealth.

GAGE: That's how they got into Vegas, too.

PILEGGI: Tommy Gambino took all of the trucking business and the garments and he only did that because his father was Carlo Gambino. I think he wound up doing time or he paid a huge fine, but that trucking business is still there, but it's third and fourth generations who are now businessmen. Even their daughters are in it. Instead of staying home making ravioli, they're running businesses.

If you were an ordinary citizen, did you encounter the mob in any day-to-day way, or was it invisible except in the pages of *New York* or in the *Times*?

GAGE: Every day, you paid extra for it, but you didn't know it. The garbage collectors, the waiters in restaurants,

the bartenders—all those unions were mob-controlled.

PILEGGI: And the teachers, which was the key.

GAGE: Every restaurant was unionized. One club was not, the Copacabana. Who owned the Copacabana? Frank Costello.

So it was like paying sales tax.

GAGE: Also, they had the cover where law enforcement was focused on Bonnie and Clyde and all these bank robbers. So there was no attention paid to organized crime. From 1878 to 1960 or '61, no made member ever talked. When Bobby Kennedy became attorney general, and he focused attention, they came around and they really did a terrific job, particularly the strike force.

PILEGGI: Oh, the FBI? Oh. Absolutely. After '57, with the Apalachin conference and then the Kefauver Committee, you could no longer deny it, and J. Edgar Hoover started the Top Echelon Informant operations, who went out and really concentrated on the mob.

GAGE: In the '60s they had a capo, Scarpa, who was the top informant.

PILEGGI: Gregory Scarpa, yeah. That was a Top Echelon Informant thing. We both really had the contacts, and the newspapers were hungry for that stuff. Right now, you could come up with the biggest mob story in the world and nobody is interested. The mob is gone, basically.

GAGE: A shadow of its former self. A lot of these families are now third and fourth generation. The traditions that protected and strengthened are

no longer there. They're working with other gangsters—Albanians, Russians, all kinds of other people. The discipline is gone. So it was both pressure from outside and erosion from within, and it disintegrated. Of the 27 families originally across the United States, I would say at least half of them are either defunct or barely operational.

It sounds like the breakdown of the tight immigrant world was really the thing that did them in.

PILEGGI: Urban renewal killed it. These mob crews operated out of Little Italys, whether it was East Harlem or Bensonhurst or Mulberry Street, and they were all in tenements where you had 10,000 people in a couple of blocks. If you were in those neighborhoods, you could not *not* know a wiseguy, because that's where they came from. Now you've got them all spread out all over Staten Island, all over Westchester, all over Queens. How the hell do you know what's going on? You don't even know who is in the next house. It could be an FBI agent across the street. In those days, they knew every single person in those apartment houses.

GAGE: In every building. Yeah.

PILEGGI: In a lot of those buildings, nobody had locks and half the kids were related. "I don't want any more of the pasta…I want to go down and see if Mary is making fried chicken." And the kid would go down and eat fried chicken with somebody on the fourth floor.

With his cousin.

PILEGGI: Yeah. Everybody watched. ∎

Prostitution had its own kind of power.

The $2,000-an-Hour Woman

By Mark Jacobson

O N PAROLE AFTER serving seventeen months of his smuggling sentence, living in a funky third-floor walk-up in Hoboken per the terms of his release, Jason Itzler started NY Confidential (he would remain on parole his entire pimp career) in late 2003. Business was spotty at first but picked up dramatically in early 2004, when Natalia walked into the company's place at 54th Street and Sixth Avenue, an office previously occupied by the magician David Blaine.

"It was my birthday," Natalia remembers. "I'd just been cast as Ingrid Superstar in this play, *Andy & Edie*. I wanted to be Edie, but Misha Sedgwick, Edie's niece, also wanted it, so forget that. I was eating in a restaurant with Peter Beard, the photographer. I was a kind of party girl for a while. I met Peter one night, and we hit it off. He said I should meet this guy Jason."

Jason says, "When Natalia came over with Peter, I said, *Wow, she's so hot. She has one of the all-time great tushes.* But there was this other girl there, too. Samantha. When she took off her shirt, she had these amazing breasts. So it was Natalia's butt against Samantha's boobies. I went with the tits. But when Natalia came back from making a movie, she moved in with us. Samantha could tell I was kind of more into Natalia. So we became boyfriend and girlfriend."

At the time, Jason's top girl was Cheryl, who was the one who came up with the mantra Jason would later instruct all the NY Confidential girls to repeat, "three times," before entering a hotel room to see a client: *"This is my boyfriend of six months, the man I love, I haven't seen him for three weeks...This is my boyfriend of six months, the man I love..."*

"That's the essence of the true GFE, the Girlfriend Experience," says Jason. As opposed to the traditional "no kissing on the mouth" style, the GFE offers a warmer, fuzzier time. For Jason, who says he never hired anyone who'd worked as an escort before, the GFE concept was an epiphany. "Men see escorts because they want to feel happier. Yet most walk away feeling worse than they did before. They feel dirty, full of self-hatred. Buyer's remorse big-time. GFE is about true passion, something genuine. A facsimile of love. I told guys this was a quick vacation, an investment in the future. When they got back to their desks, they'd tear the market a new asshole, make back the money they spent at NY Confidential in an hour.

"What we're selling is rocket fuel, rocket fuel for winners."

Jason decided Natalia would become his great creation, the Ultimate GFE. It mattered little that Natalia, for all her French-Scottish sultriness, might strike some as a tad on the skinny side. Brown-eyed, dark-haired, olive-skinned, not to mention lactose-intolerant, she didn't fit the usual description of a big ticket in an industry filled with PSE (Porn-Star Experience) babes with store-bought bazangas out to here. Jason took this as a challenge. If he was into Natalia, he'd make sure everyone else was, too. It was a simple matter of harnessing the available technology.

The main vehicle was the TheEroticReview.com, "the *Consumer Reports* of the escort industry," according to the site's founder and owner, the L.A.-based Dave Elms, a.k.a. Dave@TER. "The most important thing was to break Natalia out big," Jason says. "To get the ball rolling with a number of fabulous reviews, I sent her to some friends, to sort of grease the wheel. I knew those 10/10s would keep coming, because no man wants to admit he got less. They're brainwashed that way."

With her 10/10s piling up, Natalia's hourly rate jumped from $800 to $1,200 with a two-hour minimum. (The split: 45 percent for the escort, 45 percent for the agency, 10 percent for the booker.) If clients haggled, they would be told to call back when they were "more successful." Jason's hyping sometimes was faintly embarrassing. "Jason would be saying, 'Natalia is the greatest escort in the history of the world, as good as Cleopatra or Joan of Arc,'" says Natalia, "and I'd be like, 'Jason! Joan of Arc was not an escort, she was a religious martyr.' Then he'd be saying I was the greatest escort since Mary Magdalene."

But all the hype in the world (an Asian toy manufacturer wanted to mass-produce Barbie-style Natalia dolls, complete with tiny lingerie) wouldn't have helped if Natalia, who never imagined she'd wind up staying in "every expensive hotel in New York," hadn't turned out to be a natural. "I'm a little moneymaking machine, that's what I am," she says as she takes a languorous drag of her Marlboro while stretching out on her apartment couch in a shiny pink satin corset, Marlene Dietrich style. Then she cracks up, because "you know, the whole thing is so ridiculous sometimes."

People wonder what it is about Natalia that made her the Perfect 10. "From the start, you know this is going to be fun," says one client. "It is like having sex in a tree house." Says another, "Nat isn't this all-knowing geisha thing. But in a way, it's deeper, because she gets to a place inside where you used to be free." And another: "With her, there's none of that shit like this is costing enough for a first-class ticket to London and the girl's in the bathroom for, like, half an hour. Natalia's this one, total this-is-all-about-you."

What no one could have predicted, least of all Natalia, was how driven she would be. "I knew she was talented," Jason says. "But once she started going, she was unstoppable, like the Terminator." The records of Natalia's bookings through June and July of 2004 reveal a workload exceeding 250 hours, or nearly a normal nine-to-five. "It was like a dream," Natalia says. "I never got tired."

If Cheryl experienced "a rush of power when the guy handed me the envelope," for Natalia, collecting the "donation," while essential, had a faintly unseemly feel. "Maybe it sounds crazy," she says, "but I never felt I was in it for the money." ∎

Natalie McLennan, who advertised in *New York* under the name Natalia, was among the most expensive escorts in New York City. About a year after this ad ran, she was featured in the cover story excerpted here. In 2008, faced with changing attitudes and shifting business practices—as well as protests from women's-rights groups—the magazine stopped accepting escort-service ads.

NEW YORK

JULY 18, 2005

N.Y.'S #1 ESCORT reveals all.

The $2,000-an-hour hooker
and the sex mogul who loved her.
BY MARK JACOBSON

Ed Koch—the purest strain of New York politician, a man who zestily played the role of Mayor for Life—sweated everything, big and small.

Ed Koch's Blind Spot

By Michael Kramer

ED KOCH WAS HAVING a good day. He had toured three of the city's five boroughs, and reaction had been overwhelmingly positive. The whole town, it seemed, was a nest of Koch groupies. Wherever he went, he took a vote. "Who's *for* me?," Koch would shout. Arms would shoot up. "Who's against me?" There were always a few. "You lose," Koch would say gleefully. The crowds went wild.

The mayor was even applauded at Shea Stadium, and as Koch himself said, "that never happens. Politicians are never cheered at ball parks. It's traditional to boo. Not that the booing bothers me. It doesn't. I psych myself up when people boo. They're booing, but I know what's going on in their minds. They really like me.

"Even most of the hecklers probably are for me," continued the mayor. "And I love them. I employ them to their best disadvantage. They make it possible for me to have an interesting program on the streets."

The day ended at the Great Lawn in Central Park. After the first two songs, Paul Simon interrupted the performance to thank those who had helped arrange his reunion with Art Garfunkel. Simon mentioned the Police, Fire, and Parks Departments. And then he thanked Ed Koch. The people roared. Koch beamed.

The mayor's party left early to avoid the rush, but it seemed that a hundred thousand fans had the same idea. A phalanx of cops cleared a path, and an obviously drunk fellow appointed himself the mayor's advance man: "Hey, look. Everybody, it's Ed Koch. Right here." The crowd was friendly, and Koch raised his hands above his head. His thumbs peaked over his clenched fists. And he squealed his famous "Hi, hi, how'm I doin'?" (It's just a "way to communicate," says the mayor. "Those who say that I call out because I'm insecure don't know what they're talking about. They're schmucks.")

It went on like this for about five minutes, and then, from no more than three feet away, a man "about 30, maybe six feet," Koch would later recall, sent a stream of beer at the mayor. He scored a direct hit. A drenched Koch wheeled to his right and glared at his attacker. "You do that intentionally?" asked the mayor through clenched teeth. The man didn't say a word, and Koch stood and stared at him for a few seconds. Then he said, "You pussy."

The police hustled the mayor out of the park at 81st Street and Central Park West. Before climbing into his blue Chrysler,

Koch turned to me and said, "You see that? I felt like beating the shit out of him."

"It was just one guy," I said. "You've had an incredible day. You've just been well received by hundreds of thousands of people. So what if one guy is out of control."

"You're right," said the mayor. He was smiling again.

"Just watch," said a veteran Koch watcher at the scene. "He'll brood about it for months. He's just been through one of the best campaigning days of his political life, and he'll remember it as the day they threw beer on him."

SURE ENOUGH, a week later, Koch was still upset. "Let me tell you what went through my mind," said the mayor in his City Hall office. "First, I was frightened. I didn't know what the stuff was until it hit. It could have been acid. Second, I really did want to beat the shit out of the guy. Or at least have him arrested.

"It was a challenge to my persona. An outrage. Because I'm the mayor, should I be treated less decently? If that happened to you, would you stand by? I could have beaten him up. I mean, I looked at him, sized him up, you know, and, yeah, I could have done it, But then there would have been cross-complaints, and I'm not crazy. And then they would have said I'm too sensitive.

"Let me tell you, if that guy were on a street corner and there was no crowd around, I would have had him arrested. But doing something in the park might have caused a riot or at least have resulted in headlines like mayor causes incident. And then, because it was so close to the election, they would have said that I did it just to get attention."

Three days alter the beer "brawl," Ed Koch won unprecedented victories on both the Democratic and Republican lines. He called them "super-landslides," and that's what they were. He deserved them. He had been a good mayor, perhaps a "terrific" one, as he says. In four years in office, New York's fiscal condition has stabilized. There has been some dispute about whether Koch deserves credit for the city's having avoided bankruptcy—but not in Koch's mind. Most of the second-guessing can be traced to various private comments by Felix Rohatyn. "But he was hoisted on his own petard," says Koch. "Felix would love to believe that he was responsible for everything. But on January 11, 1978, he wrote a letter saying we were headed into worse shape than before. It's in his own writing, and it proves that when times were toughest, *I* was the mayor.

"Now, Felix and I have our ups and downs, but he's a supporter. Our problems were really over when he realized that I, in fact, was the mayor and that when I was elected, they didn't elect a committee to go with me. I wasn't going to take a backseat to anybody."

And no one is wondering any longer if New York is a sinking ship. The city now has a marketable bond rating which it will need in the face of the Reagan budget cuts. City services are terrible—Koch says many of them "stink"—but he has grand plans, if unspecific ones, for the next few years: more cops, more firemen, and so on. He's made inroads in the archaic practices that have plagued the city for decades. Many mayors, for example, spoke of two-man, instead of three-man, garbage trucks: only Koch, who stood up to the unions, was able to get them.

To be sure, the road ahead will be bumpy. New fiscal problems are forecast, and the chances of further federal bailouts are slim—at best. The Republican administration is not disposed to rescue New York again, no matter how much Koch praises Reagan and no matter how high he flies his new GOP banner. The plain truth is that New York is still Congress's favorite whipping boy. ∎

$1.95 • MARCH 6, 1989

New York

READY FOR RUDY?

Giuliani talks with JOE KLEIN
about crime, drugs, housing,
AIDS—and running for mayor

Thirty years of Rudy Giuliani coverage can barely be contained in one combative page.

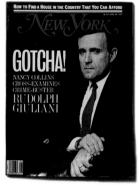

May 25, 1987

A Prosecutor with Ambitions ➤ **NOVEMBER 1985** "'I was amazed at how easy the cases have been to make,' said Rudolph Giuliani, U.S. Attorney for the Southern District. In one sting operation, 'we found that nobody turned us down...Even coming from New York and being fairly cynical, I was surprised.'" ➤ **DECEMBER 1986** "He could run for mayor in 1989. Or the Senate in '88....Or Giuliani could wait till 1990 and run for governor." ➤ **MAY 1987** "'I'm probably considerably more intelligent, much more creative, much better able to run things than lots of people who do.'" ➤ **FEBRUARY 1989** "Most polls make Giuliani the favorite in the mayoral race, if he chooses to run." ➤ **AUGUST 1989** "[He] had the toughness of a liberal and the compassion of a conservative. His polls began to dive. His campaign staff squabbled." **Who Loses to David Dinkins** ➤ **FEBRUARY 1990** "A terrible speech, vague, platitudinous, and poorly delivered. There was one applause line. Giuliani said he'd almost gotten himself elected mayor of New York. Since 'almost' is about as good as it gets for New York's Cuomatose Republicans, the party faithful cheered for a moment." ➤ **NOVEMBER 1992** "'A City Hall catfight is obviously to our benefit,' says an aide." **Then Defeats David Dinkins** ➤ **DECEMBER 1993** "Giuliani radiates a frightening preinaugural overconfidence." ➤ **APRIL 1995** "The mayor demonstrates his passionate concern for kids—by macing protesters, slashing programs, and turning Youth Services into a patronage dump." ➤ **SEPTEMBER 1995** "With [press secretary Cristyne] Lategano cleaved to the mayor's side, the gossip began." ➤ **OCTOBER 1997** "Giuliani, not content with the eighteen-point lead the most recent poll gives him, has commenced with his ammo dump on Ruth Messinger." **Gets Reelected** ➤ **JUNE 1998** "His outsize personality and emotions are too large for the problems he's tackling. It's overkill." **APRIL 1999** ➤ "To black New Yorkers, Rudy Giuliani's seemingly enlightened promise of 'one city, one standard' never rang true—as the Diallo case has now made brutally clear."

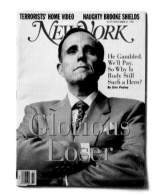

November 21, 1994

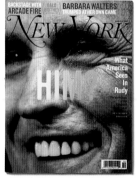

March 5, 2007

Runs for U.S. Senate Against Hillary Clinton ➤ **JANUARY 2000** "Talk about a contrast in styles: Rudy brazenly flouts the state's Republican leadership while Hillary tiptoes everywhere. Where's her moxie?" **Dumps His Wife Via Press Conference** ➤ **MAY 2000** "Another Giuliani insider sums up the situation thus: 'I mean, I don't understand his public pronouncements. I don't understand Donna's public pronouncements. And I don't understand parading Judi Nathan around in public.'" **Quits the Senate Race** ➤ **MAY 2000** "After three weeks of remarkable melodrama, Mayor Giuliani's withdrawal from the race showed him to be a different man—humble, grateful, ready to reach out. What changed him? His illness—and his romance." **Becomes the 9/11 Mayor** ➤ **OCTOBER 2001** "The mayor turned two weeks of unforgettable grace under pressure into a bald power grab." **Tries for Washington Again** ➤ **MAY 2002** "Power, for Giuliani, had always been a blunt instrument." ➤ **MARCH 2003** "Our only mayor did his level best, behind concrete barricades, to secure his homeland by shutting up cabdrivers, public advocates, city councillors, college students, street artists, AIDS demonstrators, anarchists, Farrakhans, Arafats, *New York* Magazine, and any other Chicken Little or Tiny Tim who thought out loud without his permission." ➤ **DECEMBER 2007** "Even as Giuliani runs away from New York, one fundamental thing remains the same as it was when he was shaking hands at subway stations in 1993: He's running a campaign rooted in fear." ➤ **SEPTEMBER 2011** "'If I think we are truly desperate, then I may run—which is how I got elected mayor of New York City.'" ➤ **OCTOBER 2011** "He's officially not running for president." **And, Finally, Stumps for Trump** ➤ **DECEMBER 2016** "Rudy Giuliani's unhinged, grasping embrace of Donald Trump was in fact slow and cautious—at least at first. This evolution (or devolution) almost functions as something of a stand-in for Rudy's career: a long arc of slowly moving rightward over the decades, from district attorney to America's mayor to Fox News talking head."

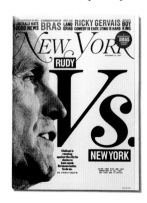

December 10, 2007

A billionaire became a three-term mayor, presiding over a better-run city that was a lot harder to afford.

He was, first of all, a CEO. ➵ "While Bloomberg's Salomon confrères were getting fat and famous in the eighties, Bloomberg was working away in obscurity, building a place for himself in the boom industry of the nineties: the multi-billion-dollar computerized-financial-information business. Instead of buying and selling money for a living, Bloomberg has spent the past decade providing data and analytics about the markets delivered via the 'Bloomberg,' a specialized computer terminal. And in the past three years, Bloomberg has become a name to reckon with in the media business too."—*Rebecca Mead, November 22, 1993*

One with ambitions beyond finance. ➵ "Randall Rothenberg, a former New York *Times* reporter who is now a Bloomberg editor, recalls a conversation he had this year with an editor at the *Times*. This editor said that he had been at a management meeting of the paper when a manager from another part of the Times company asked him what he would do to assure the future prosperity of the *Times*. 'This editor said, only half jokingly, 'Buy Bloomberg.' The other guy laughed and later came back with Bloomberg's numbers, and the editor realized that it was likelier that Bloomberg would buy the *Times*."
—*Rebecca Mead, November 22, 1993*

He was still under the radar in some circles. ➵ "At the recent Irvington Institute gala at the Four Seasons, the guest of honor, media mogul Michael Bloomberg, wasn't too shy to ask guests the uncouth question *So, what do you do these days?* One person he put it to: the hardly underexposed Regis Philbin. That's okay—Regis doesn't quite know who Bloomberg is, either, a fact that became clear when Regis recounted on air the next morning his shock that 'Paul' Bloomberg hadn't known of his work." — *"Intelligencer" item, March 17, 1997*

Yet he knew what he wanted next. ➵ "New Yorkers should rejoice in his entry into the mayoral race, if only for the sheer entertainment value of his cheerfully outrageous comments. Ask him if he's ever smoked a joint in the past, and he replies, 'You bet I did, and I enjoyed it.' He's also more than happy to joke about his single-rich-guy dating status: 'Annette de la Renta and Jayne Wrightsman see me as their boy toy; they love to fix me up with their friends.' This is not a man used to editing himself for public consumption." —*Meryl Gordon, April 16, 2001*

He never led in any poll. Then came the 9/11 attacks. ➵ "There were four Bloomberg narratives, relentlessly told. The first was the Bloomberg story: Here was a reasonable, demonstrably successful businessman who wanted to contribute his expertise to running the city in its hour of need. The second was that his opponent, Mark Green, was a sleazy fellow who was engaged in a smear campaign against a reasonable and defenseless Bloomberg (Green was smeared with a smear charge). The third was that the Democrats had exacerbated racial fault lines and that Michael Bloomberg—whose acquaintanceship with Hispanic New Yorkers, other than in a service capacity, was, one might imagine, uniquely limited—deserved to be the true heir of Freddy Ferrer. The fourth was that Rudy Giuliani had bestowed his absolute support upon Michael Bloomberg—the great man had chosen his successor. Beginning two weeks ago, everywhere you went, people ran down this list of virtues. I don't think I have ever heard a campaign pitch adopted with such fealty."
—*Michael Wolff, November 19, 2001*

He seriously considered the big run. ➵ "'There's been a subtle change in Mike in the past couple of years,' David Garth says. 'In the beginning, I don't think he saw himself as a potential candidate for president. But as time went on, he started to become more of a believer, maybe in his potential.' Garth pauses. 'Mike is not the kind of person who says, "I'll just throw my hat in the ring"; neither is Rudy, for that matter. But my feeling is, they're both going to be there at the end.'"
—*John Heilemann, December 11, 2006*

He had outsize ideas. ➵ "Nearly 40 percent of the city's landmass will have been rezoned by the end of Bloomberg's reign—probably his most significant legacy, especially considering the new construction the zoning changes enabled. The particulars vary by neighborhood, but the driving idea has been unvarying: Development equals economic growth….'People view the city as a waterfront city now, and he made that happen,' Amanda Burden says." —*Chris Smith, September 16, 2013*

Though not everyone was convinced. ➵ "A city's culture is what you see when you walk from a cab to your door. Now it's all plastic prefab, much of it involving banks, the red glow of Bank of America, the men atop their two-wheeled blue Citibank ads, riding by one of the city's 500 Dunkin' Donuts locations…Does everyone else daydream about the New York That Got Away?"
—*Choire Sicha, September 16, 2013*

He left a transformed city. ➵ "We'll be living with the city that Mike built for a long time to come. Construction has barely begun on a whole slate of megaprojects, and even as the countdown clock at City Hall clicks toward zero, the administration is still churning out proposals so quickly that it takes a spreadsheet to track them….The Bloombergification of New York isn't complete yet, and won't be for a generation."
—*Justin Davidson, September 16, 2013*

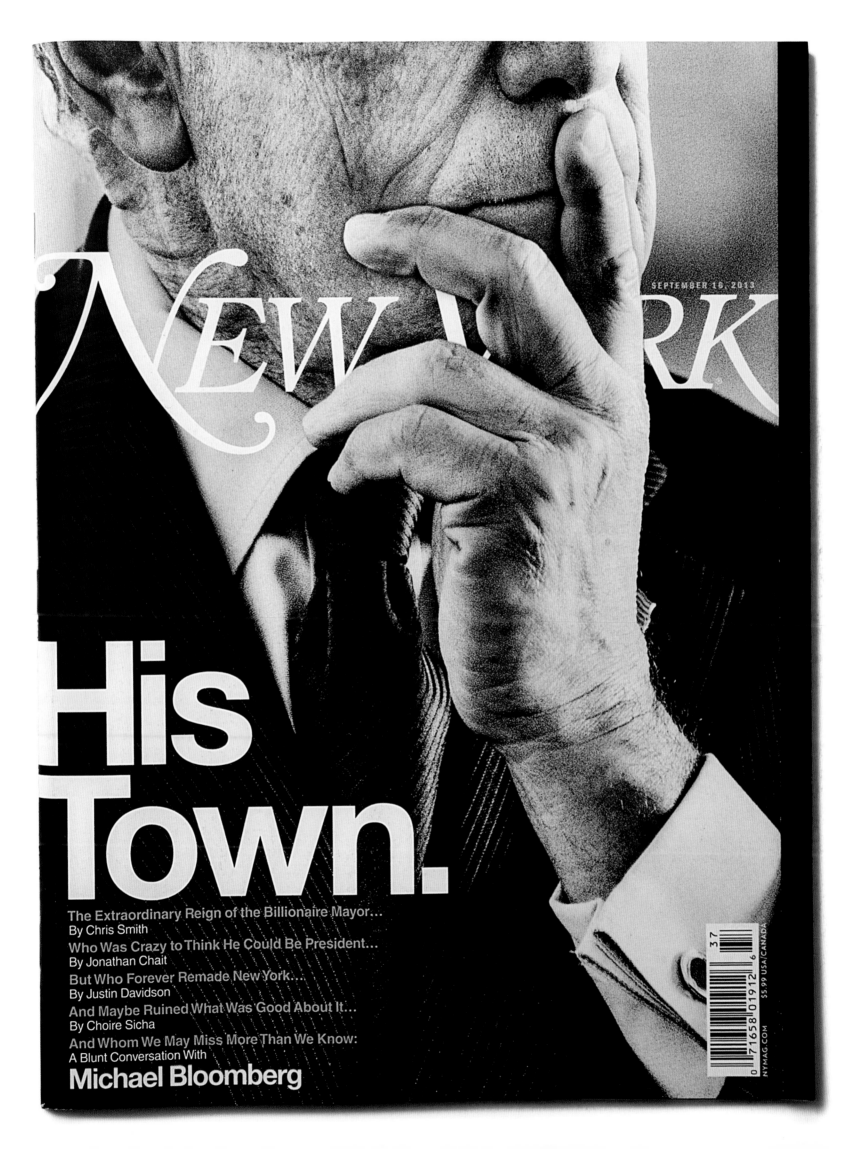

SEPTEMBER 16, 2013

New York

His Town.

The Extraordinary Reign of the Billionaire Mayor…
By Chris Smith

Who Was Crazy to Think He Could Be President…
By Jonathan Chait

But Who Forever Remade New York…
By Justin Davidson

And Maybe Ruined What Was Good About It…
By Choire Sicha

And Whom We May Miss More Than We Know:
A Blunt Conversation With
Michael Bloomberg

There was not one part of the New York 'Times' that this magazine did not find fascinating.

New York was founded in opposition to the *Times*, as grand an institution as existed in the city. The news the paper unearthed, the bitter feuds it almost seemed to encourage among its employees, the existential business challenges it faced: All of this we covered as if the subject were a royal court. Of most interest, of course, were the kings themselves—three generations of Arthur Sulzbergers ("Punch," his son Arthur Jr., and his son Arthur Gregg)—each of whom pushed the paper to become less staid and more accessible. From its intrigue to its import, the *Times* was the quintessential *New York* story.

INSIDE THE ROCKEFELLER SUPERSTRUCTURE
'ADAM SMITH': THE MONEY CRISIS IS GETTING CLOSER

NEW YORK

THE NEW FACE OF THE NEW YORK TIMES

The New York Times

1968
Five years into Arthur Ochs "Punch" Sulzberger's tenure as publisher, the magazine documented the decline of specialization among *Times* reporters, "old turgid prose" giving way to "short, vigorous sentences," and "interpretive journalism" on the rise. "The new 'hard' reporting," we wrote, "has put a strain on neutrality."

But if it was no lo had it really remain

If there is serious trouble in the newspaper business in March, **Arthur Ochs ("Punch") Sulzberger,** publisher of *The New York Times,* will be a central figure. Sulzberger has worked hard to trim down the paper's operating expenses. (One special editorial department, where four people worked, now gets by with one.) He has also tried to cre-

1973
Decades before the digitial revolution, layoffs loomed. Labor strikes, too.

"…'A lot of men are walking around without their heads today because they thought Punch was only a pleasant young man'…"

Everybody wants the *Times* to make it intact and to continue to be the world's greatest newspaper. But it won't be enough for there to exist a generalized national desire, respect, and admiration for the *Times*. Unless its editors can find a way to publish the kind of newspaper enough readers and advertisers will *need* and will be willing to pay for, the *Times* as we know it will go the way of other great but failed publications—deeply mourned, eventually forgotten, but never replaced.

1974
Another cover story, titled "The Evolution of a Pleasant Young Man," took stock of Punch's swift moves "clearing out deadwood executives."

1976
Facing shrinking advertising and falling subscriptions, the *Times* radically reshaped itself to appeal to the suburbs, and possibly even the whole country.

Neighborhoods In Flame: One Fire Company's Log

Great Summer Wines For Under $4

ONE DOLLAR JULY 18, 1977

NEW YORK

No News Is Bad News
At the New York Times

Why Your Newspaper of Record Is Getting Bigger, Not Better.

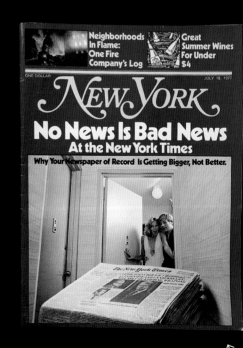

1987
A decade later, another cover story surfaced familiar worries: The paper was having trouble attracting readers, and its journalism wasn't what it used to be.

FACILITY.

Will the *Times* win the new readers of the 1990s and after? *Times* executives and editors may have seen the future, and they are uncertain that it works. In recent months, they peered through one-way mirrors at focus groups of nonreaders, convened by *Times* planners to get a clearer line on the media habits of the new audience. The news from the sessions has not been all that encouraging for the continued existence of *Times* traditions. The paper's orderly procession of foreign news ear-

1977
New features sections (on topics like dining and gardening) succeeded, bringing in record advertising dollars. And yet the magazine was concerned: "There's more of everything in the *Times*—except more news to fit the extra print."

r the gray *Times,*
the good *Times?*

1992
The editors introduced, among other changes, a new Sunday section about style that this magazine described as "loaded with attitude, big pictures, white space—and undemanding copy."

TUMULT AT THE *TIMES*

NOT LONG AGO, ARTHUR SULZBERGER JR., the 41-year-old publisher of the New York *Times,* was greeting people at a party at the Metropolitan Museum when a dignified older man confronted him. He told Sulzberger that he was unhappy about the jazzy, irreverent new "Styles of the Times" Sunday section. "It's very"—the man paused—"un-*Times*-ian."

"Thank you," Sulzberger replied. He later told a crowd of people that alienating older white male readers means "we're doing *something* right."

1991
Arthur Ochs Sulzberger Jr. inherited the role of publisher and quickly moved to make the paper more lively.

The editors listened with growing horror as focus-group members said they had no interest in the Times.

2011
Print advertising revenue collapsed precipitously in the recession, but this cover story found the paper on improbably strong footing. "Some people thought that the *Times* could actually become extinct," we wrote. (We too had floated the possibility.) "They might need to issue a correction."

THE KINGDOM AND THE PAYWALL

Some people thought that an Arthur Sulzberger Jr.'s watch, the New York Times could actually become extinct.

They might need to issue a correction.

NEW YORK

BY SETH MNOOKIN

TWO WEEKS AGO, I went to the New York *Times*' gleaming, modernist, Renzo Piano–designed head-quarters on Eighth Avenue in Manhattan to discuss some good financial news with Arthur Sulzberger Jr., the paper's publisher and the chairman of the New York Times Company. Good news has been in short supply in the world of dead-tree media, and for the *Times* in particular. ¶ For much of Sulzberger's nine-teen-year tenure, the paper that his family has con-trolled for more than a century has been embroiled in one crisis or another, ranging from the Jayson Blair fiasco, which led to the overthrow of Howell Raines, the hard-charging editor who had been handpicked by Sulzberger, to the paper's reporting on the phantom

THE NEW GUARD SPEAKS

Arthur Sulzberger fears "we will become unattended and unread, like The New Yorker."

2015
Another generation prepared to seize control. The heir apparent, Arthur Gregg, became famous in the newsroom for a memo he wrote urging the paper to modernize once more, for the digital age.

NEW YORK, AUGUST 24–SEPTEMBER 6, 2015

A THREE-WAY, MOSTLY CIVILIZED FAMILY CONTEST TO BECOME THE NEXT PUBLISHER OF The Times.

The Heirs

BY GABRIEL SHERMAN
Paintings by ROBERTO PARADA

SAM DOLNICK ARTHUR GREGG SULZBERGER DAVID PERPICH

From infuriating media magnet to activist elder: Al Sharpton was inescapable.

March 28, 1988 "The Reverend Al Sharpton is a full-time news-maker. He is 33 years old, but it seems as if he has been around for decades. The processed hair, the medallion hanging from his neck, and his very name suggest that he could have come from another age."

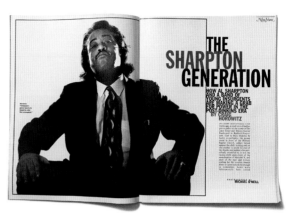

April 4, 1994 "'We strove for what was right even if wrong was done to us. That's real black history,' he told a congregation in Queens recently. 'When we had no rights, we respected and loved one another. We've gained the world and lost our own soul. We will be the disgrace of black history if things don't change.'"

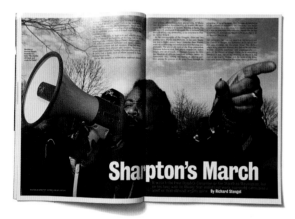

April 3, 1995 "When a white man in a suit yelled 'Get a job!' Sharpton laughed it off. 'Five years ago,' he says, 'I would have yelled back.' He tells the marchers, who number an even dozen, 'We must learn discipline. If people say things that are ugly—you can't respond to their ugliness. Rage is not a political statement.'"

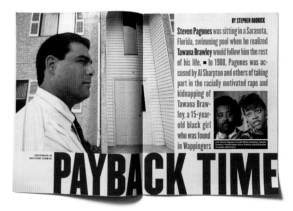

July 28, 1997 *On the notorious Tawana Brawley rape case:* "'If I saved the pope's life, the media would ask me about Brawley,' says Sharpton, quickly growing impatient of the subject. 'I think it's some of the psychological, racial, sexual implications of the case that the media is obsessed with.'"

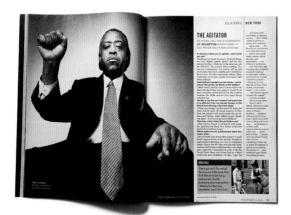

December 23–30, 2002 *On agitation:* "'I think that in the short run, you get criticized—"Aw, you just self-promoting," "Aw, you just exacerbating"—but history will say had we not done that, there probably never would have been review of police-community affairs.'"

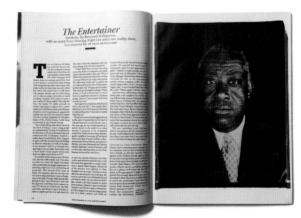

October 18, 2004 "'So, Jesse [Jackson] smiled at him [President Bush] and got in trouble when a picture of that went out—"Jesse Jackson is smiling with the president!" But what I did, when he came and worked the front row and got to me, I said, "I need to talk to you about…" and the picture is of me hitting him in the chest as I said that.'"

$2.95 • APRIL 4, 1994

New York

POWER GRAB

THE AL SHARPTON GENERATION HIJACKS BLACK POLITICS

BY CRAIG HOROWITZ

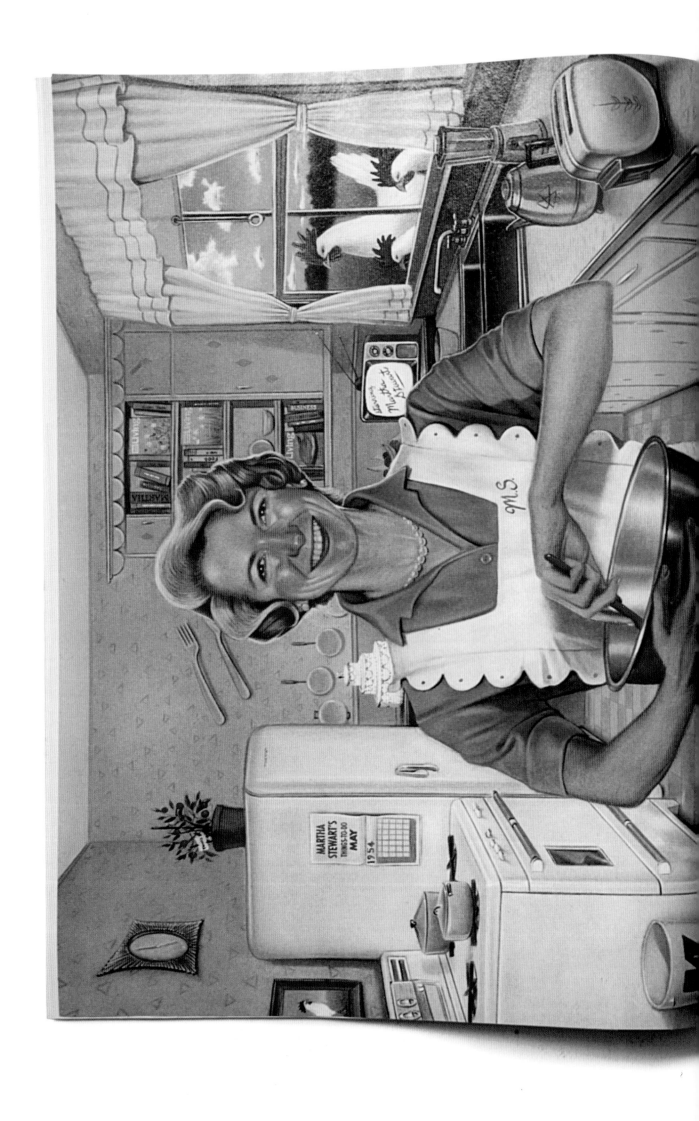

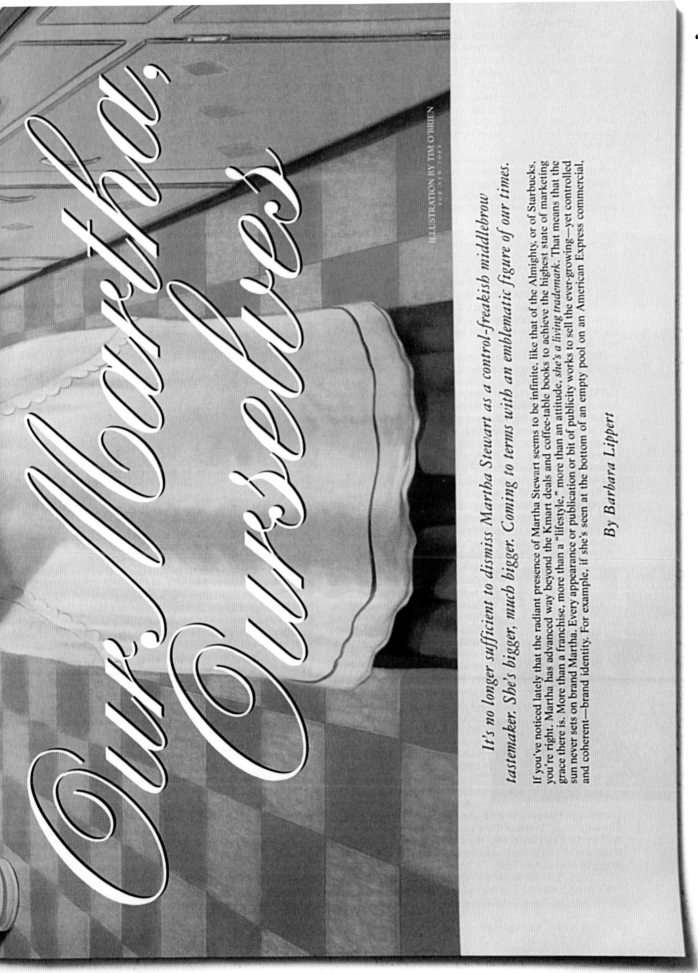

Our Martha, Ourselves

ILLUSTRATION BY TIM O'BRIEN

It's no longer sufficient to dismiss Martha Stewart as a control-freakish middlebrow tastemaker. She's bigger, much bigger. Coming to terms with an emblematic figure of our times.

If you've noticed lately that the radiant presence of Martha Stewart seems to be infinite, like that of the Almighty, or of Starbucks, you're right. Martha has advanced way beyond the Kmart deals and coffee-table books to achieve the highest state of marketing grace there is. More than a franchise, more than a "lifestyle," more than an attitude, *she's a living trademark.* That means that the sun never sets on brand Martha. Every appearance or publication or bit of publicity works to sell the ever-growing—yet controlled and coherent—brand identity. For example, if she's seen at the bottom of an empty pool on an American Express commercial,

By Barbara Lippert

1995

"Soon she's going to branch into nuclear weaponry, cold fusion, and voodoo."

Speaking to *New York*'s Barbara Lippert, Mark Leyner joked that Martha Stewart was about to achieve global corporate domination. Instead, Stewart had only a few years of high times left: Over the next decade, she took her company public, making her a billionaire; was involved in a fateful insider stock trade; was prosecuted by the U.S. Attorneys as a highly visible cautionary tale to other Wall Street figures; and spent five months in jail. Upon her release, she began to reconstitute her company and her public image, on a less imperial scale.

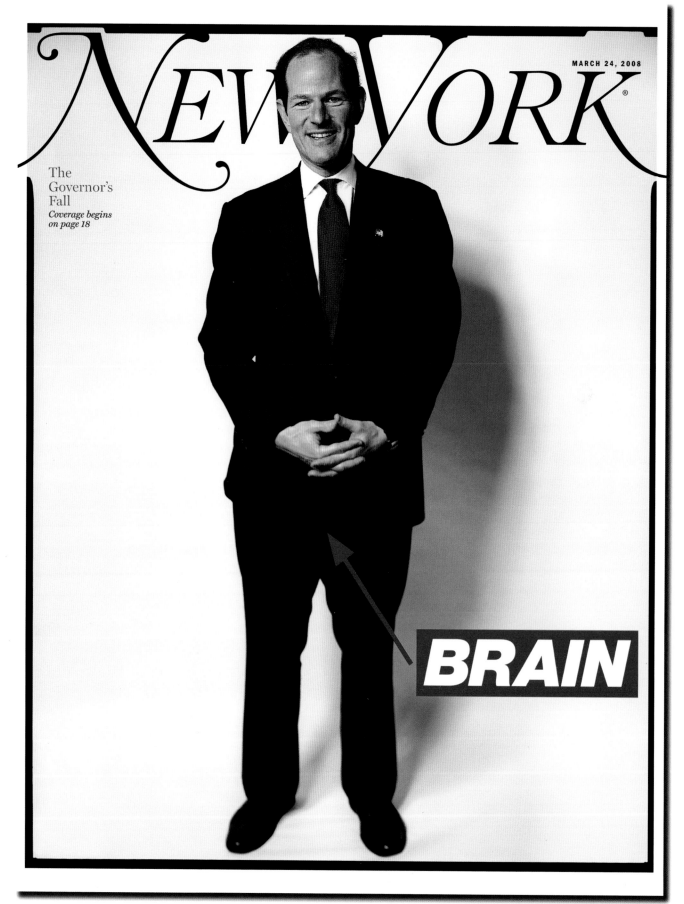

2008–2009

One was laid low by lust; the other, by greed.

Barbara Kruger's treatment of Eliot Spitzer, after his implication in a high-end-prostitution scandal,
and Darrow's rendering of Bernie Madoff, the man who stole $65 billion in a high-end Ponzi scheme, each
won an American Society of Magazine Editors award for "Cover of the Year."

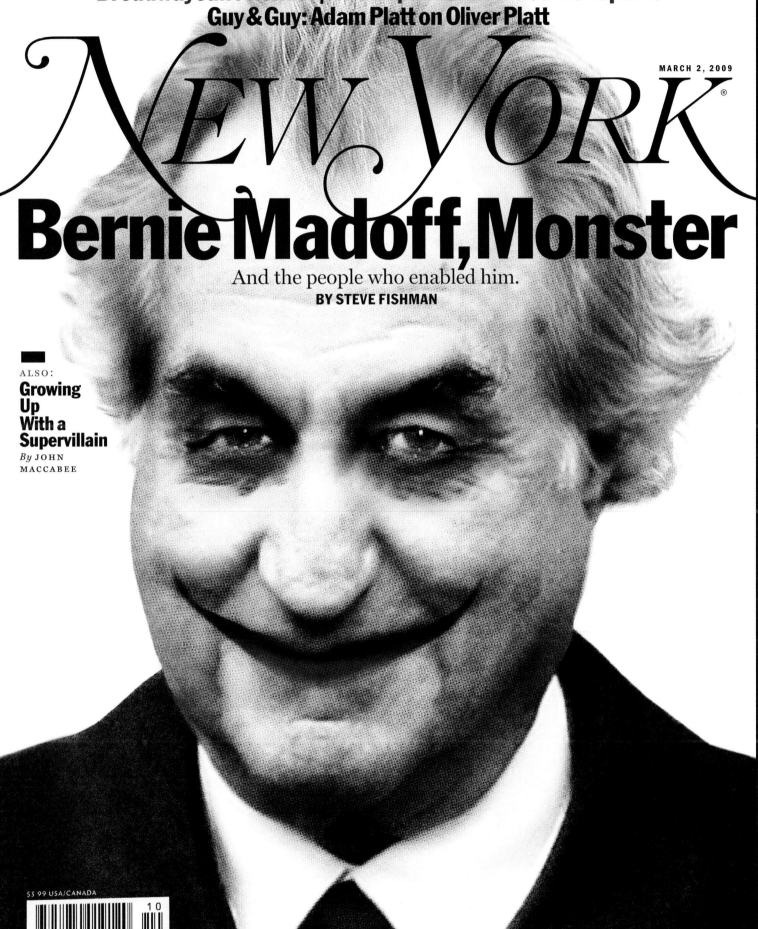

MARCH 2, 2009

NEW YORK ®

Bernie Madoff, Monster

And the people who enabled him.

BY STEVE FISHMAN

ONE EVENING, MY HOME PHONE RANG. "YOU HAVE A COLLECT CALL FROM BERNARD MADOFF, AN INMATE AT A FEDERAL PRISON," A RECORDING ANNOUNCED. AND THERE HE WAS.

BY STEVE FISHMAN

The most notorious crook in a generation, having stolen $65 billion from investors, sat in a federal prison and unburdened himself.

The Madoff Tapes

By Steve Fishman

THE CURRENT CHAPTER in Bernard L. Madoff's story began on the morning of December 11, 2010, when the prison chaplain came to his cell at Butner to tell him about his son Mark's suicide. "Ruth called the chaplain, and the chaplain came in to get me," Madoff said. "As soon as the chaplain came to get me, I knew something happened. That's how they notify you when someone dies. Ruth was hysterical. The chaplain was in tears speaking to Ruth."

I asked him what Ruth thought. Ruth was in the middle, the monster's only ally. "She's angry at me," Madoff says. "She tries not to be, but it's hard not to be. I mean, you know, I destroyed our family."

The pain that Madoff visited upon those closest to him has certain echoes in his own background, part of what drove him to succeed. "I had a father who was very successful in business," he told me, a sporting-goods-manufacturing business. "He invented the punching-bag stand," Madoff said. "The Joe Palooka punching-bag stand." But the business failed when Madoff was in college. "You watch that happen," said Madoff, "you see a father whom you idolize all of a sudden lose everything, and you're frightened about something like that happening."

His father's collapse also affected Madoff in an immediate and practical way. He headed to Wall Street without the pedigree, connections, or capital that ease a young man's way. "My father was not in a position to offer me that," Madoff told me. To the young Bernie Madoff, Wall Street was an exclusive club that barred the door. "I was upset with the whole idea of not being in the club. I was this little Jewish guy from Brooklyn," he said.

THE STORY Madoff told me is that he became a criminal near the peak of his legitimate success. In the early days, Madoff mostly employed technical and fairly low-risk arbitrage techniques built around his market-making business. "I always had a good feel for the direction of the market because of the order flow I was seeing," he said. In the eighties, he said, he produced consistent returns of 15 to 20 percent, and he insists he did it legally. (The trustee representing Madoff victims says he can't find records that Madoff ever traded, though the records are incomplete.) By the late eighties, he had, he estimates, $3 billion to $4 billion under management.

After the crash of 1987, Madoff's investment-advisory business had an early scare. The panic set in gradually. Some of his big clients got spooked, Madoff told me, leaving him to unwind long-term hedges on unfavorable terms, which depleted his capital—"They betrayed me," Madoff said. And his stalwart old trading strategy, built on arbitrage, no longer worked as effectively as it had. He'd come up with a new trading strategy based on index options. But the new strategy needed volatility to work, and in the early nineties, the recession had settled in. "The market went to sleep," said Madoff. He had too much of other people's money and not enough to invest in.

That is when, he says, the scheme began in earnest. Madoff started borrowing from his investors' capital to pay out those solid returns. The returns, false though they were, were their own advertisement. New money started pouring in, saving him in the near term. And this was a different sort of money, the kind that came from bankers who wouldn't have given Madoff the time of day earlier in his career. "The chairman of Banco Santander came down to see me, the chairman of Credit Suisse came down, chairman of UBS came down...It is a head trip. [Those people] sitting there, telling you, 'You can do this.' It feeds your ego. All of a sudden, these banks which wouldn't give you the time of day, they're willing to give you a billion dollars," he explained. "It wasn't like I needed the money. It was just that I thought it was a temporary thing, and all of a sudden, everybody is throwing billions of dollars at you. Saying, 'Listen, if you can do this stuff for us, we'll be your clients forever.'"

So Madoff took the money. While he waited for the market to wake up, he parked their billions in treasuries earning 2 percent a year, while generating statements that maintained they were earning about 15 percent—fantastic money in a slow market. He couldn't bring himself to tell them that he had failed. "I was too afraid," he said.

But Madoff distributes the guilt. "Look," he said, "these banks and these funds had to know there were problems." Madoff told them absolutely nothing about how he made those returns. "I wouldn't give them any facts, like how much volume I was doing. I was not willing to have them come up and do the due diligence that they wanted. I absolutely refused to do it. I said, 'You don't like it, take your money out,' which of course they never did."

And as Madoff sees it, as everyone seemed to be getting rich, he was the one who was secretly suffering. "It was a nightmare for me. It was only a nightmare for me. It's horrible. When I say nightmare, imagine carrying this secret," he said. "Look, imagine going home every night not being able to tell your wife, living with this ax over your head, not telling your sons, my brother, seeing them every day in the business and not being able to confide in them.

"Look," he said, "even the regulators felt sorry for me...The first day I came in here, they said, 'How did you live with this? Not being able to tell anybody?'"

"Even the regulators felt sorry for me...The first day I came in here, they said, 'How did you live with this?'"

By 2000, as spreads and profits were squeezed in the market-making business, Madoff had a chance to sell for $1 billion or more. But he refused. "As far as my sons and brother and my wife were concerned, they thought I was nuts for not selling out," he told me. His family was "livid," and he didn't dare explain it to them. "I couldn't at that time, because it would have uncovered this other problem I had."

Madoff's lies to his family are perhaps the most stunning aspect of his criminal enterprise. The intimacy of that deception, the difficulty of keeping such a secret at the core of a close family, has led some to suggest that the family must have been complicit, but no one has found any evidence that they knew about the scheme. All of the Madoffs believed that they were the happiest of families. Ruth, whom he'd begun to date when she was 13, was Madoff's constant golf and dinner companion; his brother, Peter, one of his regular ski buddies. And his two sons didn't seem to want to let him out of their sight; they were happy to spend summers with their parents at the family place in Montauk. As Andrew wrote in his high-school yearbook: "mom, dad—ur the best."

MADOFF HAD A purpose in reaching out to me. "To set the record straight," he said. The record, as he sees it, should reflect that he'd risen from modest beginnings to change the way business is done on Wall Street. Even from prison, he is determined to resurrect his legacy, one reason he talks to me.

There is another.

"With both my sons, I could never even explain to them what happened," Madoff said. "Of course, it's too late for my son Mark, but my son Andy..." Madoff often thinks of that last day, that meeting in his study when he confessed to them. "I can't get a message to Andy," he continues, getting emotional. "The lawyers don't want that to happen." I think that Madoff talks to me, in part, as a way of reaching Andrew.

But the world is not as Madoff imagines it from behind prison bars. To a friend, Andrew mocked his father's thoughts: "Yes, I stole every penny that you had, and you've got to dive into a Dumpster to get a meal, but, you know, that's the past, get over it."

And so Andrew won't change his name, but he's finally free to strike out on his own and create his own identity, an irony not lost on him. He runs a small energy company, Madoff Energy Holdings, and Abel Automatics, a fishing-reel-manufacturing company. But the most fulfilling part of his work life is Black Umbrella, his fiancée's new venture, which prepares families for disasters—"I'm helping people," he told a friend. It's the kind of activity his father had once talked him out of pursuing. Andrew won't forgive his father. He won't grant that his father is a good person who made a mistake. "Am I supposed to forgive you and feel badly that you got trapped into this terrible thing?" he asked the friend rhetorically.

Madoff knows his son's mind. "At this stage, I just have to give it time," he said. "I guess I just have to hope."

In the meantime, Bernie Madoff is still keeping his own moral ledger, adding things up in his own way, telling himself that someday, he'll come out ahead. ■

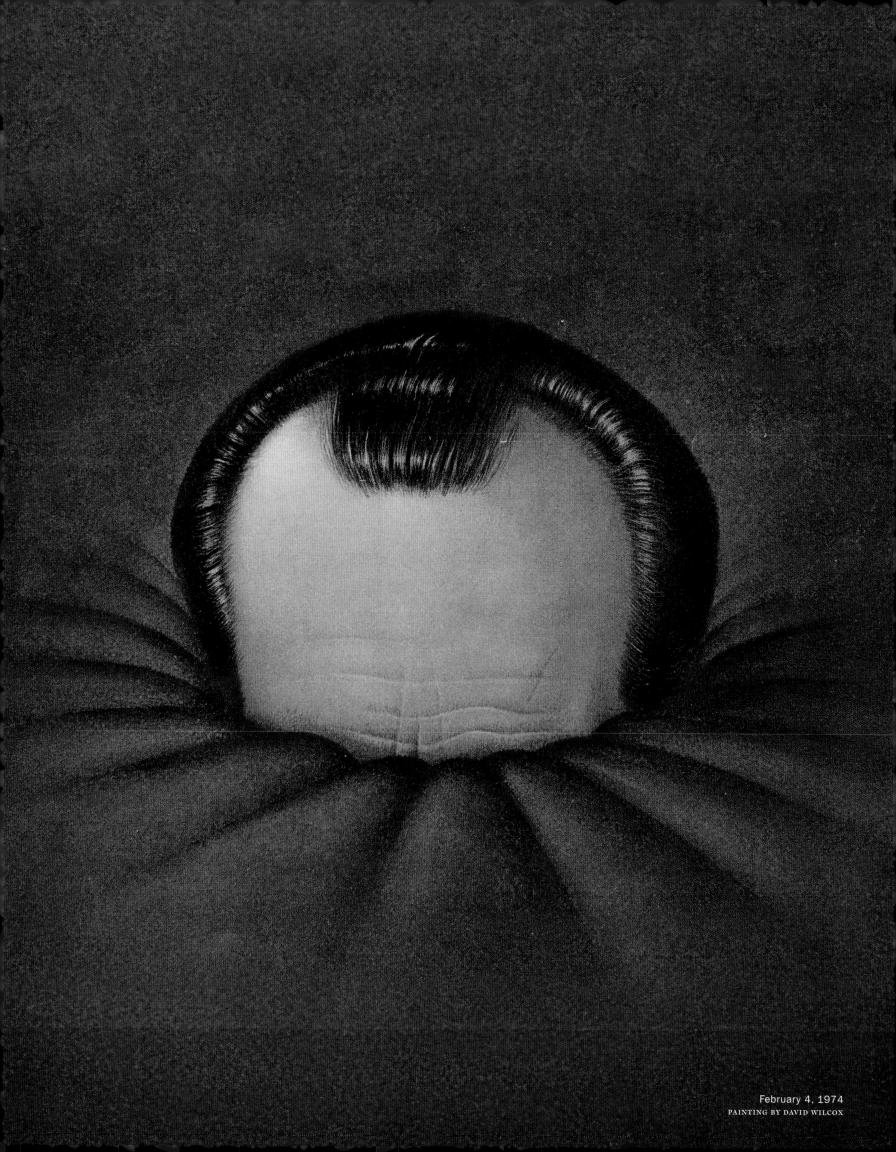

February 4, 1974

PAINTING BY DAVID WILCOX

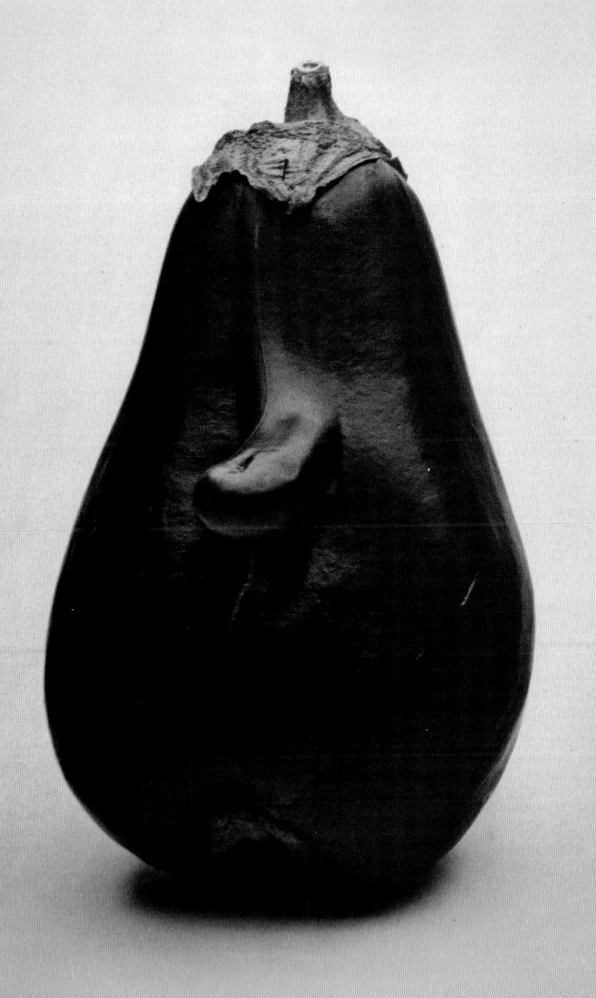

May 14, 1973
PHOTOGRAPH BY PEGGY BARNETT

June 10, 1968

October 28, 1968

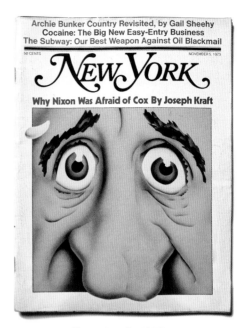

November 5, 1973

December 24, 1973

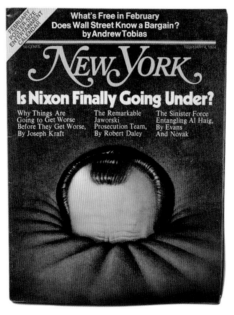

February 4, 1974

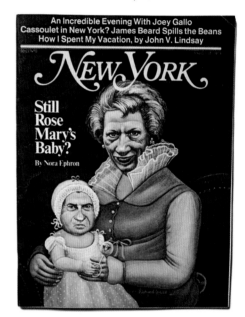

March 18, 1974

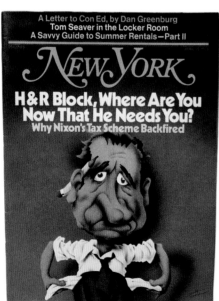

April 15, 1974

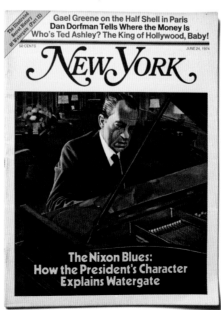

June 24, 1974

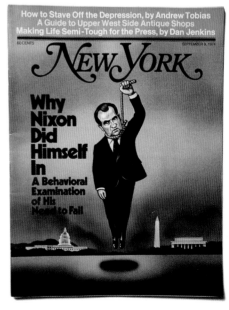

September 9, 1974

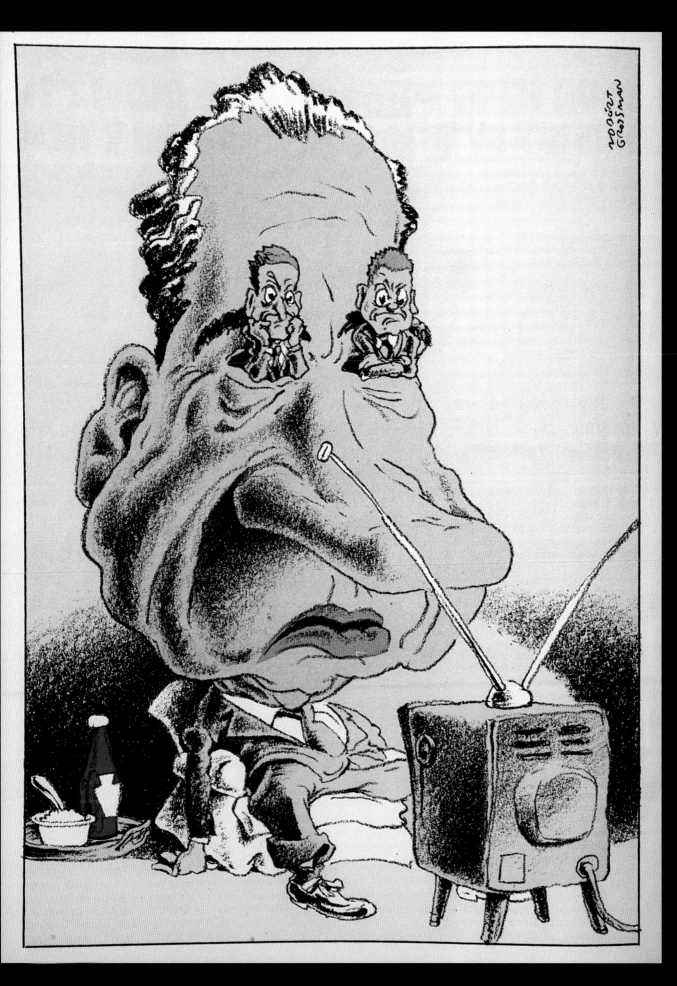

May 10, 1971

ILLUSTRATION BY ROBERT GROSSMAN

A profile of the governor of Arkansas became his first appearance on the cover of a national magazine.

Who Is Bill Clinton?

By Joe Klein

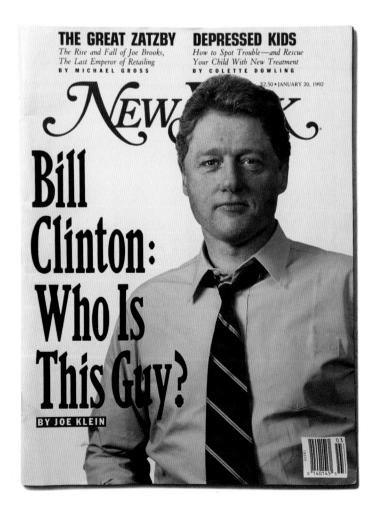

AREN'T YOU THE GUY," the editor from South Carolina's largest newspaper asked the governor of Arkansas, "who gave that awful speech for Dukakis at the 1988 Democratic Convention?"

"You want to hear the rest of it?" Bill Clinton laughed. "Go get yourself another cup of coffee."

"But what does that say about your ability to communicate your ideas to the nation?" the editor pressed.

Clinton shrugged, then retailed some boilerplate. The question seemed moot: The governor had been communicating his ideas quite nicely for the better part of an hour to several dozen editors from across South Carolina. He had, in fact, overpowered them with the clarity and detail of his answers—a Clinton trademark in this presidential year. He appeared to devour each question; he launched himself enthusiastically into each answer. The tougher the better, he seemed to say—hit me with your best shot. "What would you do about the budget deficit?" someone asked.

"Well, there are five things you need to do, but you have to do them all," and then he was off, in a fury of facts and statistics, using simple words but radiating a well-organized, serious intelligence....."But wait a minute," one of the editors interrupted. "You said one of the five things you had to do was control health-care costs; how on earth do you do that?"

"Well, there are three areas you absolutely have to deal with," and off again—to the five-point outlines for what had to be done in each of those subareas. There seemed no bottom to his specificity—indeed, it has become something of a joke among the traveling press; reporters have taken to counting the number of ideas and proposals that seem to erupt from Clinton at each appearance, just as they've taken to counting the number of times Nebraska senator Bob Kerrey cites his Vietnam War record or uses the words "fundamental change."

There was a casual, effortless quality to the performance. Clinton wasn't reciting. He was having fun. Each new stat had a *get this* quality to it: "One reason why the average German worker can be paid 20 percent more than his American counterpart is energy conservation—the German can produce the same amount of goods for half the energy." The clever economy of many of his formulations was exhilarating. On trade: "The Japanese have to understand that if they don't play by our rules, we'll play by theirs." This was a master politician strutting his stuff. The editors clearly were impressed. And yet: Something wasn't quite right. Clinton had engulfed the audience but still seemed amorphous himself: He didn't have any edges. It was all just a little too smooth. "Governor, I've just experienced you as a torrent of information," said Gil Thelen, executive editor of *The State*. "But I feel that I don't know anything about you as a person. Could you tell me the three values that are most important to Bill Clinton as a human being?"

The room fell silent. For once, Clinton didn't have a quick answer. He clasped his hands in front of him and stared at them. He took a long time. Finally, he said, "Integrity." Another long pause. "Family...and service." He proceeded to explain, but the words weren't nearly so important as the time he'd taken. Afterward, when asked if he was satisfied with Clinton's response, Thelen said, "I was really glad that he stopped and thought about it."

But what about that pause? Was it real, or just a very clever calibration? Integrity...family...service: Was this just another three-point plan? Clinton had shown his brains and spirit, but his essence—his soul—remained elusive. Who *was* this guy, anyway? ∎

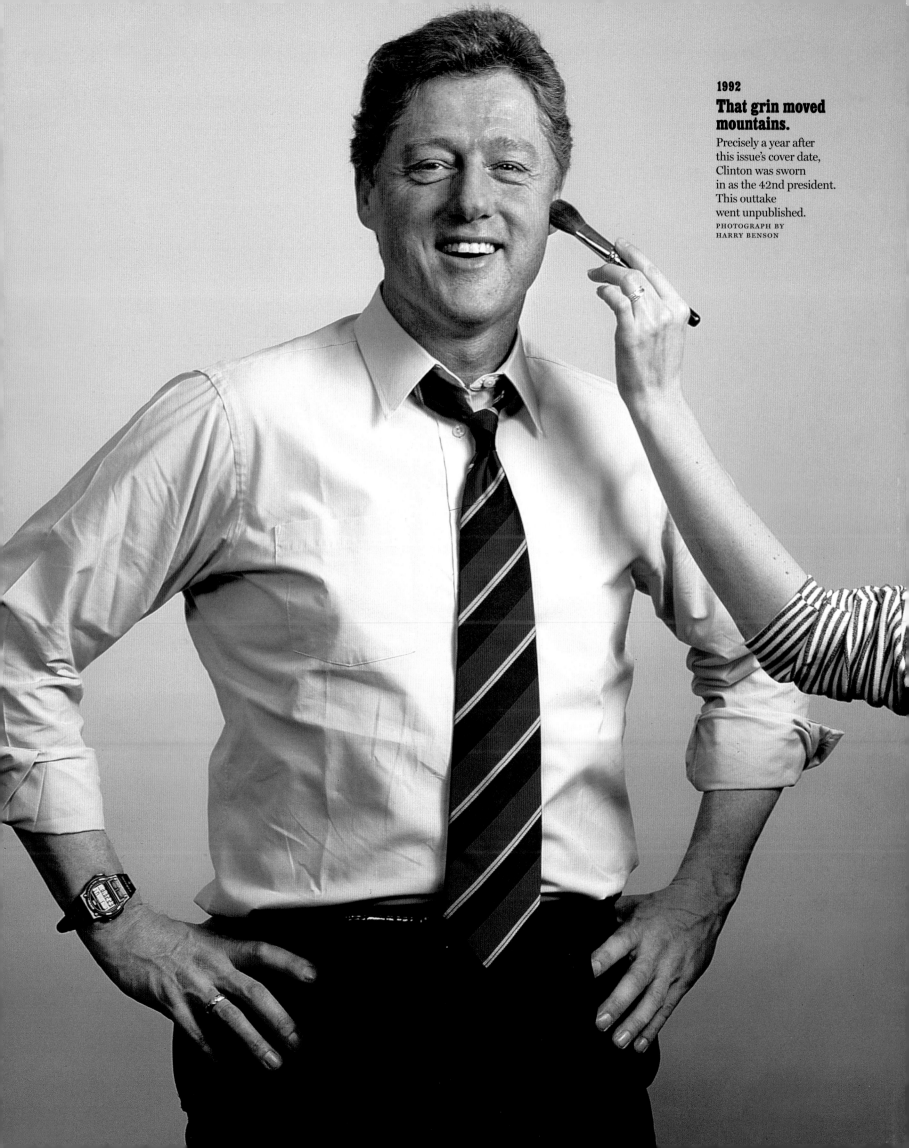

1992

That grin moved mountains.

Precisely a year after this issue's cover date, Clinton was sworn in as the 42nd president. This outtake went unpublished.

PHOTOGRAPH BY HARRY BENSON

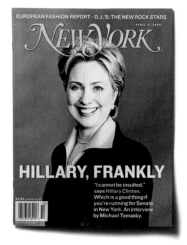

April 3, 2000

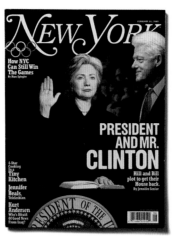

February 21, 2005

November 13, 2006

June 23, 2008

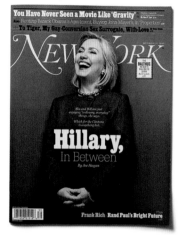

September 30, 2013

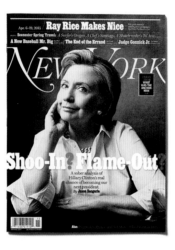

April 6, 2015

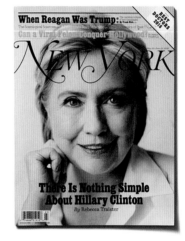

May 30, 2016

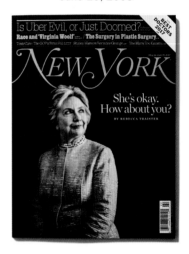

May 29, 2017

The First Lady, senator, and presidential near miss (twice) was the most polarizing woman in politics. The 2016 campaign brought every one of her contradictions into sharp focus.

Hillary Clinton vs. Herself

By Rebecca Traister

IN A LOCKER ROOM at the University of Bridgeport in Connecticut, people are waiting in line to get their pictures taken with Hillary Clinton before a rally in the school's gym. It's a kid-heavy crowd, and Clinton has been chatting easily with them.

But soon there's only one family left and the mood shifts. Francine and David Wheeler are there with their 13-year-old son, Nate, and his 17-month-old brother, Matty, who's scrambling around on the floor. They carry a stack of photographs of their other son, Benjamin, who was killed at Sandy Hook Elementary School in 2012, when he was 6. David presses the photos of his dead son on Clinton with the urgency of a parent desperate to keep other parents from having to show politicians pictures of their dead 6-year-olds.

Leaning in toward Wheeler as if they are colleagues mapping out a strategy, Clinton speaks in a voice that is low and serious. "We have to be as organized and focused as they are to beat them and undermine them," she says. "We are going to be relentless and determined and focused…They are experts at scaring people, telling them, 'They're going to take your guns'…We need the same level of intensity. Intensity is more important than numbers." Clinton tells Wheeler that she has already discussed gun control with Chuck Schumer, who will likely be leading the Senate Democrats in 2017; she talks about the differences between state and federal law and between regulatory and legislative fixes, and describes

the Supreme Court's 2008 ruling in *District of Columbia v. Heller*, which extended the protections of the Second Amendment, as "a terrible decision." She is practically swelling, Hulk-like, with her desire to describe to this family how she's going to solve the problem of gun violence, even though it is clear that their real problem—the absence of their middle child—is unsolvable. When Matty grabs the front of his diaper, Clinton laughs, suggesting that he either needs a change or is pretending to be a baseball player. She is warm, present, engaged, but not sappy. For Clinton, the highest act of emotional respect is perhaps to find something to do, not just something to say. "I'm going to do everything I can," she tells Wheeler. "Everything I can."

After the family leaves the room, Clinton and her team move quietly down the long hall toward the gym. As they walk, Clinton wordlessly hands her aide Huma Abedin a postcard of Benjamin Wheeler, making eye contact to ensure that Abedin looks at the boy's face before putting the card in her bag. The group pauses at the entrance of the gym, where 1,200 people are warmed up and screaming for Hillary. Clinton turns to me unexpectedly, and I mutter, "I don't know how you do that…"

"Yeah," she says, looking right at me. "It's really hard."

THE IDEA THAT, at this point, there is some version of Hillary Clinton that we haven't seen before feels implausible. Often, it feels like we know too much about her. She has been around for so long—her story, encompassing political intrigue and personal drama, has been recounted so many times—that she can seem a fictional character. To her critics, she is Lady Macbeth, to her adherents, Joan of Arc. As a young Hillary hater, I often compared her to Darth Vader—more machine than woman, her humanity ever more shrouded by Dark Side gadgetry. These days, I think of her as General Leia: No longer a rebel princess, she has made a wry peace with her rakish mate and her controversial hair and is hard at work, mounting a campaign against the fascistic First Order.

All the epic allusions contribute to the difficulty Clinton has long had in coming across as, simply, a human being. She is uneasy with the press and ungainly on the stump. Catching a glimpse of the "real" her often entails spying something out of the corner of your eye, in a moment when she's not trying to be, or to sell, "Hillary Clinton." And in the midst of a presidential campaign, those moments are rare. You could see her, briefly, letting out a bawdy laugh in response to a silly question in the 11th hour of the Benghazi hearings, and there she was, revealed as regular in her damned emails, where she made drinking plans with retiring Maryland senator and deranged emailer Barbara Mikulski. Her inner circle claims to see her—to really see her, and really like her—every day. They say she is so different one-on-one, funny and warm and devastatingly smart. It's hard for people who know her to comprehend why the rest of America can't see what they do.

I spent several days with Hillary Clinton near the end of primary season—which, in campaign time, feels like a month, so much is packed into every hour—and I began to see why her campaign is so baffled by the disconnect. Far from feeling like I was with an awkward campaigner, I watched her do the work of retail politics—the handshaking and small-talking and remembering of names and details of local sites and issues—like an Olympic athlete. Far from seeing a remote or robotic figure, I observed a woman who had direct, thoughtful, often moving exchanges: with the Wheelers, with home health-care workers and union representatives and young parents. I caught her eyes

> ## "How do you convince a woman whose entire career taught her to be defensive and secretive that the key to her political success might just be to lay all her cards on the table?"

flash with brief irritation at an MSNBC chyron reading "Bernie Sanders can win" and with maternal annoyance as she chided press aide Nick Merrill for not throwing out his empty water bottle. I saw her break into spontaneous dance with a 2-year-old who had been named after her, Big Hillary stamping her kitten heels and clapping her hands and making "Oooh-ooh-ooh" noises. I heard her proclaim, with unself-conscious joy, from the pulpits of two black churches in Philadelphia, that "this is the day that the Lord has made!" and watched the young campaign staff at her Brooklyn headquarters bounce up and down with the anticipation of getting to shake her hand.

But what the rest of America sees is very different. Clinton's unfavorability rating recently dipped to meet Trump's at 57 percent; 60 percent think she doesn't share their values, 64 percent think she is untrustworthy and dishonest (and that doesn't even account for the fallout from the inspector general's report about her private email server). Some of this is simply symptomatic of where we are in the election cycle, near the end of a bruising primary season, with Democratic tempers still hot even as the Republicans are falling in line behind their nominee. But some of it is also unique to Clinton, who has been plagued by the "likability" question since she was First Lady (and, indeed, even before that).

In a recent column, David Brooks posited that Clinton is disliked because she is a workaholic who "presents herself as a résumé and policy brief" and about whose interior life and extracurricular hobbies we know next to nothing. There's more than a little sexism at work in Brooks's diagnosis: The ambitious woman who works hard has long been disparaged as insufficiently human. And the Democratic-leaning voters least likely to view Clinton favorably, according to a recent Washington *Post* poll, skew young, white, and male. But those guys aren't the only ones she's having trouble reaching. And, no, it's not really because we don't know her hobbies.

The dichotomy between her public and private presentation has a lot to do with the fact that she has built such a wall between the two. Her pathological desire for privacy is at the root of the never-ending email saga, to name just one example. But how do you convince a woman whose entire career taught her to be defensive and secretive that the key to her political success might just be to lay all her cards on the table and trust that she'll be treated fairly? Especially when she might not be.

There are a lot of reasons—internal, external, historical—for the way Clinton deals with the public, and the way we respond to her. But there is something about the candidate that is getting lost in translation. The conviction that I was in the presence of a capable, charming politician who inspires tremendous excitement would fade and in fact clash dramatically with the impressions I'd get as soon as I left her circle: of a campaign imperiled, a message muddled, unfavorables scarily high. To be near her is to feel like the campaign is in steady hands; to be at any distance is to fear for the fate of the republic. ∎

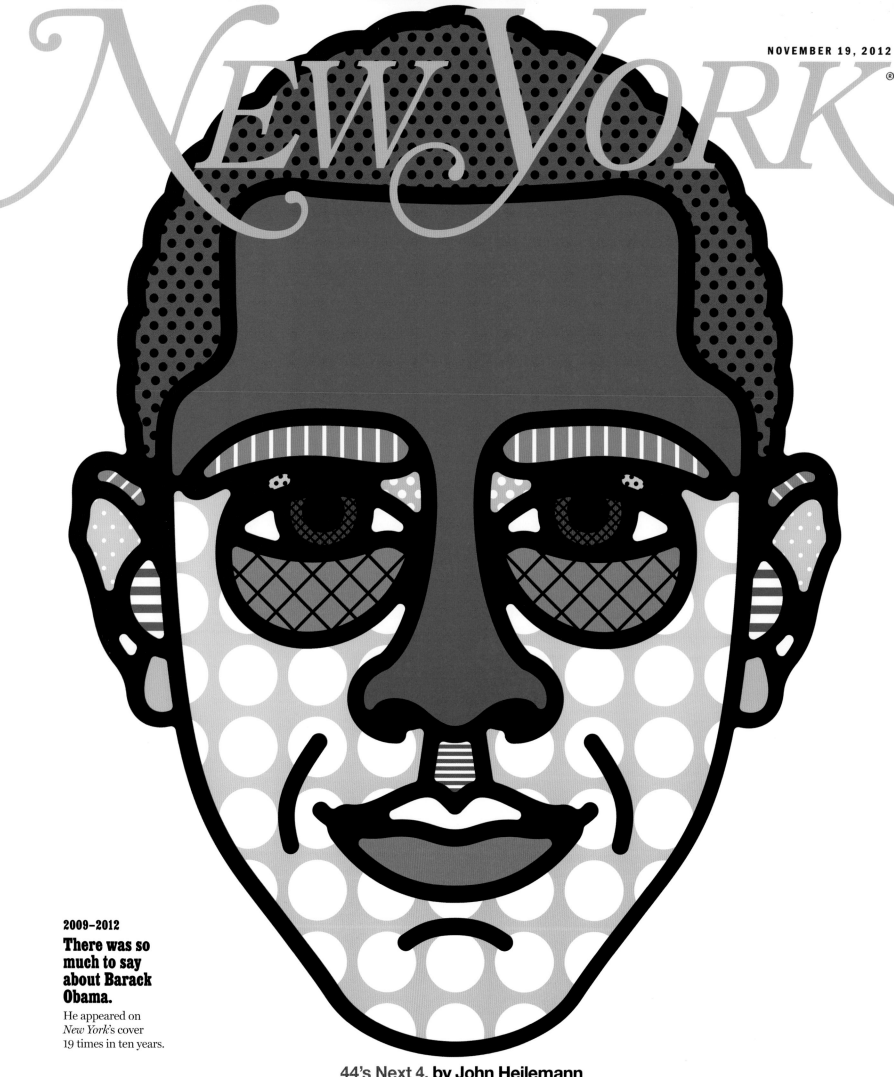

2009–2012
There was so much to say about Barack Obama.

He appeared on *New York*'s cover 19 times in ten years.

86

44's Next 4, by John Heilemann
The Say-Anything Election, by Frank Rich
V-Day for the Class War, by Jonathan Chait
Mitt Romney, With Sympathy, by Benjamin Wallace-Wells

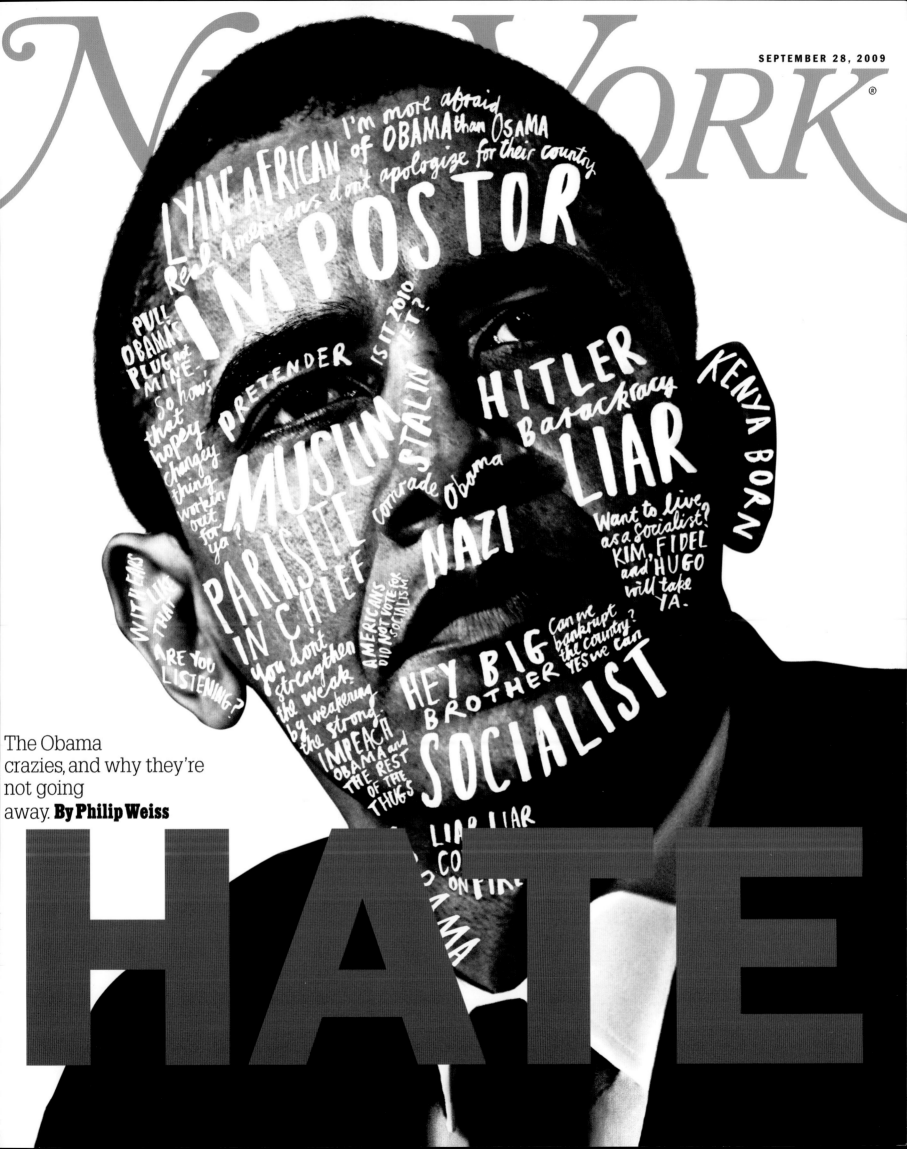

In his first story for the magazine, Frank Rich eviscerated Obama for his leniency with Wall Street.

Obama's Original Sin

By Frank Rich

WHAT HAUNTS the Obama administration is what still haunts the country: the stunning lack of accountability for the greed and misdeeds that brought America to its gravest financial crisis since the Great Depression. There has been no legal, moral, or financial reckoning for the most powerful wrongdoers. Nor have there been meaningful reforms that might prevent a repeat catastrophe. Time may heal most wounds, but not these. Chronic unemployment remains a constant, painful reminder of the havoc inflicted on the bust's innocent victims. As the ghost of Hamlet's father might have it, America will be stalked by its foul and unresolved crimes until they "are burnt and purged away."

Those who ran the central financial institutions of our fiasco escaped culpability (as did most of the institutions). As the indefatigable Matt Taibbi has tabulated, law enforcement on Obama's watch rounded up 393,000 illegal immigrants last year and zero bankers. The Justice Department's ballyhooed Operation Broken Trust has broken still more trust by chasing mainly low-echelon, one-off Madoff wannabes. You almost have to feel sorry for the era's designated Goldman scapegoat, 32-year-old flunky "Fabulous Fab" Fabrice Tourre, who may yet take the fall for everyone else. It's as if the Watergate investigation were halted after the cops nabbed the nudniks who did the break-in.

Even now, on the heels of Bank of America's reluctant $8.5 billion settlement with investors who held its mortgage-backed securities, the Obama administration may be handing it and its peers new get-out-of-jail-free cards. With the Department of Justice's blessing, the Iowa attorney general, Tom Miller, is pushing the 49 other states to sign on to a national financial settlement ending their investigations of the biggest mortgage lenders. What some call a settlement others may find a cover-up. *Time* reported in April that the lawyer negotiating with Miller for Moynihan's Bank of America just happened to be a contributor to his 2010 Iowa reelection campaign. If the deal is struck, any truly aggressive state attorneys general, like Eric Schneiderman of New York, will be shut down before they can dig into the full and still mostly uninvestigated daisy chain of get-rich-quick rackets practiced by banks as they repackaged junk mortgages into junk securities.

Those in executive suites at the top of that chain have long since fled the scene with the proceeds, while bleeding shareholders, investors, homeowners, and cashiered employees were left with the bills. Rather than purge the crash's crimes, Wall Street's leaders are sticking to their alibi: Everyone was guilty of fomenting this "perfect storm," and so no one is. But what's most galling is how many of these executives are sore winners, crying all the way to Palm Beach while raking in record profits and paying some of the lowest tax rates over the past 50 years.

The fallout has left Obama in the worst imaginable political bind. No good deed he's done for Wall Street has gone unpunished. He is vilified as an anti-capitalist zealot not just by Republican foes but even by some former backers. What has he done to deserve it? All anyone can point to is his December 2009 *60 Minutes* swipe at "fat-cat bankers on Wall Street"—an inept and anomalous Ed Schultz seizure that he retracted just weeks later by praising Dimon and Lloyd Blankfein as "very savvy businessmen."

Obama can win reelection without carrying 10021 or Greenwich in any case. The bigger political problem is that a far larger share of the American electorate views him as a tool of the very fat-cat elite that despises him. Given Obama's humble background, his history as a mostly liberal Democrat, and his famous résumé as a community organizer, this would also seem a reach. But the president has no one to blame but himself for the caricature. While he has never lusted after money—he'd rather get his hands on the latest novel by Morrison or Franzen—he is an elitist of a certain sort. For all the lurid fantasies of the birthers, the dirty secret of Obama's background is that the values of Harvard, not of Kenya or Indonesia or Bill Ayers, have most colored his governing style. He falls hard for the best and the brightest white guys.

The economic narrative of his presidency has been bookended by well-heeled appointees with tax issues. First came his Treasury secretary, Timothy Geithner, introduced to the public as a repeat tax delinquent, just too important to attend to the fine print that troubles mere mortals. This January, when Obama at long last created a jobs council, he appointed Jeffrey Immelt, CEO of G.E., to lead it. The *Times* did the due diligence the White House didn't and found that G.E. paid essentially no U.S. taxes on $14.2 billion of profit, even as it has shed one fifth of its American workforce since 2002. Were Immelt creating more new American jobs in his new administration role than he has at G.E., perhaps we could understand why Obama kept him on. But his only visible achievement has been to co-write a "progress report" on his efforts for *The Wall Street Journal*'s op-ed page in June. It read like a patronizing corporate annual report aimed at small shareholders—a boilerplate wish list of bullet points followed by a promise that "a more strategic view" would be unveiled by September, a full nine months after he took his assignment. Maybe he and the president can hash it out this summer on the Vineyard. ∎

Four years later, Jonathan Chait predicted that Obama would be judged a hugely effective president, alongside FDR and Reagan.

History Will Be Very Kind

By Jonathan Chait

TEN AND A HALF years ago, at the Democratic convention in Boston, Barack Hussein Obama was introduced to America as a youthful, magnetic man who had burst suddenly and somewhat mysteriously onto the scene. This characterization—superficially appealing yet weightless, more symbolic than substantive—followed him throughout his presidential campaign, when Hillary Clinton cast him as an inspirational speechmaker like Martin Luther King Jr., as opposed to a viable contender for president, and John McCain's campaign scathingly labeled him a "celebrity," attractive but vacuous.

The lived reality of Obama's presidency has unfolded as almost the precise opposite of this trope. He has amassed a record of policy accomplishment far deeper than even many of his supporters give him credit for. He has also survived a dismal, and frequently terrifying, 72 months when at every moment, to go by the day-to-day media, a crisis has threatened to rock his presidency to its core. The episodes have been all-consuming: the BP oil spill, swine flu, the Christmas underwear bomber, the IRS scandal, the healthcare.org launch, the border crisis, Benghazi. Depending on how you count, upwards of 19 events have been described as "Obama's Katrina."

Obama's response to these crises—or, you could say, his method of leadership—has been surprisingly consistent. He has a legendarily, almost fanatically placid temperament. He has now spent eight years, counting from the start of his first presidential campaign, keeping his head while others were losing theirs, and avoiding rhetorical overreach at the risk of underreach. A few months ago, the crisis was the Ebola outbreak, and Obama faced a familiar criticism: He had botched the putatively crucial "performative" aspects of his job. "Six years in," *Businessweek* reported, "it's clear that Obama's presidency is largely about adhering to intellectual rigor—regardless of the public's emotional needs." By year's end, the death count of those who contracted Ebola in the United States was zero, and the panic appears as unlikely to define Obama's presidency as most of the other crises that have come and gone.

The president's infuriating serenity, his inclination to play Spock even when the country wants a Captain Kirk, makes him an unusual kind of leader. But it is obvious why Obama behaves this way: He is very confident in his idea of how history works

and how, once the dust settles, he will be judged. For Obama, the long run has been a source of comfort from the outset. He has quoted King's dictum about the arc of the moral universe eventually bending toward justice, and he has said that "at the end of the day, we're part of a long-running story. We just try to get our paragraph right." To his critics, Obama is unable to attend to the theatrical duties of his office because he lacks a bedrock emotional connection with America. It seems more likely that he is simply unwilling to: that he is conducting his presidency on the assumption that his place in historical memory will be defined by a tabulation of his successes minus his failures. And that tomorrow's historians will be more rational and forgiving than today's political commentators.

It is my view that history will be very generous with Barack Obama, who has compiled a broad record of accomplishment through three-quarters of his presidency. But if it isn't, it will be for a highly ironic reason: Our historical memory tends to romance, too. Franklin D. Roosevelt's fatherly reassurance, a youthful Kennedy tossing footballs on the White House lawn, Reagan on horseback—the craving for emotional sustenance and satisfying drama runs deep. Though the parade of Obama's Katrinas will all be (and mostly already have been) consigned to the forgotten afterlife of cable-news ephemera, it is not yet certain whether this president can bind his achievements into any heroic narrative. The president's most irrational trait may be his inordinate faith in the power of reason itself. ∎

We covered Rupert Murdoch as the ruthless media tycoon he was— even between 1977 and 1990, when he owned the magazine.

He came to America via the supermarket. ⇢ "Saucy Aussie plans february start for spicy weekly national tabloid: Albert (Larry) Lamb, the Yorkshireman who heads Murdoch's editorial operation, defined the new tabloid for me. 'If you can visualize something halfway between *Time* and *The National Enquirer,* you'll be close....All the good titles are taken, but it will be something with the word "American" in it.'"
— *James Brady, October 15, 1973*

The 'Star' came first. ⇢ "Why is Australian press lord Rupert Murdoch smiling these days? He just got his weekly *National Star* into over 400 Safeway supermarket stores in Arkansas, Texas, and Southern California....The *Star* now claims to have signed up a majority of supermarket chains across the United States, including 60 per cent of the supermarket market in New York." — *unsigned "Intelligencer" item, July 21, 1975*

After he bought the 'Post,' he began kingmaking. ⇢ "The biggest break for Koch is his endorsement by the New York *Post.* This move is likely a cagey power play by the *Post*'s publisher, Rupert Murdoch, who had been expected by most journalists in this town to endorse Cuomo....Koch and Murdoch make for an interesting couple: Both are a complex mixture of liberal and conservative instincts." — *Doug Ireland, September 5, 1977*

Then network TV beckoned. ⇢ "Thinking about a fourth network: Two big deals set off all the excitement—the purchase last month of six Metromedia TV stations in New York, Los Angeles, Chicago, Washington, Dallas, and Houston by Rupert Murdoch and Marvin Davis, and Tribune Company's decision ten days later to add the leading independent station in Los Angeles to its string." — *Bernice Kanner, June 17, 1985*

Buying Metromedia meant he had to sell the 'Post.' ⇢ "Over Murdoch's eleven-year tenure, losses totaled $150 million. 'I made some mistakes, and [the new owner, Peter Kalikow] will learn from them,' Murdoch declared, during Kalikow's visit to the paper." — *Edwin Diamond, March 7, 1988*

But he had even more on his mind. ⇢ "Why Rupert? There are other charming, aggressive, disciplined visionaries. One

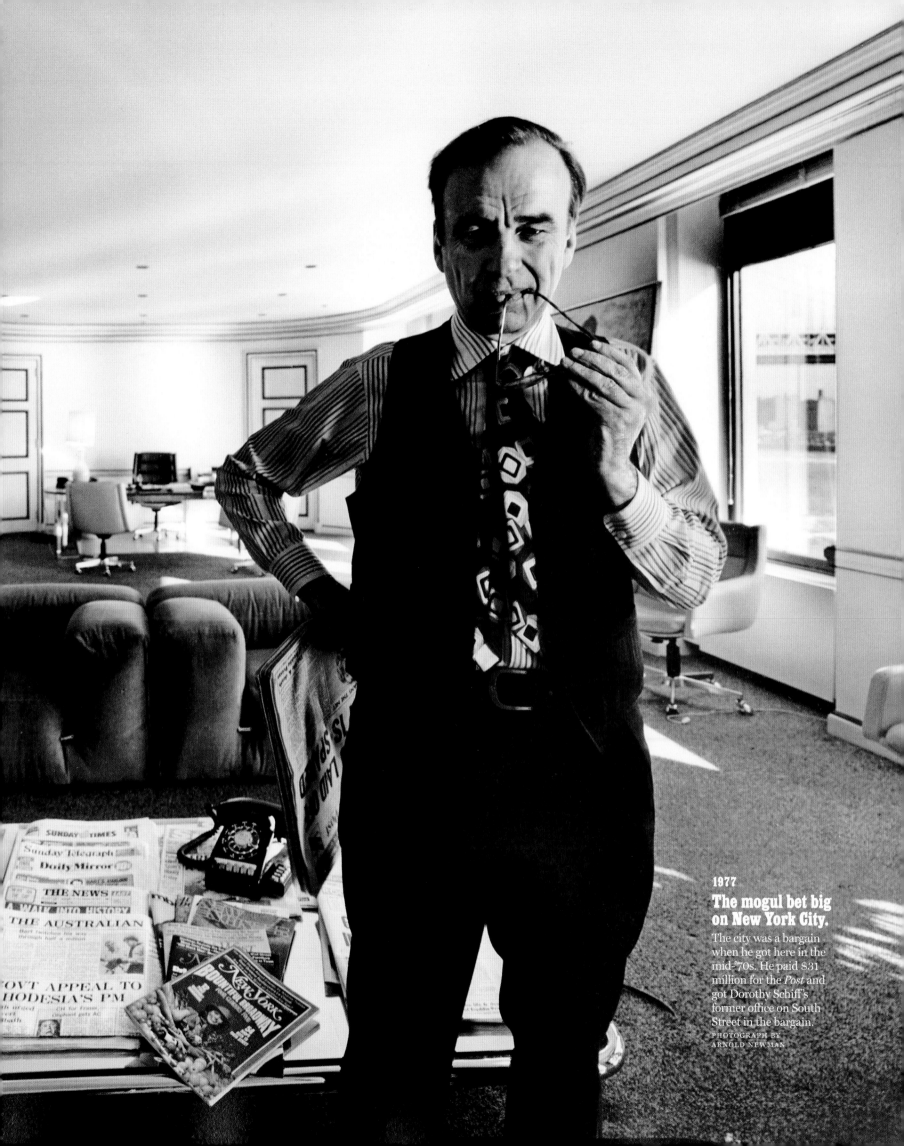

1977

The mogul bet big on New York City.

The city was a bargain when he got here in the mid-'70s. He paid $31 million for the *Post* and got Dorothy Schiff's former office on South Street in the bargain.

PHOTOGRAPH BY
ARNOLD NEWMAN

explanation might be that Murdoch is smarter than eight out of ten of his fellow entrepreneurs. (Perhaps ten out of ten: *TV Guide* may be turning around, and Fox *has* become the fourth network.) Who wouldn't have an up-yours attitude toward Establishments—as well as a taste for combat—if so many fights ended in victory?" —*Edwin Diamond, January 25, 1993*

He beat the recession and kept 20th Century Fox afloat.

➤➤ "Murdoch's move to Hollywood—the latest phase of his relentless quest for global media suzerainty—was delayed by a debt crisis of monumental proportions. But as he had done so often before, Murdoch defied predictions that he would fail. Now he hopes to form a synergy among his varied television, movie, and publishing companies and ultimately offer global, yet locally tailored, information and entertainment. He manufactures amorphous products. Hollywood is his factory." —*Michael Gross, February 8, 1993*

And he bought the 'Post' back. ➤➤ "The Ebenezer Scrooge

Bah, Humbug! Award to Rupert Murdoch, lord of the global village, who savored a glorious day of victory last April when he rescued the New York *Post* from bankruptcy court, the clutches of Steven Hoffenberg, and almost sure extinction...Since Murdoch's return, the *Post's* Newspaper Guild, with its 287 newsroom and white-collar employees, has self-destructed—while Murdoch has played the part of a gleeful Dr. Kevorkian."
—*Edwin Diamond, December 20–27, 1993*

Which he managed to do through pure political juice.

➤➤ "He is arguably the most powerful man in American media— he is certainly the only one in possession of a precious federal waiver granting him permanent ownership of a newspaper (the New York *Post*) and a television channel (WNYW) in the same market." —*Michael Tomasky, October 28, 1996*

Never mind the losses again. ➤➤ "For Murdoch and his News

Corporation, the *Post* is worth every bit of red ink, particularly because of its media-business coverage, which was beefed up after Murdoch re-acquired the paper (he had owned it from 1976 to 1988)." —*Elizabeth Lesly, September 22, 1997*

Yet TV beckoned once more. ➤➤ "In the soon-to-be world where

media will be delivered with infinite choice at an instant button-push, how do you get noticed? This is what the current reigning

obsession with 24-hour all-news cable channels is about...Fox said it wants to start one." —*Richard Turner, January 29, 1996*

And he knew the man to run that network. ➤➤ "Roger Ailes and

Murdoch are buccaneers, playing by their own rules, and it may be that Murdoch wants to fight the culture wars more than he wants a strong news product." —*David Brock, November 17, 1997*

It was a huge success. ➤➤ "The Murdoch-ization of America

has never felt so irreversible. At any given moment, according to *Business Week*, one in every five households is tuned into a show produced or delivered by News Corp.; meanwhile, Fox News is crushing CNN, the *Weekly Standard* is running the Bush administration, and three of the top six books now on the New York *Times'* best-seller list were published by Regan Books. And in perhaps the most unmistakable sign yet that New York's preeminent right-wing robber baron has become an entrenched member of the city's Establishment, Rupert Murdoch recently purchased the late Laurance Rockefeller's Fifth Avenue triplex for $44 million. In cash." —*Jonathan Mahler, April 11, 2005*

And he consolidated his hold on conservative media.

➤➤ "Shortly after the *Wall Street Journal* deal closed in December 2007, Murdoch appeared before shell-shocked staff, standing on a stack of printer paper like a general addressing a vanquished army. 'The message was clear,' one reporter in the room remembers. 'It was: "You're a bunch of lazy, self-important, past-their-prime journalists."'...But having humiliated them—and pushed many of them out—Murdoch is assimilating the remaining staffers into his merry band of raiders. He has a deep, instinctual belief in the power and importance of newspapers and the wherewithal to continue to invest in them (Dow Jones is a tiny part of his business, amounting to 3 percent of News Corp.'s total revenue). Murdoch has made the *Journal* feel like the center of his universe...And he's rebuilding *The Wall Street Journal* with an eye on destroying the New York *Times*, one of the most ancient of his enemies. For Murdoch, these conflicts amount to holy missions."
—*Gabriel Sherman, March 8, 2010*

After years of covering Fox News, Gabriel Sherman exposed Roger Ailes's crimes, ending his career.

The Revenge of Roger's Angels

By Gabriel Sherman

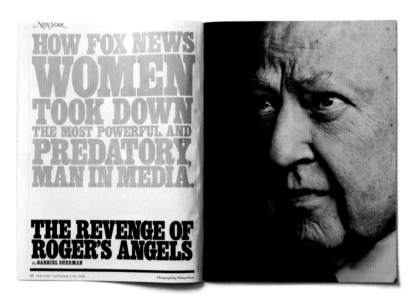

IT TOOK 15 days to end the mighty 20-year reign of Roger Ailes at Fox News, one of the most storied runs in media and political history. Ailes built not just a conservative cable news channel but something like a fourth branch of government; a propaganda arm for the GOP; an organization that determined Republican presidential candidates, sold wars, and decided the issues of the day for 2 million viewers. That the place turned out to be rife with grotesque abuses of power has left even its liberal critics stunned. More than two dozen women have come forward to accuse Ailes of sexual harassment, and what they have exposed is both a culture of misogyny and one of corruption and surveillance, smear campaigns and hush money, with implications reaching far wider than one disturbed man at the top.

It began, of course, with a lawsuit. Of all the people who might have brought down Ailes, the former *Fox & Friends* anchor Gretchen Carlson was among the least likely. A 50-year-old former Miss America, she was the archetypal Fox anchor: blonde, right-wing, proudly anti-intellectual. A memorable *Daily Show* clip showed Carlson saying she needed to Google the words *czar* and *ignoramus*. But television is a deceptive medium. Off-camera, Carlson is a Stanford- and Oxford-educated feminist who chafed at the culture of Fox News. When Ailes made harassing comments to her about her legs and suggested she wear tight-fitting outfits after she joined the network in 2005, she tried to ignore him. But eventually he pushed her too far. When Carlson complained to her supervisor in 2009 about her co-host Steve Doocy, who she said condescended to her on and off the air, Ailes responded that she was "a man hater" and a "killer" who "needed to get along with the boys." After this conversation, Carlson says, her role on the show diminished. In September 2013, Ailes demoted her from the morning show *Fox & Friends* to the lower-rated 2 p.m. time slot.

Carlson knew her situation was far from unique: It was common knowledge at Fox that Ailes frequently made inappropriate comments to women in private meetings and asked them to twirl around so he could examine their figures; and there were persistent rumors that Ailes propositioned female employees for sexual favors. The culture of fear at Fox was such that no one would dare come forward. Ailes was notoriously paranoid and secretive—he built a multiroom security bunker under his home and kept a gun in his Fox office, according to *Vanity Fair*—and he demanded absolute loyalty from those who worked for him. He was known for monitoring employee emails and phone conversations and hiring private investigators. "Watch out for the enemy within," he told Fox's staff during one companywide meeting.

Taking on Ailes was dangerous, but Carlson was determined to fight back. She settled on a simple strategy: She would turn the tables on his surveillance. Beginning in 2014, according to a person familiar with the lawsuit, Carlson brought her iPhone to meetings in Ailes's office and secretly recorded him saying the kinds of things he'd been saying to her all along. "I think you and I should have had a sexual relationship a long time ago, and then you'd be good and better and I'd be good and better. Sometimes problems are easier to solve" that way, he said in one conversation. "I'm sure you can do sweet nothings when you want to," he said another time.

After more than a year of taping, she had captured numerous incidents of sexual harassment. Carlson's husband, sports agent Casey Close, put her in touch with his lawyer Martin Hyman, who introduced her to employment attorney Nancy Erika Smith. Smith had won a sexual-harassment settlement in 2008 for a woman who sued former New Jersey acting governor Donald DiFranceso. "I hate bullies," Smith told me. "I became a lawyer to fight bullies." But this was riskier than any case she'd tried. Carlson's Fox contract had a clause that mandated that employment disputes be resolved in private arbitration—which meant Carlson's case could be thrown out and Smith herself could be sued for millions for filing.

Carlson's team decided to circumvent the clause by suing Ailes personally rather than Fox News. They hoped that with the element of surprise, they would be able to prevent Fox from launching a preemptive suit that forced them into arbitration. The plan was to file in September 2016 in New Jersey Superior Court (Ailes owns a home in Cresskill, New Jersey). But their timetable was pushed up when, on the afternoon of June 23, Carlson was called into a meeting with Fox general counsel Dianne Brandi and senior executive VP Bill Shine, and fired the day her contract expired. Smith, bedridden following surgery for a severed hamstring, raced to get the suit ready. Over the Fourth of July weekend, Smith instructed an IT technician to install software on her firm's network and Carlson's electronic devices to prevent the use of spyware by Fox. "We didn't want to be hacked," Smith said. They filed their lawsuit on July 6.

Carlson and Smith were well aware that suing Ailes for sexual harassment would be big news in a post-Cosby media culture that had become more sensitive to women claiming harassment; still, they were anxious about going up against such a powerful adversary. What they couldn't have known was that Ailes's position at Fox was already much more precarious than ever before. ∎

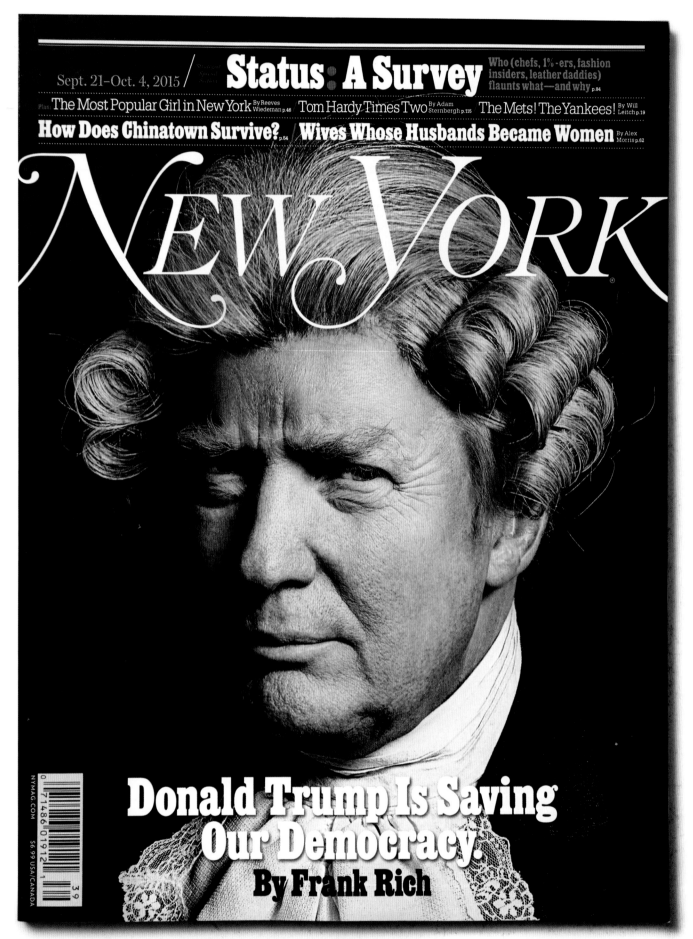

Sept. 21–Oct. 4, 2015 /

Status : A Survey

Who (chefs, 1%-ers, fashion insiders, leather daddies) flaunts what—and why p.84

Plus The Most Popular Girl in New York By Reeves Wiedeman p.46 | Tom Hardy Times Two By Adam Sternbergh p.115 | The Mets! The Yankees! By Will Leitch p.19

How Does Chinatown Survive? p.54 **Wives Whose Husbands Became Women** By Alex Morris p.62

New York

Donald Trump Is Saving Our Democracy.
By Frank Rich

NYMAG.COM $6.99 USA/CANADA 0 71486 01912 1 39

2015

He seemed like a joke.

When a victory was laughably implausible, Frank Rich argued that the outsider candidacy was a good thing, because it would blow up the Republican Party.

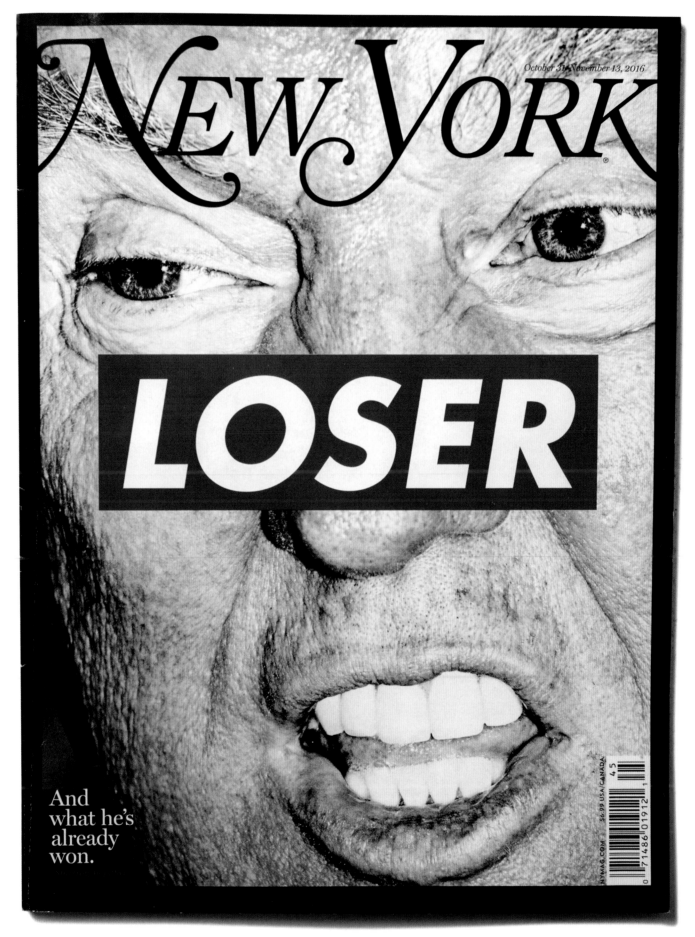

2016

It was no joke.

A week before the election, Barbara Kruger's cover art summed up Trump's epithet-laden campaign.

The morning after the 2016 election, the city—and the nation— was shaken to its core.

A country designed to resist tyranny has now embraced it. A constitution designed to prevent democracy taking over everything has now succumbed to it. A country once defined by self-government has openly, clearly, enthusiastically delivered its fate into the hands of one man to do as he sees fit. After 240 years, an idea that once inspired the world has finally repealed itself. We the people did it.

Rebecca Traister on the loser. ➻ It is a piteous irony that in finding a way past the specific hurdles long set before women with presidential ambitions—fund-raising and the support of a major party—Hillary Clinton also offered up to her opponents, on the left and the right, the ammunition to undercut the historic nature of her candidacy. The very fact that she had close relationships with big donors and garnered the support of major political institutions made her part of the political elite, vulnerable to the anti-Establishment rhetoric of both Bernie Sanders and Donald Trump. It also kept her from being understood or celebrated as the historic outsider that, as a member of a gender historically denied access to executive power, she was. In debates, when attacked as a member of the corrupt global oligarchy, Clinton would bleat about being a woman, a grandmother, different from literally everyone else ever to have been on a general-election presidential-debate stage, yet her claims never really landed. Perhaps it is a remarkable twist of fate that the outsider candidate was too much of an insider for the election she ran in, or perhaps part of today's fury at insider institutions stems from a resentment that women like Hillary Clinton can infiltrate them. Either way, in figuring out how a woman might win, she lost.

Frank Rich on the new civil war. ➻ We've lost a lot of illusions during the resistible rise of Donald Trump. An entire political culture has been leveled; it'll be a long time before we hear about the virtues of a "ground game" or the nerdy brilliance of data-driven poll analysts without laughing (or crying). The "values voter" is dead, and so is the quaint conviction that newspaper and magazine editorials might somehow save the world. But some of these illusions were due for demolition anyway. What makes this election soul-sickening is how it has crushed our most romantic ideals about America itself.

This was no 9/11. The terrorist attacks on America, after all, did not come from within, and for a while at least, they brought the country together. What awaits us now looks very much like a protracted civil war—indeed a retread of our previous Civil War. We have a Supreme Court whose Chief Justice has already hollowed out the Voting Rights Act, giving permission to the voter-suppression efforts that went off the charts in 2016 and that now will continue unchecked. We have a president-elect who has seemed to endorse discrimination by race, religion, and ethnicity, and who wants to give police more sway over the "inner cities." Next up: Attorney General Rudy Giuliani.

I keep thinking of that old *Twilight Zone* episode where the panicking neighbors on a bucolic all-American Maple Street become so fearful of an alien invasion that they start shooting each other and destroy their neighborhood before any invaders arrive. Not even when the towers came down did America feel as vulnerable as it does on this 11/9.

Andrew Sullivan on the winner. ➻ This is now Trump's America. He controls everything from here on forward. He has won this campaign in such a decisive fashion that he owes no one anything. He has destroyed the GOP and remade it in his image. He has humiliated the elites and the elite media. He has embarrassed every pollster and naysayer. He has avenged Obama. And in the coming weeks, Trump will not likely be content to bask in vindication. He will seek unforgiving revenge on those who dared to oppose him.

The only sliver of hope is that his promises cannot be kept. But hope fades in turn when you realize how absolute and total his support clearly is. It is not like that of a democratic leader but of a cult leader fused with the idea of the nation. If he fails, as he will, he will blame others, as he always does. And his cult followers will take their cue from him and no one else. "In Trump We Trust," as his acolyte Ann Coulter titled her new book. And so there will have to be scapegoats—media institutions, the Fed, the "global conspiracy" of bankers and Davos muckety-mucks he previewed in his rankly anti-Semitic closing ad, rival politicians whom he will demolish by new names of abuse, foreign countries and leaders who do not cooperate, and doubtless civilians who will be targeted by his ranks of followers and demonized from the bully pulpit itself. The man has no impulse control and massive reserves of vengeance and hatred. In time, as his failures mount, the campaigns of vilification will therefore intensify. They will have to.

Lisa Miller on the results. ➻ Our 12-year-old daughter, Josephine, found an interactive electoral map online, and on Election Night she was settled on the couch, snuggled in an old

fleece blanket, watching TV with the map booted up in her lap. Earlier in the evening, we had dinner with friends, and she had been manic with excitement, running laps around the dining table with the dog, but now, sometime around ten o'clock, she was all business, clicking on states, turning them red or blue, and announcing the electoral tally from the calculator on the app. Okay, she would say, Florida is lost, but if Hillary gets Michigan and Wisconsin, she's fine. Click. Or Michigan and New Hampshire. Click. Or Michigan and Nevada and Arizona. Click. Click. She was like a girl in a maze, trying to escape the trap before the exits were blocked. Eventually, finally, we coaxed her to bed, but only with a promise that we would wake her if Hillary pulled through.

All three of us had gone to vote very early that morning—Josephine, my husband, Charlie, and me—and we were high, ebullient, at the prospect of electing the first woman president. We stood in line at the polling place laughing, and making the people around us laugh, and when my turn came to enter the private booth, Josephine came with me and filled out the Hillary bubble herself. Josephine is our only child, and we raised her to speak her mind and to expect to be heard. We did this on purpose, without ever discussing it directly. My husband, a Midwesterner, has five strong-minded sisters: Neither one of us ever entertained a single thought about what girls could not do. Voting for Hillary was, quite literally, a vindication of all the life choices we had ever made.

Josephine is a girl with superhero dreams. When you ask her what she wants to be, her answer has, for years, been the same: a fashion photographer, a lawyer, or president. She understands that president is a stretch, but the point is, it's always been one of the options, a possibility in her mind. So when we woke her up, and it wasn't with happy news in the middle of the night, but in terrible full daylight, Josephine understood. "Trump won," she said, and I said yes. And we lay there for a while. And then she started to cry.

"It's not possible," she said.

"What's not?" I asked, dreading her reply.

"It's not possible: A girl can't be president."

David Wallace-Wells on the morning after in New York City. ⇥ New Yorkers woke up on November 8 in what seems now like a fairy-tale fog, convinced, as ever, that the future belonged to us. By midnight, the world looked very different, the country very far away (and the future, too). Eighty percent of us had voted against the man who won, and 80 percent, it seemed, were already hatching plans to leave—for Canada or Berlin or anywhere else we imagined we could live safely among the like-minded. That was when the text messages began coming in from old friends in Wisconsin and Texas and North Carolina and Missouri. They were watching the same returns we were, in the same apocalyptic panic, and all making desperate plans to come to New York. For them, the city was still the same fairy tale.

And for us, those 80 percent in denial and despair, the city itself was a consolation. The human traffic on the streets that next morning was funereal, but it did proceed, commuters stuffed shoulder-to-shoulder on subway cars, crying. More amazing, here: They were looking each other in the eye as they bawled. There were hugs among strangers, and many more bleary-eyed nods, on streets that seemed dusted with ash. It was a bubble, of course, but after the election, the city unbubbled us too—popped us out of our blister packs of despair. An

endless campaign that had unfolded mostly in the privacy of our screens was mourned outside, communally, socially. Street life was a comforting orgy, and the smallest things turned into talismans—the MetroCard, the fruit stand. It was easy to imagine the world ending when the world was a relentless cascade of panicked tweets. It became a lot harder, actually, once you stepped out your front door.

The news was full of hate—beginning that morning, with students marching through hallways chanting about white power. The city had flare-ups, too, but when swastikas showed up in Adam Yauch Park, of all places, the graffiti was plastered over with hearts. Apartments turned into little crèches: sisters coming together for quick comfort and staying over for three days; black families shaking their heads and rolling their eyes at the disbelief of their white friends. A stern male co-worker of mine made a beeline for a younger female colleague and repeated the words he'd told his daughter that morning: "It's always been this way, it always will be, and I'm so, so sorry." A West Indian immigrant asked three strangers he'd just met how he should have answered when his 8-year-old came to him, the next morning, saying plaintively, "I thought we weren't supposed to bully."

Life went on. There were babies born that day in our hospitals, half of them girls, to mothers who thought their daughters' first memories might star a female president. There were boys born named Barack. The market rallied. Pedestrians yelled at truckers for their bumper stickers, and the drivers yelled back, and that was kind of great, too. We'd almost forgotten where Donald Trump came from.

Jonathan Chait on the resistance. ⇥ Trump's loyal opposition has a duty to respect the law. More than that—for all those who are wondering, *everyone* must hope he can avoid the worst. It might help Democrats regain power if Trump throws 20 million Americans off their insurance, dissolves NATO, or prosecutes Hillary Clinton, but that is not an agenda to root for. Less horrible is better. At the same time, Americans who did not support Trump have no obligation to normalize his behavior. To the contrary: Upholding the dignity and value of the presidency means refusing to treat the ascendancy of a Trump into the office as normal. Trump is counting on a combination of media weariness and Republican partisan solidarity to allow him to grind governing norms to dust. Two days after the election, his attorney reaffirmed his intention to have his children run his business even while he serves as president—an arrangement creating limitless opportunity for corruption, as his use of the presidency enriches his brand and foreign leaders strike deals that curry personal favor.

Whatever signs of normality he has given since Tuesday's triumph are, thus far, purely superficial. To submit to a world where we say the words *President Trump* without anger or laughter is to surrender our idea of what the office means.

Trump's election is one of the greatest disasters in American history. It is worth recalling, however, that history is punctuated with disasters, yet the country is in a better place now than it was a half-century ago, and a better place than a half-century before that, and so on. Despair is a counterproductive response. So is denial—an easy temptation in the wake of the inevitable postelection pleasantries and displays of respect needed to maintain the peaceful transfer of power. The proper response is steely resolve to wage the fight of our lives. ∎

2

MIDNIGHT

"Clearly, Plato's Retreat isn't for everybody."

Dan Dorfman
in "Upstairs, Downstairs at the Ansonia," 1977

Nightlife is always dying, and never dies.

THEY USED TO SAY that television would finish it off, or AIDS, or Rudy Giuliani, or high rents. The 52nd Street jazz clubs closed, then the discos, then the bathhouses. Somehow, shockingly, people still wanted to dress up, go out, maybe dance, maybe hook up. They did it at parties at the Factory in 1968. (Andy Warhol, both in *New York* and in the city at large, became a kind of godfather figure to all New York nightlife both before and long after his death in 1987.) Through the years, readers and the people they read about went to Studio 54, or Xenon, or Nell's, or Life, or MisShapes, or the Carry Nation. Or to Maxwell's Plum or even the original T.G.I. Friday's, the city's first singles bars. Or the Bay Ridge disco called 2001 Odyssey, where a young man who lived for the weekends was first seen in the pages of *New York* in the summer of 1976, and then in the on-screen body of John Travolta. ¶ Of course, there was a dark side to making the scene. Too many young people went over the edge, got hurt or sick or addicted. But misbehavior, too, is part of the urge to go out—especially among the young and seemingly indestructible. You can't peacock, or meet someone new, if you stay home safe in your apartment, no matter how cool an apartment it is. The point is to escape into another world, and the route is through human connection, whether mannered or sweaty. A city full of Type A people, poised to blow off some steam on Saturday night.

1976

The dance floor lit up.

Saturday Night Fever, adapted from Nik Cohn's story, made 2001 Odyssey the most famous disco on earth. The underlit dance floor on which John Travolta strutted his stuff was auctioned off in 2005 (in a sale that later led to an ownership dispute) for $188,800.

75 CENTS

JUNE 7, 1976

NEW YORK

Tribal Rites of the New Saturday Night
By Nik Cohn

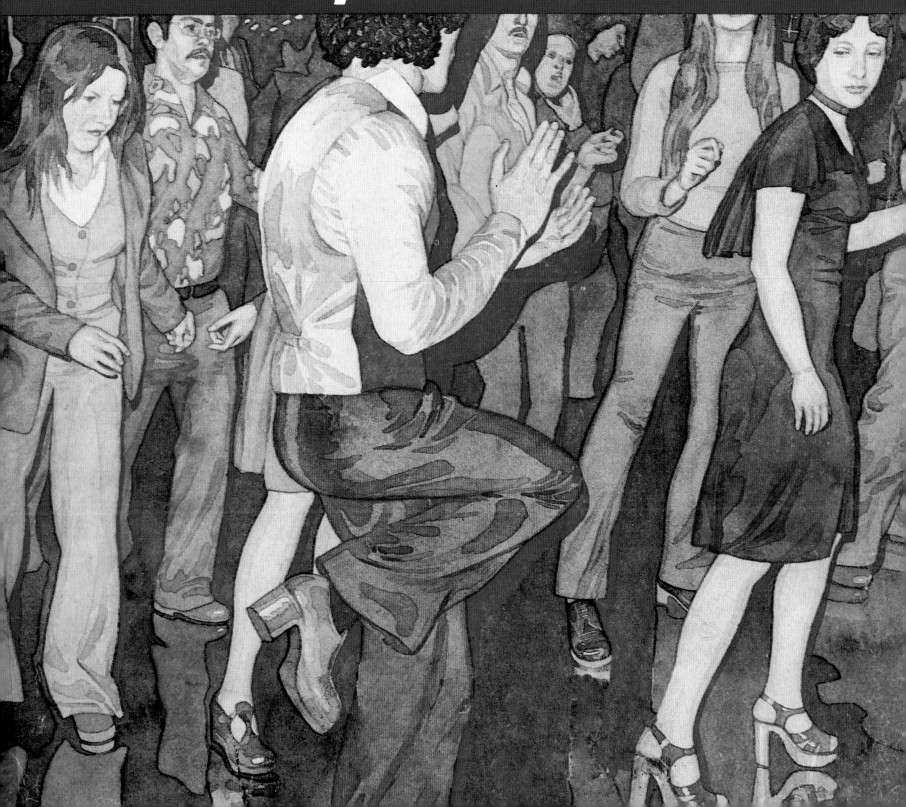

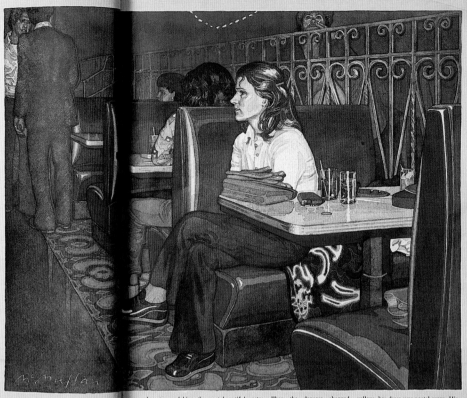

> ". . . He looked at her legs with a strange smile, a smile that made her want to run . . ."

tongue. Then he smacked right into the fence itself, and this time the dogs flung back with such frenzy, such total demonic fury, that even the steel bonds were shaken and the whole gate seemed to buckle and give.

That was enough. Somewhat chastened, though they continued to giggle and snicker, the Faces moved on. Behind them, the dogs still howled, still hurled themselves at the wires. But the Faces did not look back.

When they reached the car, they found Vincent already waiting, combing his hair. "Where were you?" asked Gus.

"Watching," said Vincent, and he climbed into the back, out of sight. Inside 2001 Odyssey, there was no more music or movement, the dance floor was deserted. Saturday night had ended, and Vincent slouched far back in his corner. His eyes were closed, his hands hung limp. He felt complete.

Another Saturday night. Easing down on Fifth and Ovington, Joey parked the car and went into the pizza parlor, the Elegante. Vincent and Eugene were already waiting. So was Gus. But John James was missing. Two nights before he had been beaten up and knifed, and now he was in the hospital.

It was an old story. When the Double J got home from work on Thursday evening, his mother had sent him out for groceries, down to Marinello's Deli. He had bought pasta and salad, toilet paper, a six-pack of Bud, a package of frozen corn, gum, detergent, tomato sauce, and four TV dinners. Paid up. Combed his hair in the window. Then went out into the street, cradling his purchases in both arms.

As he emerged, three Latins—Puerto Ricans—moved across the sidewalk toward him and one of them walked straight through him. Caught unawares, he lost his balance and his bag was knocked out of his arms, splattering on the curb.

Produce scattered everywhere, rolling in the puddles and filth. The frozen corn spilled into the gutter, straight into some dog mess, and the Latins laughed. "Greaseballs," said John James, not thinking. All that was on his mind was his groceries, the need to rescue what he'd lost. So he bent down and began to pick up the remnants. And the moment he did, of course, the Latins jumped all over him.

The rest was hazy. He could remember being beaten around the head, kicked in the sides and stomach, and he remembered a sudden sharp burn in his arm, almost as though he had been stung by an electric wasp. Then lots of shouting and scuffling, bodies tumbling all anyhow, enormous smothering weights on his face, a knee in the teeth. Then nothing.

In the final count, the damage was three cracked ribs, a splintered cheekbone, black eyes, four teeth lost, and a deep knife cut, right in the meat of his arm, just missing his left bicep.

"Three greaseballs at once," said Gus. "He could have run. But he wouldn't."

"He stuck," said Vincent. "He hung tight."

Judgment passed, the Faces finished their pizzas, wiped their lips, departed. Later on, of course, there would have to be vengeance, the Latins must be punished. For the moment, however, the feeling was of excitement, euphoria. As Eugene hit the street, he let out a whoop, one yelp of absolute glee. Saturday night, and everything was beginning, everything lay ahead of them once more.

But Vincent hung back, looked serious. Once again he had remembered a line, another gem from the screen. "Hung tight," he said, gazing up along the bleak street. "He could have got away clean, no sweat. But he had his pride. And his pride was his law."

Donna loved Vincent, had loved him for almost four months. Week after week she came to Odyssey just for him, to watch him dance, to wait. She sat in a booth by herself and didn't drink, didn't smile, didn't tap her foot or nod her head to the music. Though Vincent never danced with her, she would not dance with anyone else.

Her patience was infinite. Hands folded in her lap, knees pressed together, she watched from outside, and she did not pine. In her own style she was satisfied, for she knew she was in love, really, truly, once and for all, and that was the thing she had always dreamed of.

Donna was nineteen, and she worked as a cashier in a supermarket over toward Flatbush. As a child she had been much too fat. For years she was ashamed. But now she felt much better. If she held her breath, she stood five-foot-six and only weighed 140 pounds.

Secure in her love, she lived in the background. Vincent danced, and she took notes. He laughed, and she was glad. Other girls might chase him, touch him, swarm all over him. Still she endured, and she trusted.

And one Saturday, without any warning, Vincent suddenly turned toward her and beckoned her onto the floor, right in the middle of the Odyssey Walk, where she took her place in the line, three rows behind him, one rank to the left.

She was not a natural dancer, never had been. Big-boned, soft-fleshed, her body just wasn't right. She had good breasts, good hips, the most beautiful gray-green eyes. But her feet, her legs, were hopeless. Movement embarrassed her. There was no flow. Even in the dark, when she made love, or some boy used her for pleasure, she always wanted to hide.

Nonetheless, on this one night she went through the motions and nobody laughed. She kept her eyes on the floor; she hummed along with the songs. Three numbers went by without disaster. Then the dancers changed, moved from the Walk to something else, something she didn't know, and Donna went back to her booth.

Obscurity. Safety. She sipped Fresca through a straw and fiddled with her hair. But just as she was feeling stronger, almost calm again, Vincent appeared above her, his shadow fell across her just like in the movies, and he put his hand on her arm.

His shirt was pink and scarlet and yellow; her dress was pastel green. His boots were purple, and so were her painted lips. "I'm leaving," Vincent said, and she followed him outside.

His coat was creased at the back. He didn't know that, but Donna did; she could see it clearly as they walked out. And the thought of it, his secret weakness, made her dizzy with tenderness, the strangest sense of ownership.

"What's your name?" Vincent asked.

"Maria," said Donna. "Maria Elena."

The story of a young Brooklynite who blossomed on the dance floor became the movie *Saturday Night Fever*. Its look was drawn almost directly from James McMullan's masterly illustrations.

Tribal Rites of the New Saturday Night

By Nik Cohn

WITHIN THE CLOSED circuits of rock & roll fashion, it is assumed that New York means Manhattan. The center is everything, all the rest irrelevant. If the other boroughs exist at all, it is merely as a camp joke—Bronx-Brooklyn-Queens, monstrous urban limbo, filled with everyone who is no one.

In reality, however, almost the reverse is true. While Manhattan remains firmly rooted in the sixties, still caught up in faction and fad and the dreary games of decadence, a whole new generation has been growing up around it, virtually unrecognized. Kids of sixteen to twenty, full of energy, urgency, hunger. All the things, in fact, that the Manhattan circuit, in its smugness, has lost.

They are not so chic, these kids. They don't haunt press receptions or opening nights; they don't pose as street punks in the style of Bruce Springsteen, or prate of rock & Rimbaud. Indeed, the cults of recent years seem to have passed them by entirely. They know nothing of flower power or meditation, pansexuality, or mind expansion. No waterbeds or Moroccan cushions, no hand-thrown pottery, for them. No hep jargon either, and no Pepsi revolutions. In many cases, they genuinely can't remember who Bob Dylan was, let alone Ken Kesey or Timothy Leary. Haight Ashbury, Woodstock, Altamont—all of them draw a blank. Instead, this generation's real roots lie further back, in the fifties, the golden age of Saturday nights.

The cause of this reversion is not hard to spot. The sixties, unlike previous decades, seemed full of teenage money. No recession, no sense of danger. The young could run free, indulge themselves in whatever treats they wished. But now there is shortage once more, just as there was in the fifties. Attrition, continual pressure. So the new generation takes few risks. It goes through high school, obedient; graduates, looks for a job, saves and plans. Endures. And once a week, on Saturday night, its one great moment of release, it explodes.

VINCENT WAS THE very best dancer in Bay Ridge—the ultimate Face. He owned fourteen floral shirts, five suits, eight pairs of shoes, three overcoats, and had appeared on *American Bandstand*. Sometimes music people came out from Manhattan to watch him, and one man who owned a club on the East Side had even offered him a contract. A hundred dollars a week. Just to dance.

Everybody knew him. When Saturday night came round and he walked into 2001 Odyssey, all the other Faces automatically fell back before him, cleared a space for him to float in, right at the very center of the dance floor. Gracious as a medieval seigneur accepting tributes, Vincent waved and nodded at random. Then his face grew stern, his body turned to the music. Solemn, he danced, and all the Faces followed.

In this sphere his rule was absolute. Only one thing bothered him, and that was the passing of time. Already he was eighteen, almost eighteen and a half. Soon enough he would be nineteen, twenty. Then this golden age would pass. By natural law someone new would arise to replace him. Then everything would be over.

The knowledge nagged him, poisoned his pleasure. One night in January, right in the middle of the Bus Stop, he suddenly broke off, stalked from the floor without a word, and went outside into the cold darkness, to be alone.

He slouched against a wall. He stuck his hands deep into his overcoat pockets. He sucked on an unlit cigarette. A few minutes passed. Then he was approached by a man in a tweed suit, a journalist from Manhattan.

They stood close together, side by side. The man in the tweed suit looked at Vincent, and Vincent stared at the ground or at the tips of his platform shoes. "What's wrong?" said the man in the suit, at last.

And Vincent said: "I'm old."

BEFORE SATURDAY NIGHT began, to clear his brain of cobwebs and get himself sharp, fired up, he liked to think about killing.

During the week Vincent sold paint in a housewares store. All day, every day he stood behind a counter and grinned. He climbed up and down ladders, he made the coffee, he obeyed. Then came the weekend and he was cut loose.

The ritual never varied. Promptly at five the manager reversed the "Open" sign and Vincent would turn away, take off his grin. When the last of the customers had gone, he went out through the back, down the corridor, directly into the bathroom. He locked the door and took a deep breath. Here he was safe. So he turned toward the mirror and began to study his image.

Black hair and black eyes, olive skin, a slightly crooked mouth, and teeth so white, so dazzling, that they always seemed fake. Third-generation Brooklyn Italian, five-foot-nine in platform shoes. Small purplish birthmark beside the right eye. Thin white scar, about two inches long, underneath the chin, caused by a childhood fall from a bicycle. Otherwise, no distinguishing marks.

That was the flesh; but there was something else, much more important. One night two years before, he had traveled into Queens with some friends and they had ended up in some club, this real cheap scumhole; he couldn't remember the name. But he danced anyhow and did his numbers, all his latest routines, and everyone was just amazed. And then he danced with this girl. He'd never seen her before and he never saw her again. But her name was Petulia, Pet for short, and she was all right, nice hair, a good mover. And she kept staring right into his eyes. Staring and staring, as though she were hypnotized. He asked her why. "Kiss me," said the girl. So he kissed her, and she went limp in his arms. "Oooh," said the girl, sighing, almost swooning, "I just kissed Al Pacino." Vincent had only laughed and blushed. But since then, whenever he gazed into the mirror, it was always Pacino who gazed back. A killer, and a star. Heroic in reflection. Then Vincent would take another breath, the deepest he could manage; would make his face, his whole body, go still; would blink three times to free his imagination, and he would start to count.

Silently, as slowly as possible, he would go from one to a hundred. It was now, while he counted, that he thought about death.

Mostly he thought about guns. On certain occasions, if he felt that he was getting stale, he might also dwell on knives, on karate chops and flying kung fu kicks, even on laser beams. But always, in the last resort, he came back to bullets. It felt just like a movie. For instance, he would see himself at the top of a high flight of stairs, back against a wall, while a swarm of attackers came surging up toward him to knock him down, destroy him. But Vincent stood his ground. Unflinching, he took aim and fired. One by one they went crashing backward, down into the pit.

At one hundred, he let out his breath in a rush. The strain of holding back had turned him purple, and veins were popping all over his neck and arms. For some moments all he could do was gasp. But even as he suffered, his body felt weightless, free, almost as if he were floating. And when he got his breath back, and the roaring in his temples went away, it was true that he felt content. The week behind the counter had been obliterated. No drudgery existed. He was released; Saturday night had begun.

HE LIVED ON the eleventh floor of a high-rise on Fourth Avenue and 66th Street, close beside the subway tracks, with the remnants of his family. His father, a thief, was in jail, and his oldest brother had been killed in Vietnam. His second brother was in the hospital, had been there almost a year, recovering from a car crash that had crushed his legs. His third brother had moved away to Manhattan, into the Village, because he said he needed to be free and find himself. So that left only Vincent, his mother, and his two younger sisters, Maria and Bea (short for Beata), who were still in school.

When he kissed his mother good-bye and came down onto Fourth, strutting loose, he wore an open-necked shirt, ablaze with reds and golds, and he moved through the night with shoulders hunched tight, his neck rammed deep between his shoulder blades in the manner of a miniature bull. A bull in Gucci-style loafers, complete with gilded buckle, and high black pants tight as sausage skins.

Joey was waiting in the car. Joey and Gus in the front, Eugene and John James and now Vincent in the back, trundling through the icy streets in a collapsing '65 Dodge. Nobody talked and nobody smiled. Each scrunched into his own private space; they all held their distance, conserved their strength. The Dodge groaned and rattled. The radio played Harold Melvin and the Blue Notes. Everything else was silence, and waiting. ■

1997

Twenty-one years later, Nik Cohn owned up, admitting that he had fabricated most of the story.

"When we pulled up outside the club, a drunken brawl was in progress. Just as I opened my side door, one of the brawlers emerged from the pack, reeled over, and threw up, with fine precision, all over the side of the cab and my trouser legs.

"I took it as a sign. Quickly slamming the door, I ordered us back to Manhattan.

"One image stayed with me, though: a figure in flared crimson pants and a black body shirt, standing in the club doorway, directly under the neon light, and calmly watching the action. There was a certain style about him—an inner force, a hunger, and a sense of his own specialness. He looked, in short, like a star.

"So I faked it.

"I conjured up the story of the figure in the doorway, and named him Vincent. Imagined about how it would feel to burn up, all caged energies, with no outlet but the dance floor and the rituals of Saturday night. Finally, I wrote it all up. And presented it as fact. Bluntly put, I cheated."

—from his mea culpa, December 8, 1997

"...The guard dogs went berserk; they hurled themselves full force against the gate..."

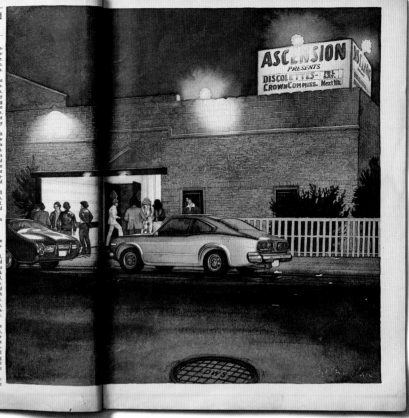

Sometime after ten, feeling ready, they stepped out on the sidewalk and moved toward Odyssey in a line, shoulder to shoulder, like gunslingers. Heads lowered, hands thrust deep in their pockets, they turned into the doorway. They paused for just an instant, right on the brink. Entered.

Vincent was already at work on the floor. By now the Faces had gathered in force, his troops, and he worked them like a quarterback, calling out plays. He set the formations, dictated every move. If a pattern grew ragged and disorder threatened, it was he who set things straight.

Under his command, they unfurled the Odyssey Walk, their own style of massed Hustle, for which they formed strict ranks. Sweeping back and forth across the floor in perfect unity, 50 bodies made one, while Vincent barked out orders, crying One, and Two, and One, and Tap. And Turn, and One, and Tap. And Turn. And Tap. And One.

They were like so many guardsmen on parade; a small battalion, uniformed in floral shirts and tight flared pants. No one smiled or showed the least expression. Above their heads, the black musicians honked and thrashed. But the Faces never wavered. Number after number, hour after hour, they carried out their routines, their drill. Absolute discipline, the most impeccable balance. On this one night, even Vincent, who was notoriously hard to please, could find no cause for complaint.

At last, content in a job well done, he took a break and went up into the bleachers, where he sat on a small terrace littered with empty tables and studied the scene at leisure, like a general reviewing a battlefield. From this distance, the action on the floor seemed oddly unreal, as though it had been staged. A young girl in green, with ash-blond hair to her shoulders, stood silhouetted in a half-darkened doorway, posed precisely in left profile, and blew a smoke ring. Two Faces started arguing at the bar, fists raised. The dancers chugged about the floor relentlessly, and the band played *Philadelphia Freedom*.

"How do you feel?" asked the man in the tweed suit.

"I'm thinking about my mother," said Vincent.

"What of her?"

"She's getting old. Sometimes she feels so bad. If I was rich, I could buy her a house, somewhere on the Island, and she could take it easy."

"What kind of house?"

"Big windows. Lots of light," Vincent said, and he spread his hands, describing a shape like a globe. "Space. Chickens in the yard. A grand piano. Grass," he said. "My mother likes grass. And blue sky."

Down below, without his presence to keep control, the order was beginning to fall apart. Around the fringes, some of the dancers had broken away from the mainstream and were dabbling in experiments, the Hustle Cha, the Renaissance Bump, even the Merengue. Vincent looked pained. But he did not intervene. "Chickens," he said. "They lay their own eggs."

A fight broke out. From outside, it was not possible to guess exactly how it started. But suddenly Gus was on his back, bleeding, and a Face in a bright-blue polka-dot shirt was banging his head against the floor. So Joey jumped on the Face's back. Then someone else jumped in, and someone else. After that there was no way to make out anything beyond a mass of bodies, littered halfway across the floor.

Vincent made no move; it was all too far away. Remote in his darkness, he sipped at a Coca-Cola and watched. The band played *You Sexy Thing* and the party kept screaming, only one. "Is this the custom?" asked the man in the suit.

"It depends."

"On what?"

"Sometimes people don't feel in the mood. Sometimes they do," said Vincent. "It just depends."

In time, the commotion subsided, the main participants were ushered outside to complete their negotiations in private. Those left behind went back to dancing as if nothing had happened, and the band played *Fly, Robin, Fly*.

John James, the Double J, appeared on the terrace, lean and gangling, with a chalky white face and many pimples. There was blood beneath his nose, blood on his purple crepe shirt. "Mother," he said, sitting down at the table. "Eff," said Vincent.

So the night moved on; he talked about basketball, records, dances. Then he talked about other nights, other brawls. The music kept playing and the dancers kept on parading. From time to time a girl would stop and look up at the terrace, hoping to catch Vincent's eye. But he did not respond. He was still thinking about his mother.

Somebody threw a glass which shattered on the floor. But the Faces just

"... When Vincent gazed into the mirror, it was always Pacino who gazed back. A killer, and a star. Heroic in reflection..."

sharp, fired up, he liked to think about killing.

During the week Vincent sold paint in a housewares store. All day, every day he stood behind a counter and grinned. He climbed up and down ladders, he made the coffee, he obeyed. Then came the weekend and he was cut loose.

The ritual never varied. Promptly at five the manager reversed the "Open" sign and Vincent would turn away, take off his grin. When the last of the customers had gone, he went out through the back, down the corridor, directly into the bathroom. He locked the door and took a deep breath. Here he was safe. So he turned toward the mirror and began to study his image.

Black hair and black eyes, olive skin, a slightly crooked mouth, and teeth so white, so dazzling, that they always seemed fake. Third-generation Brooklyn Italian, five-foot-nine in platform shoes. Small purplish birthmark beside the right eye. Thin white scar, about two inches long, underneath the chin, caused by a childhood fall from a bicycle. Otherwise, no distinguishing marks.

That was the flesh; but there was something else, much more important. One night two years before, he had traveled into Queens with some friends and they had ended up in some club, this real cheap scumhole; he couldn't remember the name. But he danced anyhow and did his numbers, all his latest routines, and everyone was just amazed. And then he danced with this girl. He'd never seen her before and he never saw her again. But her name was Petulia, Pet for short, and she was all right, nice hair, a good mover. And she kept staring right into his eyes. Staring and staring, as though she were hypnotized. He asked her why. "Kiss me," said the girl. So he kissed her and she went limp in his arms. "Oooh," said the girl, sighing, almost swooning, "I just kissed Al Pacino."

In his first surprise, assuming that she must be teasing, Vincent had only laughed and blushed. But later, thinking it over, he knew she had really meant it. Somehow or other she had seen beneath the surface, had cut through to bedrock, to his very soul. That was something incredible. It blew his mind. In fact, if anyone ever asked him and he tried to answer honestly, looking back, he would say that was the happiest, the very best, moment of his life.

Since then, whenever he gazed into the mirror, it was always Pacino who gazed back. A killer, and a star. Heroic

in reflection. Then Vincent would take another breath, the deepest he could manage; would make his face, his whole body, go still; would blink three times to free his imagination, and he would start to count.

Silently, as slowly as possible, he would go from one to a hundred. It was now, while he counted, that he thought about death.

Mostly he thought about guns. On certain occasions, if he felt that he was getting stale, he might also dwell on knives, on karate chops and flying kung fu kicks, even on laser beams. But always, in the last resort, he came back to bullets.

If it felt just like a movie. For instance, he would see himself at the top of a high flight of stairs, back against a wall, while a swarm of attackers came surging up toward him to knock him down, destroy him. But Vincent stood his ground. Unflinching, he took aim and fired. One by one they went crashing backward, down into the pit.

When the battle ended and he had won, he stood alone. Far beneath him, he knew, there was blood and smoke, a chaotic heap of bodies, dead and dying. But that did not enter the physical vision. On the screen there was only Vincent, impassive, ice cold in triumph, who put his gun back into its holster, wiped away the sweat that blinded him, straightened his collar, and, finally, in close-up, smiled.

At one hundred, he let out his breath in a rush. The strain of holding back had turned him purple, and veins were popping all over his neck and arms. For some moments all he could do was gasp. But even as he suffered, his body felt weightless, free, almost as if he were floating. And when he got his breath back, and the roaring in his temples went away, it was true that he felt content.

That was the end; the movie was complete. Turning away from the glass, and away from Pacino, he would flush the toilet, wash his hands. He combed his hair. He checked his watch. Then he went out into the corridor, back into the store. The week behind the counter had been obliterated. No drudgery existed. He was released; Saturday night had begun.

Lisa was in love with Billy, and Billy was in love with Lisa. John James was in love with Lorraine. Lorraine loved Gus. Gus loved Donna. And Donna loved Vincent. But Vincent loved only his mother, and the way

it felt to dance. When he left the store he went home and prepared for 2001 Odyssey. He bathed, he shaved, he dressed. That took him four hours, and by the time he emerged, shortly after nine, he felt reborn.

He lived on the eleventh floor of a high-rise on Fourth Avenue and 66th Street, close beside the subway tracks, with the remnants of his family. He loved them, was proud that he supported them. But when he tried to describe their existence, he would begin to stammer and stumble, embarrassed, because everything came out so corny: "Just like a soap," he said, "only true."

His father, a thief, was in jail, and his oldest brother had been killed in Vietnam. His second brother was in the hospital, had been there almost a year, recovering from a car crash that had crushed his legs. His third brother had moved away to Manhattan, into the Village, because he said he needed to be free and find himself. So that left only Vincent, his mother, and his two younger sisters, Maria and Bea (short for Beata), who were still in school.

Between them they shared three rooms, high up in a block of buildings like a barracks. Their windows looked out on nothing but walls, and there was the strangest, most disturbing smell, which no amount of cleaning could ever quite destroy.

Hard to describe it, this smell; hard to pin it down. Sometimes it seemed like drains, sometimes like a lack of oxygen, and sometimes just like death, the corpse of some decaying animal buried deep in the walls. Whichever, Vincent wanted out. He would have given anything. But there was no chance. How could there be? He could never abandon his mother. "You must understand," he said. "I am the man."

Here he paused. "I am her soul," he said. Then he paused again, pursing his lips, and he cast down his eyes. He looked grave. "Understand," he said, "my mother is me."

It was not quite his own. To be perfectly truthful, he had borrowed the line from Lee Van Cleef, some Italian Western that he'd seen on late-night TV. But he drawled it out just right. A hint of slur, the slightest taste of spit, "Hombre, you will die." Just like that. And moved away. So slick and so sly that the dude never knew what hit him.

Two blocks farther on, Joey was waiting in the car. Joey and Gus in the front, Eugene and John James and now Vincent in the back, trundling through

the icy streets in a collapsing '65 Dodge. Nobody talked and nobody smiled. Each scrunched into his own private space; they all held their distance, conserved their strength, like prizefighters before a crucial bout. The Dodge groaned and rattled. The radio played Harold Melvin and the Blue Notes. Everything else was silence, and waiting.

John James and Eugene worked in a record store; Gus was a house painter. As for Joey, no one could be sure. In any case, it didn't matter. Not now. All that counted was the moment. And for the moment, riding out toward 2001 Odyssey, they existed only as Faces.

Faces. According to Vincent himself, they were simply the elite. All over Brooklyn, Queens, and the Bronx, even as far away as New Jersey, spread clear across America, there were millions and millions of kids who were nothing special. Just kids. Zombies. Professional dummies, going through the motions, following like sheep. School, jobs, routines. A vast faceless blob. And then there were the Faces. The Vincents and Eugenes and Joey. A tiny minority, maybe two in

every hundred, who knew how to dress and how to move, how to float, how to fly. Sharpness, grace, a certain distinction in every gesture. And some strange instinct for rightness, beyond words, deep down in their blood: "The way I feel," Vincent said, "it's like we have been chosen."

Odyssey was their home, their haven. It was *the* place, the only disco in all Bay Ridge that truly counted. Months ago there had been Revelation; six weeks, maybe two months, on, there would be somewhere else. Right now there was only Odyssey.

It was a true sanctuary. Once inside, the Faces were unreachable. Nothing could molest them. They were no longer the oppressed, wretched teen menials who must take orders, toe the line. Here they took command, they reigned.

The basic commandments were simple. To qualify as an Odyssey Face, an aspirant need only be Italian, between the ages of eighteen and twenty-one, with a minimum stock of six floral shirts, four pairs of tight trousers, two pairs of Gucci-style loafers, two pairs

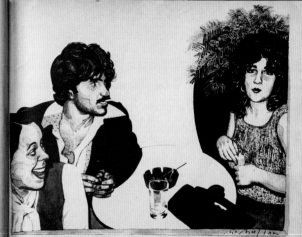

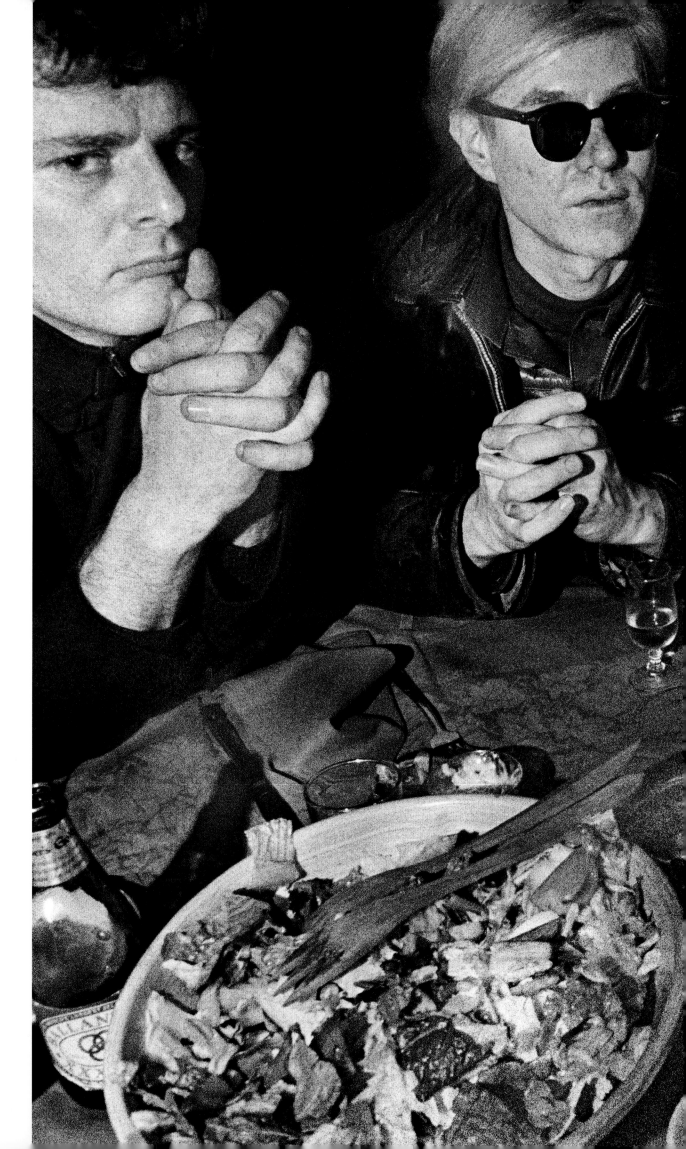

1968

Andy Warhol had a table at Max's Kansas City.

There was no actual Max at Max's. The poet Joel Oppenheimer, a friend of the club's owner, Mickey Ruskin, invented him. But Warhol was most definitely there at the back table at 213 Park Avenue South, and on March 8, 1968, he shared it with Paul Morrissey, Janis Joplin, and Tim Buckley after the opening night of the Fillmore East on Second Avenue.

PHOTOGRAPH BY ELLIOTT LANDY; PUBLISHED IN *NEW YORK* IN 2003

1971–1983
He shot everyone.

In the early 1970s, Warhol got in the habit of carrying a cheap Polaroid camera called a Big Shot everywhere he went. It had a fixed focus (38 inches from the subject), which meant that everyone appeared in the same head-and-shoulders format. He made pictures of famous friends and sexy nobodies, and also used his Big Shot to make the photos that he transferred to his silkscreens and then painted. There are tens of thousands of them.

PHOTOGRAPHS BY
ANDY WARHOL;
PUBLISHED IN *NEW YORK*
IN 2015

Diana Ross

Nico

Robert Mapplethorpe

Anjelica Huston

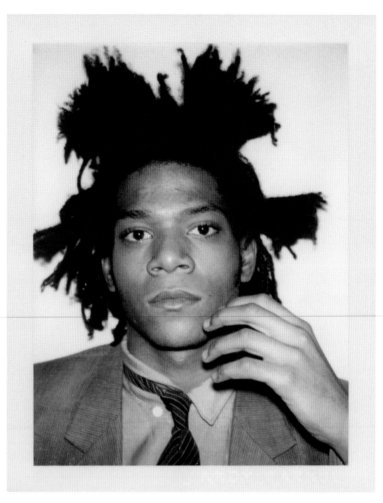

Jean-Michel Basquiat

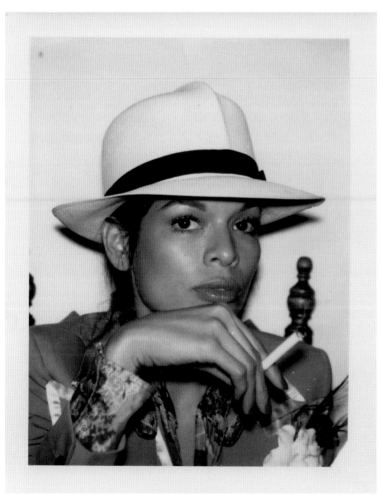

Bianca Jagger

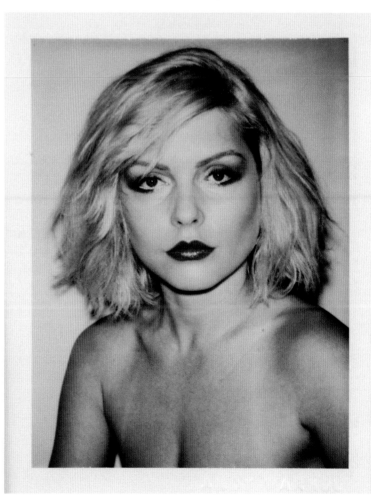

Deborah Harry

A Night at the Continental Baths

By Richard Goldstein

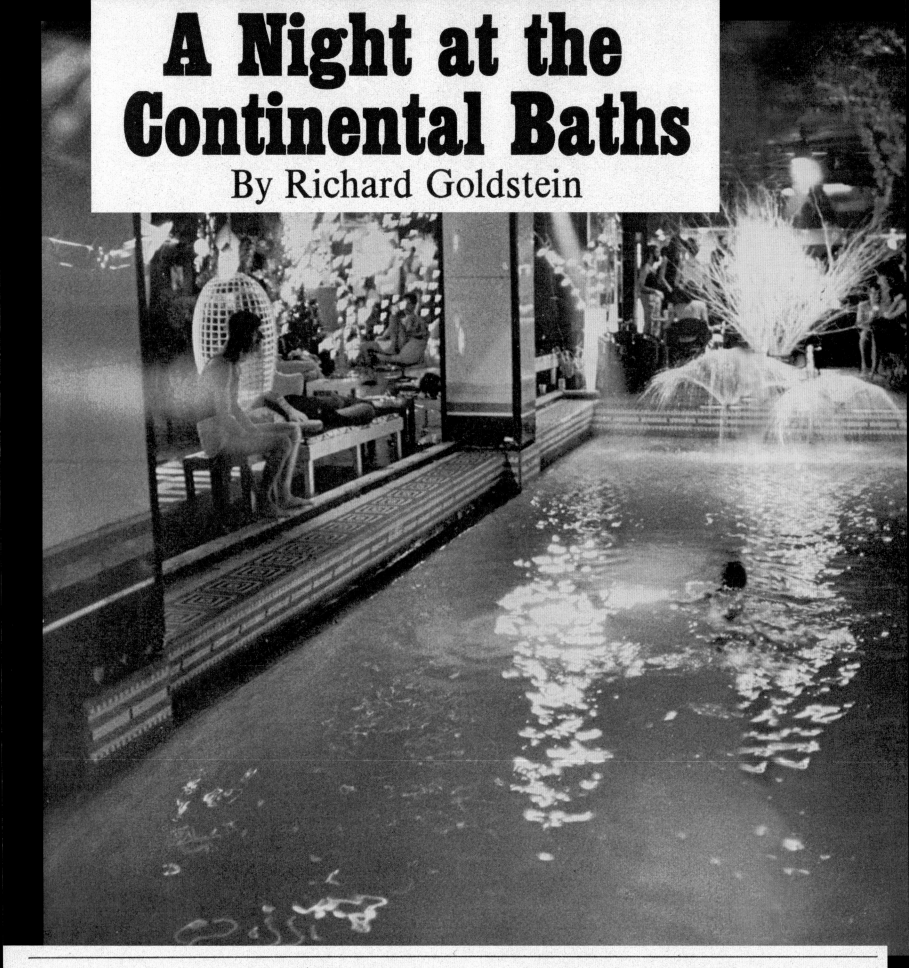

"...In the past year, the Baths has emerged as New York's most Weimarian nightspot, a sort of City of Night *à gogo*..."

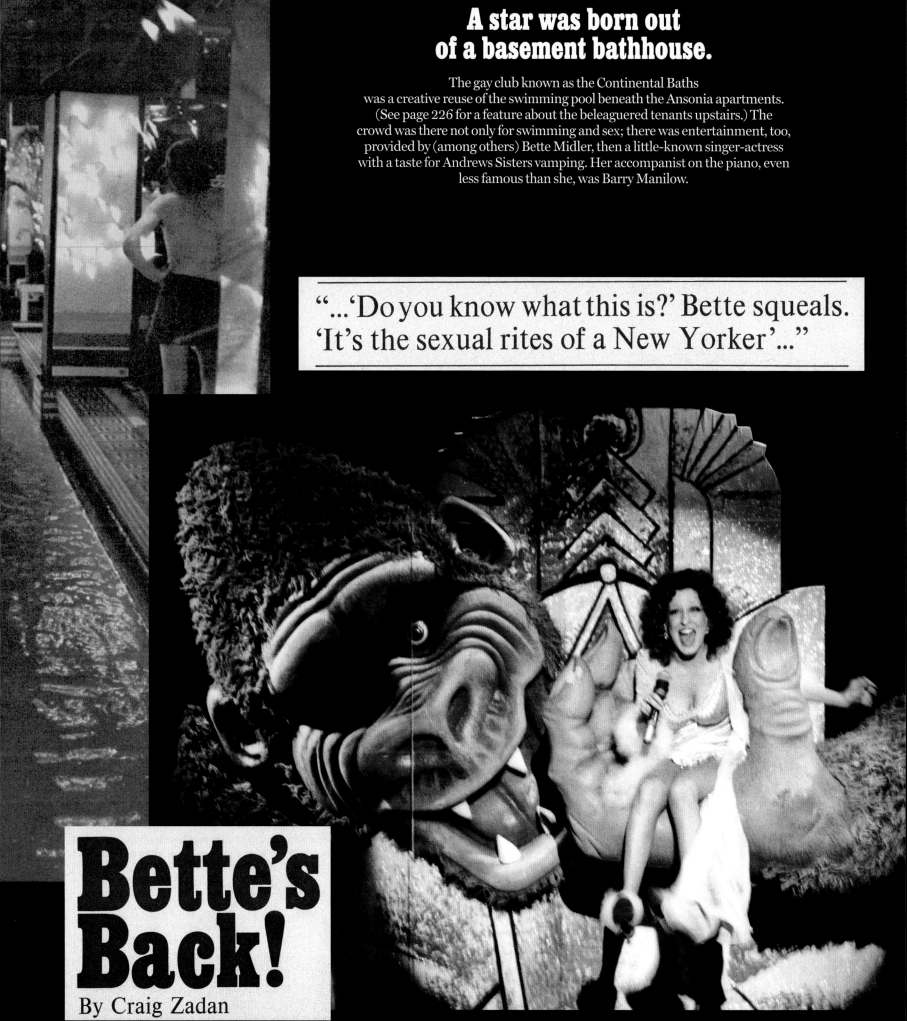

A star was born out of a basement bathhouse.

The gay club known as the Continental Baths was a creative reuse of the swimming pool beneath the Ansonia apartments. (See page 226 for a feature about the beleaguered tenants upstairs.) The crowd was there not only for swimming and sex; there was entertainment, too, provided by (among others) Bette Midler, then a little-known singer-actress with a taste for Andrews Sisters vamping. Her accompanist on the piano, even less famous than she, was Barry Manilow.

"...'Do you know what this is?' Bette squeals. 'It's the sexual rites of a New Yorker'..."

Bette's Back!

By Craig Zadan

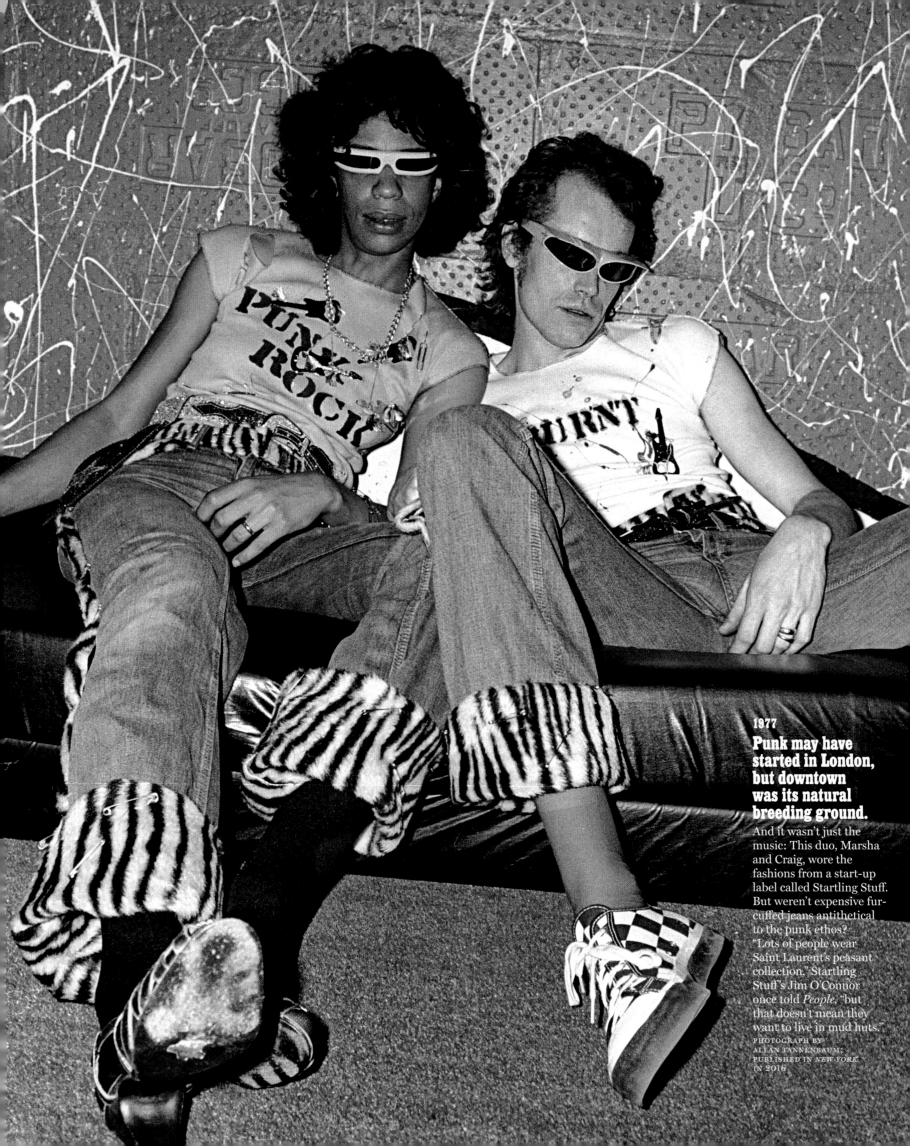

1977
Punk may have started in London, but downtown was its natural breeding ground.
And it wasn't just the music: This duo, Marsha and Craig, wore the fashions from a start-up label called Startling Stuff. But weren't expensive fur-cuffed jeans antithetical to the punk ethos? "Lots of people wear Saint Laurent's peasant collection," Startling Stuff's Jim O'Connor once told *People*, "but that doesn't mean they want to live in mud huts."

PHOTOGRAPH BY
ALLAN TANNENBAUM;
PUBLISHED IN *NEW YORK*
IN 2016

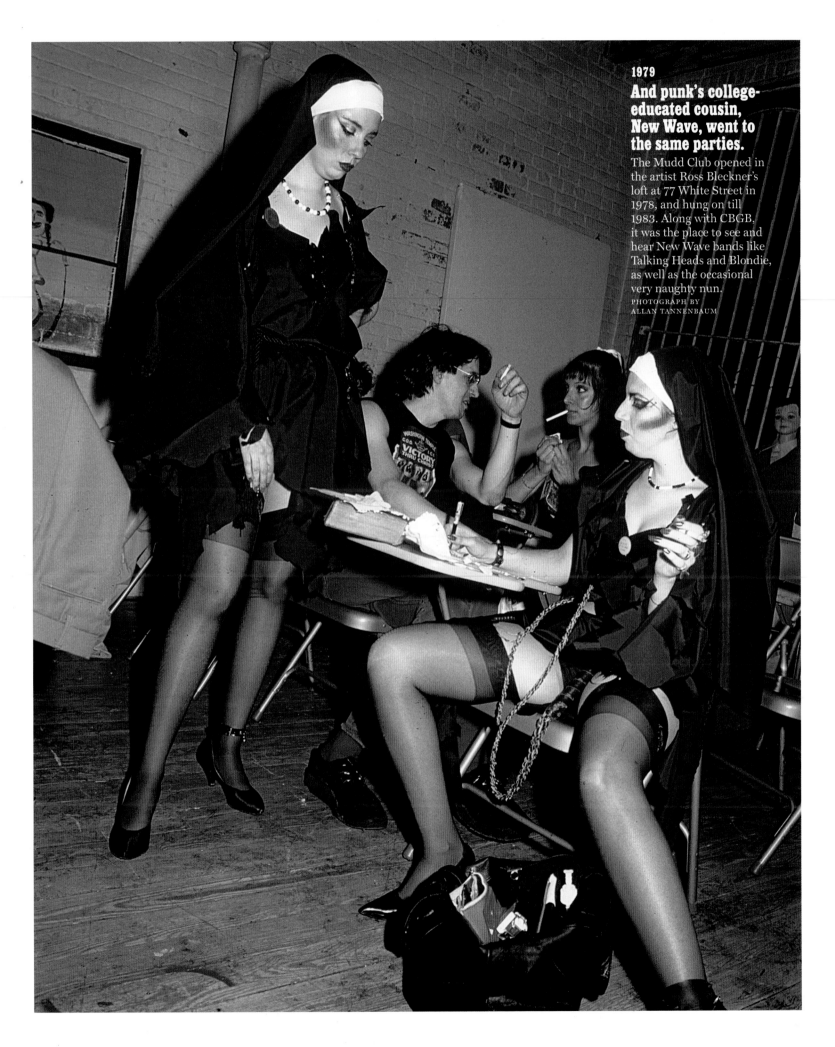

1979

And punk's college-educated cousin, New Wave, went to the same parties.

The Mudd Club opened in the artist Ross Bleckner's loft at 77 White Street in 1978, and hung on till 1983. Along with CBGB, it was the place to see and hear New Wave bands like Talking Heads and Blondie, as well as the occasional very naughty nun.

PHOTOGRAPH BY
ALLAN TANNENBAUM

1973

Glam rock met the grungy underground, and begat the New York Dolls.

They quickly became the noisy, androgynous house band at the Mercer Arts Center, a huge gone-to-hell hotel at Broadway and Mercer Street that, not too long into their residency, completely collapsed. The band kept going through 1977, though it was always more influential than hit-making. "Like that's the end-all of everything—financial success defines artistic success," David Johansen later said, disdainfully, to *New York*. "I think the success of an artist is to be inspirational."

PHOTOGRAPH BY GIJSBERT HANEKROOT; PUBLISHED IN *NEW YORK* IN 2014

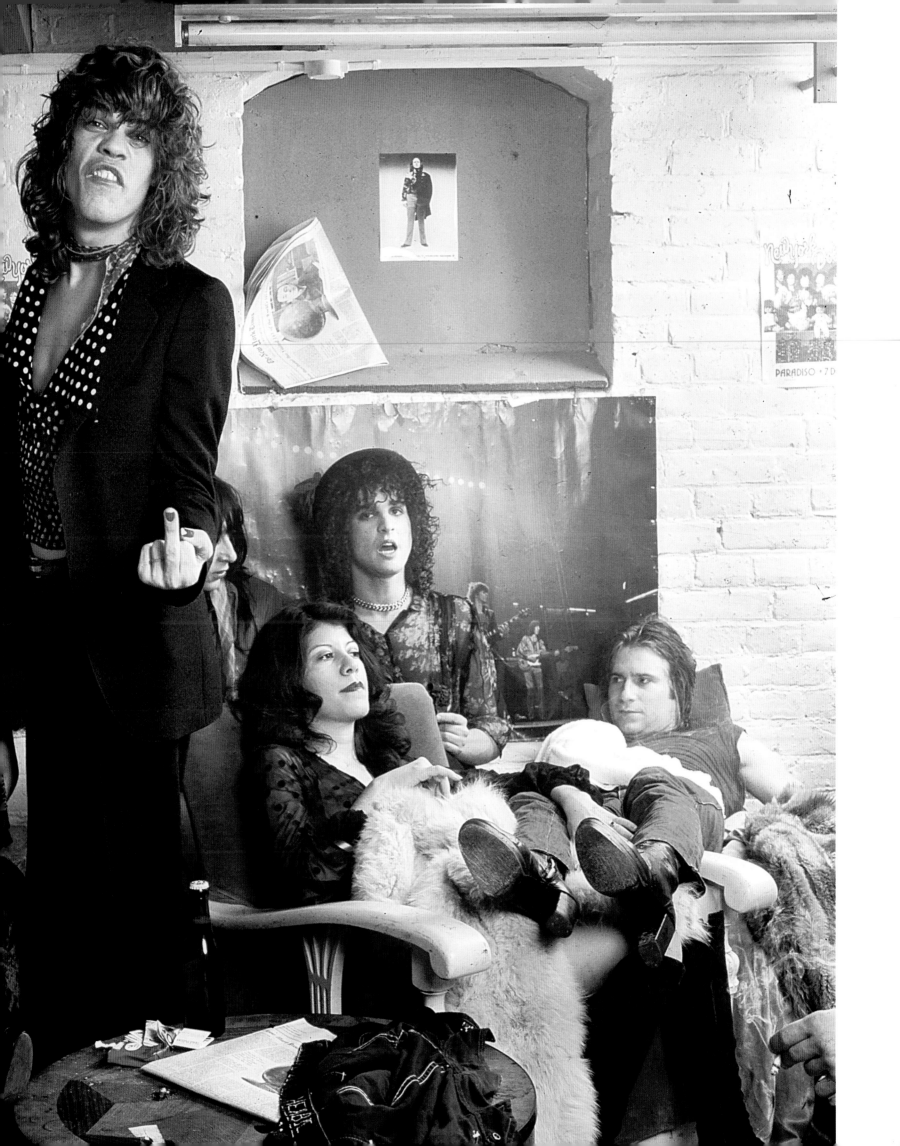

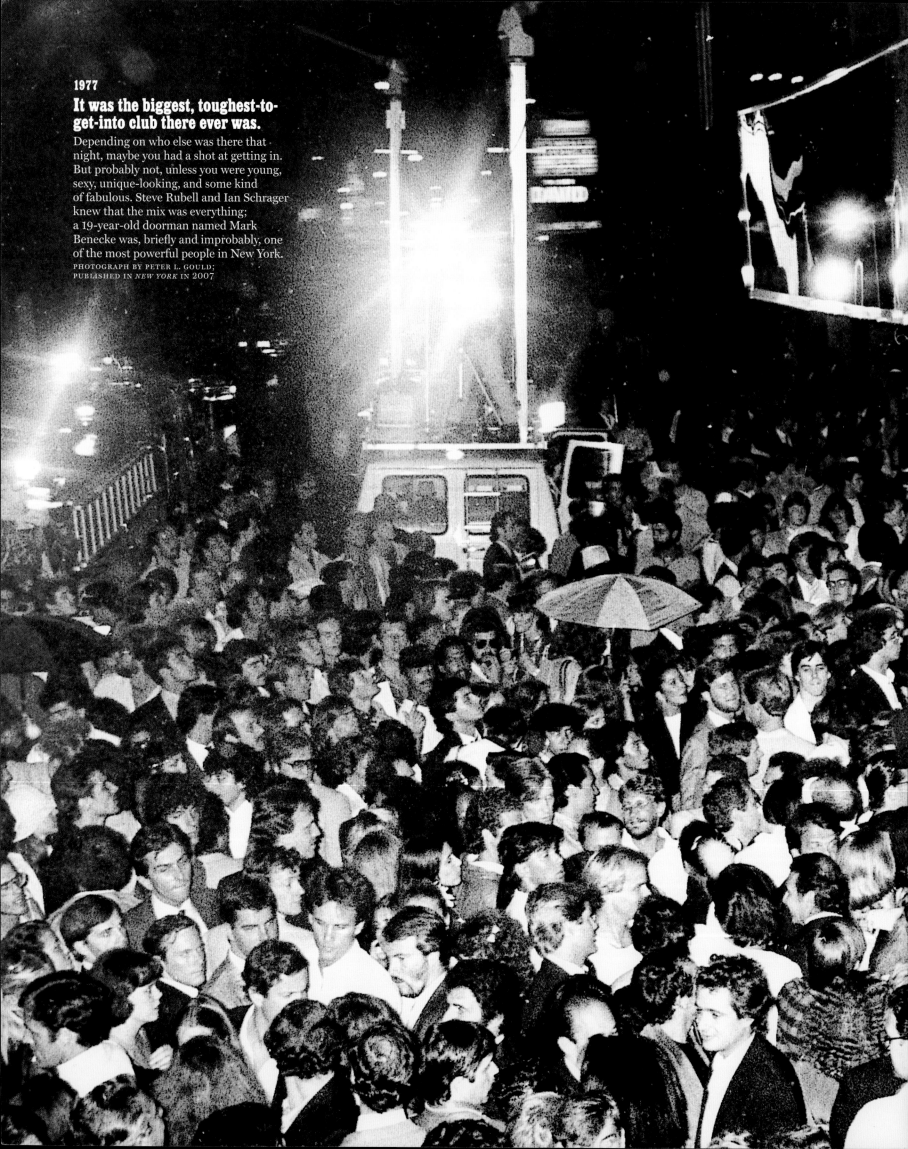

1977

It was the biggest, toughest-to-get-into club there ever was.

Depending on who else was there that night, maybe you had a shot at getting in. But probably not, unless you were young, sexy, unique-looking, and some kind of fabulous. Steve Rubell and Ian Schrager knew that the mix was everything; a 19-year-old doorman named Mark Benecke was, briefly and improbably, one of the most powerful people in New York.

PHOTOGRAPH BY PETER L. GOULD;
PUBLISHED IN *NEW YORK* IN 2007

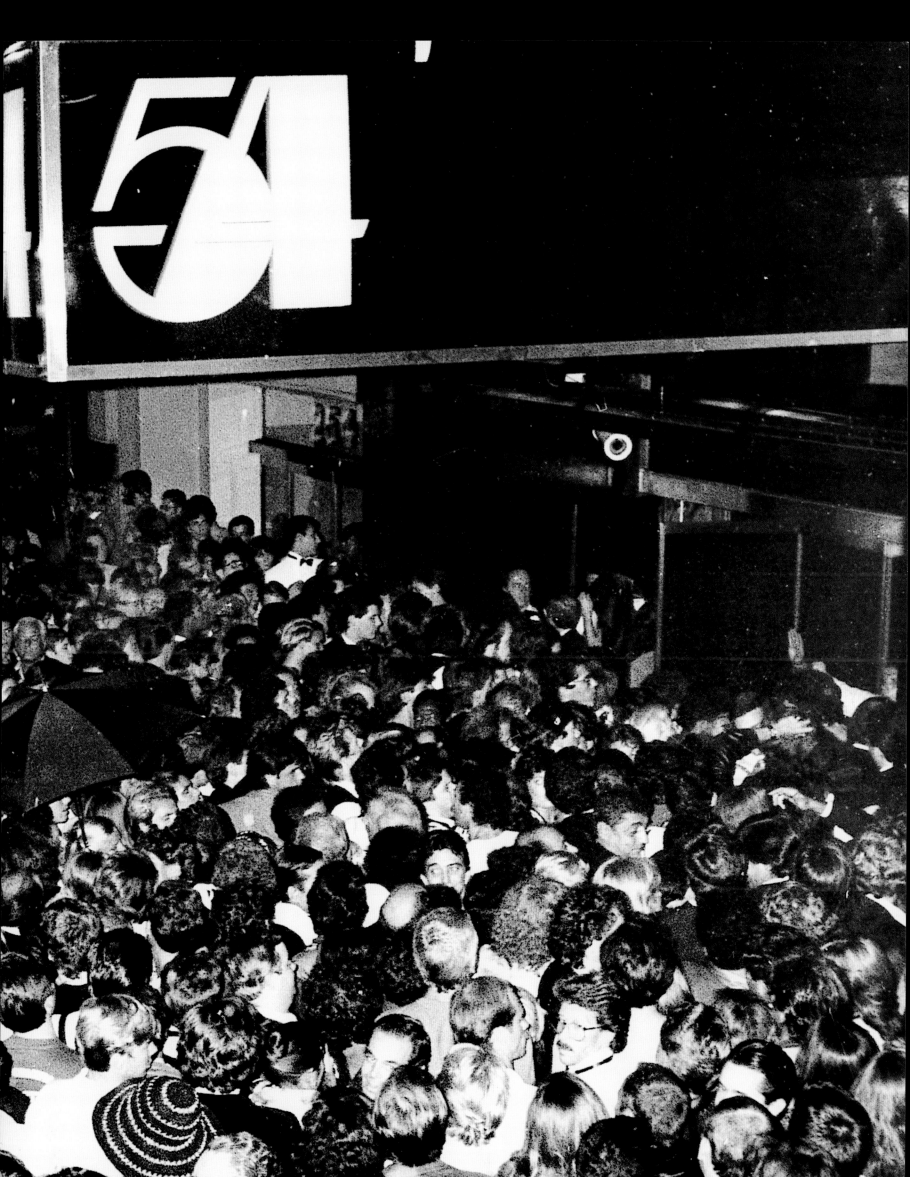

The Rise and Fall of Studio 54

By Henry Post

The party's over: *Co-owner Steve Rubell at his disco. "People come here," he says, "and it's like their own living room."*

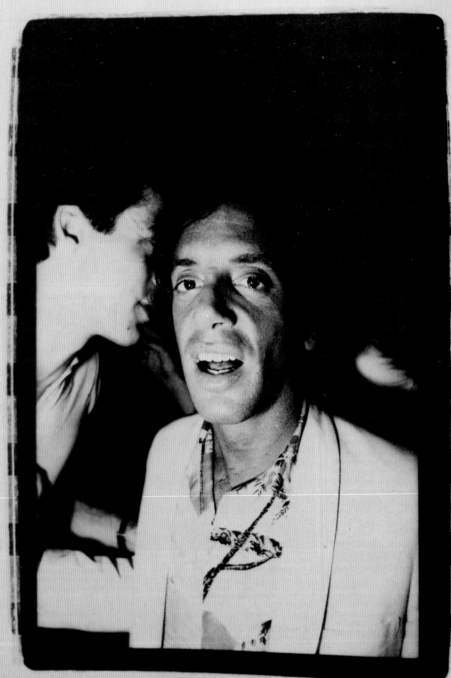

"... The disco meticulously recorded the names of celebrities to whom it gave 'party favors'..."

Photograph by William Coupon

Ian Schrager

Studio 54's $1-million defense collapsed last week as lawyers began negotiating the final pleas for two of its co-owners, Steve Rubell and Ian Schrager. Rubell says he is pleading guilty to tax evasion, a felony with a maximum charge of ten years plus fines. "I'm going to jail," said the co-owner.

The disco's fifteen lawyers apparently failed to save Rubell and Schrager in various pre-trial maneuvers, including a counterattack on White House chief of staff Hamilton Jordan for allegedly snorting cocaine at the disco. It was, according to one Justice Department source, "an airtight case" against the two co-owners.

Though the scales of justice have finally tipped against Rubell and Schrager, these men proved they and their lawyers could still muster incredible power. Even while under indictment for skimming $2.5 million from their disco, they drew on Studio 54's unequaled glamour and status, used their position at the top of society, and shook the White House with charges that would otherwise have been dismissed as those of alleged criminals. Instead, the claims made by these two former steak restaurateurs from Queens were treated with grave seriousness by some of the most respected figures in journalism.

Rubell and Schrager's "ordeal" is the story of their rise to the heights of chic notoriety, their bold bid for power, and their fall under the weight of their own greed. It is also the story of a new sort of McCarthyism in which drugs such as cocaine are first used as a lure to cement "friendships" with celebrities, then turned into a weapon.

A key to understanding the disco's accumulation of power and status in the worlds of entertainment, politics, and media is in hidden cash-expense records found by federal agents investigating the discotheque. The list, shown to many Studio 54 employees who were interviewed by the Justice Department investigators, includes the names of regular customers and celebrities who enjoyed the "generosity" of the disco. Next to their names are the dollar amounts spent by the disco

for drug purchases or "party favors."

A typical entry, according to sources: "Coke for ———— and ————. Poppers for Bianca."

Several well-known names allegedly appear on the list twenty times or more. The dollar amounts—usually in increments of $80 or $85, the 1978 price of a gram of cocaine—were recorded nightly along with other cash business expenses.

The government has done nothing with this list, showing little interest in what seems to amount to a record of the drug-taking habits of celebrities. Yet the list is revealing, apparently showing how Studio 54 bought the loyalty of café society with free drugs and gifts, thus ensuring a pool of glamorous and powerful friends. Studio 54, for example, enlisted the support of many celebrities in lawyer Roy Cohn's 1977 fight to gain a liquor license for the club after it had originally been denied one by the State Liquor Authority. These celebrities signed affidavits on behalf of the discotheque, supporting Rubell's claim that "Studio 54 is the greatest thing that had ever happened to New York."

Of course, some of the undeclared cash expenditures were not related to drugs and appear to be nothing more than influence buying among the chic. On August 6, 1978, the disco spent $800 for Andy Warhol's birthday party, at which Rubell filled a trash can with 800 dollar bills and gleefully dumped the money as a gift on the head of the

Disco on the floor; cash in the ceiling.

artist. Several months later, Rubell's picture appeared on the cover of the Warhol-owned *Interview* magazine. Warhol remained a good friend, bringing other celebrities to the club, thus helping to ensure its spiraling status.

Said the artist when informed of the alleged $800 entry and the existence of the list, "Gee, really. I mean that wasn't drugs or anything. It was my birthday. It must have been the trash can with the money. But why would Steve [Rubell] do that? No wonder people are afraid to go there now. I mean I don't know anything about the drugs. It was such a fun place. Really great."

Individuals listed for cocaine gifts expressed shock when informed of the list. Said one, a well-known fashion designer, "Those scum bags!" A public-relations representative for a singer-superstar who regularly partied at 54 and was on the list said, "This is the worst. Any of the others could have been next." Then the P.R. representative joked with an insider's casualness, "Of course, you have to give them some credit. No matter how much you hate them for what they did, the coke at 54 was never shit. It was the best."

But no matter how good the cocaine, many celebrities feel Studio 54 betrayed them by maintaining a secret list of these "business" expenses. To them, the "party favors" and drugs are now seen not as personal gifts but merely as business expenses in the course of creating the phenomenal success of Studio 54.

According to Studio 54 employees, politicians as well as entertainers were on the list, at least partially because of 54's drawing power for political fund raisers. Bob Abrams, Carter Burden, and Perry Duryea all held successful fund raisers at the club in 1978. So did Manhattan Borough President Andy Stein. Yet of them only Stein's name is said to appear on the list, he apparently having received a gift of several thousand dollars. (A spokesman said Stein had received no money from Studio 54 besides the legitimate proceeds of his fund raiser there. "Wherever you got your information," said the spokesman, "it's wrong.")

California's Governor Jerry Brown reportedly received a cash contribution. "I know nothing about it," said a spokesperson for the governor. "All you can do is check the record." Federal records show no documentation of any contribution from Studio 54 or its co-owners.

Photos: top, Bjorn Toulouse; bottom, William Coupon.

Then it all came apart.

When the Feds raided Studio 54 in December 1978, they found expense records with notations like "Poppers for Bianca" and "Coke for [*redacted*]." They also discovered enormous amounts of undeclared cash, some of it hidden in the dropped ceiling.

1986

Uptown, a different kind of exclusivity held sway.

Glenn Bernbaum served sole and salad to the ladies who lunched at his restaurant, Mortimer's. (Never mind that they barely ate.) The table everyone wanted—and C. Z. Guest or Carolina Herrera or Anne Slater (pictured) usually got— was 1B, by the window.
PHOTOGRAPH BY
HARRY BENSON

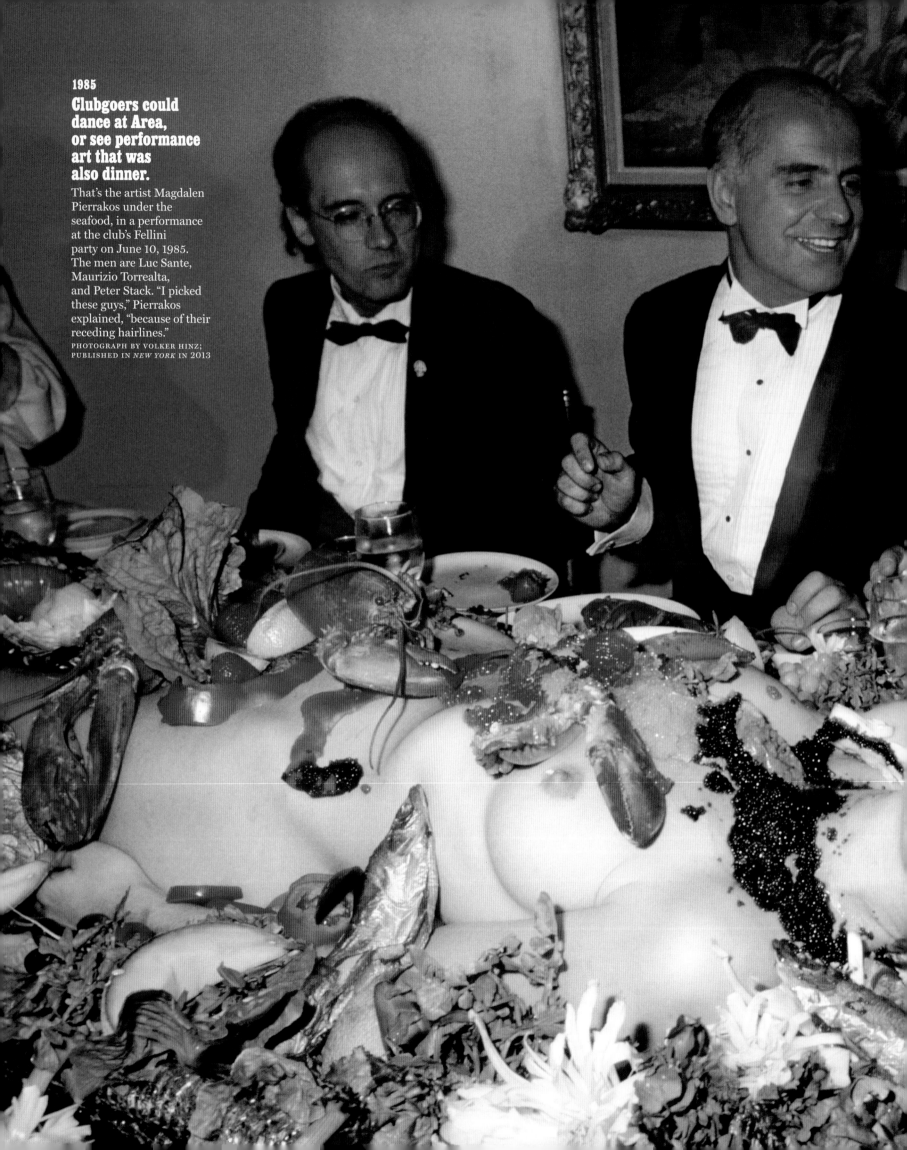

1985

Clubgoers could dance at Area, or see performance art that was also dinner.

That's the artist Magdalen Pierrakos under the seafood, in a performance at the club's Fellini party on June 10, 1985. The men are Luc Sante, Maurizio Torrealta, and Peter Stack. "I picked these guys," Pierrakos explained, "because of their receding hairlines."

PHOTOGRAPH BY VOLKER HINZ; PUBLISHED IN *NEW YORK* IN 2013

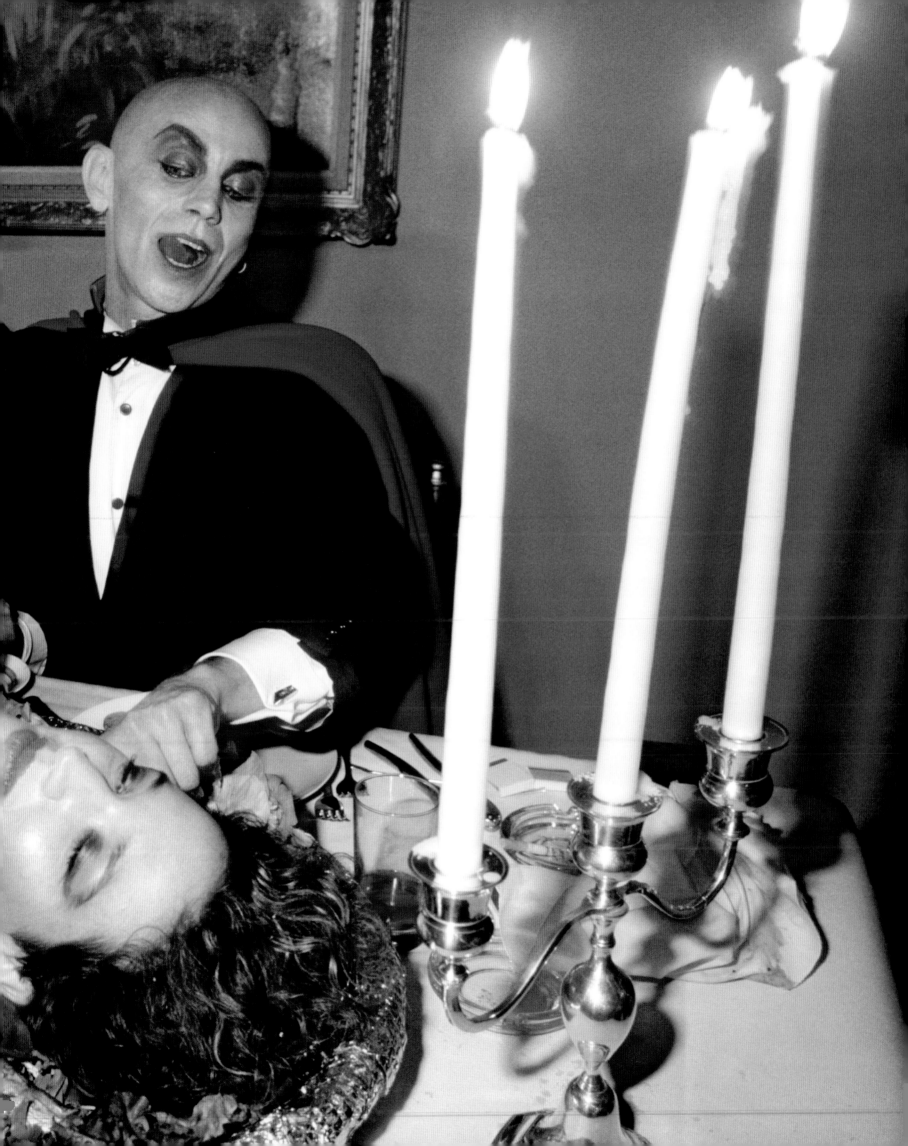

EXCERPT: MARCH 9, 1987

Andy Warhol died suddenly on Sunday, February 22. *New York* went to press the following Thursday with a 7,000-word cover story.

The World of Warhol

By Jesse Kornbluth

THE FIRST SIGN that there was something wrong with Andy Warhol, that he might be a mortal being after all, came three weeks ago. It was a Friday night, and after dinner with friends at Nippon, he was planning to see *Outrageous Fortune*, eat exactly three bites of a hot-fudge sundae at Serendipity, buy the newspapers, and go to bed. At dinner, though, he felt a pain. It was a sharp, bad pain, and rather than let anyone see him suffer, he excused himself. And as soon as he got home, the pain went away.

"I'm sorry I said I had to go home," Warhol told Pat Hackett a few days later as he narrated his daily diary entry to her over the phone. "I should have gone to the movie, and no one would ever have known."

In fact, no one remembered. And if anyone suspected trouble, it was dispelled the next week by Warhol's ebullient spirits at the Valentine's dinner for 30 friends that he held at Texarkana with Paige Powell, the young woman who was advertising director of *Interview* magazine by day and Warhol's favorite date by night. Calvin Klein had sent him a dozen or so bottles of Obsession, and before Warhol set them out as party favors for the women, he drew hearts on them and signed his name. On one—for ballerina Heather Watts—he went further, inscribing the word the public never associates with Andy Warhol: "Love."

The following afternoon, the pain returned. Brigid Berlin, his friend of 24 years, was with Warhol at his studio at 22 East 33rd Street. She was on her way to a London spa to lose weight, but she felt like one last chocolate binge. Warhol had a big box, so they went upstairs for one of the most familiar rituals of his life—someone acting

Warhol's oversize Polaroid portrait was shot for *New York* in 1980. When he died seven years later, photo director Jordan Schaps pulled it out of his bedroom closet and put it on the cover.

PHOTOGRAPH BY BILL RAY

out while he watched. "I'm dying for one," he confessed. "But I can't. I have a pain."

Warhol spent most of that weekend in bed. On Monday, for the first time in six years, he didn't go to work. That morning, he canceled his appointments with his exercise trainer for the entire week. On Tuesday, he still wasn't well, so Paige Powell canceled a lunch for potential advertisers. That night, however, Warhol and Miles Davis were scheduled to model Koshin Satoh's clothes at the Tunnel. And there was no way Andy Warhol could have tolerated an announcement that he was indisposed.

"Andy stood in a cold dressing room for hours, waiting to model," says Stuart Pivar, a trustee of the New York Academy of Art and, for the past five years, Warhol's best friend. "He was in terrible pain. You could see it in his face." Still, Warhol went out and clowned his way through the show. Then he rushed backstage.

"Stuart, help. Get me out of here," he gasped. "I feel like I'm gonna die."

Warhol knew that the problem was his gallbladder, and that surgery was long overdue. But he had an even bigger problem with traditional medicine. In 1968, as he lay in the emergency room of a downtown hospital after Valerie Solanas had shot him, he heard doctors tell his friends there was no chance of his survival—an opinion they changed, he said, only when one friend announced that the patient was famous and had money. Ever since then, he feared doctors so much that when he went to auctions at Sotheby's, he turned away to avoid even a look at New York Hospital. "If I go into a hospital again," he confided to Beauregard Houston-Montgomery, "I won't come out. I won't survive another operation."

But Warhol didn't ignore his health—he just redirected his concern about it. He consulted nutritionists, popped vitamins at every meal, was treated with tinctures, and carried a crystal in his pocket. Two weeks ago, when the pain kept coming back, he visited one of these practitioners. "She manipulated the gallstones," Warhol told a friend, "and they went into the wrong pipe."

The pain didn't go away, and Warhol finally agreed to surgery. Powell called him at home that Friday and asked him to come in and sign a copy of the new issue of *Interview* for Dionne Warwick. "I can't right now," he said. How about the ballet on Sunday? "Don't cancel."

That Saturday, surgeons at New York Hospital removed Warhol's gallbladder. That night, he was awake and stable. At 5:30 on Sunday morning, however, he suffered a heart attack. Doctors worked for an hour, but Andy Warhol was right for the last time. He died, at 58, without regaining consciousness.

The news of Warhol's death moved quickly through the city, and clusters of friends gathered to mourn. Many cried as if they'd lost a father. But as the eulogies came out, a more Warholian feeling began to overshadow this grief. It was unavoidable, really, and as the days passed, some of the people who knew him best began to say it: Andy would really have enjoyed this. ■

ANDY

$1.95 • MARCH 9, 1987

NEW YORK

BY JESSE KORNBLUTH

1985–2005

Drag went from edgy to mainstream, and did it outdoors.

When Lady Bunny and a couple of friends started Wigstock on a lark one drunken night in 1984, it was a hanging-out–in–Tompkins Square Park day of outré performance. By the time the annual festival wound down 21 years later, drag had found its glittery niche in the middle-American mainstream, so much so that RuPaul had his own TV show.

PHOTOGRAPHS BY DAVID YARRITU; PUBLISHED IN *NEW YORK* IN 2017

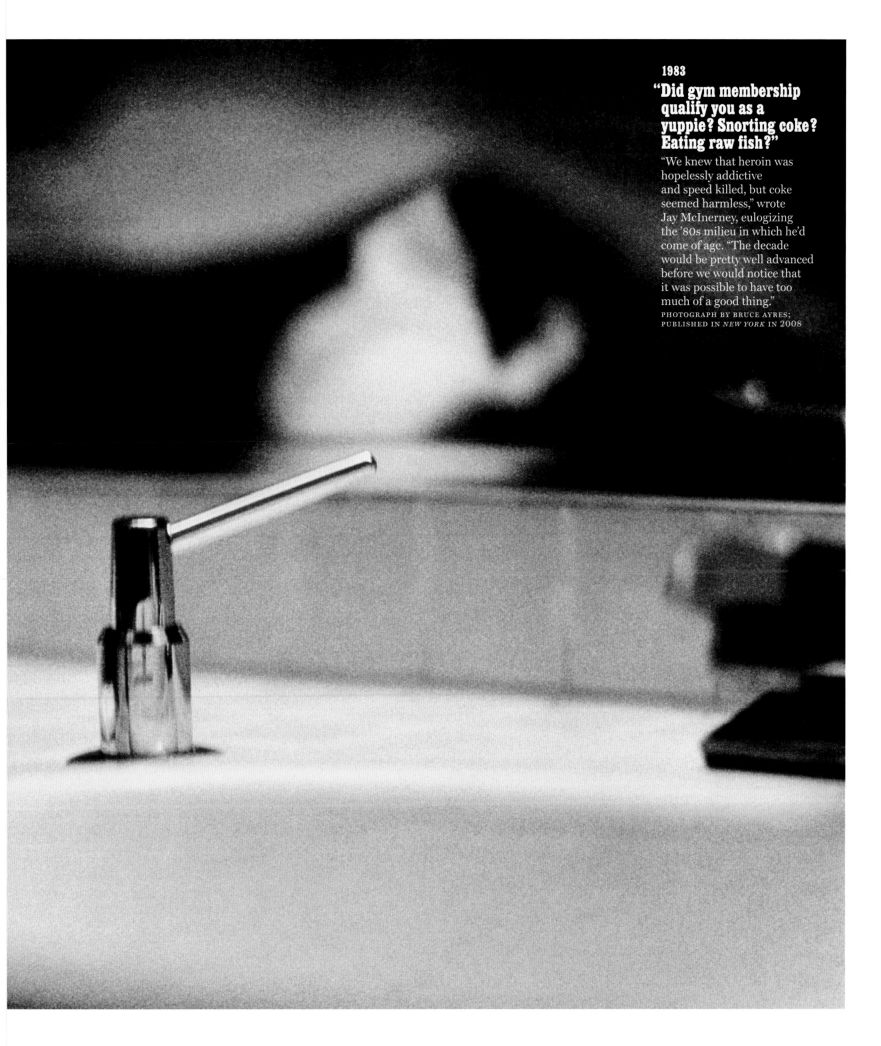

1983

"Did gym membership qualify you as a yuppie? Snorting coke? Eating raw fish?"

"We knew that heroin was hopelessly addictive and speed killed, but coke seemed harmless," wrote Jay McInerney, eulogizing the '80s milieu in which he'd come of age. "The decade would be pretty well advanced before we would notice that it was possible to have too much of a good thing."

PHOTOGRAPH BY BRUCE AYRES; PUBLISHED IN *NEW YORK* IN 2008

1982

The Bronx invented break dancing.

It was called "b-boying" in the early days, before it became a national craze. This guy spun on his head at the Roxy, the West 18th Street roller disco that eventually became a skateless dance club.

PHOTOGRAPH BY
GIANFRANCO GORGONI;
PUBLISHED IN *NEW YORK*
IN 2015

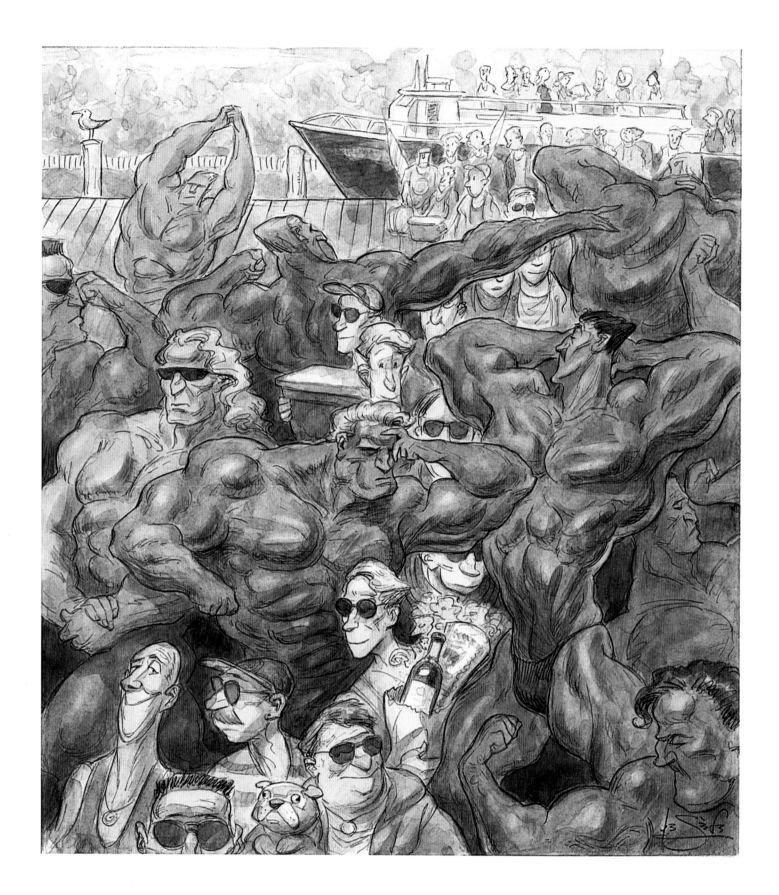

1993
AIDS threw a shadow across even the most exuberant gay scenes.

The Pines had long been a freeing place for gay men and women, but after the advent of AIDS, going to Fire Island became a different kind of release. Paul Rudnick wrote about visiting for the first time: "the crowd of excessively handsome men, many fairly naked, embracing their sooty, city-pale friends, who had come bearing sacks of gourmet bribes from Balducci's." But also: "For gays equally dedicated to personal success and political headway, a summer in the Pines has come to seem more precious than ever, a rebuke to the nightmare."

ILLUSTRATION BY PETER DE SÈVE

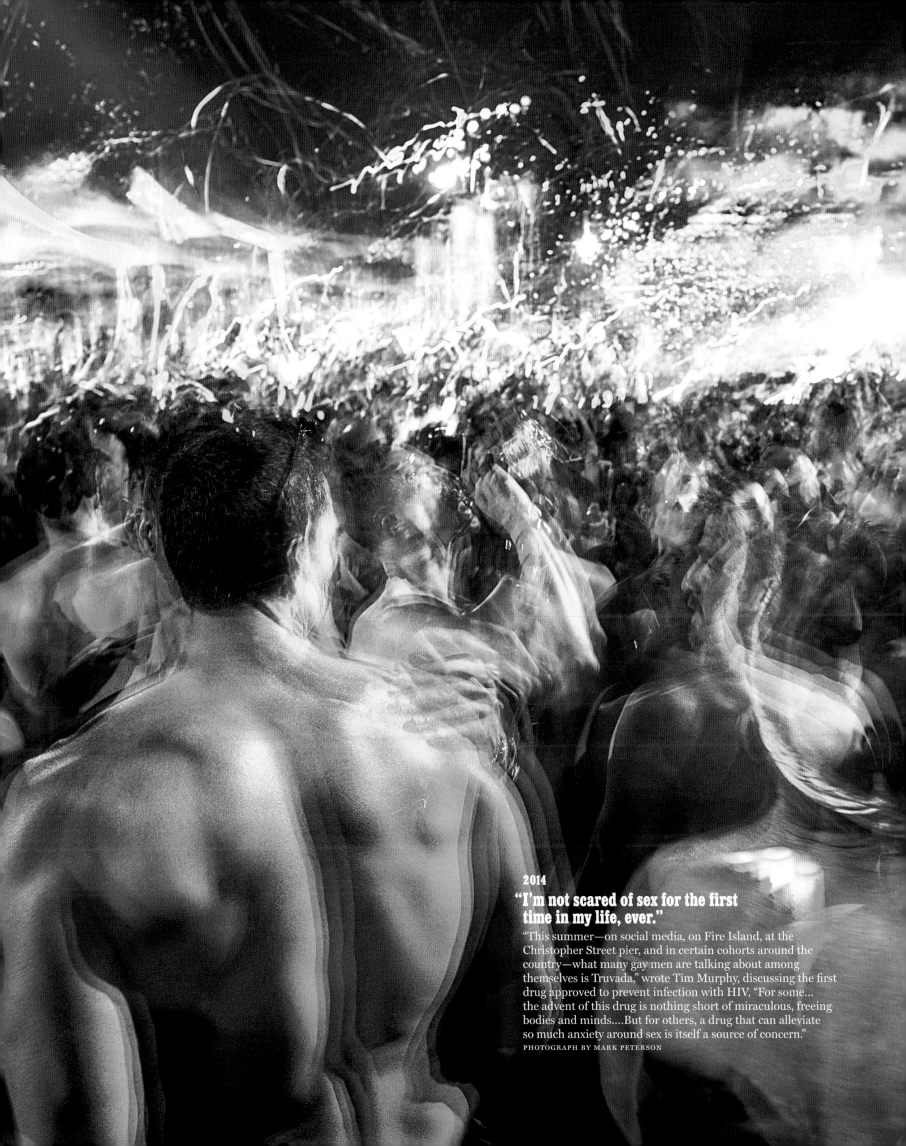

2014

"I'm not scared of sex for the first time in my life, ever."

"This summer—on social media, on Fire Island, at the Christopher Street pier, and in certain cohorts around the country—what many gay men are talking about among themselves is Truvada," wrote Tim Murphy, discussing the first drug approved to prevent infection with HIV. "For some... the advent of this drug is nothing short of miraculous, freeing bodies and minds....But for others, a drug that can alleviate so much anxiety around sex is itself a source of concern."

PHOTOGRAPH BY MARK PETERSON

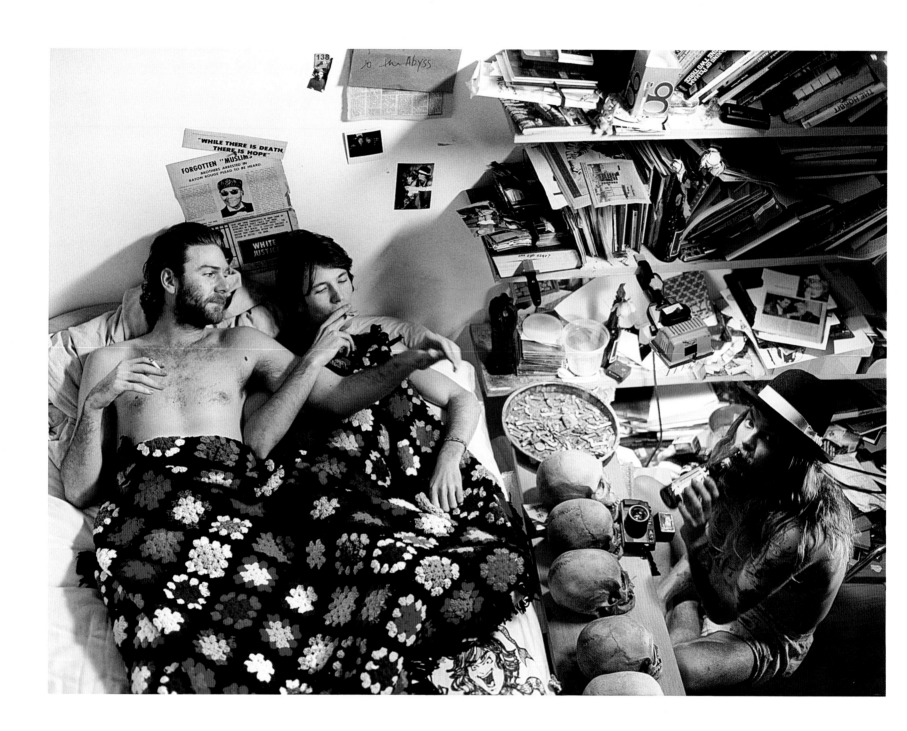

2007
New Yorkers never stopped trying to reimagine
bohemianism (with or without money).

Dash Snow, seen at right with his friends Dan Colen and Ryan McGinley, was a contradictory figure:
a trust-fund baby who lived in squalor by choice, making art projects like live-in hamster nests or
semen-streaked news clippings. Two and a half years after this story ran, he overdosed and died in a hotel room a few
blocks from this apartment on the Bowery.

PHOTOGRAPH BY CASS BIRD

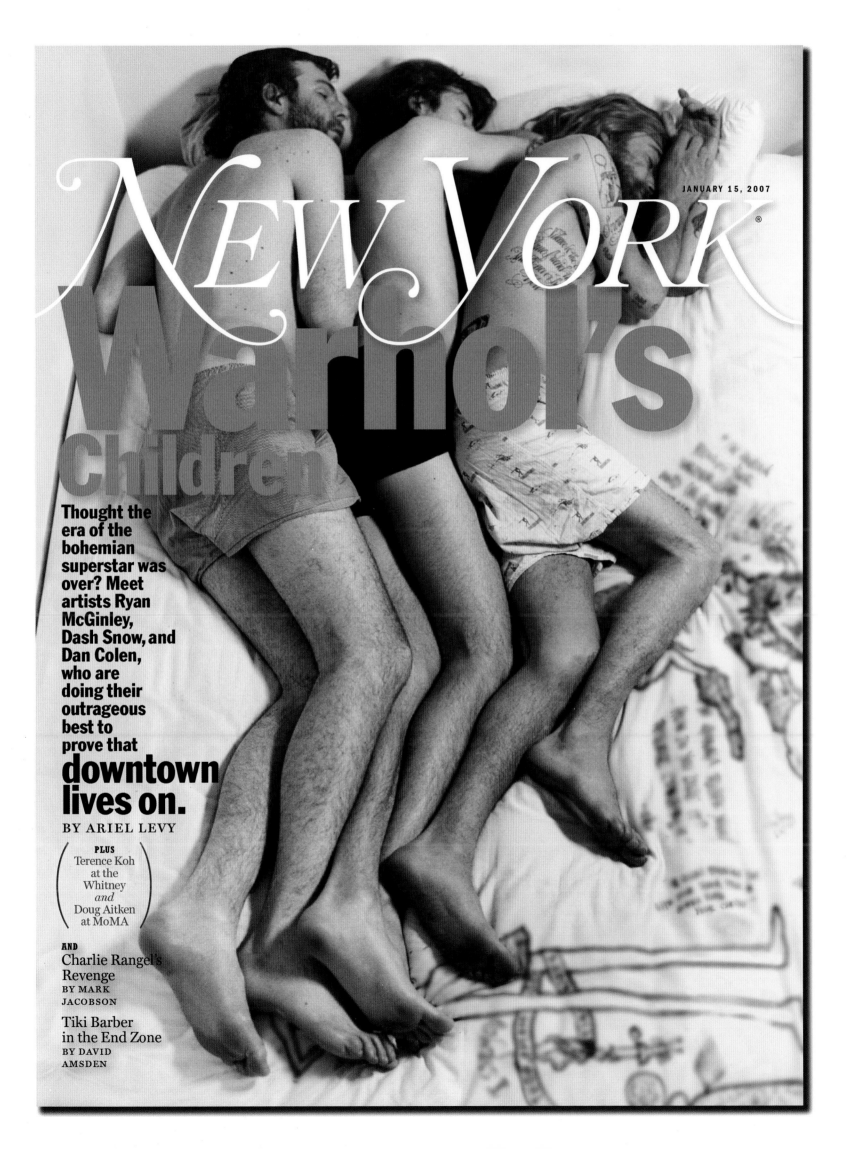

JANUARY 15, 2007

NEW YORK®

Warhol's Children

Thought the era of the bohemian superstar was over? Meet artists Ryan McGinley, Dash Snow, and Dan Colen, who are doing their outrageous best to prove that downtown lives on.

BY ARIEL LEVY

(**PLUS**
Terence Koh
at the
Whitney
and
Doug Aitken
at MoMA)

AND
Charlie Rangel's
Revenge
BY MARK
JACOBSON

Tiki Barber
in the End Zone
BY DAVID
AMSDEN

2009

Young New Yorkers figured out the Instagram future before Instagram came along.

Andy Warhol's habit of shooting party pictures with a Polaroid has gone global. Billions of people do the same with smartphones, documenting their social lives constantly. When this little story appeared, the young people who were taking all these pictures still had to post them on their own sites, or on the newish one called Facebook. A year later, Instagram launched, providing the ability to broadcast those pictures instantly, and anyone could try to become a Kardashian.

HANUK
37
hanuk.com

"I worked in fashion for years, so I know all the editors and people in the industry. And because they're my friends, everyone is super loose around me. Usually we all go out and drink too much and remember nothing, so the photos are the way to figure out what happened. (I leave the inappropriate ones at home, so no one gets mad.) I have such funny pictures, like from Halloween or Lauren [Santo Domingo]'s wedding in Colombia. I really only shoot people I know—the site is really more like my diary and less for the public. I don't pose anyone. I don't post

HOBO
26
hobogestapo.com

"I moved here from Sydney last year mostly just to explore a new city. I'm trying to figure out the social groups of the city—see who is friends with whom and how the city works at night. It's for my own education. I've been shooting a lot at Chloe on Wednesday nights, and live gigs at Webster Hall, and I also sometimes try to shoot quite secretly at Beatrice. There are six of us who work on the site; one guy is only 17, so we have to wait until he's 18 and can legally work. We want to steer clear of taking party pictures and being labeled like that because this is more

 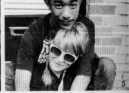

JACK SIEGEL
22
theskullset.com

"I've been shooting my same group of friends for three years. There are about twenty of us in the core group, with lots of other people coming in and out over the years. I started it as a journal, but now it's like a visual yearbook—something that's not personal but public, that outside people can look at and watch us all growing up. Most of my friends are used to me taking pictures and just do what they're gonna do—like drugs or whatever—regardless of the camera. Ryan McGinley [pictured, fourth from left] is one of my biggest influences and

NICKY DIGITAL
26
nickydigital.com

"I pick the parties I cover based on who's performing or the venue, and I prefer not to go out with friends or anyone I know (although it's rare that I don't know somebody once I'm inside). I'm not really socializing or hanging out drinking when I'm shooting. It's hard to say who I pick to shoot—mostly it's just what catches my eye, who looks like they're having fun. New York can be such a sea of black clothes, so my eye goes to color or someone in a great, interesting outfit. When I started this, I could wait for the moment and go unnoticed, but now the minute

Their art is the party. Their gallery is the Internet. Four young photographers who liv

I Go Out. I See Friends. I Take

INTERVIEWS BY DORIA SANTLOFER

52

names because that would be weird. Luckily my little point-and-shoot Leica records the date and time of each snap. Every night as I'm walking home, I always shoot a photo of, like, a garbage can or the sidewalk so the next day I can see how late I got home."

(1) Shannon Spillett at the Beatrice Inn. (2) Barnaby Roper and Camilla Staerk at a dinner party. (3) Holly Dunlap outside the Bowery Hotel. (5) Zac Posen, with a kiss from Hanuk, at the Beatrice Inn. (11) Lauren Santo Domingo in her wedding dress.

about documentation. We don't just toss anything up there; we have a real editing process to create a consistent narrative. I know the name Hobo Gestapo seems like it could be offensive, but it's not meant to be. It just sounded completely nonsensical, so I went with it."

(1) The Bag Raiders at Plan B. (4) Leather boots at the Ivy at Chloe 81. (5) Waris Ahluwalia at the New York Public Library. (10) "Random girl waiting with me for pizza. I told her to pull her top down so I could photograph her tattoos. She obliged."

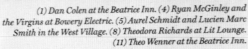

heroes. A while back I got an e-mail from him, before we'd ever met, and he told me that he used to do what I'm doing now—shoot his friends going out and doing crazy shit. He told me to start shooting during the day and do less nightlife stuff, which I've now started doing."

(1) Dan Colen at the Beatrice Inn. (4) Ryan McGinley and the Virgins at Bowery Electric. (5) Aurel Schmidt and Lucien Marc Smith in the West Village. (8) Theodora Richards at Lit Lounge. (11) Theo Wenner at the Beatrice Inn.

I walk in everyone is posing. I try to keep the site community-based. I always take pictures down of people who complain—they think they need to send me these threatening letters telling me they'll sue me, but I'd take down anything anyone asked. Not trying to offend anyone."

(1) Lady Sovereign and Agyness Deyn at Pianos. (2) D.J. Jess and Alex Malfunction at Webster Hall. (3) Samantha Noelle at Happy Ending. (8) Jessie Lee at Angels & Kings. (9) Jermain Jagger at Happy Ending. (11) Nick Pino at Le Royale.

behind the lens.

Pictures. I Post Them.

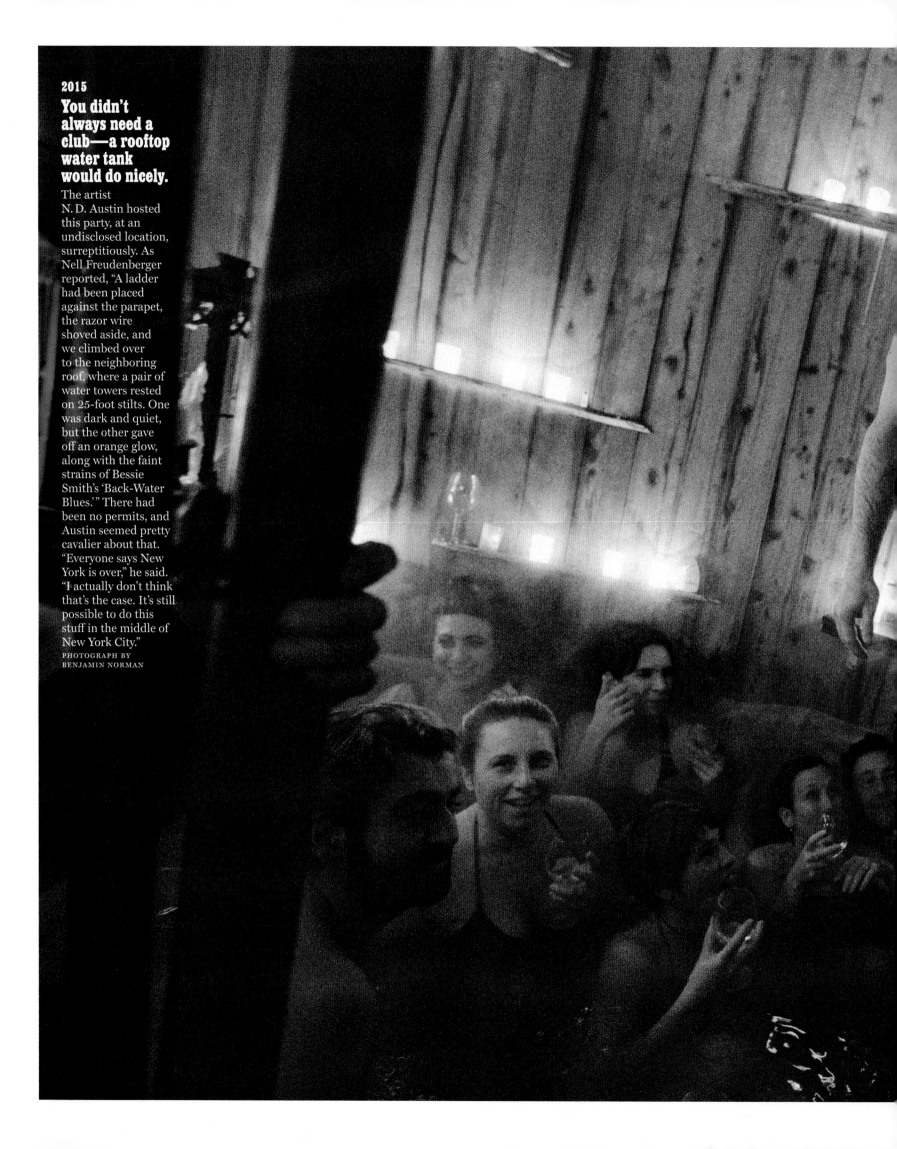

2015

You didn't always need a club—a rooftop water tank would do nicely.

The artist N. D. Austin hosted this party, at an undisclosed location, surreptitiously. As Nell Freudenberger reported, "A ladder had been placed against the parapet, the razor wire shoved aside, and we climbed over to the neighboring roof, where a pair of water towers rested on 25-foot stilts. One was dark and quiet, but the other gave off an orange glow, along with the faint strains of Bessie Smith's 'Back-Water Blues.'" There had been no permits, and Austin seemed pretty cavalier about that. "Everyone says New York is over," he said. "I actually don't think that's the case. It's still possible to do this stuff in the middle of New York City."

PHOTOGRAPH BY
BENJAMIN NORMAN

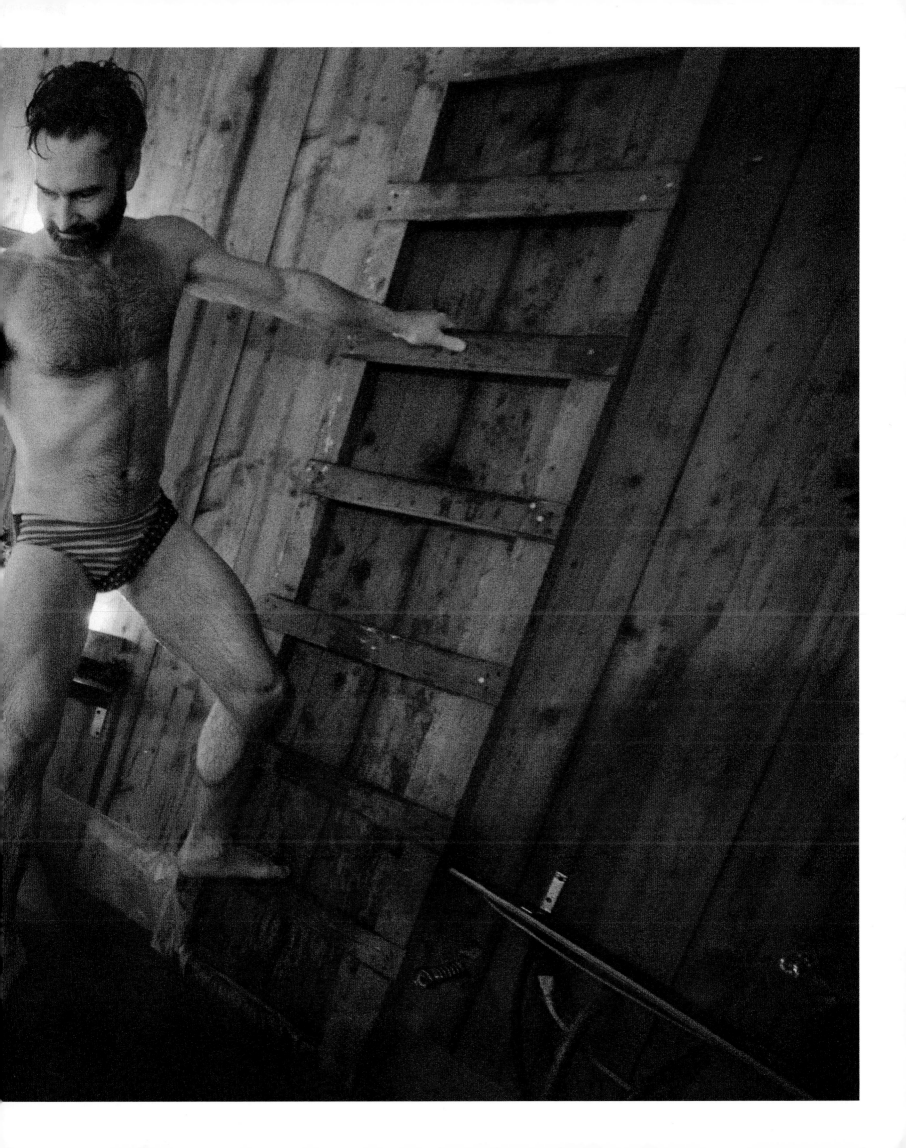

3/

FOOD

"Must it always be boring chocolate mousse?"

Gael Greene
in "I Love Le Cirque,
But Can I Be
Trusted?," 1977

Everyone learned how to eat.

"IT REALLY WAS A SHIFT in consciousness," recalls Milton Glaser, New York's co-founder and creator of the "Underground Gourmet" column. "Jerome Snyder, who was the art director of *Scientific American* and a wonderful guy—we were always one-upping each other on who knew the cheapest and best restaurant, and one day I realized that was never reported anywhere, because these little dinky joints didn't buy advertising. We were saying, *Hey, there's gold here, and we're not getting it.* It was such a reward for people." ¶ That "shift in consciousness" was true not only in journalism but in the culture at large. Fifty years ago, dining out took place in two kinds of restaurants: white-tablecloth French places that were completely bound to tradition, and ethnic dives that had great food and zero amenities. *New York*'s first critics—Gael Greene with her focus on sensual pleasure, and Glaser and Snyder on the kung-pao-and-knishes beat—saw that giant gulf beginning to close, and grasped that New York was at the leading edge of a revolution in food. Within a few years, the hidebound French were being challenged by innovators: newly sophisticated Italian, then nouvelle cuisine, then Japanese and fusion and New American. The little neighborhood places started to get more and more attention, and their cooking began to influence the uptown chefs. Getting into a hot new restaurant became like chasing tickets to a hot Broadway show. In 1980, Greene coined a new word, *foodie,* to describe these obsessive restaurant-chasers, and it eventually became such easy and widespread shorthand that *New York*'s copy desk banned its use for a while. ¶ The explosion in restaurant culture led to a parallel boom in home cooking and food awareness. The pursuit of the fresh and local and seasonal, helped along by the creation of the Greenmarket in 1976, redefined not only our way of eating but the neighborhood around Union Square. Chefs became celebrities and began to mine the world's food cultures for ideas. They discovered that, owing mostly to thrift, those little ethnic restaurants were cooking every part of the animal and not just the best cuts; the nose-to-tail movement was born. They also realized that humble dishes, like the all-American burger, could be made luxurious with custom meat blends and maybe a little foie gras in the middle. Food culture became a youth culture, one where packs of hungry 24-year-olds line up for the best ramen bar or food truck or Cronut bakery and then post a picture of every meal on Instagram. By 2017, young-skewing neighborhoods like Ridgewood and Greenpoint were blanketed with low-end-high-end places, where a dressy pizza or a superior burger and fries, instead of pâté or pike quenelles, constituted a major dining experience. The Underground Gourmet had, in a sense, eaten the whole world. Or, as Glaser puts it, "Good food, cheap. Well, what else do you want?"

1968
The magazine started out taking whitefish seriously.

The Underground Gourmet's first cover story planted the flag for vernacular, humble deliciousness.

NEW YORK

A Gentile's Guide

To Jewish Food
By the Underground Gourmet

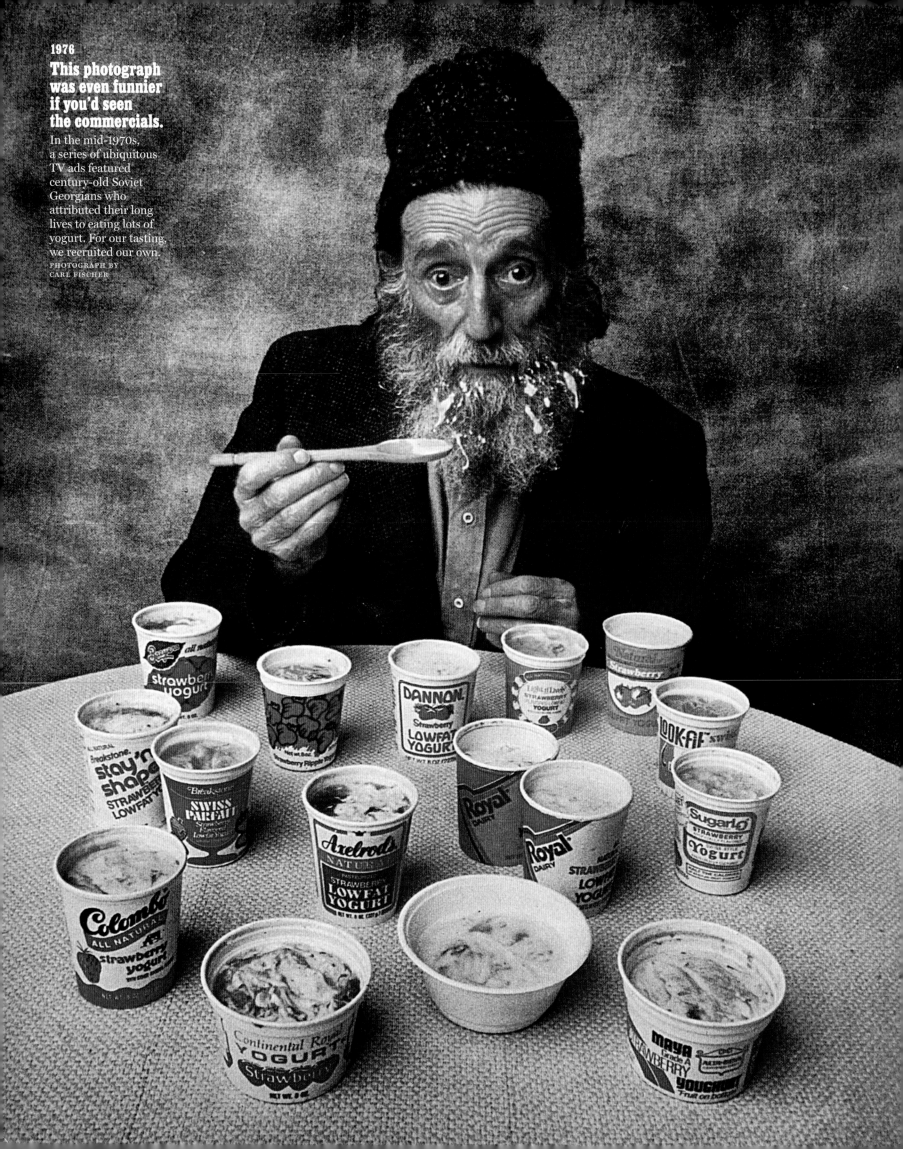

1976
This photograph was even funnier if you'd seen the commercials.

In the mid-1970s, a series of ubiquitous TV ads featured century-old Soviet Georgians who attributed their long lives to eating lots of yogurt. For our tasting, we recruited our own.

PHOTOGRAPH BY
CARL FISCHER

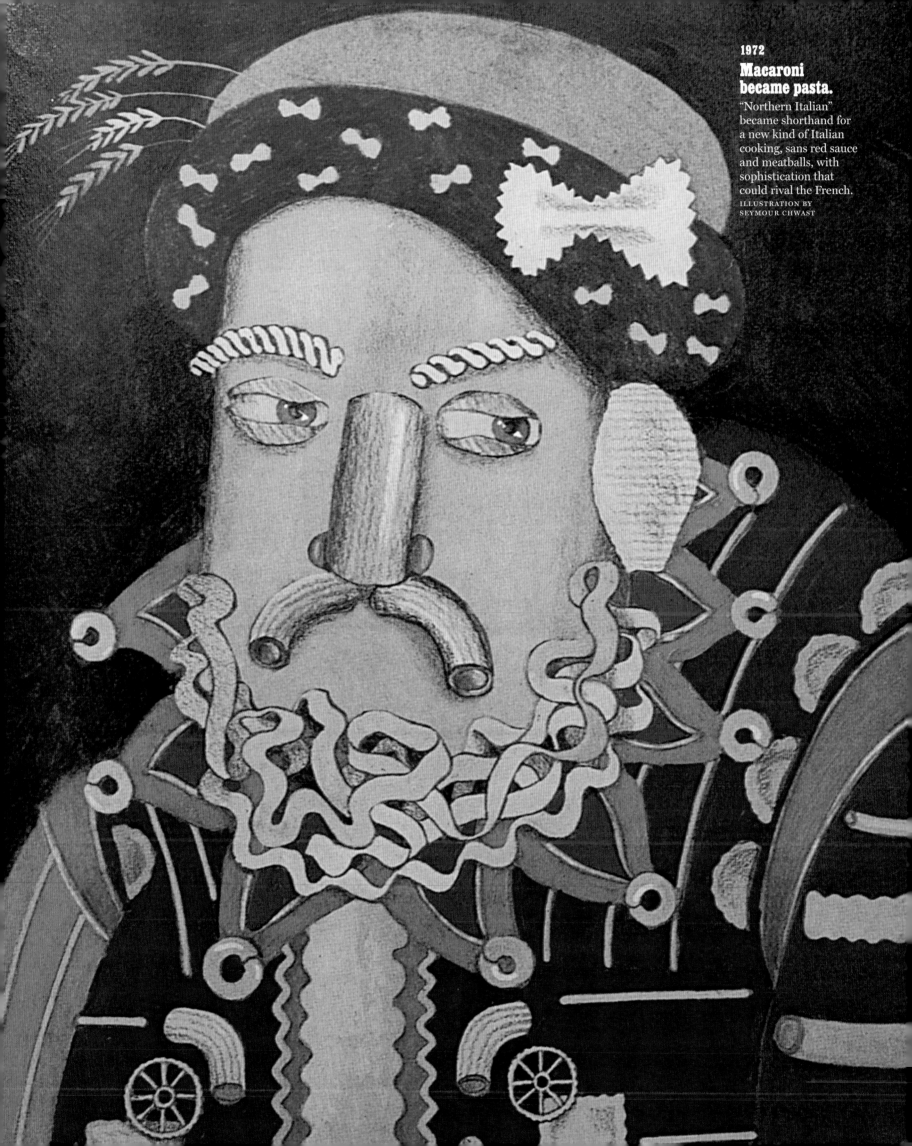

1972

Macaroni became pasta.

"Northern Italian" became shorthand for a new kind of Italian cooking, sans red sauce and meatballs, with sophistication that could rival the French.

ILLUSTRATION BY SEYMOUR CHWAST

Food fetishization proved to be a nearly inexhaustible source of cover stories.

Readers were eager for recommendations: Where's the best hero sandwich? Ice-cream cone? Zinfandel?

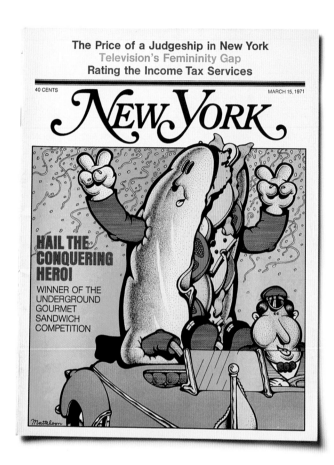

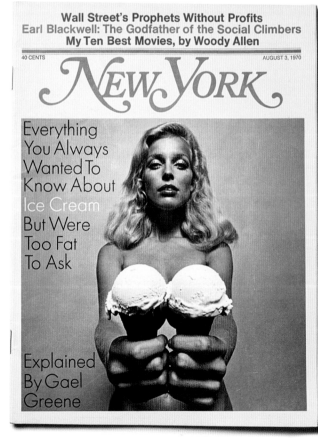

'The Times'/Lindsay Feud, by Nicholas Pileggi
Wm. F. Buckley Jr. on New York's Hottest Fireman
Hard Facts About Hand Laundries

50 CENTS

MARCH 20, 1972

New York

Gael Greene's Two-Year Quest, Con Amore, for the Greatest Northern Italian Restaurants in New York

Honor Thy Pasta

The culinary world was cultivating a bona fide Establishment, and Nora Ephron—then a young New York *Post* reporter, writing her first story for *New York*—found in its fussiness a minutely observed social comedy.

Critics in the World of the Rising Soufflé (Or Is It the Rising Meringue?)

By Nora Ephron

IN THE BEGINNING, just about the time the Food Establishment began to earn money and fight with each other and review each other's cookbooks and say nasty things about each other's recipes and feel rotten about each other's good fortune, just about that time, there came curry. Some think it was beef stroganoff, but in fact, beef stroganoff had nothing to do with it. It began with curry. Curry with 15 little condiments and Major Grey's mango chutney. The year of the curry is an elusive one to pinpoint, but this much is clear: it was before the year of quiche lorraine, the year of paella, the year of vitello tonnato, the year of boeuf bourguignon, the year of blanquette de veau, and the year of beef Wellington. It was before Michael Field stopped playing the piano, before Julia Child opened L'Ecole des Trois Gourmandes, and before Craig Claiborne had left his job as a bartender in Nyack, New York. It was the beginning, and in the beginning, there was James Beard and there was curry and that was about all.

Historical explanations of the rise of the Food Establishment do not usually begin with curry. They begin with the standard background on the gourmet explosion—background which includes the traveling fighting men of World War II, the post-war travel boom, and the shortage of domestic help, all of which are said to have combined to drive the housewives of America into the kitchen. This background is well and good, but it leaves out the curry development. In the '50s, suddenly, no one knew quite why or how, everyone began to serve curry. Dinner parties in

fashionable homes featured curried lobster. Dinner parties in middle-income homes featured curried chicken. Dinner parties in frozen food compartments featured curried rice. And with the arrival of curry, the first fashionable international food, food acquired a chic, a gloss of snobbery it had hitherto possessed only in certain upper income groups. Hostesses were expected to know that iceberg lettuce was déclassé and tuna fish casseroles de trop. Lancers sparkling rosé and Manischewitz were replaced on the table by Bordeaux. Overnight, rumaki had a fling and became a cliché.

The American hostess, content serving frozen spinach for her family, learned to make a spinach soufflé for her guests. Publication of cookbooks tripled, quadrupled, quintupled; the first cookbook-of the-month club, the Cookbook Guild, flourished. At the same time, American industry realized that certain members of the food world—like James Beard, whose name began to have a certain celebrity—could help make foods popular. The French's mustard people turned to Beard. The can opener people turned to Poppy Cannon. Pan American Airways turned to Myra Waldo. The Potato Council turned to Helen McCully. The Northwest Pear Association and the Poultry and Egg Board and the Bourbon Institute besieged food editors for more recipes containing their products. Cookbook authors were retained, at sizeable fees, to think of new ways to cook with bananas. Or scallions. Or peanut butter. "You know," one of them would say, looking up from a dinner made during the peanut butter period, "it would never have occurred to me to put peanut butter on lamb, but actually, it's rather nice."

Before long, American men and women were cooking along with Julia Child, subscribing to the Shallot-of-the-Month Club, and learning to mince garlic instead of pushing it through a press. Cheeses, herbs, and spices that had formerly been available in Bloomingdale's delicacy department cropped up all around New York, and then, around the country. Food became, for dinner party conversations in the '60s, what abstract expressionism had been in the '50s. And liberated men and women, who used to brag that sex was their greatest pleasure, began to suspect somewhat guiltily that food might be pulling ahead in the ultimate taste test.

Generally speaking, the Food Establishment—which is not to be confused with the restaurant establishment, the chef establishment, the food industry establishment, the gourmet establishment, or the wine establishment—consists of those people who write about food or restaurants on a regular basis, either in books, magazines or certain newspapers, and thus have the power to start trends and, in some cases, begin and end careers. Most of them earn additional money through lecture tours, cooking schools, and consultancies for restaurants and industry. A few appear on radio and television.

The typical member of the Food Establishment lives in Greenwich Village, buys his vegetables at Balducci's, his bread at the Zito Bakery, and his cheese at Bloomingdale's. He dines at The Coach House. He is given to telling you, apropos of nothing, how many soufflés he has been known to make in a short period of time. He is driven mad by a refrain he hears several times a week: "I'd love to have you for dinner," it goes, "but I'd be afraid to cook for you." He insists that there is no such thing as an original recipe; the important thing, he says, is point of view. He lists, as one of his favorite cookbooks, the original *Joy of Cooking* by Irma Rombauer, and adds that he wouldn't be caught dead using the revised edition currently on the market.

His cookbook library runs to several hundred volumes. He gossips a good deal about his colleagues, about what they are cooking, writing, eating, and whom they are talking to; about everything, in fact, except the one thing everyone else in the universe gossips about—who is sleeping with whom. In any case, he claims that he really does not spend that much time with other members of the Food Establishment, though he does bump into them occasionally at Sunday lunch at Jim Beard's or at one of the publishing parties he is obligated to attend. His publisher, if he is lucky, is Alfred Knopf or Simon & Schuster.

He takes himself and food very very seriously. He has been known to debate for hours such subjects as whether nectarines are peaches or plums, and whether the vegetables that Michael Field, Julia Child and James Beard had one night at La Caravelle and said were canned were in fact canned. He roundly condemns anyone who writes more than one cookbook a year. He squarely condemns anyone who writes a cookbook containing untested recipes. Colleagues who break the rules and succeed are hailed almost as if they had happened on a new galaxy. "Paula Peck," he will say, in hushed tones of awe, "broke the rules in puff paste." If the food establishmentarian makes a breakthrough in cooking methods—no matter how minor and superfluous it may seem—he will celebrate. "I have just made a completely and utterly revolutionary discovery," said Poppy Cannon triumphantly one day. "I have just developed a new way of cooking asparagus."

"WHAT FASCINATES ME," says Mimi Sheraton, "is that the more interest there is in gourmet food, the more terrible food is for sale in the markets. You can't buy an unwaxed cucumber in this country, the bread thing everyone knows about, we buy overtenderized meat and frozen chicken. You can't buy a really fresh egg because they've all been washed in hot water so the shells will be clean. And the influence of color photography on food! Oil is brushed on to make it glow. When we make a stew, the meat won't sit on top, so we have to prop it up with oatmeal. Some poor clod makes it at home and it's like buying a dress a model has posed in with the back pinned closed. As a result, food is marketed and grown for the purpose of appearances. We are really the last generation who even has a vague memory of what food is supposed to taste like.

"There have been three revolutionary changes in the food world in past years," Miss Sheraton continued. "The pressure groups have succeeded in changing the labeling of foods, they've succeeded in cutting down the amounts of pesticides used on foods, and they've changed the oversized packages used by the cereal and cracker people. To me, it's interesting that not one of these stories began with a food writer. Where are they, these food writers? They're off wondering about the boeuf en daube and whether the quiche was authentic."

Yes, that's exactly where they are. "Isn't it all a little too precious?" asks Restaurant Associates president Joseph Baum. "It's so elegant and recherché, it's like overbreeding a collie." But after all, someone has to wonder about the boeuf en daube, and whether the quiche was authentic—right? And there is so much more to do. So many soufflés to test and throw out. So many ways of cooking asparagus to discover. So many pâtés to concoct. And so many things to talk about. Myra Waldo's new book. The record Poppy is making. Why Craig finally signed onto the Time-Life Cookbooks. Michael's latest article. So much to do. So many things to talk about... ■

al parlor of
velvet—to
otees, seriou
tout Paris,
as their be

shiny blac

graze chee

s foodies, a

A word that would become ubiquitous appeared here first.
From "What's Nouvelle? La Cuisine Bourgeoise," by Gael Greene, June 2, 1980.

he men as

autiful wor

1973

Eighteen pastrami sandwiches in an afternoon? Sure.

If there's been one hallmark of *New York*'s food coverage, it's the comprehensive, careful, gleeful, exhaustive tasting. Of the 18 Olympians seen on this centerfold pullout poster, four survived into 2017; that year, *New York* declared the former last-place finisher—Katz's—the absolute best in town.

The Underground Gourmet

New York

The 1973 Pastrami Olympics

1 The Best

2 Rich and Spicy

Good Flavor
4 Excellent Quality
5 Nicely Cut
6 Good not Great
7 Pleasant
8 Thin Slices
9 Under-spiced
10 The Average
11 Slightly Fatty
12 Rubbery
13 Lacks Character
14 Too Fatty
15 Greasy
16 Undistinguished
17 Strange Aftertaste
18 The Worst

Rating	Source	Address	Telephone	Numerical Score	Sandwich Price	Total Weight	Bread Weight	Pastrami Weight	Pastrami Cost in Sandwich (per lb.)	Pastrami Cost in Bulk (per lb.)
1	Pastrami and Things	297 3rd Avenue (near 23rd St.)	683-7185	4.08	$1.75	6.25 oz.	2.5 oz.	3.75 oz.	$7.46	$5.00
2	Nathan's Famous, Inc.	Broadway and 43rd St.	594-8550	3.91	$1.50	6.25 oz.	2.5 oz.	4 oz.	$5.92	$4.65
3	Gitlitz	2183 Broadway (77th St.)	SU 7-2149	3.50	$1.65	7.25 oz.	2.75 oz.	4.5 oz.	$5.12	$5.00
4	Gaiety West	224 West 47th St.	765-1240	3.50	$2.00	5.25 oz.	2.25 oz.	3 oz.	$10.56	$6.00
5	Junior's Restaurant	386 Flatbush Ave Extension (Bklyn)	852-5257	3.41	$1.95	9.5 oz.	2.75 oz.	6.75 oz.	$4.58	$5.50
6	Carnegie	854 7th Ave (55th St.)	PL 7-2245	3.26	$2.20	7.5 oz.	2.25 oz.	5.25 oz.	$6.56	$5.80
7	2nd Avenue Delicatessen	156 2nd Ave. (10th St.)	AL 4-7144	3.08	$1.60	6.75 oz.	2.5 oz.	4.25 oz.	$5.92	$4.80
8	Smokehouse	867 3rd Ave. (57th St.)	421-4040	3.00	$1.95	6 oz.	2.5 oz.	3.5 oz.	$8.80	$5.20
9	Regency Restaurant	1311 2nd Ave. (69th St.)	628-8200	2.83	$1.75	6 oz.	1.75 oz.	4.25 oz.	$6.58	$5.20
10	Harry & Ben's	225 West 47th St.	CI 5-8421	2.75	$1.85	6.5 oz.	2.25 oz.	4.25 oz.	$6.88	$6.00
11	P.J. Bernstein	1215 3rd Ave	879-0914	2.58	$1.75	5 oz.	1.75 oz.	3.25 oz.	$8.61	$5.40
12	Roxy	77 East 161st St. Bronx	LU 8-6882	2.58	$1.75	7 oz.	2.75 oz.	4.25 oz.	$6.40	$3.60
13	Henry's Delicatessen	195 East Houston	OR 4-2200	2.58	$1.70	7.5 oz.	2 oz.	5.5 oz.	$4.94	$5.00
14	Fine and Schapiro	138 West 72nd St	TR 7-2721	2.58	$2.10	5.75 oz.	2 oz.	3.75 oz.	$8.96	$6.60
15	Hole in the Wall	1055 1st Ave (58th St.)	752-0540	2.50	$1.90	7.5 oz.	2.25 oz.	5.25 oz.	$5.79	$5.60
16	Stage	834 7th Ave (54th St.)	245-7850	2.50	$2.45	8.5 oz.	2.5 oz.	6 oz.	$6.53	$6.40
17	Ershowsky	39 West 46th St. (6th Ave.)	247-5630	2.41	$1.55	5.5 oz.	2 oz.	3.5 oz.	$7.08	$5.20
18	Katz's	205 East Houston	AL 4-2246	1.33	$1.60	8 oz.	2.5 oz.	5.5 oz.	$4.65	$4.40

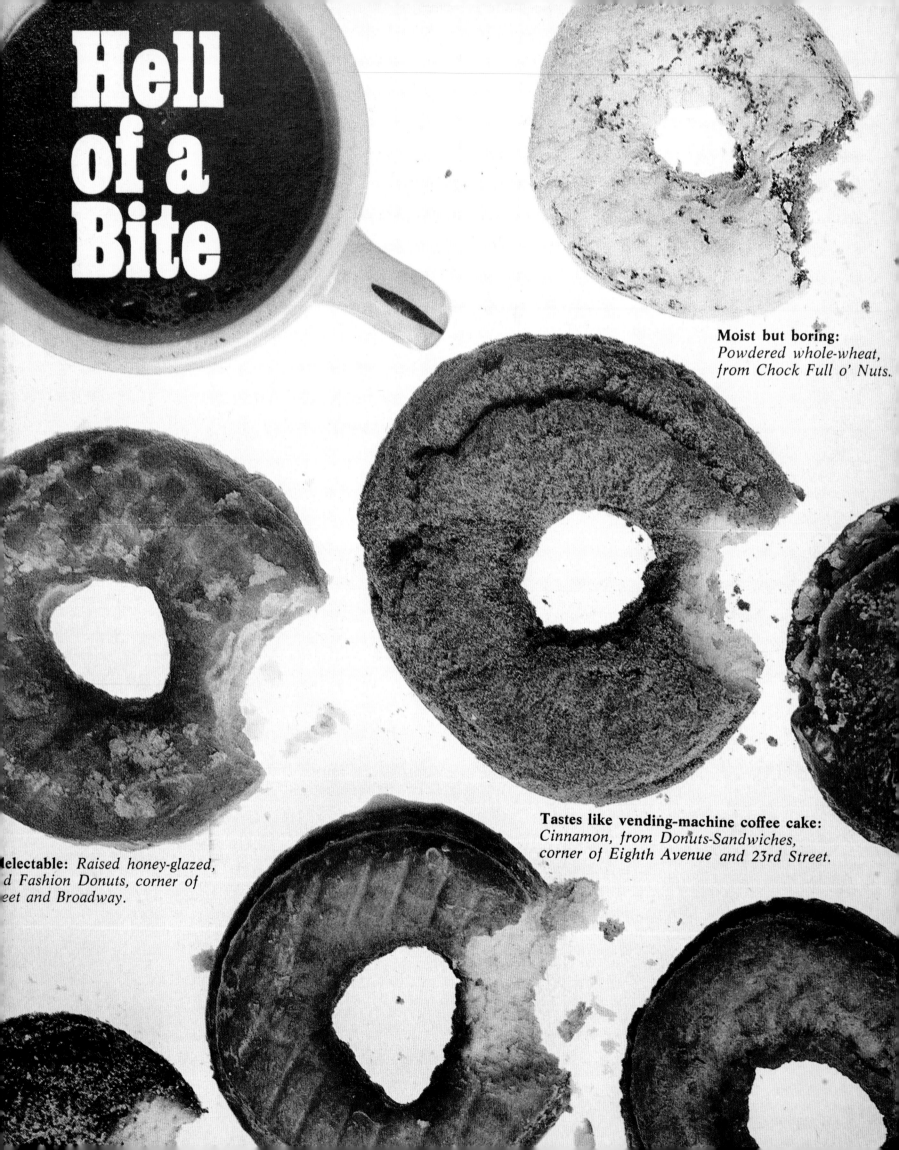

Hell of a Bite

Moist but boring: *Powdered whole-wheat, from Chock Full o' Nuts.*

Tastes like vending-machine coffee cake: *Cinnamon, from Donuts-Sandwiches, corner of Eighth Avenue and 23rd Street.*

Delectable: *Raised honey-glazed, Old Fashion Donuts, corner of ...eet and Broadway.*

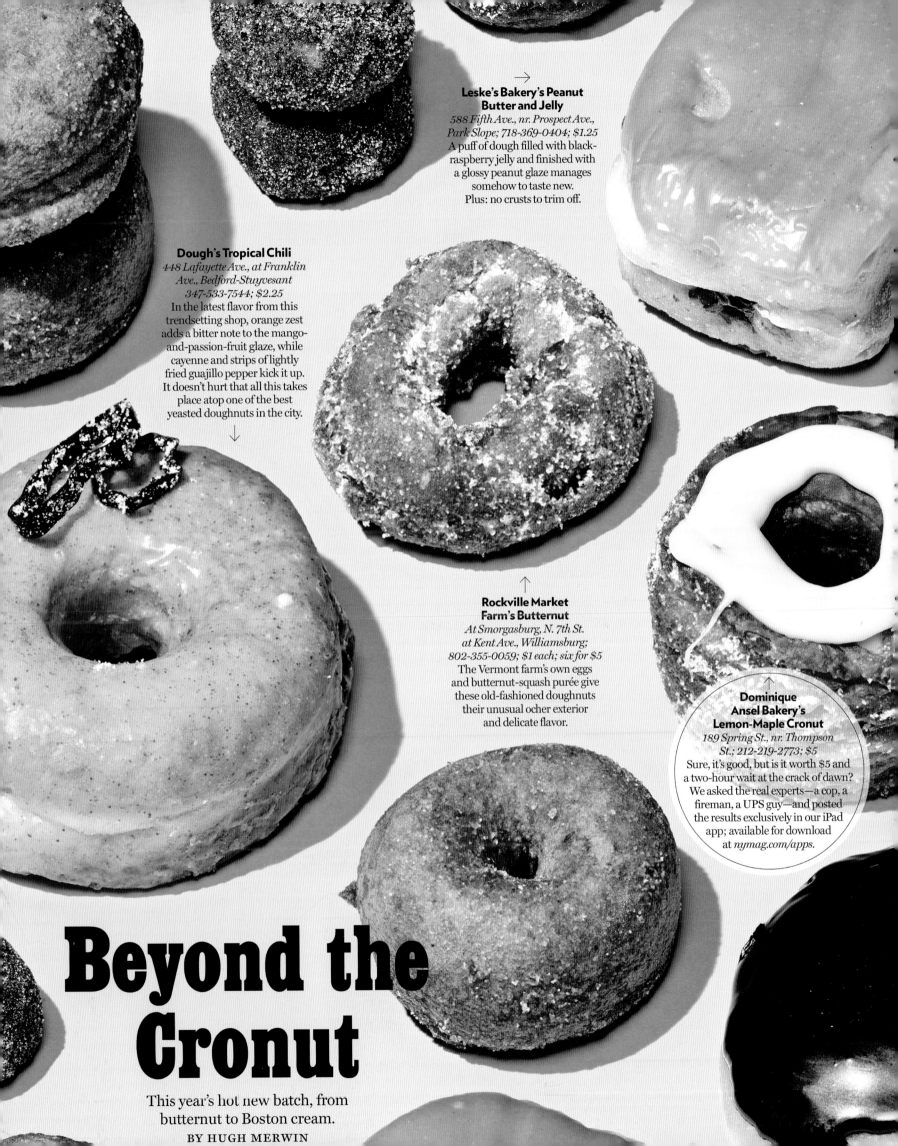

Leske's Bakery's Peanut Butter and Jelly
588 Fifth Ave., nr. Prospect Ave., Park Slope; 718-369-0404; $1.25
A puff of dough filled with black-raspberry jelly and finished with a glossy peanut glaze manages somehow to taste new. Plus: no crusts to trim off.

Dough's Tropical Chili
448 Lafayette Ave., at Franklin Ave., Bedford-Stuyvesant 347-533-7544; $2.25
In the latest flavor from this trendsetting shop, orange zest adds a bitter note to the mango-and-passion-fruit glaze, while cayenne and strips of lightly fried guajillo pepper kick it up. It doesn't hurt that all this takes place atop one of the best yeasted doughnuts in the city.

Rockville Market Farm's Butternut
At Smorgasburg, N. 7th St. at Kent Ave., Williamsburg; 802-355-0059; $1 each; six for $5
The Vermont farm's own eggs and butternut-squash purée give these old-fashioned doughnuts their unusual ocher exterior and delicate flavor.

Dominique Ansel Bakery's Lemon-Maple Cronut
189 Spring St., nr. Thompson St.; 212-219-2773; $5
Sure, it's good, but is it worth $5 and a two-hour wait at the crack of dawn? We asked the real experts—a cop, a fireman, a UPS guy—and posted the results exclusively in our iPad app; available for download at *nymag.com/apps.*

Beyond the Cronut

This year's hot new batch, from butternut to Boston cream.

BY HUGH MERWIN

One writer, one store, 1,961 reviews.

At the time, Bloomingdale's had the best gourmet-food department in town, and the
food writer Mimi Sheraton made a deal: If they'd let her sample everything, she'd taste it all.
Eleven months later, the catalogue filled nearly twelve pages in print.

I Tasted Everything in Bloomingdale's Food Shop
By Mimi Sheraton

"…Some foods, I knew, would be perfect; others would be hideous. The important thing is to know which is which, once and for all…"

HERRING

★**Herring in Aspic.** The bright blue schmaltz herrings are set in a spicy, clear, pickling jell much like yellow glass, and are delicious. **$1.95/lb.**

Herring in Horseradish Sauce. Needs more fiery, fresh horseradish root, but the schmaltz herring was meaty and not salty. **$2.95/lb.**

Herring in Mustard-Dill Sauce. A dash of vinegar, fresh dill and pepper would greatly improve this product, though the fork size chunks of herring were tender and sweet. **$2.95/lb.**

★**Rollmops and Filets.** One of the best selections in this case, both made of the same sapphire blue schmaltz herring and expertly pickled in brine with lemon and onion. **$1.75/lb.**

Herring in Sour Cream. Although lacking in personality, this could easily be perfected with some onion rings and white vinegar. **$2.95/lb.**

★**Kungli's Maatjes Filets.** The best, for the raw, red, North Sea maatjes pieces are tender and have enough bite. **$1.95/5½ oz. can.**

★**Danish Crown Herring Bits.** In curry, or tomato sauce, or plain in brine, and all are excellent. **$1.25/12 oz. jar.**

HONEY

The variety was staggering, representing over two dozen countries and more than 50 kinds of blossoms, a selection that has become a tradition in this department because in its early days it built a reputation on honeys.

The best honey is the least tampered with, preferably unstrained and unpasteurized, in which case it will turn cloudy, then thicken to a buttery spread, and may even harden completely. At any stage, it will return to liquid clarity if the jar is placed in hot (not boiling) water until the honey dissolves. It is, however, edible in the thickened state, if a bit granular. The taste for light, medium or dark honey is purely personal, but the highest commercial value is on the lightest, known as "water-white," and on honey that is "unifloral," made of the nectar of only a single type of flower. Blends are as likely to be undistinguished in honey as in wine, and so are varieties in sampler sets.

Of the 97 honeys I tried, here are the most noteworthy.

"…My kitchen was awash for two weeks as I brewed 86 varieties of tea in seven pots…"

APPLE
★**Bato Apple Spread.** Dark and soothing, the best apple butter I know. **$1.05/lb.**

APRICOT
★**Novia.** Small bits of ripe apricots in a honey-like base. **$2.40/1 lb. 1 oz.**

BLACKBERRY
★**Primula's Blackberry Preserves.** Taste almost like the fresh berries and are in a thickly-dark, purple-red purée. **$1.75/lb.**

BLUEBERRY
★**Primula's Bilberry Jam.** Blueberries by another name, were almost liqueur flavored and extremely good on vanilla ice cream and waffles. **$1.75/lb.**

"...Bread is one of Bloomingdale's biggest attractions, with ethnic breads gathered daily from all over the city..."

SAUSAGES, CHARCUTERIE AND DELICATESSEN MEATS

Sausages atop the counter here come and go on a trial basis, and those I tried are probably long gone. Usually the same varieties are sold sliced from the case. The three homemade pâtés I tried were undistinguished mainly because they had been frozen. A big glass jar of old-fashioned kosher-style garlic pickles now sits on this counter, and they are huge, crisp, pungent and cry out for a heel of rye bread. The old pitch, "a nickel for a pickle," has been changed to 35 cents.

★**Norwegian Ling Honey.** From a clover blossom, and intriguingly like a liqueur. **$3.25/lb.**

★**Mellona's [a brand named for the Greek goddess of honey] Heather.** A rich, amber Dutch honey, the best heather in the department. **$2.65/15¾ oz.**

★**Mellona's Linden.** Light and blossomy, with a faint glow of mauve under its gold-brown color. **$2.25/15¾ oz.**

★**L'Abeille D'Or's Belgian Orange Blossom.** Sharply aromatic. **$3.50/1 lb. 1½ oz.**

★**L'Abeille D'Or's Floral Blend.** One of the best floral blends that actually seems to taste of sunshine and fresh air. **$1.75/9 oz.**

★**Villeneuve's Honey With Nuts.** This is one of the rare cases when the less expensive product is the better one, both because of the honey and because Villeneuve's almonds are unblanched, therefore crisper; their dry-tasting husks are a better foil for the honey's sweetness. With almonds, walnuts or hazelnuts. **$2.50/14 oz.**

★**Rucher's Gatinais.** Has a strong, almost musky odor and a ripe aftertaste. **$2.55/16 oz.**

★**Pure Narbonne, Grand Cru, Reserve du Rucher.** The best French honey, and with that pedigree, no wonder. It is a light amber color, with a lemony flavor, and of top quality. **$2.55/16 oz.**

★**Bouchardeau's Honeys.** An enormous assortment of unusual and tantalizing honeys, light to dark, and each with characteristics of the blossoms behind it: rosemary, thyme, heather, fir-tree, high mountain flowers, lavender, and Acacia, a pale diamond-yellow, thin syrup with an ethereal flavor. When royal jelly is added, as in one version, the honey becomes slightly more orange and thicker in taste and body. **In assorted new packages, not yet priced.**

★**Ambrosoli Sicilian Orange Blossom.** Italy's incredible chestnut honey is missing from this collection, but this citrusy, aromatic one almost makes up for it. **$2.05/13 oz.**

★**Attiki Honey.** Honey from Hymettus is literature's most poetic, and this version has a wine-like and lemony savor and a deep, rich essential honey taste. **$1.80/lb.**

★**Pinewoods German Honey.** Very dark and thick golden-brown, with a molasses flavor and the merest hint of a resin scent. **$2.20/lb.**

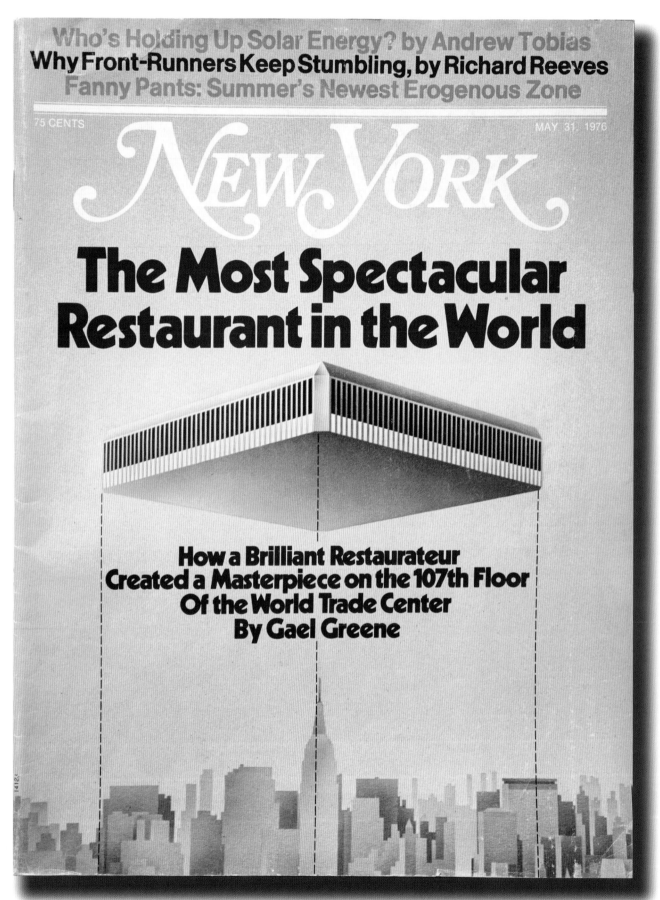

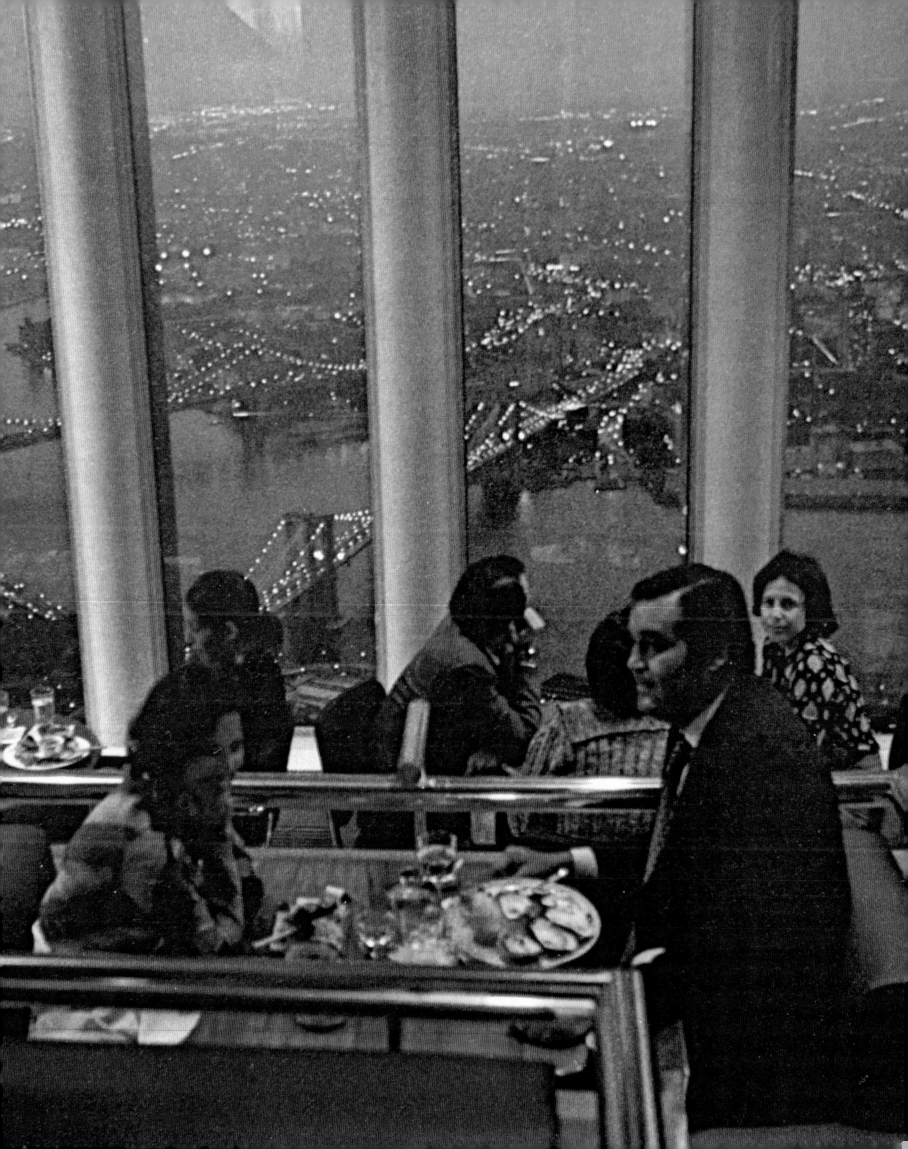

EXCERPT: SEPTEMBER 24, 1979

When the typical American reaction to sushi was still "That's not dinner, it's bait," a famous friend guided Gael Greene into a whole new world.

The Joy of Sushi

By Gael Greene

THERE ARE TASTES that sing like a heavenly chorus. Tastes to record in the mouth's hall of fame. Sudden gastronomic epiphanies as striking to one's innocent sensibilities as *Nude Descending a Staircase* must have been that long-ago day in the armory. Now I am going to tell you about a transcendent hour between one and two at a tiny lunch counter one flight up over East 48th Street—lunch on a plateau of bliss at Take-zushi. The tribute may seem rash, I know. There is no way the BLT-on-crustless-toast crowd will be able to comprehend my fever.

I knew Take-zushi—this spare little second-story eatery—was a celebrated sushi sanctuary. Take-zushi, alas, does not need to be discovered. By one o'clock there is always a line. Saturday dinner is a bargain lure for Japanese families. Weekdays after two the crowd does thin and regulars arrive. "Just give me the usual," I heard one man say, and the waitress nodded instant assent.

But I was a novice in the sushi faith. I had dabbled warily in sashimi—exploring raw tuna and mackerel...toying with salmon roe on sticky rice in seaweed ribbons...quite pleased with the sweet subtlety of raw fish. And I had eaten, here, one beautiful briny morsel after another. Still I had a sense that beyond the supernal tuna and the crunchy sea clam were mysteries Take-zushi had yet to reveal.

My friend Joel Grey, schooled in sushi lore and coached in Japanese fish talk by his secretary, Violet Arase, was pleased to play spiritual guide. As he explained: Sit at the tables and you'll have glorious fresh fish and ethereal egg pancake, the exquisite morsels arranged in a lacquered lunch box. But the cognoscenti hug the counter, improvising. "Okonomi," the house calls it. Choosing lunch by the item, you can easily spend $35 for two—tax, tip, and beer included. The secret, Joel confided, is to wait for a spot at the counter, develop a meaningful relationship with your sushi chef, and explore the rare exotica of the day.

"Like Englewood," said Joel.

"Englewood?"

"It's the muscle of the fin of the fluke," he explained. "Engawa. I just say 'Englewood' wherever I go and they seem to understand."

Behind the counter, the master chef is slamming a side of tuna belly with his knife. It looks like ritual violence. But no. "He just wants to see how the fish responds, how it bounces," says Joel. Our chef is fussy. What he won't use, his confreres will. Some touches are stunning. His seaweed wrappers go into the toaster oven behind him. He offers tiny seaweed squares so fingertips need not bruise his delicate temaki (fish and rice hand-rolled in seaweed). How calm he is, how casual, as he sets the stage: two small lacquered trays on a riser above the counter...a swirl of pickled ginger and a neat dab of pale-green wasabi—Japanese horseradish. A waitress brings tea for me, beer for Joel. Joel pours soy into a tiny saucer and dissolves a whammy of wasabi in the mahogany pool. The knife-slashed sea clam (mirugai) is crisp and firm. Joel dips a crisp curl in the soy. I use very little, dipping every third bite so the salty counterpoint restores lulled taste buds.

"I never order shrimp here," says Joel, indicating rosy cooked scampi. "Except when they have the baby ones...raw." Six raw shrimplets (amaebi) are set anuzzle before us. The taste is all scent. The thrill now is texture. "Slimy," I observe. "Wonderfully slimy."

"Better say 'soft,'" Joel advises. "Or better...'insinuating.'" And they are insinuating, soft and rich...sweetly perfumed. Between shrimp, Joel hooks a slice of ginger on his chopsticks. "Not too pickled, not too bland," he comments. "This is like a sorbet in a French dinner...a palate cleanser to me."

Next the chef examines wooden crates of sea urchin—prodding, squeezing, rejecting. "He is doing that for us," I surmise. "No," says Joel. "He does it for himself. He has his own standards." The moment for uni is near. The master wraps it in vinegared rice in a crisp seaweed finger roll. I remember my first sea urchin, at a sidewalk bistro in Paris. It was harsh with iodine. It took years till I found my sea-urchin courage again. Take-zushi's uni are miraculously sweet. The briny perfume goes right to the brain, wafting intimations of cosmic joy. We're both giggling now. Joel has the madness too. "That taste," he marvels. "Deep funk."

Uni is a bit like grass...a distorter of time. Suddenly we are eating fiercely blushing tuna belly. "Look at the color," says Joel. "It's like a Rothko." Next, herring roe on a seaweed leaf (komuchi-kombu)—a unique crunch never before experienced. The chef minces swordfish with scallion (kajiki-to-kirami-negi-temaki) to wrap with sticky rice in crisp toasted seaweed. "I think he invented this one," says Joel. *"Oishii, oishii,"* he salutes the chef. "So good." And to me: "You don't want to dip the rice in soy, just the fish or the seaweed."

Next to us a woman is savoring the sashimi blue-plate special, sipping beer and cutting a swath through the *Times* crossword puzzle. We are floating a Zen level above her, I suspect, nibbling yamaimo-ume-temaki with a kick of pickled plum in a rice-seaweed finger roll. The yamaimo has crunch and makes a sticky, stringy slime. You cannot taste it. But you can see it. After a pause of reverence, Joel orders a futomaki. The chef overlaps a couple of crisp wrappers, spreading them with rice. He dabs a bit of fish powder and arranges odd sticks of pickled things. Rolled and sliced, it is a beautiful galantine—sweet and salt, soft and crunch.

Now he announces we will finish with soup. Now? "Yes. I noticed last week, the Japanese eat soup at the end. To seal everything in." We share a bowl of thin bean purée with scallion and floats of seaweed. But Joel seems restless...unfulfilled. "Two uni sushi, please," he says.

"Joel, we just sealed everything in."

"I know. But I think we should leave with uni in the mouth."

The master chef smiles indulgently. We both pop the uni sushi into our mouths whole. The brine curls into my brain. Joel leaves a great pile of money behind. I feel like a kid who's just swallowed a Hostess Twinkie whole. Rich and wicked and greedy...and happy to be alive, delirious imagining life's astonishments yet to come. ∎

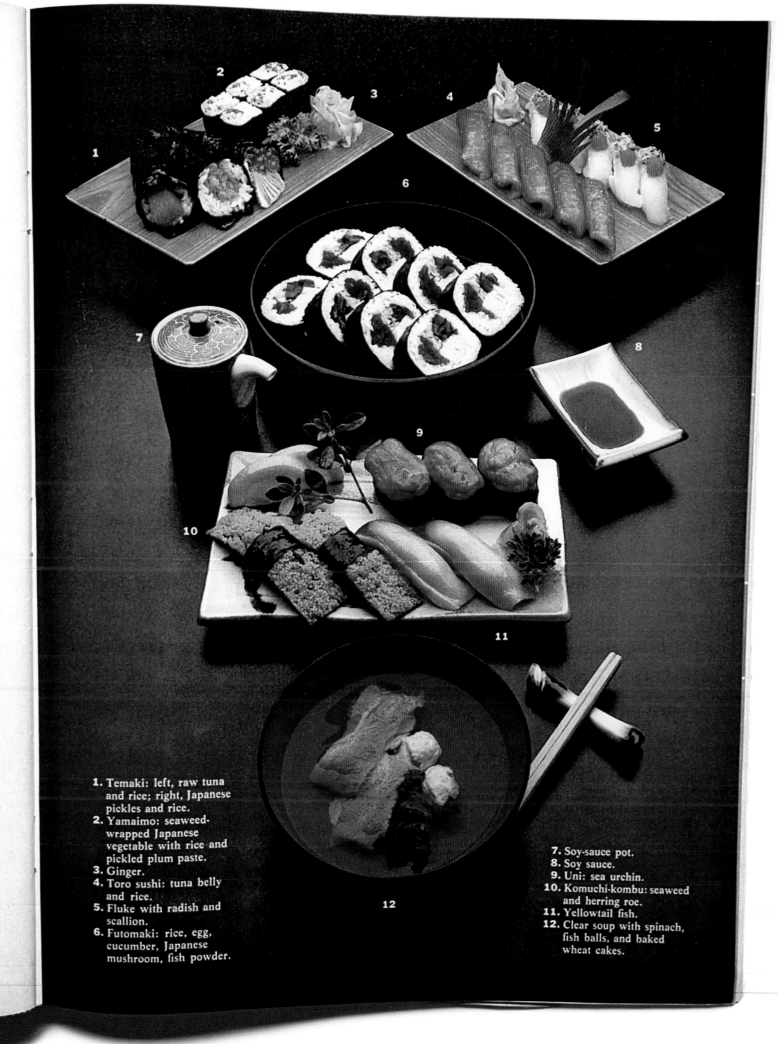

ty of
l..."

n (mate-
d and de-
en fresh
ssion.
crates of
zing, re-
"He is

s it for
ndards."
e master
a crisp
mber my
lk bistro
iodine. It
ea-urchin
uni are
perfume
g intima-
giggling
madness
s. "Deep

. a dis-
re eating
na belly.
el. "It's
roe on a
mbu)—a
experi-
fish with
emaki) to
p toasted
his one,"
alutes the
: "You
soy, just
aked rice
ehicle of

ring the
–fukiyose
and cut-
es cross-
Zen level
yamaimo-
pickled
roll. The
makes a
not taste
pause of
maki. The
wrappers,
dabs a
nges odd
olled and

1. **Temaki:** left, raw tuna and rice; right, Japanese pickles and rice.
2. **Yamaimo:** seaweed-wrapped Japanese vegetable with rice and pickled plum paste.
3. **Ginger.**
4. **Toro sushi:** tuna belly and rice.
5. **Fluke** with radish and scallion.
6. **Futomaki:** rice, egg, cucumber, Japanese mushroom, fish powder.
7. **Soy-sauce pot.**
8. **Soy sauce.**
9. **Uni:** sea urchin.
10. **Komuchi-kombu:** seaweed and herring roe.
11. **Yellowtail fish.**
12. **Clear soup** with spinach, fish balls, and baked wheat cakes.

155

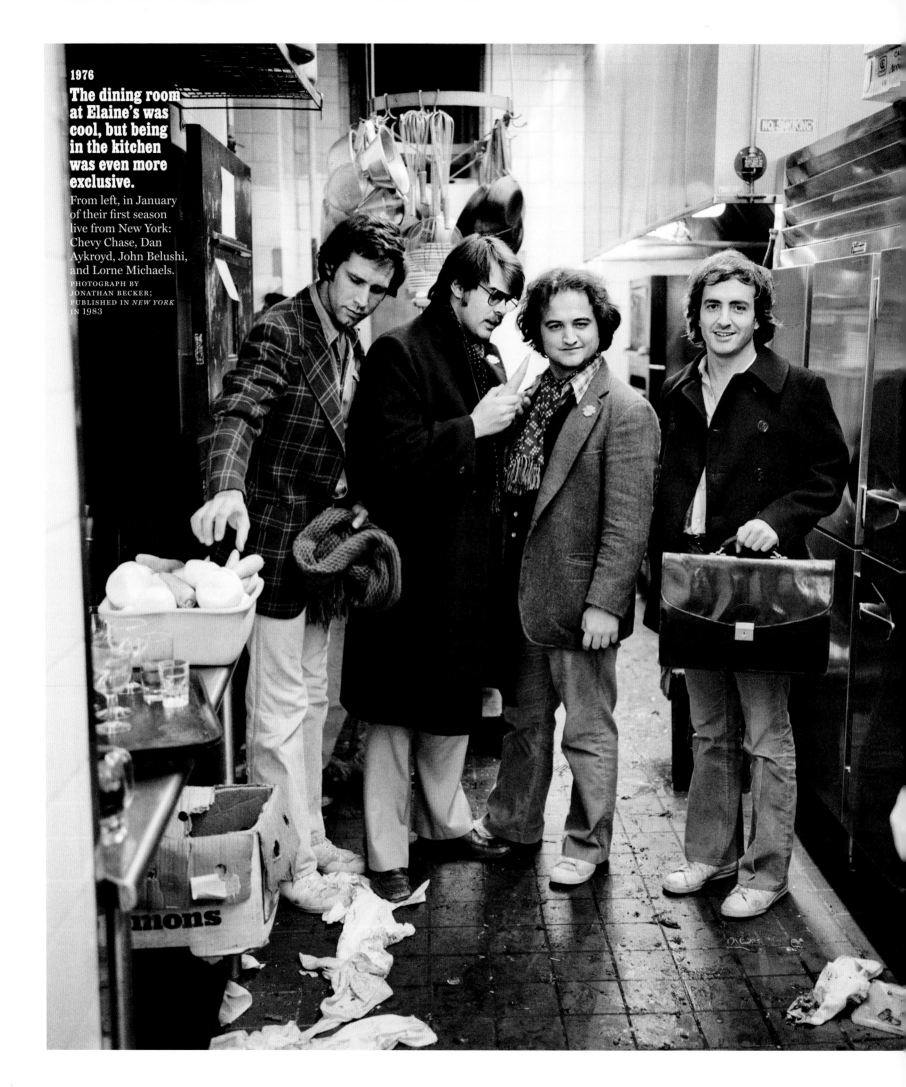

1976

The dining room at Elaine's was cool, but being in the kitchen was even more exclusive.

From left, in January of their first season live from New York: Chevy Chase, Dan Aykroyd, John Belushi, and Lorne Michaels.

PHOTOGRAPH BY JONATHAN BECKER; PUBLISHED IN *NEW YORK* IN 1983

Sometimes a restaurant's appeal had nothing to do with the food. At Elaine's, it was the intimidating crowd: authors, performers, jocks, and, always, Woody Allen in back.

If You've Been Afraid to Go to Elaine's These Past 20 Years, Here's What You've Missed

Gay Talese ➻ In my twenty years of nights at Elaine's—during which I have consumed roughly but unprotestingly 3,000 meals, have drunk 1,800 bottles of wine, have lost twelve pounds, and have gained two friends, both of them waiters—I have seen Woody Allen 2,300 times, but I have never said hello to him, because he invariably enters the restaurant looking at the floor, being guided through the crowd to his celebrated obscurity in the corner by a frightfully frail Mia Farrow and by an affable Drusean gentleman who often waves in my direction but whose name I do not know.

The celebrities at Elaine's, however, along with the dishes that have failed to enchant Mimi Sheraton, are not determining factors in the restaurant's enduring presence in New York. Its success is due rather to Elaine herself, an ebullient woman with a large heart that she extends selectively to a group of New Yorkers who are too disorganized to arrange their own dinner parties or nightlife, and thus she has created a rather permanent immovable feast at 1703 Second Avenue. Since she is that rarest of restaurateurs, one who actually reads books, she has always welcomed writers to her tables, elevating them from the status that most of them had occupied since the 1920s, when George Orwell was washing dishes at the Ritz.

Norman Mailer ➻ Elaine and I had a fight once, and it went on for years. I guess there was a period when I could have been the only writer in America who didn't enter her door. Now we've made up, and we are as sweet and tender to each other as the classiest Chinese mandarins. I want to tell you, this is the best side of Elaine, and the best side of me.

Peter Stone ➻ "Reflections on Twenty Years of Ordering From the Same Menu at Least Once a Week"

Pasta?
Basta.

Scungilli?
Not really.

Calamari?
I'm sorry.

Espresso?
I guesso.

Irwin Shaw ➻ Whom the gods adore they first make plump and equip with a curly smile, a twinkling, welcoming eye in which, almost hidden, lurks the steely calculation of a riverboat gambler and the nerve of a cat burglar. The gods free their favorites, in this case Elaine, from all sentimentalities of democracy, and by instinct furnish them with the invaluable arbitrary snobbish gift of choosing favorites, relying only upon their own taste in such delicate matters. They then find for them disreputable quarters in dilapidated and unfashionable parts of town and teach them how to keep potential patrons clamoring outside the door while a sea of empty tables awaits within. Sworn professional enemies are admitted gladly, to liven up the late nights and early mornings with accusation and invective, and booze flows freely to keep the clamor at its utmost height. The lady in question then carves herself into a more gracious shape, so that her hug is no longer an overwhelming tidal wave of affection and approval, but a motherly caress. She also reads, knowing that an unread writer can empty a lively room in ten seconds flat.

She is an institution who refuses to become institutionalized. No pity is ever expressed; she never says, "Time, gentlemen, please." She knows that the first night you are in town, from no matter what quarter of the globe you have come, you must pay the ceremonial visit to the uptown Queen of the Night. At the busiest hour there is always one more chair ready for the poor devil who has just finished the first act of his play or been locked out of his apartment by his wife.

The plaque on Second Avenue will finally read, THIS WAS THE PLACE.

Barbara Goldsmith ➻ I always thought Elaine Kaufman had her favorites. I was not one of them. I always thought her favorites were men. One night I was with James Brady, and I asked the waiter to bring us some bread. "Let Jim speak for himself," snapped Elaine. Another night I was there with my husband, and I asked the waiter to remove the bread. "Let Frank speak for himself," Elaine snarled. About three years ago, I was eating dinner when I suddenly felt quite ill. I said I wanted to go home, but someone at the table insisted that all I needed was a stomach settler. "Bring her a Fernet-Branca," they told the waiter. Suddenly Elaine was at my side. Her voice boomed out, "Let Barbara speak for herself." Then she hugged me. ∎

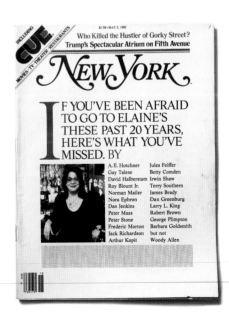

Barbara Walters

Michael Korda

Steve Florio

Vern

Zac Posen

Paula Zannie

Charlie Rose

KERRY KITTLES

Ron Perlman Barry Diller

HENRY KISSINGER

JOAN COLLINS

Lally Wehmouth
G. Paltrow

Harvey Weinstein
STAR JONES

GWEN STEFANI

GRAYDON CARTER

BAR & GRILL

FRI GE CH JA

Philip Johnson

ordan

DI KLUM

Oscar
De La
Renta

LEO HINDERY

LOU
DObbS

Patricia
Field

NNA
VTOUR

PETE
PETERSON

David
BROWN

ZESLAN

2003

The seats at The Four Seasons were all about power. Philip Johnson commanded Table 32.

In the Grill Room, the power lunch reached its epitome. Johnson—who had designed the restaurant in 1959—ate there regularly till his death in 2005; Henry Kissinger moved up to Table 32 thereafter. When the restaurant closed in 2016, that banquette sold at auction for $35,000.

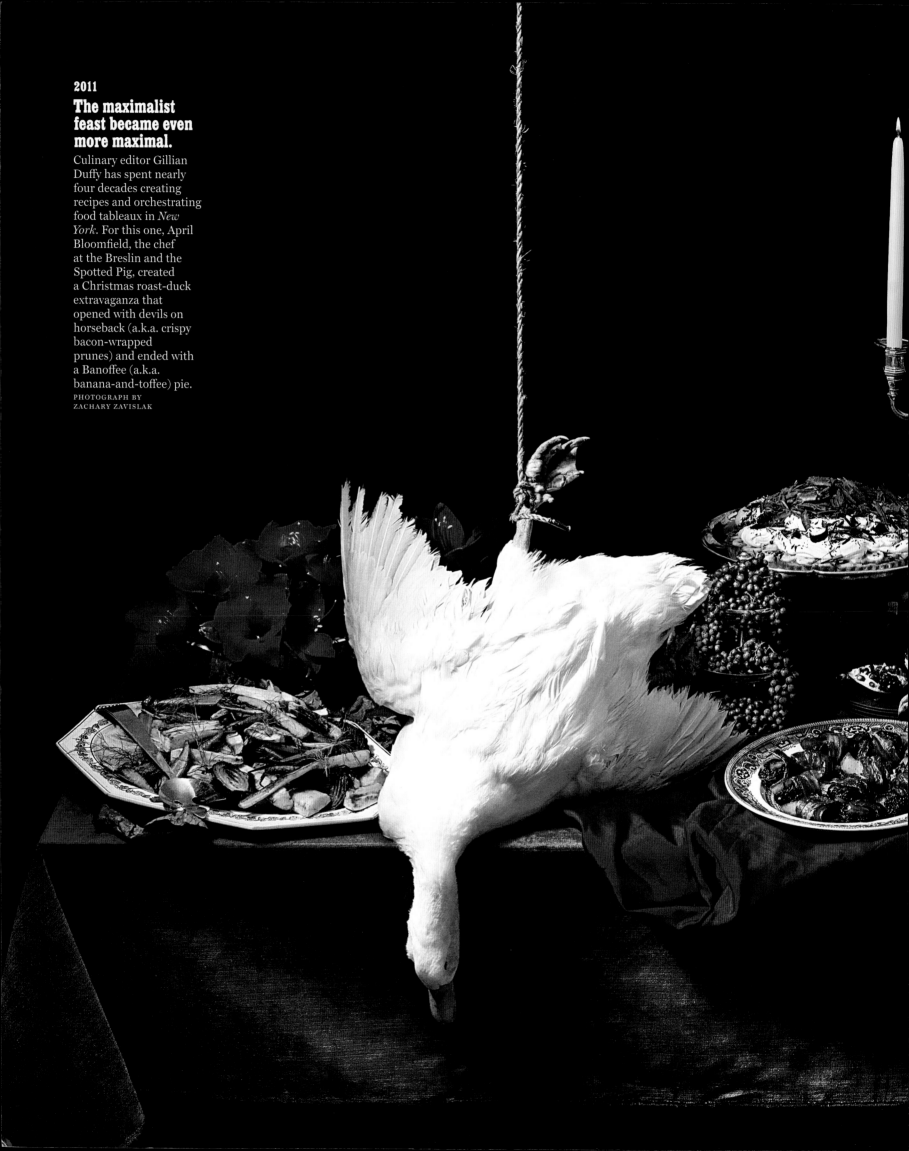

2011

The maximalist feast became even more maximal.

Culinary editor Gillian Duffy has spent nearly four decades creating recipes and orchestrating food tableaux in *New York*. For this one, April Bloomfield, the chef at the Breslin and the Spotted Pig, created a Christmas roast-duck extravaganza that opened with devils on horseback (a.k.a. crispy bacon-wrapped prunes) and ended with a Banoffee (a.k.a. banana-and-toffee) pie.

PHOTOGRAPH BY
ZACHARY ZAVISLAK

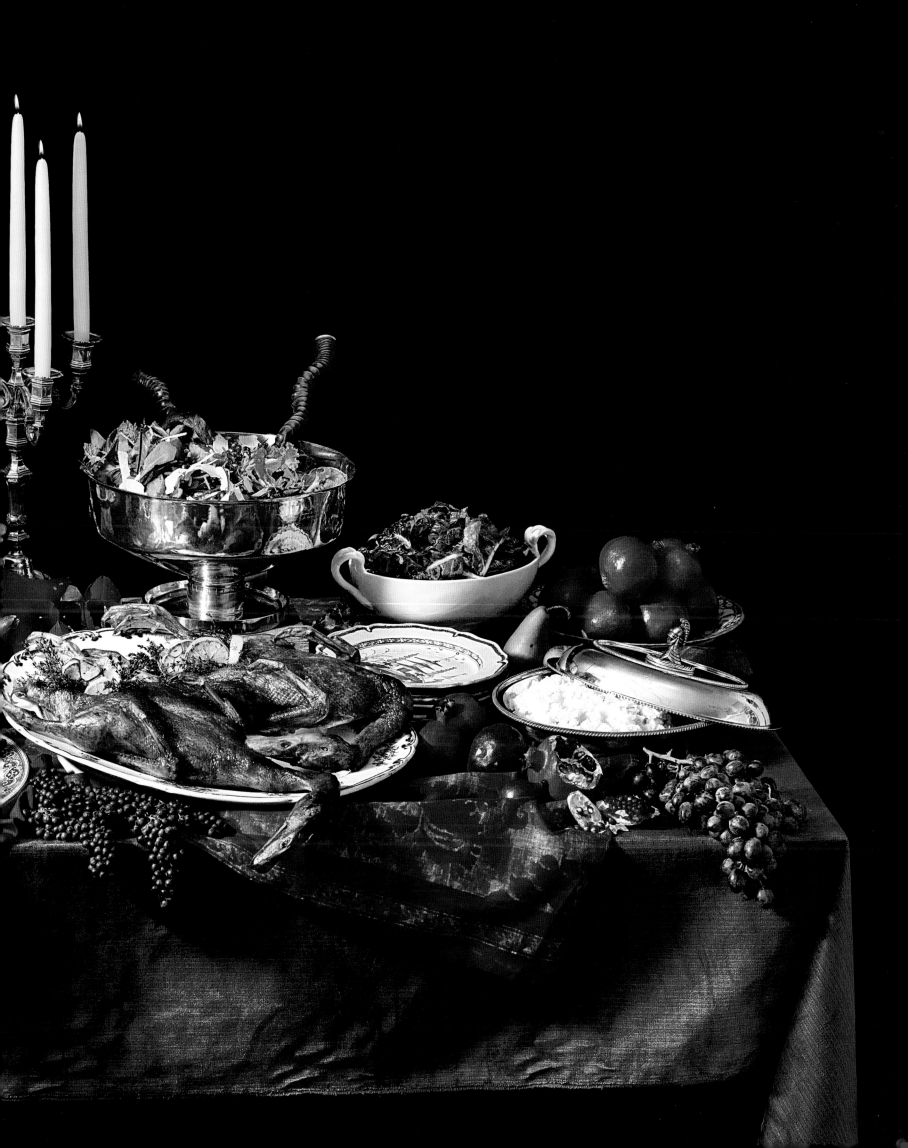

2012

Food culture became youth culture—especially in Brooklyn.

Yes, it is by now a cliché: a fussed-over product, probably made in a converted warehouse in Greenpoint, by people with trust funds and sometimes beards. But it's usually delicious! And some of those companies were no joke. Of the 24 start-ups whose founders were photographed for this story, 19 were still in business five years later.

BREWERS, BAKERS & BEEF-JERKY MAKERS

A FEW MEMBERS OF THE TRIBE.

GRADY'S COLD BREW — GRADY LAIRD

DAVE SANDS →

BEVERAGES

BREUCKELEN DISTILLING — BRAD ESTABROOKE →

MORRIS KITCHEN — KARI MORRIS →

BAKED GOODS

ROBICELLI'S CUPCAKES — MATT ROBICELLI

ALLISON ROBICELLI

SWEETS

MAST BROTHERS CHOCOLATE — RICK MAST

MICHAEL MAST →

LIDDABIT SWEETS — LIZ GUTMAN

JEN KING

EARLY BIRD GRANOLA — NEKISIA DAVIS →

SAVORY

SOURPUSS PICKLES — CHRIS FORBES

EVELYN EVERS →

BROOKLYN BRINE CO — SHAMUS JONES

KYLE BUCKLEY

KOMBUCHA BROOKLYN
— ERIC CHILDS —

P&H SODA CO.
ANTON NOCITO

BROOKLYN SODA WORKS
ANTONIO RAMOS

CAROLINE MAK

KIN COU DISTI
COL SPOE.

JAMS

THE JAM STAND
SABRINA VALLE
JESSICA QUON

ANARCHY IN A JAR
LAENA McCARTHY

SPREADS

EMPIRE MAYONNAISE CO.
ELIZABETH VALLEAU
SAM MASON

PEOPLE'S POPS
NATHALIE JORDI
JOEL HOROWITZ

DAVID CARRELL

WHIMSY & SPICE
JENNA PARK
MARK SOPCHAK

SAL ROM
MARIS

KINGS COUNTY JERKY CO.
ROBERT STOUT

THE BROOKLYN SALSA COMPANY
MATT BURNS
ROB BEHNKE

HOME

STANLEY & SONS
LINDSAY CARVER
CHRIS GRODZKI

C

2016
Sustainability could maybe be taken a little too far.

"Bugs, being coldblooded and short-lived," wrote Carl Swanson, "turn what they eat into protein for us much more efficiently than a cow does." Yay?

PHOTOGRAPH BY BOBBY DOHERTY

165

Custom beef blends, foie gras add-ons, déclassé but delicious American cheese: The "Play-Doh of meats" eventually became whatever a chef wanted it to be. Benjamin Wallace considered the gestalt of patty on bun.

This Is the Story of the Hamburger

By Benjamin Wallace

WHAT IS A HAMBURGER, ANYWAY? Wherein lies a burger's burgerness? It's a patty of cooked ground beef, everyone can agree, but there consensus ends. In his improbably brilliant monograph, *The Hamburger: A History* (Yale University Press), Josh Ozersky makes the eccentric, supremacist argument that an enriched white bun is vital—thereby denying burgerhood to, among other burgers, Shake Shack's, which comes on a potato roll. George Motz—he directed the documentary *Hamburger America*, wrote the book *Hamburger America*, developed the burger-locating app Burger GPS, hosted the Travel Channel show *Burger Land*, and is now finishing up work on *Hamburger America: The Cookbook*—requires only a bread of some sort. But is bread even necessary? Is the bunless "chopped steak" burger at Via Carota, in the West Village, not a burger? More important, what is it about the burger that has made it so enduring, so ubiquitous, so mutable? How did a flat piece of nothing become the magic food?

THERE ARE DUELING SCHOOLS of thought. Essentialists credit the burger's outsize appeal to something intrinsic. They point to its shape: Because the hamburger has a lot of surface area relative to its volume, it packs in an inordinate quantity of delicious Maillard flavors (as browning is more technically known). They point to its typical size, a portion that makes the burger a meal in itself. "They translate really well from street food to sit-down," says Adam Fleischman, founder of Umami Burger. Together, the size and shape give the burger portability: From the beginning, you could eat it in your car, even with one hand on the wheel. Essentialists also point to the singular character of beef, which Pat LaFrieda describes as "the most sought-after, subtle, yet flavorful meat protein." Ozersky writes that "there is an inevitability to the hamburger" and calls it "the rock-bottom entry point to the American beef dream."

As the poor man's steak (and now the upper-middle-class man's steak, too), the hamburger, then, becomes a passport to a better life. "The idea of putting ground beef between two pieces of bread and eating it is specifically an American invention," Motz says. "And people know that. I think Americans are intensely proud of their hamburger heritage." (Competing burger-origin claims have been made on behalf of the Mongolian steppe, where Tatars packed raw chopped meat under their horse saddles, and Germany, since the hamburger was known in 19th-century America as Hamburg steak, but Ozersky, like Motz, situates the burger's conception in America.) Motz, hardly the most objective source, sees the hamburger as possessing a formal perfection, complete in itself. "I always see grease as a condiment," he says. "Technically, whenever you cook a burger, it's cooking in its own grease. I consider it almost a hamburger confit."

Then there are the Circumstantialists. Andrew F. Smith, a culinary historian at the New School and, as the author of *Hamburger: A Global History*, Ozersky's rival burger Herodotus, argues that the burger is contingent, a fluke of history. While acknowledging some of its virtues (that it's a neutral platform for other flavors, a cheap foodstuff, and a delivery vehicle for the quadruple cortical-pleasure whammy of salt, sugar, fat, and amino acid), he sees it chiefly as the right-place-right-time beneficiary of White Castle's Billy Ingram and McDonald's Ray Kroc, entrepreneurs whose pioneering business strategies (the fast-food chain and the fast-food franchise) happened to cross paths with the hamburger. To this way of thinking, it could just as easily have been the hot dog that achieved dominance.

In the view of this Frankfurter School, the burger continues to prevail merely through a combination of corporate inertia, consumer convenience, and a perpetual nostalgia machine that keeps encoding new generations with childhood memories of hamburgers that they will summon and nourish by continuing to eat hamburgers for the rest of their lives, while also exposing their children to them, ad infinitum.

I find the Essentialists more convincing. The hot dog, independent of its history, comes up short. Where the roughly textured hamburger has at least the patina of transparency, the hot dog is stonewalling by design, its seamless envelope concealing God-knows-what, its emulsified monotony defying analysis. It has never escaped its shady reputation—we still speak of "dirty-water dogs" and "watching the sausage get made." It's hard to imagine a hot dog's price point supporting a high-enough check average to ever justify it as an entrée in a good restaurant. And unlike the burger, which you can make in your own kitchen and customize (mixing in chopped onions, say), the hot dog is always prepackaged, always something you buy from other people. Even all-beef hot dogs have a processed flavor, and they are a demonstrably less expressive meat product than the burger. As David "Rev" Ciancio, founder of the blog Burger Conquest, says: "A hot dog is a hot dog. The best one I've had is only marginally better than the worst one I've had."

Finally, there are the seditious few who see the whole discussion as being beside the point. Damian Lanigan, a British-born Brooklyn comedy writer, recently tweeted his annoyance about Americans' "undue reverence for hamburgers." When I called seeking clarification, he suggested that instead of being a patriotic badge of honor, the hamburger is a nationalist crutch. "I'm not denying that two bites tastes good," he said. "I'm just questioning the lionizing...C'mon, lads, it's basically a pretty simple, straightforward, slightly disgusting thing that has its pleasures." ∎

New York

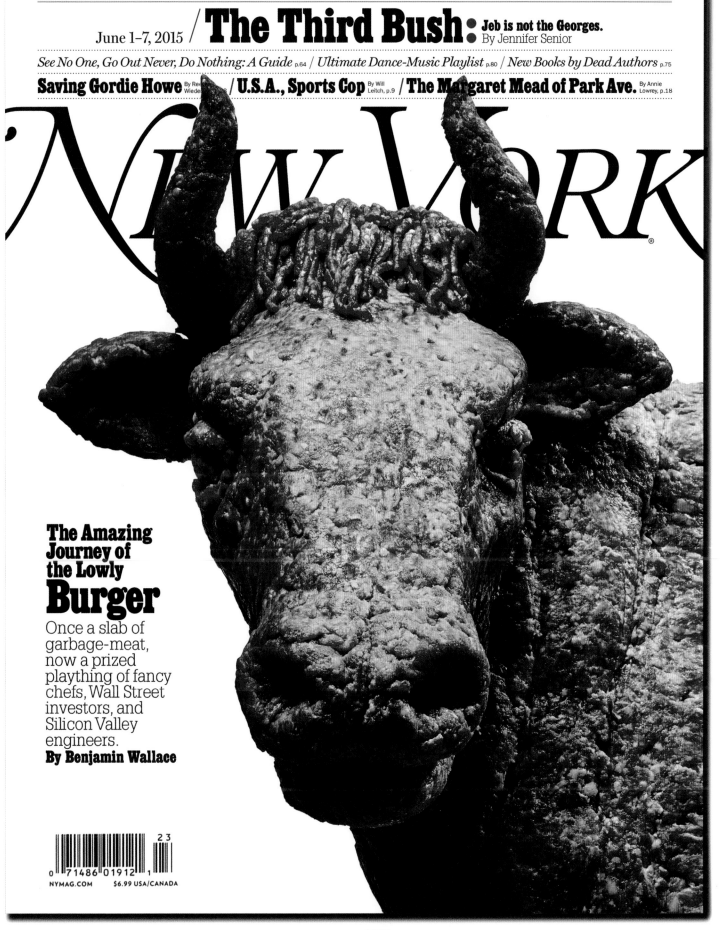

The Amazing Journey of the Lowly Burger

Once a slab of garbage-meat, now a prized plaything of fancy chefs, Wall Street investors, and Silicon Valley engineers.

By Benjamin Wallace

NYMAG.COM $6.99 USA/CANADA

2015

Vegetarians were horrified.

When this ground-beef sculpture commissioned from the artist Carl D'Alvia landed on *New York*'s cover, the reaction was notably divided: Readers were either completely entertained or completely repulsed.

4

CRISIS

"The streets of New York are a calamity."

John DeLury

president of the Uniformed Sanitationmen's Association, to writer Elizabeth Barlow, 1970

Blight, crime, plague, recession, attack, hurricane.

IF YOU WEREN'T HERE, it's hard to explain just how rotten most of New York City looked in the 1970s. The Lower East Side and the manufacturing districts downtown contained endless rows of boarded-up buildings, stripped and burned-out cars, and vacant lots full of garbage. The subway was barely functional, with constant track fires and breakdowns—which only seemed appropriate, because it had lost nearly half its ridership in twenty years. Bedford-Stuyvesant and Brownsville and the South Bronx burned. The crime rate spiked, and then spiked again. In 1975, the city came within 24 hours of declaring bankruptcy, saved only by the last-second capitulation of one union official and then the creation of a business consortium that helped pull New York's finances onto firmer ground. Two years later, one summer delivered a double dose of horror: the Son of Sam serial killings, and a blackout that led to a night of looting and rioting. *New York,* although it was written and edited by true-believing New Yorkers who loved their city, saw all of this with clear eyes. In just its third issue, seen at right, the magazine put it quite boldly. ¶ Even as the city began to stabilize in the ensuing decades—to make over its blighted neighborhoods, beat back crime, rebuild its tax base, cultivate industries to replace all those closed factories—it also dealt with new body blows. Crack, a new cheaper form of cocaine, swept through poor neighborhoods in the early 1980s, creating a generation of addicts and sending the murder rate even higher. Starting in 1981, a strange disease began to kill off young, otherwise vigorous gay men, and the sluggish political response to its discovery—by turns fearful and indifferent and contemptuous—turned AIDS into a global epidemic. ¶ Yet by the start of the new century, New York, at least on a macro level, had turned the corner, first haltingly and then with astonishing speed. It became, in the space of a decade or so, a place less concerned with abandoned buildings than with the crushingly high costs of housing. (The subways improved, too, to the point where the MTA began dealing with the problems of too many passengers rather than too few.) Certainly problems remained—the school system, divisions of class and wealth and race, questions about how much policing was too much—but it was undeniable that the city as a whole had come back from the brink. Yet in its new gilded age, the city once again faced an acute shock: the terrorist attacks that took down the World Trade Center and made New Yorkers feel vulnerable as never before. Then, in 2012, Hurricane Sandy forced residents to confront the fact of rising, warming seas and their effect on this low-lying waterfront city. In the aftermath, New York, as it had so many times before, staggered to its feet and rebuilt itself, fortified.

1968

New York was barely hanging together.

Mayor John Lindsay went out walking among his constituents in Harlem the night Martin Luther King Jr. was killed, and was often credited with saving New York from the full-scale rioting that other cities experienced. "Somebody white has to go up there," Lindsay told Gloria Steinem and Lloyd Weaver, who wrote this cover story. "Somebody white just has to face that emotion and say that we're sorry."

New York

The City on the Eve of Destruction

CRISIS: COLLAPSE

EXCERPT: JUNE 1, 1970

In 1970, the magazine devoted a special issue to a ruined block of 174th Street, near Washington Avenue in the Bronx. Its residents spoke of despair, garbage, and rats.

The Block: Portrait of an Urban Disaster

As Told to Herb Goro

YOU SEE MY KID. He got something in the back of his neck, a rash. I think maybe it was from playing in that garbage down here. The children use that lot as their playground. They play in the lot, and somebody throws garbage from the windows down to the lot where the kids are playing.

"Last week a lady from the top floor threw a big empty box, and my kid was playing in the lot and the box hit him right on the head. The city doesn't do anything about cleaning this lot. They don't do nothing. One day the sanitationmen came and all they did was push the garbage back, and a week later it was the same. Every night there is a fire in the lot. Last night, three times. And the kids set fires to the buildings next door, the ones that were abandoned. So I can't sleep. I'm afraid that the building burn down while I'm sleeping."

"WELL, WE WERE SLEEPING and it was two or three o'clock in the morning and I heard a rat scratching on my bed so I woke up my mother. Then the rat runned away over my sister's arm and my sister woke up and started screaming and screaming. Then two or three days passed and my mother was sleeping in the little bed, and a bigger rat than the other climbed up on the bed and tried to get between my mother's legs. My mother shook her leg, and he run away. Yesterday I was watching the TV and I seen a rat—a big, big rat standing next to the refrigerator looking at us."

"YOU COULDN'T SLEEP AT NIGHT, I let my baby sleep with me 'cause we were afraid to let her sleep in the crib. And it got so that like sometimes you would come through here at night and they would run out from under the chairs, and you're screaming all over the place and waking up everybody."

"RATS, BIG RATS. I SEE THEM. I told Mr. Gonzalez, the landlord. He put poison. But I didn't put it because then the rat dies and smells no good. I can't eat and long time smells no good in my apartment. It smells, smells, smells. I open all the windows."

"WE HAVE LIKE JUNKIES. Dope addicts. We have winos laying in the streets. There are fights and killings all up and down the street. Right out here on Third Avenue. On this block. In the past year there have been three or four killings on this block. Last summer there was a man shot right here on the corner by the subway. There was another man shot down on the other corner. He was in a car and somebody shot him through the window."

"ACROSS THE STREET HERE, about six months ago, some man shot his wife. And it hasn't been two months since we had our own trouble. Some little kid was out throwing rocks at my windows. So he threw one and it came all the way through and it broke the window. So I told my son Manley to go downstairs to make that boy stop throwing rocks. So Manley went down there, and the kid got into a little fight. So the landlord of this building went across the street and got the child's mother. So she comes back over here and she started shaking Manley around and Ellie, my friend, comes running upstairs and tells me that this lady is grabbing Manley's throat and shaking him. And then right behind her comes Sharon, another friend, and she tells me that the lady smacked Manley a couple of times. So my husband, David, went downstairs to see what it was about. He had grabbed my house shoes and I didn't have anything on my feet. So she started yelling and cursing at him, and she told him about what she would do to him. So David called me downstairs. He told me, "You come on downstairs and talk to her." So I went downstairs and quite naturally I was kind of upset and I pushed her a couple of times, and I smacked her. That would have been the end of it as far as I was concerned. Then she started back across the street and she started calling me, you know, "black nigger," and "MF" and all these kind of stuff. So I went and I grabbed her again. And we started tussling. So her friends come running from across the street and one boy handed her a knife. And she started at me with this knife so I started backing up. And I backed into David, and he handed me a knife. So I showed her my knife and I said, "Now, you come on." So she threw the knife down and I gave David mine back. And we started fighting again and then somebody else handed her an iron pipe. So when I saw her with that pipe I naturally turned around to run.

"But when I turned to run she caught me across the back with the pipe. So, you know, you're kind of stunned. But maybe because I was mad it didn't really hurt. So I turned around and grabbed the pipe away from her and I swung it at her a couple of times—she was running and I missed. But when I swung the third time I caught her. I hit her in the mouth. I knocked her teeth out. She was mad and spitting blood and she picked up another pipe and she hit David across his leg with it. And for about three or four weeks he couldn't even hardly walk on that leg. He had to use a cane. This woman is from across the street. A Spanish woman. When the Negroes say prejudice nobody pays much attention. But you would be surprised at how much prejudice the Spanish people have against the Negroes. And those are the two races that should be the closest together because we are really the underdog." ∎

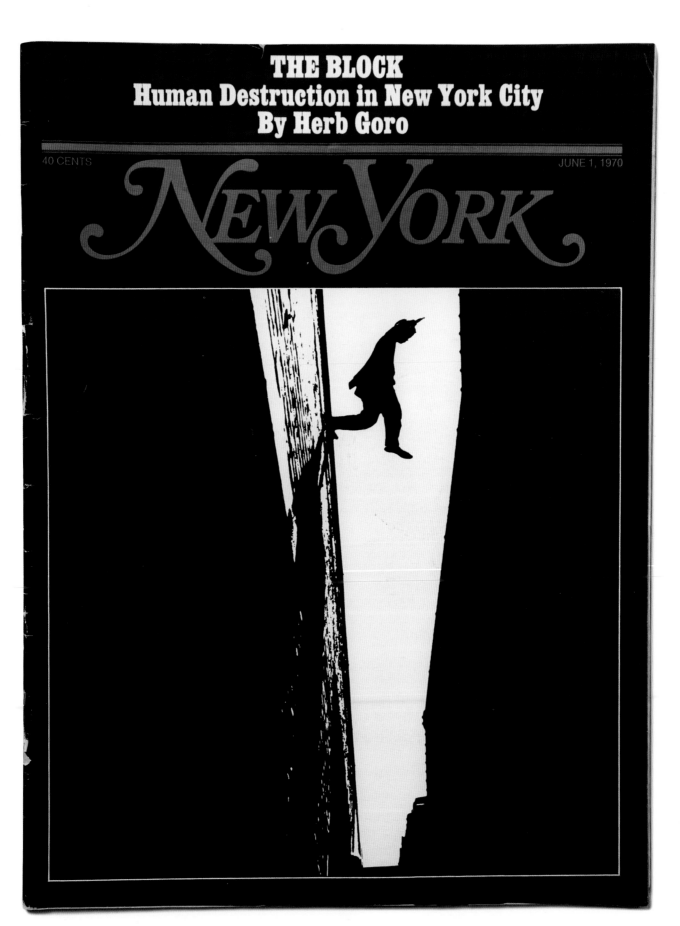

THE BLOCK
Human Destruction in New York City
By Herb Goro

40 CENTS

JUNE 1, 1970

New York

1970

"The people of the Block live in two rotting tenements separated by a garbage-filled lot."

The Bronx block that inspired an oral history and a photo-essay in *New York* is almost unrecognizable today. Before the story was even finished, one of the two buildings was destroyed by fire, and the elevated train line nearby to them was closed in 1973 and torn down. Both tenements are now gone, replaced by low-scale, nearly windowless industrial buildings.

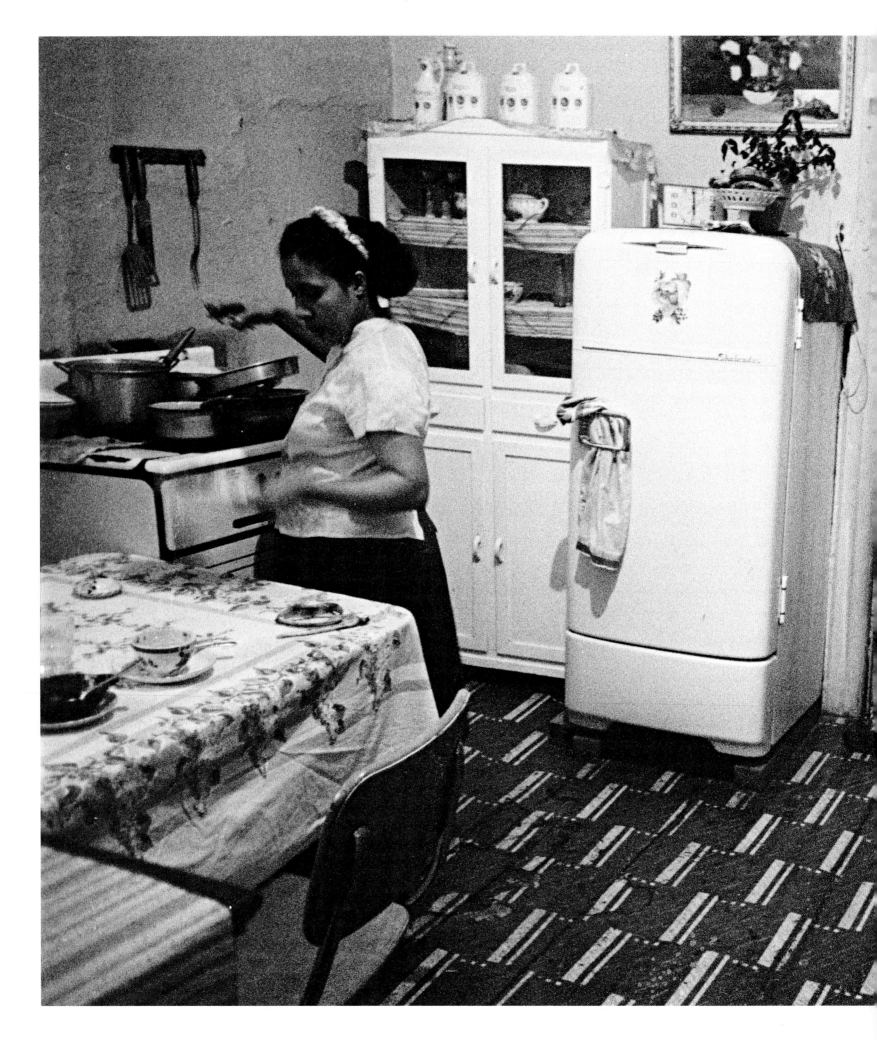

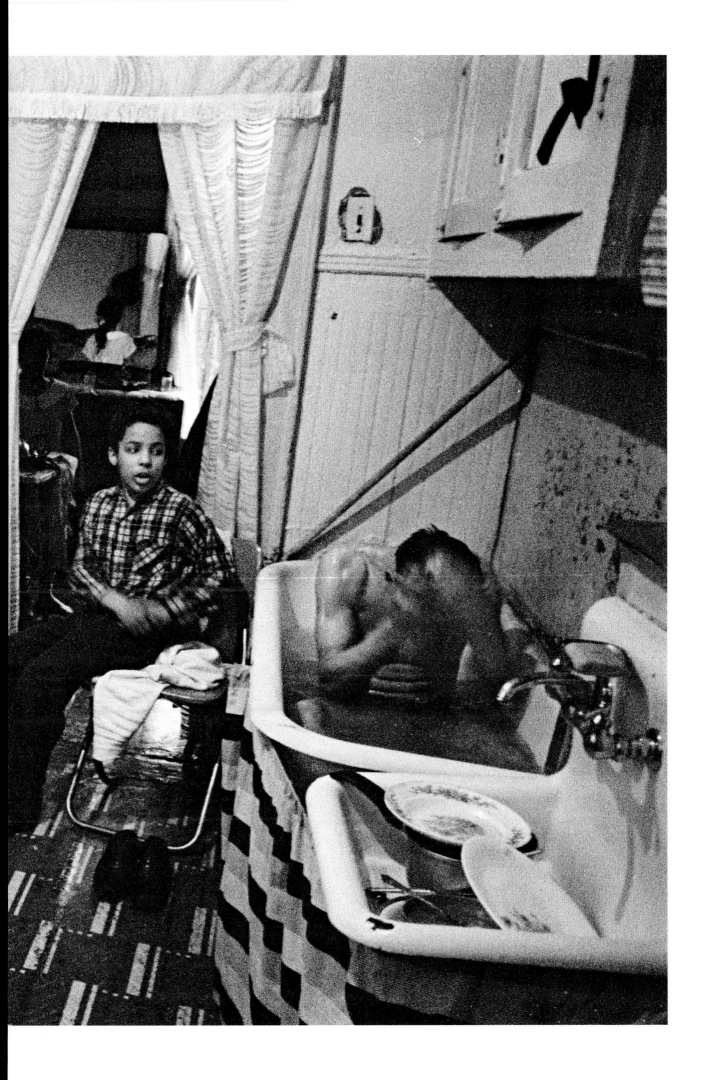

1969

"There is a great deal wrong with New York City."

An issue devoted to planning the future city did not shy away from urban problems. "Greatest of all is the problem of the slums," wrote the editors. "Traditionally they have offered a route to something better in life, but no longer do they seem to. The blacks and Puerto Ricans who are crowded into them have been finding the way blocked in a way groups before did not."

PHOTOGRAPH BY CHARLES HARBUTT

For an entire year, New York City was riveted by the story of Son of Sam.

Robert Daley, a former deputy police commissioner, wrote about why it took so long to catch David Berkowitz: the endless paperwork, the slow process of sifting through paper records and interviewing tipsters. In the end, the killer was found by old-fashioned means: He'd got a parking ticket near the site of one of the murders, and police were able to trace the car back to him.

The Search for 'Sam' Why It Took So Long

By Robert Daley

☐ On July 29, 1976, Donna Lauria was shot dead by a .44 caliber revolver as she sat with a girl friend in a parked car at night in the Bronx. A year and two days later, Stacy Moskowitz and Robert Violante were shot by the same gun and, therefore, presumably, by the same gunman, his twelfth and thirteenth victims.

Finally, fully 54 weeks after Donna Lauria was slain on her way home from a disco, the police had nabbed a man—David Berkowitz—who they are convinced is the Son of Sam, the notorious .44 caliber killer.

The Innocent Face Of Evil

 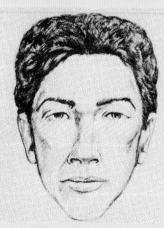

Early composite sketch: December 9, 1976. *Latest composite sketch: August 9, 1977.* *The accused, David Berkowitz: August 11, 1977.*

"...The public called in false leads except, perh

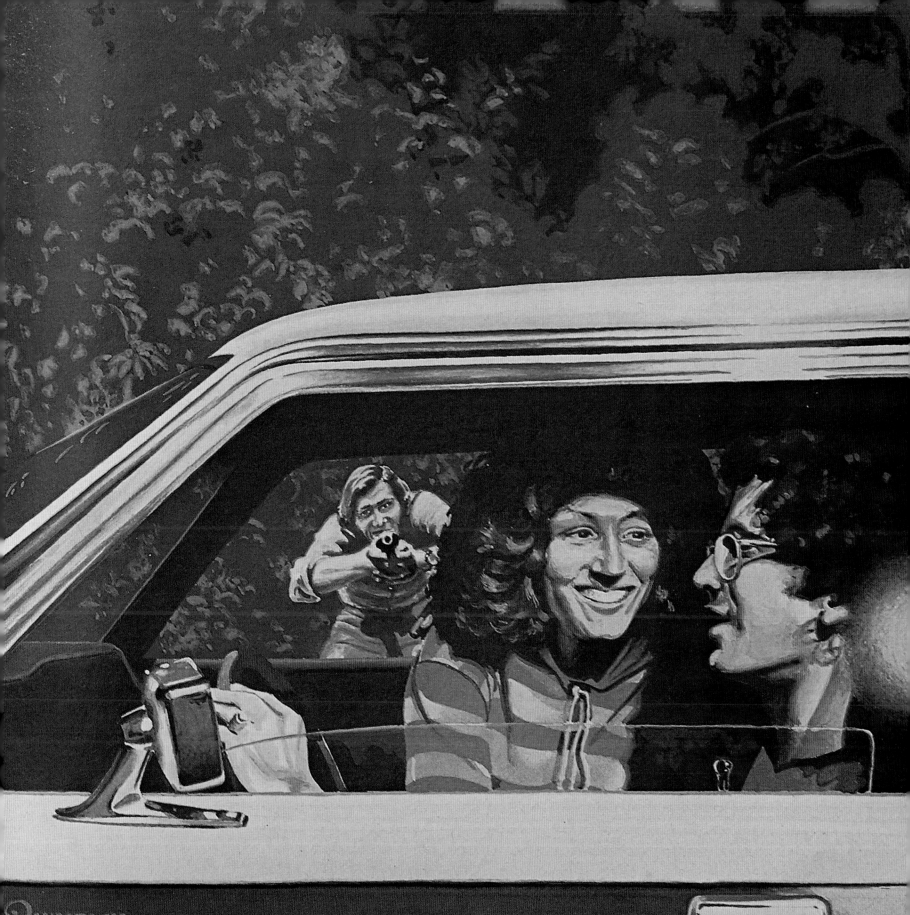

he names of 7,000 suspects, all of them
ps, one—David Berkowitz of Yonkers..."

1977

The blackout brought the city's tensions to a boil.

"The city erupted instead of partied" was how writer William Flanagan described the night of July 13, 1977, when a cascading power failure darkened all of New York City. More than 3,800 people were arrested, many for looting. Stores were stripped bare, buildings burned. Yet by some measures the city weathered the night well. The police, by and large, kept their guns holstered, and only two civilians died. "Oddly enough," wrote another *New York* contributor, Thomas Plate, "the city with the largest, most Calcutta-like ghetto in the country suffered nothing so terrible as a Watts or a Detroit. Was New York just lucky? Or should we have tipped our hats in the direction of our local gendarmerie? Maybe."

PHOTOGRAPH BY TYRONE DUKES; PUBLISHED IN *NEW YORK* IN 2008

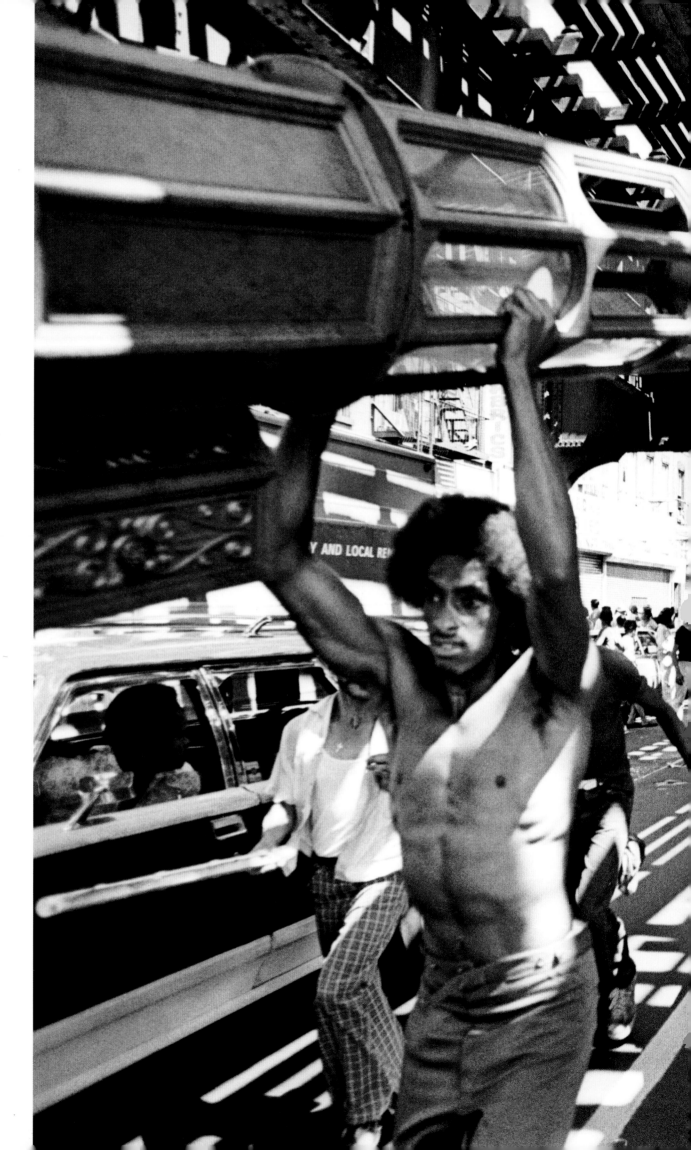

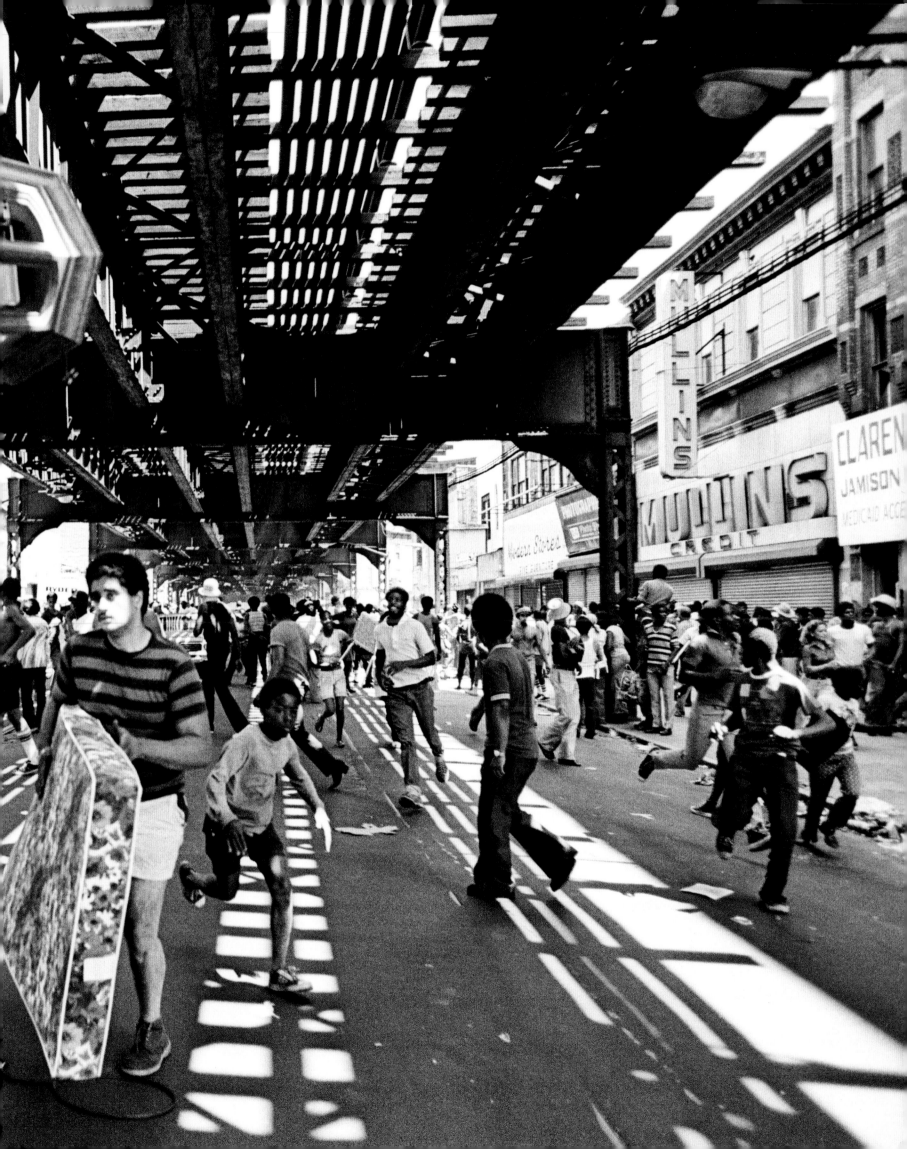

CRISIS: FEAR

EXCERPT: DECEMBER 12, 1977

Between 1960 and 1980, the murder rate in New York quadrupled, and the number of muggings and burglaries rose similarly. Law-abiding New Yorkers grew desperate to defend themselves.

Nice People Who Carry Guns

By Susan Hall

OVER THE PAST five years increasing numbers of the city's most law-abiding, nine-to-five, subway-riding New Yorkers have begun to arm themselves—many illegally. It is a phenomenon that has law-enforcement types worried, because the majority of these gun owners—estimates range from 50,000 to 200,000—have no real need for their guns. According to the police, these new gun toters, a group of average New Yorkers that includes schoolteachers, telephone operators, office workers, dentists, accountants, psychiatrists, even children's-book editors, are using these guns as psychological shields against their fear of the nightmare mugger.

There are currently 30,000 legitimate handgun owners in the city. The truth, of course, is that there are many, many times that number of guns in the apartments and houses of middle-class New Yorkers. Official estimates by the Alcohol, Tobacco, and Firearms Bureau of the federal government state that there are approximately 1.3 million illegal handguns in the city. While many of these guns may be in the hands of criminals, ever increasing numbers are finding their way into the hands of the city's respectable and frightened middle class. And, while the Police Department's official figures for licensed handguns may not have risen, there are any number of indications from the businesses allied with the gun industry that more and more New Yorkers are arming themselves.

Jessica R., *ad copywriter*

I bought this gun—a .35-caliber Browning Automatic—in Arizona and the salesman taught me how to use it. You don't need any permits outside New York. I've never bothered to get a license here. I didn't know you had to have one. My pistol gives me a feeling of security, but I'd be scared to fire it because it makes a lot of noise. Actually, my dog makes me feel more secure.

Dr. R. Sutter Wolfram, *dentist in midtown Manhattan*

I have a gun because of my occupation. The permit to carry a pistol was given to me by the New York City Police Department to protect me from people seeking money and drugs. In practice, a dental office rarely has cash, and no drugs that a criminal or addict would be interested in, but they might believe that there are. Carrying a pistol is not for a feeling of security—emotionalism of any kind is contraindicated in dealing with deadly weapons. It is put on routinely, like shoes.

My children were brought up to be familiar with guns. From an appropriate age, both boys shot at the range, under strict supervision. No violation of safety rules was countenanced, because there is no permissible laxity in safety.

I believe that you must restrict gun possession, but there are deficiencies in the way licensing is currently handled. It is necessary to show need to obtain a permit, but the department does not determine if one is familiar with the weapon, or capable of handling it safely and adequately. Evidence of proficiency in the use of firearms should be required. I think a psychological screening test, such as is given to corporate executives before promotion, would be appropriate.

I would never draw a gun to threaten. It is not common sense, nor is it legal. Having considered the possible confrontations, I have, like those who carry a gun in their daily duties, determined those situations in which its use would be unavoidable.

J.J. De Mairo, *Pepsi distributor*

I've been in the Pepsi-distributing business for twenty years. When my father ran this route, he never carried a gun. He didn't need to. This was our neighborhood—everyone was either family or friends. Now we just hope my grandmother, who's lived on the block for 70 years, can continue to live here. That's how bad it is. I've been able to avoid bad situations more than once because I carry a gun.

Ten years ago I had some soul-searching to do. I had to ask myself: If I get a gun, will I be the maniac everyone in New York says I would be? The only things you hear about guns are bad. I wanted to know for myself.

Now it's my philosophy that if there is resistance on the part of the good, honest, upright people against the perpetrators of crime or whatever you want to call them—bums—there will be less confrontations and criminals will think twice.

I do a lot of target shooting. I have to be better than good, because when I'm confronted with deadly force, I don't know how I'll feel or how I'll react. I have to be accurate when I'm calm so that I'll be relatively accurate when I'm under stress.

The politicians and the people who issue permits don't know what big-city life is like these days. No cops. Revolving-door justice. The only people who can talk about constitutional rights are criminals and junkies. They can say, "I have a constitutional right under the Fifth Amendment not to answer this question." Cite the Second Amendment right to bear arms and you'd better get a lawyer.

Myself, I'm cleaner than Kleenex. I abide by all the rules and regulations. I carry a million-dollar umbrella insurance policy for all possible uses of this gun. Sometimes I wonder why I do it. When I go down to 1 Police Plaza, I feel like I'm going into Russia. I have no faith in the police license bureau at all. They operate just like they want to, with no rules. At any time a policeman can decide to confiscate my gun.

I could pick up an illegal gun. If and when I used it, God forbid, I'd just dump it in the river. And I'm free. The situation of the legitimate gun owner in New York is ridiculous. ∎

ONE DOLLAR

DECEMBER 12, 1977

New York

Nice People Who Carry Guns

Jessica R., 32, advertising copywriter,
at home in Manhattan.

REDPANTS AND SUGARMAN

"...'Sugarman digs you, baby,' he purrs. 'We got a little family here, see? You don't have to be lonely no more.'..."

1971

Sex was sold openly in midtown.

On Lexington Avenue near the Waldorf-Astoria, prostitutes and pimps worked the sidewalks each night. The writer Gail Sheehy spent many hours there, dressed in hot pants and go-go boots in order to blend in, getting to know their difficult lives. After "Redpants and Sugarman" was published, it became notorious in journalism circles because Sheehy had used composite characters; her editor (and, eventually, husband) Clay Felker had snipped out the explanation of her methodology, without telling her, before the story went to press.

"...Hu
East S

ers are always looking for a new game. They found the
: rich, bored and horny. The Waldorf is home plate…"

1970–1973

Crime was a constant preoccupation.

Story after story covered the increasing violence on the streets. "The most dangerous hour" turned out to be between 6 and 7 p.m.: "New Yorkers are plodding home physically and emotionally fatigued, burdened with groceries and shirts from the laundry, fists full of mail—a perfect setup."

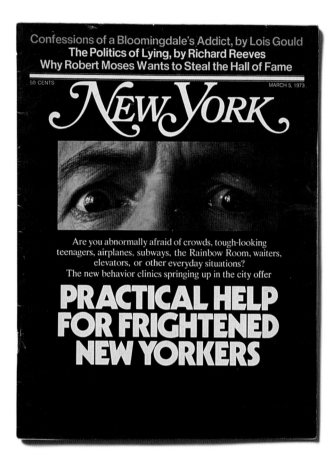

Confessions of a Bloomingdale's Addict, by Lois Gould
The Politics of Lying, by Richard Reeves
Why Robert Moses Wants to Steal the Hall of Fame

50 CENTS MARCH 5, 1973

NEW YORK

Are you abnormally afraid of crowds, tough-looking teenagers, airplanes, subways, the Rainbow Room, waiters, elevators, or other everyday situations?
The new behavior clinics springing up in the city offer

PRACTICAL HELP FOR FRIGHTENED NEW YORKERS

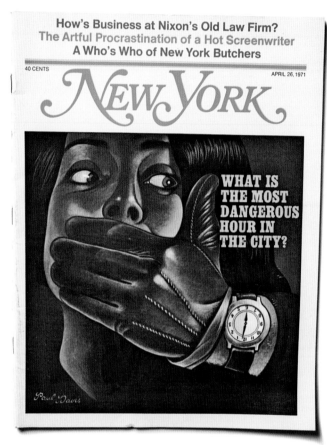

How's Business at Nixon's Old Law Firm?
The Artful Procrastination of a Hot Screenwriter
A Who's Who of New York Butchers

40 CENTS APRIL 26, 1971

NEW YORK

WHAT IS THE MOST DANGEROUS HOUR IN THE CITY?

Paul Davis

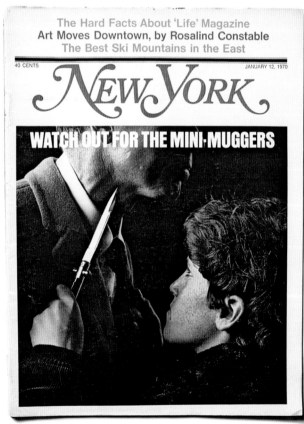

The Hard Facts About 'Life' Magazine
Art Moves Downtown, by Rosalind Constable
The Best Ski Mountains in the East

40 CENTS JANUARY 12, 1970

NEW YORK

WATCH OUT FOR THE MINI-MUGGERS

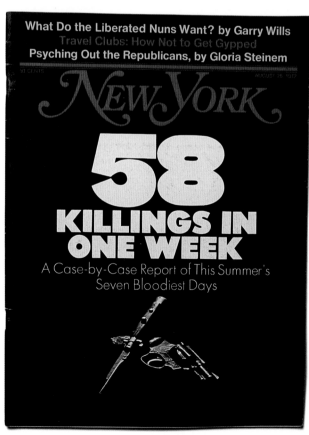

What Do the Liberated Nuns Want? by Garry Wills
Travel Clubs: How Not to Get Gypped
Psyching Out the Republicans, by Gloria Steinem

NEW YORK

58 KILLINGS IN ONE WEEK

A Case-by-Case Report of This Summer's Seven Bloodiest Days

The Best French Pastry Shops in Town
My Private Seminar with Galbraith, by Jane O'Reilly
Trysting for Lunch, by Gael Greene

40 CENTS

AUGUST 17, 1970

New York

WHO MURDERS WHO IN NEW YORK

1972

The numbers kept getting worse.

Peter Hellman documented every one of the 58 murders in one record-setting week in July 1972.

Seven Days of Killing

By Peter Hellman

"…It was a week when almost everybody hated to be in New York…"

Time: 12:30 a.m.
Victim: Sydney (last name unknown)
Place: Northwest corner Flushing & Throop Aves., Bklyn.
Weapon: Knife

SATURDAY, JULY 15, 1972

Time: 12:45 a.m.
Victim: Elijah Jones Jr.
Place: Franklin Arms Hotel, Bklyn.
Weapon: Knife

Time: 8:00 p.m.
Victim: Edwardo Rivera
Place: Intervale Ave. & Beck St., Bx.
Weapon: Gun

Time: 8:00 p.m.
Victim: Billy Wilson
Place: 287 Sumpter St., Bklyn.
Weapon: Knife

Time: Unknown
Victim: David Levine
Place: Unknown
Weapon: Gun

Time: Unknown
Victim: Eddie Nix
Place: Queens
Weapon: Gun

Time: 12:50 a.m.
Victim: Thomas Eboli
Place: In front of 388 Lefferts Ave., Bklyn.
Weapon: .32-calibre gun

Time: 8:00 p.m.
Victim: Unidentified Negro male
Place: 315 West 134th St.
Weapon: Gun

Time: 10:15 p.m.
Victim: Carlos Garay
Place: 1867 Bathgate Ave., Bx.
Weapon: Knife

Time: 11:15 p.m.
Victim: Timothy Neil
Place: 1081 Sheridan Ave., Bx.
Weapon: Gun

Time: Unknown
Victim: Ralph Kennedy
Place: Unknown
Weapon: Gun

TUESDAY, JULY 18, 1972

Time: 2:00 a.m.
Victim: William Gambrell
Place: 110 West 116th St.
Weapon: Gun

Time: 3:15 p.m.
Victim: Melvin Fredricks
Place: Southwest corner Lenox Ave. & 115th St.
Weapon: Knife

Time: 4:30 p.m.
Victim: Joseph Dear
Place: 140th St. & St. Nicholas Ave.
Weapon: Gun

Time: 9:20 p.m.
Victim: Ronald Basket
Place: 113-29 197th St., Queens
Weapon: Gun

Time: 10:45 p.m.
Victim: Gino Morales
Place: 301 West 117th St.
Weapon: Gun

Time: 11:00 p.m.
Victim: Winston Clarke
Place: Barber Shop at 2062 Seventh Ave.
Weapon: Scissors

Time: 2:15 a.m.
Victim: Jo-Anne Rowe
Place: Bar & Grill at 401 Lenox Ave.
Weapon: Gun

Time: 6:00 a.m.
Victim: Dorothy Wunsch
Place: Stairwell at 9610 57th Ave., Queens
Weapon: Knife

Time: 9:10 a.m.
Victim: Allan W. McDonald
Place: 150th St. and Conduit Blvd., Bklyn.
Weapon: Knife

Time: 2:00 p.m.
Victim: John Stevens
Place: 179 East 100th St.
Weapon: Knife

Time: 8:15 p.m.
Victim: Ertha Mack
Place: 277 Rockaway Pkwy., Bklyn.
Weapon: Gun

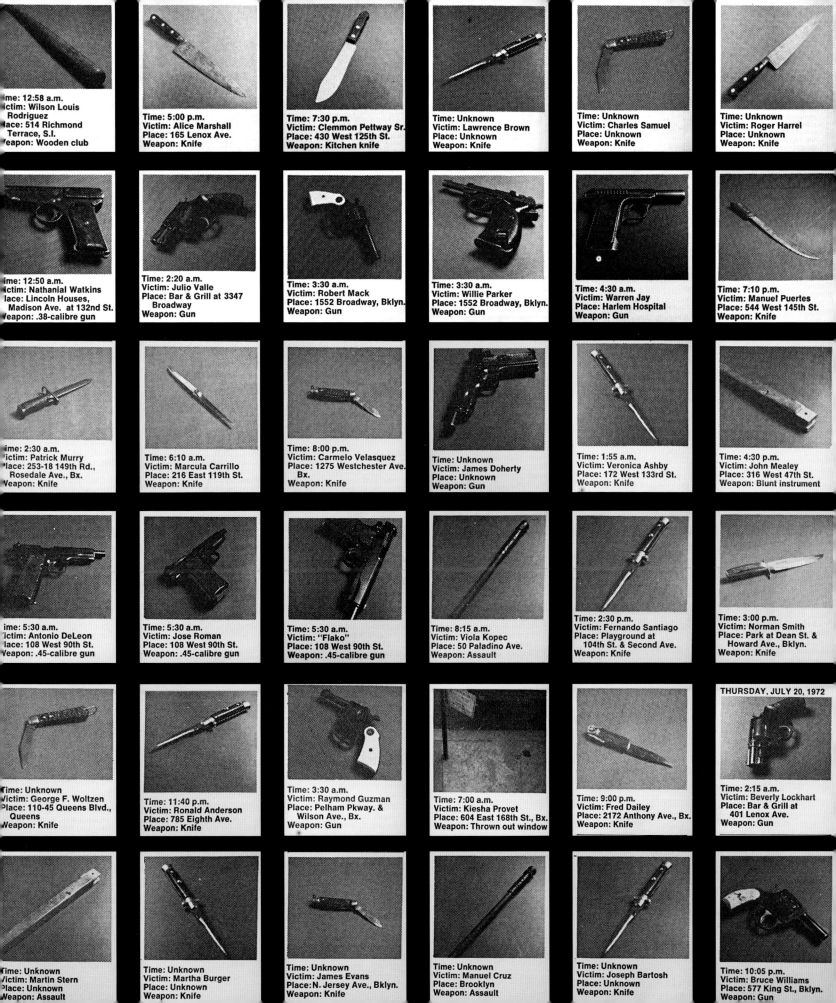

Time: 12:58 a.m.
Victim: Wilson Louis
Rodriguez
Place: 514 Richmond
Terrace, S.I.
Weapon: Wooden club

Time: 5:00 p.m.
Victim: Alice Marshall
Place: 165 Lenox Ave.
Weapon: Knife

Time: 7:30 p.m.
Victim: Clemmon Pettway Sr.
Place: 430 West 125th St.
Weapon: Kitchen knife

Time: Unknown
Victim: Lawrence Brown
Place: Unknown
Weapon: Knife

Time: Unknown
Victim: Charles Samuel
Place: Unknown
Weapon: Knife

Time: Unknown
Victim: Roger Harrel
Place: Unknown
Weapon: Knife

Time: 12:50 a.m.
Victim: Nathanial Watkins
Place: Lincoln Houses,
Madison Ave. at 132nd St.
Weapon: .38-calibre gun

Time: 2:20 a.m.
Victim: Julio Valle
Place: Bar & Grill at 3347
Broadway
Weapon: Gun

Time: 3:30 a.m.
Victim: Robert Mack
Place: 1552 Broadway, Bklyn.
Weapon: Gun

Time: 3:30 a.m.
Victim: Willie Parker
Place: 1552 Broadway, Bklyn.
Weapon: Gun

Time: 4:30 a.m.
Victim: Warren Jay
Place: Harlem Hospital
Weapon: Gun

Time: 7:10 p.m.
Victim: Manuel Puertes
Place: 544 West 145th St.
Weapon: Knife

Time: 2:30 a.m.
Victim: Patrick Murry
Place: 253-18 149th Rd.,
Rosedale Ave., Bx.
Weapon: Knife

Time: 6:10 a.m.
Victim: Marcula Carrillo
Place: 216 East 119th St.
Weapon: Knife

Time: 8:00 p.m.
Victim: Carmelo Velasquez
Place: 1275 Westchester Ave.
Bx.
Weapon: Knife

Time: Unknown
Victim: James Doherty
Place: Unknown
Weapon: Gun

Time: 1:55 a.m.
Victim: Veronica Ashby
Place: 172 West 133rd St.
Weapon: Knife

Time: 4:30 p.m.
Victim: John Mealey
Place: 316 West 47th St.
Weapon: Blunt instrument

Time: 5:30 a.m.
Place: 108 West 90th St.
Weapon: .45-calibre gun

Time: 5:30 a.m.
Victim: Jose Roman
Place: 108 West 90th St.
Weapon: .45-calibre gun

Time: 5:30 a.m.
Victim: "Flako"
Place: 108 West 90th St.
Weapon: .45-calibre gun

Time: 8:15 a.m.
Victim: Viola Kopec
Place: 50 Paladino Ave.
Weapon: Assault

Time: 2:30 p.m.
Victim: Fernando Santiago
Place: Playground at
104th St. & Second Ave.
Weapon: Knife

Time: 3:00 p.m.
Victim: Norman Smith
Place: Park at Dean St. &
Howard Ave., Bklyn.
Weapon: Knife

Time: Unknown
Victim: George F. Woltzen
Place: 110-45 Queens Blvd.,
Queens
Weapon: Knife

Time: 11:40 p.m.
Victim: Ronald Anderson
Place: 785 Eighth Ave.
Weapon: Knife

Time: 3:30 a.m.
Victim: Raymond Guzman
Place: Pelham Pkway. &
Wilson Ave., Bx.
Weapon: Gun

Time: 7:00 a.m.
Victim: Kiesha Provet
Place: 604 East 168th St., Bx.
Weapon: Thrown out window

Time: 9:00 p.m.
Victim: Fred Dailey
Place: 2172 Anthony Ave., Bx.
Weapon: Knife

THURSDAY, JULY 20, 1972

Time: 2:15 a.m.
Victim: Beverly Lockhart
Place: Bar & Grill at
401 Lenox Ave.
Weapon: Gun

Time: Unknown
Victim: Martin Stern
Place: Unknown
Weapon: Assault

Time: Unknown
Victim: Martha Burger
Place: Unknown
Weapon: Knife

Time: Unknown
Victim: James Evans
Place: N. Jersey Ave., Bklyn.
Weapon: Knife

Time: Unknown
Victim: Manuel Cruz
Place: Brooklyn
Weapon: Assault

Time: Unknown
Victim: Joseph Bartosh
Place: Unknown
Weapon: Knife

Time: 10:05 p.m.
Victim: Bruce Williams
Place: 577 King St., Bklyn.
Weapon: Gun

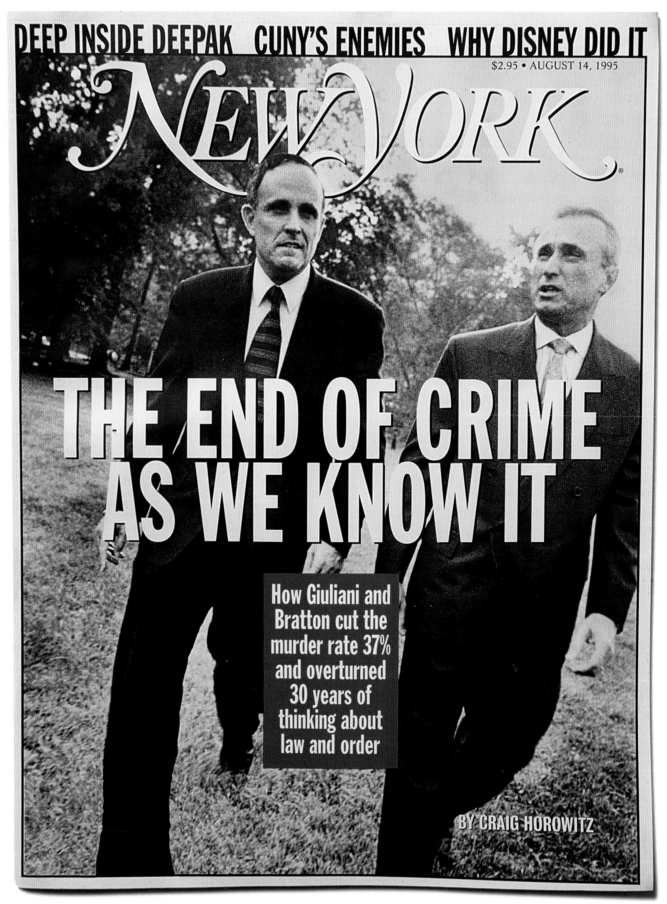

$2.95 • AUGUST 14, 1995

New York

THE END OF CRIME AS WE KNOW IT

How Giuliani and Bratton cut the murder rate 37% and overturned 30 years of thinking about law and order

BY CRAIG HOROWITZ

1995

After three decades of rising crime, the lawlessness was abruptly vanquished.

We're still arguing over why: Was it Rudy Giuliani's toughness? David Dinkins's changes to the police force just before Rudy got there? The CompStat crime-data system? "Broken windows" policing? Simply that the city got richer? Whatever the reason, the crime rate fell 70 percent in less than a decade, utterly changing New York City life.

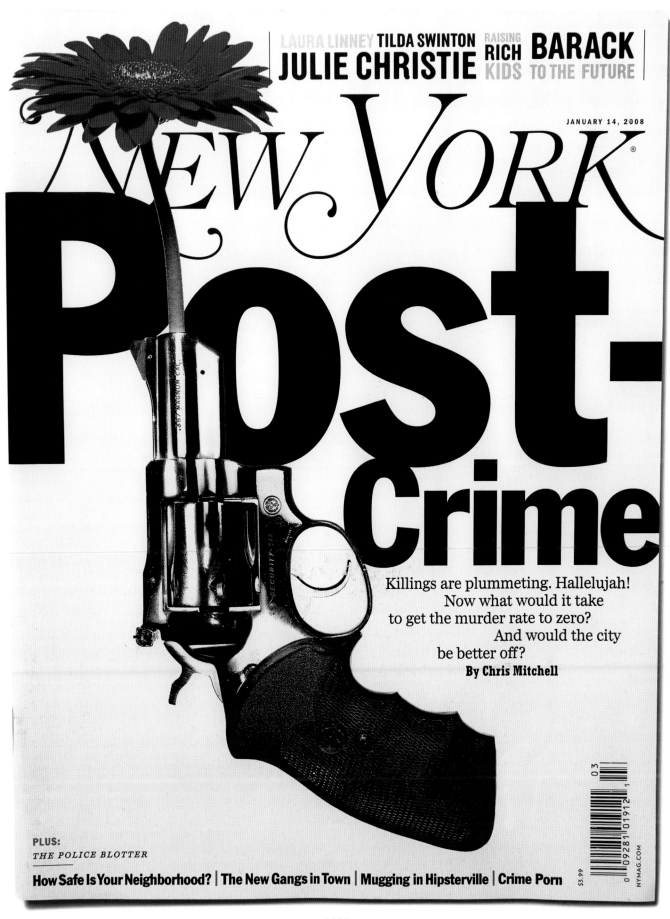

JANUARY 14, 2008

*N*EW *Y*ORK

Post-Crime

Killings are plummeting. Hallelujah!
Now what would it take
to get the murder rate to zero?
And would the city
be better off?
By Chris Mitchell

PLUS:
THE POLICE BLOTTER

How Safe Is Your Neighborhood? | **The New Gangs in Town** | **Mugging in Hipsterville** | **Crime Porn**

$3.99

0 09281 01912 1

03

NYMAG.COM

2008
And the murder rate kept dropping.

The risk of violence or theft became so remote for many New Yorkers that, by 2008,
it was not completely outlandish to contemplate a crime-free city.

189

CRISIS: FEAR

EXCERPT: SEPTEMBER 22, 1997

Plummeting crime rates brought new concerns: After Abner Louima was nearly killed by two cops in the restroom of the 70th Precinct, New Yorkers began to ask whether an effective police department was incompatible with a humane one.

Show of Force

By Craig Horowitz

THE MAYOR AND the police commissioner need to take a long, hard look at the factors that created the environment in which an incident like the one at the 70th Precinct could take place. Those factors directly relate to the way cops are trained, broken in, and managed. For while the particular kind of violence inflicted on Abner Louima was extraordinary, the events surrounding it, from the alleged blows he took before he got to the precinct to the light supervision at the Seven-oh that night, were not.

"The cops who committed the act clearly believed they could tell some bogus story and get away with it," one NYPD veteran says. "They weren't worried about the desk sergeant, who was the ranking officer on duty that night. Then the relief cops believed they could walk into the hospital and tell a bogus story. And it appears that reports were even written to cover up what happened, which indicates that supervisors were somehow involved. People want to say the act was an aberration, but everything about it seems to involve the abuse of authority as well as brutality. So clearly there's something more going on here."

In fact, the late tour has been a chronic problem not only at the 70th Precinct but everywhere. It has its own rules and its own style, and is like a separate department within the department. One that doesn't, according to a 30-year veteran, always attract the best people. "I remember I walked into a station house really late one night with [former deputy police commissioner] Jack Maple. And I looked at the cops," a former member of the department says. "Their coats were dirty, their shirts were dirty, their holsters were all worn down, their shoes weren't shined. So I looked at them and I said to Jack, 'Pretty scruffy precinct.' And

Jack looked at me and smiled. 'Ahhh,' he said, 'you'll learn very quickly that the cops of the night are very different from the cops of the day. They don't get all dressed up for anybody. At this hour, they're not gonna be meeting the Astors or the Vanderbilts, and if they do, they're gonna be dead already anyway.'"

"Nobody ever gets hurt in a precinct where the sergeant's a scumbag," says a former precinct commander who several years ago was brought in to try to reorder a notoriously difficult and problematic station house. "It's an image thing, and it's a reality thing. The cops gotta know you're right on top of them. You gotta

make them feel uncomfortable, let them know, 'I'm in your face.' If somebody comes through the door, they better not be bleeding, or I'm gonna be out asking questions.

"Everybody wants to be liked," he says, "and that's true in any work situation. But with cops, because of their insularity and the degree to which they depend on one another, everybody really wants to be a good guy. It's like, 'Oh, the sarge? He's a good guy. He's a real stand-up guy.' Well, I don't know exactly what a good guy is, but it sounds like somebody who won't report me when I do something wrong." ■

1997

Seven thousand people marched on City Hall.

Louima had been sodomized by officer Justin Volpe with a stick that may have been the broken handle of a toilet plunger. (Louima also said the cop had shouted "It's Giuliani time," then retracted that claim.) The protesters waved plungers in solidarity. Volpe was convicted and went to federal prison.

PHOTOGRAPH BY ANDREW LICHTENSTEIN

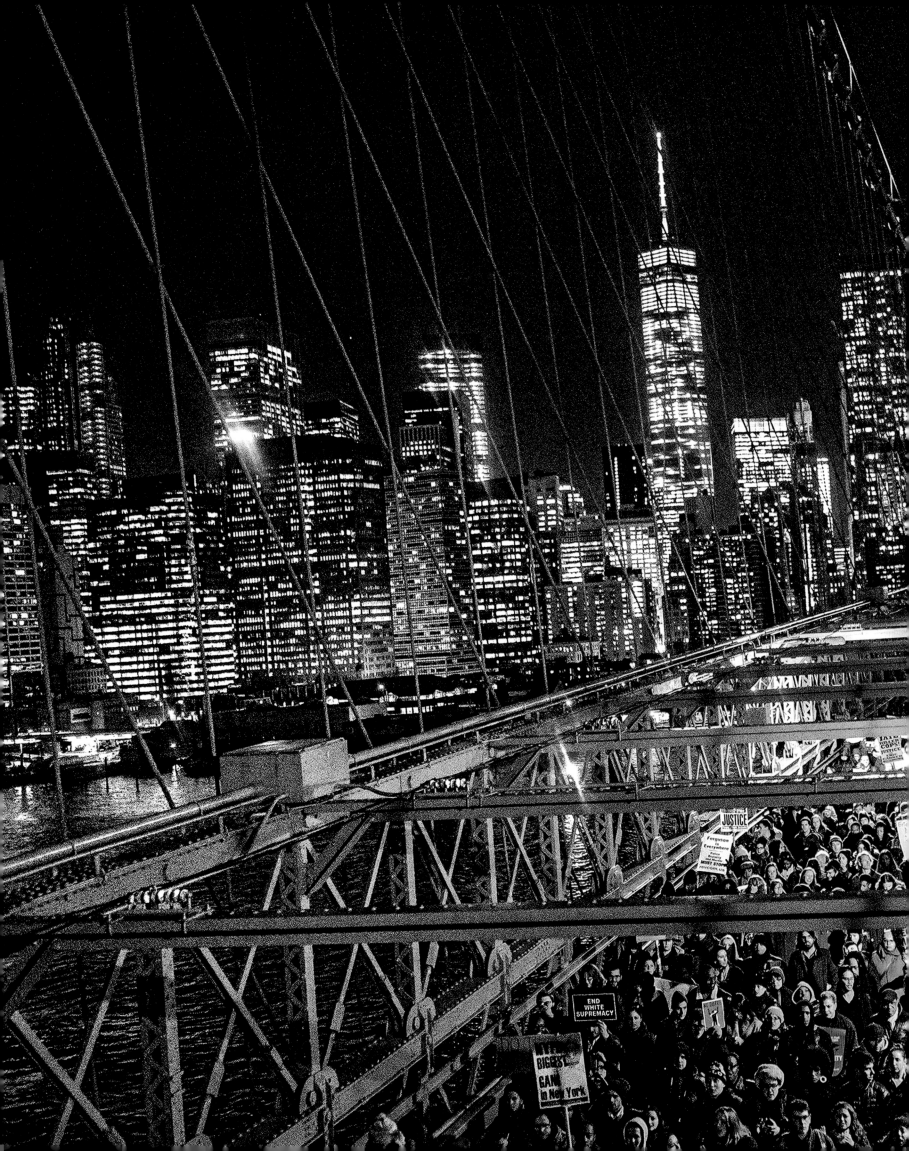

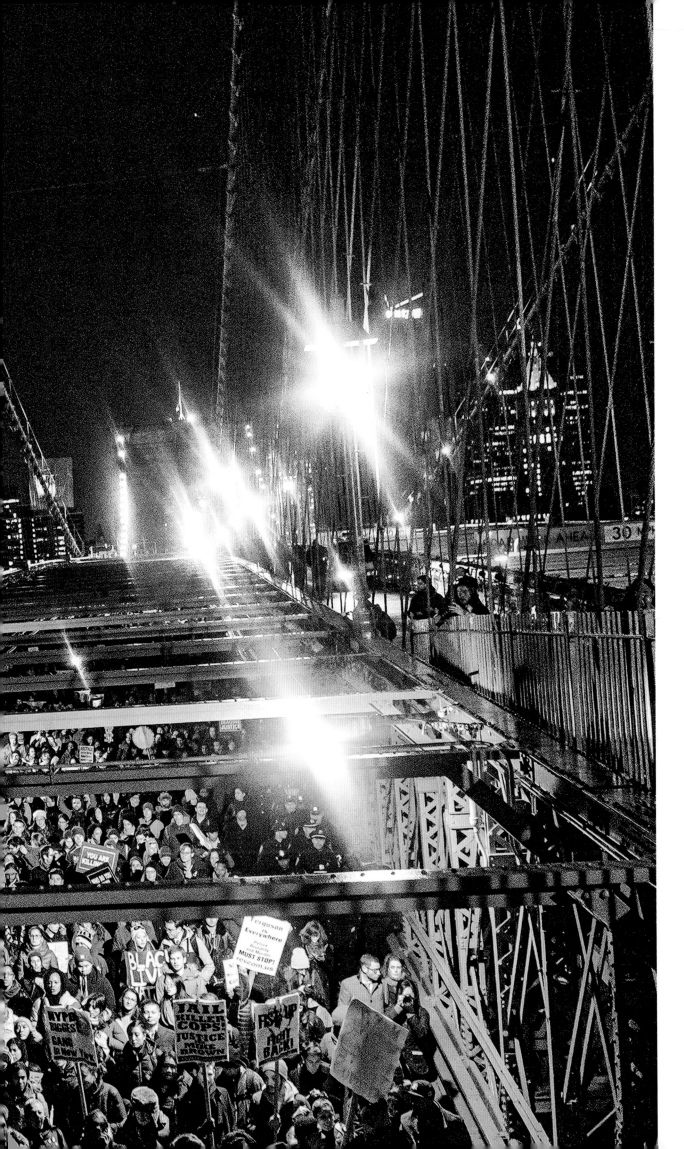

2014

And two decades after that, another brutal police assault on a black man again galvanized the city.

In the summer of 2014, Eric Garner died after a police officer put him in a chokehold that was caught on video. On December 3, a grand jury voted not to indict the cops who'd restrained him; days of protests followed, including this march across the Brooklyn Bridge. "You're seeing [change] before your eyes because you already demanded it," Mayor Bill de Blasio told the protesters, referring in part to the reconsideration of stop-and-frisk and marijuana-arrest policies. "Keep demanding it."

PHOTOGRAPH BY
BENJAMIN LOWY

193

The rancor surrounding police tactics crushed the department's morale.

A decade into the new century, the city had never been safer, but much of the NYPD felt as frustrated as ever. "What I expected to hear when I began my conversations with cops of many different ranks, from many different parts of the city," wrote Chris Smith in 2012, "was some well-deserved boasting about being part of the winningest team in Western urban-law-enforcement history. And there are plenty of cops who talk proudly about their colleagues' acts of heroism or, more quietly, about their own small moments of doing good. But the collective NYPD mood is surprisingly dark."

PHOTOGRAPHS BY
CHRISTOPHER ANDERSON

CRISIS: AIDS

EXCERPT: MAY 31, 1982

There had been 351 cases reported, and the disease didn't even have its name yet.

The Gay Plague

By Michael VerMeulen

A BIZARRE ASSORTMENT OF rare and deadly ailments are striking a significant number of young homosexual men and spreading with terrible swiftness to the straight population as well. The diseases, which vary from patient to patient, are known as markers because they signal the presence of an invisible—and, so far, irreparable—collapse of the victim's normal immune defenses.

The extraordinary illnesses began appearing almost simultaneously at hospitals in New York and California two and a half years ago. The cases of Kaposi's sarcoma (K.S.), named for its discoverer, Moritz Kaposi, received some publicity because it had never before been spotted in young men. Infections of *Pneumocystis carinii* pneumonia (P.C.P.) got less attention, even though it occurs as often as Kaposi's and tends to be far more tenacious and deadly. Also seen were unusual microorganisms—cousins of tuberculosis—normally found only in cave explorers, who contract them from bats; uncontrollable herpes lesions that erupted into ulcerlike sores the size of a man's hand; aberrant meningitis; and a raft of other so-called opportunistic infections—illnesses seldom if ever seen except in humans with some explicable defect in their natural immunity.

This mysterious plague is, according to *The New England Journal of Medicine,* "a truly new syndrome." No one knows what causes it, how to cure it, where it began, nor even precisely what it is. What researchers know all too well is that it has already killed almost as many people as legionnaires' disease and toxic shock combined. Out of 351 reported cases, 40 percent—141 people, gays and straights, men and, now, women—have died. The mortality rate of those stricken exceeds that of smallpox before the introduction of its vaccine.

Last June, the federal Centers for Disease Control, in Atlanta, organized a special Task Force on Kaposi's Sarcoma and Opportunistic Infections, and currently sees six to ten new cases each week. Dr. James Curran, who heads the task force, claims, "This is the first epidemic of acquired immunodeficiency in history." For want of a better name, the acronym A.I.D. has stuck. Of the current 351 A.I.D. cases, 338 have been male and 13 female. Their ages have ranged from 15 to 60. Of the males, 278 have been homosexual or bisexual, 60 have been either heterosexual or their preference is not known. All the females have been heterosexual. To date, A.I.D. has killed 107 gay or bisexual men and 27 who were straight or whose sexual orientation was unknown. Seven of the thirteen women have died.

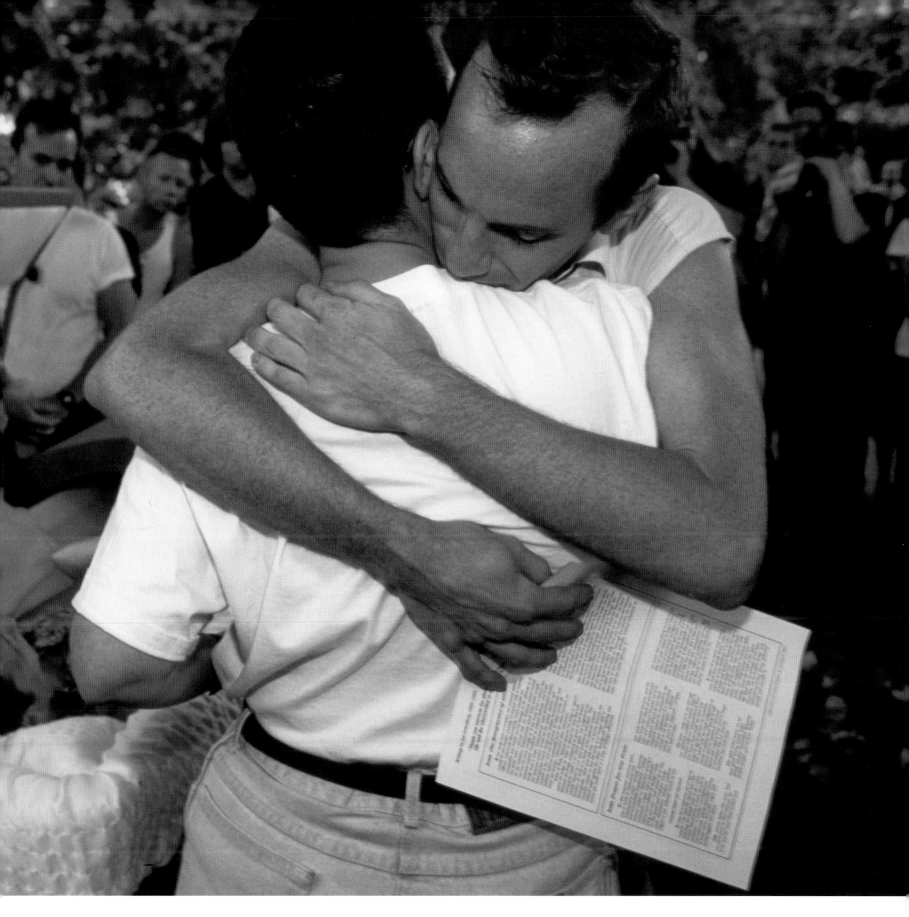

One of the most troubling features of the syndrome is that, although the cancer, pneumonia, or other marker disease may in some cases be cured, the prognosis is often hopeless because the underlying immune disorder itself seems permanent. Says Dr. Frederick Siegel, chief of clinical immunology at Mount Sinai Medical Center and author of one of the *New England Journal* papers, "It is like the plague, in the sense that we don't know how to alleviate this disease any more than did the physicians of the fifteenth century." ∎

1993

There were funerals for the young every day.

The photographer Donna Binder started photographing scenes from the AIDS crisis in 1986. "It was just unavoidable," she later explained. "If you were a social documentary photographer, whether you were gay or not—I mean, I don't think that you could stay away from that."

PHOTOGRAPH BY DONNA BINDER

1995

A half-million cases later, hope was scarce.

In its first years, AIDS was essentially an irrevocable death sentence. Two *New York* writers, Orde Coombs and Henry Post, were early casualties. By the time the story at right appeared, fourteen years and 300,000 deaths into the epidemic, the virus had been isolated but depressingly little had changed; the treatments (principally AZT) were only partially effective, and the best estimates suggested that half the gay men in New York City were infected. "I don't know a major lab at the NIH where there isn't a morale problem," one activist told Craig Horowitz. Two years later, the introduction of the new and powerful class of drugs called protease inhibitors began to buy many (though by no means all) of the diagnosed a second life.

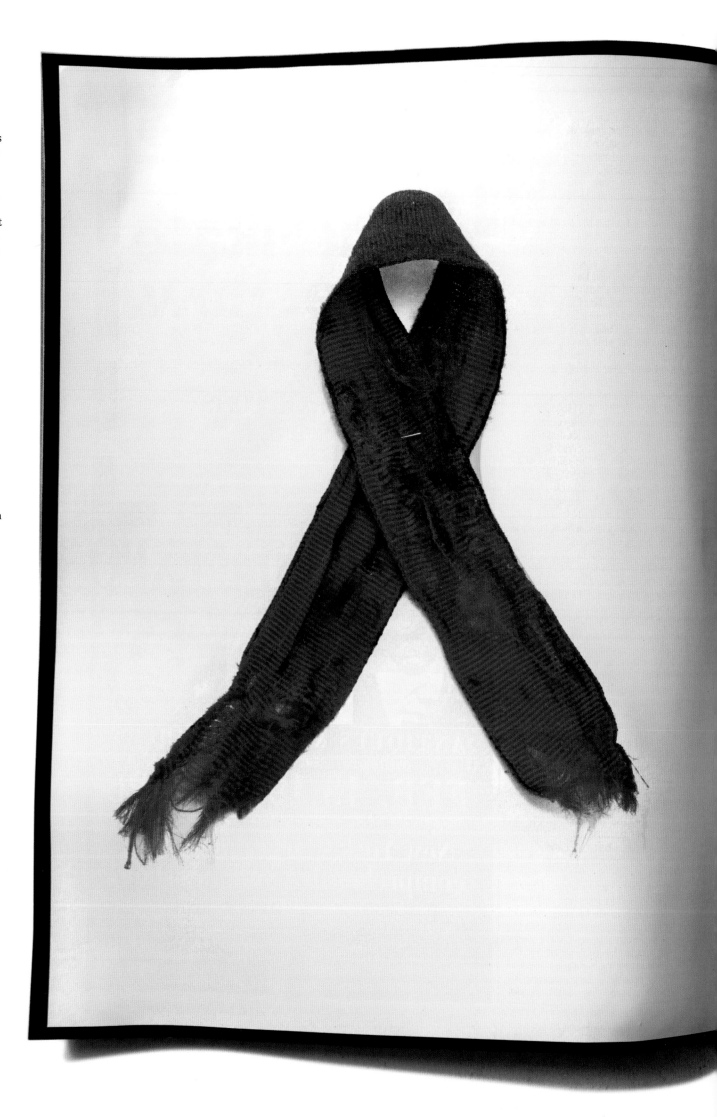

Has

AIDS

Won?

By Craig Horowitz

1990

The love-in became a "die-in."

The June 1990 Gay Pride parade, the largest to date, commemorated those lost to AIDS. "It's tough being gay these days," one member of the pugnacious protest group ACT UP joked ruefully. "You not only have to be hot-looking, you also have to be politically correct."

PHOTOGRAPH BY
DONNA BINDER

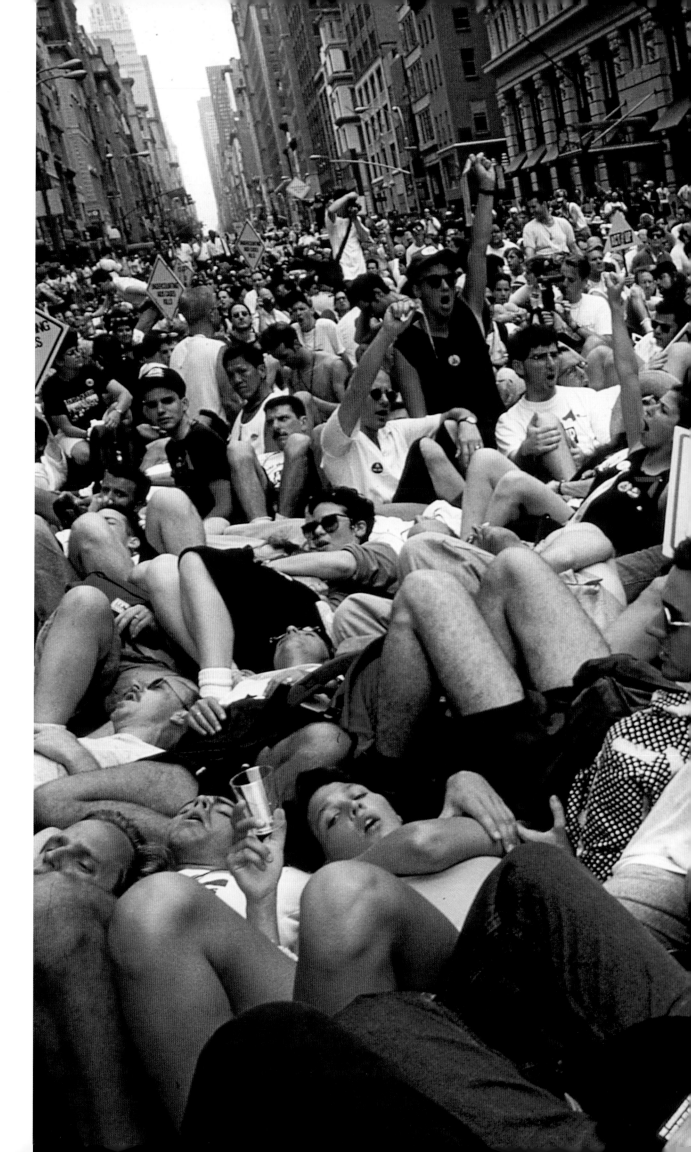

200

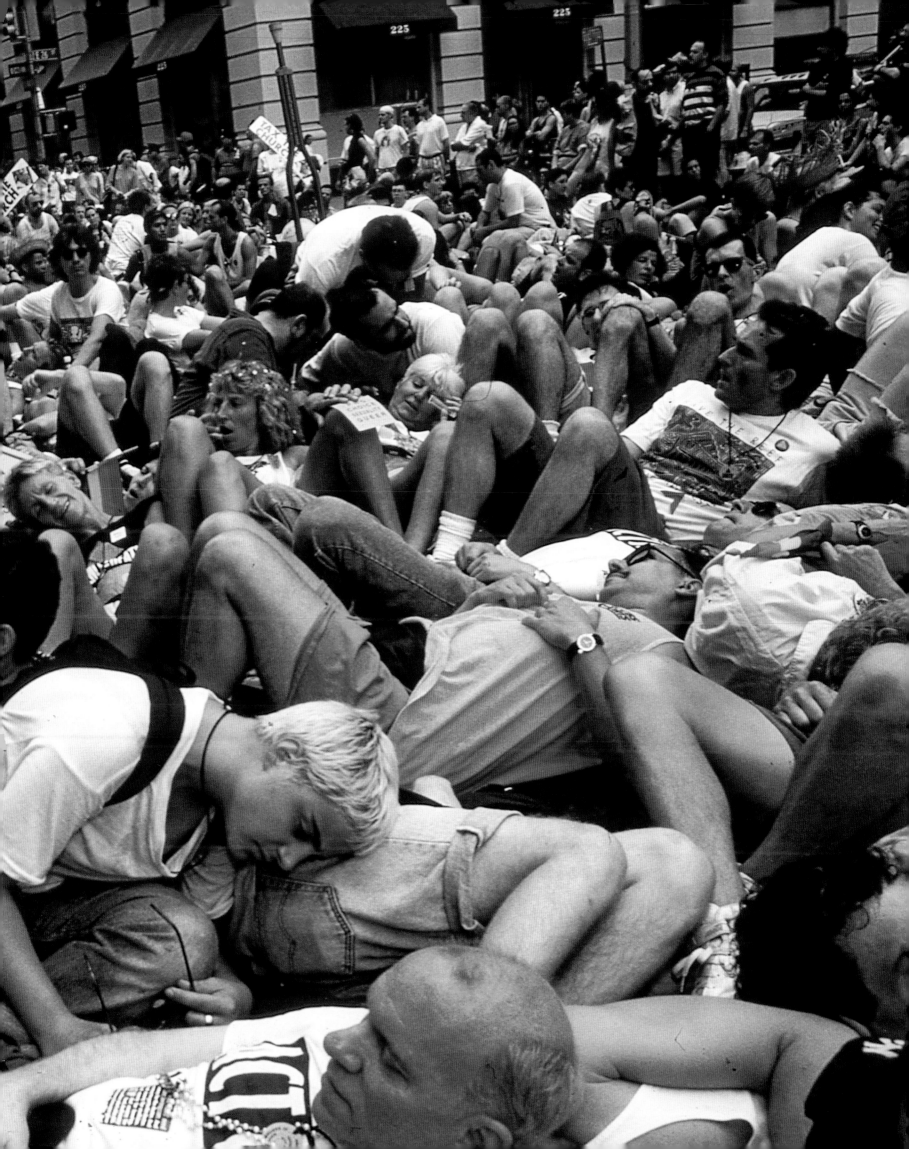

CRISIS: PANIC

EXCERPT: NOVEMBER 30, 1987

The first big crash came in 1987, when the Dow plunged 22 percent in a week. Things that seemed giddily New Yorky were suddenly out-of-date.

Dancing on the Lip of the Volcano

By Julie Baumgold

THERE ARE LIGHTS skating up 51 stories to the copper tops of the buildings of the World Financial Center. They are lights from the windows of Merrill Lynch and Oppenheimer, Dow Jones and American Express. Each light is a Suit working late because of the stock crisis, guys in shirts looking at numbers and making late, painful calls, but downstairs, downstairs—it's burning.

"Mi amica divina!" It's Donatella Girombelli of Genny, who is making Christian Lacroix's ready-to-wear. As usual, she has a black ribbon in her hair that trails to her ankles. And Carolyne Roehm in a gold-and-silver lochrosen beaded mini-dress ($5,500) with what someone says is a $2 million necklace; Nan Kempner, covered in Saint Laurent's trembling black feathers, arrives with Mikhail Baryshnikov, for whom Lacroix will design the costumes for the ABT's *Gaîté Parisienne.* Blaine Trump is, of course, wearing her purple Lacroix, which was sprung from the customs broker just in time. Ivana Trump in Chanel couture by Karl Lagerfeld. Malcolm Forbes, Brooke Shields, Diane von Furstenberg. These are the Whirlers, turning madly on the fiery rim, ready to lose their balance, fall in, and be consumed, swallowed up.

Onstage at this benefit fashion show, Mounia, who used to be Saint Laurent's house model, his very muse, kisses Lacroix. They come backstage. "I've never seen anything like it, and I never will again," Ira Neimark, the chairman of Bergdorf's, tells Lacroix. No one is pulling back, no one is hurting. Money lost, money left. There are no containers of English furniture at the docks going home. They are dancing on the lip under the yellowing 40-odd-foot palms. They sit down, knees tucked under the mango bengaline cloths. Christian walks in with Hebe, who discovered him, and sits next to her and Blaine at a table with Bianca Jagger and Anne Bass and Misha Baryshnikov, as Bill Cunningham and Tony Palmieri circle the table. Calvin and Kelly Klein and Donna Karan come to congratulate him. Tama Janowitz hover-cruises the table, and the Spanish music plays. ∎

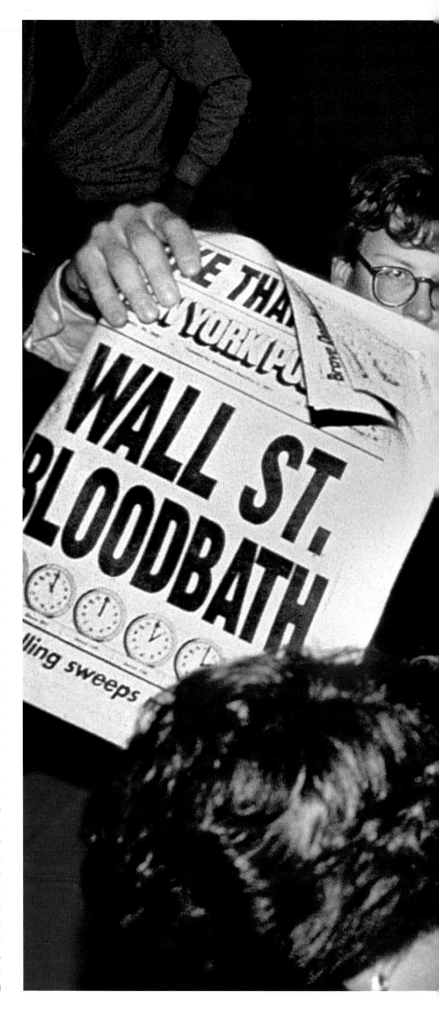

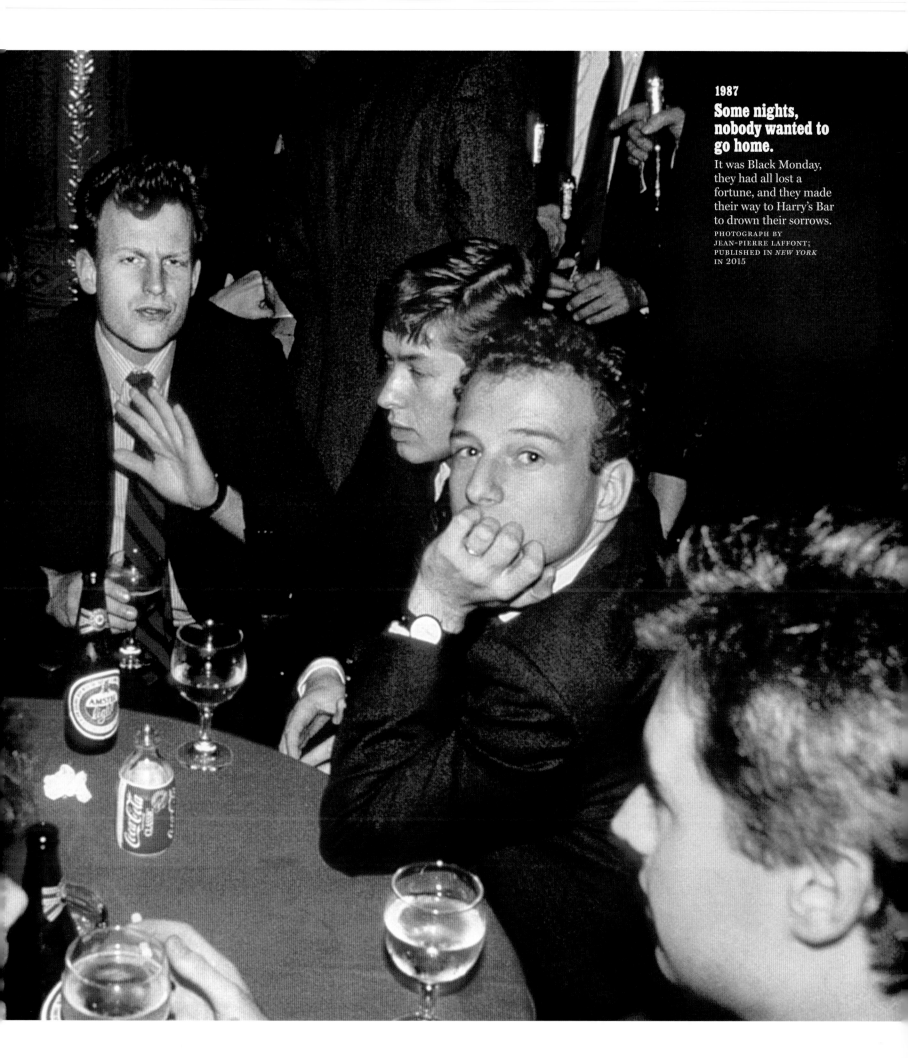

1987

Some nights, nobody wanted to go home.

It was Black Monday, they had all lost a fortune, and they made their way to Harry's Bar to drown their sorrows.

PHOTOGRAPH BY JEAN-PIERRE LAFFONT; PUBLISHED IN *NEW YORK* IN 2015

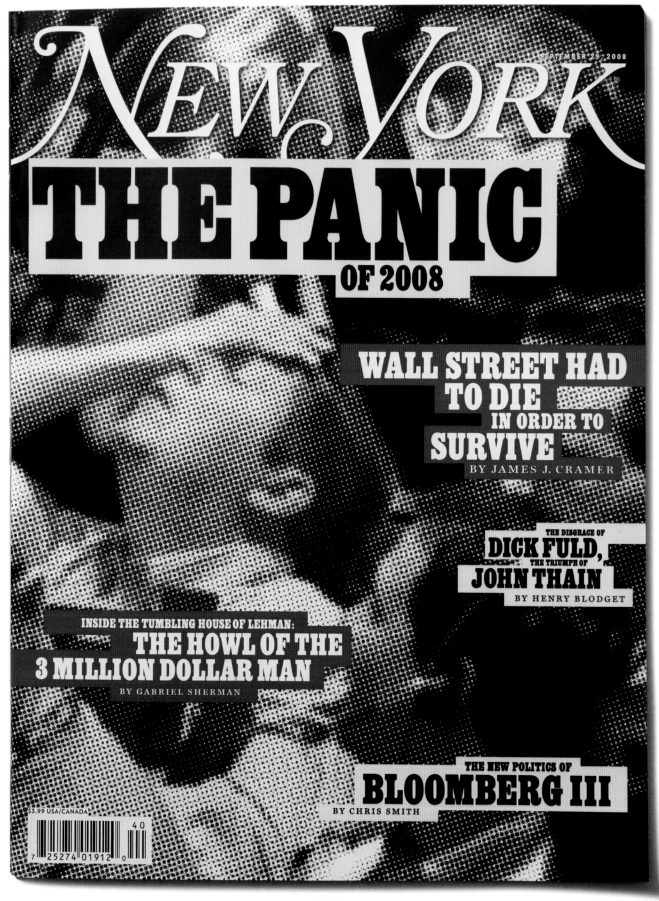

New York

SEPTEMBER 29, 2008

THE PANIC
OF 2008

WALL STREET HAD TO DIE IN ORDER TO SURVIVE
BY JAMES J. CRAMER

THE DISGRACE OF DICK FULD, THE TRIUMPH OF JOHN THAIN
BY HENRY BLODGET

**INSIDE THE TUMBLING HOUSE OF LEHMAN:
THE HOWL OF THE 3 MILLION DOLLAR MAN**
BY GABRIEL SHERMAN

THE NEW POLITICS OF BLOOMBERG III
BY CHRIS SMITH

$3.99 USA/CANADA

40

7 25274 01912 0

2008
The Great Recession began.

"The '97 Barbaresco was not supposed to be opened for this," Gabriel Sherman wrote of a banker's sudden-onset poverty. "But on Friday, September 12, as Lehman's stock flatlined at $3.65 per share, the Trader knew it was time to uncork the Santo Stefano…As one recently laid-off Lehman staffer said, in characteristic Wall Street vernacular, 'These assholes on another floor completely dropped our pants.'"

CRISIS: PANIC

EXCERPT: OCTOBER 29, 2012

The 2008 crash was even worse, throwing the world into recession and upending American politics. Wall Street's most powerful bankers got through it mostly unpunished, becoming national symbols of entitlement and greed.

The Randian and the Bailout

By Jessica Pressler

THERE'S NOTHING SUBTLE about Bob Benmosche. "I'm an in-your-face CEO," he told me one day, looking down from his vantage point six feet and four inches above the ground. He is a big guy. Big block-shaped head. Big ham-size arms. Infamously big mouth. "People say I use colorful language," he told a room of people once. "Well, that's a bunch of bullshit!"

Occasionally Benmosche will lapse into the kind of lingo you expect to hear from someone who has spent 40 years on Wall Street, like when he talks about "cost structure" and "maximizing value," but those are just the lemons in an otherwise rich and varied cornucopia of anecdotes, parables, fragments of talking points, historical data, conspiracy theories, and opinions that tumble forth whenever you ask him a question.

For example: "Who are you going to vote for this year, Bob?," which is a question I pose to him in August. We are sitting in the outdoor living room of his villa near Dubrovnik. The moon is high in the sky, cicadas chirp in the lemon trees, and the faint thump-thump of Rihanna wafts over from a yacht docked in the Adriatic. Benmosche is leaning against a wicker sofa in postprandial repose, wineglass perched atop his belly, having just completed a long story that began with a disquisition on the phylloxera blight in nineteenth-century France and ended with an explanation of why Warren Buffett's claim that his tax rate is lower than his secretary's is "bullshit."

He runs a hand over his scruffy white beard. "Somebody who has the best overall approach to things," he says vaguely, then launches into a rundown of his voting history. "Didn't like Kennedy. Too much of liberal thinking. Didn't like people giving away stuff. Didn't like Nixon but thought he was better than Kennedy. I voted for Clinton both times. I supported Hillary, even though she made me angry. In '88, I just gave up, I didn't vote. I mean, Dukakis was

a joke, and I was not happy with Bush Senior. I always worried about James Baker and his attitude toward Israel. Turns out I was dead right. On the settlement thing, he said he was worried about 'excessive force.' What he was really doing was trying to show Israel who's boss. I've always been amazed that people can be penalized for too strong a reaction. That's the problem with this George Zimmerman thing down in Florida. When is it 'excessive' force? Say there's a guy and he had a knife. Okay, so I'm supposed to wait for him to cut me once or twice and then I should shoot him? We don't know who attacked who. People don't do things like that without good reason."

There's a silence. Benmosche knits his eyebrows together. His wife, Denise, refills her wine. "Let's put it this way," he says finally. "I think we need a change. I believe that we need a leader that's pro-individual, that's pro-business, and recognizes that there's no free lunch anywhere. There has never been anyone in history that has proven a free lunch works."

This sounds a bit odd coming from the CEO of AIG, most obviously because his company received the largest free lunch the world has ever seen, after it was revealed that its Financial Products unit had gone off the rails writing credit-default swaps—insurance—on mortgage-backed securities. When the market tanked, its parent company was left on the wrong side of billions of dollars of IOUs to major banks and hedge funds, which had been using the swaps to bet against the housing market. The insurer was in hock to so many systematically significant institutions that the federal government felt obliged to step in with a $182 billion rescue package, the largest government bailout in history, to prevent the collapse of the global economic system.

After the U.S. government took a majority ownership in AIG, everyone expected it to stay that way, possibly forever. But in August, the company paid back the money it received from the Federal Reserve. And while we are sitting in Benmosche's villa in Croatia, the Treasury is making plans to sell off the majority of its stake, reducing it to 16 percent. By next year, the government estimates it will have earned a $20 billion profit on its "investment" and will be entirely rid of its AIG problem. Or, as Benmosche might put it, AIG will be rid of its government problem. The entire reason I've been invited to Croatia for four days is to hear about how this free lunch *did* work.

"But it *wasn't* a free lunch," Benmosche insists. It's a point of view that I am apparently not the first to fail to appreciate. "Everybody said it's just not going to happen, they'll never pay it off," he goes on. "SIGTARP, Elizabeth Warren, Gretchen Whatshername in the New York *Times*. The fact is we now have succeeded in getting the Fed back all of their money, and we're just close to getting the Treasury paid back. And do you know," he adds, an indignant note

creeping into his voice, "neither of them have ever said 'Thank you'? We have done all the right things. Somebody should say, 'By golly, those AIG people made a promise and they are living up to a promise!' We're left with a major part of the economy in America; they're going to make a profit on top of everything else they've got," he finishes, settling back into his chair. "God bless America. And God bless AIG. And God bless Tiny Tim." ∎

CRISIS: 9/11

SEPTEMBER 5–12, 2011

The 21st century's Pearl Harbor put an entire city, and country, into mourning.

Good-bye

By Beverly Eckert

Eckert's husband, Sean Rooney, worked for Aon on the 105th floor of Tower Two. She told this story of his final moments to StoryCorps, and New York *published the account after she herself died in a plane crash in 2009.*

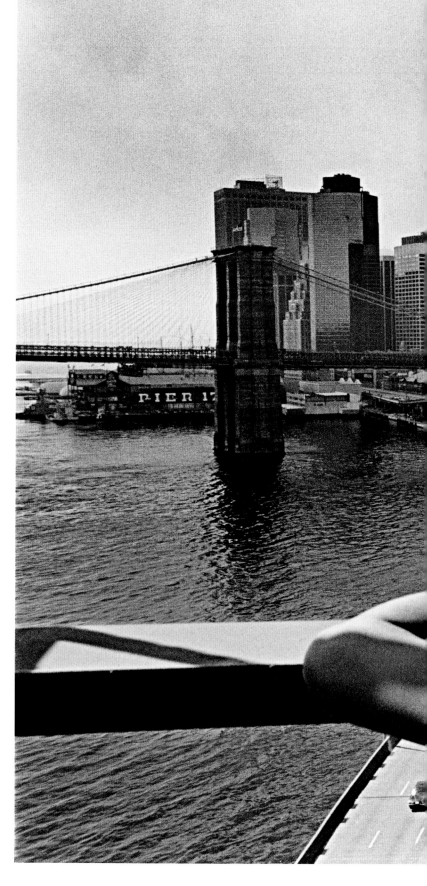

IT WAS ABOUT 9:30 a.m. when he called. When I heard his voice on the phone, I was so happy. I said, "Sean, where are you?," thinking that he had made it out and that he was calling me from the street somewhere. He told me he was on the 105th floor, and I knew right away that Sean was never coming home.

He was very calm. He told me he had been trying to find a way out and what he wanted was information. So I relayed to him what I could see on TV, what floor the flames had reached and on what side of the building. I also used my other phone, my cell phone, and called 911 and told them where Sean was and that he needed to be rescued.

Sean told me that initially he was with some people that tried to escape by going down the stairs, but they had to turn back because of the smoke and the heat. They headed for the roof, but when they got there, they found that the roof doors were locked. He told me the other people were now in a conference room and that he was alone. I asked him to go back and try the roof doors again, to pound on them, and that somebody on the other side would hear him…

Sean was gone for maybe five minutes, and then he came back to the phone. He hadn't had any success, and now the stairwell was full of smoke: He had actually passed out for a few minutes while pounding on the doors.

There was a building in flames underneath him, but Sean didn't even flinch. He stayed composed, just talking to me the way he always did. I will always be in awe of the way he faced death. Not an ounce of fear—not when the windows around him were getting too hot to touch; not when the smoke was making it hard to breathe.

By now we had stopped talking about escape routes. I wanted to use the precious few minutes we had left just to talk. He told me to give his love to his family, and then we just began talking about all the happiness we shared during our lives together, how lucky we were to have each other. At one point, when I could tell it was getting harder for him to breathe, I asked if it hurt. He paused for a moment, and then said, "No." He loved me enough to lie.

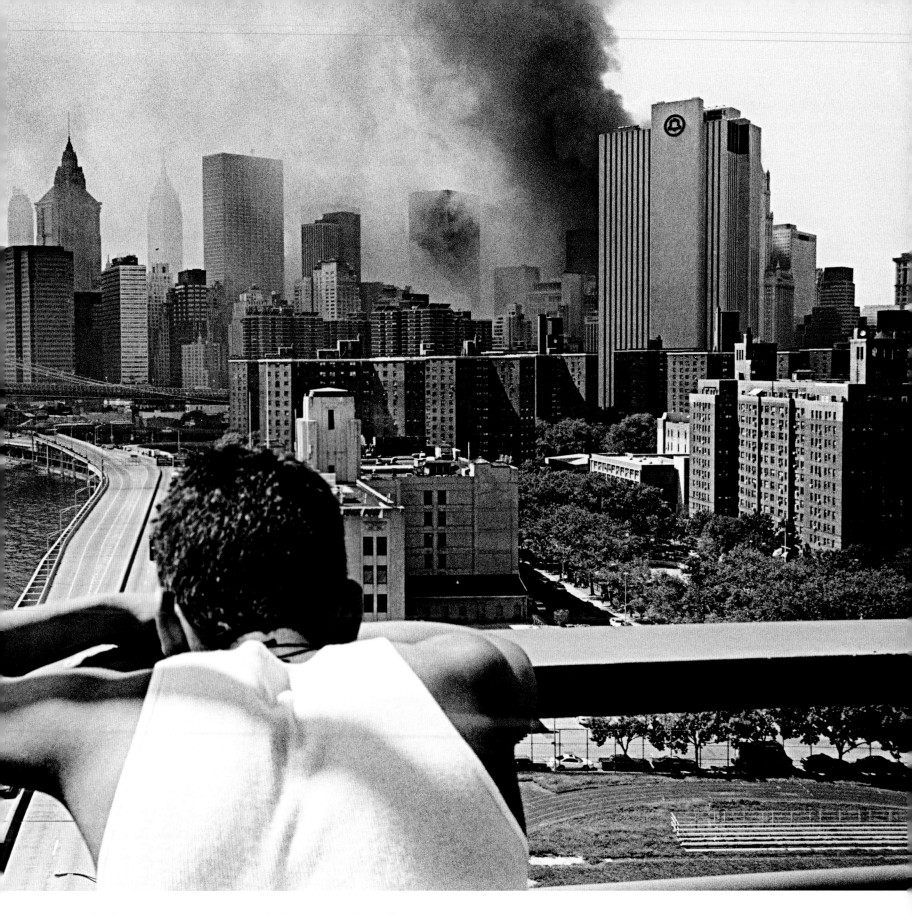

In the end, as the smoke got thicker, he just kept whispering, "I love you," over and over. Then I suddenly heard this loud explosion through the phone. It reverberated for several seconds. We held our breath; I know we both realized what was about to happen. Then I heard a sharp crack, followed by the sound of an avalanche. I heard Sean gasp once as the floor fell out from underneath him. I called his name into the phone over and over. Then I just sat there huddled on the floor holding the phone to my heart. ∎

2001
We all watched it happen.

Most of the country experienced the attacks through television; Pennsylvania and the Pentagon had their own unmediated scenes. Manhattan's density, though, meant that millions of people watched firsthand—and could smell the smoldering pile for months.

PHOTOGRAPH BY JOSEPH RODRIGUEZ; PUBLISHED IN *NEW YORK* IN 2011

2001

First responders came from everywhere.

Michael B. Sauer— a member of the Woodmere, Long Island, fire department who'd raced into the city that day to help— rinsed the dust off his face and hands at a fire hydrant a few hours after the collapse. Sauer is still with the department in Woodmere, and was one of the lucky ones who didn't get sick from the toxic cloud.

PHOTOGRAPH BY YONI BROOK; PUBLISHED IN *NEW YORK* IN 2011

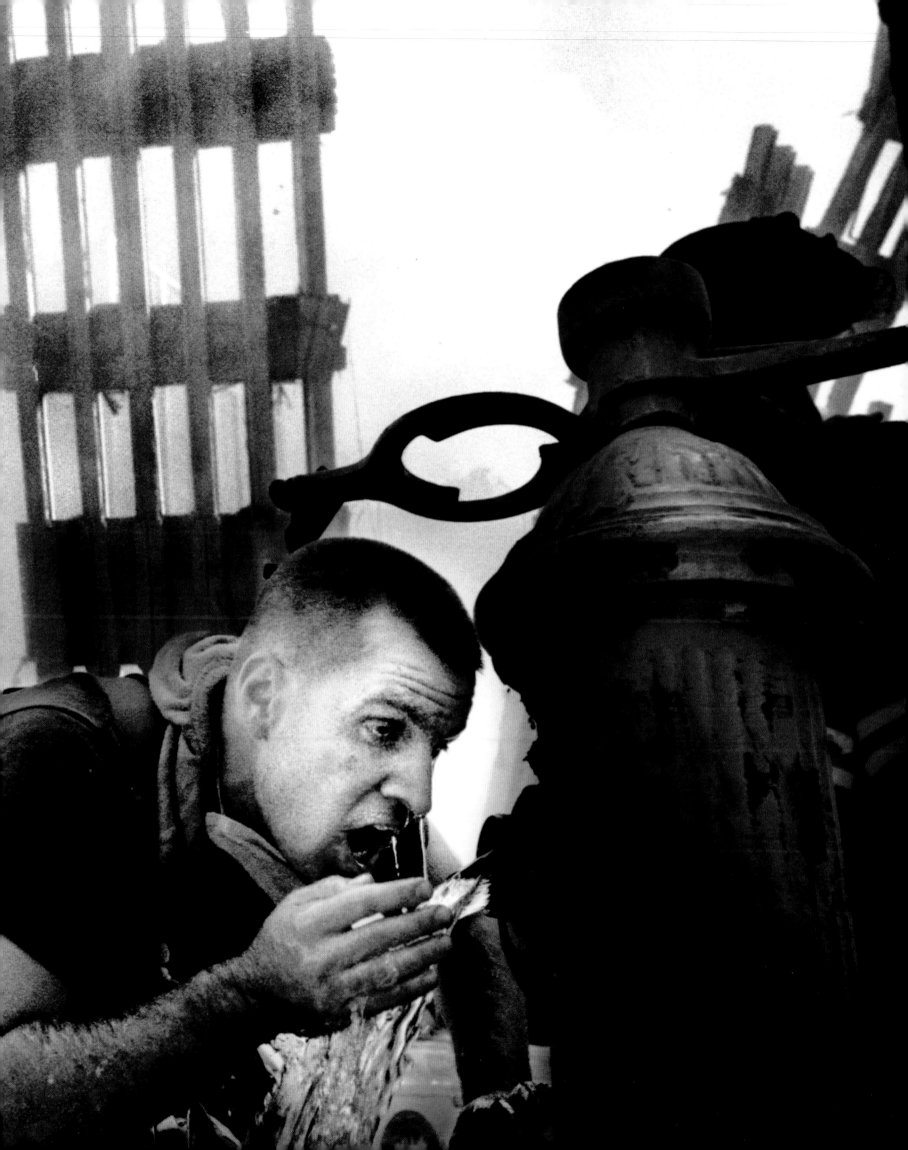

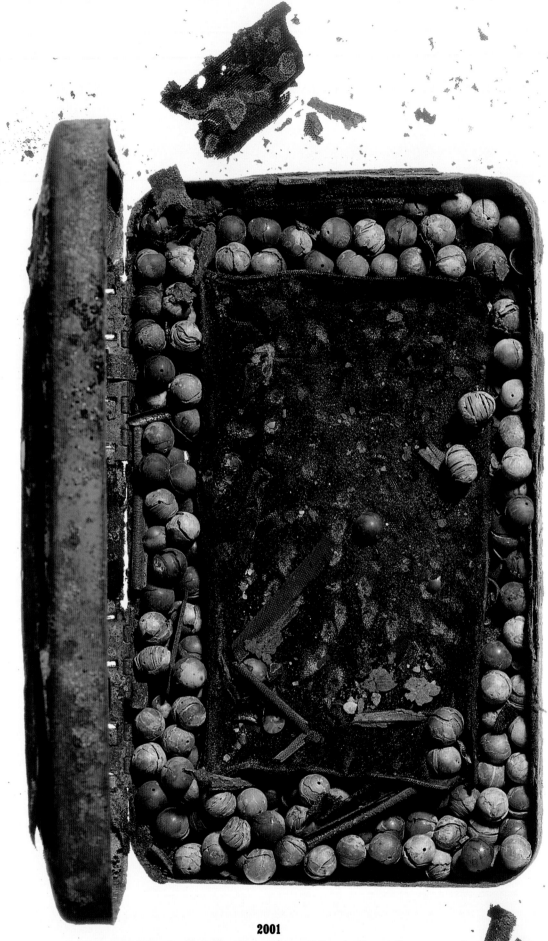

2001

Artifacts of daily life emerged from the ruins.

This jewelry case filled with pearls was kept in a safety-deposit box at the
Chase bank in 5 World Trade Center, which was heavily damaged
by fire. The remains of the building were demolished the following January.

PHOTOGRAPH BY SIVAN LEWIN; PUBLISHED IN *NEW YORK* IN 2006

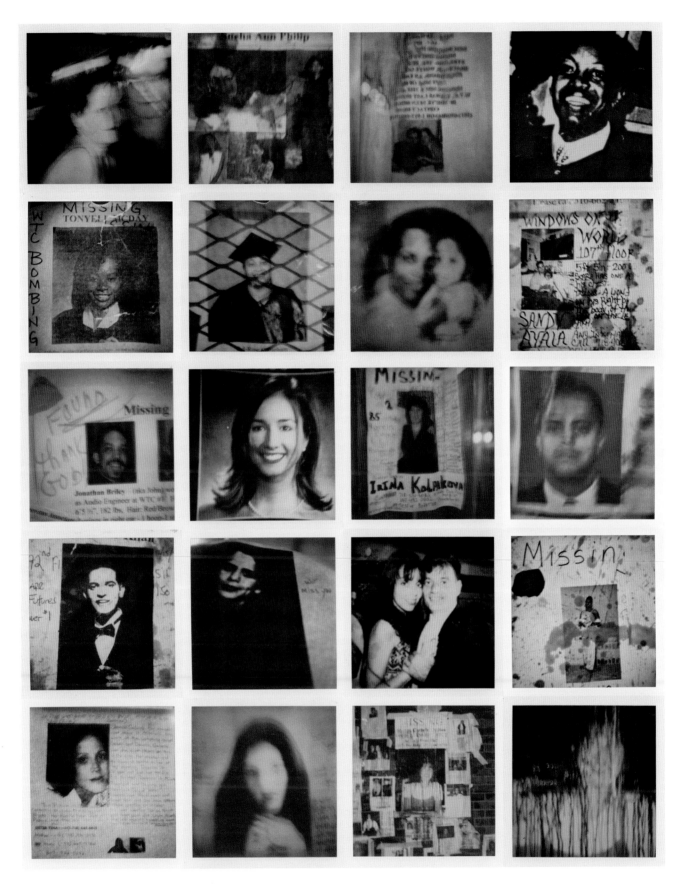

2001

New Yorkers prayed that their friends and family had made it out.

In the first days after the attacks, impromptu missing-persons posters appeared all over New York.
Each was imbued with the hope that the person in question had been stuck on a train, taken a smoke break,
gone off on a bender—anything, in other words, that would have kept him or her from getting to work that morning.
At least one of these stories (third row, left) appears to have had a happy ending. Most did not.

PHOTOGRAPHS BY MICHAEL ACKERMAN; PUBLISHED IN *NEW YORK* IN 2011

Commander-in-Chief, Accidental

The brief, harrowing administration of Richard A. Clarke.

C

On the morning of September 11, Richard A. "Dick" Clarke served as the de facto leader of the United States. As a national-security and counterterrorism adviser to the last three presidents, Clarke had warned relentlessly against the looming threat posed by Osama bin Laden (he had alerted Condoleezza Rice of a possible Al Qaeda attack in a personal note exactly one week before). That morning, he raced to the White House shortly after the second plane struck the World Trade Center, arriving at Dick Cheney's office, where Cheney and Rice were meeting alone. The two immediately handed over significant authority to Clarke as "crisis manager" and were escorted to a bunker. (The president, famously reading to a kindergarten classroom in Florida, was kept from returning to Washington.)

Clarke rapidly posited an Al Qaeda attack, the ambition and duration of which would remain unknown to everyone—including those at the highest levels of U.S. government—for as long as it progressed. From a secure teleconferencing room in the West Wing, he conferred with cabinet members across Washington. Of the 4,400 planes above the U.S. ordered grounded, eleven were initially unaccounted for. From Cheney and Bush, Clarke sought—and received—permission to shoot down any aircraft believed to be a threat; because of a training exercise, however, fighter jets were not immediately available over Washington and New York.

A plane hit the Pentagon; smoke began filling the studio in which Secretary of Defense Donald Rumsfeld sat. There were reports of a car bomb at the State Department and a fire on the Capitol Mall. Clarke was told another suspected hijacked plane was eight minutes away from the White House. Staffers were fleeing; the Speaker of the House lifted off in a helicopter. Clarke and the rest of those in the room wrote their names on a piece of paper, a list e-mailed to the outside so that rescue teams could search for them.

Clarke ordered all landmark buildings across the country evacuated. The borders were closed. The Department of Defense went to DEFCON 3, alerting the Russians of the rationale. A plane was reported hijacked over Alaska. "Continuity of government" protocols, a vestige of the Cold War, were instituted. And before the first Tower had even fallen, Clarke received a secure call from the FBI: Passenger manifests showed several known Al Qaeda names.

For the rest of the day it went on like this, until both Towers had fallen and all the airplanes in the sky had landed and the president arrived back at the White House, just before 7 P.M. Clarke continued on in the administration, as an adviser for Cyberspace Security, before resigning in 2003. In 2004, he published a memoir, *Against All Enemies,* in which he chastised the Bush administration for its refusal to heed his and others' pre-9/11 warnings and for the ensuing war in Iraq, which he viewed as wholly counterproductive. DAN P. LEE

D

Dead, Accounting of the

From the dust, a numerology of loss.

Because so many questions about the attacks were at first unanswerable, the one we kept coming back to was the one that seemed most straightforward: How many died? From among the 21,817 fragments of life eventually found in the rubble—yes, exactly that many, says the chief medical examiner's office—how many lives could be puzzled back together?

In the minutes after the collapse, rumors suggested a number in the tens of thousands. This was based on the population of the Towers at full capacity: 50,000 workers and, over the course of a day, up to 200,000 visitors. At first it seemed that those enormous numbers made sense and that most of the people in the buildings must be dead, as it was impossible to tell how many dust-covered figures were emerging. Furthermore, such a number was just large enough to match the size of the calamity as it was internalized by people watching in terror. Thinking in the upper five-figures put the loss in the mathematical range of wars (nearly 60,000 American soldiers died in Vietnam) and natural disasters (Krakatoa: 36,000). The attacks and collapse felt, in some ways, like both.

But according to later analyses, only between 14,000 and 19,000 people were in the buildings at 8:46 that morning; within a few days the city's estimate of the dead, based on missing-persons reports, accordingly shrank to about 6,700. Even that was too high. "As you recall, Mayor Giuliani told everyone to report anyone missing to the city, anyone you hadn't heard from, which led to a lot of double and triple reporting," said Ellen Borakove, director of public affairs for the medical examiner's office. "There were people who were reported missing who weren't [D1], and people who weren't reported who were, and they had to sort that out."

They—a multi-departmental committee led by the NYPD's Missing Persons Squad—halved the figure fairly quickly. By the end of October, confirmed deaths numbered 3,478, and by the first anniversary, the official count—including the 147 victims on Flights 11 and 175 but not the 224 dead at the Pentagon and in Pennsylvania—hovered around 2,800. Thereafter, the number drifted down more slowly, to around 2,750 by November 2003, where it has pretty much stayed for eight years, occasionally creeping up by one.

But much is lost in that "pretty much." A paradox of

D1

THE DELISTED

Four of the many people officially counted as dead on 9/11 who ultimately turned up alive.

Nickola Lampley: Worked near Towers; heard her name announced while watching 9/11 first-anniversary ceremony.

Olivia Khemraj: Last seen by her mother, leaving for a job interview at WTC the morning of 9/11; found by police a year later.

Peter Montoulieu: Reported missing by ex-wife; told CNN in November 2002 he was "shocked" about his place on victims list.

George Sims: Selling trinkets near Towers on 9/11; showed up at a New York City hospital eleven months later, suffering from amnesia.

→ FDNY chaplain Mychal Judge, the first confirmed 9/11 casualty, and Jerry J. Borg, the most recent addition to the list.

our mostly innumerate society is that we require unreal numbers to make things real. In order to get those numbers, we are usually willing to accept certain estimates as sufficient, indulging in the fiction that we can measure, say, federal spending to the dollar, population tracts to the person. The World Trade Center attacks demanded a different kind of precision. No one could be fractionally dead; no family could be missing an approximate number of loved ones. Inaccurate, incomplete lists that floated around the Internet or that appeared, horribly enough, in overhasty memorials made the problem worse. As does the fact that only about 1,629 of the missing have been positively identified from among those 21,817 remains. The rest, some 40 percent of the total, were issued death certificates by judicial decree, with no real evidence except their absence (see "Unidentified Remains," page 130).

So it wasn't enough to say that the largest contingent among the World Trade Center victims worked in finance (658 at Cantor Fitzgerald alone), followed by the FDNY (343). That the oldest was 85; that the youngest, not including an unborn child, was a 2-year-old on Flight 175. We must have a full accounting. Many of the dead were, after all, accountants, including Jerry J. Borg, who developed pulmonary sarcoidosis after inhaling toxins in the dust cloud that day. He died last December and was officially added to the list in June, bringing the tally to 2,753. For now. **JESSE GREEN**

Dragnets
A season of suspicion in Little Pakistan.

→ Candidate Bloomberg takes the 6 train to a campaign event on July 21, 2001.

In the weeks after 9/11, many Arab and Muslim immigrants were awakened in the middle of the night by the sound of FBI agents knocking on their doors. Nationwide, the government imprisoned 762 immigrants, who became known as the "September 11 detainees." Sixty-four percent were from New York City; one third were Pakistani. None was charged with terrorism-related crimes, although most were deported for violating immigration law. In November 2001, Attorney General John Ashcroft called for the interrogation ("voluntary interviews" in Department of Justice parlance) of up to 5,000 immigrants from countries known to harbor terrorists; five months later, the department announced plans to question 3,000 more Arabs and Muslims.

In New York City, no neighborhood was harder hit than Brooklyn's Little Pakistan. Before 9/11, Mohammad Razvi owned a 99-cent store on Coney Island Avenue, Little Pakistan's main street. After 9/11, the area became a ghost town. While some residents had disappeared into immigration jails, many more left the city on their own, fleeing to Canada or back to Pakistan. And after the federal government announced its "Special Registration" program in 2002—which required male visa holders from Pakistan (and 24 other countries) to be photographed, fingerprinted, and questioned—there was a second exodus.

Razvi eventually sold his store and opened a non-profit called COPO across the street, giving the neighborhood free legal help. Today his office doubles as a sort of unofficial museum. A red plastic inmate bracelet sits on a side table, once worn by a college student wrongly detained in a New Jersey jail. He keeps a white binder stuffed with post-9/11 surveys of area residents. A 13-year-old girl wrote, "This lady called me a terrorist and made killing signs." And on Razvi's desk, he has the business cards that were left in doorways all over the neighborhood, each with same job title: FBI Special Agent. **JENNIFER GONNERMAN**

E

Election, Mayoral
How America's Mayor created New York's mayor.

"Bullshit," Mike Bloomberg said. The televisions inside Bloomberg campaign headquarters had been showing smoke and fire billowing from the World Trade Center's North Tower for fifteen minutes. Now a plane smashed into the South Tower, and a news anchor wondered whether there had been a disas-

2011

It took years to get the death toll right.

For the tenth anniversary of the attacks, *New York* produced an issue called "The Encyclopedia of 9/11." Jesse Green, in "The Accounting of the Dead," reported that 40 percent of the 2,753 victims left no remains to be found. They had been, in the chilling description of the chief medical examiner, "vaporized."

213

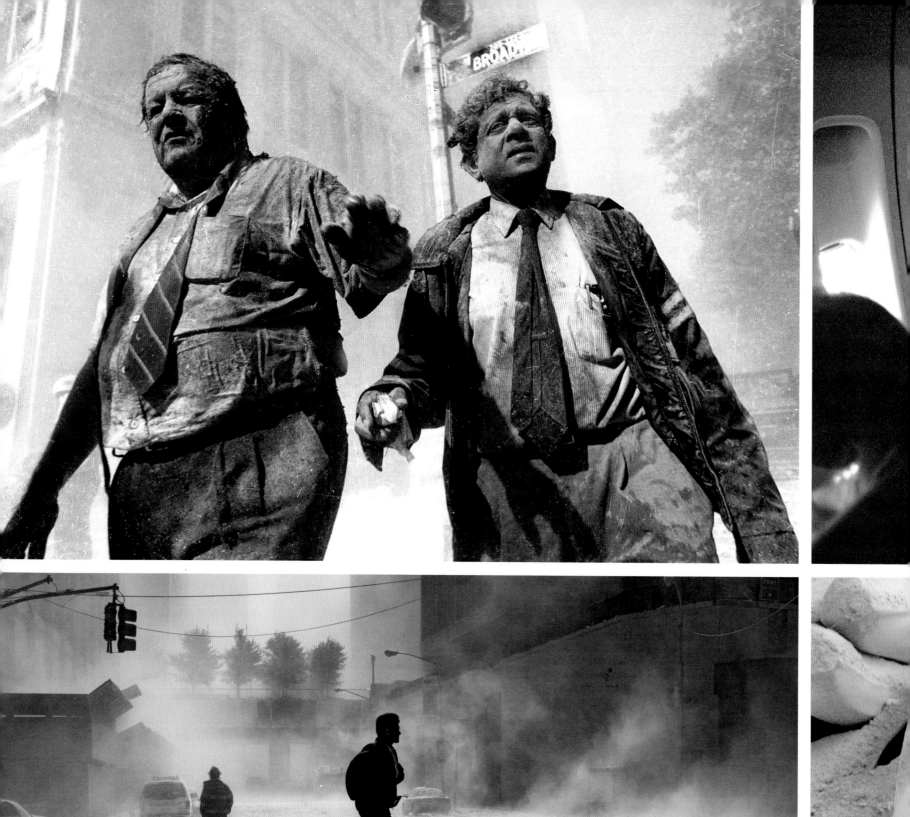
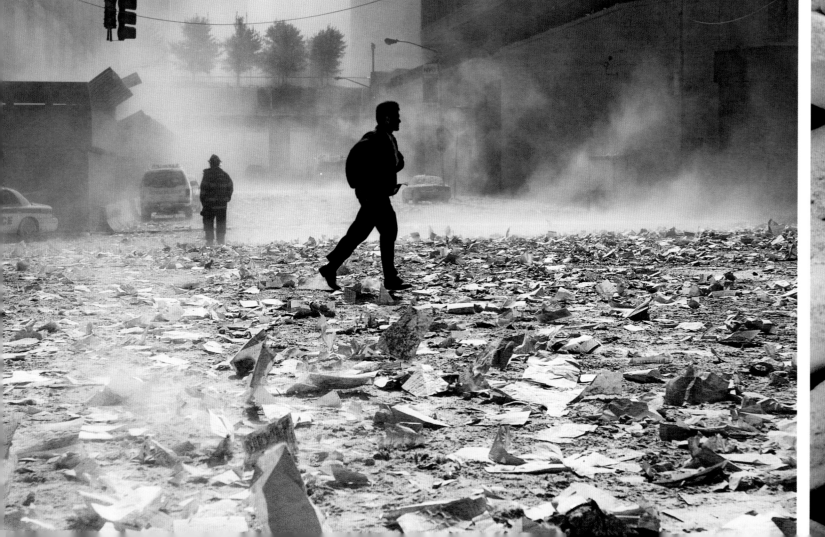

2001

Concrete dust and paper and ash covered everything.

Research for "The Encyclopedia of 9/11" revealed a huge number of unpublished images. Photo director Jody Quon soon realized why: 2001 had been the last major news event before digital photography superseded film, and the preponderance of photos made that day hadn't been processed right away. By the time the film had been developed, the needs of the media had changed, and the pictures had gone straight into the drawer.
PUBLISHED IN *NEW YORK* IN 2011

215

CRISIS: SANDY

EXCERPT: NOVEMBER 12, 2012

It wasn't even a hurricane by the time it got to New York Harbor, and it still brought Manhattan to its knees.

The City and the Storm

By John Homans

FOR THOSE WITHOUT POWER, the days after Sandy were a strange interregnum, a kind of shadow life. It turned out that what we were waiting for right before the storm was…waiting, which was its own special kind of suffering. It was the calm after the storm, and calm is not why New Yorkers live here. Without electricity, the whole point of New York seemed to fray, then disappear. New Yorkers live with the illusion that you can do anything in the world that you might possibly want to do, even if in fact you may pass out on your couch. And the absence of phones and internet further cut our ties. In New York, many of us live partly vicariously. We're image processors, symbol manipulators. Things that happen elsewhere are evaluated and reworked and sent back out. After the gusts, there was a sense of airlessness, which was the absence of information. Cell phones drained to 45 percent, then 37, then 8, a metric that augured the end of connection itself. "It's almost like you're dead," said a downtowner. "The people are trying to contact you, but you're beyond all that now."

With nowhere to go, the pace slowed down. Downtown was populated by walkers in groups of two to three, ambling like hayseeds—or extras in *The Walking Dead*—looking for an open deli, of which there were only a few, to be browsed in the dark with a flashlight. Suddenly, downtown was not the place to be.

Because life was going on elsewhere. Uptown, they had lights and cell phones and coffee and web service and delis and restaurants. They could live like New Yorkers, like human beings. Rumors filtered down from this paradise, rubbing it in. But making the trek uptown could be disappointing.

The borderland is not the most appealing of neighborhoods in the best of circumstances. But at the dividing line between darkness and light, residents of SoPo (newly coined, for South of Power) engaged in a hellish 10 a.m. scramble for coffee and bagels, or queued up in long lines for Korean-deli steam tables, as the morning patrons of Muldoon's on Third Avenue had their smokes and watched. The most desperate search, of course, was for outlets to charge cell phones. A couple of days in, the always trendy Ace Hotel took pity on these poor refugees and ran power strips onto the sidewalk—attracting a kind of information bread-line. In the West Village, people lined up with their phones on the waterfront, trying to catch a signal from New Jersey.

A bit gallingly, downtown's most foresighted and well-heeled swells had already relocated uptown. Graydon Carter and Anna Wintour, among others, were said to have taken up residence at the Mark; a lot of the younger crowd, led by Emma Watson, were at the Carlyle. Uptown was the new downtown. On Halloween Night, Bemelmans was packed.

Lower Manhattan, rather than the ultimate destination, became a place to go through to get somewhere else, as the enormous traffic jams attested. Downtown was driveover country. At night, it seemed to be a natural landscape, a dark canyonland, gorgeous and lonely. As in all New York disasters, New Yorkers weren't strangers anymore. Out surveying the damage with flashlights, people stopped to talk in tones of hushed amazement. Neighbors needed food and news. Just as with 9/11, the community of New York, always present, was brought into the open.

In some ways, Sandy confirmed our communitarian values, underlining the importance of a government that makes a point of helping out—and that global warming was a problem to be dealt with. (Chris Christie even precipitously switched presidential-candidate best friends.) But no New Yorker can stay a sentimentalist too long. It didn't take much time before the complaints and bickering began, and everything turned darker as the real misery became more apparent. The death toll kept rising as searchers pushed into the worst-hit areas—it stood at 100 people as of Friday—and some lost everything, over 100 houses in Breezy Point alone. And the city was not exactly overwhelmed with rescue workers and Red Cross trucks. Fury mounted with every hour that electricity and heat and food failed to arrive. In Alphabet City, in Red Hook, out in Staten Island, there were people who needed to fill buckets from hydrants, or scrounge from Dumpsters. By the end of the week, it was clear who was suffering and who had been merely inconvenienced. The news from the outer-boroughs was especially grim; people were fighting over gasoline; scenes from *The Road*.

The images of water pouring into subways and banks, cars submerged on Avenue A, escalators that needed to be ridden with scuba equipment, brought to mind an apocalypse of a specific kind, another lost city—Atlantis. Was this what New York could become?

It's hard to remember, a decade after 9/11, how fragile downtown seemed then, and how long it struggled. But one of the many differences between that event and this one is that, for all the struggle, no one doubted for a moment in the months after 9/11 that New York was at the center of the world, which was a consolation, reinforcing the amour-propre that is a city hallmark. Out-of-towners were solicitous for years afterward. Whereas by Thursday of last week, Los Angelenos were already complaining about not getting their calls returned.

One of the ways to look at a natural disaster is as a test, a challenge to be met, and by these measures, New York City was succeeding. By week's end, normalcy was being returned—if not yet those L.A. phone calls. The arguing over the marathon was a healthy sign: not could we, but should we? The world should have such troubles.

But for hundreds of years, the harbor had given New York its power. In less than 24 hours, it took it away. As we are reminded more and more often these days, it doesn't take long to turn everything on its head. ∎

NEW YORK

The City and the Storm

Starting on p.17

5
LIVING

"Suddenly, everything is stainless steel."

Cover line, interior-design issue, 1996

New York apartments are impossible.

THEY ARE TOO SMALL, too hot, too old, and ridiculously expensive—and people will kill to hang on to one. Even in the New York of 1968, when planners were saying the entire idea of the metropolis was obsolete, a certain type of slightly crazy city person would go to extremes to carve out a living space here. And not just to make it tolerable—to make it interesting, expressive, comfortable, beautiful, and sometimes delightfully strange. New Yorkers established many home-design trends that the rest of the country then adopted: the home kitchen with commercial fittings, the hard-edged '80s look known as high tech. It was here, in the beat-up spaces below Houston Street, where artists and gallerists discovered that a 19th-century factory floor, with giant windows and high ceilings and rough brick walls, made a fantastic 20th-century home and studio. Today, in cities like Houston and Phoenix, developers build fake 19th-century factories and advertise "loft living" as the ultimate in sophistication. Their version, however, has central air conditioning. ¶ A lucky few New Yorkers get to live the fantasy of a deluxe apartment in the sky. Nearly everyone else imagines a version of that ideal, braces for the worst, and ultimately settles for something in between, with a hope that the radiators don't knock all night. A nice place in a nice neighborhood has never been cheap. If you want more space for less money, the solution is simple: expand your definition of "nice neighborhood," and be willing to cross a river. Even as the loft boom was barely getting started, *New York* published a prescient piece by Pete Hamill in the summer of 1969. "Brooklyn: The Sane Alternative" offered the astonishing observation that Manhattanites were beginning to buy up and renovate old houses in the slum known as Park Slope. A pretty good brownstone, he noted, could be had for less than $30,000. If you were smart enough to follow Hamill's lead—and not just in Park Slope; *New York* appears to have published a buyer's guide to every single "emerging neighborhood" that ever emerged—you could now sell that same house for roughly a 10,000 percent profit.

1968

Even when everyone seemed to be fleeing the city, finding a place to live in New York was still hard.

According to *New York*'s co-founder Milton Glaser, this issue—though its cover printed horribly, all muddy and out of register—marked the week he and his colleagues figured out much of what *New York* would become: a mix of fine-grained social observation and useful service journalism.

SEPTEMBER 30, 1968 40 CENTS

NEW YORK

What Does It Take to Get a Decent Apartment In the Year of The Great Apartment Squeeze?

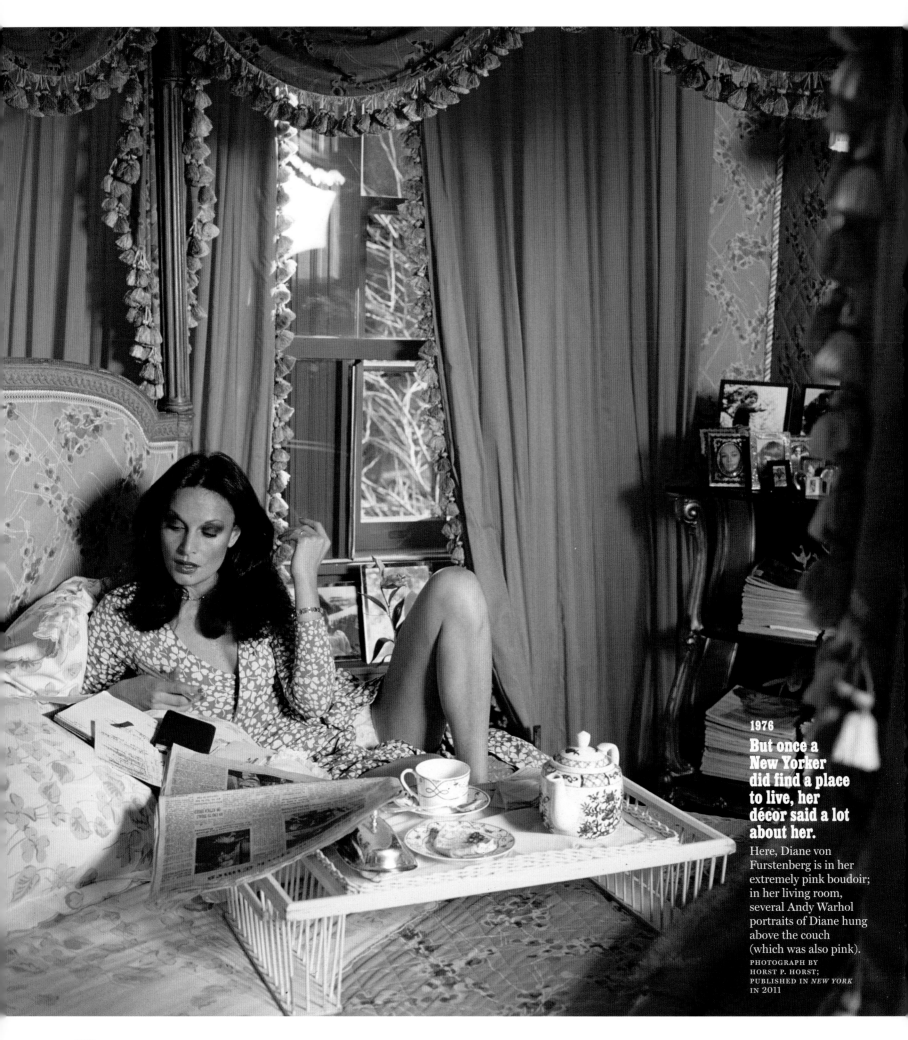

1976
But once a New Yorker did find a place to live, her décor said a lot about her.
Here, Diane von Furstenberg is in her extremely pink boudoir; in her living room, several Andy Warhol portraits of Diane hung above the couch (which was also pink).
PHOTOGRAPH BY HORST P. HORST; PUBLISHED IN *NEW YORK* IN 2011

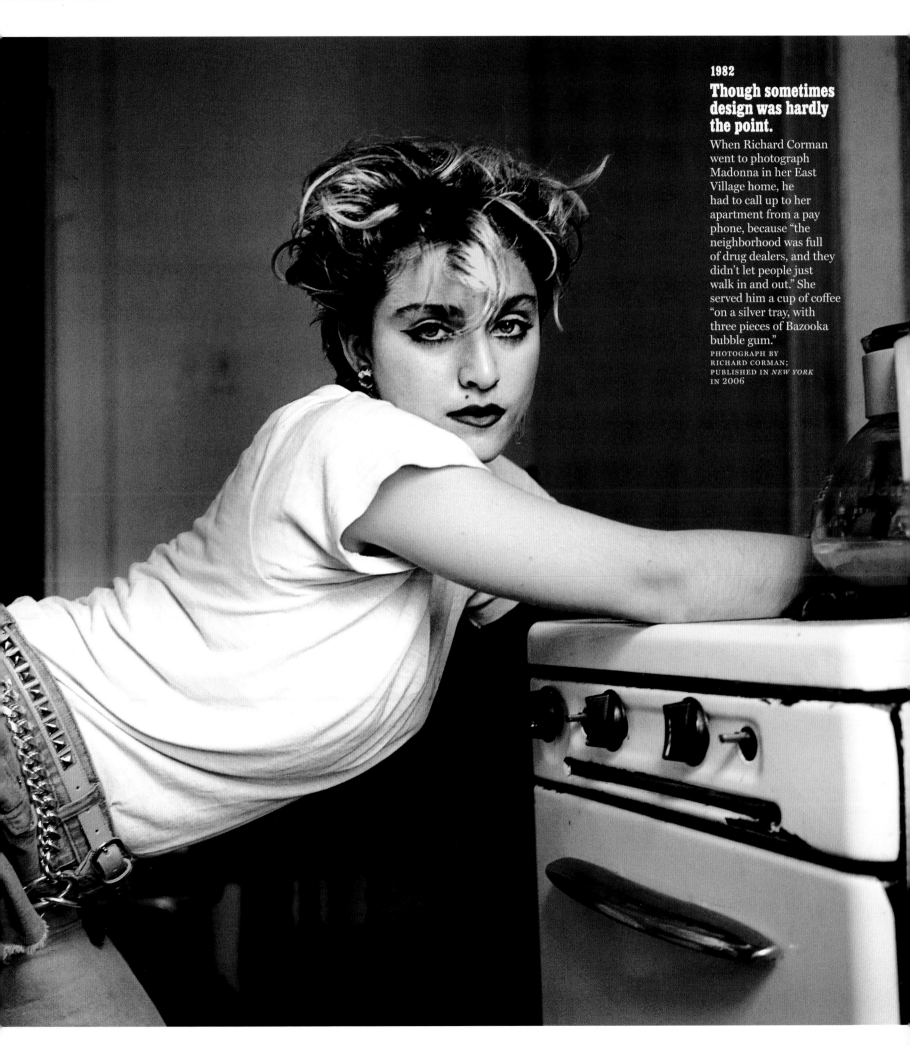

1982

Though sometimes design was hardly the point.

When Richard Corman went to photograph Madonna in her East Village home, he had to call up to her apartment from a pay phone, because "the neighborhood was full of drug dealers, and they didn't let people just walk in and out." She served him a cup of coffee "on a silver tray, with three pieces of Bazooka bubble gum."
PHOTOGRAPH BY RICHARD CORMAN; PUBLISHED IN *NEW YORK* IN 2006

1977

For those seeking a certain kind of city glamour, "prewar" became a magic word.

When it was new in 1904, the Ansonia apartments had a farm on the roof offering fresh eggs to its well-off residents. By the 1970s, the building was a dowager empress, with bad plumbing in the walls and a sex club in the basement (see page 107). Its unfamous residents, as this story made clear, were crazy about it anyway. Since then, it's gradually regained much of its splendor, and the pipes have been fixed.

PHOTOGRAPHS BY
HENRI DAUMAN

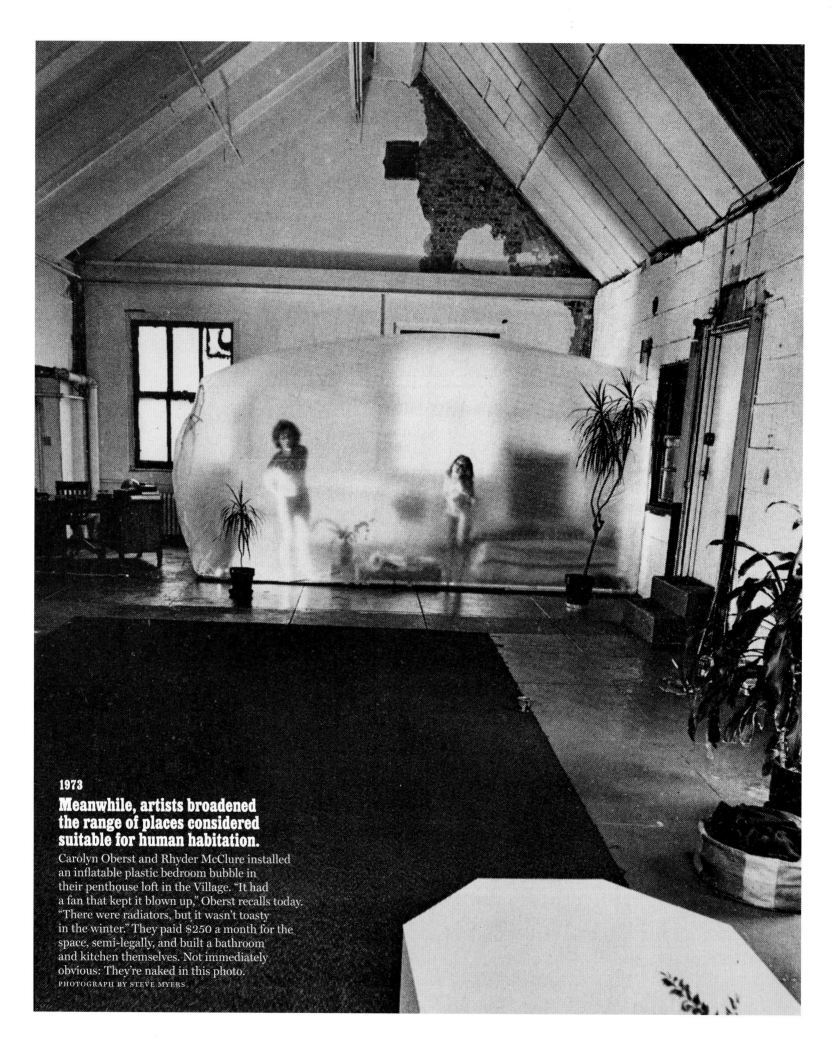

1973

Meanwhile, artists broadened the range of places considered suitable for human habitation.

Carolyn Oberst and Rhyder McClure installed an inflatable plastic bedroom bubble in their penthouse loft in the Village. "It had a fan that kept it blown up," Oberst recalls today. "There were radiators, but it wasn't toasty in the winter." They paid $250 a month for the space, semi-legally, and built a bathroom and kitchen themselves. Not immediately obvious: They're naked in this photo.

PHOTOGRAPH BY STEVE MYERS

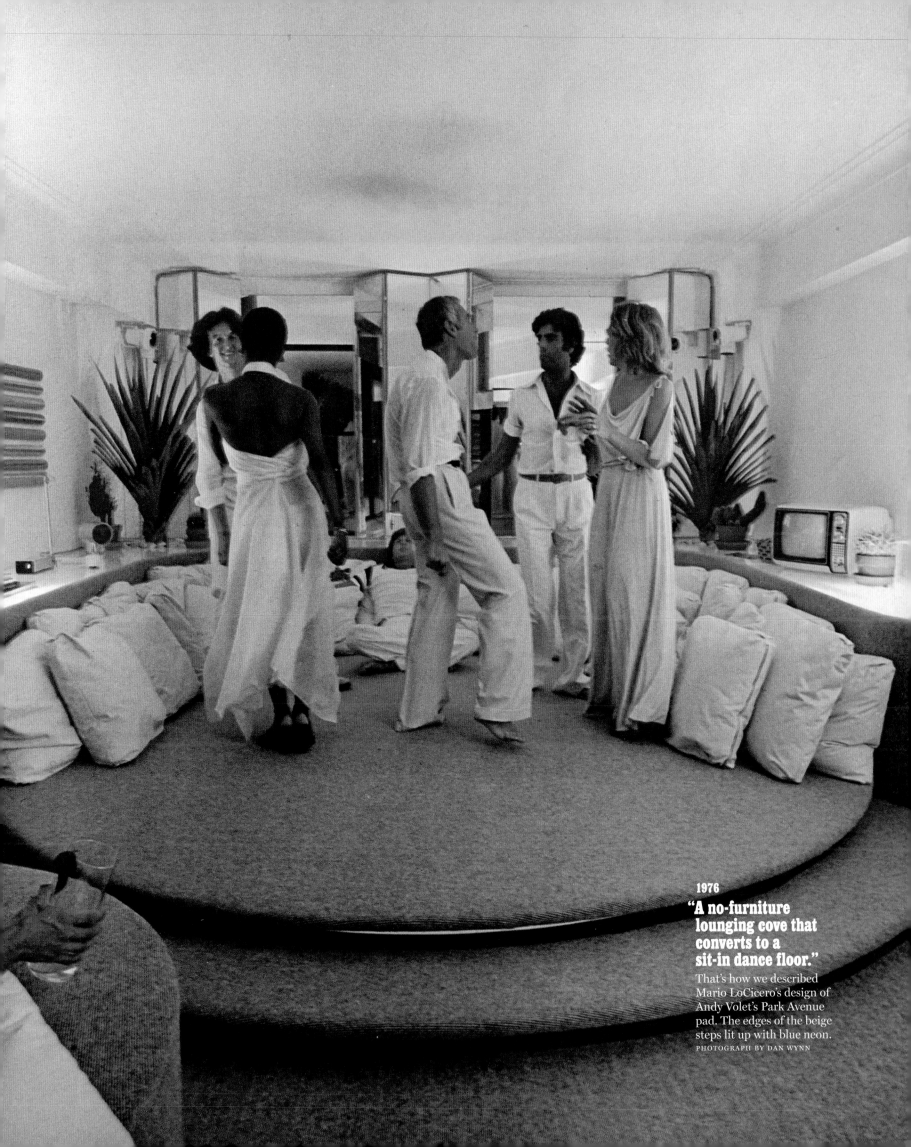

1976

"A no-furniture lounging cove that converts to a sit-in dance floor."

That's how we described Mario LoCicero's design of Andy Volet's Park Avenue pad. The edges of the beige steps lit up with blue neon.

PHOTOGRAPH BY DAN WYNN

1972–1976

Apparently someone on the editorial staff was really into houseplants.

Yes, fern bars and potted palms were popular décor choices in the 1970s. It's still a little hard to understand why they merited six magazine covers in five years.

1975

Also cats.

Opposite: "The Only Perfect Relationship in This Fickle World" was the headline on this photo feature about New Yorkers and the felines who own them. That's the sculptor Louise Nevelson at top right, holding Fat-Fat.

Walter Hickel.

Walter Hickel.
Owner: Dr. Mark Kac, mathematician.

Walter (left) has, like his namesake, very few friends in high places. Professor Kac's daughter has refused to have anything to do with Walter Hickel ever since he bit her husband. Dr. Kac likes him fine, though: "I like cats because they don't adore me. Dogs make me feel guilty because they always seem to think I'm a far better person than I am."

Catty Corners
Fat-Fat.
Owner: Louise Nevelson, sculptor.

Ms. Nevelson (right), admires cats' "beauty and elegance." Fat-Fat likes to sit in the nooks of Ms. Nevelson's sculptures and he is allowed to roam through her SoHo house, because "he knows not to disturb me when I'm at work."

Cat Nips
Mitten Drinen and Tina Too.
Owner: Betty Lee Hunt, theatrical press agent.

"People tell me I have the most refined cats in the city," says Ms. Hunt (below) of ten-year-old Mitty and Tina, her nine-year-old Siamese. "They come running at the sound of a champagne cork popping. Usually, they'll play with the cork, but if they walk away, I won't drink the stuff."

Lady and the Tigger
...er.
...er: Barbara Gelb, ...er.

...like dogs, too," says ...Gelb (above), "but I ...ose we got Tigger be- ...e cats are so much easier ...e care of. Basically, we ...him because we've had him so long, although one can't help admiring cats for their grace, humor, and aloofness. Now that our children have grown up, however, he's much more sociable. Jason Robards once had a long conversation with him—it's a monologue, of course, but we have it all down on tape."

Person to Purrson
Maurice, Ollie, and Bernie.
Owner: Dan Greenburg, writer.

Mr. Greenburg reports: "Pictured at left are Maurice, Ollie, Bernie, and Dan Greenburg. Maurice, age three, is orange. Ollie and Bernie, age ten, are black and white. Dan, age 38, is the one who is not wearing contact lenses. All are frequent contributors to the 'New York Magazine Competition.' Maurice, weary of being mistaken for a TV actor with a similar name, has no theatrical aspirations. He is, however, fascinated by draining tubs and flushing toilets and hopes to be a plumber when he grows up. The Greenburgs are shown in accurate scale. Maurice weighs 324 pounds and wins most family disputes."

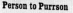

Kit and Caboodle
Consuelo.
Owners: Pegeen and Ed Fitzgerald, WOR radio talk hosts and animal adoption specialists.

Mr. and Mrs. Fitzgerald own 39 cats, fourteen deer, eleven raccoons, two red foxes, and three skunks. Every year they place some 3,000 orphaned and abandoned dogs and cats and even horses in good homes. All of their animals live year round in and around the Fitzgeralds' log cabin in Kent, Connecticut, but each week the couple bring four cats (all the cats take turns) to Manhattan. Consuelo, pictured below, is an albino and must be watched carefully because her eyes swell if she is exposed to bright sunlight for any length of time.

Name Dropping
Puttsie and Puttsie.
Owner: Frances Stellof.

And Baby Makes Three
Luisito and Baby.
Owner: Elaine Kaufman, ...

SoHo's Loft Generation

Louis Pruitt, Greene Street

Gerhardt Liebmann, West Broad

Esteban Emilio Fernandez, West Broadway

Ken and Louise Ewers, West Bro

Georges Noël, Greene Street

Vivian Browne, West Broadway

The pioneers weren't lonely for long.

By the time this story ran in 1970, residents in Soho were already beginning to feel real-estate pressure: Their formerly quiet enclave had been "discovered," and the better-off professional classes were eyeing their living and working spaces. In the new millennium, a big loft became not a discovery but a luxury, and Tribeca, just to the southwest of Soho, became the richest Zip Code in New York.

1983

Out of the Lower East Side's tenements came the new '80s art scene.

Keith Haring lived at 325 Broome Street with his boyfriend Juan Dubose and a roommate, Samantha McEwen. She had to walk through their bedroom to get to hers, so Haring and Dubose slept in a camping tent to maintain a (slight) bit of privacy.

PHOTOGRAPH BY LAURA LEVINE; PUBLISHED IN *NEW YORK* IN 2011

The Three-Room Line: Six Identical Living Rooms

Nothing to Get Excited About

Jeanette Lieberman, a composer and *Newsweek* proofreader, pictured here on her snake sofa with her German shepherd, Kyrie, took this apartment for the dropped living room and what she calls "the bay windows."

Like all the tenants in this series of photos, she said that Barbara Pfeffer changed nothing in the room for the photo.

Lieberman says that the people who lived in this apartment before she did meditated in the living room, and she too felt it was "a very peaceful room." So she made it a place to read and relax. "I kept nothing in the room to remind me of my daily occupation." The bedroom was used for sleep and work. In addition to her desk, her two pianos are here, so as not to disturb her neighbors in the room adjoining her living room.

Something Old, Something Blue

"This apartment has everything I want," says trademark attorney Barbara Dill, who works at Fish & Neave. "It's sunny, quiet, and it has thick walls and a fine kitchen. I wanted it to be a refuge."

She says that all through law school she lived in studio apartments and now she's enjoying the luxury of space for her piano, which she's had since she was a child. She likes to play the piano ("no one ever complains about the noise") and listen to the radio. She gave the TV away because she has "no time for it." She sees TV occasionally at friends' homes.

After this picture was taken she moved the chair and blue sofa to make them more "conversational" (extra guests sit on the floor), and moved the bookcase to the bedroom to make more space. "I feel my place is very feminine; I furnished it to suit myself."

That's Entertainment

The Hutner sisters have lived in this building for 21 years. Rosalind (near right) is administrative assistant to the head of a shirt company. Ada is the retired head of customer relations at the Firth Carpet Company.

Almost every piece of bric-a-brac —ashtrays, match books, pictures, clocks, even miniature liqueur bottles —in the sisters' gold-, pumpkin-, and toast-colored living room was picked up on various trips abroad.

The Hutners' room was designed for comfort, conversation, and entertainment—but not for playing cards. An extension table on the raised gallery can open to seat twelve. Or, "we can have buffets for 30 people," says Rosalind. And when there's no company, the sofa is a perfect spot for watching the swivel-TV.

The furniture is never rearranged for company. If a guest wants to pull up a chair, "it's his privilege."

Turkish Delight

Linda Güyer, a former foreign-exchange dealer, and her husband, architect Cengiz Güyer (pictured with son Shan), like old buildings. "A lot of people don't like East Side boxes," says Mrs. Güyer. "I like these old moldings. It's virtually soundproof here. And there are only about fifteen buildings in New York that have these dropped living rooms."

Mrs. Güyer describes her décor as "poverty modern. We built the couches and I made the drapes. It's all homemade and very cheap. Poverty patchwork and African batik. The rugs are Turkish kilims"—because her husband is Turkish—and kilims are "a poor man's craft." For their frequent extra guests, dining chairs do double duty. When the Güyers' ship comes in, "we'll stick to primitive design." Meanwhile, they are moving to Virginia, and this apartment has already been rented for $348.

Eat Your Heart Out, Bloomie's

Jill Paperno, an independent producer of TV commercials, such as Jungle Habitat's, took this apartment for the southern exposure and the "clear view for five blocks." She and singer / songwriter / guitarist Roland Parkins (he wrote "The Sludge") use the sunken living room for music and entertainment. And downstairs neighbor Barbara Pfeffer complains constantly about the noise. They keep adding extra padding to the piano's keyboard. Jill says proudly, "There is nothing in this room from Bloomingdale's. I try never to buy anything new. Old furniture is warmer and seems to last longer." They used to have the couch facing the mirrors, but people couldn't stand facing themselves "so we turned it around," she says. The TV is in the bedroom because, she says, "I don't like to watch TV with company." "It's crude," adds Roland.

Space Exploration: Global Décor

Free-lance photographer Barbara Pfeffer rented this apartment because of its European feeling (all the living rooms are dropped two steps) and because it could accommodate her concert grand piano. "Where I go, my piano goes," says the former professional pianist.

Pfeffer is a perfect example of her own theory that "we express ourselves by the way we use space." Her space wasn't planned, she says. "Very little has been bought purposefully." The Oriental rug was a gift from her mother. And most everything else was picked up in her travels—"tsatskes from everywhere." The mirror frame is from Mexico. The coffee grinder was a gift that came from a Bedouin in Israel.

But recently Pfeffer's place has become less crowded—expressing something new: "I have a longing for a great deal more space."

1976

Everyone was curious about the neighbors.

A story perfectly suited to a city of high-rises: What do six vertically stacked tenants do differently with their identical rooms? The photographer, Barbara Pfeffer, was motivated by professional interest but also nosy-neighborness; it was her building, and her living room is the one at bottom right.

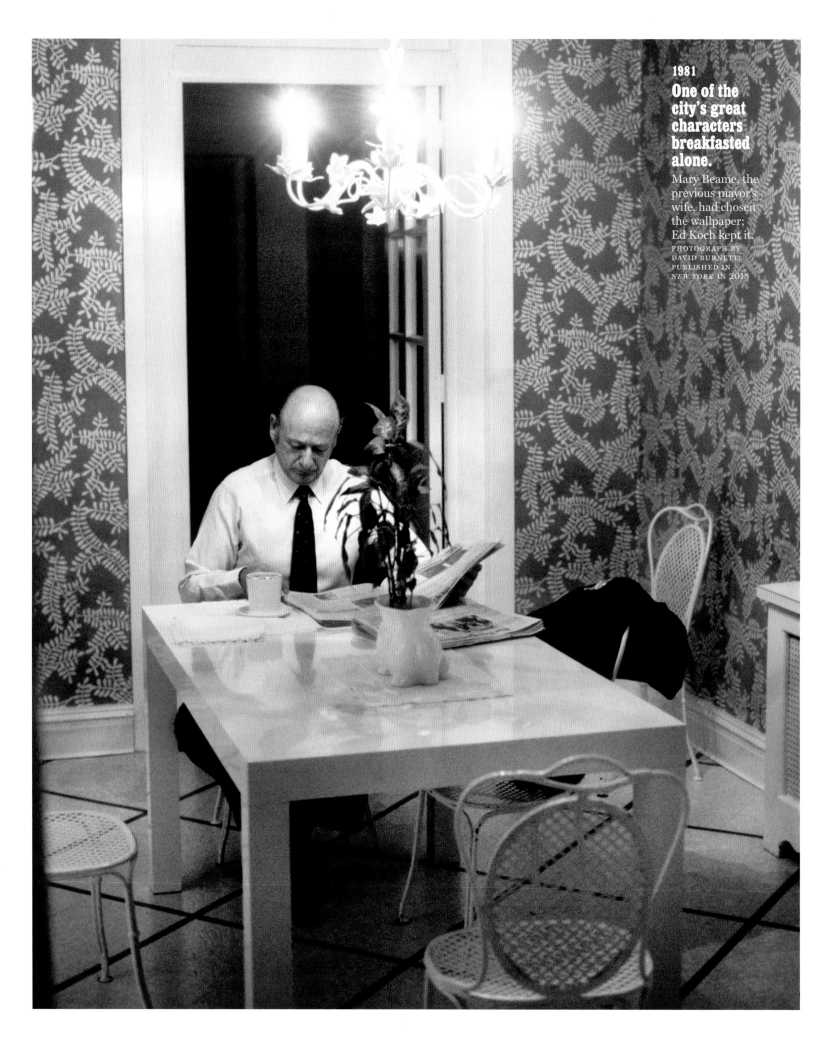

1981
**One of the
city's great
characters
breakfasted
alone.**
Mary Beame, the
previous mayor's
wife, had chosen
the wallpaper;
Ed Koch kept it.
PHOTOGRAPH BY
DAVID BURNETT;
PUBLISHED IN
NEW YORK IN 2013

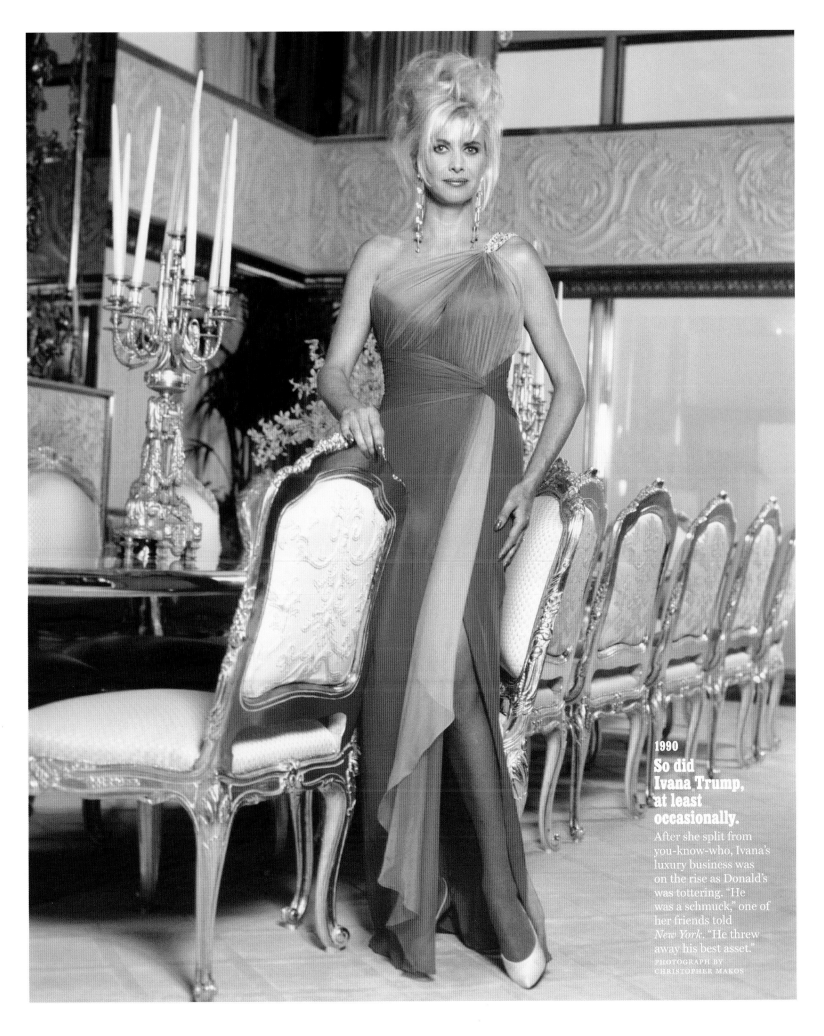

1990
So did Ivana Trump, at least occasionally.
After she split from you-know-who, Ivana's luxury business was on the rise as Donald's was tottering. "He was a schmuck," one of her friends told *New York*. "He threw away his best asset."
PHOTOGRAPH BY CHRISTOPHER MAKOS

239

Discovering the next new neighborhood before the prices went up became an obsession.

Now the reason the artists came to SoHo in the first place was that it was ignored and cheap. It is no longer ignored, and soon it will not be cheap.

Long Island City's industrial skyline an eyesore, these publishing executives revel in the sight. With its underutilized waterfront, postcard view of the Manhattan skyline, low property values, and the best transportation in the city, Long Island City just has to take off, or so these men think. Plainly, *something* is happening in Long Island City. It's time to buy in. Next week they're going for a drive with some of their backers.

One of them whispers, "It's like an oil field."

In 1980 it was
Long Island City.

In 1992 it was
Williamsburg.

"In the seventies, it was SoH East Village. In the nineties, it

Hell's Kitchen

In 2001 it was
Hell's Kitchen.

Now that Chelsea and the Upper West Side have been thoroughly digested by the forces of gentrification, brokers and developers have been elbowing one another for a piece of this rent-regulated working-class stronghold. Along Eighth Avenue, residential towers are springing up like wildflowers, housing people who work in the new Times Square office district. Restaurants such as Esca and

In 1984 it
as **Harlem.**

tate columns from the Upper West and Lower East Sides to the once shunned blocks north of 96th Street. Speculators are buying up battered Harlem buildings, confident that renovations there will soon command the high prices that have been creeping steadily northward. The occasional lottery sales of city-owned buildings in the area draw many more would-be homeowners than the shabby offerings could satisfy.

TriBeCa/Manhattan

The rather desolate stretch of warehouses and onetime produce marts on Manhattan's lower West Side has sprouted the fashionable loft community of TriBeCa—6,000 people strong by the latest census. Police rate TriBeCa (shorthand for "triangle below Canal," the section between Canal and Chambers, Broadway and the Hudson River) one of the most secure downtown neighborhoods, with very few assaults involving residents and comparatively low burglary and robbery rates. (The bulk of the area's crime takes place on heavily trafficked commercial fringes like Church Street and West Broadway.) In fact, the only homicide police and residents can recall was the 1978 street murder of a Scottish fashion designer by two youths on a crime spree through lower Manhattan. "Not too many people even know about this area, and we'd love to keep it that way," said a smiling cop patrolling the district.

band, who was in Chicago, and said, "We bought a house."

I responded in a professional manner: "When? Where? *Why?*"

"In Clinton Hill," she said.

"You've got to be kidding," I replied, but it has worked out for the best. The neighborhood is not only beautiful but determinedly interracial, middle class, and safer than we had any right to hope. The trek to Manhattan isn't nearly as bad as we feared; some of our more adventurous old friends even cross the bridge to visit us.

In 2002 it was
"North Chelsea."
(Huh?)

THE PRICE IS RIGHT: North Chelsea (the flower district, newly renamed Chelsea Heights) has for decades been the place for wholesale foliage; now it's becoming a place to put down roots. "Some people think I'm crazy moving into this neighborhood because they don't see what it's going to be in three years," Gregrey says. Gourmet groceries and pharmacies and laundromats are popping up between old factories—it's like SoHo in 1979, or the Flatiron district in 1989. "This area represents

In 1986 it was
Clinton Hill.

," he says. "In the eighties, the ill be Williamsburg."

In 1982 it
was **Columbus
Avenue.**

opening every week. And not only the pace but the scale of development has accelerated. The expensive goods have drawn an expensive crowd, which has encouraged landlords to raise rents, which in turn have drawn big-league investors who make the "pioneers" of only five years ago seem amateurs. What started quaint is growing increasingly slick. Like it or not, Columbus Avenue has come of age.

In 2005 it was
**Prospect–Lefferts
Gardens.**

something "more surprising." Instead, he and his partner, interior designer John Loecke, bought a four-story, $675,000 Tudor in Prospect–Lefferts Gardens.

For years, Manhattan expats have been creeping around the edges of Prospect Park, from the Slope into Kensington and Prospect Heights. Now the eastern edge of the park—Prospect–Lefferts Gardens, a neighborhood few of them had probably heard of till recently—is fair game. "It's become a destination for Manhattanites," agrees Aguayo & Huebener associate broker and local resident Mark Dicus.

In 1981 it was
TriBeCa.

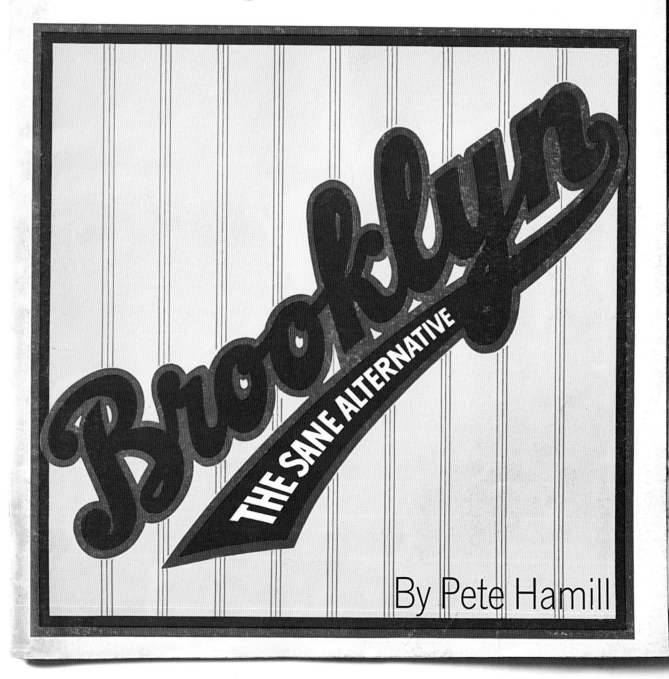

Cheap Brownstones/Friendly Natives/Lush Parks
Only 15 Minutes from Broadway
Live the Good Urban Life Without Going Crazy

40 CENTS

JULY 14, 1969

NEW YORK

By Pete Hamill

1969
The magazine discovered Brooklyn...
(See the following pages for an excerpt from Pete Hamill's story.)

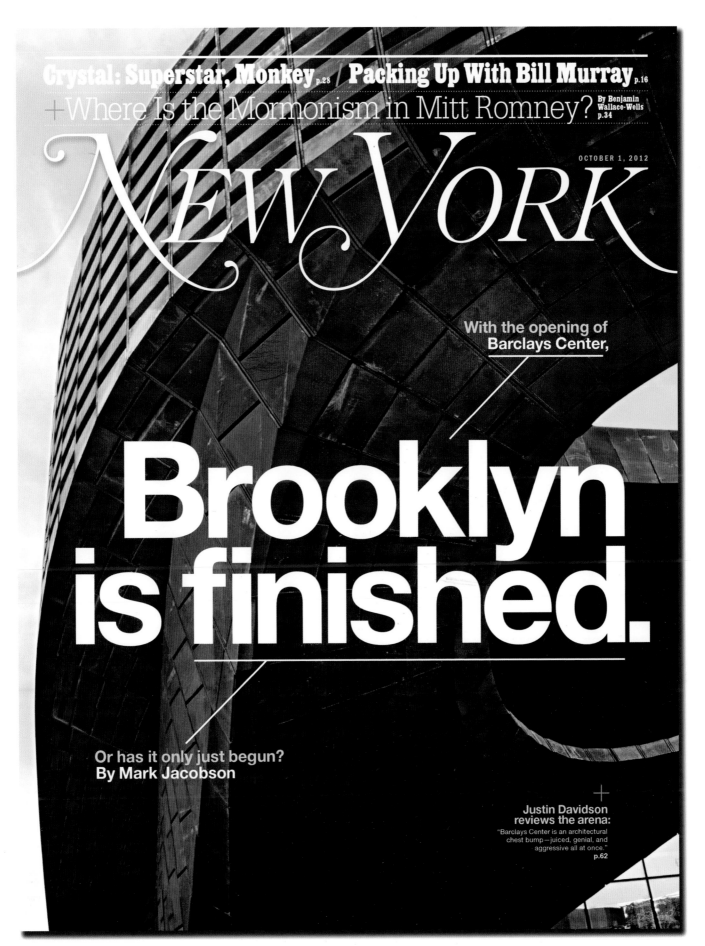

OCTOBER 1, 2012

NEW YORK

With the opening of
Barclays Center,

Brooklyn is finished.

Or has it only just begun?
By Mark Jacobson

+

Justin Davidson
reviews the arena:
"Barclays Center is an architectural
chest bump—juiced, genial, and
aggressive all at once."
p.62

2012
... And then declared it over.
Or at least that its transformation was complete.

In 1969, Pete Hamill—who had grown up in Park Slope when it was run-down and blue-collar—noticed, with some surprise, that new professional-class people were moving there to put down roots.

Brooklyn: The Sane Alternative

By Pete Hamill

THE BROOKLYN I CAME HOME to has changed. For the first time in 10 years, it seems to have come together. In Park Slope, people like David Levine, Jeremy Larner, Joe Flaherty, Sol Yurick have moved into the splendid old brownstones; the streets seem a bit cleaner; on some streets, citizens are actually planting trees again, with money they have raised themselves through block associations and block parties. Art galleries are opening.

Neighborhoods like Bay Ridge and South Brooklyn now have boutiques and head shops. People who have been driven out of the Village and Brooklyn Heights by the greed of real-estate operators are learning that it is not yet necessary to decamp for Red Bank or Garden City. It is still possible in Park Slope, for example, to rent a duplex with a garden for $200 a month, a half-block from the subway; still possible to buy a brownstone in reasonably good condition for $30,000, with a number of fairly good houses available for less, if you are willing to invest in reconditioning them. Hundreds of people are discovering that Brooklyn has become the Sane Alternative: a part of New York where you can live a decent urban life without going broke, where you can educate your children without having the income of an Onassis, a place where it is still possible to see the sky, and all of it only 15 minutes from Wall Street. The Sane Alternative is Brooklyn.

Impressions can be backed up by any number of statistics. In a study called "The Next Twenty Years," the New York Port Authority predicts a 7.7 percent growth in jobs by 1985, while the population will grow at only 2 percent. The median income ($5,816) is still $175 less than that in Manhattan; but the median age of the 2,627,420 citizens is 33.5, lower than New York City's as a whole (35) and lower than the median (34) in the metropolitan region that includes Westchester, Rockland, Nassau and Suffolk Counties. But no set of statistics can adequately explain what has happened to Brooklyn in the years since the end of the Second World War. They don't explain its decline. They don't explain its renaissance.

YOU STILL CANNOT get a taxi to take you from the Village to any neighborhood remotely near Bed-Stuy. But the borough has halted its own decline, stopped, brought the panic and the despair almost to an end.

Again, the reasons are complicated, and have certain emotional roots. The wound of the Dodgers' departure seems finally healed; the arrival of the Mets gave the old Dodger fans something to cheer for, and there are no more of the old Brooklyn Dodgers now playing for the Los Angeles team. Baseball itself has declined in interest: it's slow, dull, almost sedate these days, especially on television. Pro football excites more people in the Brooklyn saloons, and it is a measure of the anti-Establishment, anti-Manhattan feelings of Brooklynites that they all seem to root for the Jets (not all, of course, not all, but the romantics do).

Word also began to drift in from the suburbs: things were not all well out there. Those who left Brooklyn because the schools were overcrowded soon found that the schools were also overcrowded in Babylon. Those who fled the terrors of drugs soon found that there were drugs in Rahway and Red Bank and Nyack too, and that flight alone would not avoid that peril. There was cultural shock. A childhood spent leaning against lampposts outside candy stores could not be easily discarded, especially on streets where there were no candy stores, where the bright lights did not shine into the night, where the laughter of the neighborhood saloon was not always available. People started longing for the Old Neighborhood. "These people can't even make a egg cream right." "I tried to get a bits-eye-oh out here an' it tastes like a pair a Keds." When I would go out to California on various assignments, I learned that I would be serving as a courier from the Real World; guys who had gone out to Costa Mesa and San Jose and L.A. 20 years before wanted me to bring veal, real-thin-honest-to-Jesus veal cutlets so they could make veal Parmigiana the way it is supposed to be made. In the suburbs late at night, people would sit in their living rooms and talk about boxball, devilball, buck-buck-how-many-horns-are-up? (called Johnny Onna Pony by the intellectuals), ringalevio, and always, always,

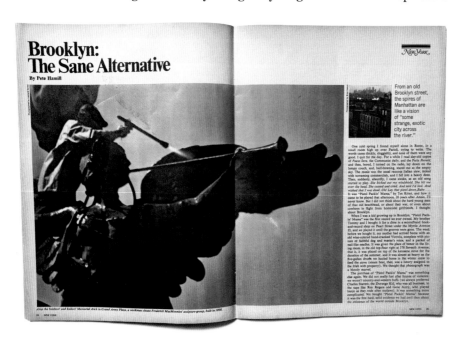

Brooklyn:
The Sane Alternative
By Pete Hamill

From an old Brooklyn street, the spires of Manhattan are like a vision of "some strange, exotic city across the river."

stickball. Remember the time Johnny McAleer hit three spaldeens over the factory roof? Or the time Billy Rossiter swung at a ball, the bat flew out of his hands, hit an old lady on the head, and went through the window on 12th Street? Remember the Arrows, and the great money games they had on 13th and Eighth? Nostalgia worked its sinister charms. The Old Neighborhood wasn't much, but it wasn't this empty grub-like existence in the suburbs, struggling with mortgages and crabgrass and PTA meetings and water taxes and neighbors who had never shared one common experience with you. A little at a time, people started to drift back. It was not, and is not, a flood. But it has begun.

For younger people, the suburbs seemed to hold a special horror. If you were a writer, and you were faced with a move to the suburbs, you would rather go all the way into exile: to Mexico or Ireland or Rome. You could not live in the Village or Brooklyn Heights, because the real-estate scoundrels had made those places special preserves for the super-affluent (you could live in those places, of course, but the things you would have to do to afford it would make it impossible to live with yourself). Younger people started looking over the neighboring terrain. They cracked Cobble Hill first, reclaiming a number of fairly good buildings. Then Park Slope started to open up; the boarding houses were bought for as little as $14,000, cleaned out, re-built and re-wired. That was only four and five years ago. Today, the prices are slowly being driven up, and the great fear is that the real-estate people will take over this place too.

The New People, as they are called, saw Brooklyn fresh. They had not known it before, so they knew nothing about its decline. Most important, they carried with them no old emotional wounds. Instead they saw it as a place with great broad boulevards like Eastern Parkway and Ocean Parkway (once, my brother and I walked out Ocean Parkway all the way to Avenue T because we read in the papers that Rocky Graziano lived there; we sat around on benches for hours, but we never saw Rocky, who was the middleweight champion of the world). They know that Prospect Park is a masterpiece of landscape architecture, the park that learned from the mistakes of Central Park, which by comparison is bland and flat, and they know that during the Revolutionary War, George Washington had a command post in its hills (but they've never been inside Devil's Cave, nor did they know what happened in the night in the shrubs along the Indian War Path, and they don't know the spot where Yockomo was shot to death near the Swan Lake by Scappy from South Brooklyn, and they weren't there the night that Vito Pinto dove into the Big Lake at three in the morning and found himself wedged in the mud three inches below the surface, and they never saw Jimmy Budgell come tearing down the horse path on a strawberry roan like one of the Three Musketeers). They saw Brooklyn in a way that we had not seen it when we were young, and they saw it in a way that Brooklyn had not seen itself, perhaps, since the years before the 1898 Mistake. I just wish that they could have been there that afternoon at the now-shuttered 16th Street Theatre, when Tim Lee (now at the *Post*) and his brother Mike were taken by their mother for the usual Saturday matinee of three Republic westerns. At one point, a Superman chapter came on, and Mike Lee stood up and shouted at the top of his lungs: "Hey, Ma! I can see the crack of his ass!" His mother beat him mercilessly with a banana that was part of the lunch, and then took them all home.

The New People are part of the emotional cure. There are other, more practical cures under way. Bedford-Stuyvesant has

been developing its own institutions. Quietly and steadily, the Bedford-Stuyvesant Restoration Corporation, which was started through the efforts of Robert Kennedy, has been working very hard at bringing jobs to the area. IBM has already announced that it will build a manufacturing plant there. Plans are under way to build a new Boys' High. The city has committed itself to building a community college in the area. Through one of the two corporations set up by Senator Kennedy, a $75,000,000 mortgage loan fund has been put together and a job-training program for 1,200 persons is under way. With federal help, three firms (Advance Hudson Mounting and Finishing Co.: Campus Graphics Inc.; Day Pac Industries Inc.) have begun a $30,000,000 project of plant construction that will employ 1,435 people. Say what you will about the Black Panthers, they probably have a small point to make about ghetto businesses owned by whites: through reform of the insurance laws, more and more black businesses are starting in New York, the vast majority of them in Brooklyn.

It seems to me that despite the problems, Brooklyn has become the only sensible place to live in New York. Much has changed since I was a boy, but what the hell. If you consider jars of mixed peanut butter and jelly as the final sign of the decline of a great nation, people my age think the same thing about that modern abomination, the manufactured stickball bat. It is, after all, a terrible thing to deprive a kid of the chance to acquire lore, and the lore of the stickball bat is arcane and mysterious. Nevertheless, on the first day of spring this year, with a high bright sun moving over Prospect Park and a cool breeze blowing in from the harbor, I bought one of the abominations, and a fresh spaldeen, and talked some of the local hippies into playing a fast game. It was the first time I had played since moving away from Brooklyn, and in one small way I wanted to celebrate moving back.

We played in the old skating rink at Bartel Pritchard Square, and the young lean kids with the long hair simply could not hit the ball. They might have been playing cricket. But the first time up, I smacked one long and high, arcing over the trees, away over the head of the furthest outfielder. On the old court at 12th Street and Seventh Avenue, it would have been away over the avenue, at least three sewers, and probably more. Standing there watching the ball roll away in the distance, I realized again that despite all the drinking, sins, strange cities, remorse, betrayals, and small murders, there was still a part of me that had never left Brooklyn, that wanted desperately to stay, that was still 14 years old and playing stickball through long and random days and longing to be a Great Heart. I hoped that Carl Furillo, wherever he was, was shagging flies with an honored antique glove, and hearing the roars in his ears from the vanished bleachers.

The next time up, I grounded out, but it didn't really matter. ∎

Young couples renovating old brownstones could come out a little bruised.

Initial Costs

In order to get legal ownership of your brownstone, you can expect these costs (plus, of course, a 20 per cent down-payment on the house itself). Costs are figured on a house selling for $50,000.

Title Guarantee $800
This involves a title search, to make sure that the seller's right to sell you the house was unencumbered, and title insurance, to protect you against future claims.

Attorney's Fees $500
To navigate you through legal shoals, throw some weight around in obtaining a mortgage, write up the papers and show you where to sign. Usually figured at 1 per cent of cost.

Surveyor's Fee $150
To make sure your property and house are where they're supposed to be, and not three inches over onto someone else's property.

Recording Fee $5
To make public the fact of your ownership.

State Mortgage Tax $200
One-half of one per cent, figured on a $40,000 mortgage (cost of house less 20 per cent down payment).

N. Y. C. Property Transfer Tax $200
Required on all title transfers of property selling for more than $25,000.

N. Y. State Property Transfer Tax @ 55 cents per $500 $55

Mortgage Insurance $150
In case title complications come up, you are covered by Title Insurance; this premium is to protect the bank against the same eventuality.

Total $2,060

They dove in anyway, **budget be damned.**

The house in the cover photo—which had futuristic smoked-Plexiglas bubble windows installed in those oval openings— is on East 71st Street, and **has barely changed since.**

Are Wall Street's Young Millionaires Paid Enough?
By Martin Mayer

40 CENTS MARCH 31, 1969

NEW YORK

The Consequences of Brownstone Fever

Those houses had been unfashionable and neglected for decades, which meant renovations got **expensive fast.**

Later Costs

Here is what it cost one New Brownstoner, after taking possession, to remodel.

Permits (incl. blueprints) and insurance	**$680**
Architect	**$2,100**
Watchman (during construction)	**$80**
Tools	**$220**
Debris removal	**$3,900**
Plumbing	**$10,700**
Electricians	**$3,100**
Painters & paint	**$3,975**
Carpenters	**$11,575**
Roofing and duct	**$1,160**
Supervision	**$5,200**
Masonry supplies	**$875**
Flooring	**$2,550**
Lumber	**$4,085**
Doors	**$1,400**
Stairs	**$410**
Windows	**$630**
Glass	**$120**
Lighting fixtures	**$430**
Kitchen equipment	**$3,960**
Air conditioners	**$1,325**
Medicine cabinets	**$150**
Iron railings	**$825**
Fireplace fixtures	**$310**
Shelving	**$140**
Boiler tank lining	**$125**
Window shades	**$75**
Hardware	**$250**
Locks	**$135**
Tree (has since died)	**$168**
Moving	**$390**
Personal miscellaneous	**$1,790**
Rental ads in N.Y. Times	**$65**
Total	**$62,898**

In 2017 dollars, these costs total up to **$423,105.**

"When new brownstoners move into a neglected block, wallflower homes bloom. Property values go up faster than they went down."

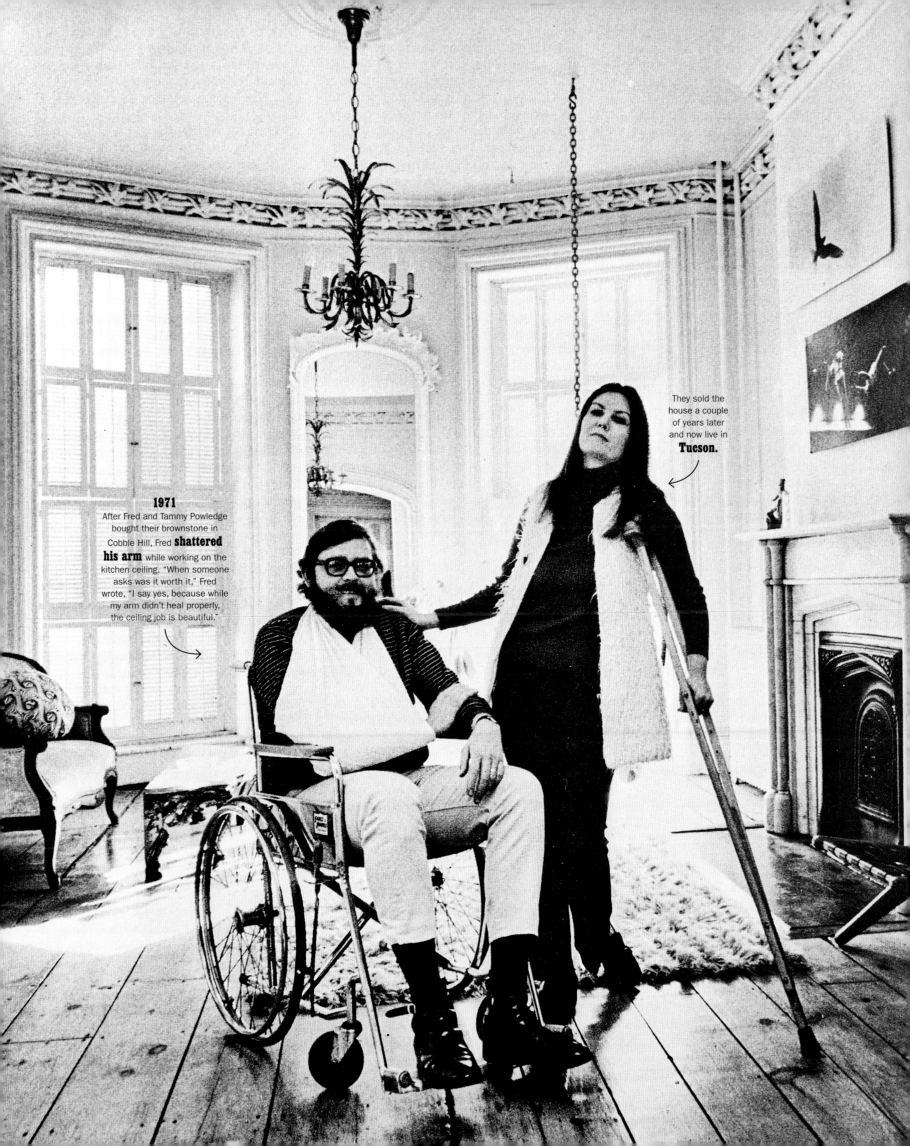

1971

After Fred and Tammy Powledge bought their brownstone in Cobble Hill, Fred **shattered his arm** while working on the kitchen ceiling. "When someone asks was it worth it," Fred wrote, "I say yes, because while my arm didn't heal properly, the ceiling job is beautiful."

They sold the house a couple of years later and now live in **Tucson.**

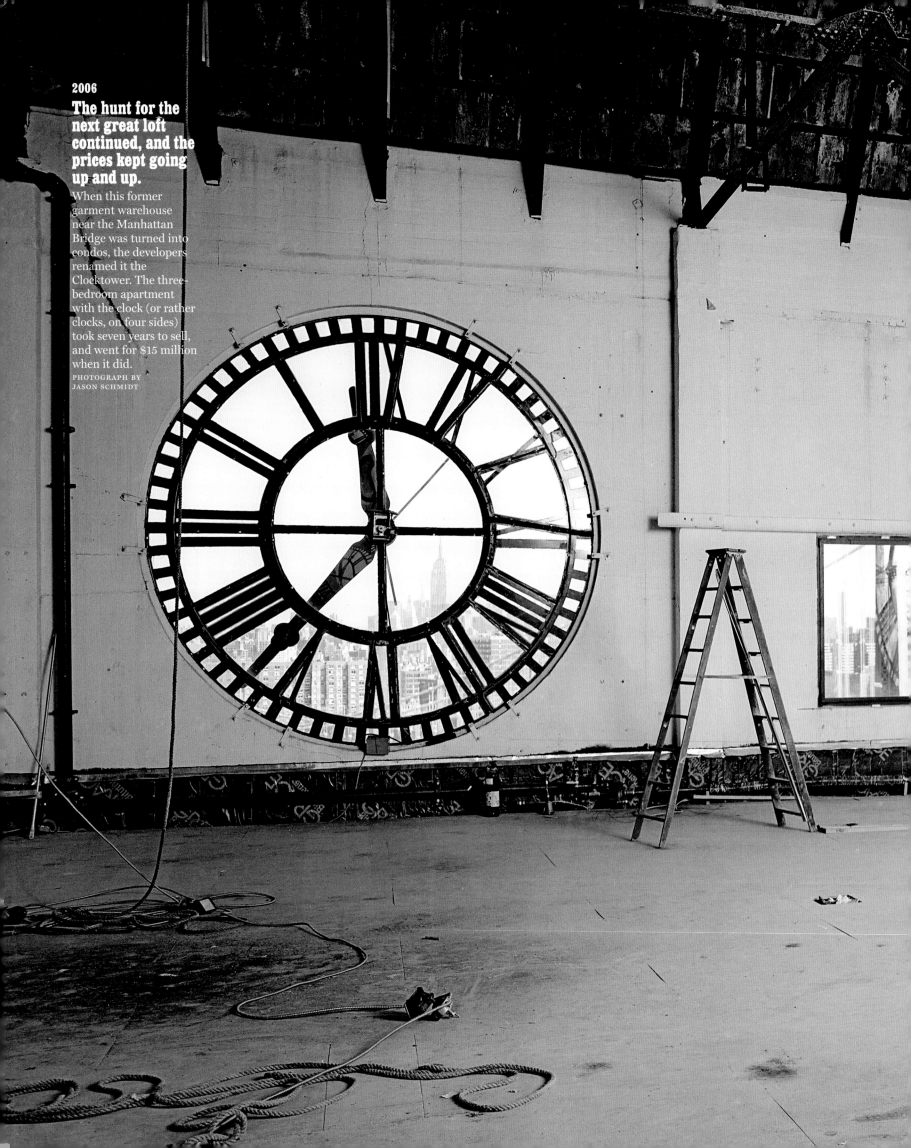

2006

The hunt for the next great loft continued, and the prices kept going up and up.

When this former garment warehouse near the Manhattan Bridge was turned into condos, the developers renamed it the Clocktower. The three-bedroom apartment with the clock (or rather clocks, on four sides) took seven years to sell, and went for $15 million when it did.

PHOTOGRAPH BY
JASON SCHMIDT

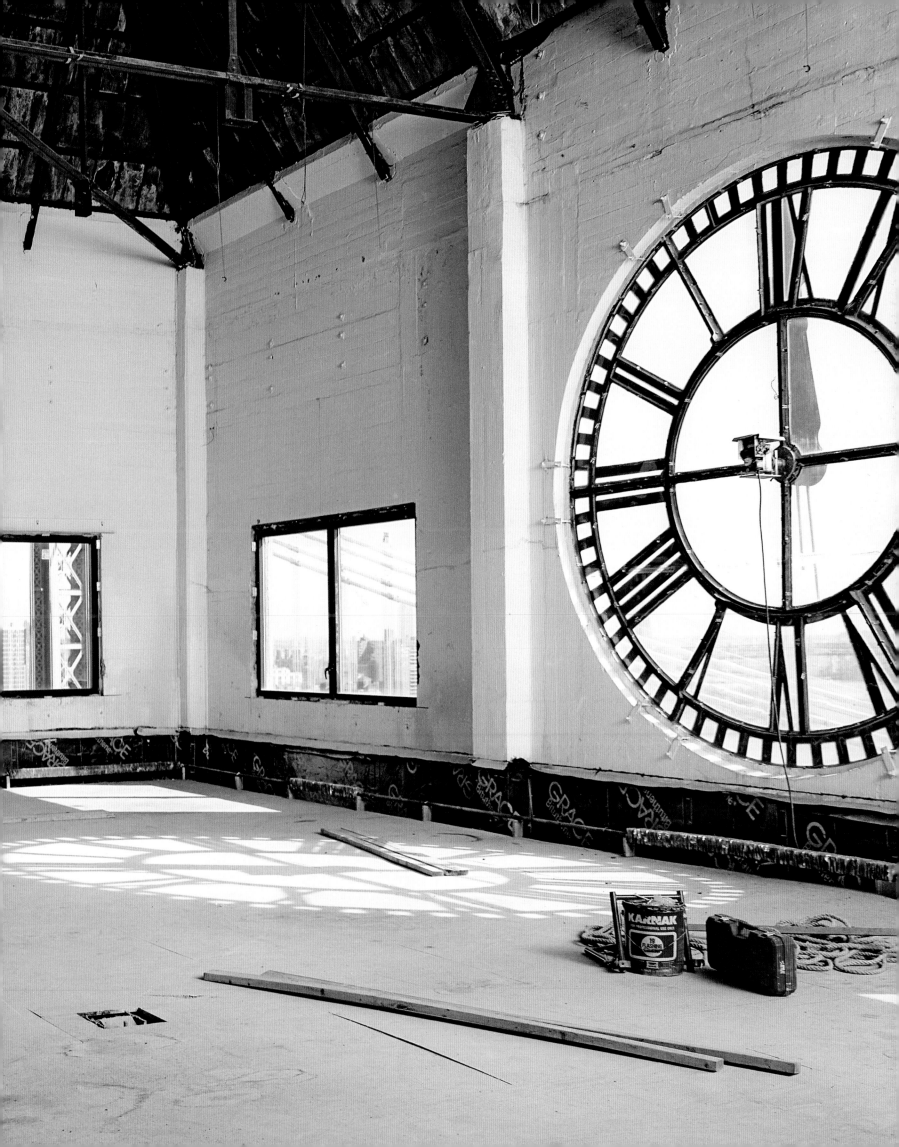

1968–2017

To furnish those apartments, we shopped. Oh, how we shopped.

"Best Bets"—whose first appearance, seen at right, was in *New York*'s Vol. 1, No. 1.—began as an ominvorous column that included movies and concerts along with food and retail recommendations. Those eventually moved to other sections of the magazine, and within a few years "Best Bets" became the highly selective, eclectic shopping column it remains today. Its distinct personality really came to the fore during the two decades in which it was edited by Corky Pollan. Reading its 50 years' worth of pages reveals high-tech period pieces (groovy rotary phones, the first iPod), memories of retailers past (B. Altman, Mxyplyzyk), and an amazing cultural history of what a sophisticated New Yorker coveted.

RECOMMENDATIONS OF CURRENT

Bes

AND CHOICE EVENTS OF THE WEEK

Bets

t

"Is Liberalism Dead?
Tune in Channel 5, 10:30 p.m.
and find out what Gor
Tom Hayden and Nat Hente

2010–2016

Designers went nuts, in the best possible ways.

Yarn-bombing every exposed surface? Creating a wormhole pod for your bed? Eccentric creativity was not limited by space constraints.

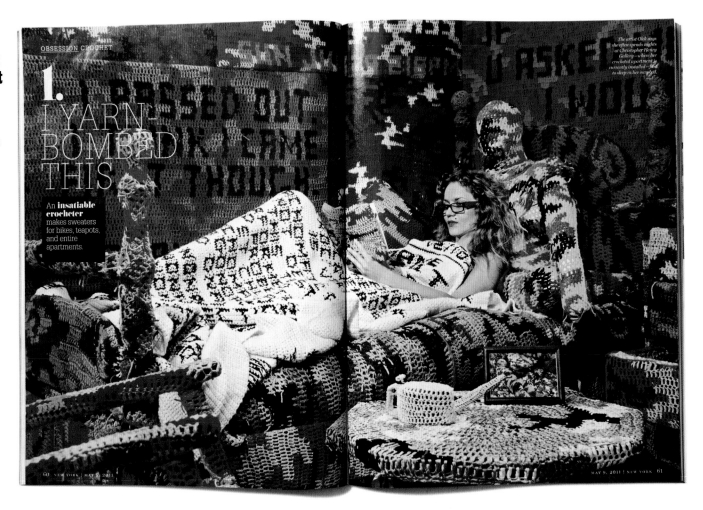

1.

I YARN-BOMBED THIS

An **insatiable crocheter** makes sweaters for bikes, teapots, and entire apartments.

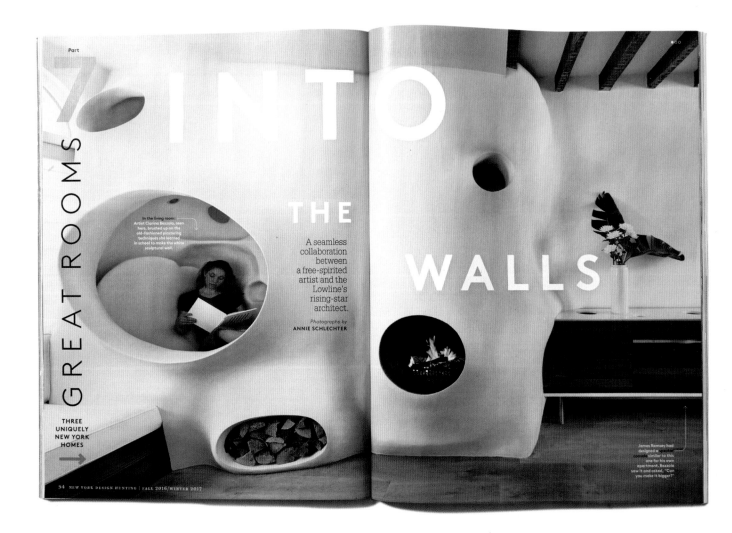

Part 7

GREAT ROOMS

INTO THE WALLS

THREE UNIQUELY NEW YORK HOMES

A seamless collaboration between a free-spirited artist and the Lowline's rising-star architect.

Photographs by **ANNIE SCHLECHTER**

FASHION DESIGNER Sylvia Heisel has worked with Matthew Barney on his "Cremaster" cycle and created a Kevlar evening gown in "bulletproof yellow polymer." So she's not averse to over-the-top anything. But when it came to a Chelsea rental, she and her husband, Scott Taylor, had gone "round and around with all the usual decorating stuff," not getting much of anywhere. The idea of doing something *really* different decor-wise was not in Heisel's blood; she grew up in a "pretty conventional house in Princeton. No one did madcap decorating. They had restrained, elegant taste."

Things only took a more radical turn when a contractor's crew had an accident—producing a very large crack in the very large kitchen window. "We thought, well, let's just follow the lines of that," says Heisel. But it was a rental; they weren't about to start making artistic cracks and fissures everywhere. So with their friend Doug Meyer, an interior designer, the couple experimented for a couple of days with artists' tape, trying to ascertain what would have the most impact. "It sort of became like an ABC Afterschool Special art project," Meyer says. The tape room—their kitchen and dining area—took about three weeks. The mesmerizing result is comparable to entering a walk-in spiderweb.

The bedroom followed. "It had to be more abstract, and we had to be able to sleep in it," says Heisel. Here, after coating the room in fabric, they continued with the motif but switched to paint (à la Jackson Pollock, except they did it with squirt bottles).

"Everything we did had to go back to the same white space it was when we moved in," says Heisel. The tape doesn't damage walls, the fabric can be whisked away, the duvet is portable. So new tenants will have no idea, when they gaze upon their freshly anodyne surroundings, that such a thing ever existed. WENDY GOODMAN

THEY DRIZZLED THE BEDROOM...

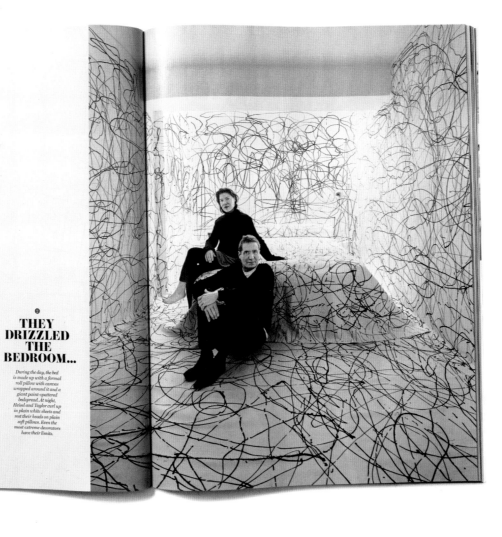

During the day, the bed is made up with a formal roll pillow with canvas wrapped around it and a giant paint-spattered bedspread. At night, Heisel and Taylor curl up in plain white sheets and rest their heads on plain soft pillows. Even the most extreme decorators have their limits.

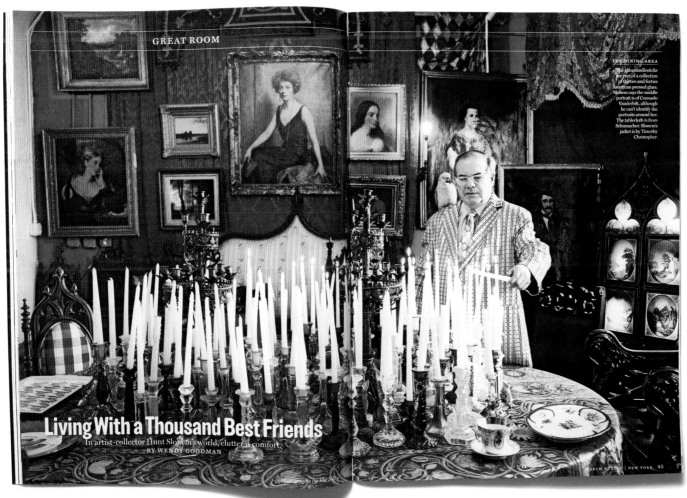

GREAT ROOM

THE DINING AREA
The glass candlesticks are part of a collection of thirties and forties American pressed glass. Slonem says the middle portrait is of Consuelo Vanderbilt, although he can't identify the portraits around her. The tablecloth is from Schumacher. Slonem's jacket is by Timothy Christopher.

Living With a Thousand Best Friends
In artist-collector Hunt Slonem's world, clutter is comfort.
BY WENDY GOODMAN

Photographs by Fle Solé

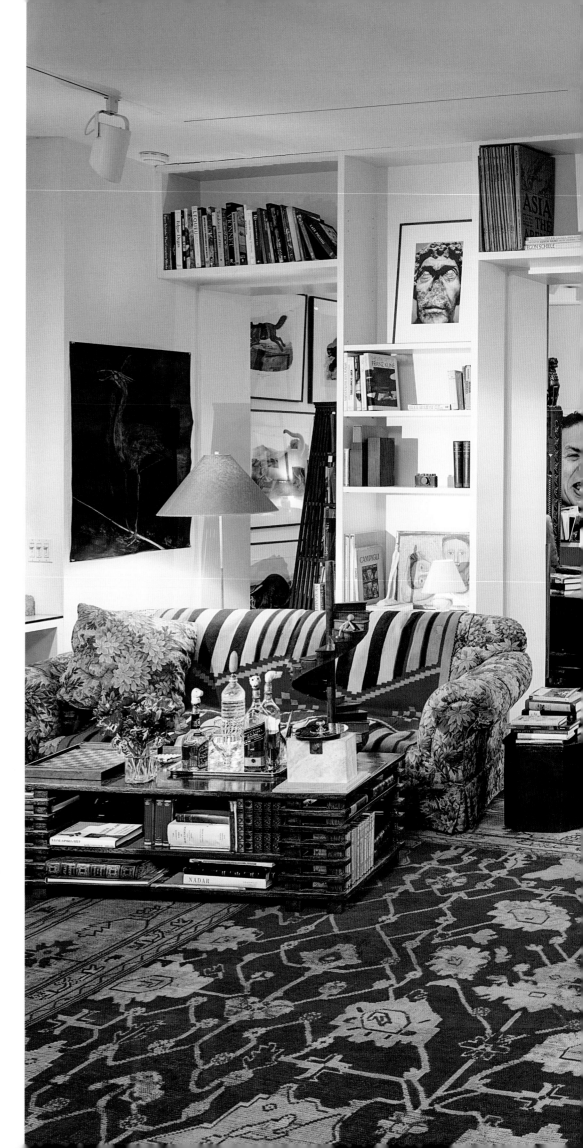

2005

Great artists' apartments carried a special mystique.

Above Richard Avedon's Upper East Side studio was his own live-work apartment, its walls covered in soft Homasote so he could tack up photographs and tearsheets anywhere. *New York* photographed it, the contents untouched, after his unexpected death.

PHOTOGRAPH BY
ANDREW MOORE

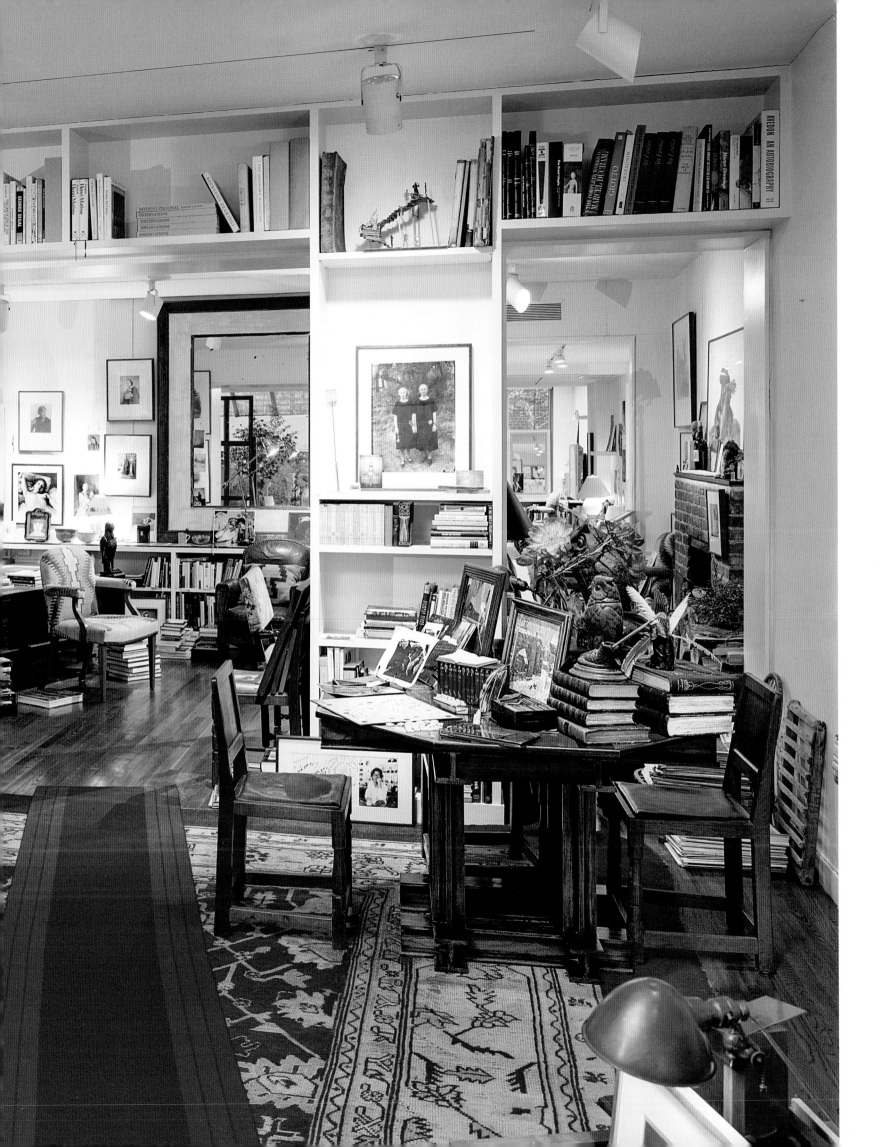

2015

A single block of brownstones told an epic story.

For a multimedia feature called the "One Block" project, *New York* reporters and photographers dove deep on a single block of MacDonough Street in Bedford-Stuyvesant, interviewing nearly every resident, and tracing the purchase histories of many of the houses. The result was a unique portrait of the shifting lines of race, money, class, and power over 120 years.

BOUGHT IN 1991
$145,000

BOUGHT IN 2015
$1.1 MILLION

BOUGHT IN 2009
$499,000

BOUGHT IN 1997
$110,000

BOUGHT IN 1998
$115,000

BOUGHT IN 1967
UNDISCLOSED

BOUGHT IN 2
$1.55 MILLI

DEBRA AND ALVIN LAMB
Both 57, owners
LIVES WITH: Their daughter Alexis.
HISTORY: Debra's father, a school principal who grew up in the neighborhood, **bought the house at auction in 1985 for $40,000.** It had been abandoned and, in 1982, taken over by the city. Her parents still live a few blocks away on Stuyvesant Avenue, and own several houses in the area. Debra bought it from them in 1998.

ALEXIS LAMB
21, tenant
OCCUPATION: Student at Hunter College.
LIVES WITH: Her parents.
HISTORY: "This is the house I grew up in. I like the area. I hate that it's kind of far from all of my friends—I went to school in Soho. Maybe five years ago, my friends never wanted to come down here. They were like, 'Oh, no, something bad is going to happen.' I'm just, like, **'It's not like you're going to die.'"**

MICHAEL "CHAD" HOEPPNER AND HILARY KOLE
41 and 39, owners
OCCUPATION: Communications consultant and singer.
LIVE WITH: Their baby girl.
HISTORY: Bought in April 2015 for $1.55 million from the next-door neighbors, Rodney Hughes and Desmond Prince (see right). **It had been owned by the Hood family since 1968**; in 2006, Ricky Hood, who inherited it, sold for $655,000 to Hughes and Prince.

RODNEY HUGHES
50, co-owner
OCCUPATION: Perfumer.
LIVES WITH: Desmond Prince, his partner.
HISTORY: The Scott family **lived here for four generations until 1996,** when the estate of Gloria Jean Scott sold it for $50,000 to a real-estate holding company, which then flipped it to Prince. Hughes and Prince also bought the house next door; they recently sold it to Hoeppner and Kole (see left). "I had told Desmond I could wait" to sell, Rodney recalls. But "we met Hilary, and it was a perfect fit. She was having the baby and she's a jazz singer, and art and artists appeal to us. It's important to have neighbors that you like. 'Cause we're not going anywhere."

BOUGHT IN 1980
$10,500

BOUGHT IN 1983
$12,000

BOUGHT IN 1988
$110,000

BOUGHT IN 2015
$1.56 MILLION

BOUGHT IN 1976
UNDISCLOSED

BOUGHT IN 2002
$280,000

BOUGHT IN 2012
$500,000

BOUGHT IN 2
$250,000

LYNN BOWDEN
90, owner
OCCUPATION: Retired kosher butcher.
HISTORY: Bought the house with his late wife in 1983 for $12,000. Bowden, whose parents were fruit-and-vegetable farmers in North Carolina, came to New York in 1955 after a stint in the Army and apprenticed in a butcher shop, where he was, at first, paid mostly in meat. "When I bought this house, there wasn't two cars on this street! That streetlight wasn't even there." **Was once robbed at the point of a .38 on this block.**

ROSLYN MORRISON
42, tenant
OCCUPATION: Public defender.
LIVES WITH: Her son.
HISTORY: Moved from a Brooklyn Heights co-op in 2006; now pays $1,050 for a two-bedroom. "On Montague Street, I was constantly being asked whether I was a nanny. Was I surprised? Not all that much. I'd been to boarding school, where there were few people of color. So **I was accustomed to that 'What are you doing here?'–type attitude."**

TRAVIS BRATHWAITE
26, owner
OCCUPATION: Film-production freelancer.
HISTORY: Parents are from Barbados; grew up first in Jamaica, Queens, then on Halsey Street. Bought this house in 2012; previous owner had moved back to be closer to family in the South. Brathwaite's aunt is Cheslyn Lorde, who owns the house 12 doors down (see following pages). "I had her come over and look at the house. We all liked it. I don't foresee selling— I haven't had any offers, other than **those papers that keep getting dropped on everybody's steps."**

HERBERT POLLARD
54, owner
HISTORY: His grandparents bought the house in 1945; Pollard lived here till age 18, then left and went into the Air Force. "To me, at that time, New York felt more like a giant small town. You had a million little small towns inside New York. Jervey Ector was my best friend, and Mrs. Ector [see opposite page] still lives in the house. There were much more kids on the block back then than there are today. We'd ride our bikes up and down, around the neighborhood, play touch football in the street, a little bit of stickball. In a lot of respects, the block is pretty much the same—**it was a quiet block then, it's quiet now.** But I know people around here much less."

BOUGHT IN 1996 $184,000	BOUGHT IN 2015 $1.54 MILLION	BOUGHT IN 1978 $35,000	BOUGHT IN 2009 $649,000	BOUGHT IN 1973 $20,000	BOUGHT IN 2001 $275,000	BOUGHT IN 2005 $725,000	BOUGHT IN 2000 $236,000	BOUGHT IN 1988 $115,000

GREGORY "DOC" WALKER
51, former owner
OCCUPATION: Paralegal; now unemployed.
NOW LIVES: Around the corner on Decatur Avenue.
HISTORY: Grew up in what is now the Lambs' house and **has spent his whole life in the neighborhood.** Moved around the corner with his mother, Connie Walker (see next pages), when the family sold their house in 2007. A regular on Brother Spears's stoop.

JAMES "BROTHER" SPEARS
50, co-owner
OCCUPATION: Carpenter.
LIVES WITH: His father and a tenant, Daniel "June" Farquhar.
HISTORY: His parents bought the house in 1978. Has lived here for his entire life: "I'm maintaining, taking care of my father— he's 90 years old. I think I'll be here for good. And I'll pass it on to my kids."

DANIEL "JUNE" FARQUHAR
49, tenant
LIVES WITH: Brother Spears.
HISTORY: Arrived on the block from Antigua **with his parents in 1972.** Isn't sure about the changing neighborhood: "Sandwiches went from $2 to $4.50—not even that, this shit is going up to $7. Who the fuck can afford that?"

BENJAMIN CHAPMAN AND BROOKE VERMILLION
39 and 38, owners
OCCUPATIONS: Reporter and forensic linguist.
HISTORY: Vermillion bought the house in 2009 for $649,000. It had been owned by the Coppedge family since 1964. She says, "I grew up in Northern California, and *Do the Right Thing* and *Sesame Street* sort of represented New York to me, but I didn't realize that was Bed-Stuy. And then when I got here, I was like, *Oh, this is New York. This is what I was looking for.* I first visited on a Sunday. There were all these nice old ladies dressed up going to church. **People would have bars in their basements**— 50-year-old women would have bars, would sell food."

TERRI HANNA
51, owner
HISTORY: Bought the house in 2000 with her husband for $236,000; he died in 2005. "I had to go through grieving counseling, and she said you have to make it your space. I didn't know if I could stay here. The people on the block were really, really friendly. They saw me when I was in that depressed mode. They would comfort me. It was like a little family." She became president of the block association the next year. "We didn't have tree guards. I got them. We didn't have lampposts in the yards. There were city programs we could sign up for, so **I went around and said, 'Hey, would you like a lamppost?'** So we got that."

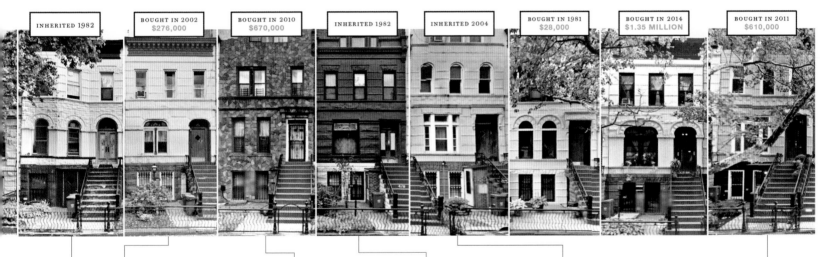

INHERITED 1982	BOUGHT IN 2002 $276,000	BOUGHT IN 2010 $670,000	INHERITED 1982	INHERITED 2004	BOUGHT IN 1981 $28,000	BOUGHT IN 2014 $1.35 MILLION	BOUGHT IN 2011 $610,000

SHARON AND RONN KOONTZ
45 and 50, owners
OCCUPATIONS: IT program manager, property manager.
LIVE WITH: Their daughter, Mackenzie, 4. A two-bedroom in the house is listed on Airbnb, and according to Ronn, the booking is "just constant."
HISTORY: Sharon bought the house in 2002 for $276,000 from its longtime owner, Rita Holder Wilson, who had bought it with her husband in 1988 for $55,000. "I'd been coming back and forth to Bed-Stuy for the last 20 to 25 years," Ronn says. "I never thought that Brooklyn, and specifically Bed-Stuy, would become what it has. **I never would've thought someone would pay $1 million** for a brownstone where you don't even have parking! I don't get it—but I kind of get it."

MORIAM JOHNSON
31, tenant
OCCUPATION: Self-employed.
LIVES WITH: Daughter Chloé and sister Laurie.
HISTORY: Born in Nigeria, grew up in Brooklyn, and moved here in 2014 to be near Chloé's school. Pays $1,500 for a two-bedroom. "When my landlord bought the house in 2012, he paid $600-something. After a house sold for $1.2 million, he's like, 'I want $1.5.' **Your piece-of-shit house?** You're not going to make that."

WILMA ECTOR
81, owner
LIVES WITH: Her son Jervey stays here part time.
HISTORY: Has lived in Bedford-Stuyvesant brownstones since she was 9 months old, when her parents moved up from South Carolina. Her husband's parents, owners of **a soul-food restaurant nearby called Ector's,** bought this house in 1951, and she moved here after she married in 1955. Her husband, who worked at Ector's and then for the Department of Correction, died in January 2015.

LYNETTE LEWIS-ROGERS
60, owner
OCCUPATION: Retired Housing Authority manager.
HISTORY: Her father, from St. Vincent, bought the house in 1957. She arrived with her mother two years later. "It's funny—if you're on the C, Clinton-Washington was for many years the cutoff. You didn't expect white people to come any further. Then it was Franklin: Well, now, that's odd. Nostrand? Kingston? *Utica?* Now it's **Ralph Avenue. *Really?!'***

ANDREAS KOKKINO
39, owner
OCCUPATION: Fashion stylist.
LIVES WITH: A roommate, plus a tenant who pays $1,900 a month.
HISTORY: Moved from Halsey Street in 2011, buying the house for $610,000, $80,000 under asking. The seller, Thelma Akins, who had just died, had lived there since the 1950s. "It's a classic trajectory. East Village to further in the East Village to Williamsburg to lower in Williamsburg. Then at some point I was like, *Oh, I can afford to live on the Lower East Side,* then I got priced out of the LES, then I was like, *Oh, I actually hate Manhattan.* I've been called a gentrifier by, like, someone on a stoop—**'Get out of here, gentrifier.'** Should I not live where I can afford to?"

In the newly wealthy city of the 2000s, it seemed as though every other street corner was a construction site, and that the old walkup brick city was vanishing into a forest of giant towers.

The Glass Stampede
By Justin Davidson

OUR CITY IS MOLTING. Bricks flake away. So do brittle fire escapes, terra-cotta encrustations, old paint, cracked stoops, faded awnings, sash windows, and stone laurels fashioned a century ago by Sicilian carvers. New York is shucking off its aging walk-ups, its small and mildewed structures, its drafty warehouses, cramped stores, and idle factories. In their place, the city is sprouting a hard, glistening new shell of glass and steel. Bright, seamless towers with fast elevators spring up over a street-level layer of banks and drugstores. In some cities, a building retains the right to exist until it's proved irredeemable. Here, colossal towers are placeholders, temporary arrangements of future debris. New York lives by a philosophy of creative destruction. The only thing permanent about real estate is a measured patch of earth and the column of air above it. The rest is disposable.

And the metamorphosis has sped up. In the past fifteen fat years, more than 76,000 new buildings have gone up, more than 44,000 were razed, another 83,000 were radically renovated—a rate of change that evokes those time-lapse nature films in which flowers spring up and wither in a matter of seconds. For more than a decade, we have awakened to jackhammers and threaded our way around orange plastic netting, calculating that, since our last haircut, workers have added six more stories to that high-rise down the block. Now that metamorphosis is slowing as the economy drags. Buildings are still going up, but the boom is winding down. Before the next one begins is a good time to ask, has this ferment improved New York or eaten away at the city's soul?

In the last 25 years, the city's population has increased by a million people, and another million will be here 25 years from now. The question is not whether to make room for them but how. We could, in theory, rope off most of Manhattan to new development and push new arrivals to the city's fringes. Had we done that years ago, we would have created a museum of shabbiness. Even doing so now would keep the city in a state of embalmed picturesqueness and let the cost of scarce space climb to even loonier heights than it already has. In its 43-year existence, the Landmarks Preservation Commission has tucked more than 25,000 buildings under its protective wing, which seems about right. Protect every tenement, and eventually millionaires can no longer afford them.

The jaundiced view of the Lower East Side is that it can no longer be rescued from the sneaker boutiques or the bulbous Blue condo. But we should put this transformation in context. A century ago, when the neighborhood was among the most congested places on Earth, New York kept bounding beyond its three-dimensional borders. By the city's own standards, the current spasms of construction are not really so severe. What makes the current escalation feel so sharp is that it comes after a long period of decline. The fortysomething who grew up here knew a metropolis that was not just smaller but rapidly desiccating. Between 1970 and 1980, more than a million people leached out of the five boroughs, their numbers only partially offset by new immigrants and aspiring actors. Crime rose, property prices collapsed, and plenty of smart people began to write New York off as another Newark, Cleveland, or Detroit.

Urban nostalgists reserve their greatest animus for gentrification, which is a stark word for a complicated phenomenon. It does not describe only the relentless territorial expansion of the rich at the expense of everybody else: Gentrification eddies across the city, polishing formerly middle-class enclaves to an affluent shine, prettying up once-decrepit neighborhoods for new middle-class arrivals, and making awful slums habitable. In the intricate ecology of New York, each current triggers a dizzying series of countercurrents. Low crime rates make city life more desirable, so fewer middle-class families feel like they are being forced to flee to the suburbs. That causes real-estate prices to climb, which forces out some of those same families. Rising housing costs in low-income areas require the poor to spend a growing slice of their income on rent but also make it financially feasible for developers to build affordable housing.

The way to deal with this tangle of paradoxes is not to rail against gentrification or lunge to halt it but to mitigate its impact on the poor through activism, governance, and good design. New York has the country's largest municipal affordable-housing program, not just now but ever. It doesn't manifest itself in jerry-built towers of despair, because below-market housing is often mixed with the expensive kind; a quarter of the apartments in the Avalon complex are reserved for low-income families. That kind of housing, too, can rescue a neighborhood. The needle-strewn South Bronx seemed beyond redemption until a collective of developers, nonprofits, and city agencies built Melrose Commons, a low-rise, low-income housing complex that is safe, durable, and appealing. That, too, is gentrification.

Do the dedicated yearners who would roll back this tide look fondly on the charred South Bronx of the '80s? Would they stick by the most depressed and derelict expanses of Brooklyn, or the cracked-out squats around Tompkins Square Park, or the blocks of boarded-up windows in Harlem? That New York was not authentic or quaint; it was miserable and dangerous. Intelligent preservation is precious, but nostalgia is cheap, and every era nurtures its own variety. Those late-nineteenth-century Upper West Siders resented the incursion of brownstones in the 1880s. Bitterness springs eternal. So rail, if you must, at the forest of mediocrities sprouting furiously in every Zip Code, at the way they bleach out character and promote a bland parade of chain stores. But keep in mind that when all those buildings have begun to age, the architecture of our immediate future will get down to the task of becoming the past. ∎

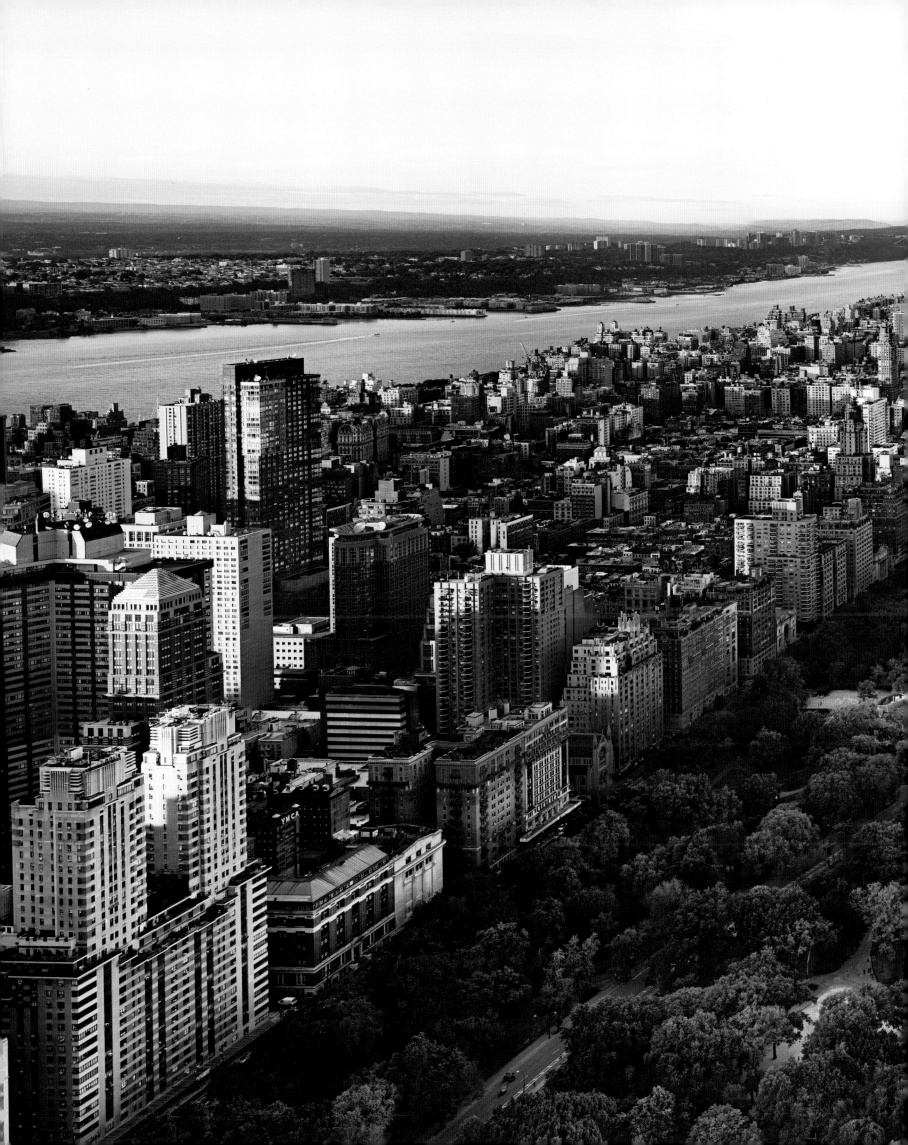

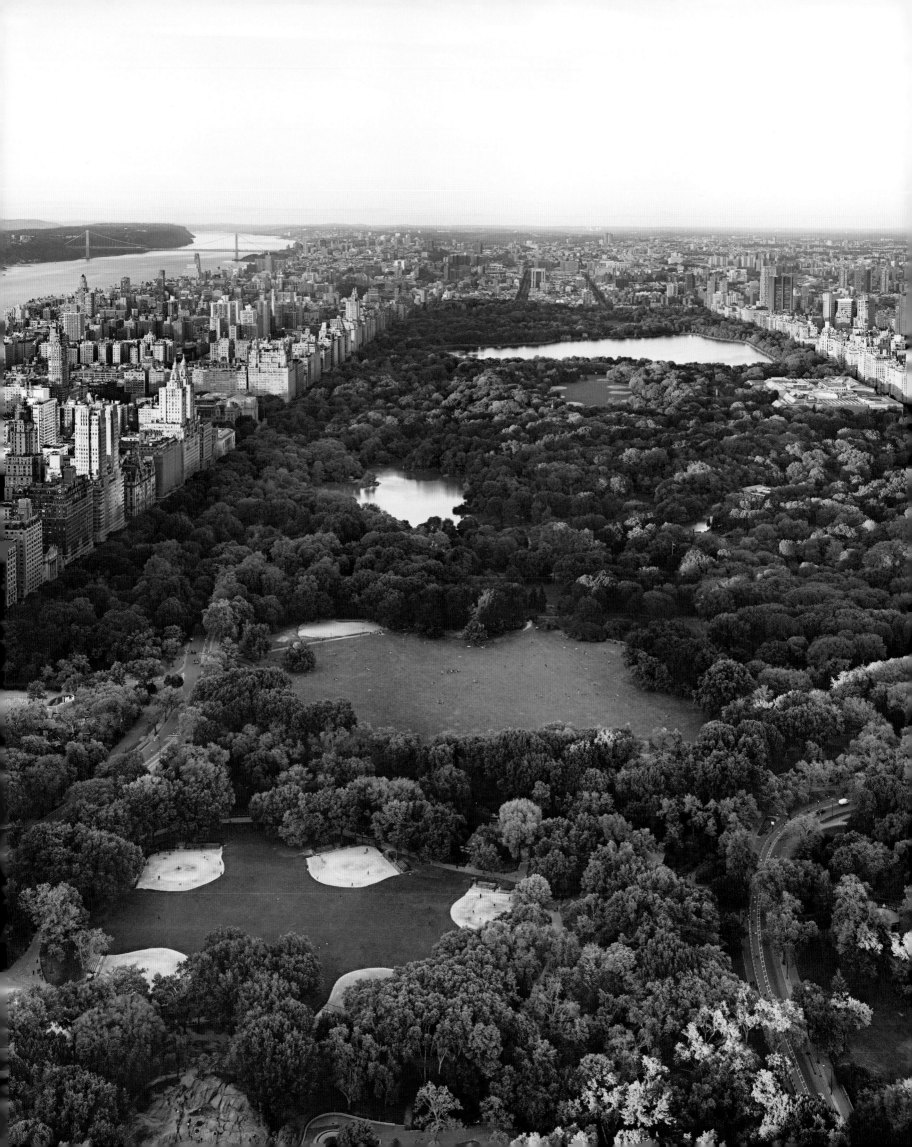

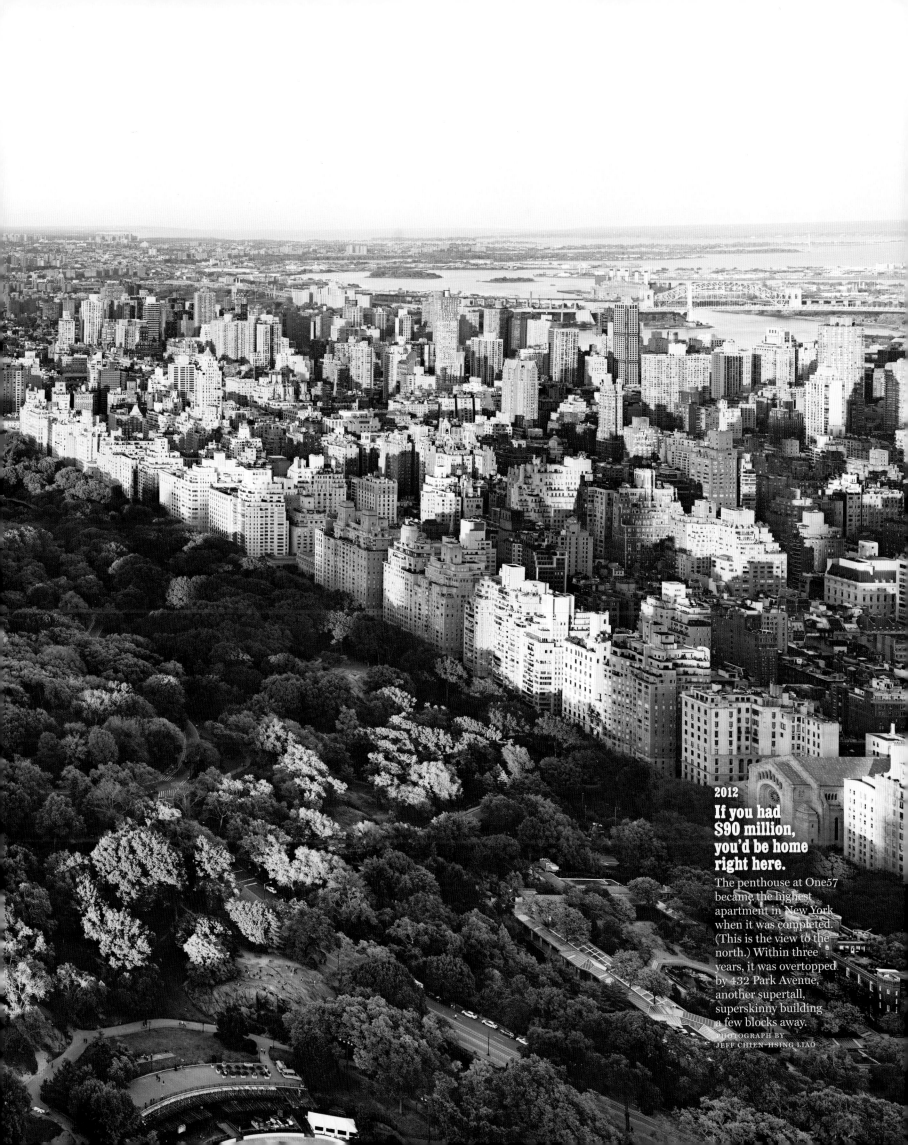

2012

If you had $90 million, you'd be home right here.

The penthouse at One57 became the highest apartment in New York when it was completed. (This is the view to the north.) Within three years, it was overtopped by 432 Park Avenue, another supertall, superskinny building a few blocks away.

PHOTOGRAPH BY
JEFF CHIEN-HSING LIAO

6

CULTURE

"I'm from New York. I will kill to get what I need."

Lady Gaga
in "Growing Up Gaga," by Vanessa Grigoriadis, 2010

Our stars live among us.

THROUGHOUT ITS HISTORY, *New York* has tried to define what constitutes a New York celebrity. Certain people are, by dint of accent or birth, unmistakably so: Martin Scorsese, Lena Dunham, Lin-Manuel Miranda. But it's hardly inborn. Tina Fey is from suburban Pennsylvania, but she is unquestionably a New Yorker. Bob Dylan is from Hibbing, Minnesota, but he's ours, too. New Yorkiness exists where the circles meet on a hard-to-draw Venn diagram of talent, stage chops, life choices, and (most of all) attitude. Anywhere else, Chloë Sevigny would have been a misfit oddball. Here, she became, and in her 40s remains, an "It" girl. Which is not to say that New Yorkers, and *New York*, are interested only in the local talent: Every Hollywood star (and sports star, for that matter) worth his salt has a connection to New York, and to *New York* as well. ¶ Certain celebrities appear and reappear in the magazine, individuals who feel like they belong to the very conception of New Yorkiness. Meryl Streep has been featured in our pages more times than we can count. Likewise Woody Allen, sometimes as genius, sometimes in court, and occasionally as a contributor. Brooke Shields has been a recurring presence since she was 11. Dunham first showed up when she was still a postcollegiate maker of short films about her art-brat friends; three years later, she was on our cover. *New York*'s readers have watched its stars grow up, develop as artists, age. And, occasionally, pick up milk at the neighborhood deli.

1976

Katharine Hepburn got around on two feet and two wheels.

"She never goes to restaurants, she doesn't shop," wrote photographer John Bryson. "But New Yorkers still catch glimpses of those famous cheekbones all over the city, for Hepburn goes striding—despite warnings—through Central Park at dusk." She occasionally dived into the East River, too: "The coldest I ever swam, it was eight above zero."
PHOTOGRAPH BY JOHN BRYSON

If you were a drink, Barbra, what drink would you be? "Tab."

Barbra Streisand had just made *Funny Girl* (which eventually got her an Oscar) and was about to film *Hello, Dolly!* when she sat for this loose interview with the writer John Hallowell. "Barbra, are you happy?" he asked her. "Are you kidding?" she answered. "I'd be miserable if I was happy!"

Lively Arts

The Truth Game

Barbra Streisand
Talks to
John Hallowell

HALLOWELL: Let's start with something different. There's this game called "The Truth Game" and I'd like to play it.

STREISAND: Okay.

HALLOWELL: If you were a car, what car would you be?

STREISAND: Well, at times I'm an Excalibur. At times a 1925 Rolls . . . and at times I'm a broken down Ford.

HALLOWELL: What about—what animal?

STREISAND: My husband says I'm a hamster.

HALLOWELL: If you were a color, what color would you be?

STREISAND: I think . . . wine.

HALLOWELL: What bird?

STREISAND: (laughs) Tweety bird. No, I'm some exotic jungle bird. And maybe an ordinary—not a pigeon—a little sparrow.

HALLOWELL: What century?

STREISAND: I think the 19th, and the 15th, or is it the 14th?—Oh, Christ! Oh yeah! B.C.

HALLOWELL: What composer?

STREISAND: Bartok . . . a little strange and dissonant . . . maybe I'm mauve.

HALLOWELL: What article of clothing?

STREISAND: A crepe black satin slip.

HALLOWELL: What painting by a famous painter?

STREISAND: This is a good game. I like it. It's great for an interview, because it's sensuous and the only things that are important are the five senses. What painting by a famous painter? *A Woman Bathing* by Rembrandt.

HALLOWELL: What city in the world?

STREISAND: Well, I've hardly been anywhere, so it's hard for me to say.

HALLOWELL: What famous historical character?

STREISAND: Hmmm. I don't really identify with anybody.

HALLOWELL: What drink?

STREISAND: Tab.

HALLOWELL: What period of furniture?

STREISAND: Louis XV, XVI, Victorian, and at the moment, especially Art Nouveau.

HALLOWELL: What flower?

STREISAND: Gardenia.

HALLOWELL: What fish?

STREISAND: A smoked one.

HALLOWELL: What astrological sign?

STREISAND: A Taurean, who likes Virgos, Pisces and Aries . . . Actually, I'm a mixture of heliotrope, burnt orange, fuchsia and gray—with a little dab of taupe on the side.

HALLOWELL: What other singers?

STREISAND: Ray Charles and Florence Foster Jenkins.

HALLOWELL: What thing that can be bought at a soda fountain?

STREISAND: Seltzer.

HALLOWELL: Now, let's talk about the press.

STREISAND: Gee, from seltzer to the press.

HALLOWELL: How do you feel about some of the terrible press?

STREISAND: Terrible!

HALLOWELL: Do you think your personality has been captured by the press?

STREISAND: Captured??? (She laughs) Slaughtered, barbecued, pickled!

HALLOWELL: How do you think the public interprets what has been written about you?

STREISAND: Well, I think most people believe what they read, because of the power of the printed word.

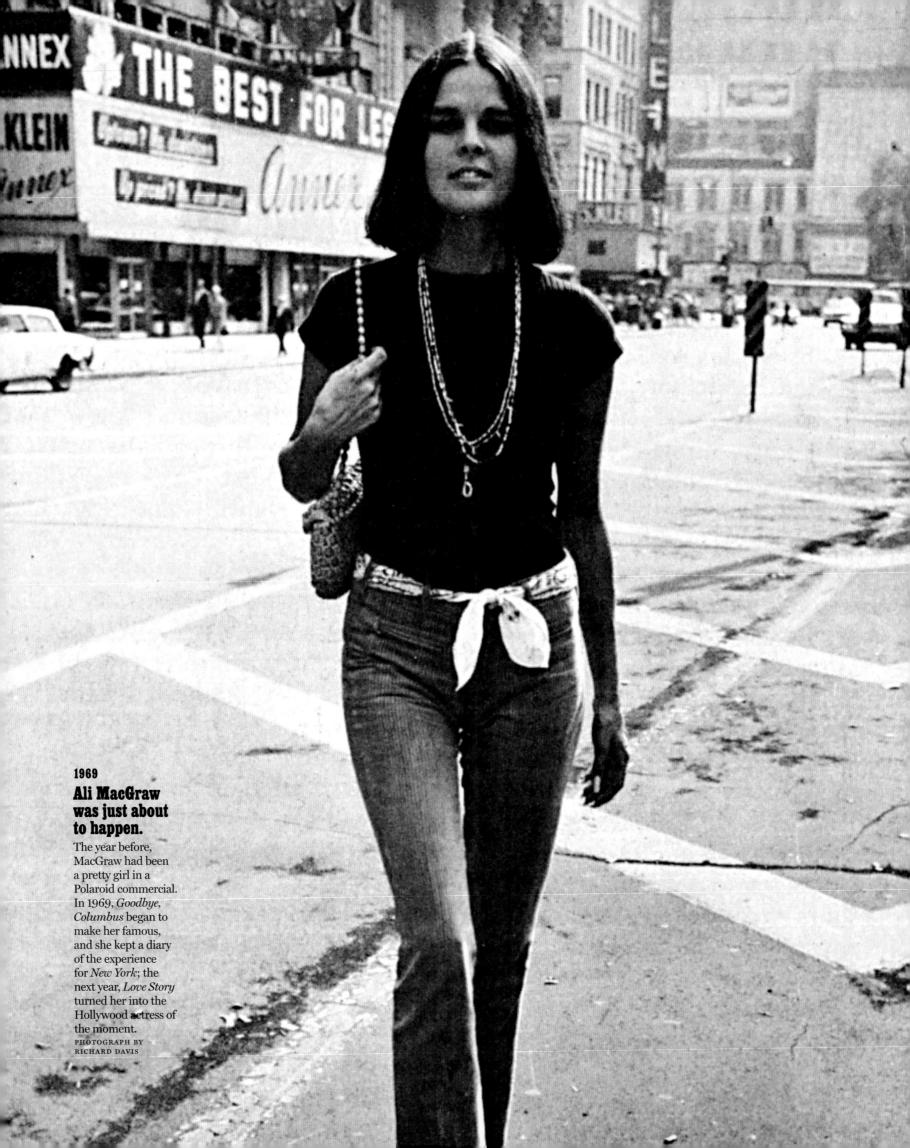

1969
Ali MacGraw was just about to happen.
The year before, MacGraw had been a pretty girl in a Polaroid commercial. In 1969, *Goodbye, Columbus* began to make her famous, and she kept a diary of the experience for *New York*; the next year, *Love Story* turned her into the Hollywood actress of the moment.
PHOTOGRAPH BY RICHARD DAVIS

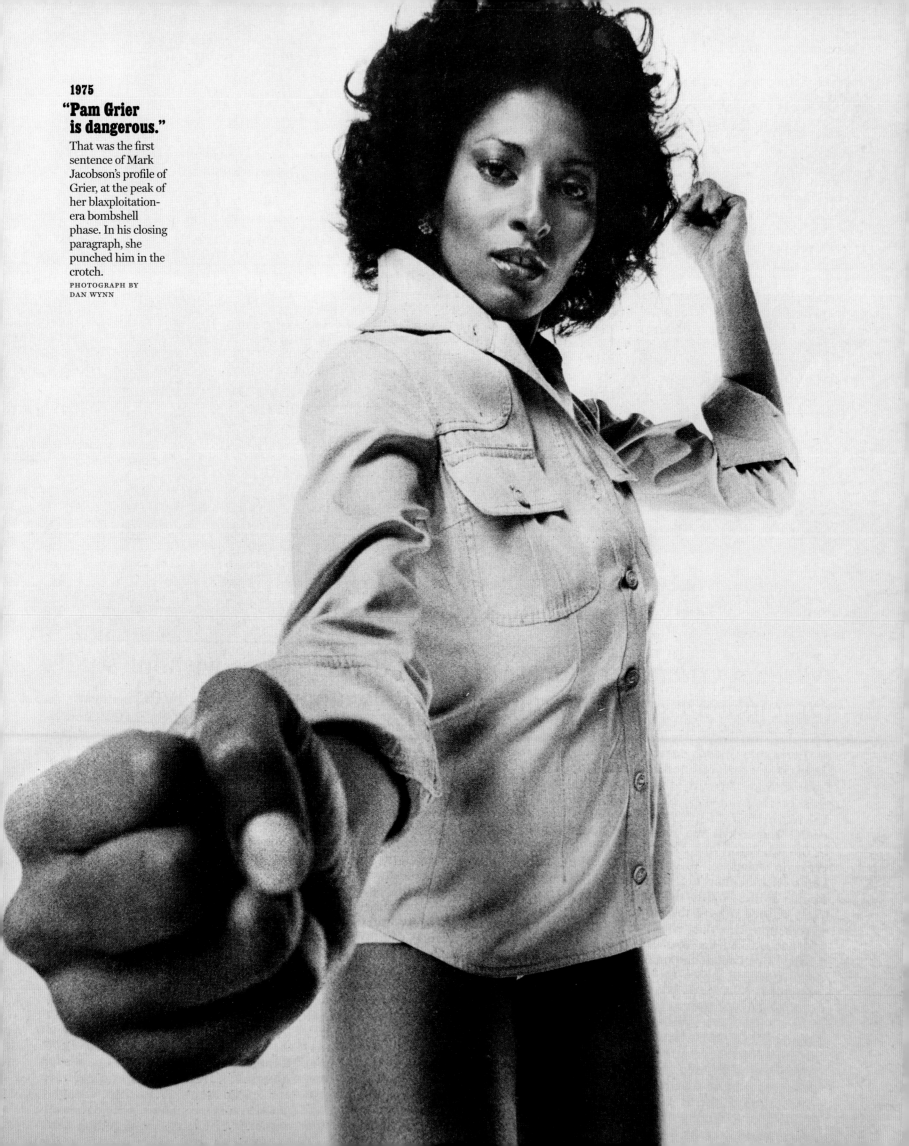

1975

**"Pam Grier
is dangerous."**
That was the first
sentence of Mark
Jacobson's profile of
Grier, at the peak of
her blaxploitation-
era bombshell
phase. In his closing
paragraph, she
punched him in the
crotch.
PHOTOGRAPH BY
DAN WYNN

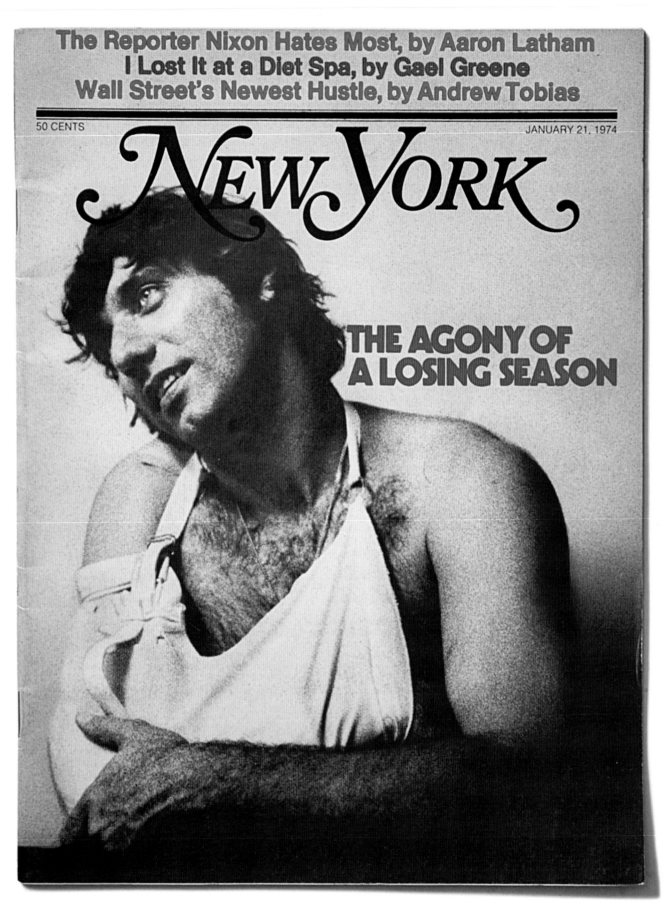

The Reporter Nixon Hates Most, by Aaron Latham
I Lost It at a Diet Spa, by Gael Greene
Wall Street's Newest Hustle, by Andrew Tobias

50 CENTS JANUARY 21, 1974

NEW YORK

THE AGONY OF A LOSING SEASON

1974

Joe Namath was in twilight.

Five years after driving his team to an unexpected win in Super Bowl III, the Jets quarterback separated
his shoulder in the second game of the 1973 NFL season, and the team fell apart
on the field. Harry Benson photographed the whole grim year, and was given free rein to walk through
the locker room—access that would be unheard-of today.

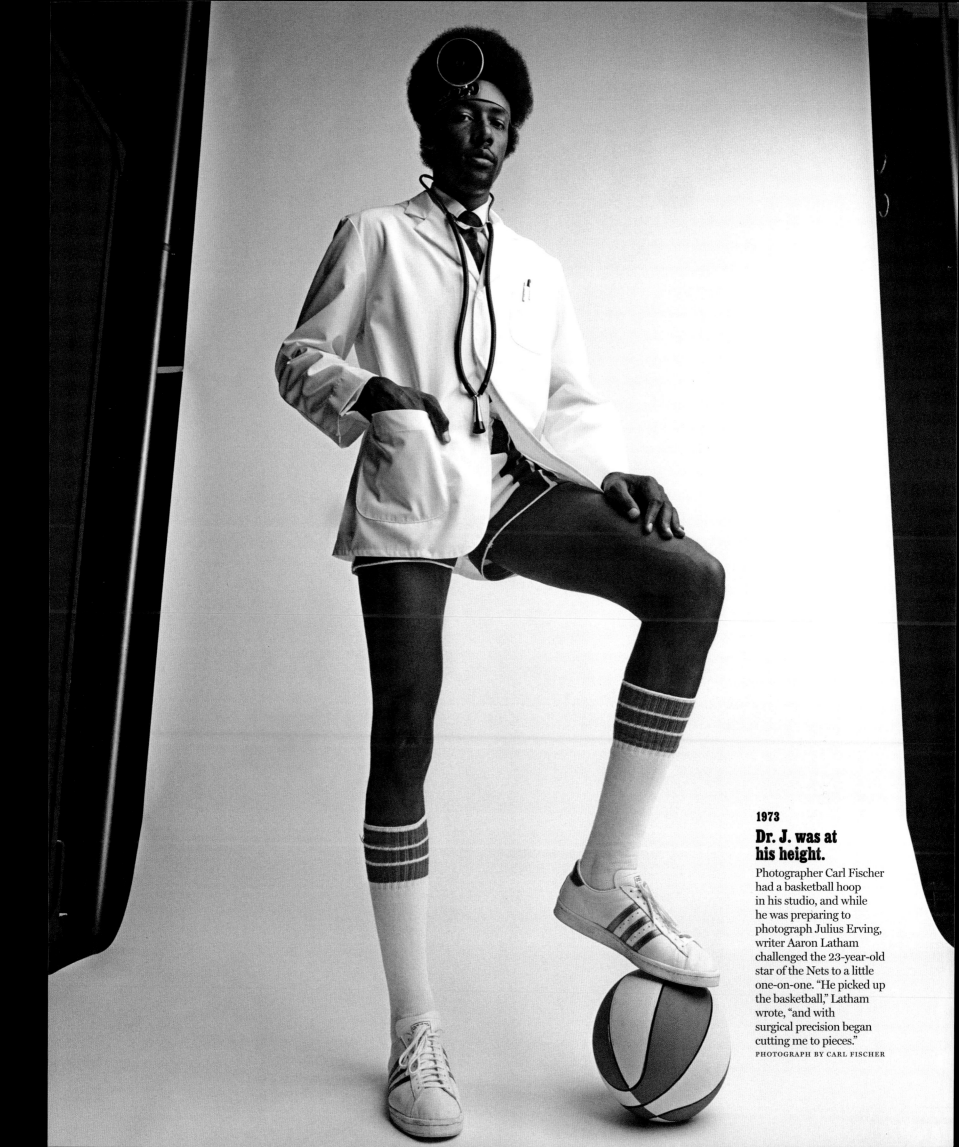

1973

Dr. J. was at his height.

Photographer Carl Fischer had a basketball hoop in his studio, and while he was preparing to photograph Julius Erving, writer Aaron Latham challenged the 23-year-old star of the Nets to a little one-on-one. "He picked up the basketball," Latham wrote, "and with surgical precision began cutting me to pieces."
PHOTOGRAPH BY CARL FISCHER

1977

Grace Jones was proto-Photoshopped.

"A sudden swirling and whooshing" is how Nik Cohn described Grace Jones's arrival in a room. "With every gesture, as she told me her life, her muscles rippled and flexed." Jean-Paul Goude photographed her many times; as you can see below, he constructed this nearly impossible pose out of many, painting the joinery and removing (without digital assistance) the bits of scaffolding that propped her up.

PHOTOGRAPHS BY
JEAN-PAUL GOUDE

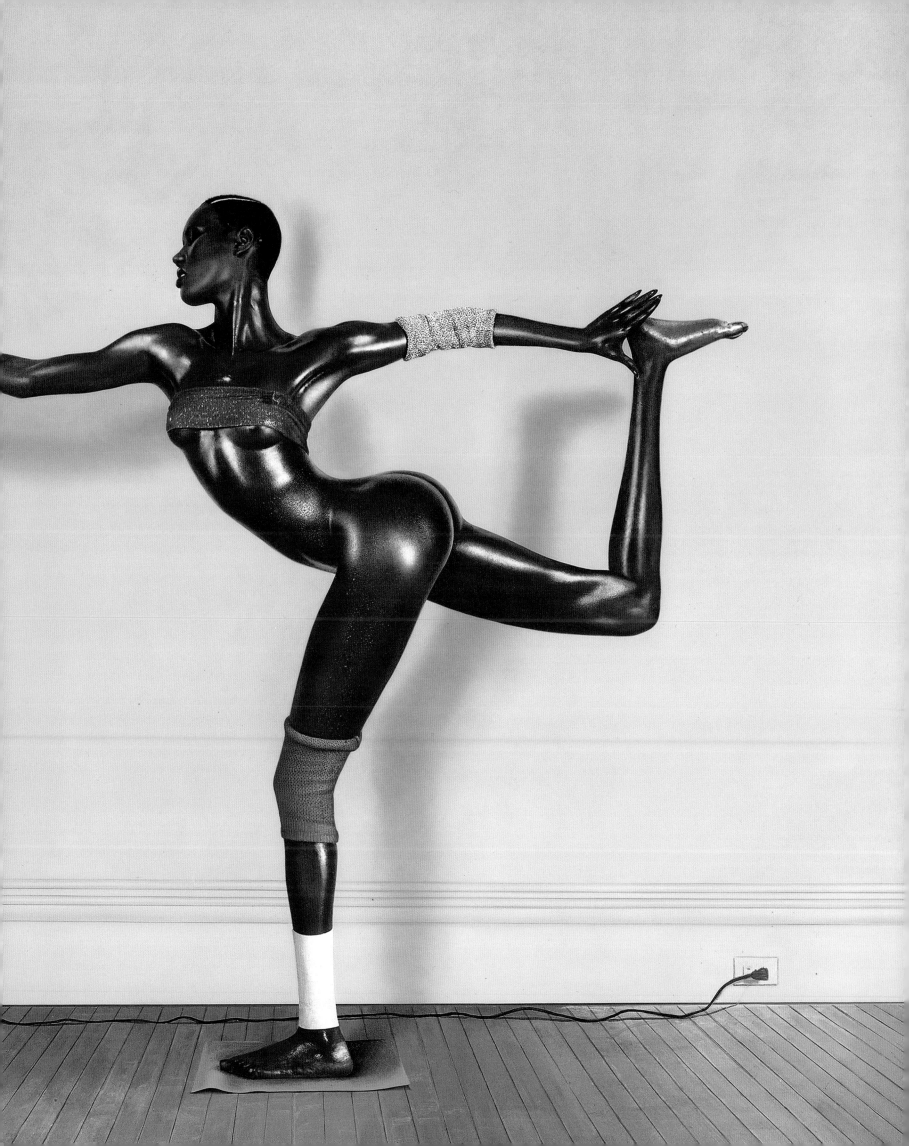

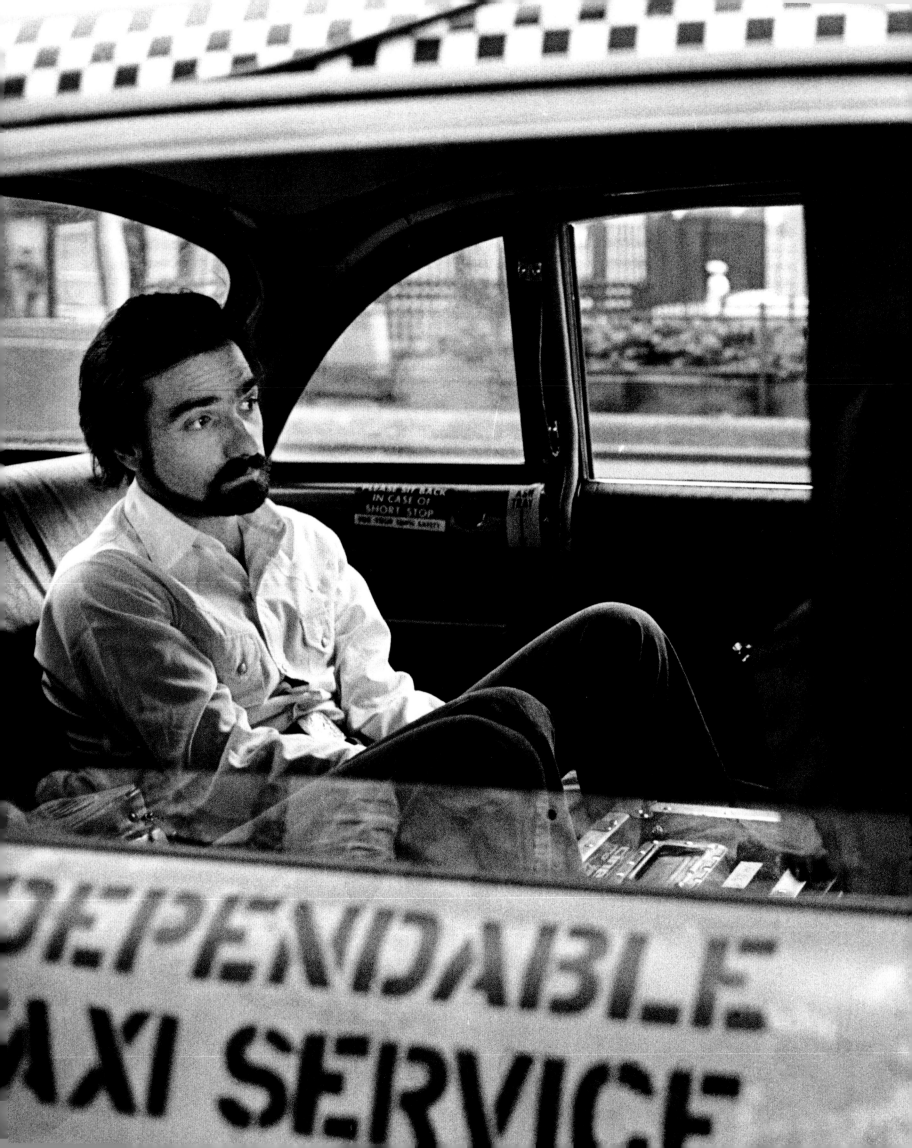

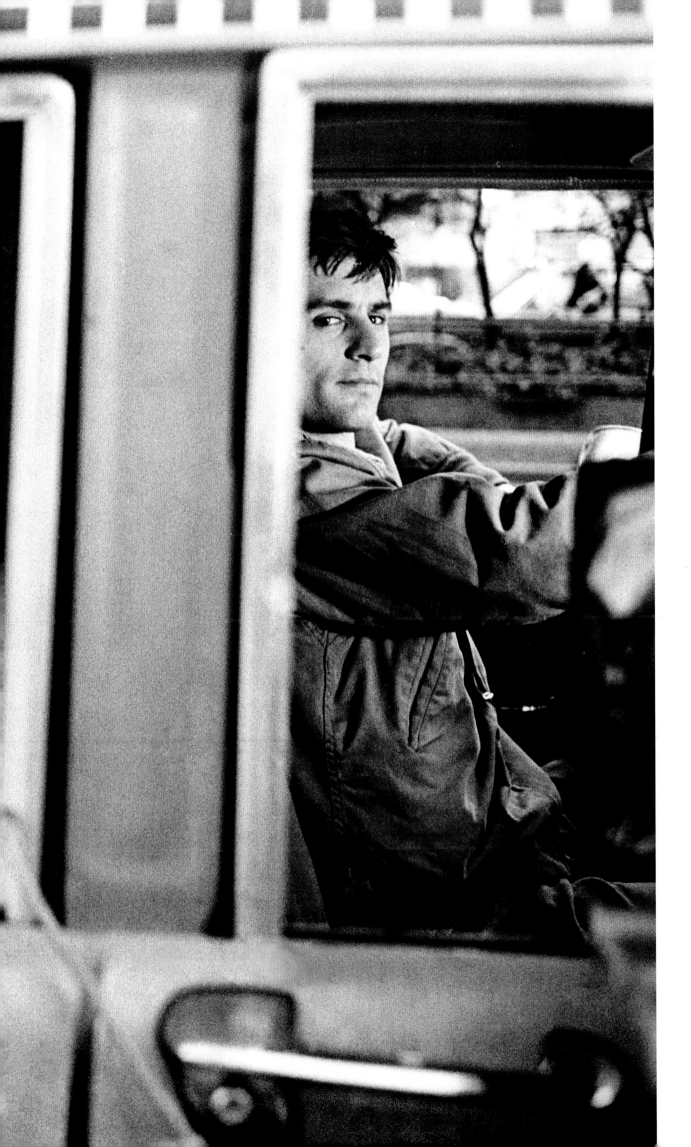

1976

We called Robert De Niro America's greatest actor. (But we got Scorsese all wrong.)

New York's film critic panned Martin Scorsese's *Taxi Driver* when it was released. (See an excerpt from the review, page 279.) A year later, though, a cover story declared its star an enigmatic genius. "Acting for De Niro is a psychological, clincal adventure," wrote Paul Gardner. "And with each role he finds a new persona."
PHOTOGRAPH BY STEVE SCHAPIRO

271

Mario Puzo sold out, and liked it.

"I have written three novels. *The Godfather* is not as good as the preceding two; I wrote it to make money," Puzo explained in a cover story. When he turned in the manuscript, he used his last $1,200 from the advance to go on vacation, where he blew through the cash (and went into heavy debt) at the casino. When he got back to New York and met his agent, "she informed me that my publisher had turned down $375,000 for the paperback rights....They were holding out for $410,000." Which they got.

PHOTOGRAPH BY STEVE SCHAPIRO

Puzo Apportions Credit for the Success of 'The Godfather' Film

The Novel Itself
40% for the fame of the novel.
30% for the characters and incidents.
Total 70%

Director Francis Coppola
3% for being faithful to the book.
3% for fighting for Pacino (against everybody).
2% for fighting for Brando (against everybody but me).
1% for being Italian.
5% for rewriting script and keeping it a three-hour movie.
Total 14%

Author Puzo
3% for writing basic script.
2% for rewriting the rewrite.
2% for suggesting Brando.
2% for keeping it a three-hour movie against everybody's advice.
2% for insisting that it would be fatal to leave out Sicily sequence (against everybody except Francis Coppola).
3% for quitting the movie when shooting began and so getting out of everybody's way so they could work.
Total 14%

Minus 5% for fighting against Al Pacino's playing Michael.
Net Total 9%

Puzo's Credits *(continued)*

Producer Al Ruddy
5% for getting the project moving.
3% for holding everybody's hands and keeping them from killing each other.
5% for taking the rap for everything and taking it with a smile.
Total 13%

Minus 5% for giving wrong advice on how to write the script.
Net Total 8%

Studio Vice President Robert Evans
5% for listening with an open mind to everyone and making the right decisions.
2% for making the first cut of the movie so commercially swift. (One viewer complained the movie was like having dinner in a restaurant where the food was delicious, but the waiter kept whipping away the dishes before you could finish.)
Total 7%

Paramount Vice President Peter Bart
5% for suggesting Francis Coppola to direct the picture on the theory that an Italian could do the best job. (Not as simple reasoning as it sounds.)
2% for nagging everybody.
Total 7%

Paramount President Frank Yablans
5% for distribution and exploitation.
2% for minding his own business.
Total 7%

Owner of Paramount Pictures Charles Bludhorn
1% for not insisting Charles Bronson play the Godfather role.

The Actors
Total 10%

The Crews and Technical and Costumes and Art, etc.
Total 5%

Grand Total 138%

(Because you always give more credit in the movie business than exists.)

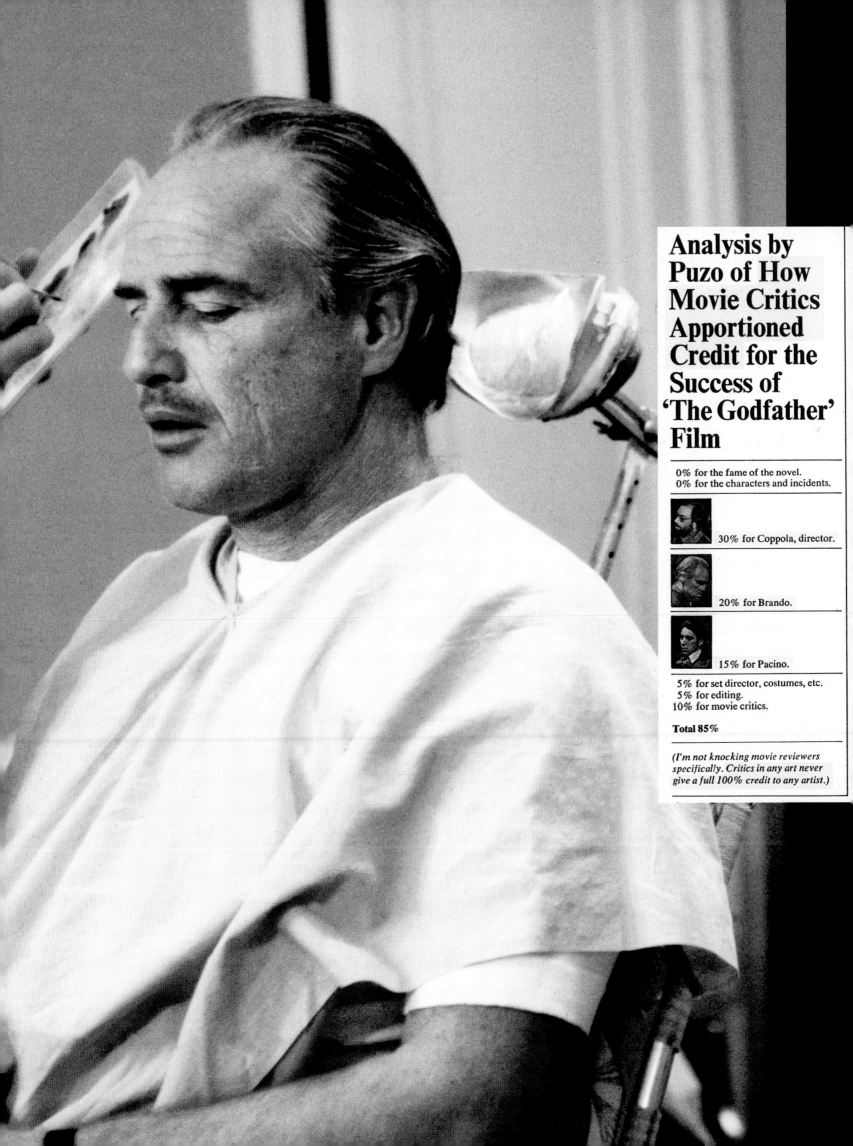

Analysis by Puzo of How Movie Critics Apportioned Credit for the Success of 'The Godfather' Film

0% for the fame of the novel.
0% for the characters and incidents.

30% for Coppola, director.

20% for Brando.

15% for Pacino.

 5% for set director, costumes, etc.
 5% for editing.
10% for movie critics.

Total 85%

(I'm not knocking movie reviewers specifically. Critics in any art never give a full 100% credit to any artist.)

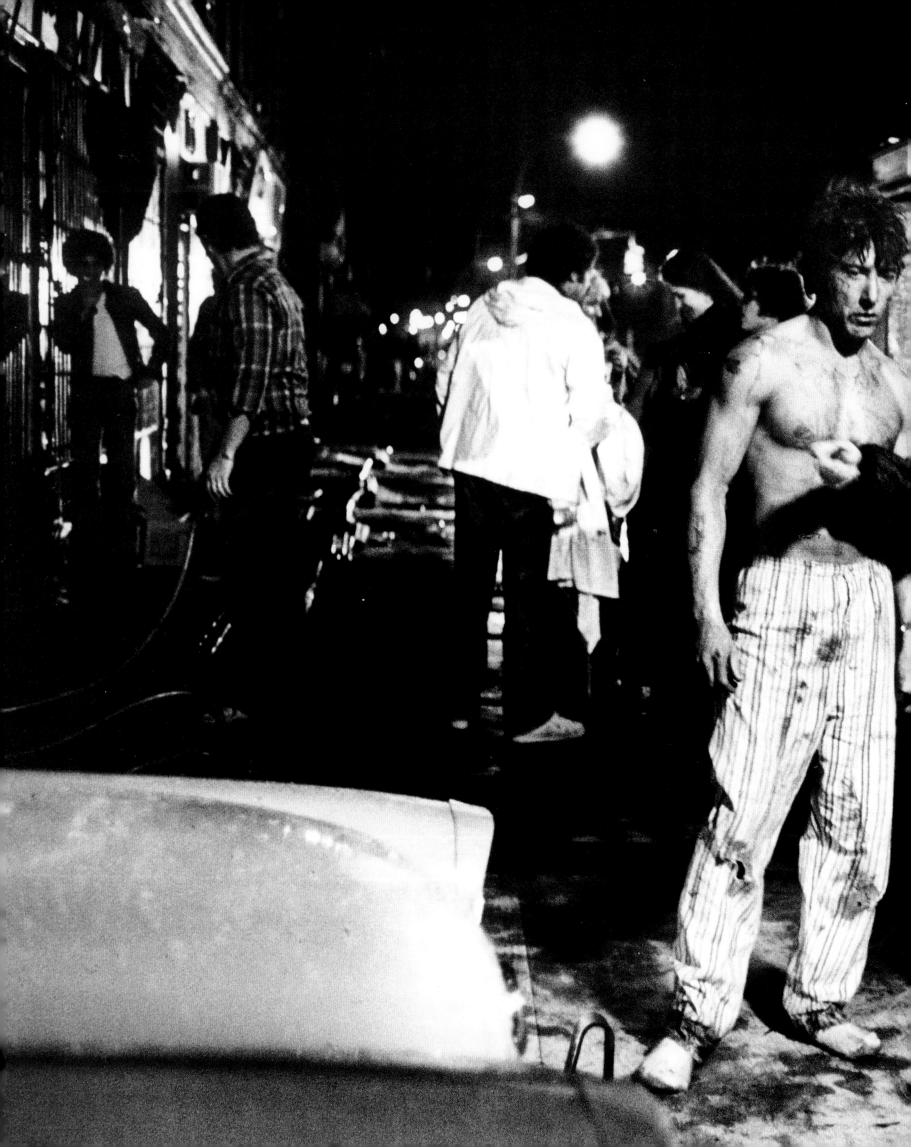

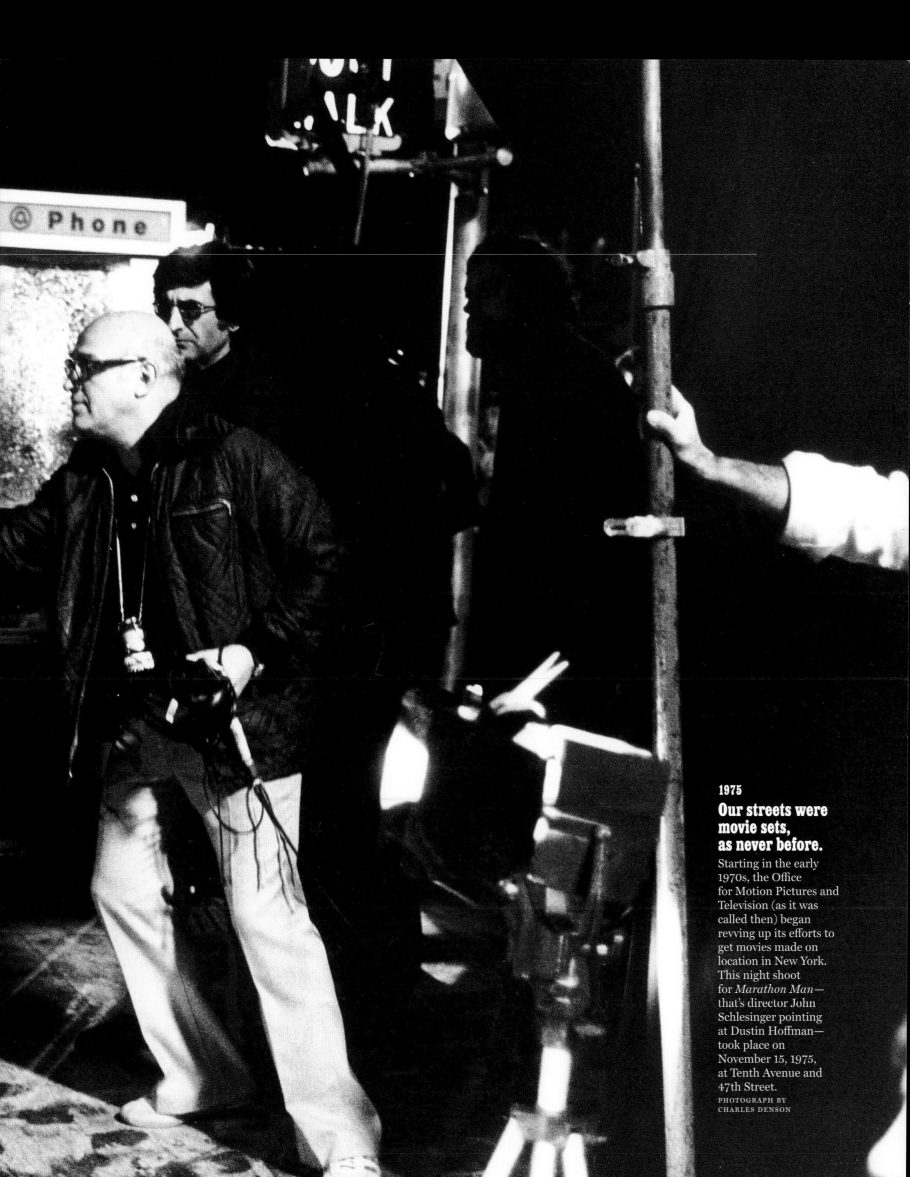

1975

Our streets were movie sets, as never before.

Starting in the early 1970s, the Office for Motion Pictures and Television (as it was called then) began revving up its efforts to get movies made on location in New York. This night shoot for *Marathon Man*— that's director John Schlesinger pointing at Dustin Hoffman— took place on November 15, 1975, at Tenth Avenue and 47th Street.

Our critics opined on thousands of breakout hits, sophomore slumps, delicious flops, surprise album drops— and, often, larger shifts in the culture.

John Simon on "the Boo Taboo," 1968 ➤➤ And the voice of the booer shall be heard in the land! What our theaters, opera houses, and concert halls need is the introduction of the two-party system; as of now, all they have got is a dictatorship. It is the dictatorship of the assenters over the voices of dissent, of the applauders and cheerers over the booers and hissers, and its effect on our performing arts is to encourage the status quo, however mediocre or lamentable it may be. There is an urgent or, if I may say so, crying need for the voices of protest to be given equal rights and equal time.

When the Hamburg State Opera brought to New York its production of Gunther Schuller's derivative, pretentious, and vacuous *The Visitation*, there was, I gather, quite some booing at its first performance at the Met. I attended the second, at which, for whatever reason, there were no boos, except for mine at the final curtain. A man came up to me and congratulated me on my good sense and courage. This was typical: The average American theatergoer, even when he realizes that he is being abused, wants someone else to do his protesting for him.

The most illuminating occurrence for me was a recent Saturday matinee at the Met. It was Barrault's wretched staging of *Carmen*, with Richard Tucker as Don José. Tucker's voice was as off as it had been for years, his phrasing as unlovely as it had always been. Visually, he was a geriatric travesty; histrionically, even by the shockingly low standards of operatic acting, a farce. After he got through mangling the Flower Song, and after the orchestra was through as well, I added to the general applause three loud phooeys.

The reaction was instantaneous. From several boxes around the one I sat in came frantic retaliation—mostly of the "Shut up!" or "How dare you?" or "Go home!" variety, though one middle-aged woman intoned lachrymosely, "He has given you years of beauty!" When the lights went on, [Met general manager] Rudolf Bing, who was sitting a couple of boxes away, had already dispatched his Pinkerton men after me, accompanied by a polite and human-sized person who introduced himself courteously as James Heffernan, house manager. To summarize the ensuing battle of wits—if that is the term for it—Mr. Heffernan's point was that in Italy, where such a tradition exists, booing was fine, but that in "this house" it just wasn't done. My point was that if there was no such tradition here, it was high time to instigate one for the need was dire. Heffernan put forward that such booing might discourage the singer, to which I replied that that was the general idea.

Molly Haskell on arty porn, 1976 ➤➤ As a critic, I've never celebrated the advent of hard-core film as a breakthrough in artistic freedom and self-expression, but I haven't been entirely blameless in helping to maintain an atmosphere in which such films were taken seriously. In the name of intellectual curiosity and "covering the beat," and possibly not wanting to appear square, I've kept up with these movies, with the antics of Harry Reems and Georgina Spelvin and Marilyn Chambers—and I've been utterly and excruciatingly bored.

A year ago I even attended a conference in New Orleans of the Adult Film Association of America. The porn people wanted their movies reviewed, and thus legitimized, by the critics; the critics wanted better movies. My own long-cherished illusion was that some gifted filmmaker working in this marginal area would take advantage of his freedom and come through with the kind of imaginative handling of adult sensuality that had escaped the powers of the major American directors. But after we had finished the panel and I had harangued them for making such witless and unimaginative films, I realized that we were talking at cross

RICHARD DREYFUSS

"INSERTS"

a degenerate film with dignity.

RICHARD DREYFUSS "INSERTS"
JESSICA HARPER · BOB HOSKINS · VERONICA CARTWRIGHT · STEPHEN DAVIES
HARRY BENN · DAVINA BELLING · CLIVE PARSONS
JOHN BYRUM · COLOR · United Artists

purposes. There was absolutely no commercial reason why they should take our advice and upgrade their products when they could make them so cheaply and get a steady return from their regular audience—the "raincoat brigade," with occasional drop-ins from the curious chic.

Recently, I went with my husband to see *Inserts* at our neighborhood 86th Street theater. We sat in the middle of an almost empty theater—he on my left, my pocketbook and coat (a buffer) on my right. When a man came in and sat next to them, I was immediately on guard. My concern, since my borders were protected, was for my purse. But when the man's hand went out, it wasn't for my purse but for his penis. As I kept my eyes fixed on the screen, he proceeded to pump away, looking in my direction for the expression (shock? Embarrassment? Interest?) that would stimulate him to complete his work. Disappointed in me, or perhaps in the movie (which didn't live up to its X rating), he moved off. But in the meantime I had been rigid in my seat, unable to take in the last fifteen minutes of the movie. When it was over, I felt overwhelmed, furious, remembering all the times I had been victimized by such incidents or by their possibility; all the times I have had to be on guard, my antennae alert, my attention dis-

tracted; and all of the times I have averted my eyes, or moved away, conceding the field to him!

Why hadn't I turned to my husband, who remained unaware of this sidebar performance? Partly because I thought of myself as a reviewer and therefore professionally alone. But also because in this permissive atmosphere, it seemed unsophisticated to make a fuss. The exhibitionist's attitude might have been, "Well, what are you doing here if you're not interested in any action?"

When do we hold our ground and say *"Enough!"?* Perhaps it is up to women—for men, our friends, are of the same sex as our abusers and our attackers, and rarely seem to understand the special ever-present nature of our vulnerability, and the degree to which any assault on women in films and plays is a reminder of that vulnerability and a warning.

John Leonard on event television, 1990 ⇥ At 10:01 p.m.
Thursday, April 19, the telephone started like a tribal drum. Everybody in the continental United States—including my children, my editors, my enemies—wanted to know about the dwarf. What did the dwarf mean? Why was he talking backwards?

In Cambridge, Massachusetts, in Madison, Wisconsin, and in Berkeley, California, there are *Twin Peaks*–watching parties every Thursday night, after which...Deconstruction. About the dwarf: Like, wow. Buñuel was mentioned, and Cocteau, and Fellini.

Jane O'Reilly shouldn't have been watching television at all. The author of *The Girl I Left Behind* should have been finishing her book on radical nuns. After the dwarf, she went to Central Park, where the dog-walkers were extremely upset about the way parents treat their children in the Pacific Northwest, as if *Twin Peaks* were their own hometown, as if something strange were always happening to them in the woods. O'Reilly herself wants Leo, the wife-beating, coke-dealing, ponytailed trucker, dead.

Friday morning, in the bowels of the CBS Broadcast Center on West 57th Street, there was a gathering of the Lynched. A graphic artist has programmed and imaged a "tree" of *Twin Peaks* relationships: Harry and Jocelyn; Benjamin and Catherine; Ed, Norma, and Nadine; James, Laura, and Donna; Bobby and Laura and Shelly; Dr. Jacoby and the Log Lady. In *Twin Peaks*, every Other is Significant. Friday noon, Elizabeth Pochoda, book editor of *Entertainment Weekly*, and Andrew Kopkind, the radical journalist, met for lunch. Instead of Lithuania or Earth Day, they discussed *Twin Peaks*.

Lynch, who seems to have an unlimited and unedited access to his own unconscious, lets us think we recognize ourselves; we're seeing our favorite movies, reading our favorite books, standing in front of our favorite paintings. Linda Wolfe, author of *Wasted*, wanted *Winesburg, Ohio*, and for a while she had it. Jane O'Reilly was looking for Don DeLillo—"the theology of secrets" elaborated in *Libra*—just as her son Jan Fisher wanted *L'Avventura*. Marshall Berman was watching for F. E. Church and the Hudson River School; he's a bit weary now of so many waterfalls.

And me? For a while I wanted Agent Cooper to be Wittgenstein, arriving in Cambridge from Vienna, the capital of alienation, with his clarinet (and his despair) in an old sock; the philosopher of the impasse and the cul-de-sac, afraid of open spaces; the poet and prophet of the Unsayable: "Whereof one cannot speak thereof one must be silent." This, of course, is ridiculous. By the time of the dwarf, I was hoping instead for something like Tom Pynchon among the Thanatoids in *Vineland*. This is almost as silly. Wittgenstein had a philosophy, and Pynchon has some politics. Lynch is merely moody, more of a Warhol. Though beautiful to look at, there isn't much of anything inside his soft labyrinth except an unimportant secret. *Twin Peaks* has nothing at all in its pretty little head except the desire to please. In this, and only in this, it resembles almost everything else on television. But beautiful is better. Must we, like the Deconstructionists, moisten everything with meaning?

Sam Anderson on the new kind of leading man, 2010 ⇥
James Franco's main artistic obsession—the subject that echoes across all of his various media—is adolescence. We're watching him transition, a little awkwardly, from one creature (the Hollywood-dependent star) to another (the self-actualized, multi-platform artist). Like real adolescence, it's a propulsive phase in which energy exceeds control. It's about extremes—the hysteria to distinguish oneself, to break the rules, to leap into the world and do impossible things. Franco is developing all kinds of new strengths, but at the cost of some of his dignity: His intellectual skin is a little spotty, his artistic legs are suddenly too long for the rest of his body.

It's the kind of ragged transition that most actors pay good money to have smoothed over by publicity teams. Yet Franco is making a spectacle of it. Which is, in a way, brave. One of the central points of Franco's art and career, as I read them, is that adolescence isn't something we should look away from, a shameful churning of dirty hormones. It's the crucible of our identity, the answer to everything that comes later, and we need to look long and hard at it, no matter how gross or painful it might sometimes feel.

And as Franco adds layer upon layer, wink upon wink—as he slides further along the continuum from Gyllenhaal to Warhol—his entire career is beginning to look less like an actual career than like some kind of gonzo performance piece: a high-concept parody of cultural ambition. He's become a node of pop-cultural curiosity in roughly the same universe as Lady Gaga. Blogs report Franco's texting habits at parties and spread bizarre secondhand rumors about his film shoots. Here are YouTube tributes that splice together all his onscreen kisses, a Tumblr account that publishes daily pictures of him, and even an online interactive James Franco dress-up doll. It's hard to imagine this is all accidental: For an earnest guy, Franco has always been ragingly addicted to meta. He loves to play James Franco—not just in *General Hospital* (sort of), but in *Knocked Up, 30 Rock*, and a series of short videos he's

made for the website Funny or Die (e.g., "Acting With James Franco," in which he instructs his younger brother Dave in the rudiments of the profession). The more Franco self-dramatizes like this, and the more we become accustomed to it, the more he's actually James Franco playing James Franco playing James Franco—a mise en abyme of artsy pomo heartthrob.

David Edelstein on "Torture Porn," 2006 ➻ Seen any good surgery on unanesthetized people lately? Millions have, in *Hostel*, which spent a week as America's top moneymaker. It's actually not a bad little thriller, if you can live with the odd protracted sequence of torture and dismemberment. The director, Eli Roth, captures the mixture of innocence and entitlement in young American males abroad: They breeze into a former Soviet-bloc country the way teens in old sex comedies headed for Daytona, confident that their country's power and prestige will make them babe magnets. And those are some supermodelish babes in *Hostel*'s Slovakian village, where life appears to be a nonstop naked sauna party. One of our heroes is confused about his sexuality, though, and sympathetic to an old man who makes a pass at him. It's quite a shock when he wakes to find himself in chains, with that same old man preparing to eviscerate him. The poor sap screams, pleads, weeps: He doesn't understand why he's in that place.

As for me, I didn't understand why I was in that place either, watching through my fingers—or why I'd found myself in similar places many times during the past few years. Explicit scenes of torture and mutilation were once confined to the old 42nd Street, the Deuce, in gutbucket Italian cannibal pictures like *Make Them Die Slowly*, whereas now they have terrific production values and a place of honor in your local multiplex. As a horror maven who long ago made peace, for better and worse, with the genre's inherent sadism, I'm baffled by how far this new stuff goes—and by why America seems so nuts these days about torture.

There's no doubt that something has changed in the past few decades. Serial killers occupy a huge—and disproportionate—share of our cultural imagination: As potential victims, we fear them, yet we also seek to identify with their power. Fear supplants empathy and makes us all potential torturers, doesn't it? Post-9/11, we've engaged in a national debate about the morality of torture, fueled by horrifying pictures of manifestly decent men and women (some of them, anyway) enacting brutal scenarios of domination at Abu Ghraib. And a large segment of the population evidently has no problem with this. Our righteousness is buoyed by propaganda like the TV series *24*, which devoted an entire season to justifying torture in the name of an imminent threat: a nuclear missile en route to a major city. Who do you want defending America? Kiefer Sutherland or civil-liberties lawyers?

Back in the realm of non-righteous torture, the question hangs, Where do you look while these defilements drag on? Consider a nightmarish film that many critics regard as deeply moral, Gaspar Noé's *Irreversible*, which delivers a nine-minute anal rape (of a pregnant woman). Noé means to rub your nose in the violence and make you loathe it, but my nose had been pretty well rubbed after the first two minutes. For a while I stared at the EXIT sign, then closed my eyes, plugged my ears, and chanted an old mantra. I didn't understand why I had to be tortured, too. I didn't want to identify with the victim or the victimizer.

I am complicit in one sense, though. I've described all this freak-show sensationalism with relish, enjoying—like these filmmakers—the prospect of titillating and shocking. Was it good for you, too?

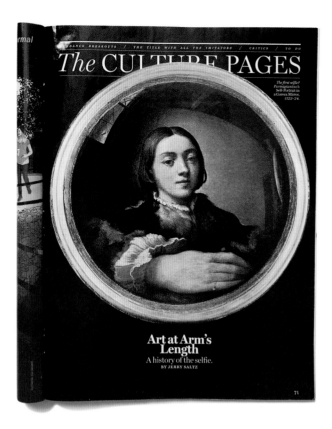

Jerry Saltz on the Selfie, 2014 ➻ We live in the age of the selfie. A fast self-portrait, made with a smartphone's camera and immediately distributed and inscribed into a network, is an instant visual communication of where we are, what we're doing, who we think we are, and who we think is watching. Selfies have changed aspects of social interaction, body language, self-awareness, privacy, and humor, altering temporality, irony, and public behavior. It's become a new visual genre—a type of self-portraiture formally distinct from all others in history. Selfies have their own structural autonomy. This is a very big deal for art.

Let's stipulate that most selfies are silly, typical, boring. Guys flexing muscles, girls making pouty lips ("duckface"), people mugging in bars or throwing gang signs or posing with monuments or someone famous. Still, the new genre has its earmarks. Excluding those taken in mirrors—a distinct subset of this universe—selfies are nearly always taken from within an arm's length of the subject. There is the near-constant visual presence of one of the photographer's arms, typically the one holding the camera. Bad camera angles predominate, as the subject is nearly always off-center. The wide-angle lens on most cell-phone cameras exaggerates the depth of noses and chins, and the arm holding the camera often looks huge. If both your hands are in the picture and it's not a mirror shot, technically, it's not a selfie—it's a portrait.

Selfies are usually casual, improvised, fast; their primary purpose is to be seen here, now, by other people, most of them unknown, in social networks. They are never accidental: Whether carefully staged or completely casual, any selfie that you see had to be approved by the sender before being embedded into a network. This implies control as well as the presence of performing, self-criticality, and irony. The distributor of a selfie made it to be looked at by us, right now, and when we look at it, we know that. (And the maker knows we know that.) The critic Alicia Eler notes that they're "where we become our own biggest fans and private paparazzi," and that they are "ways for

celebrities to pretend they're just like regular people, making themselves their own controlled PR machines."

When it is not just PR, though, it is a powerful, instantaneous ironic interaction that has intensity, intimacy, and strangeness. In some way, selfies reach back to the Greek theatrical idea of methexis—a group sharing wherein the speaker addresses the audience directly, much like when comic actors look at the TV camera and make a face. Finally, fascinatingly, the genre wasn't created by artists. Selfies come from all of us; they are a folk art that is already expanding the language and lexicon of photography. Selfies are a photography of modern life—not that academics or curators are paying much attention to them. They will, though: In a hundred years, the mass of selfies will be an incredible record of the fine details of everyday life. Imagine what we could see if we had millions of these from the streets of imperial Rome.

Kathryn Schulz on Twitter, 2013 ⇥ I owe an apology to anyone who was following me those first few months after I joined Twitter. On the good side, that includes almost nobody. On the bad side, I signed up under professional duress, and it showed. I was a few months from publishing a book about being wrong, and my handle back then—@wrongologist, which I can no longer type without cringing—tells you everything you need to know about my early Twitter persona. For all of 2010, my feed was wrongness-heavy—and, because I joined so reluctantly, tweet-light: 28 of them in March, 23 in April, 13 in May.

In November of 2010, already privately a bit bored with wrongness, I broke form—or, more aptly, began to find it—and tweeted a video about cephalopods. Then came an intrepid nineteenth-century nurse and her irresistibly titled book: *On Sledge and Horseback to Outcast Siberian Lepers.* One evening in December, on the train home from a literary event, I tweeted a handful of imaginary book-band mash-ups: Pale Arcade Fire. Rabbit, Run DMC. When Bad Things Happen to Good Village People. A stranger tweeted back at me: Jane Eyre Supply. Ha! I thought. This is fun.

That was the beginning of my Twitter fall, or rise, or whatever direction I'm heading here. What I can tell you is that by January of 2011, the wrongness tweets had all but disappeared. By February, I'm tweeting about Libyan politics, lenticular cloud formations, hand-carved tombstones in Transylvania, and the mesmerizing weirdness of Robyn's video for "Dancing on My Own." By April, forgive me, I tweet my first cat. In October, I finally drop the @wrongologist handle in favor of @kathrynschulz, but that is an ex-post action if ever there was one. On Twitter, I've long since become myself.

Or rather: I have become myself with an addiction. This is something of a paradox, since having an addiction feels quite a lot like not being me. I don't smoke. I average maybe five drinks a month. I've tried the predictable range of drugs, most of them exactly once. I've steered clear of things like online Boggle and Words With Friends, well aware that they could torpedo the productivity of a writer who works from home. I've never before gone mad for any type of technology. Even the internet did not particularly seduce me before the Twitter portal. I used it only for e-mail, and for targeted research; as recently as 2009, I probably spent, on average, under 30 minutes a day online. I didn't have a cell phone until 2004, didn't have a smartphone until 2010. I only got addicted to coffee three years ago. But then along came that goddamned bluebird, which seems to have been built with uncanny precision to hijack my kind of mind.

And we didn't always recognize a classic when we saw one.

'Rosemary's Baby,' 1968 ⇥ "A pedantic and slavish re-telling of the tale, strangely attenuated (running 135 minutes) but with elisions that will frustrate those familiar with the nuances of the novel and ellipses that will simply confuse those who do not know the book. Cinematic style boils down to below-the-waist photography (for a while one seems in a world inhabited by the headless). Mia Farrow is the baby-doll victim, and a monotonous one at that." —*Judith Crist*

'Taxi Driver,' 1976 ⇥ "Another undisciplined film by Martin Scorsese, this time about a maladjusted loner who drives a taxi by night and gets crazier by the day. The film tries to be too many things, and manages to flub most of them if not all. Insecure direction, but mostly good performances, particularly by Robert De Niro and Jodie Foster. And one dreadful one by Cybill Shepherd. Also pretentious cinematography and a bombastic score." —*unsigned*

'Annie Hall,' 1977 ⇥ "Woody Allen has truly underreached himself. His new film is painful in three separate ways: as unfunny comedy, poor moviemaking, and embarrassing self-revelation. It is everything we never wanted to know about Woody's sex life and were afraid he'd tell us anyway. And now he does. Here is the on-again, off-again love affair of a shlemiel and a meshuggeneh. The obvious trouble with such an affair is that it is off even when it is on: We cannot care. It is a film so shapeless, sprawling, repetitious, and aimless as to seem to beg for oblivion. At this, it is successful." —*John Simon*

'Seinfeld,' 1998 ⇥ "The passing of *Seinfeld,* that Cheez Doodle of urban fecklessness, into cryogenic syndication inspires no tear in this cave. I know we're all so postmodern-hip that we can be ironic about our own nostalgia—but nostalgic about our own irony? The worst thing about the sensibility of the '80s is that it bequeathed to us those sitcoms of the '90s in which every young adult on television is either a yuppie or a slacker, and too often both—sun-dried as if in extra-virgin olive oil; crouched in sports bars and faux bistros to consume minimalist meals, tethered to all that's trendiest, waiting for either Bret Easton Ellis or maybe David Letterman. Instead of *Howl,* yadda yadda." —*John Leonard*

After seeing *Do the Right Thing*, two *New York* columnists expressed alarm in print. Spike Lee wrote them a public letter.

Say It Ain't So, Joe

By Spike Lee

> These two represent the dominant strains of black leadership in the civil-rights era. Spike Lee, however, represents a third, more contrived strain: Like Stokely Carmichael, he is a middle-class intellectual trying to prove his solidarity with "the people" by demonstrating his outrage over white oppression. After he starts the riot in the movie, Lee sits and watches the violence from the curb. Perfect.
>
> Lee has said that he hopes *Do the Right Thing* will have an impact on the mayoral campaign—presumably by rousing blacks

> But if Spike Lee is a commercial opportunist, he's also playing with dynamite in an urban playground. The response to the movie could get away from him.

—Joe Klein and David Denby, June 26, 1989

TO THE EDITOR:

LO AND BEHOLD, we have a new black stereotype, according to Joe Klein, as if pimps, prostitutes, and crackheads weren't enough. Now there is that rampaging, "wilding" wolf pack—black youth. It is because of them that Klein tells the mostly white readers of *New York* to hope that *Do the Right Thing* will not open in "too many theaters near you."

He feels young black people across the country will see *Do the Right Thing* and come out of the theaters rioting. That all the subtleties that are likely to leave audiences (especially white liberal ones) debating the meaning of the film will be lost on black teenagers. Are we to conclude that only whites are intellectually and morally endowed to tackle an issue as complex as race relations in New York City? Why didn't Klein write an article on Costa-Gavras last year when *Betrayed* was released and warn us that white youth would see his film and be transformed, in the course of two hours, into neo-Nazi white supremacists?

Klein calls my film "reckless" and says it contains "dangerous stupidity." These are more accurate descriptions of the assumptions Klein chooses to draw about the film and its impact. In fact, Klein's hook—that David Dinkins will "have to pay the price" for *Do the Right Thing*—is the most dangerously stupid assumption of all. And the shame is, Klein thinks he's doing Dinkins a favor by pointing this out. By drawing such a connection in the first place, Klein commits the same crime he is so quick to charge New Yorkers with—that of holding Dinkins accountable for everything done or said by any black person in this city.

Political leaders should not be held responsible for the violent act of one of their constituents. Why should Dinkins have to answer for the rape in Central Park? Did anyone ask Ed Koch to account for the white teenagers who recently gang-raped a retarded girl in New Jersey? HELL NO! And why, as Klein suggests, should Dinkins's fate, more than any other candidate's, be decided by the degree of racial polarization in the city this summer? If anyone is to blame for allowing New York to become a racial war zone, it's Koch. He's been the mayor for the past eleven years, not Dinkins.

Klein goes on to charge that my film teaches that white people are the enemy. Comments like this only feed white fears and white hysteria. *Do the Right Thing* says no such thing. What I have done is to tell the story of race relations in this city from the point of view of black New Yorkers. Certainly it's one side of the story. It's not the side Joe Klein would tell (or could, for that matter), but it's the side I want to tell. Klein further chides me for "rather pointedly" dedicating this film to the families of victims of police brutality. Could it be that these families are any less worthy of attention than the families of slain police officers?

Though I wouldn't say that the cops in *Do the Right Thing* patrol the streets like "Nazi concentration-camp guards," this film is very accurate in its portrayal of the attitude that black and Hispanic New Yorkers have toward the police. Visit any black-Hispanic neighborhood in the city to confirm this. Innocent grandmothers like Eleanor Bumpurs are shot by cops, but the drug trade continues in open air.

David Denby's review of *Do the Right Thing* also is full of such troubling double standards. Klein and Denby were so busy accusing me of inciting the black masses to riot, they didn't stop to take stock of their own inferences. Denby asks where the drugs are in *Do the Right Thing*. He says I've presented a "sanitized" black community "without rampaging teenagers, muggers, or crack addicts." I guess Denby hasn't spent much time in Bedford-Stuyvesant. It has its share of crime and drugs like every neighborhood in the city. Black people in Bed-Stuy actually work; some even own homes and take care of them.

The drug plague affects us all. It's not just a "black problem." Drugs is another movie. Has any journalist asked a white director why the drugs were missing from his or her film? Denby feels that the anger of the black crowd that gathers at the end of *Do the Right Thing* is not "justified." It's hard to justify it only if you feel that when "some white policemen arrive and kill a black boy" it's an event of little consequence, but the burning of Sal's pizzeria is of major consequence. And that the black people in the film, who watch one of their own killed, wouldn't feel compelled to respond. By representing such a response realistically (this is America, not Heaven), am I endorsing it?

The truth is a bitter pill. But do we endorse it by confronting it? I think not. ∎

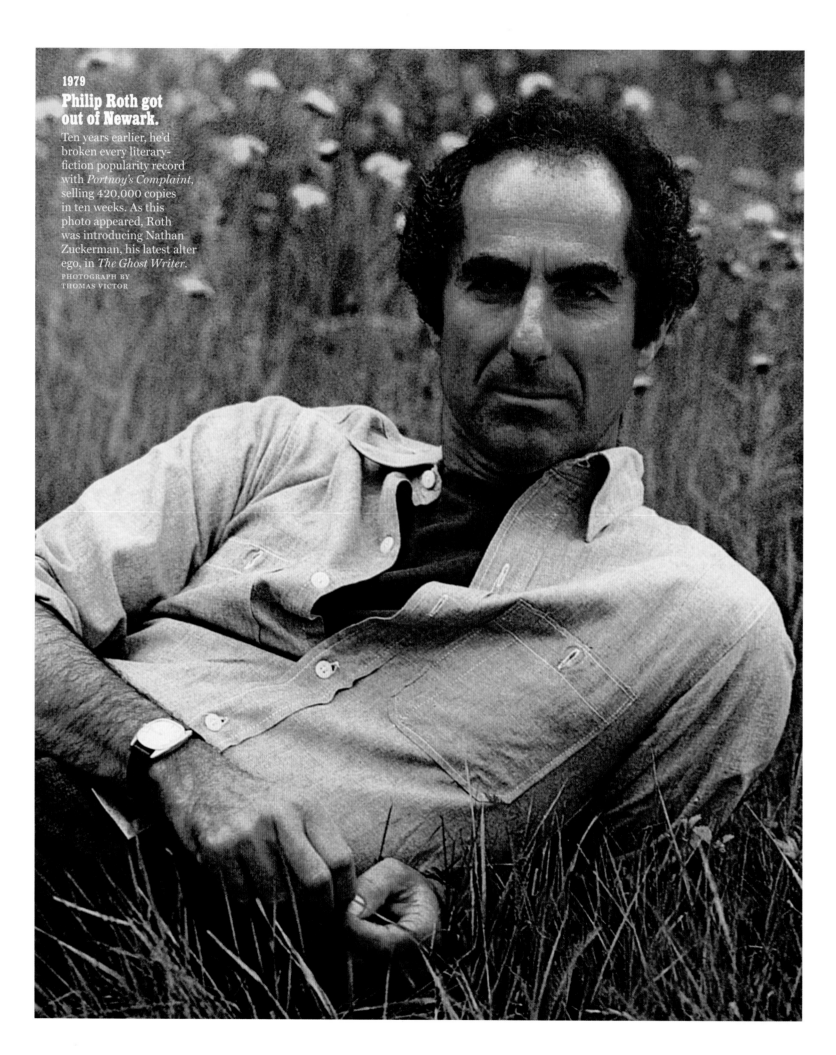

Philip Roth got out of Newark.

Ten years earlier, he'd broken every literary-fiction popularity record with *Portnoy's Complaint*, selling 420,000 copies in ten weeks. As this photo appeared, Roth was introducing Nathan Zuckerman, his latest alter ego, in *The Ghost Writer*.
PHOTOGRAPH BY
THOMAS VICTOR

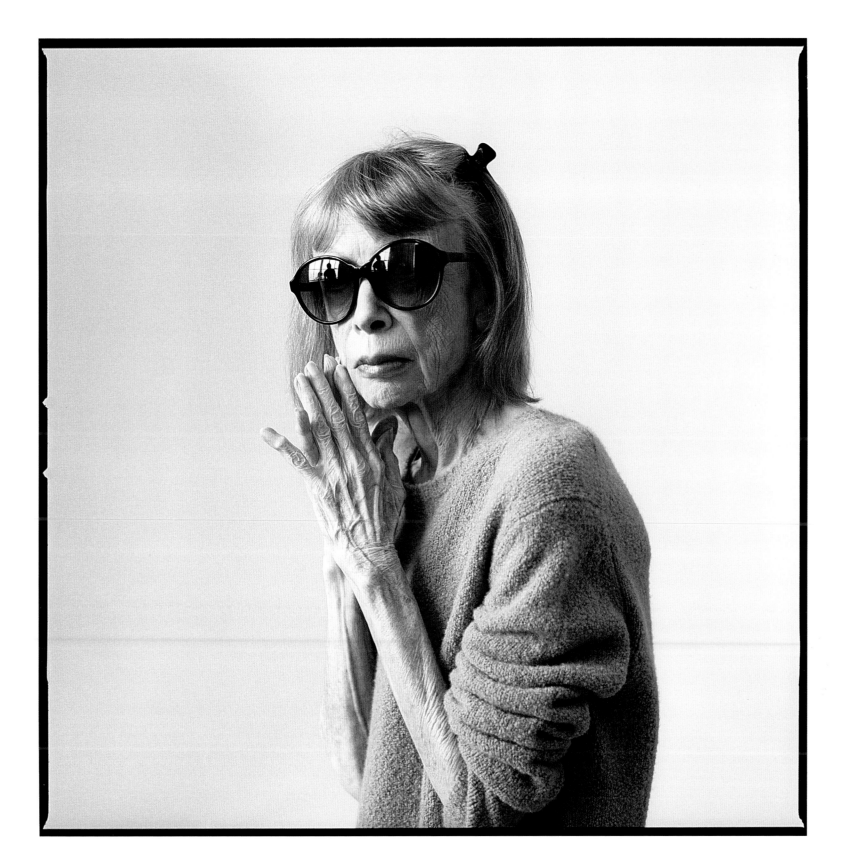

2005

Joan Didion wrote her way through a horrible two years.

After her husband died suddenly, she turned her grief into a remarkable memoir, *The Year of Magical Thinking;*
just before it was published, Didion's daughter died, too. "She is," wrote Jonathan Van Meter, "as has always been
obvious from her writing, a lot tougher than she looks."
PHOTOGRAPH BY BRIGITTE LACOMBE

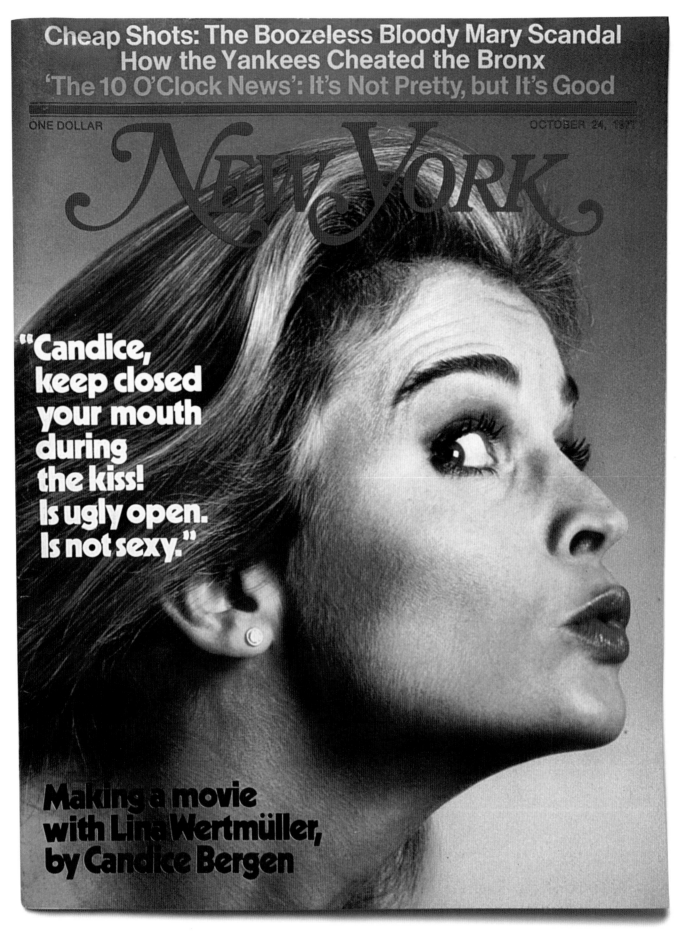

1977
Candice Bergen took notes.
She'd just been directed by Wertmüller in *A Night Full of Rain*.

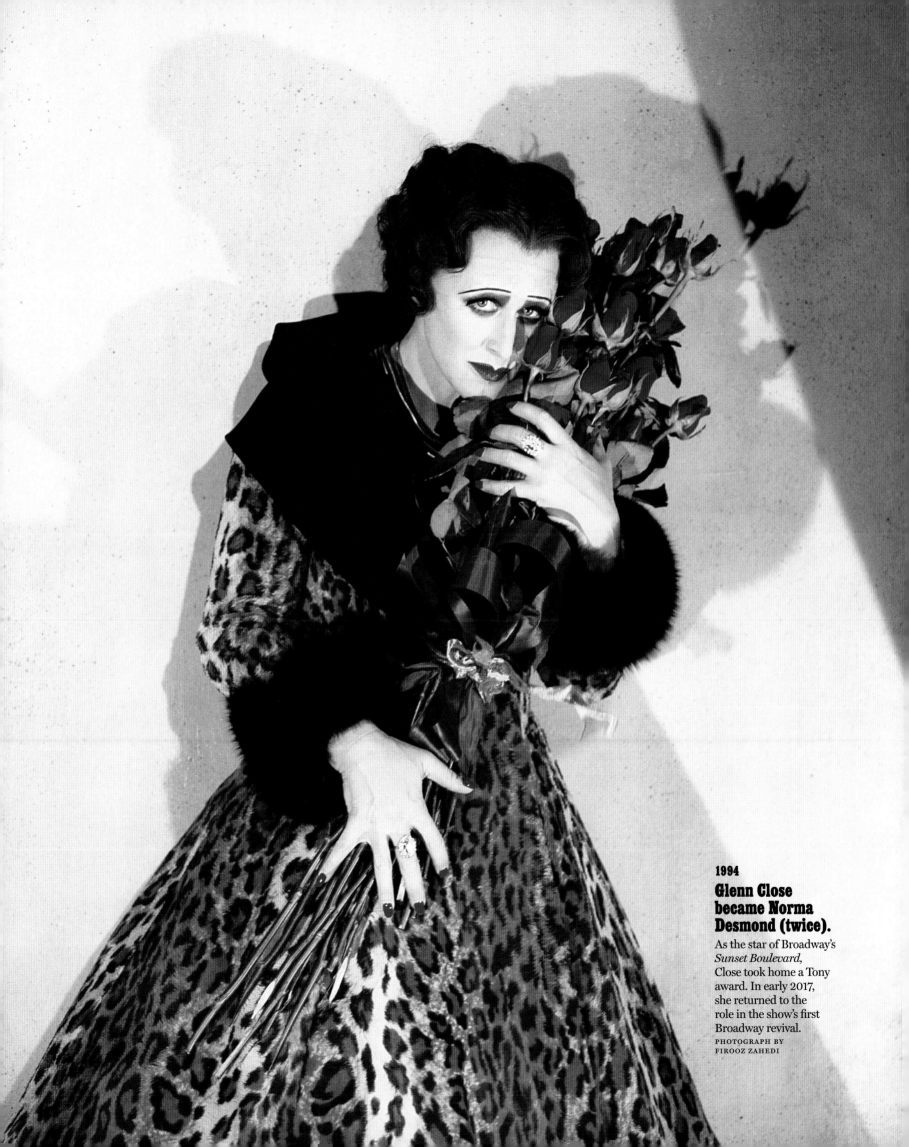

1994

Glenn Close became Norma Desmond (twice).

As the star of Broadway's *Sunset Boulevard*, Close took home a Tony award. In early 2017, she returned to the role in the show's first Broadway revival.

PHOTOGRAPH BY
FIROOZ ZAHEDI

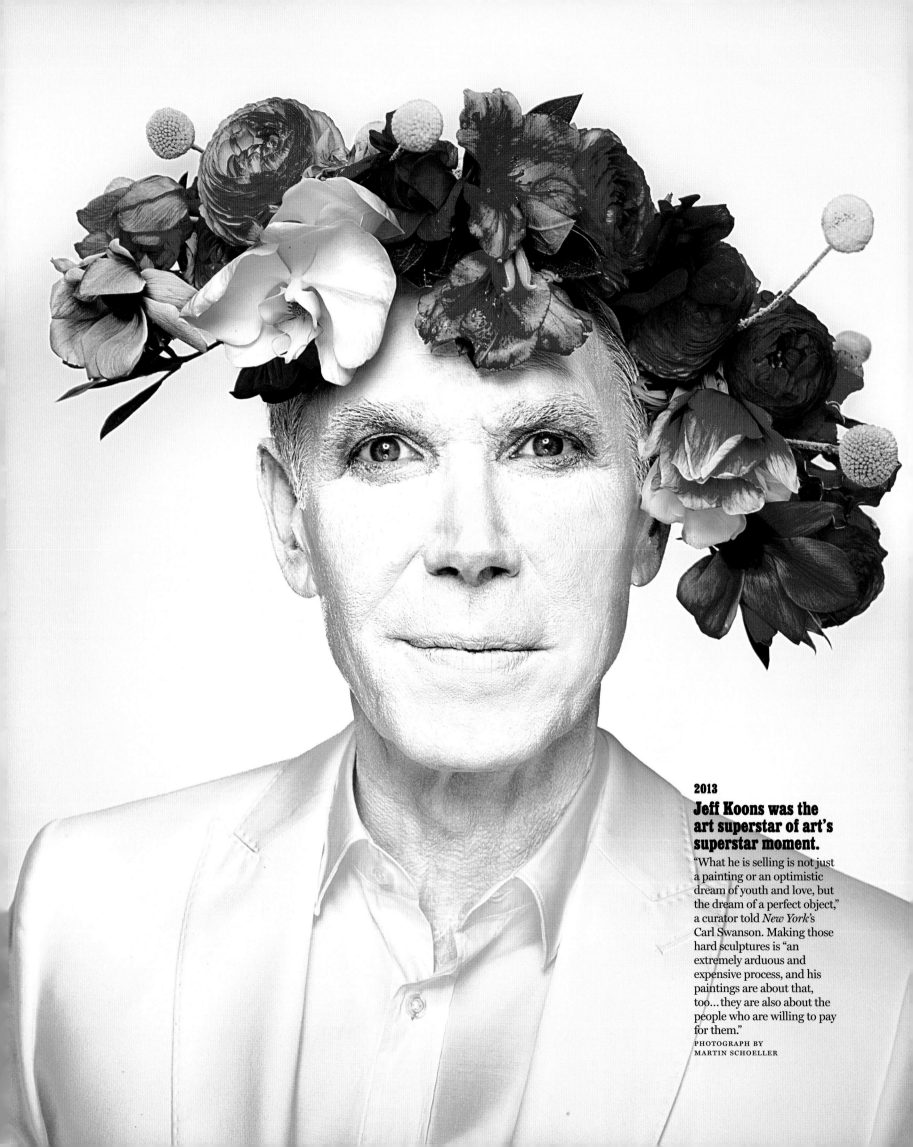

2013

Jeff Koons was the art superstar of art's superstar moment.

"What he is selling is not just a painting or an optimistic dream of youth and love, but the dream of a perfect object," a curator told *New York*'s Carl Swanson. Making those hard sculptures is "an extremely arduous and expensive process, and his paintings are about that, too…they are also about the people who are willing to pay for them."

PHOTOGRAPH BY
MARTIN SCHOELLER

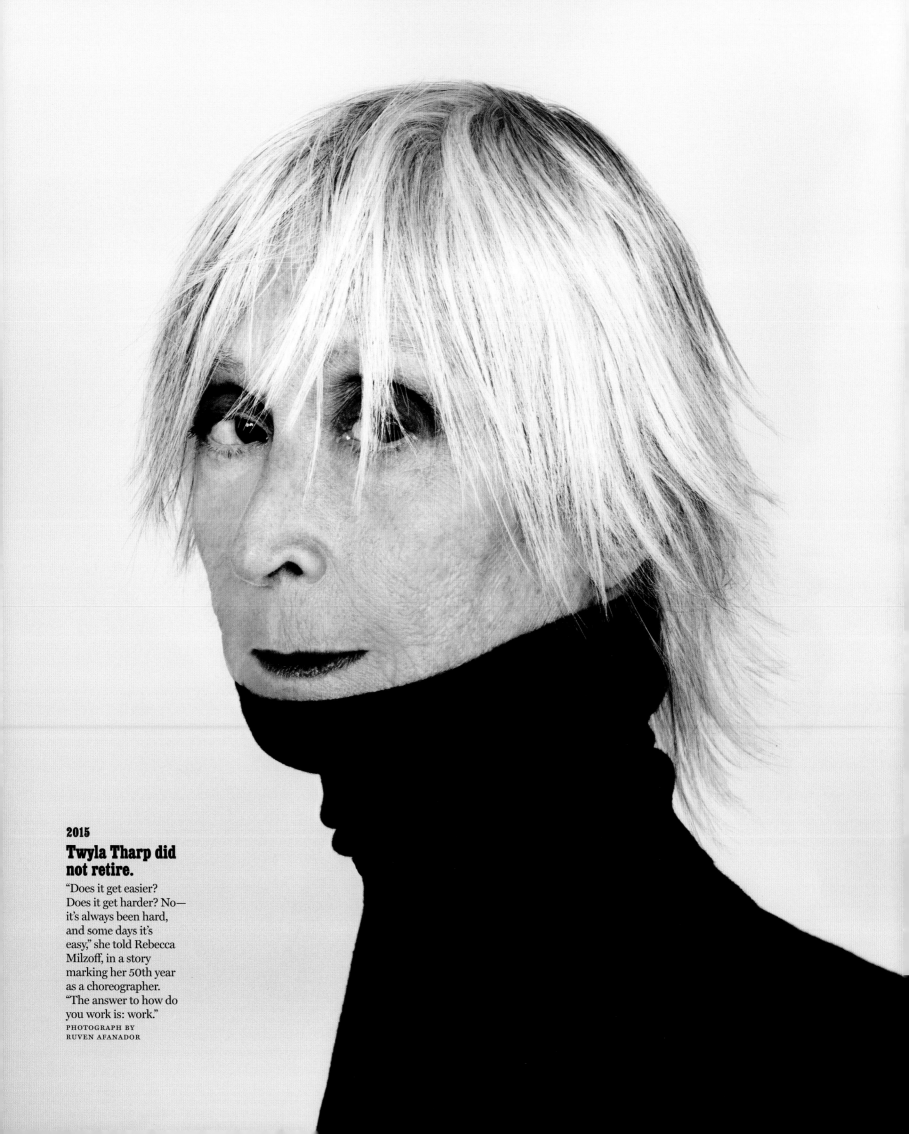

2015

Twyla Tharp did not retire.

"Does it get easier? Does it get harder? No— it's always been hard, and some days it's easy," she told Rebecca Milzoff, in a story marking her 50th year as a choreographer. "The answer to how do you work is: work."

PHOTOGRAPH BY RUVEN AFANADOR

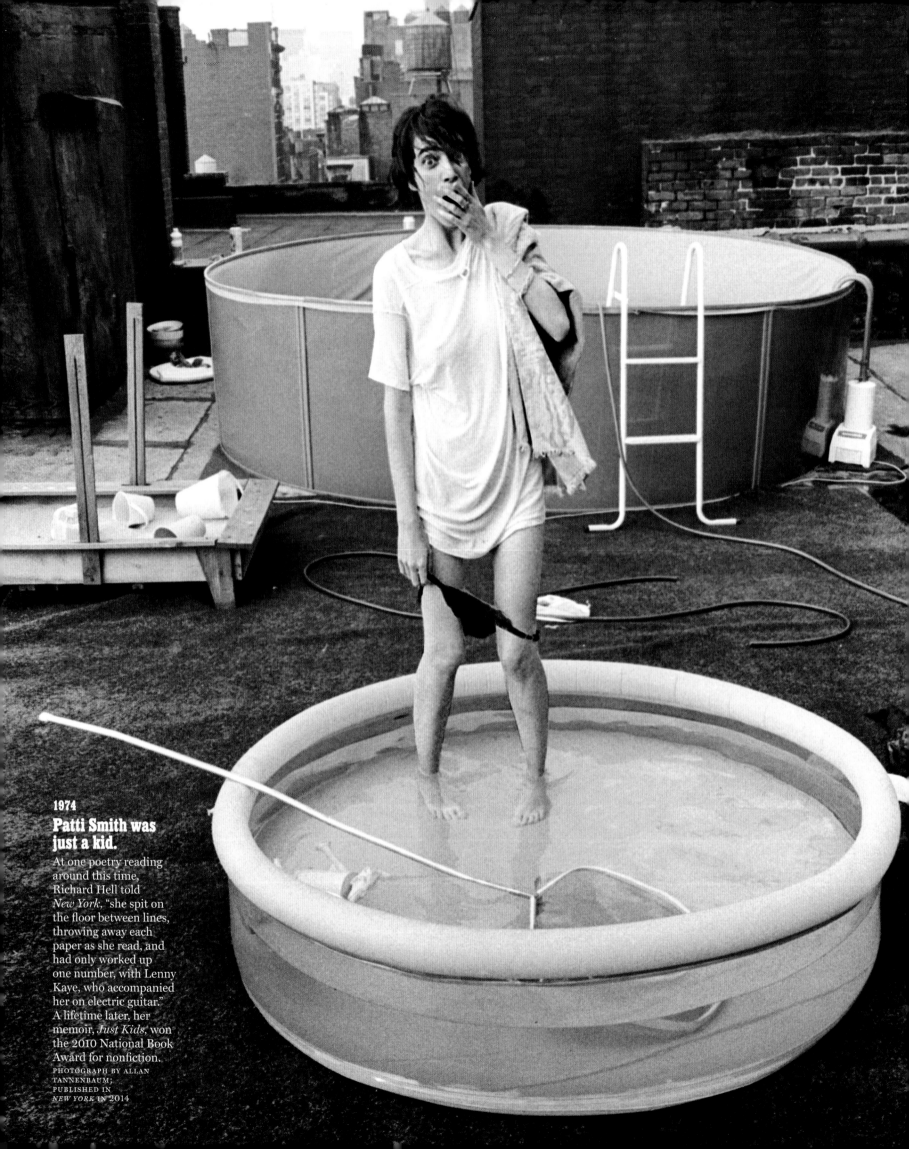

1974

Patti Smith was just a kid.
At one poetry reading around this time, Richard Hell told *New York*, "she spit on the floor between lines, throwing away each paper as she read, and had only worked up one number, with Lenny Kaye, who accompanied her on electric guitar." A lifetime later, her memoir, *Just Kids*, won the 2010 National Book Award for nonfiction.
PHOTOGRAPH BY ALLAN TANNENBAUM; PUBLISHED IN *NEW YORK* IN 2014

1976

Blondie made its first album.

"Chris [Stein] and I got a loft at 266 Bowery, right down the street from CBGB," Deborah Harry recalled in 2014.
"It was a pretty strange building. It had once been a sweatshop, maybe a doll factory. On the ground floor,
the street floor, was a liquor store, where all the Bowery bums would get their Night Train. We thought it was haunted."
The album didn't blow up; that happened two years later, with *Parallel Lines* and "Heart of Glass."

PHOTOGRAPH BY ROBERTA BAYLEY; PUBLISHED IN *NEW YORK* IN 2014

After following Rob Lowe, Emilio Estevez, and the rest of their young-Hollywood crew out on the town, David Blum gave the group a name that still sticks.

Hollywood's Brat Pack

By David Blum

IT WAS A THURSDAY NIGHT, and like all the Thursday nights in all the bars in all the cities in all the world where young people live, the Hard Rock Cafe brimmed over with boys and girls. This was Los Angeles, so the boys wore T-shirts and sunglasses and shorts, and the girls wore miniskirts and Madonna hairdos. Over the blare of rock music, the boys and girls were shouting jokes and stories to one another, talking about their jobs and their classes and their dreams, eating enormous cheeseburgers and washing them down with swigs from long-necked bottles of Corona beer. The waitresses were dressed in punk uniforms, and they smiled and laughed as the boys and girls floated from table to table, partying with the endless spirit of those who have no place to return to, no person waiting nervously at home, no responsibility the next day that could possibly be more important than this night, right here, right now.

At one round table in the middle of the room sat a group of boys who seemed to exude a magnetic force. As the boys toasted each other and chugged their beers, the prettiest of the girls would find some excuse to walk by the table, and they would eye the boys as languorously as they possibly could, hoping for an invitation to join them. The boys knew that they had this force, and they stared back with equal vigor—choosing with their eyes the prettiest of the pretty and beckoning them with their smiles. Without fail, the girls would come, and they would stay, bringing with them all the charms they could muster. There were many boys in the bar that Thursday night, many of them as handsome as those at this one round table, but these boys—these young studs, all under 25 years old, decked out in *Risky Business* sunglasses and trendish sport jackets and designer T-shirts—they were the Main Event.

A girl named Alice straightened her long, white T-shirt over her blue skirt, brushed her jet-black bangs away from her eyes, patted her hips with her hands, and walked slowly to the table. She went to the handsomest of the group, the boy with the firmest chin and the darkest sunglasses. She knew that he was Rob Lowe and that he had been in *The Hotel New Hampshire*, and she probably also knew that he was involved with an actress named Melissa Gilbert, but from the open, white-toothed smile he gave her as she walked over, she felt confident.

"Hi," she said. He took her hand and shook it.

"Nice to meet you," he said.

"My name is Alice," she said.

He did not tell her his name. He had already turned his head toward a pretty blonde who had just walked by and turned her head toward him. He flashed the blonde his open, white-toothed smile; she returned it and walked over to the table.

But by the time the blonde girl arrived, Rob Lowe had long since forgotten she was coming. He had turned back to the table, where his friends had once again lifted their bottles in a toast: For no reason, with no prompting, for what must have been the twentieth time of the night, the boys were about to clink bottles and unite in a private pact, a bond that could not be broken by all the pretty young girls in the room, or in the world, or even, perhaps, by the other, less famous young actors who shared the table with them as friends. As the bottles clinked, the boys cried together at the top of their lungs, "*Na zdorovye!*"—Russian for "good health," but really something else, a private signal among the three famous boys that only they understood. After they finished their toast, the three boys turned their attention back to Alice and the other girls who surrounded the table, and smiled. The girls smiled back.

If Rob Lowe seemed to be inviting all too much attention from the girls, Judd Nelson acted as though he wanted nothing to do with it. His fame, too, helped attract them—they recognized his tough-guy looks from his role as the wrong-way kid in *The Breakfast Club* and sought his attention. But as Alice sat down in an empty chair next to him, Judd Nelson announced to anyone within earshot, including Alice, "There is a line. When someone crosses the line, I get angry. And when someone sits down at the table, they have crossed the line. You can let them get close"—he looked around at Alice and the swarm of girls—"but you can't let them sit down."

Only one of the famous young boys seemed to take the attention in stride—perhaps because he grew up the son of a famous actor, Martin Sheen. Just 23 years old, Emilio Estevez looks like his famous father and is a star on his own; he played the young punk in *Repo Man* and the jock in *The Breakfast Club*. His sweet smile of innocence drew still more women to the table, and he could not resist them.

"She was a Playmate of the Month," he whispered as an exotic-looking young woman in a purple jumpsuit took the seat next to him and smiled like an old friend. "The last time she was here, we were telling her about a friend who had passed the bar exam, and she said, 'I didn't know you needed to take a test to become a bartender.'" He laughed at her stupidity. But then he turned his attention to her, and before long, the toasts were over. Rob Lowe went back home to his girlfriend, waiting for him in Malibu. And at 1:35 A.M., after leaving the Hard Rock and stopping at a disco and then an underground punk-rock club, Judd Nelson took off by himself in his black jeep. Emilio Estevez and the Playmate went off together into the night. ∎

ILLUSTRATION BY DANIEL MAFFIA

1995

Chris Farley did not think this was funny.

The portrait was playful, but the accompanying cover story about *Saturday Night Live* was not. Writer Chris Smith spent three months hanging around NBC's Studio 8H, and delivered a spectacularly detailed portrait of the miserable, fractious backstage atmosphere. After it was published, Farley, Adam Sandler, and David Spade conspired to show up at the magazine and beat him up, and were talked out of it at the last moment.

PHOTOGRAPH BY CHRIS BUCK

1993

**Robin Williams
was game
for anything.**

A grunge Mrs. Doubtfire?
Sure. *New York* turned
the British drag-nanny
into a Seattle rocker.

PHOTOGRAPH BY FIROOZ ZAHEDI

1974

Bob Dylan went back on the road.

Before he co-founded *New York,* Milton Glaser's best-known work was probably the bright psychedelic
Bob Dylan poster that hung in almost every late-'60s dorm room. For Richard Goldstein's essay about Dylan's
first tour in nearly a decade, Glaser revisited him, this time in monochrome.

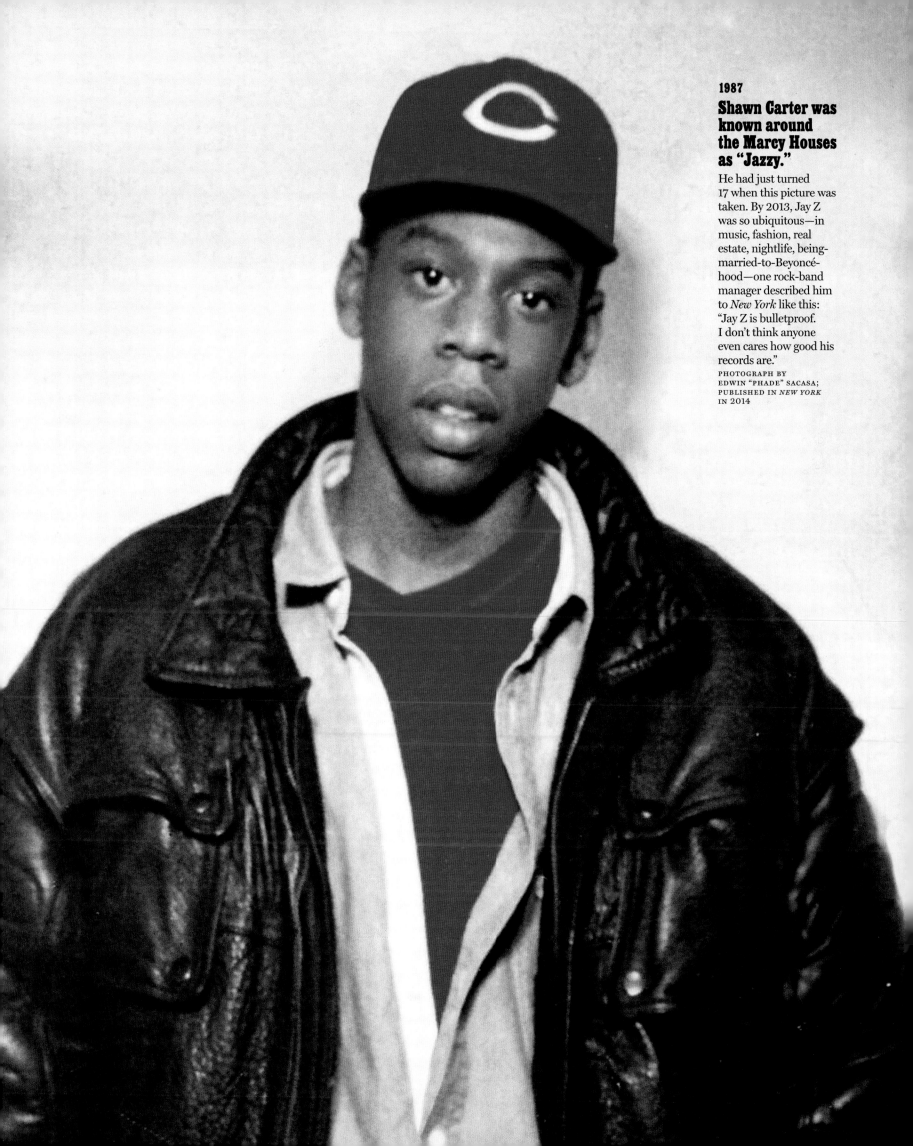

1987

Shawn Carter was known around the Marcy Houses as "Jazzy."

He had just turned 17 when this picture was taken. By 2013, Jay Z was so ubiquitous—in music, fashion, real estate, nightlife, being-married-to-Beyoncé-hood—one rock-band manager described him to *New York* like this: "Jay Z is bulletproof. I don't think anyone even cares how good his records are."

PHOTOGRAPH BY EDWIN "PHADE" SACASA; PUBLISHED IN *NEW YORK* IN 2014

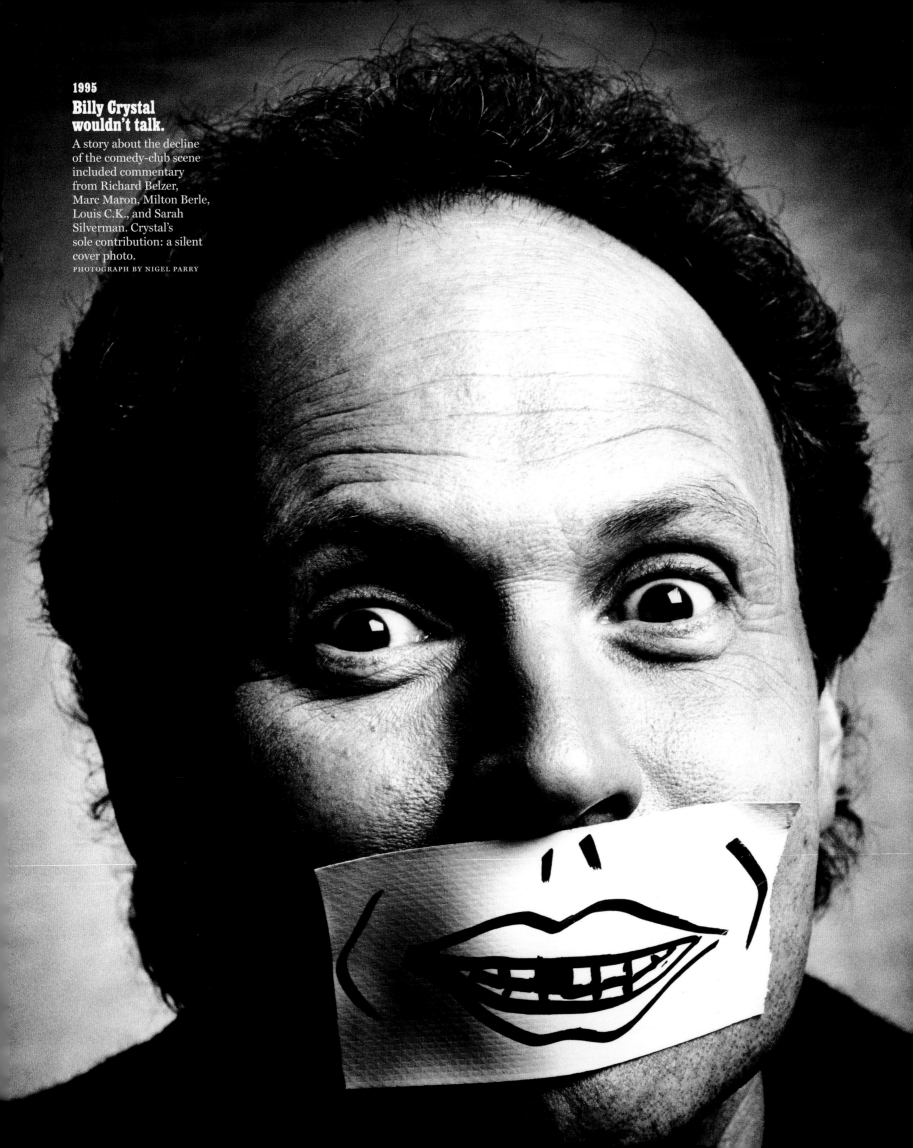

1995

Billy Crystal wouldn't talk.

A story about the decline of the comedy-club scene included commentary from Richard Belzer, Marc Maron, Milton Berle, Louis C.K., and Sarah Silverman. Crystal's sole contribution: a silent cover photo.

PHOTOGRAPH BY NIGEL PARRY

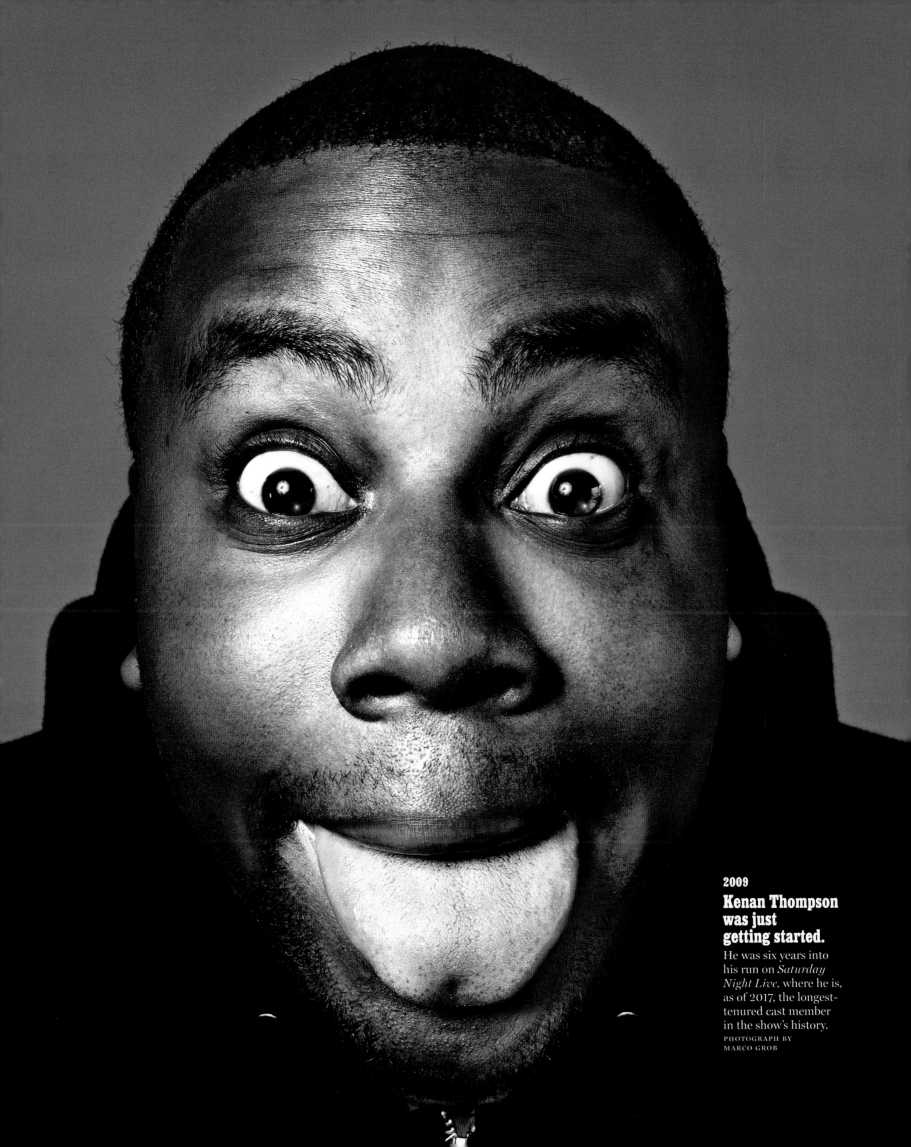

PHOTOGRAPH BY
MARCO GROB

2009
**Kenan Thompson
was just
getting started.**
He was six years into
his run on *Saturday
Night Live*, where he is,
as of 2017, the longest-
tenured cast member
in the show's history.

In the year of *Titanic*, at the absolute peak of Leomania, Nancy Jo Sales went out on the town with a Leo lookalike just to see what would happen. It didn't go as expected.

Leo, Prince of the City

By Nancy Jo Sales

WAS THERE SOMETHING about being Leo that attracted trouble? Do these sorts of things just happen to you if you're the most sought-after young man in the world? I was at Ñ on Crosby Street, not looking for Leo, when I thought I saw him. I jumped out of my chair. "That guy doesn't look like Leo," said my friend Greg, pushing me down. "Maybe Leonardo Smith."

It turned out the young man's name was Troy Allen, and he was a recruit from Detroit for a large brokerage firm. He was the same age and height as Leo, had the same paleness, the same loose-limbed, lanky look. The fires of Leomania licked at my brain. "How'd you like to be Leo for a night?" I asked him.

"Well, sure!" he said.

My worst fear for this experiment was that nothing would happen, and I'd have wasted everyone's time on a harebrained scheme. Quite the opposite occurred, which turned out to be much scarier.

I brought along a photographer (Catherine McGann) and a bodyguard (a large fellow who goes by "Brick"), and I rented a limo, white stretch, from the Yellow Pages. It was all at the last minute, and the car was not exactly prime; it looked like the limo of losers.

The driver, Raymond, had a long shiny ponytail under his shiny black cap and a Pancho Villa mustache. He was told we were picking up "Leo," to which he stammered, "Oh! I will drive very carefully!"

It was a Friday night. We picked "Leo" up around ten. I'd told him to wear sunglasses. "Welcome to my limousine!" Raymond said nervously, throwing open the back door.

"Gee, thanks!" Troy said.

Three of Troy's friends—Kara, Lee Ann, and Steve—came along for the ride. They were all in their early twenties, all in marketing and the financial sector, all quite giddy at being part of the stunt. Troy confessed he had never been in a limousine before.

"How does it feel to be so famous?" I asked him.

"It's awesome!" he said, fiddling with the power windows.

He was taking to his role with alacrity. "What's Kate Moss like?" I probed.

"She's gorgeous," said Troy. "And she's a really nice person."

Our first stop was the Virgin Megastore in Times Square. There was a small crowd on the sidewalk surrounding a woman holding a large Gila monster on her shoulder—you could touch it for a fee. When the limo pulled up, Catherine jumped out, snapping pictures of "Leo" emerging; the onlookers rushed over, leaving the Gila monster in the dust.

"Who's that?" they demanded. "Out the way!" ordered Brick.

Some of them zoomed after us into the store, where "Leo" pretended to shop for CDs; it was a bit difficult for him to concentrate, however, as a gaggle of teenage girls and so-excited-they-could-burst tourists were shamelessly scrutinizing his every move. Security guards were suddenly appearing, hissing at one another on walkie-talkies. "Gosh," Troy whispered, growing paler, "they really think I'm him! Let's get outta here!"

Back outside, as we moved down the street, the number of fans trailing us had tripled; some were running around in front of "Leo" taking pictures of him with disposable cameras and then dashing away, as if they had gotten away with something. Brick pretended to order back the limo driver on a cell phone. "Where's the limo at?" he barked. "We can't leave Leo out here on the street!"

While Raymond was circling the block—perhaps nervous about his precious cargo—he had gotten into an accident; a tow truck had hit the limousine. We were now driving "Leo" around in a dented limo. "Once you go down with the *Titanic*," "Leo" said magnanimously, "you can deal with just about anything."

But "Leo" was getting antsy; he decided he had to have something to eat. "I'm hungry!" he moaned, at which we all jumped, making suggestions. After all, he was the star. "I wanna go to Planet Hollywood!" he said.

Troy was not aware of it, but the real Leo has been talking to the owners of the wildly popular snack joint (Schwarzenegger, Bruce and Demi, et al.) about becoming a shareholder. I didn't think this would be a problem; in fact, I thought it might be a good cover for why "Leo" would have nothing better to do on a Friday night than go check out the movie-star tchotchkes at Planet Hollywood. I called ahead: "We're coming with Leo," I said.

"Oh, okay!" said the maître d', Kathy, her voice taking on a solicitous tone. Would Leo be comfortable in the main dining room—or would he like them to set up the function room? "Leo" said to tell her he wanted to eat with everybody else, just like "regular people. Just because I'm a star, I don't think I'm better than anybody," Troy said sincerely.

Outside Planet Hollywood, a wait staff of about seven was waiting for us on the sidewalk. "They look like they should be holding up *swords*," Lee Ann observed. We all peered out the windows timorously. "Uh, this looks serious," Troy said.

Raymond flung opened the door. "Come on, *Leo*!" Brick boomed. Catherine started snapping pictures. "Leo" climbed out, baseball hat pulled down low.

They'd arranged for us to enter through a side door. Maître d' Kathy and Brett, the night manager, were following along behind us, peppering me with questions about Leo's visit. "Well, frankly, I was surprised he wanted to eat at Planet Hollywood," I said fishily. "Well, frankly, so were we," Kathy said.

As soon as we were in the main dining room—packed with patrons devouring mounds of fried food—heads began swiveling around; people were talking through their hands, mouthing "Lee-Oh," eyes wide, mouths full. Waiters from all over the restaurant were rushing into the room to get a look. "They on him," whispered Brick.

It all felt very dicey. I began to panic. "What do we do?"

"Talk to me. I'm the star!" hissed "Leo."

We sat down. I pretended to conduct an interview. "Uh, so you're thinking about becoming a shareholder of Planet Hollywood?" I asked.

"I don't want to disclose anything right now," muttered "Leo," sinking down behind his menu.

We had sent Kara and Lee Ann to the front to take the temperature (where, little did we know, Leo's tuxedo from *Titanic* is hanging in a large glass case; apparently, his legs are several inches shorter than Troy's). Later on, they told us that just then, a waiter passed by them announcing: "You girls are gonna pass out in a few seconds—I'm gonna pass out, too!"

On our side, the room had become strangely loud and animated, everyone showing off the way people do when they feel they're in the presence of someone known. "They *on* him," Brick said again, in disbelief.

"Can I get a picture?" said a portly woman who had appeared beside our table, flashing us with a disposable camera before we could answer.

"A sweet-sixteen birthday party was already in progress. Long Island girls in short, sleeveless dresses were whipping out cell phones, mouthing 'Lee-Oh!' excitedly into receivers."

A sweet-sixteen birthday party was already in progress. Long Island girls in short, sleeveless dresses and chunky heels were whipping out cell phones, mouthing "Lee-Oh!" excitedly into receivers.

Two 12-year-old girls in jeans came right up to us, arms crossed, faces drenched with disgust. "That's not *Leo*!" one said, turning on her heel.

But others weren't sure; a line of maidens was now circling the room like little Nerf sharks, in Gap shirts.

Brett was back. "Can you come with me?" he asked, in a high, pinched voice. Uh-oh, I thought; I telegraphed alarm to my tablemates, but they were transfixed by the weird swelling of the room. "Don't let them tear my hair out or anything," Troy was imploring Brick.

Brett and Kathy led me to an empty back office, where I expected to be dipped in batter and fried.

Instead, I was handed a telephone. Patty Caruso, the publicist of Planet Hollywood, had been called on Long Island (it was midnight). "How long is he going to be there?" she asked urgently. "Because I know Keith Barish"—the principal owner of Planet Hollywood—"will want to come down and meet with him. Would that be all right? He could be there in fifteen minutes—"

"Uh, I'll have to ask," I said, handing back the phone.

"We have to go," I told our party through clenched teeth.

Things were getting out of control. We got up. Brick had to wave people out of the way. "Leo just wanted to come down here and have a few drinks, get something to eat," he was shouting, "and look what y'all did! Y'all fucked up! We outta here! Come on, Leo, let's go!"

"Just let him know Eric took care of him," the waiter informed me politely.

We ran out to the limo. People were running after us, smashing their faces against the windows after "Leo" climbed in. "It's her 16th birthday; can't we get a picture?" People were taking pictures—of the car.

Back inside the car, Troy said, bewildered, "I'm a superstar. I can't believe what they did to me."

We took off into the night. The limo phone rang. Brick informed "Leo" that Raymond wanted his autograph.

Troy took off his sunglasses; he looked dazed. "Being in that situation is really stressful," he said unhappily. "I don't like being Leo anymore." ∎

We talent-scouted.

New York always tried to cover up-and-comers, or at least the newly arrived. Woody Allen interviewed himself in 1968; Sylvester Stallone, Matthew Broderick, and Alec Baldwin all posed just as their careers took off.

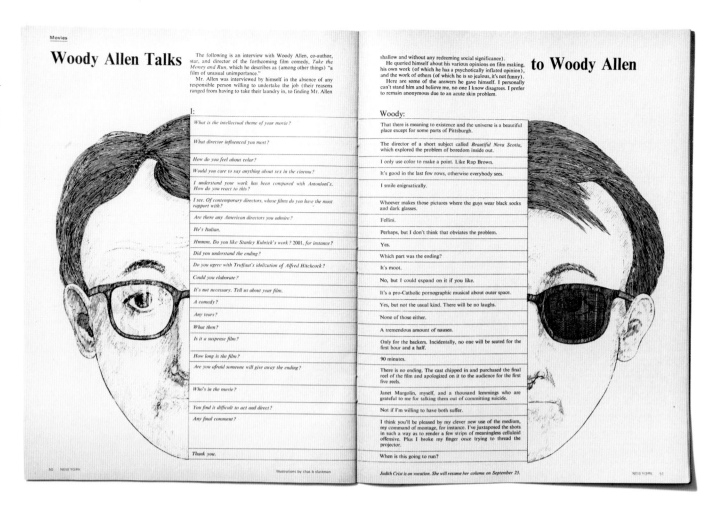

Movies

Woody Allen Talks

The following is an interview with Woody Allen, co-author, star, and director of the forthcoming film comedy, *Take the Money and Run*, which he describes as (among other things) "a film of unusual unimportance."

Mr. Allen was interviewed by himself in the absence of any responsible person willing to undertake the job (their reasons ranged from having to take their laundry in, to finding Mr. Allen

I:

What is the intellectual theme of your movie?

What director influenced you most?

How do you feel about color?

Would you care to say anything about sex in the cinema?

I understand your work has been compared with Antonioni's. How do you react to this?

I see. Of contemporary directors, whose films do you have the most rapport with?

Are there any American directors you admire?

He's Italian.

Hmmm. Do you like Stanley Kubrick's work? 2001, for instance?

Did you understand the ending?

Do you agree with Truffaut's idolization of Alfred Hitchcock?

Could you elaborate?

It's not necessary. Tell us about your film.

A comedy?

Any tears?

What then?

Is it a suspense film?

How long is the film?

Are you afraid someone will give away the ending?

Who's in the movie?

You find it difficult to act and direct?

Any final comment?

Thank you.

50 NEW YORK

Illustrations by chas b slackman

to Woody Allen

shallow and without any redeeming social significance).

He queried himself about his various opinions on film making, his own work (of which he has a psychotically inflated opinion), and the work of others (of which he is so jealous, it's not funny).

Here are some of the answers he gave himself. I personally can't stand *him* and believe me, no one I know disagrees. I prefer to remain anonymous due to an acute skin problem.

Woody:

That there is meaning to existence and the universe is a beautiful place except for some parts of Pittsburgh.

The director of a short subject called *Beautiful Nova Scotia*, which explored the problem of boredom inside out.

I only use color to make a point. Like Rap Brown.

It's good in the last few rows, otherwise everybody sees.

I smile enigmatically.

Whoever makes those pictures where the guys wear black socks and dark glasses.

Fellini.

Perhaps, but I don't think that obviates the problem.

Yes.

Which part was the ending?

It's moot.

No, but I could expand on it if you like.

It's a pro-Catholic pornographic musical about outer space.

Yes, but not the usual kind. There will be no laughs.

None of those either.

A tremendous amount of nausea.

Only for the backers. Incidentally, no one will be seated for the first hour and a half.

90 minutes.

There is no ending. The cast chipped in and purchased the final reel of the film and apologized on it to the audience for the first five reels.

Janet Margolin, myself, and a thousand lemmings who are grateful to me for talking them out of committing suicide.

Not if I'm willing to have both suffer.

I think you'll be pleased by my clever new use of the medium, my command of montage, for instance. I've juxtaposed the shots in such a way as to render a few strips of meaningless celluloid offensive. Plus I broke my finger once trying to thread the projector.

When is this going to run?

Judith Crist is on vacation. She will resume her column on September 23.

NEW YORK 51

'Rocky':
It Could Be a Contender

By Louise Farr

"*...Rocky*, written by and starring Sylvester Stallone, is a fight story that has made hardened cinema cynics stand up and cheer..."

Sylvester Stallone's mother is coming to California on October 28. She says she's coming for the Oscar nominations. Actually she's coming for a screening at the Academy Theater on Wilshire Boulevard, but she *thinks* it's for the nominations. Sylvester can't imagine where she got that idea. It's almost arranged that he's been selected, his mother says. But they can't just nominate one person. They put about ten in the race who they feel will have a chance. No one knows for *sure* who's going to win, but he's one of the ten—there's no mystery as far as that goes, she says. After all, she was a professional astrologer for fifteen years.

The film that Mrs. Stallone is coming out to see is called *Rocky*, a prizefight story written by and starring her son. In a film season that has so far seen sizable numbers of preview audiences leaving screening rooms on both coasts in varying degrees of disappointment, disbelief, and downright horror, *Rocky* (which opens in New York in late November) is an oasis of upbeat expectations. Hardened cinema cynics have actually been seen standing up and cheering the climactic fight scene, and the final applause seems unanimous and sincere.

Sylvester Stallone wanted to be an actor, but until someone gave him a break, he was working as an usher at Walter Reade's Baronet Theater in New York. He didn't like it. Didn't like the humiliation of wearing a bow tie and shiny blue pants that skinnied up to his shins. Didn't like the god-awful B.O. of his predecessors ingrained in the armpits of the shiny blue jacket . . . especially didn't like the $37 a week he was being paid. Even in

1970, that didn't keep him in nuts and berries, let alone real food.

So Sylvester Stallone (rhymes with "Tyrone," which his mother would have called him if she'd had her way) decided to scalp a few tickets. Selling out every night. These fat cats would come in from Jersey with their old ladies ready for an evening out, and they'd pay 20 or 30 bucks not to be turned away at the door. And for 20 or 30 bucks, Sylvester would have carried them to their seats.

He raked in about $600 a weekend for the first two weeks. Then the third week he spotted a man walking by and thought to himself—now, there's a sucker: white suit, red carnation—must be rich. So Sylvester sidled up to the man, appraised him from beneath arrogant, drooping, Italian eyelids, and said, "Hey . . . for twenty bucks I can get you a good seat." The man looked at him and said, "Hey . . . for nothing I can get you your walking papers. I'm Walter Reade."

And so Sylvester Stallone got his walking papers, turned in his shiny blue suit, and slunk away from Walter Reade's Baronet Theater never, one would have expected, to return.

Except (Oh, God! It's the stuff Hollywood legend is made of, but almost too corny), there he was back at the Baronet in 1976 for the preview of *Rocky*, starring Sylvester Stallone, screenplay by Sylvester Stallone, box-ing choreography by Sylvester Stallone. Also appearing in minor roles: Frank Stallone (who didn't want any kid of his named "Tyrone"); Frank Jr., Sylvester's brother; and Butkus Stallone, Sylvester's bull mastiff. Sylvester's wife, Sasha, was in *Rocky* too, but un-

fortunately her scene was cut.

Rocky is not a home movie. It's a Chartoff-Winkler production, a United Artists release, co-starring Burt Young, Talia Shire, Burgess Meredith, and Carl Weathers. Says U.A.'s Mike Medavoy, "It's a picture about human dignity . . . a combination of *Marty* and *Somebody Up There Likes Me*—if you want to categorize it." *Rocky*, which everyone seems to describe as "simple" and "heartwarming," is a story about a has-been boxer who could have been a contender if he hadn't gone to work for a loan shark on the waterfront. "The hard thing in doing it," says executive producer Gene Kirkwood, "was to stay away from every cliché that's ever been written." "If I can just go the distance," Rocky says, eyes misting, when he gets his chance to fight the world champ, "I'll know I'm not just another bum from the neighborhood."

Sylvester Stallone, who a few years back was strangling an old lady with a crutch in *Bananas*, and stealing Jack Lemmon's wallet in *The Prisoner of Second Avenue*, now finds himself the center of a chorus of cheers. "Genius," says his manager, Jane Oliver. "Renaissance man," say Gene Kirkwood and Irwin Winkler. And because Hollywood can't resist categorizing, he is being compared to Brando, Pacino, De Niro—even Bob Mitchum, Rock Hudson, and Victor Mature. "He's the first leading man to come along that's a *man*," Gene Kirkwood says, "and yet he's still like a little gentle kitten in the film."

"Sly" Stallone: He has animal presence, the voice of an aging Mafioso, Al Pacino eyes, Victor Mature biceps, and Rock Hudson's mouth. He's also being called a genius.

70 NEW YORK/OCTOBER 18, 1976

Photographed by Kenneth McGowen

THE KID WITH THE MILLION-DOLLAR SMILE

"I'm not so good at Hollywood parties . . . I get intimidated and make a fool of myself."

MATTHEW BRODERICK BRIGHTENS BROADWAY · BY JESSE KORNBLUTH

F THE WALDEN SCHOOL GAVE COURSES IN FAKE GUN-fights, thunderous falls, and agonizing death spasms, Matthew Broderick would have been on the honor roll. And if Walden also offered classes in pinball or line-by-line renditions of *Young Frankenstein*, he would have been at the head of his class. But Walden is not a playpen, and so, at sixteen, Matthew Broderick found himself bringing home the kind of report cards that make parents throw up their hands and ask, "What will become of this child?"

His parents, painter Patricia Broderick and actor James Broderick, did not ask such questions. In fact, the issue of Matthew's academic future came up only once, when Matthew and Kenny Lonergan, his best friend, were hanging out in the Brodericks' living room one evening.

"Kenny, are you going to college?" James Broderick asked.

"I don't know."

"Matthew, are you?"

"No, Dad."

"Patsy, Matthew's not going to college."

"Oh."

And nothing more was ever said about higher education. Still, Matthew Broderick thought about college a great deal. What he thought was that if he didn't get work as an actor within a year of his high-school graduation, he was going to have to go to one.

In the four years he's been out of Walden, Matthew Broderick has appeared in five films: *WarGames, Max Dugan Returns, Master Harold . . . and the Boys*, the as yet unreleased *1918*, and *Ladyhawke*, which will hit the theaters next month. On-stage, he has played Harvey Fierstein's adopted son in the original production of *Torch Song Trilogy*, won a Tony for his role as the narrator of Neil Simon's *Brighton Beach Memoirs*, and, this week, begins a six-month run in *Biloxi Blues*, the second play in Simon's trilogy about his coming of age as a writer.

The day it opens, *Biloxi Blues* will make history: This will be the first time a playwright has had two related plays on Broadway at the same time. *Biloxi Blues* should also add a sheaf of glowing notices to the resumé of Matthew Broderick, who continues his portrayal of Eugene Morris Jerome. But Eugene is no longer the fifteen-year-old of *Brighton Beach Memoirs*, living happily at home with his parents, his widowed aunt and her two daughters, one of whom inspired the first lust he'd ever known. *Biloxi Blues* is set in 1943, and Eugene's in the army, cut off from his protective and nurturing family.

He's still the narrator, the observer, the Brooklyn wit—but in addition to a standard-issue sergeant, he must now confront anti-Semitism, his first sexual encounter, his first romance, and the very real possibility that he will die before he can achieve literary fame.

As written, Simon's play is an ensemble piece for six soldiers. Broderick tries to make sure that it plays like one, but if audience reaction to *Biloxi Blues* on its fourteen-week tryout in Los Angeles and San Francisco is any barometer, Broderick is this play's irresistible, natural star. This gives Broderick some distress. In *Brighton Beach Memoirs*, despite the success of *WarGames*, he was relatively unknown as a stage actor. "In *Brighton Beach*, I didn't have too much to lose—though I wouldn't have said that then," he says. "This time, there's the feeling of trying to equal something."

Any actor in his position would say this, just as any actor with roots in New York and the leading role in an ensemble piece would say he wants to be known as an actor, not as a star. Matthew Broderick's great appeal, despite his million-dollar film salary and the stack of scripts he gets each week, is that he really means it. Not because he's as awkward, as endearing, or as innocent as the characters he's been playing—as Kenny Lonergan says, "'Innocent' is the *last* word I'd use to describe him"—but because, at 25, he's been around so long and endured so much that the roar of the crowd and the applause of the critics can't quite reach him.

Photograph by Moshe Brakha

THE HUNT FOR ALEC BALDWIN

RISING TO THE TOP IN 'RED OCTOBER'

BY PHOEBE HOBAN

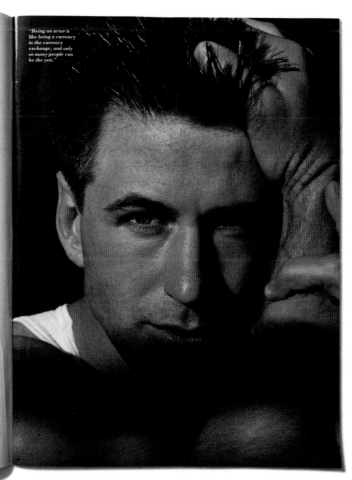

"Being an actor is like being a currency in the currency exchange, and only so many people can be the yen."

CTOR ALEC BALDWIN GIVES MARY-Louise Parker a big kiss, then pulls back.

A kiss is just a kiss, but not this one. This kiss requires discussion. This kiss presents an acting choice. Baldwin and Parker and director Norman René talk it through.

"I don't think I should kiss him, because of the other kiss," says Parker to René.

"I want you to kiss me at every opportunity," jokes Baldwin.

"I think the kiss should be a full kiss, like you know what's going on," suggests René.

Baldwin stuffs a handful of popcorn into his mouth and tries it again.

He pulls back.

"This isn't working for me," he says. "Which makes more sense—for me to kiss or be kissed? I mean, is it a test? How about I don't even look at her? She kisses me and I peel her off me. It's like I can't believe how far she's gone, how f---ing sick this is." He stamps his foot. "It's like I've got to jump off a volcano. This guy is going to jump off a f---ing building. It's like I feel like I could put my fist through her head. Does that bother you if I do it that way?"

"No," says René. "Let's try it."

Baldwin does the scene again, and this time it works. Out of nowhere, tears roll down his cheeks. As *Saturday Night Live*'s Master Thespian would say, "*Acting!*"

It's the first week of rehearsals for *Prelude to a Kiss*, the Craig Lucas play opening at the Circle Rep on March 14. Baldwin plays Peter, and Parker plays Rita. They're a yuppie couple whose marriage takes a strange detour when an old man named Julius (played by veteran actor Barnard Hughes) arrives on the scene. "It's basically a fairy tale about a prince, a princess, and a frog," says Lucas. Baldwin doesn't play the frog.

AST YEAR IT WAS KEVIN COSTNER, but now Alec Baldwin is the contender for hottest 30-something leading man. He's the kind of physical actor who can nail a part with a few choice movements. He's played blue-collar thugs and TV evangelists, but 31-year-old Baldwin hasn't quite figured out how to play the Star.

"Being an actor is like being a currency in the currency exchange, and only so many people can be the yen," he says over breakfast at Sarabeth's Kitchen, not far from his Upper West Side apartment. "It's tough. Today they are going, 'Hey, you're the deutsche mark. We think you're great. Wake up; it's not a dream.' Then they turn around the next day and say, 'Hey, we changed our minds. Somebody else is the deutsche mark. You're the peso.' The experience of acting becomes like nuggets of gold, and you have to pan through all the other stuff to get to the thing you love most. Is it the money? The attention? The what? The *acting*. You really have to love acting, because in this business you get to do so little of it." He wolfs down a plate of fried potatoes, followed by a huge plate of pancakes. "Although anyone who says it's not for the recognition is a liar."

Baldwin's peso days are over; this year he's the yen. Baldwin plays CIA analyst Jack Ryan in *The Hunt for Red October*, which opens this Friday. (His name is right after Sean Connery's in the credits.) In April, he stars as Junior, the violently wacko ex-con in *Miami Blues*, with Fred Ward and Jennifer Jason Leigh. He's just finished shooting his first role in a Woody Allen film. "It was just *outstanding*," he says, always the smart Alec. "It was *incredible*. I can't say enough about him. I laughed. I cried. I loved it more than *Cats!*" Baldwin was also supposed to play

PHOTOGRAPH BY SUSAN SCHACTER

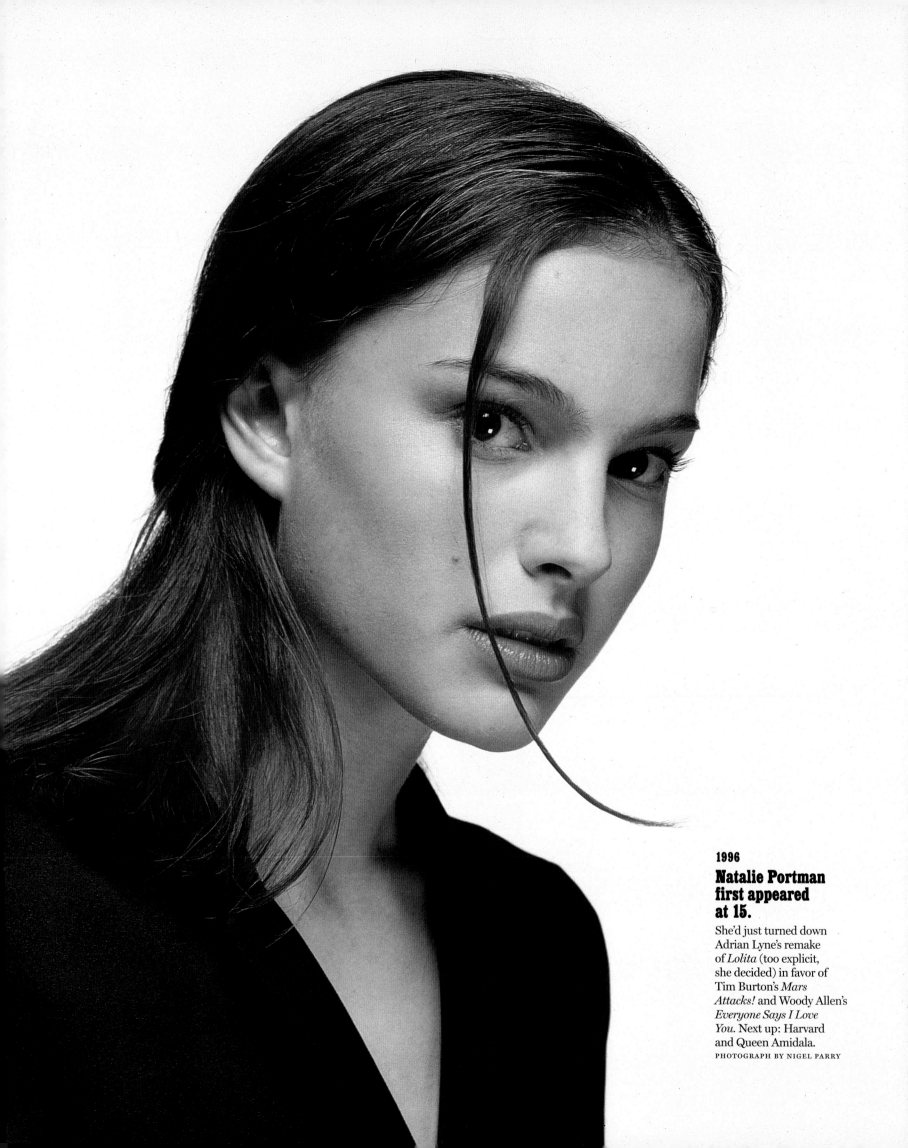

1996
**Natalie Portman
first appeared
at 15.**

She'd just turned down
Adrian Lyne's remake
of *Lolita* (too explicit,
she decided) in favor of
Tim Burton's *Mars
Attacks!* and Woody Allen's
*Everyone Says I Love
You.* Next up: Harvard
and Queen Amidala.

PHOTOGRAPH BY NIGEL PARRY

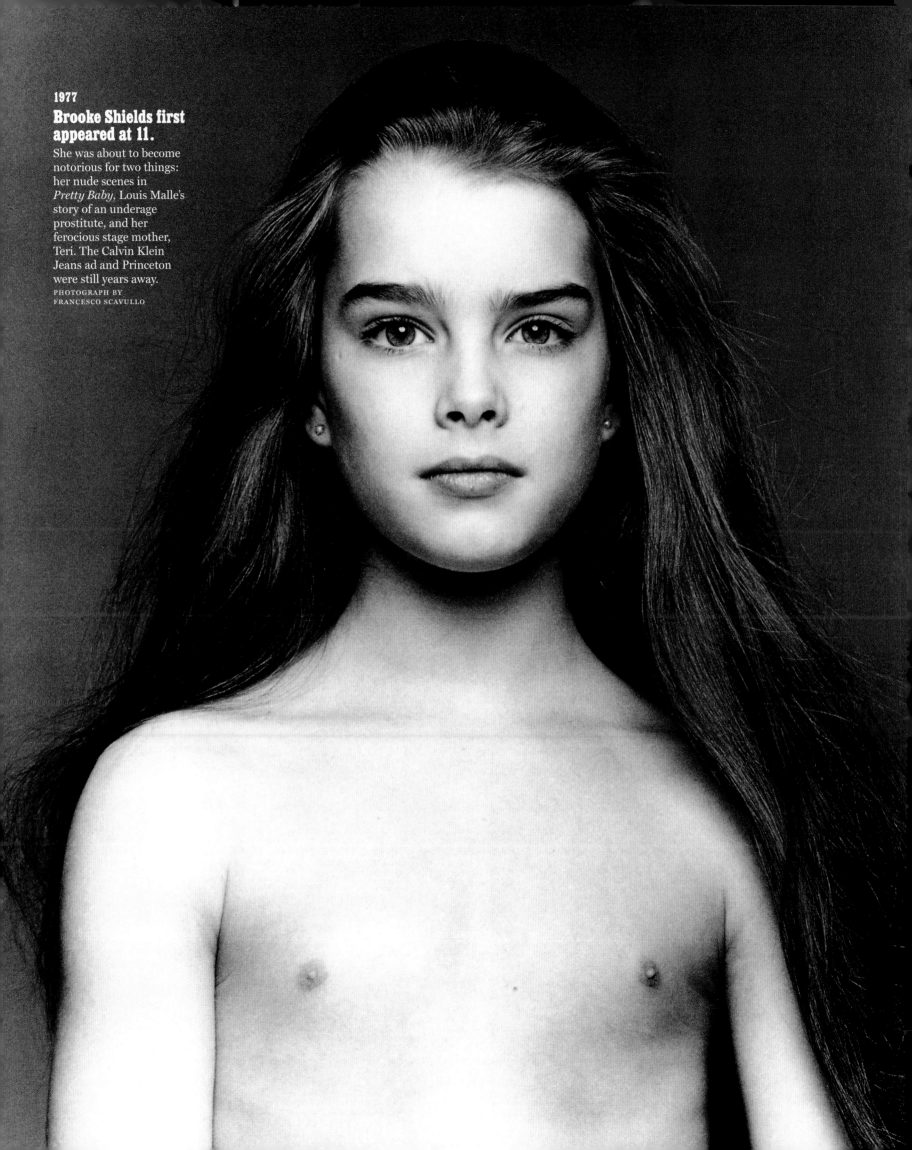

1977

Brooke Shields first appeared at 11.

She was about to become notorious for two things: her nude scenes in *Pretty Baby*, Louis Malle's story of an underage prostitute, and her ferocious stage mother, Teri. The Calvin Klein Jeans ad and Princeton were still years away.

PHOTOGRAPH BY
FRANCESCO SCAVULLO

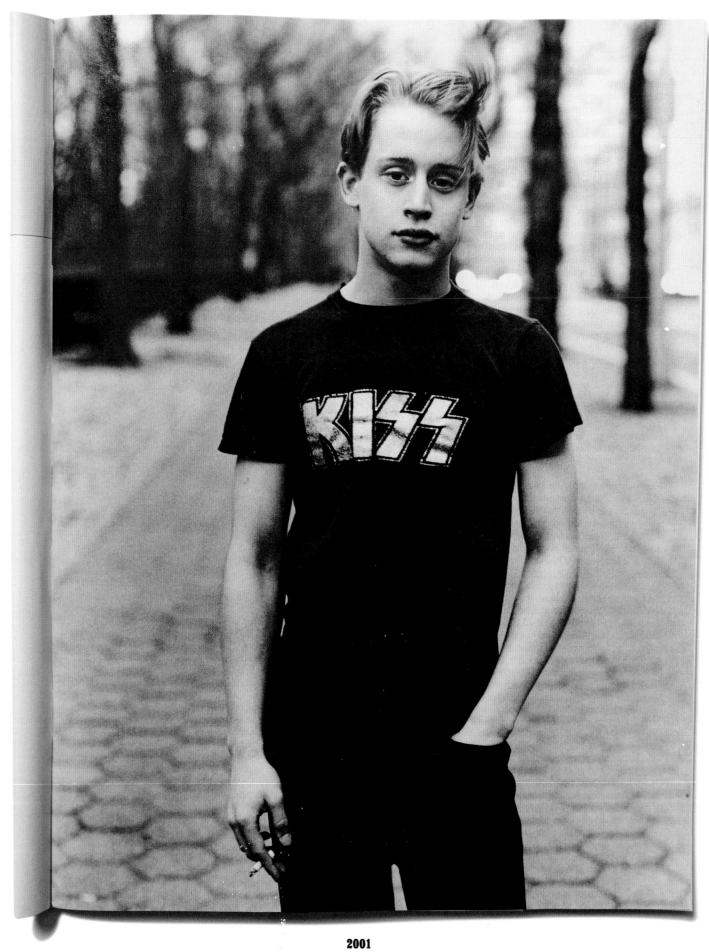

2001

Macaulay Culkin was still young.

He was 20, a decade past his *Home Alone* moment, and barely navigating early adulthood.

2010

Justin Bieber was even younger.

The teen pop star was 16, caught in a moment only slightly removed from the packs
of screaming teens who followed him everywhere.

PHOTOGRAPH BY GILLIAN LAUB

Woody Allen

Meryl Streep

As women like Tina Fey, Amy Schumer, and Sarah Silverman began to dominate the smart comedy world, Joan Rivers refused to give them an inch.

Joan Rivers Always Knew She Was Funny

By Jonathan Van Meter

EXPECT NOTHING AND you won't be disappointed. This is the mantra of the pessimist and the persecuted, the preemptive strike of those who tend to paint the picture a little blacker than it is. And then there is Joan Rivers, the orneriest creature ever to darken Hollywood's door. She once told me that her husband, Edgar Rosenberg, who killed himself in 1987, lived by the motto "Fuck them over before they fuck you over first."

We are sitting in her study eating cake. It has been served to us by Kevin and Debbie, her butler and housekeeper, who have been living with her for twenty years in their own quarters in her grand apartment, a mini-Versailles on East 62nd Street. ("Marie Antoinette would have lived here," Rivers likes to say, "if she had money.") Joan loves cake, loves anything sweet. The Joan Rivers diet: You can eat anything you want before 3 p.m. and then nothing for the rest of the day. When she goes out to dinner, she puts a small pile of Altoids on the table next to her plate, which she eats one after another while barely touching her food.

We are talking about the peculiar turn of events her life has taken recently, how she is suddenly squarely at the center of the culture again—something that has escaped her since her Fox debacle. At the age of 76, it seems, she has been rediscovered. Much of it has to do with a new documentary about her life, *Joan Rivers: A Piece of Work*, which opens in theaters on June 11. Roger Ebert wrote, in one of the film's many rave reviews, that it is "one of the most truthful documentaries about show business I've seen. Also maybe the funniest." The film comes at the end of a remarkable year for Rivers, one that began when she won *The Celebrity Apprentice* (after one of the uglier reality-TV showdowns), outfoxing all those bimbos, has-beens, and two-bit poker players to emerge—somehow—as the sympathetic character. At long last, not fired! It's unfamiliar territory for Rivers: to be the one people root for.

"It's amazing," says Rivers, shaking her head in disbelief. But then this: "People who have seen the film come up to me and say, 'I never liked you until now.' TV interviewers say, right in front of me, 'Even if you have always hated Joan Rivers…you are going to love her and be mesmerized by this film.' They spit right in my face and then spend the next ten minutes wiping it dry." That is when she shows me the pillow she has embroidered that sits on a leather couch in her study: DON'T EXPECT PRAISE WITHOUT ENVY UNTIL YOU ARE DEAD.

If Joan Rivers has a hard time taking a compliment, she has an even tougher time handing one out. "I will only praise someone who can't take anything away from me," she says with a mordant laugh. "People ask me all the time: 'What do you think about Sarah Silverman?'" She switches into a comically polite-insincere voice. "Hmmm. She's nice, I guess. I really haven't seen her."

She shoots me a get-real look. "She's terrific. She's very funny and very pretty. But why should I admit it?"

Even at this late stage in her 40-year career, Rivers is nowhere near ready to cede the stage to a younger generation. I am reminded of an e-mail she sent me a couple of years ago, when she was at yet another low point in her career. I asked her what she thought of Kathy Griffin. "I am her friend but also furious," she wrote. "She is the big one now. My club dates have simply vanished and gone to her. She will last as she is very driven. Like me, she *wants* it. But every time a gay man tells me, 'Oh, she is just like you! I love her!' I fucking want to strangle them. But, please God let someone give me credit. I feel so totally forgotten. The fucking *New Yorker* did this big piece on the genius of Rickles, who is brilliant but who hasn't changed a line in fifteen years. Meanwhile, I am totally 'old hat' and ignored while in reality I could still wipe the floor with both Kathy and Sarah. Anyhow, fuck them all. Age sucks. It's the final mountain."

ON THE LAST NIGHT at the Sundance Film Festival, after a packed screening ("Listen to them laugh," Rivers had said backstage, her eyes lit with joy), Rivers and her entourage are going to dinner to celebrate her assistant Jocelyn's birthday. We arrive at the restaurant and Rivers immediately begins to kvetch and worry about where we are going to be seated. But as soon as we settle at the table—a big round corner table with a beautiful view of the snow falling on the side of the mountain—her mood lifts. She ignores her mints and actually eats her dinner. She also knocks back a couple of glasses of red wine and before long is on a serious roll, telling funny stories and teasing the waitress ("You are never going to meet a man with that butch haircut").

As we await the arrival of the birthday cake, Rivers launches into a story about a night in the early nineties when she performed at a big Comedy Central event at Radio City Music Hall. What I remember most about that night is how great she looked, how nervous she was in the limo as she ran her lines, and how she roared through her set and the audience went nuts. I have never once heard her brag about a performance. But now, at dinner, she is telling the group, "I walked in there and *killed.*" The disappointing part was what happened next. "They wanted to do, like, an original-cast moment. They wanted to put me up there with the Greats and the Has-Beens. I thought, *What don't you understand here?* Don't you put me out there with Phyllis Diller and Milton Berle. I was so angry that I wouldn't stay for the finale. Into the limo!" She pauses. "But that was a big night in my life." And then she says, more quietly, "I was at such a low point then. And they were all coming over to me, all these comediennes, and each one has their own little show and I don't. And they were all"—mockingly—"'Thank you, Joan. I wouldn't be where I am but for *yoooou.*'" She takes a big gulp of her wine. "You want to say to them, 'I will show you how it's done, pussycat. Follow *that.*'"

∎

1998

Joan was joined by Spike, Veronica, and Lulu.

"I like to match my dogs fashion-wise," Rivers explained. "So we all wear leather and we all tinkle on fire hydrants."

PHOTOGRAPH BY BEN WATTS

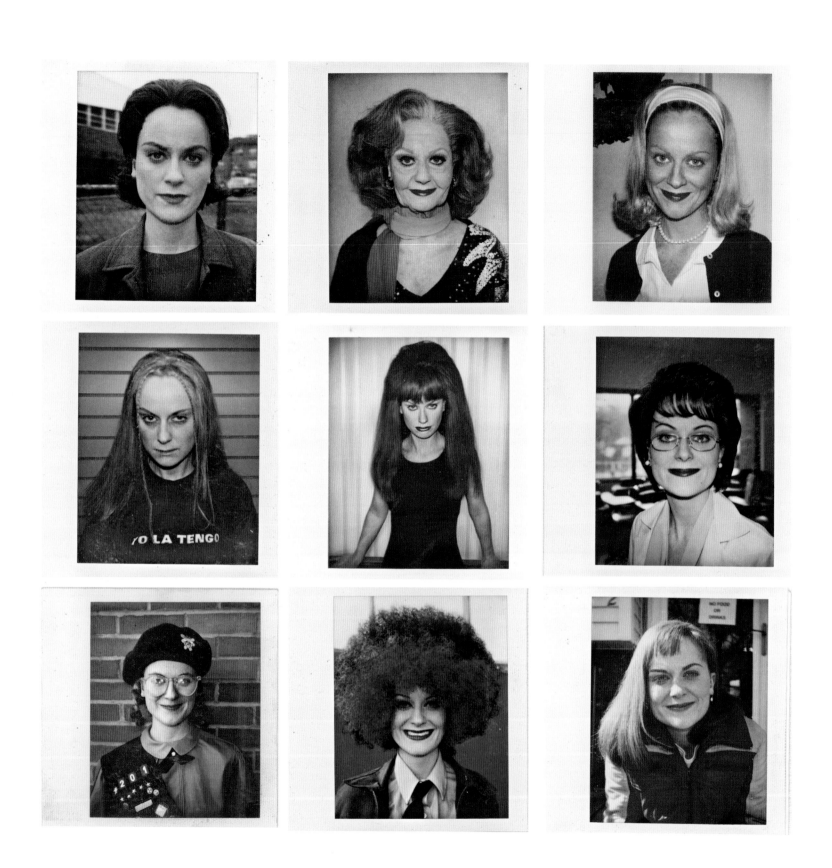

1998
Amy Poehler had it before she was famous.

When she was part of the Upright Citizens Brigade comedy troupe, Amy Poehler posed for dozens
of in-character makeup tests. In 2011, when *New York* wrote about the UCB Theatre, a looseleaf binder full
of them turned up in a cabinet backstage.

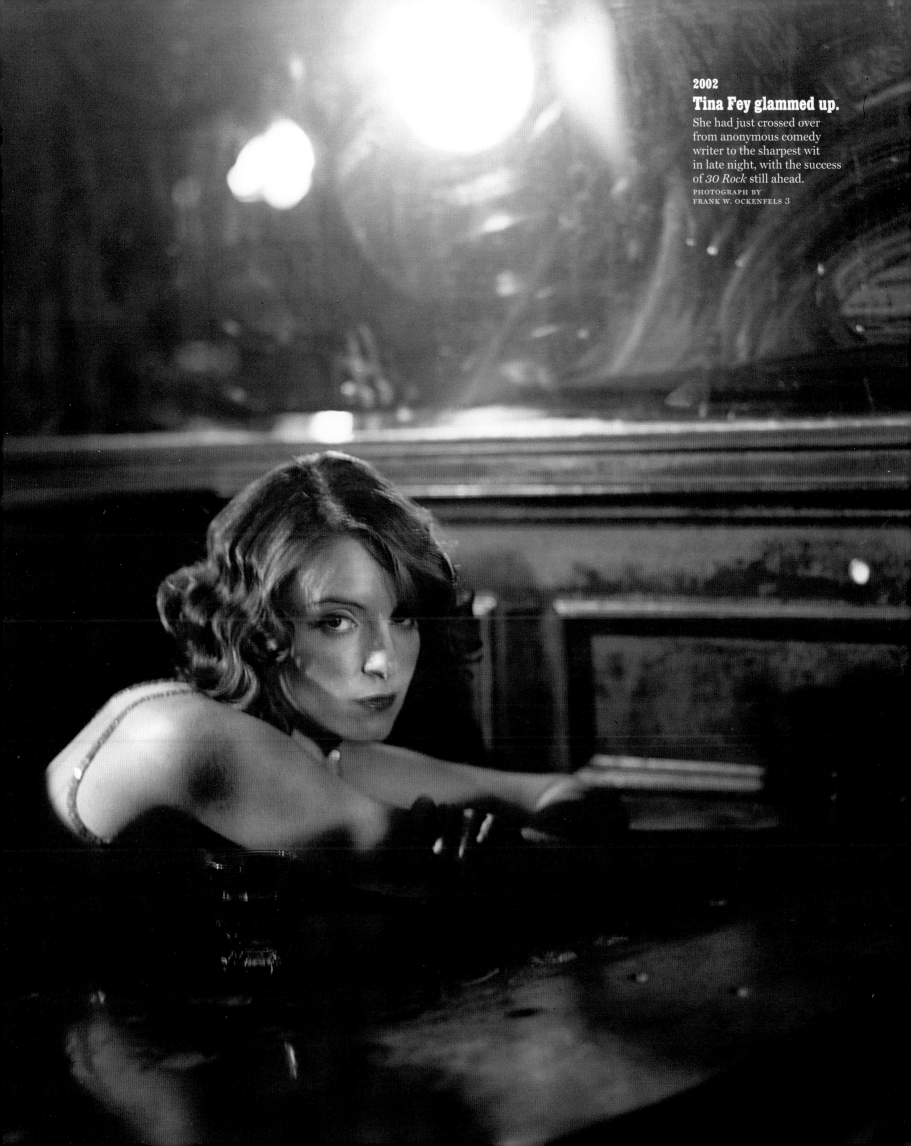

2002
Tina Fey glammed up.
She had just crossed over from anonymous comedy writer to the sharpest wit in late night, with the success of *30 Rock* still ahead.
PHOTOGRAPH BY
FRANK W. OCKENFELS 3

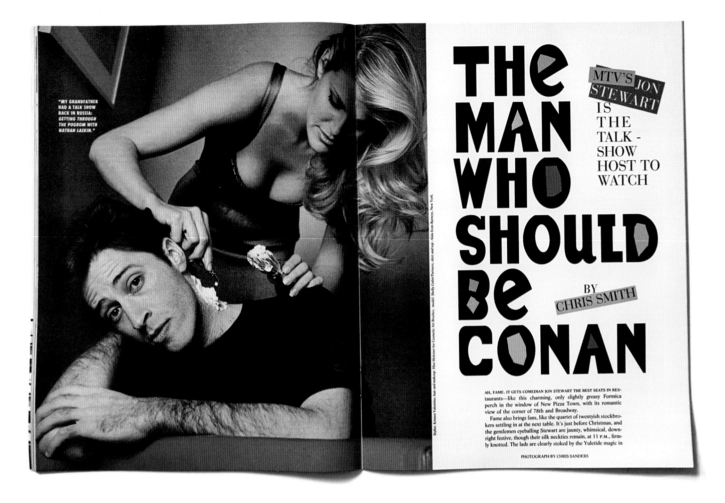

THE MAN WHO SHOULD BE CONAN

MTV'S JON STEWART IS THE TALK-SHOW HOST TO WATCH

BY CHRIS SMITH

"MY GRANDFATHER HAD A TALK SHOW BACK IN RUSSIA: GETTING THROUGH THE POGROM WITH NATHAN LASKIN."

AH, FAME. IT GETS COMEDIAN JON STEWART THE BEST SEATS IN RES-taurants—like this charming, only slightly greasy Formica perch in the window of New Pizza Town, with its romantic view of the corner of 78th and Broadway.
Fame also brings fans, like the quartet of twentyish stockbro-kers settling in at the next table. It's just before Christmas, and the gentlemen eyeballing Stewart are jaunty, whimsical, down-right festive, though their silk neckties remain, at 11 P.M., firm-ly knotted. The lads are clearly stoked by the Yuletide magic in

PHOTOGRAPH BY CHRIS SANDERS

Jon Stewart had been the runner-up to take over NBC's *Late Night* after David Letterman left for 11:30, and his consolation prize had been an MTV talk show. Five years later, *The Daily Show* called.

The Man Who Should Be Conan

By Chris Smith

AH, FAME. It gets comedian Jon Stewart the best seats in restaurants—like this charming, only slightly greasy Formica perch in the window of New Pizza Town, with its romantic view of the corner of 78th and Broadway.
Fame also brings fans, like the quartet of 20-ish stockbrokers settling in at the next table. It's just before Christ-mas, and the gentlemen eyeballing Stewart are jaunty, whimsical, downright festive, though their silk neckties remain, at 11 p.m., firmly knotted. The lads are clearly stoked by the Yuletide magic in the air—or maybe just cheap office-party eggnog.

"Hey! Are you that fucking guy? With the fucking show?" bellows broker No. 1. "You're on LTV, right?"

"I think you mean MTV," Stewart says dryly. "I'm Jon."

"You *do* look like him, you prick. What's the show called?"

"*The Jon Stewart Show.*"

This rouses broker No. 2. "Your commercials *suck*. And if it is your show, which I don't believe, how do I get into Duff's pants?"

"You?" Stewart says, "You'd have no problem, you're so smooth."

No. 3, wearing a bow tie, pipes up. "So where do you live?"

"In a suite at the Dakota. I told John not to go out that day, but he went."

This sails right over their drunken heads. The abuse spews for another ten minutes; eventually the Wall Street worthies ask a really offensive question. "Hey," yells No. 1, "what are you doing with your short-term money?"

Stewart shakes his head as we escape to the sidewalk. "I was kind of hoping you'd get to see a really pretty girl come up and

say, 'I love your show; would you like to date?' Guys like that, you don't have any one thing you can say to them that would totally sum up the damnation you feel in your heart. There's not one sentence."

He pauses for a half-second. "That's why I've written this song..."

Here in the '90s, when everybody except Chevy Chase has a talk show, Jon Stewart brings three all-important qualities to MTV's entry in the chat wars: He's funny. He's not afraid to tackle tough issues with guests like the 7-year-old Olsen twins from *Full House*. And he has an abundance of body hair. "They have to shave my neck during the hour between taping," Stewart says. "Is that something I shouldn't have shared?"

This is the man who should have been Conan. In fact, Stewart made it to the finals of NBC's Replace Dave Sweepstakes, only to have Lorne Michaels choose O'Brien, who'd spent as much time in front of a television camera as Doris Duke.

"And what do we have for the losers?" Stewart intones in his most unctuous game-show-host voice. "A week at Giggles Comedy Club in Rochester!" Stewart's consolation prize turned out to be more valuable: MTV launched *The Jon Stewart Show*.

All the standard talk-show elements are present in Stewart's speedy half-hour, but they're slightly skewed: Announcer Howard Feller looks heavily sedated (he played an inmate in *Awakenings*). The musical guests (the Breeders; 4 Non Blondes; Gin Blossoms) are loud and quirky. Then there's the host, a boyish, smartly sarcastic comic who's a regular guy—quick-witted, but not overpowering like Robin Williams; ironic, but not smug like Dennis Miller.

Stewart is also doing his best to be perky. "Jon's shown more of his nice-guy side so far," says pal Denis Leary. "As this show continues, it will get uglier; eventually it will just be this raging little Jewish man screaming into the camera."

Even with a cheesy set and an odd schedule—weeknights at 10, except Thursdays—Stewart is beginning to draw the hip, younger audience that eludes *Late Night With Conan O'Brien*. MTV will make the challenge more overt in February, when it moves Stewart to 12:30 a.m., directly opposite Conan.

By then, Stewart will have paid his cable bill and had his service reconnected. There's one talk-show competitor he's had his eye on for years. "Robin Byrd," he says. "The other night I'd been dialing for an hour and I finally got through. I said, 'I just want to tell you ladies, I fought in Vietnam, and you are the kind of people that make America worth dying for.'"

ONE FRIDAY NIGHT at Stand-Up NY, Stewart prowls the stage wearing an Agnes b. leather jacket and a hooded Nike sweatshirt. He moves from the pope ("the guy's a hat choice away from being grand wizard of the Ku Klux Klan...round hat—good; pointy hat—bad") to Yom Kippur. "Jewish day of atonement. You don't eat for one day, all your sin for the year is wiped clean. Tremendous deal," Stewart says. "What do the Catholics have? Forty days of Lent. Forty! Even in sin you're paying retail."

Despite his success on the club circuit, Stewart didn't feel he'd arrived until he appeared on *Letterman* last March. "When I walked onstage, I blanked," Stewart says. "The audience is dark, and there's just a little red light. At that moment you'd realize, it'll be really quiet here if I don't talk." Stewart's comedy reflexes kicked in, and the rest is hysterical.

Besides doing stand-up, Stewart's also spent a year hosting Comedy Central's *Short Attention Span Theater*, and 13 weeks

"The audience is dark, and there's just a little red light. At that moment you'd realize, it'll be really quiet here if I don't talk."

trying to rise above the fart jokes on MTV's *You Wrote It, You Watch It*. In October, he returned with the cheerfully low-rent *Jon Stewart Show*. "Other talk shows, their bits are like, 'All right, we're going to fly Costas in a helicopter; then he's going to parachute down and present me with the Soupy Sales figurine,'" Stewart says. "We're like, 'Can we afford that picture of Hasselhoff?'"

Stewart presides from behind a Nok-Hockey table instead of a desk. In the first nine weeks, he hasn't come up with anything as inspired as Letterman's legendary Alka-Seltzer suit, but he's showing a talent for the loopy device. On one show, the aged Margarita Sames hunched over a blender, mixing the frozen tequila drink she claims to have invented 45 years ago. Then there was Blind Date Night, when the producers fixed up Stewart with Leonora, a gangly blonde so opinionated that she should have her own show. "It was not the start of something big between us," says Stewart, who is single.

But Tisha Campbell slow-danced with him, and William Shatner caressed him gently. "Captain Kirk," Stewart deadpanned on the air, "you're boldly going where no man has gone before."

"You want to take Jon home with you," says Tawny Kitaen, a recent guest. "Like a puppy. You want to make sure he's okay."

Now, that's a compliment that makes every man cringe, but Tawny's right—Stewart's got a vulnerable quality. When the show's first guest, Howard Stern, launched a hilarious assault on MTV ("They ruin people's careers") and Stewart ("I don't know who Gene is"), Stewart played right along; "I'm scared to death," he said, and the quiver in his voice sounded real.

Stewart is sometimes too nice to his guests. His show's other big weakness is that it can seem like an MTV infomercial, stuffed with fellow MTV talking heads like Kurt Loder and Cindy Crawford. "I agree," Stewart says. "In the beginning, it was really important to get a lot of people on the air that the MTV audience recognized."

The show's appeal has broadened since then, to the point where MTV says its ratings are only second to those of *Beavis and Butt-head*. "I've met Butt-head," Stewart says. "Beavis has an attitude. You can't talk to him. He's got an entourage."

The modest success of Stewart hasn't gone unnoticed at NBC, where execs also considered Stewart as a successor to Bob Costas on *Later*. Says a Lorne Michaels staffer, "Jon would make a good replacement for somebody—you fill in the name."

Stewart's keeping everything in perspective. "I used to watch MTV in college," he says. "You're with your roommate, watching Duran Duran's 'Hungry Like the Wolf,' and you're high and you're eating an egg sandwich, and you're like, 'Martha Quinn is cool!' Somewhere I bet there's a 19-year-old kid, high, eating an egg sandwich, saying to his roommate, 'Hey, where's Martha Quinn? And who's this hairy guy?'" ∎

**Two hometown heroes, each with
three sidekicks, turned the mannerisms
of New York life into great television.**

"It was the best place in
the world. It was literature.
It promised everything."

Sarah Jessica Parker

on the New York of her childhood

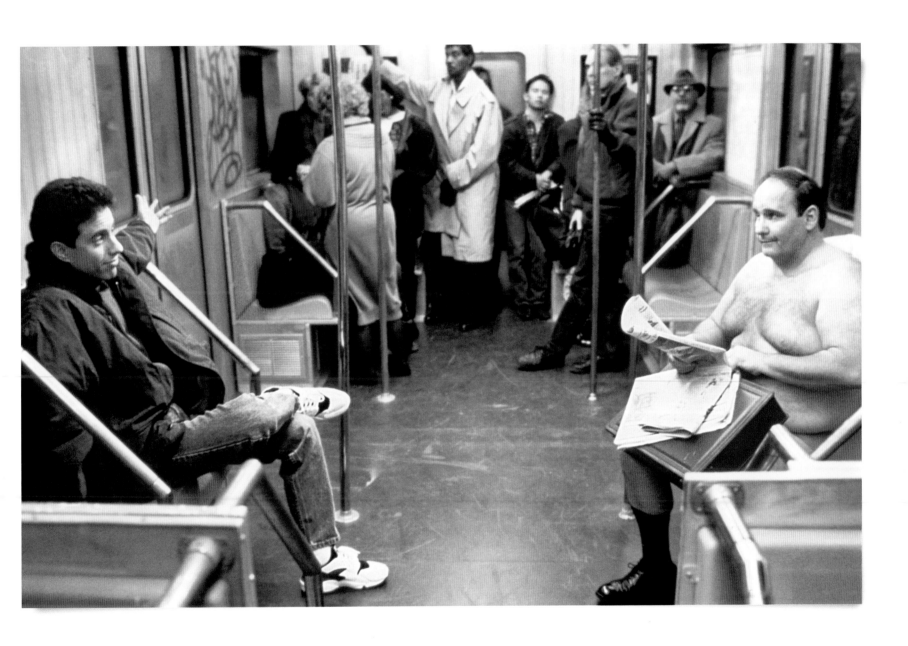

"New York is such an exciting
city that even being on a model of
it 3,000 miles away is exciting."

Jerry Seinfeld
on his back-lot Upper West Side

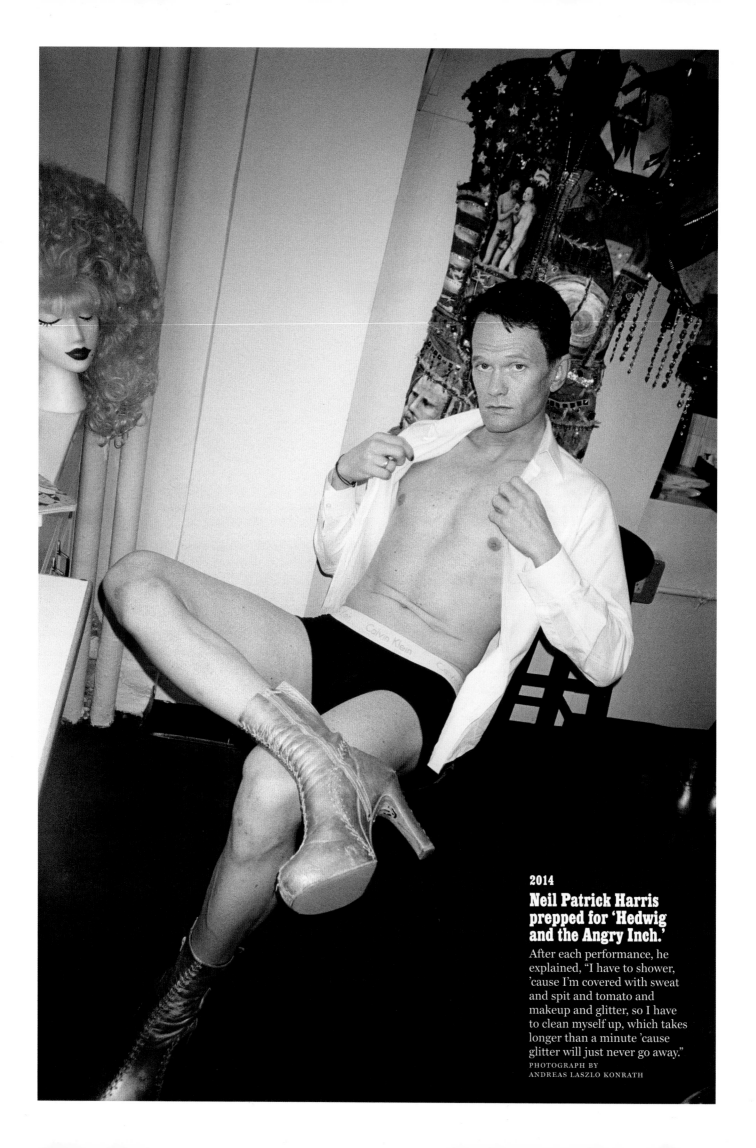

2014

Neil Patrick Harris prepped for 'Hedwig and the Angry Inch.'

After each performance, he explained, "I have to shower, 'cause I'm covered with sweat and spit and tomato and makeup and glitter, so I have to clean myself up, which takes longer than a minute 'cause glitter will just never go away."

PHOTOGRAPH BY
ANDREAS LASZLO KONRATH

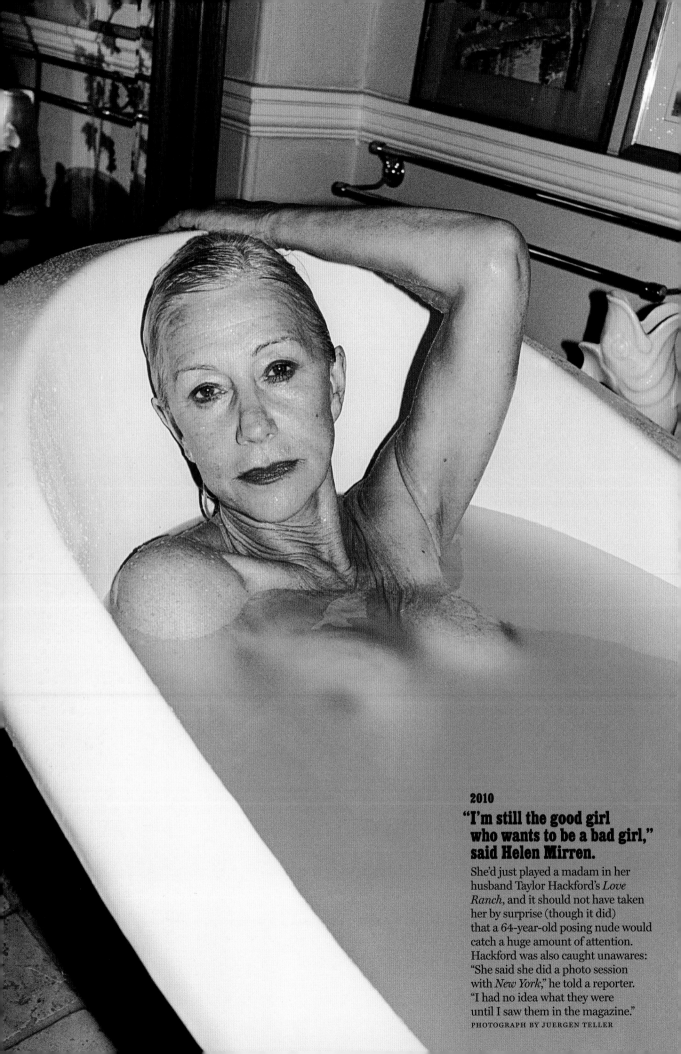

2010

"I'm still the good girl who wants to be a bad girl," said Helen Mirren.

She'd just played a madam in her husband Taylor Hackford's *Love Ranch*, and it should not have taken her by surprise (though it did) that a 64-year-old posing nude would catch a huge amount of attention. Hackford was also caught unawares: "She said she did a photo session with *New York*," he told a reporter. "I had no idea what they were until I saw them in the magazine."

PHOTOGRAPH BY JUERGEN TELLER

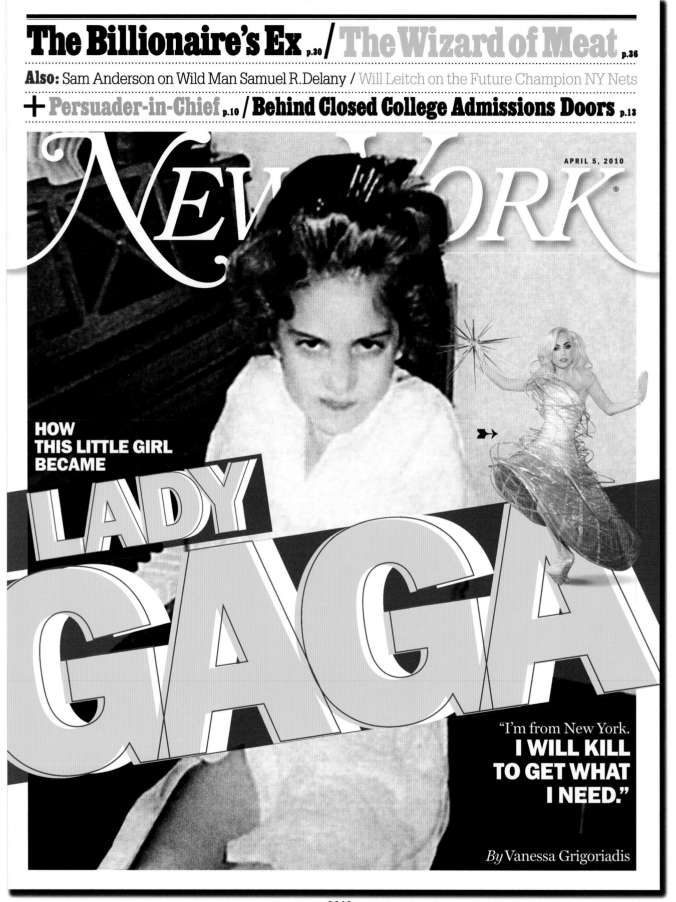

New York

APRIL 5, 2010

HOW
THIS LITTLE GIRL
BECAME

LADY GAGA

"I'm from New York.
**I WILL KILL
TO GET WHAT
I NEED."**

By Vanessa Grigoriadis

2010

Stefani Germanotta grew up.

"I went through a great deal of creative and artistic revelation, learning,
and marination to become who I am," she told Vanessa Grigoriadis. "Tiny little lie? I wanted
to become the artist I am today, and it took years."

314

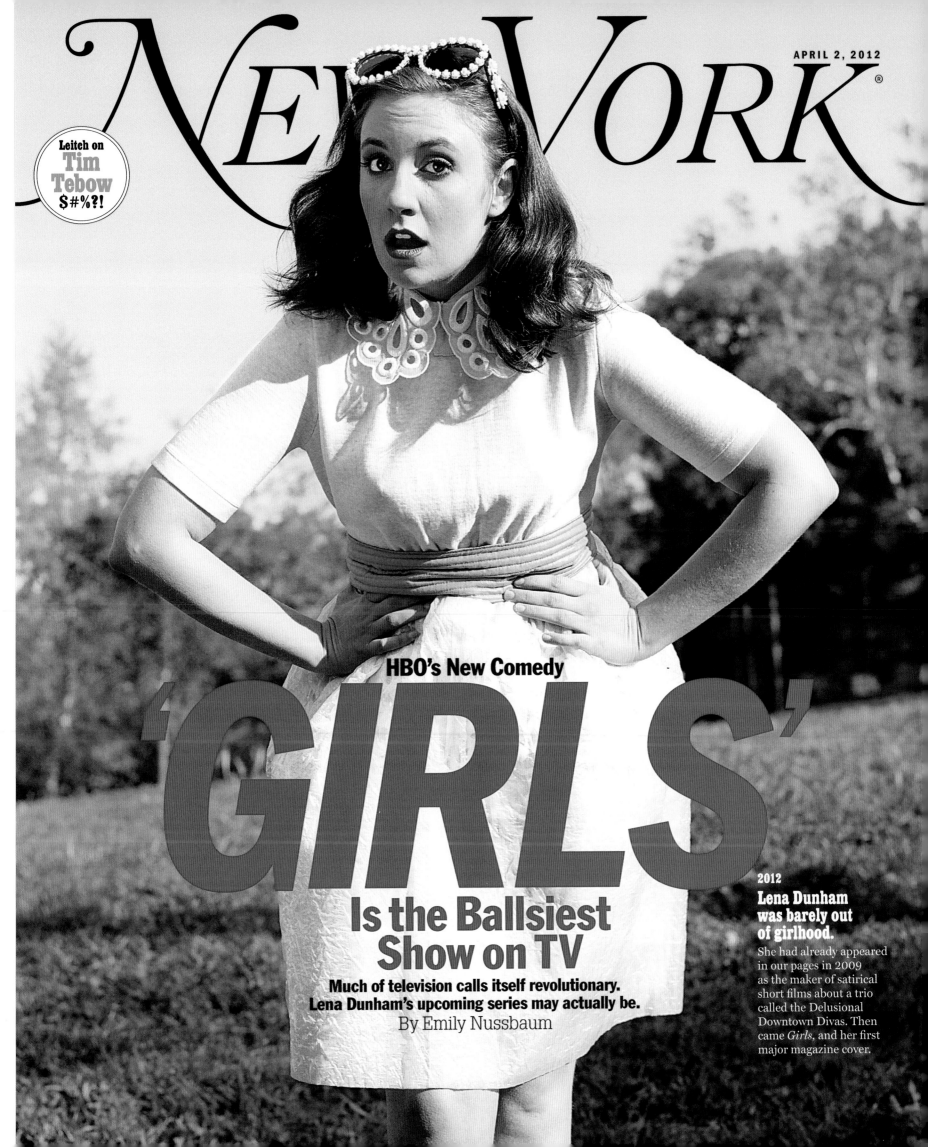

New York

APRIL 2, 2012

Leitch on
Tim Tebow
$#%?!

HBO's New Comedy

'GIRLS'

Is the Ballsiest Show on TV

Much of television calls itself revolutionary. Lena Dunham's upcoming series may actually be.

By Emily Nussbaum

2012
Lena Dunham was barely out of girlhood.
She had already appeared in our pages in 2009 as the maker of satirical short films about a trio called the Delusional Downtown Divas. Then came *Girls*, and her first major magazine cover.

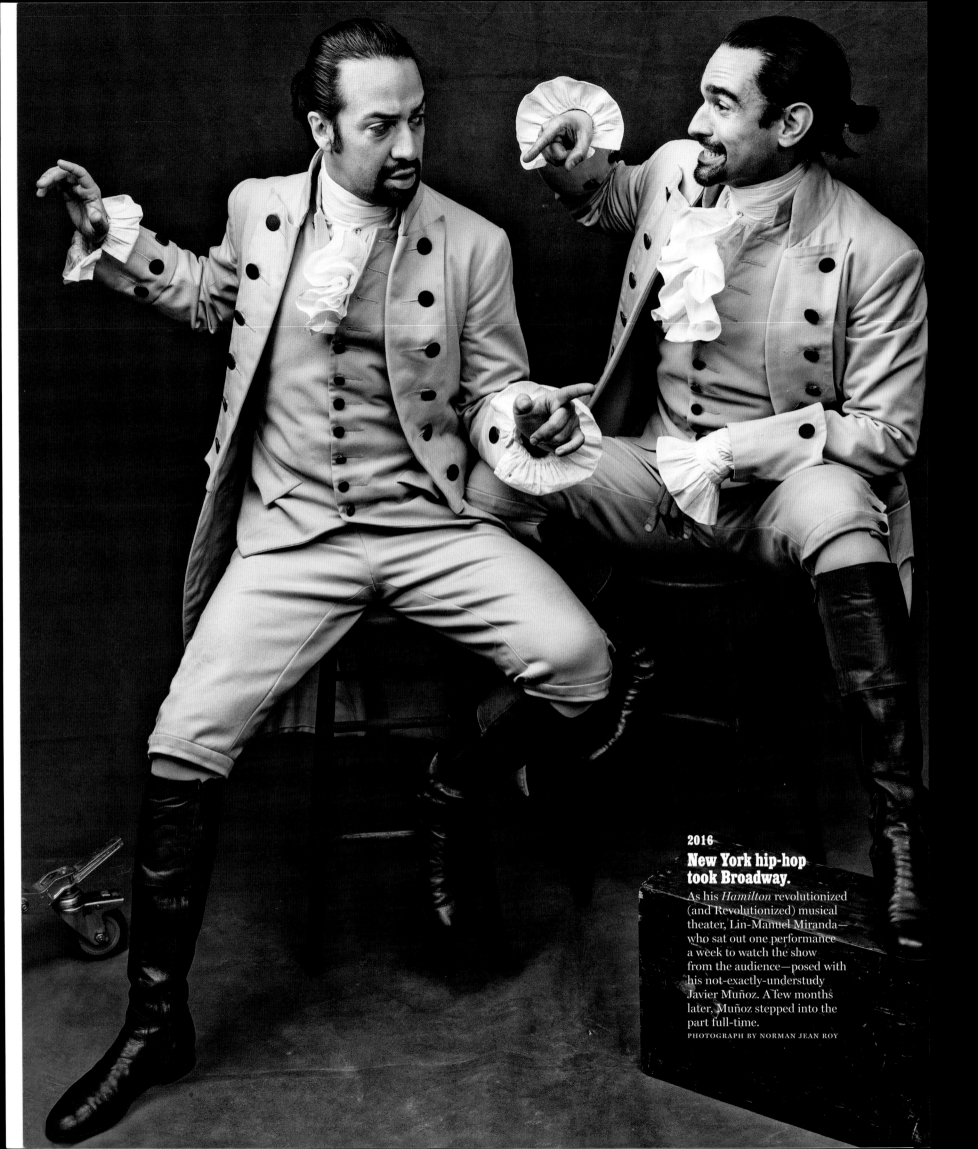

2016

New York hip-hop took Broadway.

As his *Hamilton* revolutionized (and Revolutionized) musical theater, Lin-Manuel Miranda—who sat out one performance a week to watch the show from the audience—posed with his not-exactly-understudy Javier Muñoz. A few months later, Muñoz stepped into the part full-time.

PHOTOGRAPH BY NORMAN JEAN ROY

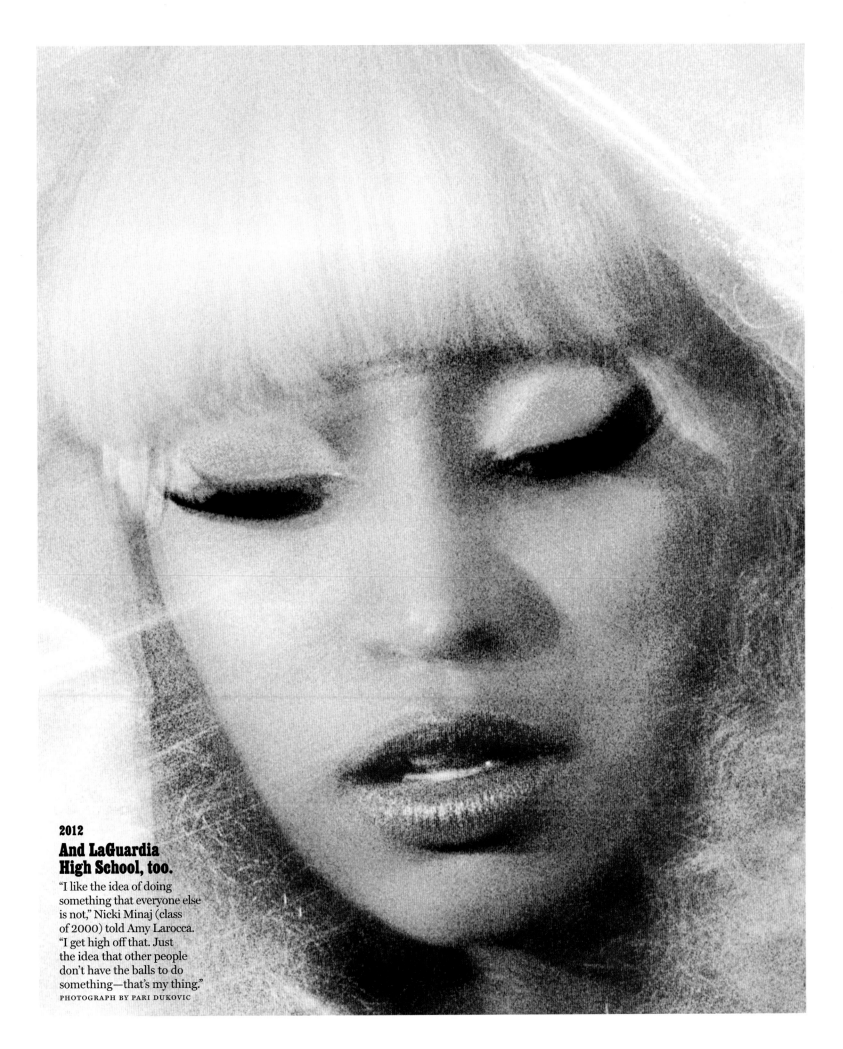

2012

And LaGuardia High School, too.

"I like the idea of doing something that everyone else is not," Nicki Minaj (class of 2000) told Amy Larocca. "I get high off that. Just the idea that other people don't have the balls to do something—that's my thing."

PHOTOGRAPH BY PARI DUKOVIC

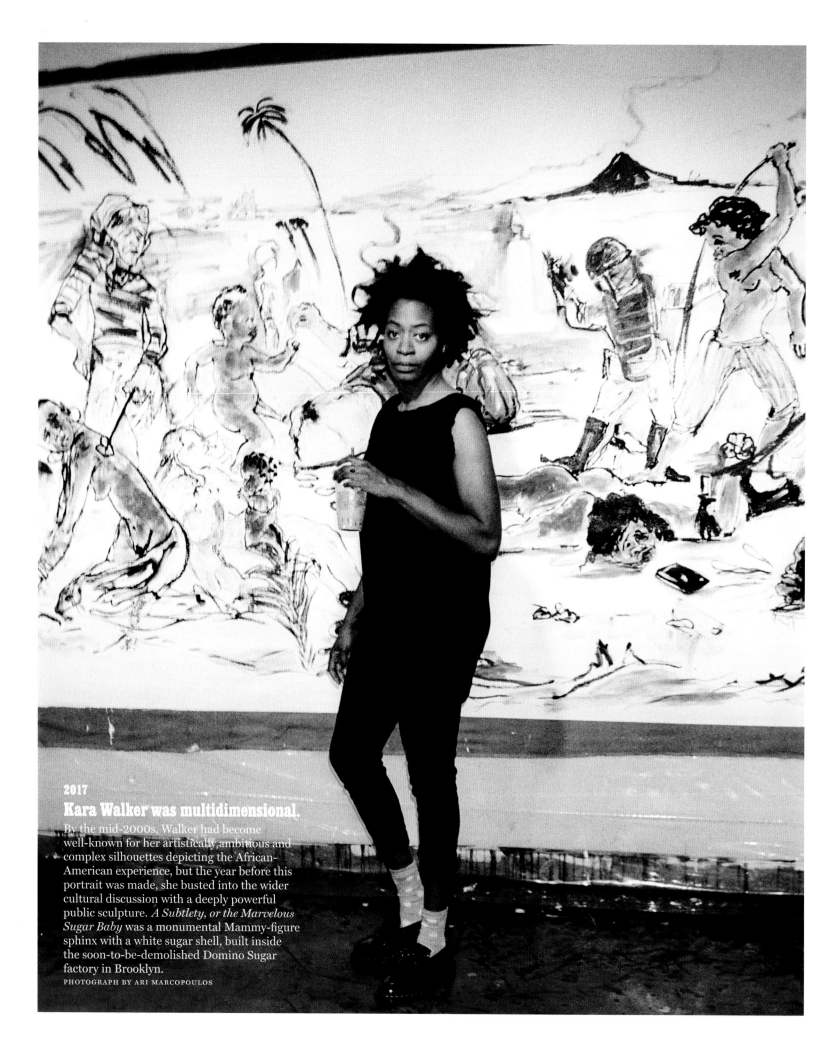

2017

Kara Walker was multidimensional.

By the mid-2000s, Walker had become well-known for her artistically ambitious and complex silhouettes depicting the African-American experience, but the year before this portrait was made, she busted into the wider cultural discussion with a deeply powerful public sculpture. *A Subtlety, or the Marvelous Sugar Baby* was a monumental Mammy-figure sphinx with a white sugar shell, built inside the soon-to-be-demolished Domino Sugar factory in Brooklyn.

PHOTOGRAPH BY ARI MARCOPOULOS

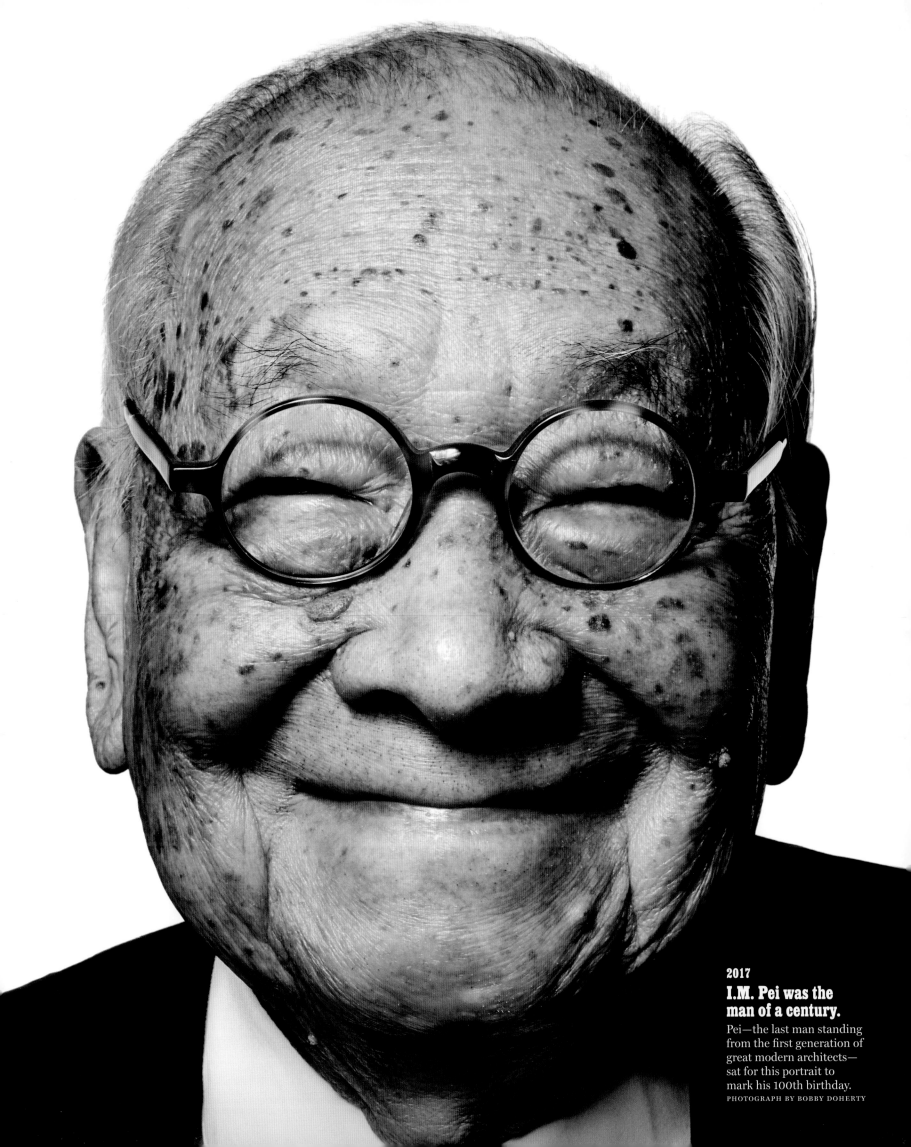

2017

I.M. Pei was the man of a century.

Pei—the last man standing from the first generation of great modern architects— sat for this portrait to mark his 100th birthday.

PHOTOGRAPH BY BOBBY DOHERTY

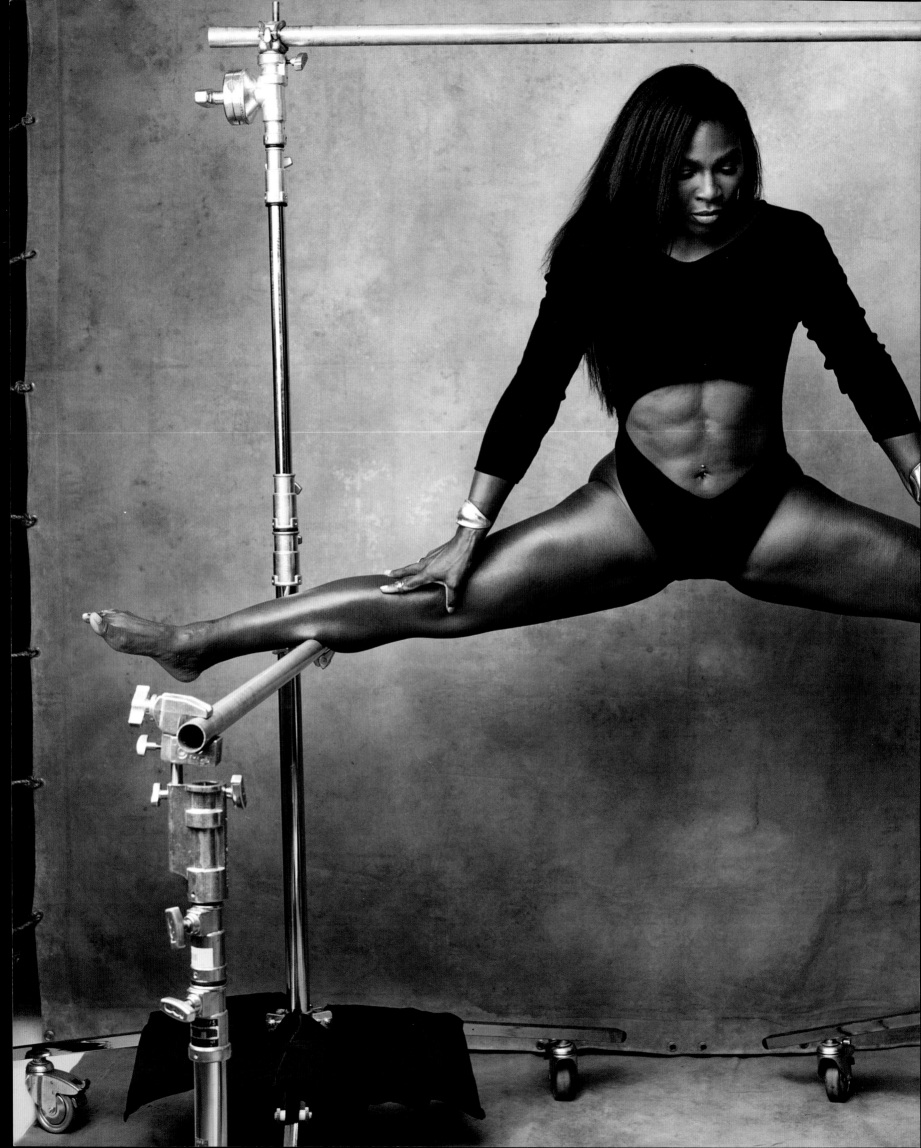

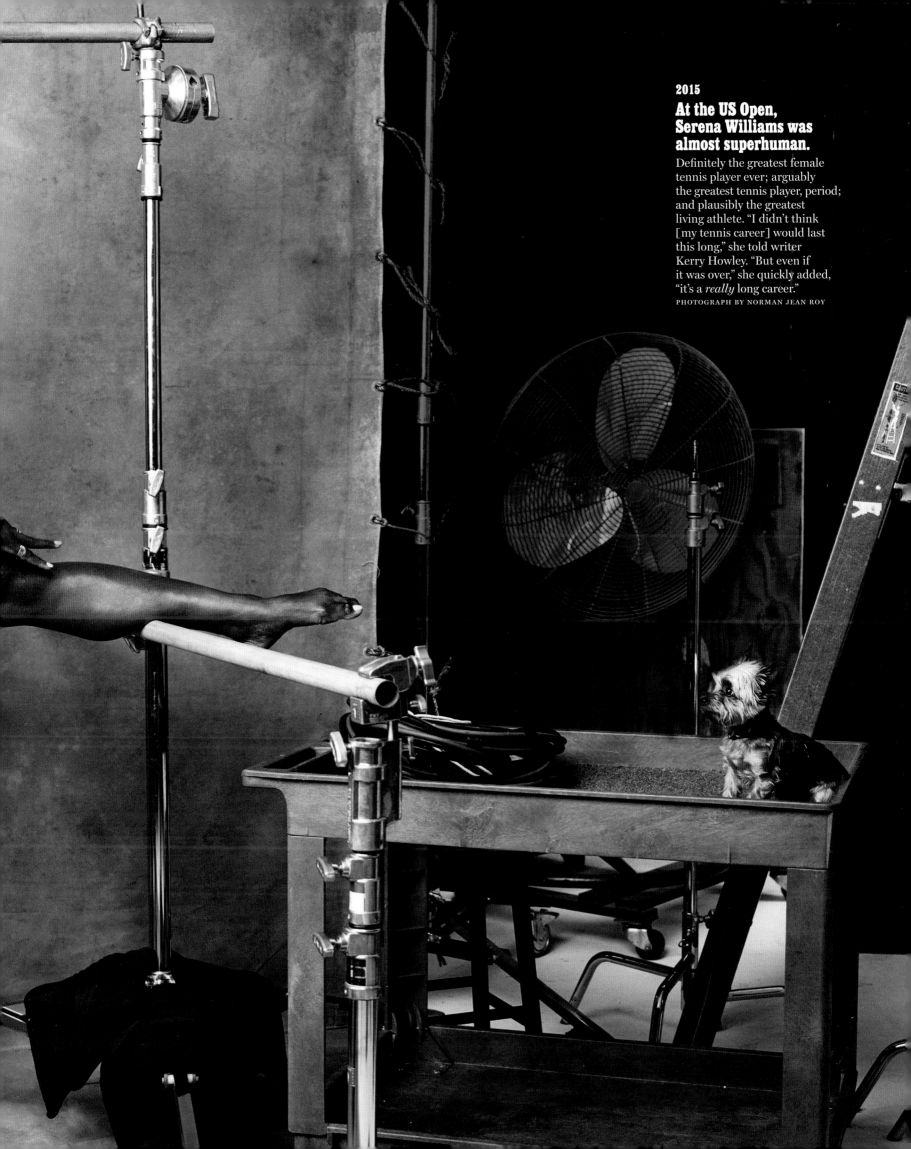

2015

At the US Open, Serena Williams was almost superhuman.

Definitely the greatest female tennis player ever; arguably the greatest tennis player, period; and plausibly the greatest living athlete. "I didn't think [my tennis career] would last this long," she told writer Kerry Howley. "But even if it was over," she quickly added, "it's a *really* long career."

PHOTOGRAPH BY NORMAN JEAN ROY

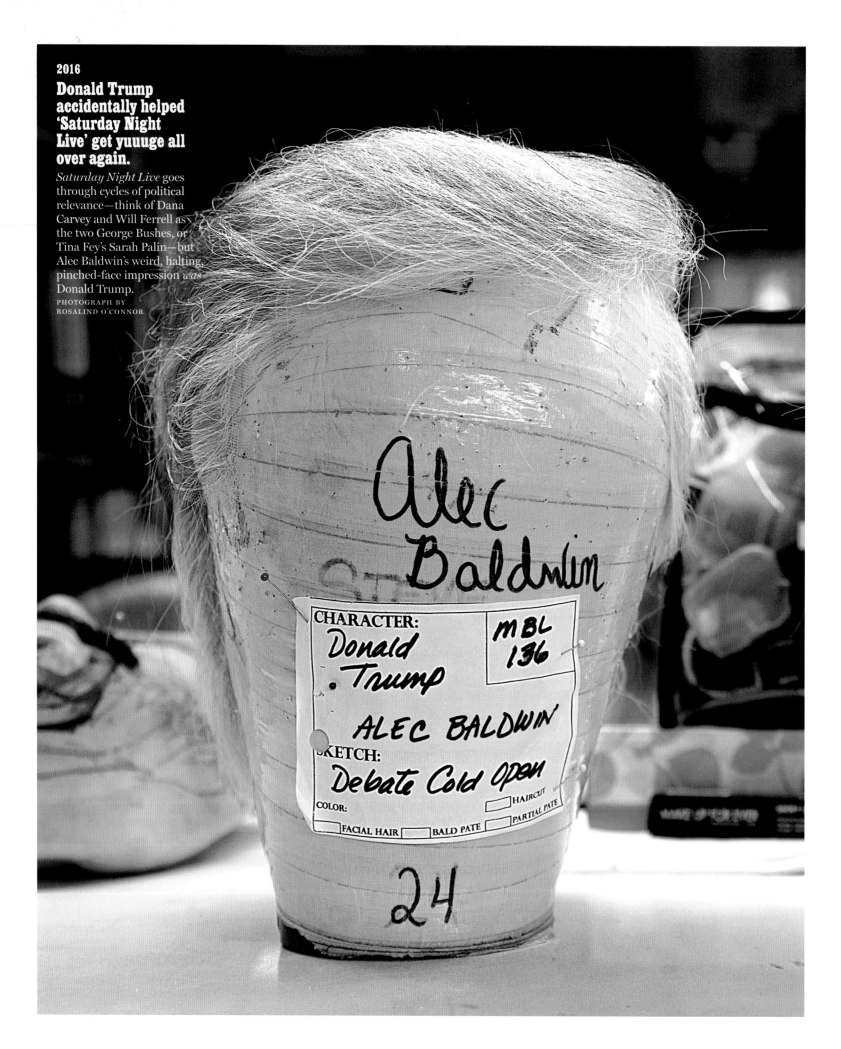

2016

Donald Trump accidentally helped 'Saturday Night Live' get yuuuge all over again.

Saturday Night Live goes through cycles of political relevance—think of Dana Carvey and Will Ferrell as the two George Bushes, or Tina Fey's Sarah Palin—but Alec Baldwin's weird, halting, pinched-face impression *was* Donald Trump.

PHOTOGRAPH BY
ROSALIND O'CONNOR

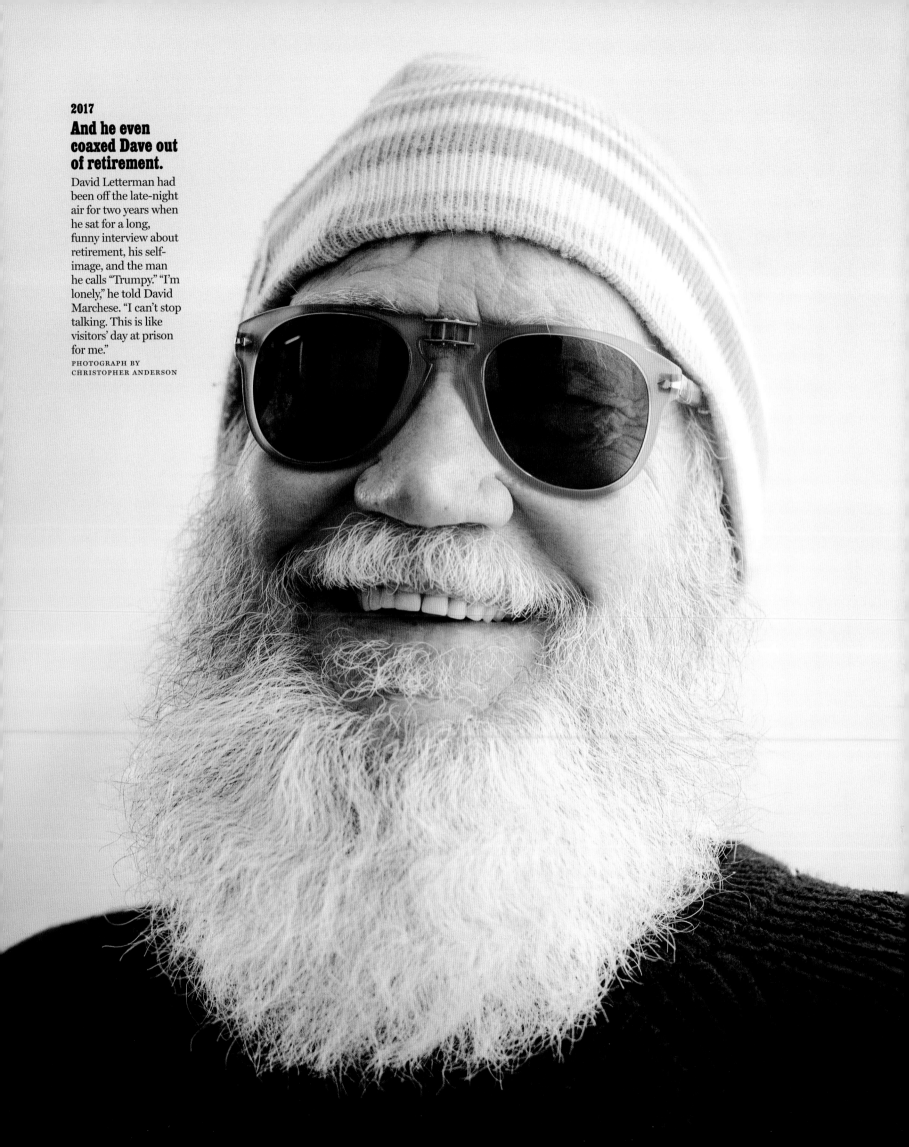

2017

And he even coaxed Dave out of retirement.

David Letterman had been off the late-night air for two years when he sat for a long, funny interview about retirement, his self-image, and the man he calls "Trumpy." "I'm lonely," he told David Marchese. "I can't stop talking. This is like visitors' day at prison for me."

PHOTOGRAPH BY CHRISTOPHER ANDERSON

7 / FAMILY

"I love my children. I hate my life."

From
"All Joy and No Fun,"
by Jennifer Senior, 2010

New Yorkers made families, and worried about them.

WE ARE A CITY OF STRIVERS, and that applies to our personal lives as much as to our professional ones. It can sometimes seem as though single New Yorkers approach dating like a military campaign, setting goals and deploying special weapons and tactics and detailed intelligence reports. (In the fog of war, or hormones, sometimes those plans get thrown aside.) In *New York*'s often sex-mad pages, those maneuvers have been analyzed in lively, poignant, sometimes hilarious detail, adding up to a 50-year album of scenes and snapshots and, above all, anxiety about how and whether and when we mate. In the early 1970s, divorce was just shaking off its stigma of sin, and was beginning to be not only acceptable but even empowering, especially for women. Same-sex couplings started to come out into the open. People began to marry later in life, having had far more sexual experience than their parents did. In *New York* in 1976, Gail Sheehy got a lot of this down on paper in "The Sexual Diamond," about the predictable (and unevenly matched) developmental stages of baby-boomer lives and relationships. That story developed into her book *Passages,* one of the best sellers of the decade. Tom Wolfe, in our pages a few months later, gave those unprecedently self-involved boomers a collective name: the "Me" Generation. ¶ If love and marriage were a major source of story ideas for *New York,* they paled next to the prospect of bearing and raising children in the city. First of all, there was the matter of getting pregnant, and as marriages got later and lives got busier, that was no small feat. *New York* covered the new science of baby-making and its implications with great interest: in vitro fertilization, the wave of twin births that followed, New York City's status as the only-child capital of America, the baby-boom among gay and lesbian couples. ¶ And once those kids arrived? High-achieving parents want their children to succeed, and that meant even more attention—and, in *New York,* coverage. Where should they go to school? When can they travel there alone? (The answer to that question changed in 1979, when a Soho 6-year-old named Etan Patz disappeared, having been kidnapped and murdered, on the way to school.) How authoritarian should parents be? When should children be allowed to date? And for God's sake, what do you do when *they* start to have sex? Suddenly, the kids were the ones having all the fun, and the parents were, like so many parents before them, getting exactly what they'd wished for, with unexpected results. And, of course, it usually turned out fine.

1971

No matter what school a child went to, somebody would say it was the wrong one.

"Some Thoughtful Parents Care Enough About Their Kids' Education to Send Them to Public Schools," read the cover line on Mel Ziegler's story. The boy in the bubble appears in front of P.S. 116, a high-achieving school that just happened to be next door to *New York*'s offices on East 32nd Street.

PHOTOGRAPH BY HAROLD KRIEGER

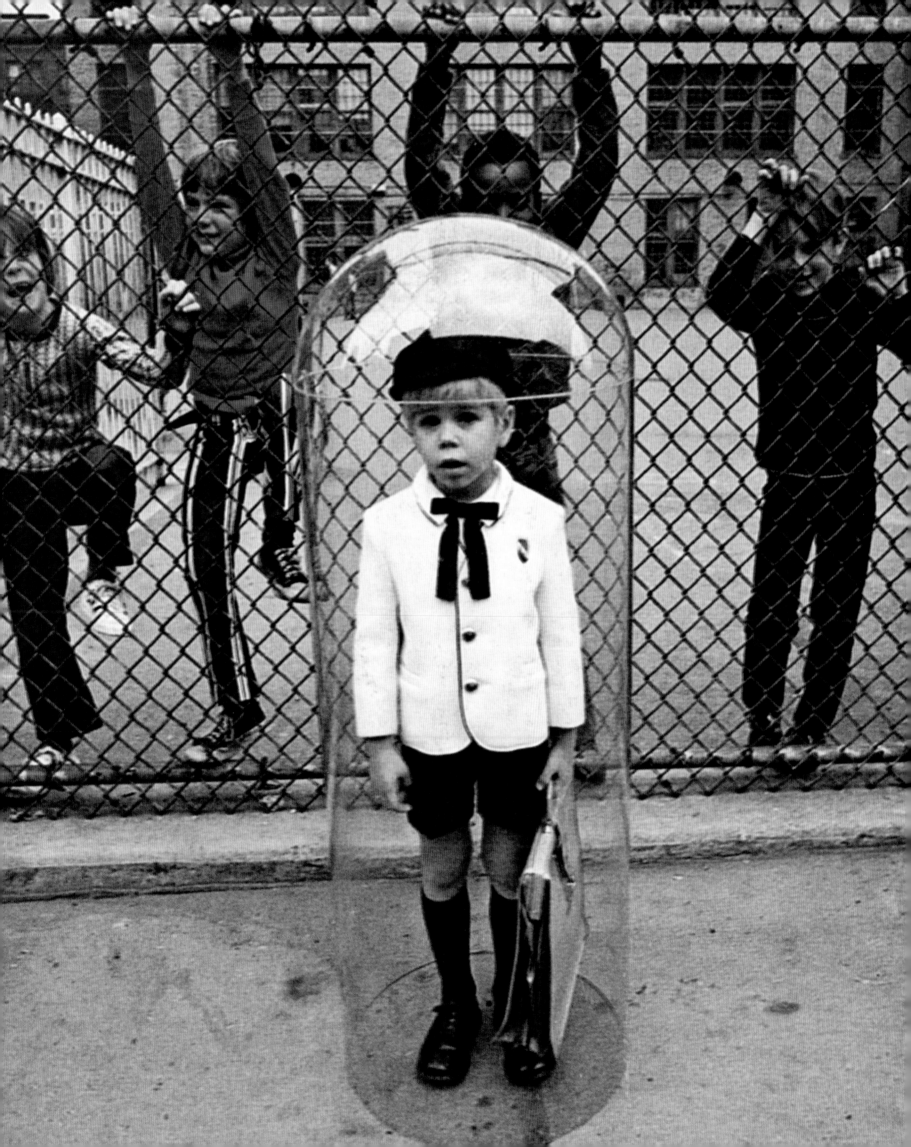

For $37 per line of type, you could seek same.

Before the internet changed the meet-up dynamic forever, *New York*'s "Strictly Personals" section included 200 ads and fielded 10,000 responses (by mail) every week.

Women Seeking Men

Sharon Stone Look/IQ-Alike—Seeks very generous man, 60 plus. 7845 ✉☎

My Fortune Cookie Said—I was about to meet a warm, intelligent, secure, spontaneous, tall, good-looking, Jewish man ready to be steady. This very attractive, accomplished, tall, slim, Jewish woman, 35, doesn't want to eat her words. NYM B034.

WASP Princess, Late 30's—Seeks slim man, over 5'10", educated, dry, quick wit, sincere, a gentleman with traditional values. Bio, photo, phone. NYM M 193.

What Is Cuddly, Solid—Playful, loyal and responsive? Highly desirable woman, 29, seeks tall man of "breeding" who believes his best friend doesn't have to be his dog. No dachshunds, please. Send papers. NYM C882.

I Can't Believe I Forgot—To have children, send them to private school from our 12 room penthouse on Central Park West, as the housekeeper prepares dinner and we dash off to opening night at the Met. Let's do it! Photo/phone. 3668 ✉

Halley's Comet—Is gone, but this shining star remains. 31, petite, spunky, adorable female, seeks attractive, fit, professional Jewish male, 30's, to circle my orbit for caring relationship. Send signal by note/phone/photo. NYM G757.

Charming French Lady—30's, seek upper class gentleman for exotic relationship, quiet dining and good conversation. NYM B200.

'What A Pair!'—They say, seeing us laughing, talking over pizza or pate, cheering at Shea, passing customs at Kennedy, in line at the movies, holding hands in the theater. We enjoy each other, friends and sometimes being apart. We're striking they say. You're 6' plus, 48 plus, fit. I'm tall, blond, slim, pretty. We're both divorced. We both require quality. You're successful, decisive, macho. I admire/respect/adore you. You love my style, think I'm the best that happened to you except for my Jewish cooking. I'll try harder if we're a pair again. NYM R435.

I'm The Most Wonderful Woman—I've ever met, and guess what? I'm not short on self-esteem either. Hilarious, beautiful, ultra-engaging, entirely self-realized Ivy League brainstorm princess seeks one of her own in funny, real, happy, smart-guy version, 35-45. Must have charm to the nth degree and nonstop smarts/humor. Looks and letters should be sent designed to entice and amuse. 2973 ✉

Orient Pearl Professional—Desires love, marriage and kids. NYM B191.

Yankee Fan—Female, 32, Jewish, attorney, likes sports, movies, politics, children. Seeks unpretentious, professional male with similar interests for relationship. NYM Box D174.

Latin Man Wanted—Tall, 30-40, single, successful, and sexy. I am Italian, 5'6", 30, intelligent, pretty, seeking lasting relationship. Photo/phone. NYM Box 805.

Have I Got A Woman For You—She just moved into my building and I can't get over how gorgeous, sweet and intelligent she is. You wouldn't believe she has two kids in college (she must have been 12 when she had them). She's a professional artist and a devotee of all the arts. Now where can I find a tall, attractive, substantial Jewish man to introduce me (oops) her to? NYM C879.

Manhattan Lady Beauty—Brains and class. Heads turn wherever I go, but I don't know where to go to meet a clever, tender man in his 50s, comfortable with who he is. See if this 5'3", loving lady turns your head! You need be good-looking only in my eyes. Only Manhattan. Photo and phone. 2977 ✉

Into A Smile?—Are you a white male professional, 35-45, A-1 sense of humor, tall, trim, athletic, well-bred, secure and very witty? I'm 38, divorced, trim, blonde, blue eyes, very attractive and a reason for smiling. Write. NYM B193.

Women Seeking Women

Lipstick Lesbian—Creative, Jewish, 50, woman of substance seeks romantic to share ethics, secrets, tennis and concerts, silk and cotton, walks in the Bois, sails on the Mer and to avoid the merde. 5249 ✉☎

Gay White Female—Fit, romantic, well-educated professional with many interests, seeks similar, classy, sincere, nonsmoker, 44-50, European gay white female for relationship. 5295 ✉

Richard Gere Type—Wall Streeter turning 30, not meeting right people. Not the sort to use an ad, so if you're not the sort of woman to respond, please send photo and phone. NYM E366.

Last Of A Dying Breed—Rugged individualist, 35, successful business (non-Yuppie) with soul, ethics and a cocky sort of class. Seeks an attractive woman who's pretty and bright and who understands enough to know that the three greatest criminals this century are Hitler, Stalin and Walter O'Malley. NYM K407.

GQ Handsome—30s, super-successful, with heart of gold, seeks beauty, 22-35, with zest for life. Race not an issue. Photo for response. 2979 ✉

I've Searched The Universe—And still haven't found you. Respond now or I'll move to another galaxy. I'm 44, male, overeducated, love to hike. If you're a smart, funny woman - and like the road less traveled, I'll spoil you rotten. 3663 ✉

White Male Angel—45, not ugly, not short. Why compromise? Photo! 3015 ✉

The Purpose Of Life—Revealed here for the first time: fun, intimacy, bearing witness to eachother's days and nights, creativity, sensuality, lazy Sundays, art, music and (with the right person) raising children. Very bright, attractive, 31-year-old man seeks pretty gal in her 20's with similar views, prominent ideals and prominent derrierre; and who is not the type to answer an ad like this! I suggest a casual meeting over coffee. Photo appreciated. NYM K162.

The Third Most—Eligible bachelor in metro NY is ready to re-marry, after a wonderful decade of being single. Early 40's, athletically trim, extremely successful and one of the last truly Renaissance men; spiritually eclectic, mellow and mature and witty, suave, and pleasingly packaged. I am seeking one genuinely slim and petite woman (translate almost skinny and under 5'4"), 30 plus, with a formidable intellect and a romantic heart. I am honestly one of the rare catches in this town, and if you can honestly say that you are too, please send a short hand-written note. However, replies with photographs will receive the highest priority. I will gladly send my photo to you in exchange! NYM M111.

I Am Not Handsome—5'8" and over 50, nevertheless I would like you to be in your 30's, 5'2" to 5'6", intelligent, compassionate, slim, attractive and have an outgoing personality. My shortcomings are too numerous to outline in this ad, my assets are I'm Jewish, honest, considerate, have a sense of humor, slightly above average intellectually, served in the US Army, don't smoke, drink sparingly, can run and complete a 26.2 mi. marathon, company owner, enjoy travel, dining, holding hands, sending flowers and old-fashioned values. If you are the woman I'm describing, there is no need for your photo nor life history. Your name, your phone number and specific times to call, since I prefer not to talk to a recording machine, will suffice. My only interest is matrimony. NYM T854.

Geographically Undesirable Male—45, slightly north of Westchester - but has Ferrari and will travel. Not feloniously ugly, comfortable in jeans but can be dressed up and taken anywhere. Seeking interesting woman, 25-40, with a touch of class. Photo appreciated, will exchange. NYM H939.

Professional—60, young and not yet dead. Married to a good woman who is. Seeks trim, warm, sensitive, cheerful and intelligent daytime married friend (female). Mutual discretion essential. NYM Box 1787.

Was That You?—At Bendel's? You were quietly elegant (pearls around your neck, I think). I was in a dark blue suit, thin, brown hair, 5'10". I was there looking for a gift when you passed by - a hint of perfume and an air of confidence lingered in your path. I hoped that small smile was for me, as the elevator doors closed. I should have spoken up - waved - done something! If you are as sincere and warm inside as you are elegant and confident on the outside, I've missed a rare opportunity. Perhaps it's not too late. I'd like you to find out about me, beyond the mere biographical details: I'm single, live in Manhattan, own my own small company and have a PhD. I'm also a tender and caring person. And more. At least let's talk. It might not work out, but we'll both feel better knowing we tried. Please send me your number and I'll call you. You can count on it. NYM K183.

Straight-Gay Buddies—I am looking for a straight white, black or Latin male buddy, 26-66 more or less, unmarried, sociable, cool, fit, modern professional, to hang out with (especially on my frequent visits to Detroit and LA). I'm a NYC gay black male, 40-something, high brown complexion, very intelligent, very attractive, West Indian rock star looks. No sex. Just a beautiful, joyful friendship. Photo. 4042 ✉ ☎

Adam And Steve!!—Me, Steve, solo and soon 60. 6'2", 195, salt/pepper hair/beard. Nice looks and life in Eden: 7 acres, gardens and pool, country house. Seeks new Adam for Eternity!! You: Adam (30-50), top gun, top butch brain, Alpha male brawn, leading-man pitcher, topgallant rooster, serious wolf, sizzling seducer, cocksure take-charge guy who leaves a lasting impression!! Get the picture?? Two Average Gay Joes: Adam (30-50) and Steve (60), together, crowing!!! Phone/write. 4055 ✉ ☎ Dare to e-mail me: @earthlink.net

1976–2013
Sex sold magazines. And, occasionally, led to overexposure.

After the cover at far right was published in 2005, *New York*'s editors discovered that—despite endless rounds of vetting—they had inadvertently left one vagina on view in the tangle of body parts. Can you find it? *(Answer below.)*

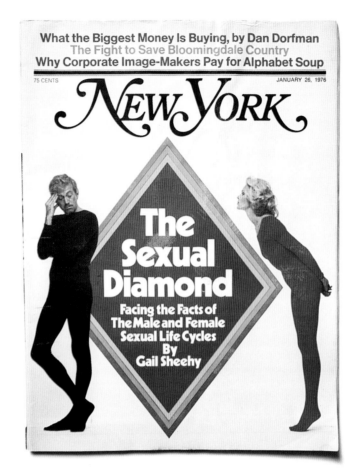

What the Biggest Money Is Buying, by Dan Dorfman
The Fight to Save Bloomingdale Country
Why Corporate Image-Makers Pay for Alphabet Soup

75 CENTS JANUARY 26, 1976

New York

The Sexual Diamond

Facing the Facts of The Male and Female Sexual Life Cycles By Gail Sheehy

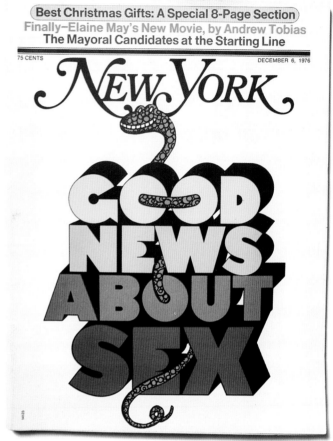

Best Christmas Gifts: A Special 8-Page Section
Finally—Elaine May's New Movie, by Andrew Tobias
The Mayoral Candidates at the Starting Line

75 CENTS DECEMBER 6, 1976

New York

GOOD NEWS ABOUT SEX

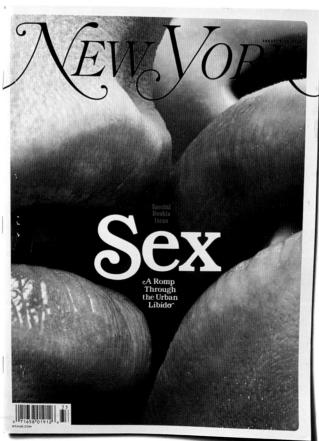

New York

Special Double Issue

Sex

A Romp Through the Urban Libido

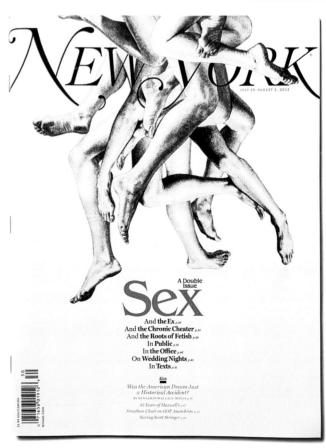

New York

JULY 29–AUGUST 5, 2013

Sex
A Double Issue

And the Ex *p.38*
And the Chronic Cheater *p.31*
And the Roots of Fetish *p.42*
In Public *p.45*
In the Office *p.46*
On Wedding Nights *p.41*
In Texts *p.51*

Also

Was the American Dream Just a Historical Accident?
BY BENJAMIN WALLACE-WELLS *p.19*
35 Years of Maxwell's
Jonathan Chait on GOP Anarchists
Saving Scott Stringer

ANSWER: It's slightly to the left of the N in the logo, just under the arch of a man's foot.

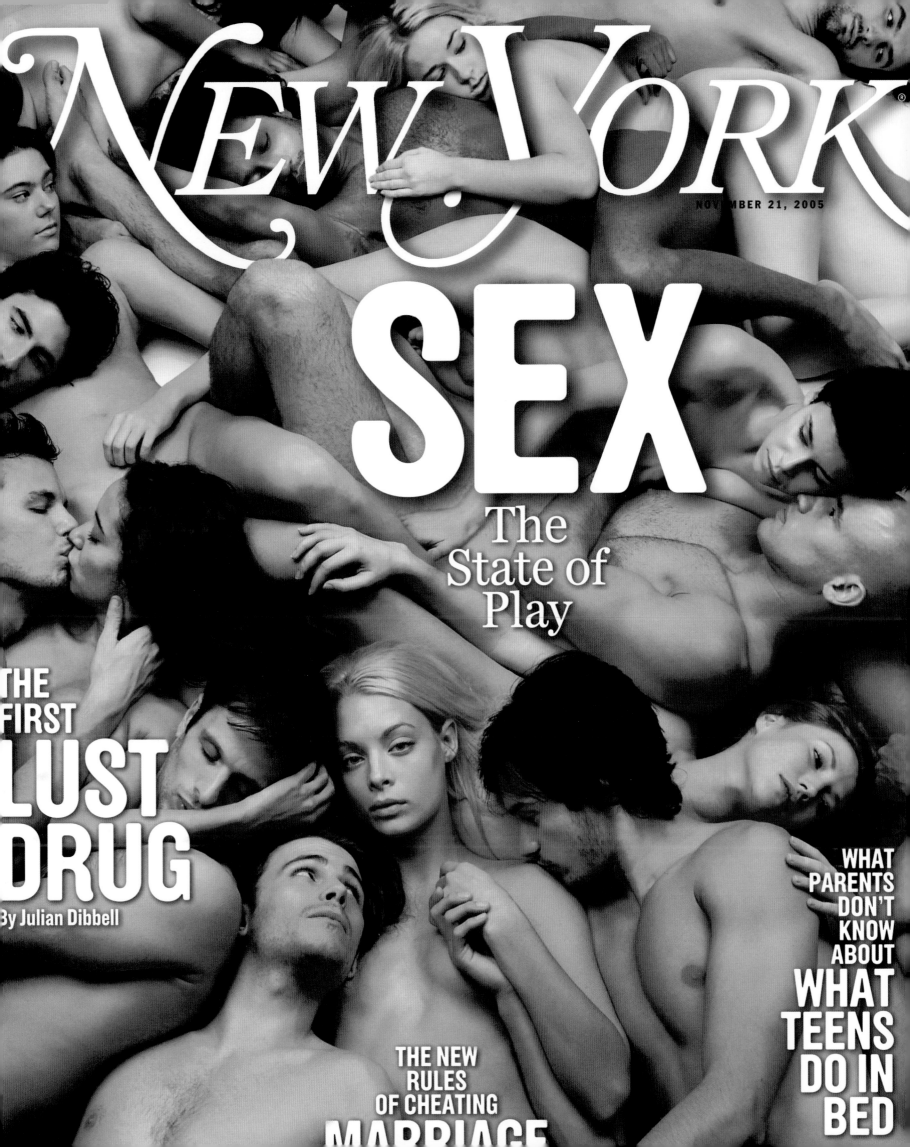

New York

NOVEMBER 21, 2005

SEX
The State of Play

THE
FIRST
LUST
DRUG
By Julian Dibbell

WHAT
PARENTS
DON'T
KNOW
ABOUT
WHAT
TEENS
DO IN
BED

THE NEW
RULES
OF CHEATING
MARRIAGE

In 2007, *New York* started "The Sex Diaries": weeklong journals of intimate thoughts, actions, sexts, and almosts. Then we sized up two years' worth of dirty data.

A Critical (But Highly Sympathetic) Reading of New Yorkers' Sexual Habits and Anxieties

By Wesley Yang

The anxiety of too much choice.

↣ A fact so readily apparent that it has escaped reflection: The cell phone has changed the nature of seduction. One carries in one's pocket the means of doing something other than what one is presently doing, or being with someone other than the person one is with. Take this excerpt from a 31-year-old straight male Diarist ("The Transportation Coordinator Seeing Three Partners") living on the Upper West Side:

> **12:32 P.M.** I get three texts. One from each girl. E wants oral sex and tells me she loves me. A wants to go to a concert in Central Park. Y still wants to cook. This simultaneously excites me—three women want me!—and makes me feel odd.

This is a distinct shift in the way we experience the world, introducing the nagging urge to make each thing we do the single most satisfying thing we could possibly be doing at any moment. In the face of this enormous pressure, many of the Diarists stay home and masturbate.

The anxiety of making the wrong choice.

↣ A Diarist with any game at all has unlimited opportunity. A few are up to the task: Identify the single best sexual partner available, or at least the person most amenable to their requirements. They use their cell phone to disaggregate, slice up, and repackage their needs, servicing each with a different partner, and hoping to come out ahead. This can get complicated quickly, however.

An inordinate number of Diarists find themselves at the brink of enjoying one sexual experience, only to receive a phone call or text from another potential suitor. Consider these snippets in a week of one Diarist, who is deeply conflicted between her Pseudo and Ex:

> **2:55 P.M.** Pseudo G-chats me. Looks like he might be interested in hanging out tonight after all.
>
> **9:30 P.M.** Meet up with Ex and friends at bar. Text Pseudo to see if he's up for doing anything.
>
> **2:20 A.M.** At a bar with Pseudo and other friends. Ex drunk-texts me: "Wanna fuck?"
>
> **3:17 A.M.** Half-bottle of wine plus mucho beer plus a few rounds of shots leads to me texting Pseudo, "Let's get out of here and go back to my place."
>
> **3:18 A.M.** Pseudo texts back, "I don't feel like dealing with you."
>
> **11:45 P.M.** At a bar with Pseudo. Ex drunk-texts me.
>
> **1:30 P.M.** Ex calls and wakes me up. Says he needs to talk in person.
>
> **7:49 P.M.** Text Pseudo and tell him about convo with Ex. Pseudo replies that he's sorry, he hopes I end up getting what I want. What the hell does that mean? I have no idea what I want, clearly.

This compulsive toggling between options winds up inflicting the very damage it was designed to protect against.

The anxiety of not being chosen.

↣ Among active Diarists, the worry that they will make the wrong choice is surpassed by the fear that they might find themselves without one. Everybody is on somebody's back burner, and everybody has a back burner, maintained through open-ended texts, sporadic Facebook messages, G-chats, IM's, and terse e-mails. The Diarists appear to do this regardless of whether or not they are in a committed relationship.

> **12:22 A.M.** Tell him I want him. Clothes off, oral sex given and received.
>
> **12:45 A.M.** IM sound from my computer. I'm currently busy, but I have a feeling who it is at this hour. Continue deliciously illicit activities which turn into both intercourse and mutual masturbation.
>
> **1:50 A.M.** After we finish, check IM. I was spot-on; it is Mr. 34. And we all know what 2 A.M. IM's mean. Anyone's.

The back burner is a confusing, destabilizing, and exhausting place to be, and yet none of the Diarists appear to view it as anything but a fact of life. It is clearly less terrifying than the alternative, which is to not be on anyone's.

The anxiety of appearing over-enthusiastic.

↣ The back burner is a game, and while the Diarists have various ideas about what constitutes winning, they all agree on how you lose: by betraying a level of emotional enthusiasm unmatched by the other party. To disarm unilaterally is a strategic error on so many levels—it commits you to a degree of openness you might not be able to maintain, and it exposes vulnerabilities. Most of all, it risks exposing the fond hope that one yearns to leave behind the serial fuck buddies, friends with benefits, and other relationships to which one had inured oneself. The goal, therefore, is to withhold one's own expectations until one understands what is expected. If you betray the wrong kind of avidity, your counterparty will not hesitate to pitch you into the shark tank:

> **3:30 A.M.** I text Mike...that I had a good time and would really like to hang out. Ten minutes later he texts me back saying the he would "be down" for hanging out and that we should do it on a weeknight when things aren't crazy with the parties. I text him back saying he is confusing. He asks how. I felt daring and told him because I can never tell what he wants from me. I haven't heard from him since.

The Diaries are filled with these kinds of casualties and near misses. ("I love this man," thinks one Diarist mid-coitus. "Mental anxiety attack when I realize I almost said this out loud.") The commenters have no sympathy for these emotional miscalculations. This, by contrast, from one of the most well-received Diaries ("The TV Producer Who Knows Everyone") that ever ran:

> **3 P.M.** Already received two texts and countless IM's from the Brit. Am slowly starting to realize I have a Stage Five Clinger on my hands. He asks me to hang out again this coming Sunday. I do not respond. ∎

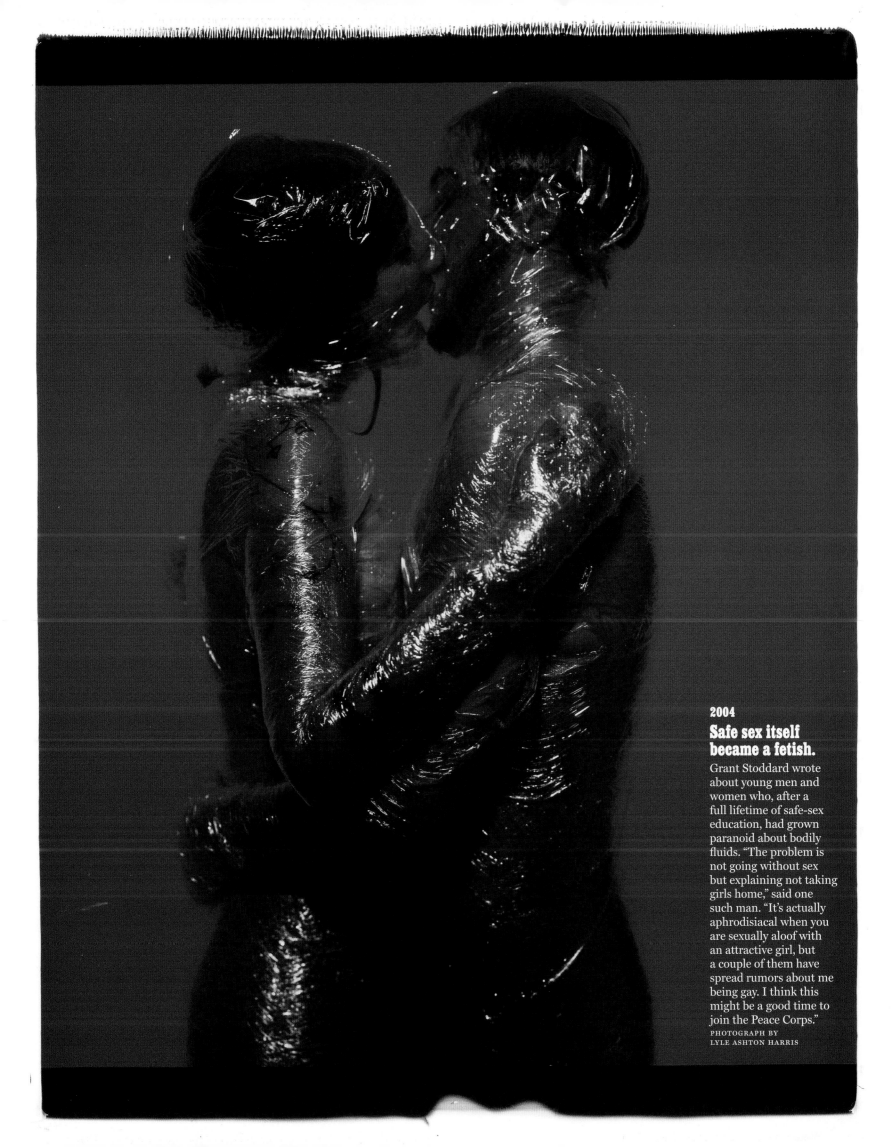

2004

Safe sex itself became a fetish.
Grant Stoddard wrote about young men and women who, after a full lifetime of safe-sex education, had grown paranoid about bodily fluids. "The problem is not going without sex but explaining not taking girls home," said one such man. "It's actually aphrodisiacal when you are sexually aloof with an attractive girl, but a couple of them have spread rumors about me being gay. I think this might be a good time to join the Peace Corps."
PHOTOGRAPH BY
LYLE ASHTON HARRIS

In 1978, our reporters met these couples at the Municipal Building. Four decades later, we tracked them down to see how the marriages worked out.

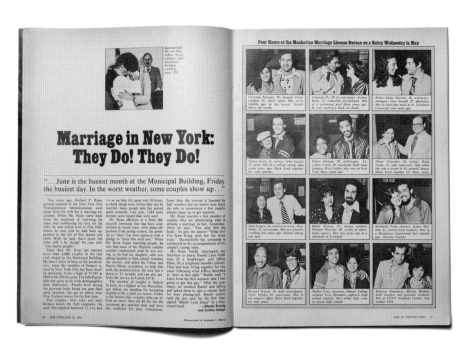

Still Married
Robin and Michael Plevener
Living on the Upper East Side.

Robin Krauss, 21, drama student; Michael Plevener, 29, works in advertising agency. Met two years ago at a rehearsal of Godspell.

Kimberly Feeks, thirteen, Julian Marrero Jr., twenty; both students. Met in a Manhattan Laundromat five months ago. (License denied.)

Robin, you're wearing a floral silk shirt or something.
ROBIN: That's actually a men's shirt.
You met at a rehearsal of 'Godspell,' you'd said?
ROBIN: It was my dad's show.
MICHAEL: I was with a friend who played Judas.
ROBIN: It was the dress rehearsal when it moved from Off Broadway to Broadway. I was working for my dad that summer, who was general manager. Michael found me adjusting my bra, and he used the whole haven't-we-met-somewhere-before line. It took him 35 years to admit it, that he hadn't...
MICHAEL: It worked!
How's your life together been?
MICHAEL: I unfortunately got sick—I ingested tainted L-tryptophan, and was bedridden for seven and a half years. It took almost nine years for me to be able to go out and work.
ROBIN: But the happy ending of that story is once Michael did get better—and thank you very much, I was a great nurse—we have a son, an 18-year-old son. Happily together, 39 years. Although I'm no longer brunette—I'm now platinum with blue highlights.

Divorced
Russ Fedey and Joan Cangro
Almost no contact.

You're not together anymore.
RUSS: The legal term was "abandonment." I looked at the lawyer, I said, "What the hell do you mean *abandonment*?" When the lawyer explained it to me, it was "no sex." Hell, yeah, that's fine. It's just a catch-all thing, 'cause we hated each other's guts.
How did you get to that point?
I'm not gonna give you the vulgar and derogatory things they called my mother, but my ex-wife said to me, "Why don't you go back to that blankity-blank in Queens." What I called her is another story—it's vulgar and derogatory also.
How long were you married?
Happily, maybe four years. And the rest was torment.
When did you actually divorce?
In 2002, 2004. Something like that.
Are you in touch with her?
I don't see her too frequently. I saw her and my son at the supermarket—she looked tired. I don't know what he does. I don't see my daughter at all. They're not my problem; they're her problem now.

Joan Cangro, 26, registered nurse; Russ Fedey, 27, accountant. Met at a friend's wedding five years ago. Started dating last year.

Diane Schneider, 45, writer; Rudy Tache, 31, sales supervisor. Met when she was a tenant in his parents' house. Have lived together for three years.

Still Married
Rudy and Diane Tache
Still in the same house in Brooklyn.

A woman that much older than her husband— that was less common then.
RUDY: It was unheard of. Anybody you told, they'd say, *You're suicidal. It'll never work.*

How did your family react?
They disowned me, for a period of two years. Number one, the age difference. Number two, she had been married before and there were two kids from her previous marriage. She had been married three times, not just once. Some of what they were thinking was legitimate.

Did you ever have a traditional wedding?
At the time, we did not, because my family objected so heavily. But we did in 2006 [when] our daughter—first her daughter, I adopted her— got married. To a Jewish fellow, so the thing was done in a temple, traditional. By that time all the truces were made with my family, so I says 'you know, why don't we just get married at the same time?' Together, same day. Only a handful of people knew. We went upstairs, did the wedding, then we went back down to the reception.

And you're still in Brooklyn.
Same house that we were in in 1978. Six years ago, she tripped and fell and broke her hip. They didn't replace the hip, they only repaired it, and she had lost some balance. A year and a half ago, she tripped again and broke the knee. So she had to have that repaired. And then she had an infection, so they said, "Rehab." That's where she is now. I just came from visiting her—I'm there twice a day.

Walter Cruz, nineteen, Hunter College student; Lucy Montalvo, eighteen, high school student. Met while they were in junior high school.

Eileen Morgan, 20, clerk-typist; Lascelles Foster, 26, machinist. Both from Jamaica, West Indies, they met in New York three years ago.

Bernard Woods, 46, field investigator; Alyce Denby, 42, supervisor. Met in the mayor's office. Have lived together for four years.

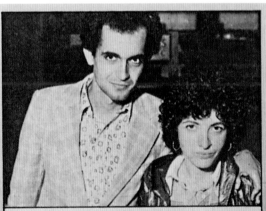

Renison Gonsalves, Marcia Babbitt; both teachers and graduate students. Met at CUNY Graduate Center, September 1974.

Still Married
Marcia and Rennie Gonsalves
Living in Clifton, New Jersey.

Did you have a big wedding?
MARCIA: We had a small wedding, which is what we wanted. And we're still very happy together. It's been 39 years. We're still together, still happy with each other.

You're both teachers, I see.
We met at the Graduate Center. We both have our Ph. D.'s in linguistics. I was teaching at Kingsborough, and Rennie got his job at Brooklyn College right after we were married, and he's still a professor there. I'm retired from Kingsborough—there was a really good deal in 2011— but I stayed part-time for another year because I was directing a program. He teaches linguistics, he teaches the novel, he wrote the curriculum for the West Indian Novel, 'cause he's from St. Vincent.

What's your home life been like since 1978?
We have a daughter. She's 37. She's a speech pathologist. She lives in Chatham, which isn't that far. And we have little grandchildren! One is 4, Natalie, and the other, Matthew, is 3. We spend a lot of time with them. I babysit.

You didn't give your age back then...
I didn't want to say!

You still don't want to?
We may not want to say, but we're young at heart. Whatever.

INTERVIEWS BY
ALEXA TSOULIS-REAY

Baby-making anxiety made headlines. Over and over.

How many times can a magazine publish that story? Turns out that it—unlike the mothers—never got old.

1977:
"Fertility will start to rise around 1980, with women again having an average of more than three children each in the 1990s."

The Coming Baby Boom:
Fertility Fever Is on Its Way
By Linda Wolfe

2005:
"I think a lot of decisions women make will change because of egg freezing."

1989:
"Now obstetricians say that it is not unusual for them to have a few 44-year-olds under their care."

New York

MOMMY OLDEST

The risky new technology that lets women put their own eggs–and motherhood–on ice

FREEZE YOUR BIOLOGICAL CLOCK.
BY SARAH WILDMAN

BABY PANIC

For a while, there was nothing better than being young and single in the city. Now, suddenly, women are being told to stop playing around and get down to the business of having babies. Is this the sexual counterrevolution?

BY VANESSA GRIGORIADIS

2002:
"By 42, most of the time, you're cooked."

The Sperm King

Dr. Joseph Feldschuh runs Idant, one of the largest semen-storage facilities in the country. But the state Health Department says its deposits may not be safe

BY AMY CLYDE

1995:
"At Idant (aptly located in the Empire State Building), sperm is produced in [a room called] the ejaculatorium."

1985:
"Today, in vitro...is no longer experimental."

LAST-CHANCE BABIES
The Wonders of In Vitro Fertilization

Mommy Only
The Rise of the Middle-Class Unwed Mother

1983:
"Phrases like 'elective parent' and 'single mother by choice' are suddenly cropping up in cocktail conversations."

1982:
"Parents 'of a certain age' are all over town."

Mommy's 39, Daddy's 57 —And Baby Was Just Born

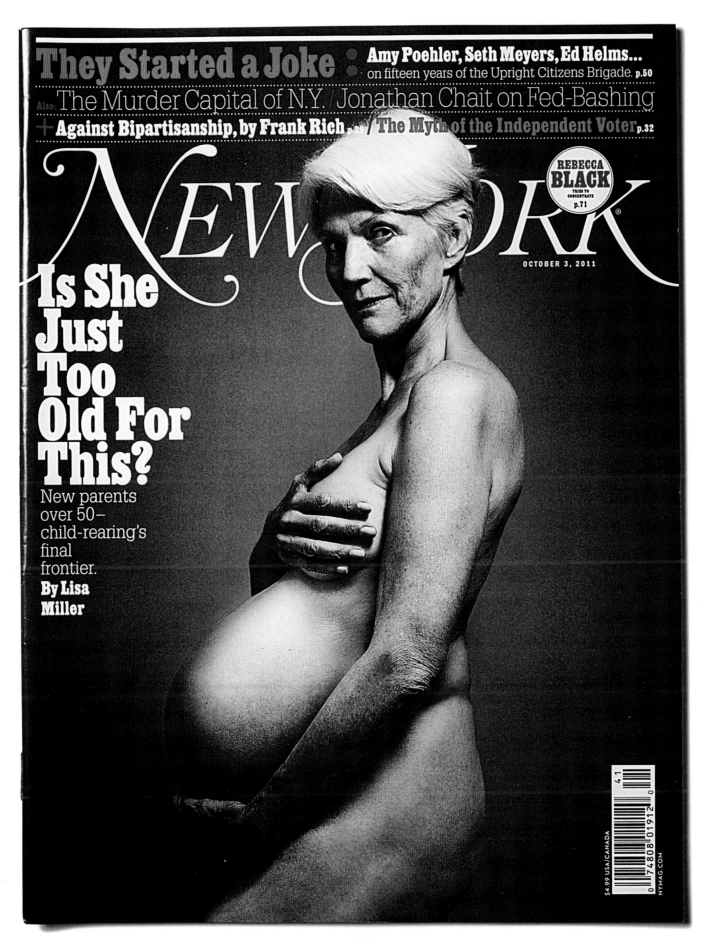

2011

Her baby got famous!

Maye Musk had been a model for five decades when she posed (and had a belly digitally
grafted on) for this cover. In her actual childbearing life, one of her babies grew up to be Elon Musk,
the Silicon Valley entrepreneur who started Tesla Motors and SpaceX.

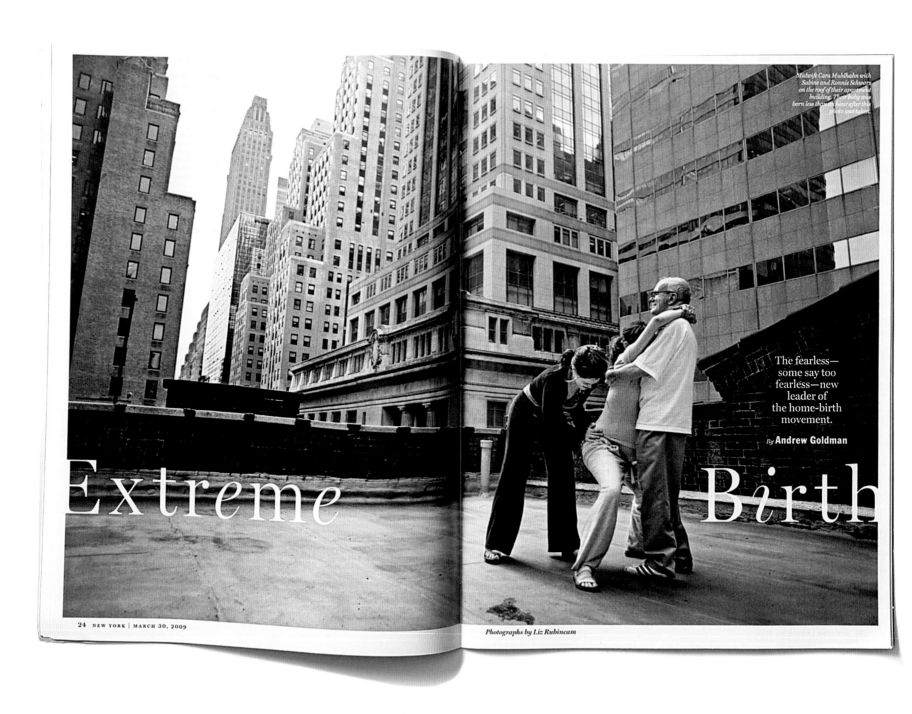

Midwife Cara Muhlhahn with
Sabine and Ronnie Schwarz
on the roof of their apartment
building. Their baby was
born less than an hour after this
photo was taken.

The fearless—
some say too
fearless—new
leader of
the home-birth
movement.

By **Andrew Goldman**

Extreme Birth

Photographs by Liz Rubincam

2009
Extreme natural childbirth became an accepted alternative.

While looking for a place to walk around in the open air during her home birth, Sabine Schwarz—along with
her husband, Ronnie, and their midwife—headed to her apartment building's roof. The couple's son was
delivered, downstairs, less than an hour later.

PLACENTA COOKBOOK

For a growing number of
new mothers, there's no better nutritional
snack after childbirth
than the fruit of their own labor.

By **ATOSSA ARAXIA ABRAHAMIAN**

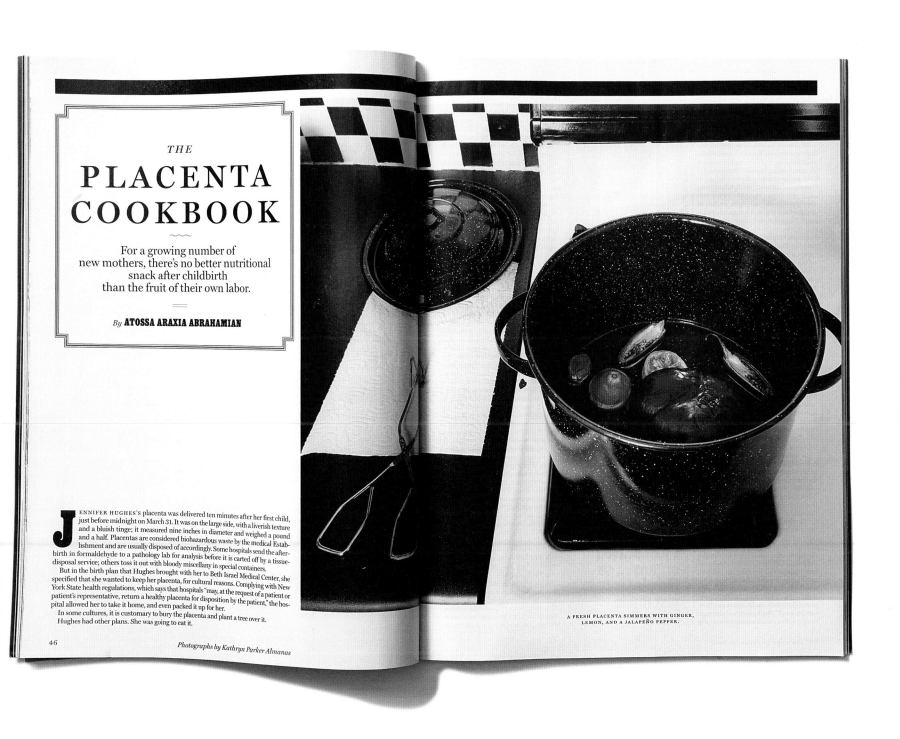

A FRESH PLACENTA SIMMERS WITH GINGER,
LEMON, AND A JALAPEÑO PEPPER.

JENNIFER HUGHES'S placenta was delivered ten minutes after her first child, just before midnight on March 31. It was on the large side, with a liverish texture and a bluish tinge; it measured nine inches in diameter and weighed a pound and a half. Placentas are considered biohazardous waste by the medical Establishment and are usually disposed of accordingly. Some hospitals send the afterbirth in formaldehyde to a pathology lab for analysis before it is carted off by a tissue-disposal service; others toss it out with bloody miscellany in special containers.

But in the birth plan that Hughes brought with her to Beth Israel Medical Center, she specified that she wanted to keep her placenta, for cultural reasons. Complying with New York State health regulations, which says that hospitals "may, at the request of a patient or patient's representative, return a healthy placenta for disposition by the patient," the hospital allowed her to take it home, and even packed it up for her.

In some cultures, it is customary to bury the placenta and plant a tree over it. Hughes had other plans. She was going to eat it.

46 *Photographs by Kathryn Parker Almanas*

2011
And after the birth, the afterbirth became...lunch.

Eating one's own placenta? "It's a New Age phenomenon," explained Mark Kristal, a behavioral neuroscientist. "Every ten or twenty years people say, 'We should do this because it's natural and animals do it.' But it's not based on science. It's a fad."

Nice Baby

By Judith Viorst

Last year I talked about black humor and the impact of the common
market on the European economy and
Threw clever little cocktail parties in our discerningly eclectic living room
With the Spanish rug and the hand-carved Chinese chest and the Lucite
chairs and
Was occasionally hungered after by highly placed men in communications, but
This year we have a nice baby
And pablum drying on our Spanish rug,
And I talk about nursing versus sterilization
While the men in communications
Hunger elsewhere.

Last year I studied flamenco and had my ears pierced and
Served an authentic fondue on the Belgian marble table of our
discerningly eclectic dining area, but
This year we have a nice baby
And Spock on the second shelf of our Chinese chest,
And instead of finding myself I am doing my best
To find a sitter
For the nice baby, banging the Belgian marble with his cup
While I heat the oven up
For the TV dinners.

Last year I had a shampoo and set every week and
Slept an unbroken sleep beneath the Venetian chandelier of our
discerningly eclectic bedroom, but
This year we have a nice baby,
And Gerber's strained bananas in my hair,
And gleaming beneath the Venetian chandelier,
A diaper pail, a portacrib, and him,
A nice baby, drooling on our antique satin spread
While I smile and say how nice. It is often said
That Motherhood is very maturing.

1968

Alexander's mother was the magazine's house poet.

After Judith Viorst sent "Nice Baby" on spec to *New York*, it appeared in our third issue. For several years thereafter, she was
a frequent contributor of little verse slices of the urban social dance, and has published 11 well-loved books of poetry—as well as
Alexander and the Terrible, Horrible, No Good, Very Bad Day, one of the best-selling children's books in history.

ILLUSTRATION BY ROBERT GROSSMAN

The Fix Up
By Judith Viorst

I have this friend Muriel who is attractive and intelligent and
terribly understanding and loyal and
My husband has this friend Ralph who is handsome and witty and
essentially very sincere and
Since they weren't engaged or even tacitly committed
The least we could do, I said, is fix them up,
So I cooked this very nice boned chicken breasts with lemon-cream
sauce and
Put on a little Herb Alpert in the background and
Before Muriel came I told Ralph how she was attractive and
intelligent and terribly understanding and loyal and
After Muriel came I drew out Ralph to show how he was witty and
very sincere and
When dinner was over my husband and I did the dishes
Leaving Ralph and Muriel to get acquainted
With a little Petula Clark in the background and
We listened while they discovered that they both loved Mel Brooks
and hated Los Angeles and agreed that the Supremes had lost
their touch and
He insisted on taking her home even though she lived in the opposite
direction and
The next day he phoned to ask is that what I call attractive, after which
She phoned to ask is that what I call sincere
And from now on
I cook lemon-cream sauce
For young marrieds.

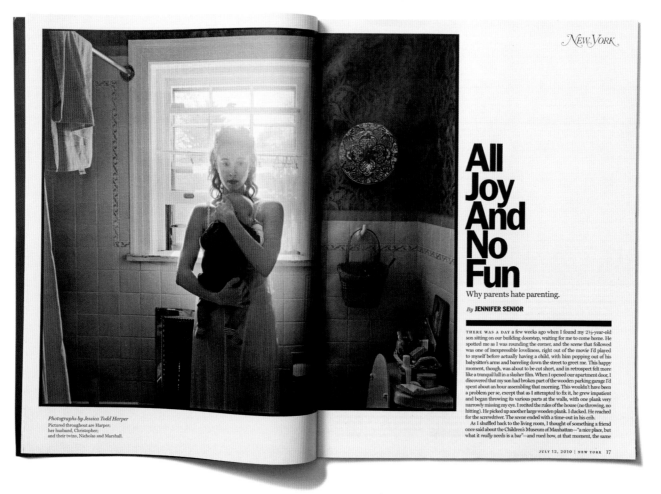

Photographs by Jessica Todd Harper
Pictured throughout are Harper;
her husband, Christopher;
and their twins, Nicholas and Marshall.

NEW YORK

All Joy And No Fun

Why parents hate parenting.

By **JENNIFER SENIOR**

THERE WAS A DAY a few weeks ago when I found my 2½-year-old son sitting on our building doorstep, waiting for me to come home. He spotted me as I was rounding the corner, and the scene that followed was one of inexpressible loveliness, right out of the movie I'd played to myself before actually having a child, with him popping out of his babysitter's arms and barreling down the street to greet me. This happy moment, though, was about to be cut short, and in retrospect felt more like a tranquil lull in a slasher film. When I opened our apartment door, I discovered that my son had broken part of the wooden parking garage I'd spent about an hour assembling that morning. This wouldn't have been a problem per se, except that as I attempted to fix it, he grew impatient and began throwing its various parts at the walls, with one plank very narrowly missing my eye. I recited the rules of the house (no throwing, no hitting). He picked up another large wooden plank. I ducked. He reached for the screwdriver. The scene ended with a time-out in his crib.

As I shuffled back to the living room, I thought of something a friend once said about the Children's Museum of Manhattan—"a nice place, but what it *really* needs is a bar"—and rued how, at that moment, the same

If raising children was so exhausting and draining and miserable, how come so many of us kept doing it?

All Joy and No Fun

By Jennifer Senior

THERE WAS A DAY a few weeks ago when I found my 2½-year-old son sitting on our building doorstep, waiting for me to come home. He spotted me as I was rounding the corner, and the scene that followed was one of inexpressible loveliness, right out of the movie I'd played to myself before actually having a child, with him popping out of his babysitter's arms and barreling down the street to greet me. This happy moment, though, was about to be cut short, and in retrospect felt more like a tranquil lull in a slasher film. When I opened our apartment door, I discovered that my son had broken part of the wooden parking garage I'd spent about an hour assembling that morning. This wouldn't have been a problem per se, except that as I attempted to fix it, he grew impatient and began throwing its various parts at the walls, with one plank very narrowly missing my eye. I recited the rules of the house (no throwing, no hitting). He picked up another large wooden plank. I ducked. He reached for the screwdriver. The scene ended with a time-out in his crib.

As I shuffled back to the living room, I thought of something a friend once said about the Children's Museum of Manhattan— "a nice place, but what it *really* needs is a bar"—and rued how, at that moment, the same thing could be said of my apartment. Two hundred and 40 seconds earlier, I'd been in a state of pair-bonded bliss; now I was guided by nerves, trawling the cabinets for alcohol. My emotional life looks a lot like this these days. I suspect it does for many parents—a high-amplitude, high-frequency sine curve along which we get the privilege of doing hourly surfs. Yet it's something most of us choose. Indeed, it's something most of us would say we'd be miserable without.

FROM THE PERSPECTIVE of the species, it's perfectly un-mysterious why people have children. From the perspective of the individual, however, it's more of a mystery than one might think. Most people assume that having children will make them happier. Yet a wide variety of academic research shows that parents are not happier than their childless peers, and in many cases are less so. This finding is surprisingly consistent, showing up across a range of disciplines. Perhaps the most oft-cited datum comes from a 2004 study by Daniel Kahneman, a Nobel Prize–winning behavioral economist, who surveyed 909 working Texas women and found that child care ranked sixteenth in pleasurability out of nineteen activities. (Among the endeavors they preferred: preparing food, watching TV, exercising, talking on the phone, napping, shopping, *housework*.) This result also shows up regularly in relationship research, with children invariably reducing marital satisfaction. The economist Andrew Oswald, who's compared tens of thousands of Britons with children to those without, is at least inclined to view his data in a more positive light: "The broad message is not that children make you less happy; it's just that children don't make you more happy." That is, he tells me, unless you have more than one. "Then the studies show a more negative impact." But some of the studies are grimmer than others. Robin Simon, a sociologist at Wake Forest University, says parents are more depressed than nonparents no matter what their circumstances—whether they're single or married, whether they have one child or four.

The idea that parents are less happy than nonparents has become so commonplace in academia that it was big news last year when the *Journal of Happiness Studies* published a Scottish paper declaring the opposite was true. "Contrary to much of the literature," said the introduction, "our results are consistent with an effect of children on life satisfaction that is positive, large and increasing in the number of children." Alas, the euphoria was short-lived. A few months later, the poor author discovered a coding error in his data, and the publication ran an erratum. "After correcting the problem," it read, "the main results of the paper no longer hold. The effect of children on the life satisfaction of married individuals is small, often negative, and never statistically significant."

Yet one can see why people were rooting for that paper. The results of almost all the others violate a parent's deepest intuition. Daniel Gilbert, the Harvard psychologist and host of *This Emotional Life* on PBS, wrote fewer than three pages about compromised parental well-being in *Stumbling on Happiness*. But whenever he goes on the lecture circuit, skeptical questions about those pages come up more frequently than anything else. "I've never met anyone who didn't argue with me about this," he says. "Even people who believe the data say they feel sorry for those for whom it's true."

So what, precisely, is going on here? Why is this finding duplicated over and over again despite the fact that most parents believe it to be wrong?

One answer could simply be that parents are deluded, in the grip of some false consciousness that's good for mankind but not for men and women in particular. Gilbert, a proud father and grandfather, would argue as much. He's made a name for himself showing that we humans are pretty sorry predictors of what will make us happy, and to his mind, the yearning for children, the literal mother of all aspirations for so many, is a very good case in point—what children really do, he suspects,

is offer moments of transcendence, not an overall improvement in well-being.

Perhaps. But there are less fatalistic explanations, too. And high among them is the possibility that parents don't much enjoy parenting because the experience of raising children has fundamentally changed.

BEFORE URBANIZATION, children were viewed as economic assets to their parents. If you had a farm, they toiled alongside you to maintain its upkeep; if you had a family business, the kids helped mind the store. But all of this dramatically changed with the moral and technological revolutions of modernity. As we gained in prosperity, childhood came increasingly to be viewed as a protected, privileged time, and once college degrees became essential to getting ahead, children became not only a great expense but subjects to be sculpted, stimulated, instructed, groomed. (The Princeton sociologist Viviana Zelizer describes this transformation of a child's value in five ruthless words: "Economically worthless but emotionally priceless.") Kids, in short, went from being our staffs to being our bosses.

This is especially true in middle- and upper-income families, which are far more apt than their working-class counterparts to see their children as projects to be perfected. (Children of women with bachelor degrees spend almost five hours on "organized activities" per week, as opposed to children of high-school dropouts, who spend two.) Annette Lareau, the sociologist who coined the term "concerted cultivation" to describe the aggressive nurturing of economically advantaged children, puts it this way: "Middle-class parents spend much more time talking to children, answering questions with questions, and treating each child's thought as a special contribution. And this is very tiring work." Yet it's work few parents feel that they can in good conscience neglect, says Lareau, "lest they put their children at risk by not giving them every advantage."

But the intensification of family time is not confined to the privileged classes alone. According to *Changing Rhythms of American Family Life*—a compendium of data porn about time use and family statistics, compiled by a trio of sociologists named Suzanne M. Bianchi, John P. Robinson, and Melissa A. Milkie—all parents spend more time today with their children than they did in 1975, including mothers, in spite of the great rush of women into the American workforce. Today's married mothers also have less leisure time (5.4 fewer hours per week); 71 percent say they crave more time for themselves (as do 57 percent of married fathers). Yet 85 percent of all parents still—still!—think they don't spend enough time with their children.

These self-contradictory statistics reminded me of a conversation I had with a woman I met through a parenting group, a professional who had her children later in life. "I have two really great kids"—ages 9 and 11—"and I enjoy doing a lot of things with them," she told me. "It's the drudgery that's so hard: *Crap, you don't have any pants that fit?* There are just So. Many. Chores."

This woman, it should be said, is divorced. But even if her responsibilities were shared with a partner, the churn of school and gymnastics and piano and sports and homework would still require an awful lot of administration. "The crazy thing," she continues, "is that by New York standards, I'm not even overscheduling them."

I ask what she does on the weekends her ex-husband has custody. "I work," she replies. "And get my nails done." ■

2006

Giant-stroller gridlock took over Brooklyn.

"So wait, it had worked? Twice?" Hugo Lindgren and Sarah Bernard—married writer-editors—had abruptly switched from "struggling with infertility" to "twins on the way." Their 2006 story revealed that they were not alone: In well-off New York City neighborhoods, where IVF and older mothers were more common, the twin-birth rate had hit 8 percent, and even triplets were eerily frequent. This double-triplet scene presented itself near Prospect Park.

PHOTOGRAPH BY
EDWARD KEATING

The Brightest Kids

Too Smart for Parents, Teachers, and Their Own Good

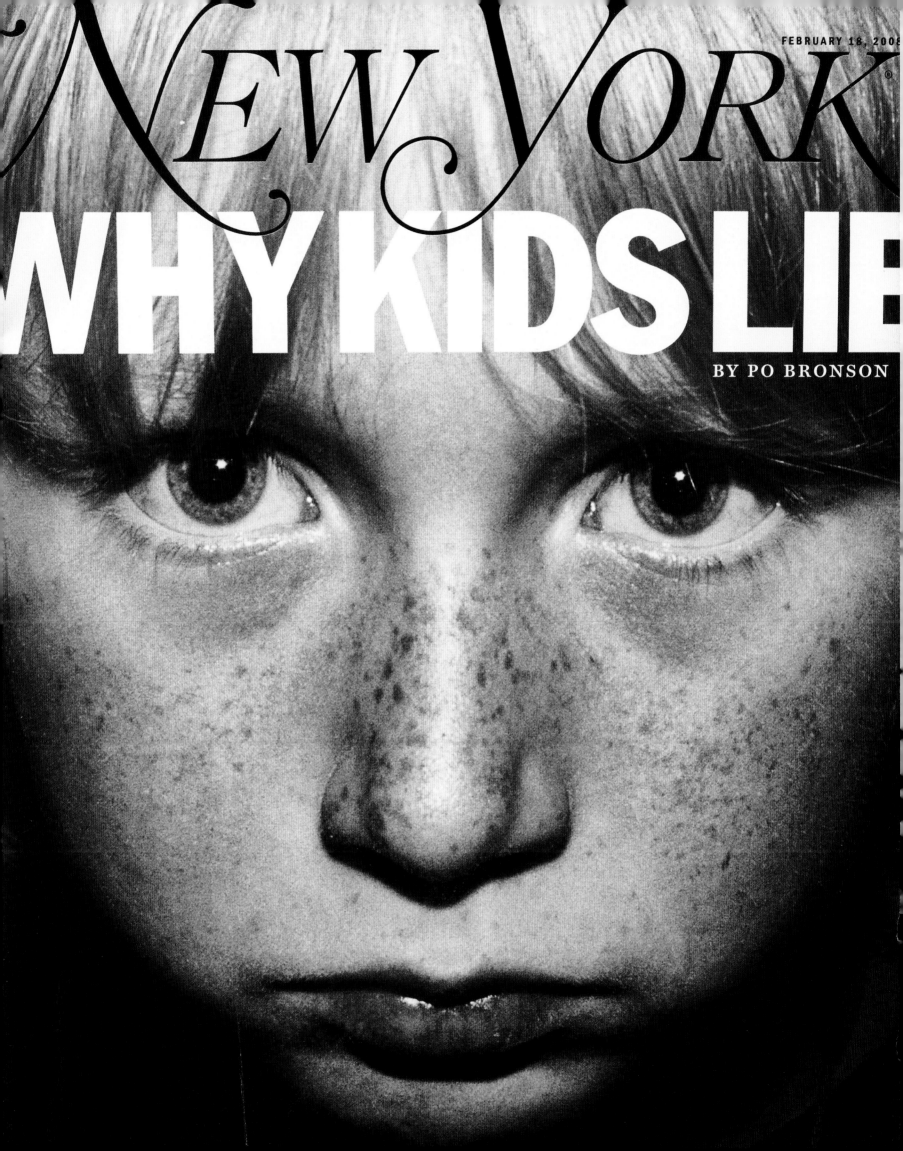

NEW YORK

WHY KIDS LIE

BY PO BRONSON

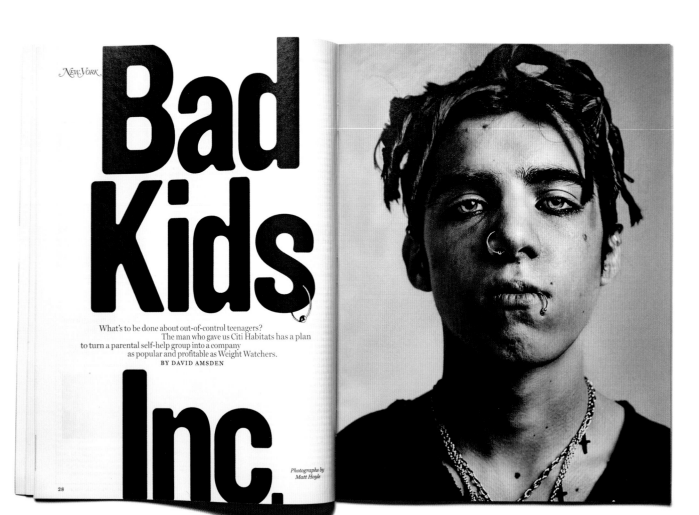

Bad-Seed Anxiety: January 9, 2006

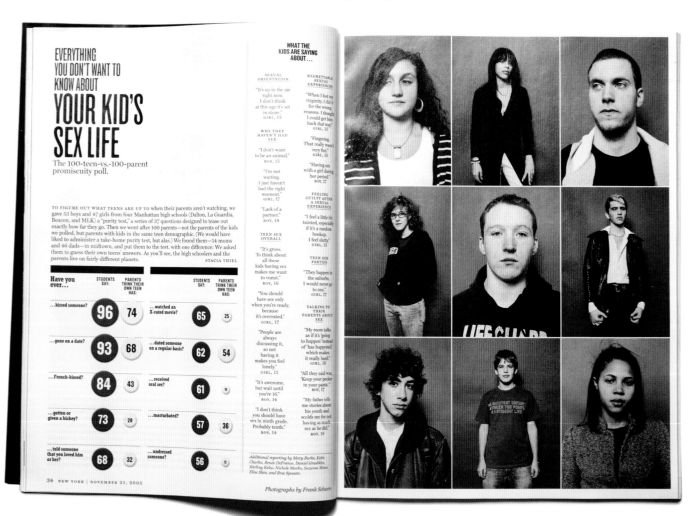

My-Kid-Is-Having-Sex Anxiety: November 21, 2005

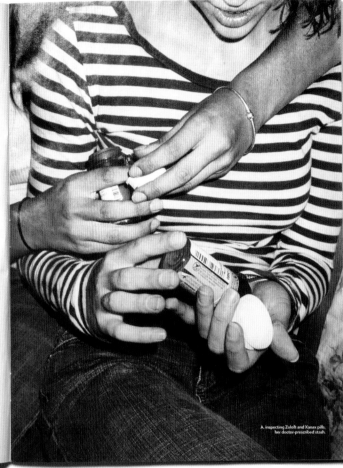

A. inspecting Zoloft and Xanax pills, her doctor-prescribed stash.

Pop. Snort. Parachute.
To many New York teenagers, all the world's a pharmacy. There is a vanishing distinction between pills for medication and for recreation, and the much-touted risk of suicide misses the point.
BY DAVID AMSDEN

TIMOTHY CHERNYAEV wasn't having an easy time in life. There were issues with close friends, issues at home, issues at school—issues that, frankly, he didn't feel like deconstructing on a therapist's oily leather couch. What was the point? To his mind, you could save a lot of money by just talking to a mirror—or, better yet, speaking into a tape recorder, then playing it back while skimming a psychiatry textbook: comparing, contrasting, reaching a diagnosis. And yet he couldn't shake the idea that what was making his mind and body literally *ache* might just be . . . depression. So he called a friend who had a prescription for Prozac, and asked if he could "borrow" her pills. This was in April. Middle of his sophomore year at Bronx Science. He was 15 years old.

The decision, in a way, made perfect sense. Though he'd never been prescribed anything by a doctor, pharmaceuticals had become impossible to avoid, an intrinsic part of his life. Timothy had taken Ambien (his grandmother's prescription), at first simply to unwind, then in larger doses—three pills, five, one time seven—discovering that doing so caused minor hallucinations. He'd sampled Xanax (a friend's prescription), which he called "tombstones" because the pills resembled two gravestones stuck together. He'd dabbled with Vicodin when his mother got a prescription to treat a pulled muscle, which cracked him up: that a doctor would prescribe a synthetic opiate—*wasn't that sort of like heroin?*—for such a routine ailment. And once he'd used Adderall for kicks, something seemingly every other kid he knew had done. Prozac, he understood, was different, an SSRI,

PHOTOGRAPHS BY MICHAEL SCHMELLING

Pill-Popping Anxiety: October 4, 2004

THE
ONLIES

Only children are just like most New York kids— sophisticated, precocious, sometimes a little lonely—only more so.
BY VANESSA GRIGORIADIS

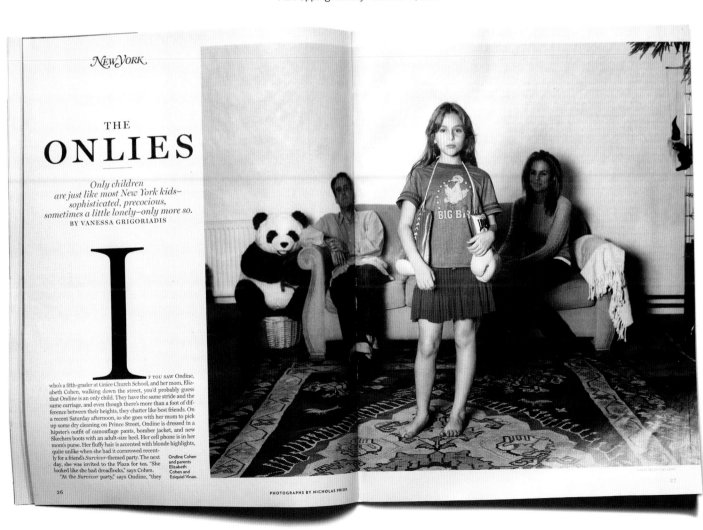

IF YOU SAW Ondine, who's a fifth-grader at Grace Church School, and her mom, Elizabeth Cohen, walking down the street, you'd probably guess that Ondine is an only child. They have the same stride and the same carriage, and even though there's more than a foot of difference between their heights, they chatter like best friends. On a recent Saturday afternoon, as she goes with her mom to pick up some dry cleaning on Prince Street, Ondine is dressed in a hipster's outfit of camouflage pants, bomber jacket, and new Skechers boots with an adult-size heel. Her cell phone is in her mom's purse. Her fluffy hair is accented with blonde highlights, quite unlike when she had it cornrowed recently for a friend's *Survivor*-themed party. The next day, she was invited to the Plaza for tea. "She looked like she had dreadlocks," says Cohen. "At the *Survivor* party," says Ondine, "they

Ondine Cohen and parents Elizabeth Cohen and Eziquiel Vinao.

PHOTOGRAPHS BY NICHOLAS PRIOR

Only-Child Anxiety: November 8, 2004

EXCERPT: FEBRUARY 12, 2007

A new digital generation revealed itself to have an entirely new approach to privacy—essentially, forgoing it.

Say Everything

By Emily Nussbaum

"YEAH, I AM NAKED on the Internet," says Kitty Osta-powicz, laughing. "But I've always said I wouldn't ever put up anything I wouldn't want my mother to see."

She hands me a Bud Lite. Kitty, 26, is a bartender at Kabin in the East Village, and she is frankly ador-able, with bright-red hair, a button nose, and pretty features. She knows it, too: Kitty tells me that she used to participate in "ratings communities," like "nonuglies," where people would post photos to be judged by strangers. She has a MySpace page and a Livejournal. And she tells me that the Internet brought her to New York, when a friend she met in a chat room introduced her to his Website, which linked to his friends, one of whom was a photographer. Kitty posed for that photographer in Buffalo, where she grew up, then followed him to New York. "Pretty much just wanted a change," she says. "A drastic, drastic change."

Her Livejournal has gotten less personal over time, she tells me. At first it was "just a lot of day-to-day bullshit, quizzes and stuff," but now she tries to "keep it concise to important events."

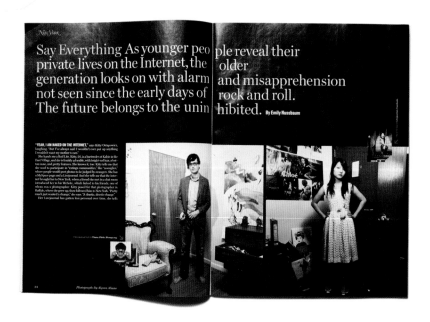

Say Everything As younger people reveal their private lives on the Internet, the older generation looks on with alarm and misapprehension not seen since the early days of rock and roll. The future belongs to the uninhibited. By Emily Nussbaum

When I ask her how she thinks she'll feel at 35, when her postings are a Google search away, she's okay with that. "I'll be proud!" she says. "It's a documentation of my youth, in a way. Even if it's just me, going back and Googling myself in 25 or 30 years. It's my self—what I used to be, what I used to do."

We settle up and I go home to search for Kitty's profile. I'm expecting tame stuff: updates to friends, plus those blurry nudes. But, as it turns out, the photos we talked about (artistic shots of Kitty in bed or, in one picture, in a snowdrift, wearing stilettos) are the least revelatory thing I find. In posts tracing back to college, her story scrolls down my screen in raw and affecting detail: the death of her parents, her breakups, her in-securities, her ambitions. There are photos, but they are candid and unstylized, like a close-up of a tattoo of a butterfly, adjacent (explains the caption) to a bruise she got by bumping into the cash register. A recent entry encourages posters to share stories of sexual assault anonymously.

Some posts read like diary entries: "My period is way late, and I haven't been laid in months, so I don't know what the fuck is up." There are bar anecdotes: "I had a weird guy last night come into work and tell me all about how if I were in the South Bronx, I'd be raped if I were lucky. It was totally unprovoked, and he told me all about my stupid generation and how he fought in Vietnam, and how today's Navy and Marines are a bunch of pussies." But the roughest material comes in her early posts, where she struggles with losing her parents. "I lost her four years ago today. A few hours ago to be precise," she writes. "What may well be the worst day of my life."

Talking to her the night before, I had liked Kitty: She was warm and funny and humble, despite the "nonuglies" business. But reading her Livejournal, I feel thrown off. Some of it makes me wince. Much of it is witty and insightful. Mainly, I feel bizarrely protective of her, someone I've met once—she seems so exposed. And that feeling makes me feel very, very old.

Because the truth is, at 26, Kitty is herself an old lady, in Internet terms. She left her teens several years before the rev-olution began in earnest: the forest of arms waving cell-phone cameras at concerts, the MySpace pages blinking pink neon rev-elations, Xanga and Sconex and YouTube and Lastnightsparty.com and Flickr and Facebook and del.icio.us and Wikipedia and especially, the ordinary, endless stream of daily documentation that is built into the life of anyone growing up today. You can see the evidence everywhere, from the rural 15-year-old who records videos for thousands of subscribers to the NYU students texting come-ons from beneath the bar. Even 9-year-olds have their own site, Club Penguin, to play games and plan parties. The change has rippled through pretty much every act of grow-ing up. Go through your first big breakup and you may need to change your status on Facebook from "In a relationship" to "Single." Everyone will see it on your "feed," including your ex, and that's part of the point.

IT'S BEEN A LONG time since there was a true generation gap, perhaps 50 years—you have to go back to the early years of rock and roll, when old people still talked about "jungle rhythms." Everything associated with that music and its greasy, shaggy culture felt baffling and divisive, from the crude slang to the dirty thoughts it was rumored to trigger in little girls. That musical divide has all but disappeared. But in the past ten years, a new set of values has sneaked in to take its place, erecting another barrier between young and old. And as it did in the fifties, the

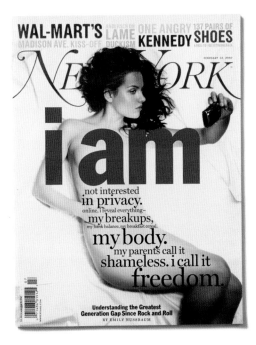

older generation has responded with a disgusted, dismissive squawk. It goes something like this:

Kids today. They have no sense of shame. They have no sense of privacy. They are show-offs, fame whores, pornographic little loons who post their diaries, their phone numbers, their stupid poetry—for God's sake, their dirty photos!—online. They have virtual friends instead of real ones. They talk in illiterate instant messages. They are interested only in attention—and yet they have zero attention span, flitting like hummingbirds from one virtual stage to another.

"When it is more important to be seen than to be talented, it is hardly surprising that the less gifted among us are willing to fart our way into the spotlight," sneers Lakshmi Chaudhry in the current issue of *The Nation.* "Without any meaningful standard by which to measure our worth, we turn to the public eye for affirmation."

Clay Shirky, a 42-year-old professor of new media at NYU's Interactive Telecommunications Program, who has studied these phenomena since 1993, has a theory about that response. "Whenever young people are allowed to indulge in something old people are not allowed to, it makes us bitter. What did we have? The mall and the parking lot of the 7-Eleven? It sucked to grow up when we did! And we're mad about it now." People are always eager to believe that their behavior is a matter of morality, not chronology, Shirky argues. "You didn't behave like that because nobody gave you the option."

None of this is to suggest that older people aren't online, of course; they are, in huge numbers. It's just that it doesn't come naturally to them. "It is a constant surprise to those of us over a certain age, let's say 30, that large parts of our life can end up online," says Shirky. "But that's not a behavior anyone under 30 has had to unlearn." Despite his expertise, Shirky himself can feel the gulf growing between himself and his students, even in the past five years. "It used to be that we were all in this together. But now my job is not to demystify, but to get the students to see that it's strange or unusual at all. Because they're soaking in it."

One night at Two Boots pizza, I meet some tourists visiting from Kansas City: Kent Gasaway, his daughter Hannah, and two of her friends. The girls are 15. They have identical shiny hair and Ugg boots, and they answer my questions in a tangle of upspeak. Everyone has a Facebook, they tell me. Everyone used to have a Xanga ("So seventh grade!"). They got computers in

third grade. Yes, they post party pictures. Yes, they use "away messages." When I ask them why they'd like to appear on a reality show, they explain, "It's the fame and the—well, not the fame, just the whole, 'Oh, my God, weren't you on TV?'"

After a few minutes of this, I turn to Gasaway and ask if he has a Web page. He seems baffled by the question. "I don't know why I would," he says, speaking slowly. "I like my privacy." He's never seen Hannah's Facebook profile. "I haven't gone on it. I don't know how to get into it!" I ask him if he takes pictures when he attends parties, and he looks at me like I have three heads. "There are a lot of weirdos out there," he emphasizes. "There are a lot of strangers out there."

There is plenty of variation among this younger cohort, including a set of Luddite dissenters: "If I want to contact someone, I'll write them a letter!" grouses Katherine Gillespie, a student at Hunter College. (Although when I look her up online, I find that she too has a profile.) But these variations blur when you widen your view. One 2006 government study—framed, as such studies are, around the stranger-danger issue—showed that 61 percent of 13-to-17-year-olds have a profile online, half with photos. A recent pew Internet Project study put it at 55 percent of 12-to-17-year-olds. These numbers are rising rapidly.

It's hard to pinpoint when the change began. Was it 1992, the first season of *The Real World*? (Or maybe the third season, when cast members began to play to the cameras? Or the seventh, at which point the seven strangers were so media-savvy there was little difference between their being totally self-conscious and utterly unself-conscious?) Or you could peg the true beginning as that primal national drama of the Paris Hilton sex tape, those strange weeks in 2004 when what initially struck me as a genuine and indelible humiliation—the kind of thing that lost former Miss America Vanessa Williams her crown twenty years earlier—transformed, in a matter of days, from a shocker into no big deal, and then into just another piece of publicity, and then into a kind of power.

"What we're discussing is something more radical if only because it is more ordinary: the fact that we are in the sticky center of a vast psychological experiment, one that's only just begun to show results."

But maybe it's a cheap shot to talk about reality television and Paris Hilton. Because what we're discussing is something more radical if only because it is more ordinary: the fact that we are in the sticky center of a vast psychological experiment, one that's only just begun to show results. More young people are putting more personal information out in public than any older person ever would—and yet they seem mysteriously healthy and normal, save for an entirely different definition of privacy. From their perspective, it's the extreme caution of the earlier generation that's the narcissistic thing. Or, as Kitty put it to me, "Why not? What's the worst that's going to happen? Twenty years down the road, someone's gonna find your picture? Just make sure it's a great picture." ■

New York natives never tired of recalling what it was like to grow up here.

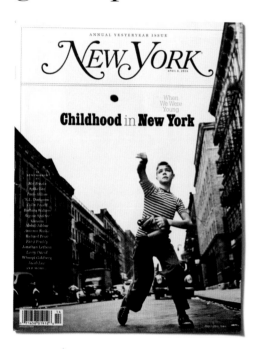

Paris Hilton
TV personality and DJ, born 1981

"My mom and Michael Jackson had been best friends since they were like 13. I grew up around Michael, and anytime he'd have a music video or a concert, he would always invite my family. I literally went to every single video he did."

Nicky Hilton (left) and Paris Hilton, with their parents and Michael Jackson, at the Hoyt-Schermerhorn subway stop during the music-video shoot for "Bad."

Broderick on a Ferris wheel at Little Italy's Feast of St. Anthony.

Matthew Broderick
Actor, born 1962

"I remember playing in Washington Square Park, all day basically. It was not as finished-looking as it is now—you could play pickup games on the fields. Now I think you're not even supposed to walk on them. We would play Frisbee around the fountain. We played handball against the arch, and sometimes on the courts that are on Sixth Avenue between 3rd and 4th. We also just walked around and ate slices of pizza—a lot of pizza. And large drinks, though not as large as what they're up against now. And we ate lots and lots of Blimpies. I guess it's a miracle we're all alive.

"As long as I was with friends, we were pretty much left to it. We'd go to Central Park. We'd go ice skating at Wollman Rink or Lasker Rink uptown. We would go to Times Square to play pinball. I should also mention that I was constantly robbed. I don't know if that still happens. But every now and then, somebody would come up to you and say, 'I have a knife. Give me whatever—' and you'd give them your change. That happened a lot to us children. I never would fight. I would always just give—or try to run. Everybody was afraid somebody had a knife. Whether it was true or not: 'Don't get into a fight, because somebody might stab you.'"

"I should also mention that I was constantly robbed."

Jonathan Lethem (left), with his mother, sister, brother, and great-grandmother on the Upper West Side.

Jonathan Lethem
Novelist, born 1964

"For a child from a quadrant of Brooklyn where every block was a fresh reality zone, no assumption safe to carry over from one to the next, the dark mosaic of neighborhoods and boroughs was the same, writ larger— a Disunited States of its own. My family's voyages to Manhattan were to Soho and Greenwich Village and Chinatown, to attend gallery openings of my dad's friends and rival painters, to revisit landmarks of my parents' lives before children, the folk-music clubs, the Szechuan restaurants. The Upper West Side was terra incognita except for visits to see my great-grandmother, known to me as 'Omi.' We'd be dressed up, wearing uncomfortable button shirts and dark shoes. Omi was a refugee from upper-middle-class Lübeck, Germany, where she'd been an opera singer. She landed in a residence hotel on Broadway and Eighty-something, in a small apartment full of lace and Meissen china. She spoke barely any English and expressed her affection for me by running her fingers through my hair while calling me 'Yonatan'—so, for me, a drive to the Upper West Side might as well have been a voyage to Europe. If we went for a walk, nothing on the street much contradicted this sensation—we'd cross Broadway just as far as the traffic islands between the streams of traffic, there to pay our respects to other German-Jewish refugees sunning themselves on the benches. To be truthful, I still can't cross Broadway on foot and not be reminded of the Holocaust."

"The Upper West Side was a museum of European refugees."

Spike Lee
Director, born 1957

"It's not rocket science growing up—as a young child, you notice that people of color are poorer than white people. That's just like the sky is blue. You've got to fight for what you want. You learn that by just trying to find a fucking seat on the subway and the bus. I was riding the subway when I was 6 years old."

New kinds of families brought new kinds of surprises.

When Emily Kehe and Kate Elazegui, a married couple, underwent overlapping fertility treatments, they figured that the odds of a simultaneous pregnancy were almost nil. Maybe so, but "almost" is a tricky word: Nine months later, they gave birth to boys four days apart. A year later, happy but exhausted, Kehe admitted that any mommy judginess the couple had had before the kids were born had gone out the window. "We've both had to eat some words," she said. Like what? "Screen time. YouTube Kids has saved our lives."

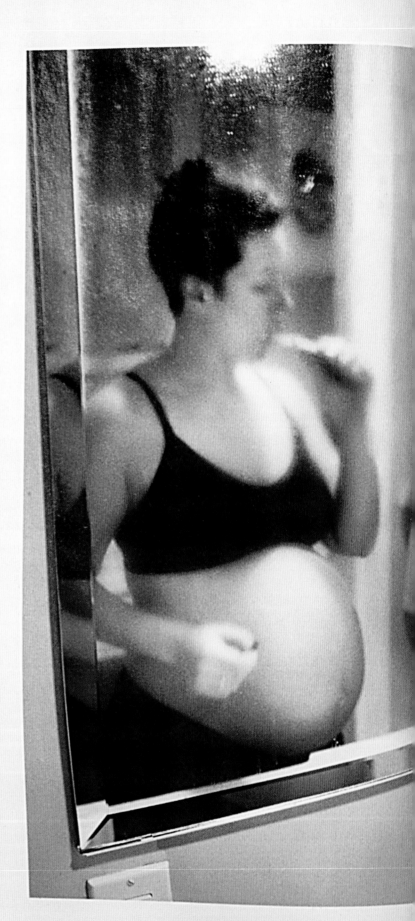

Life in Pictures:
We're Pregnant!

Both of us.

By Alexa Tsoulis-Reay

AT 1:47 A.M. ON DECEMBER 9, Emily Kehe delivered an eight-pound baby boy named Reid. Three days later, she found herself back at New York Presbyterian—but this time it was her wife, Kate Elazegui, giving birth to their five-pound-ten-ounce son, Eddie.

"The chances of you both getting pregnant are so slim," the couple's fertility specialist, Dr. Hey Joo Kang, had told them last January. Kate, then 40, was coming off six months of failed attempts at artificial insemination (the online-chosen sperm donor was a half-Asian, half-white poet who looked like Keanu Reeves—at least in his baby pictures). Emily, who is three years younger, had wanted to give Kate the chance to try first because of her

Photographs by Sara Naomi Lewkowicz

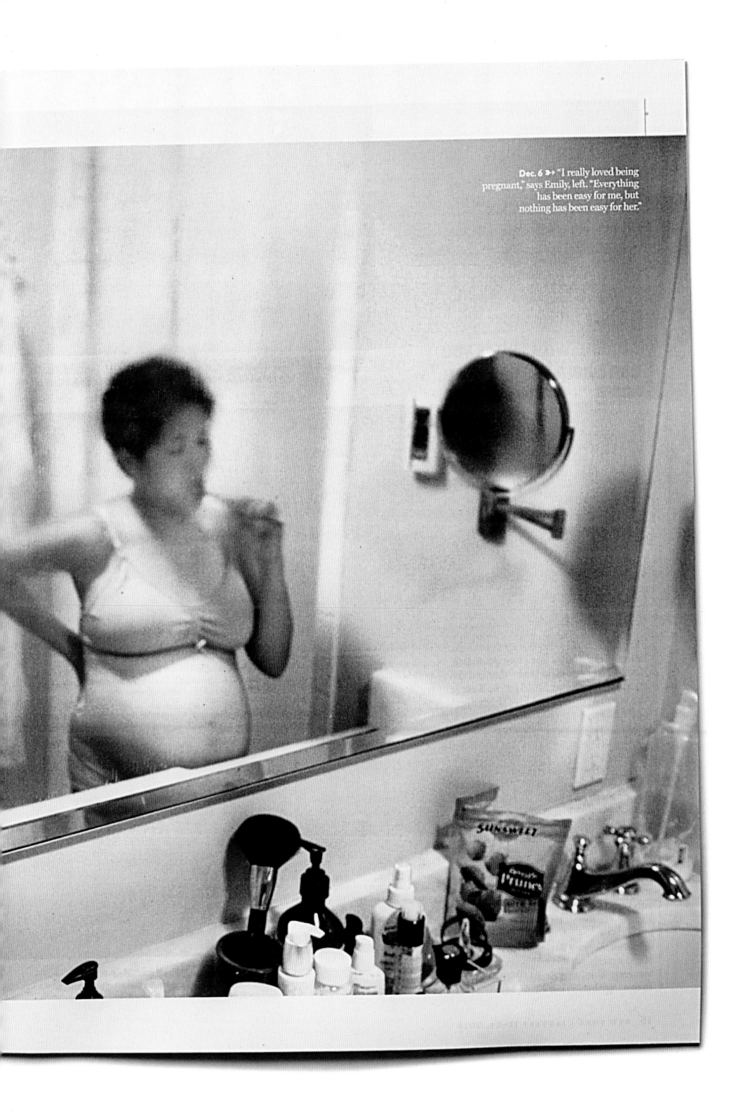

Dec. 6 ▶▶ "I really loved being pregnant," says Emily, left. "Everything has been easy for me, but nothing has been easy for her."

8

STYLE

"Shee–uh fucking puh–fection!"

Donna Karan
to Calvin Klein, in "The Triumph of Calvinism," by James Kaplan, 1996

Our streets are fashion runways.

PARIS HAS THE COUTURE SALONS, Milan has the business, Tokyo has the outlandishly plugged-in kids. Doesn't matter: Nowhere else in the history of the world has there been the stylish mix that can be seen on a New York street on a warm sunny day. There will be ladies in suits with tiny dogs, hip-hop kids flashing their high-top sneakers, young cool guys peacocking the latest season, artsy gutter punks wearing a look that would cost others a small fortune. It is the most invigorating visual cocktail in the world. ¶ You could see that interplay in 1968, when Betsey Johnson dresses and Carnaby Street imports dominated our pages: Youth, modern and fun and rock-and-roll-inflected, was making inroads. From that point on, with every movement that came along—YSL and FUBU, minimalism and maximalism, the '80s slouchy suit and the '90s rejection of the suit and the millennial embrace of the skinny suit—high fashion was increasingly met, and joined, and affected, by street fashion. In the fall of 1992, the young Marc Jacobs got fired for trying to meld the two in a collection for Perry Ellis, but he was right: Street style and high style had become one, and despite various temporary separations, they have never split up. If you need proof, just wait for the next warm day, pick a sidewalk, and watch.

1968

"Do you sleep in the nude?"

For one of *New York*'s first fashion shoots, five actresses answered the question by posing in nightgowns and negligees. Lauren Hutton skipped the sleepwear. PHOTOGRAPH BY OTTO STUPAKOFF

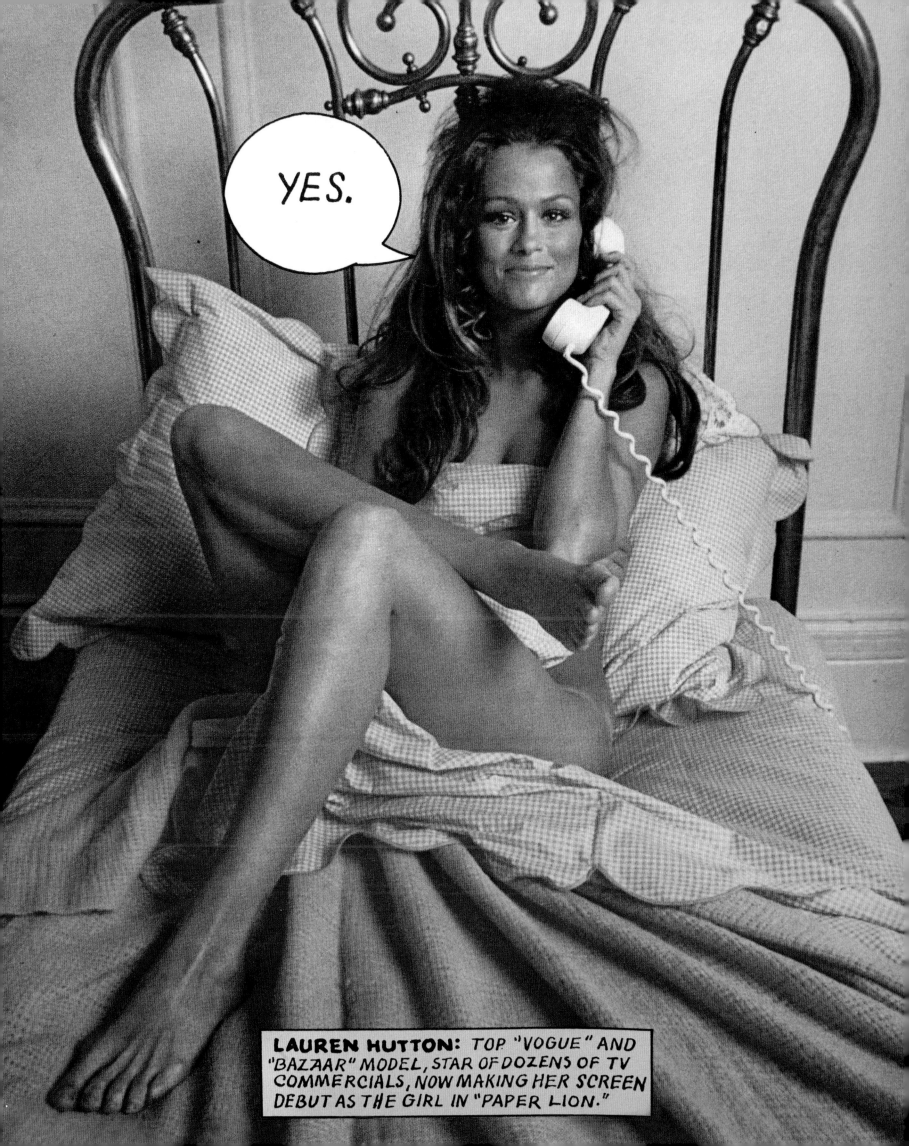

LAUREN HUTTON: TOP "VOGUE" AND "BAZAAR" MODEL, STAR OF DOZENS OF TV COMMERCIALS, NOW MAKING HER SCREEN DEBUT AS THE GIRL IN "PAPER LION."

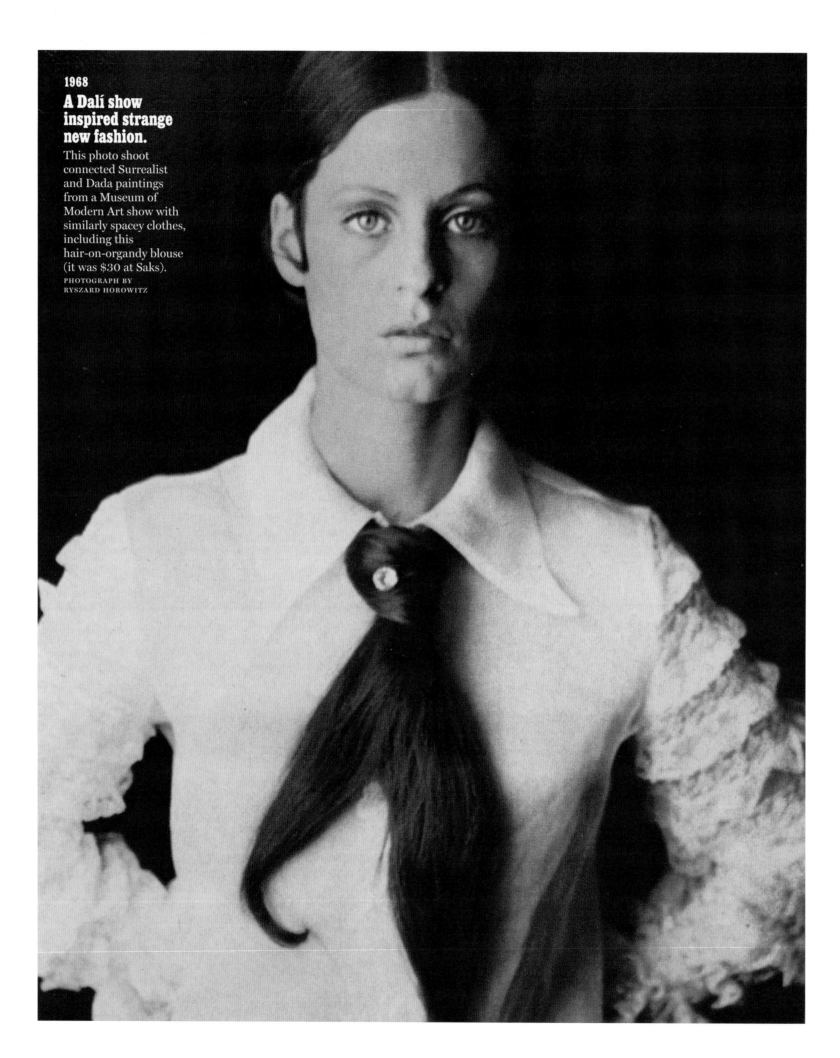

1968

A Dalí show inspired strange new fashion.

This photo shoot connected Surrealist and Dada paintings from a Museum of Modern Art show with similarly spacey clothes, including this hair-on-organdy blouse (it was $30 at Saks).

PHOTOGRAPH BY
RYSZARD HOROWITZ

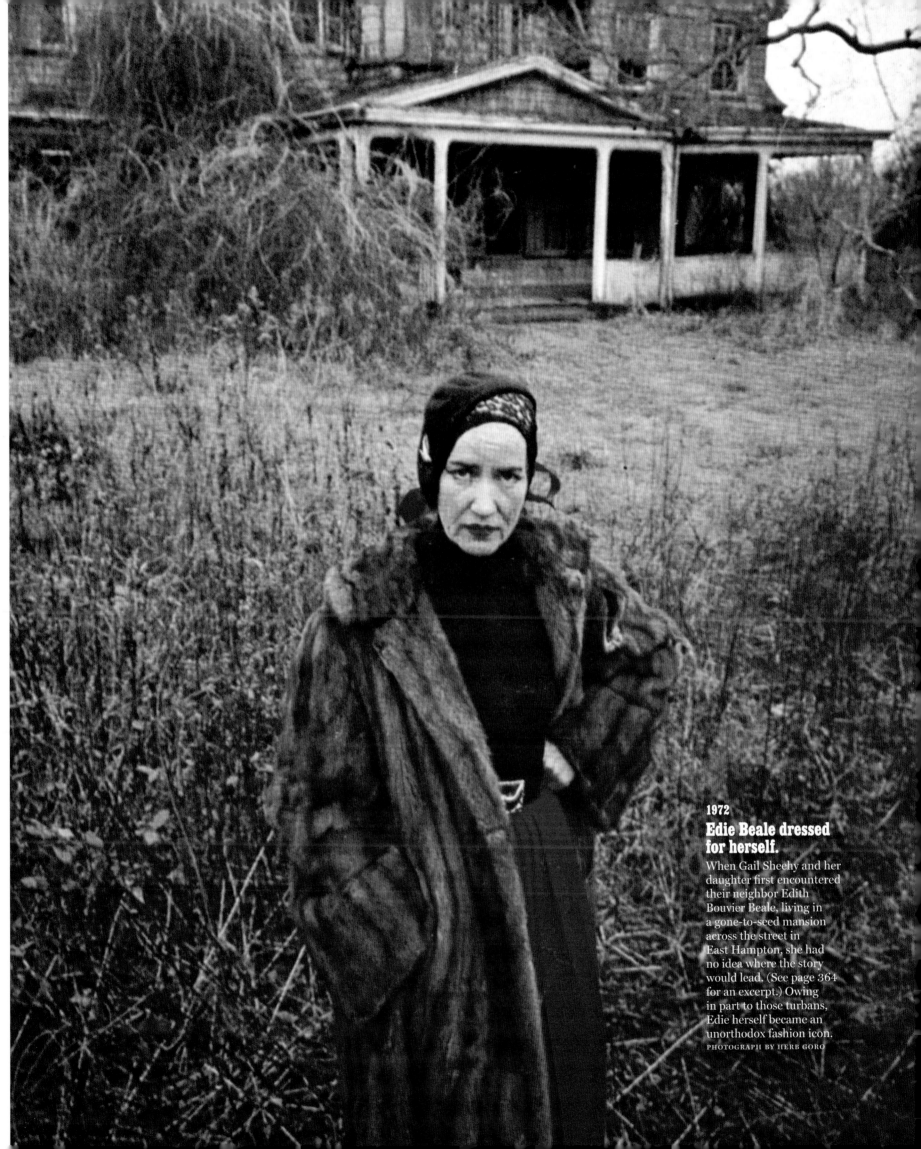

1972

Edie Beale dressed for herself.

When Gail Sheehy and her daughter first encountered their neighbor Edith Bouvier Beale, living in a gone-to-seed mansion across the street in East Hampton, she had no idea where the story would lead. (See page 364 for an excerpt.) Owing in part to those turbans, Edie herself became an unorthodox fashion icon.

PHOTOGRAPH BY HERB GORO

1968
Peggy Moffitt appeared with a doll...

This fashion story was written and laid out like a singsong children's book: *"Pretty Peggy Moffit / for fun and for profit / shows Gernreich's new knitwear for fall. / Matching tunic and stocking / makes bending less shocking / The short skirt's not dead after all."*

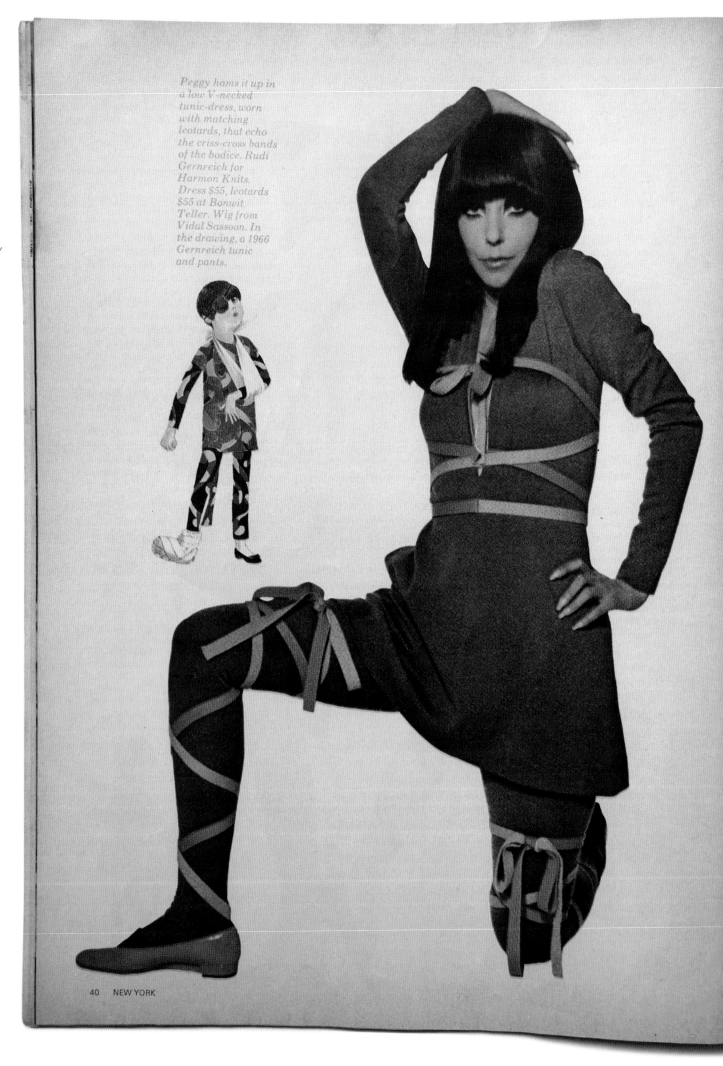

Peggy hams it up in a low V-necked tunic-dress, worn with matching leotards, that echo the criss-cross bands of the bodice. Rudi Gernreich for Harmon Knits. Dress $55, leotards $55 at Bonwit Teller. Wig from Vidal Sassoon. In the drawing, a 1966 Gernreich tunic and pants.

366

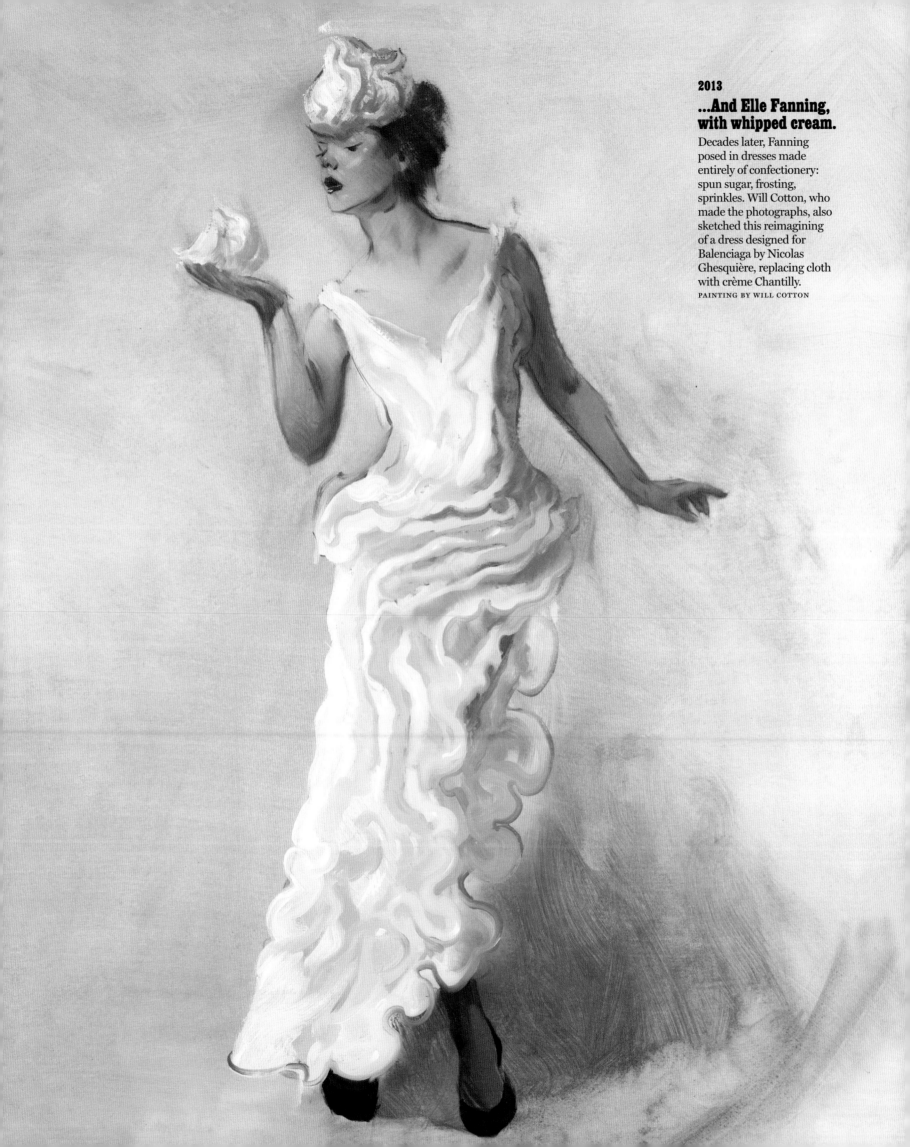

2013

...And Elle Fanning, with whipped cream.

Decades later, Fanning posed in dresses made entirely of confectionery: spun sugar, frosting, sprinkles. Will Cotton, who made the photographs, also sketched this reimagining of a dress designed for Balenciaga by Nicolas Ghesquière, replacing cloth with crème Chantilly.

PAINTING BY WILL COTTON

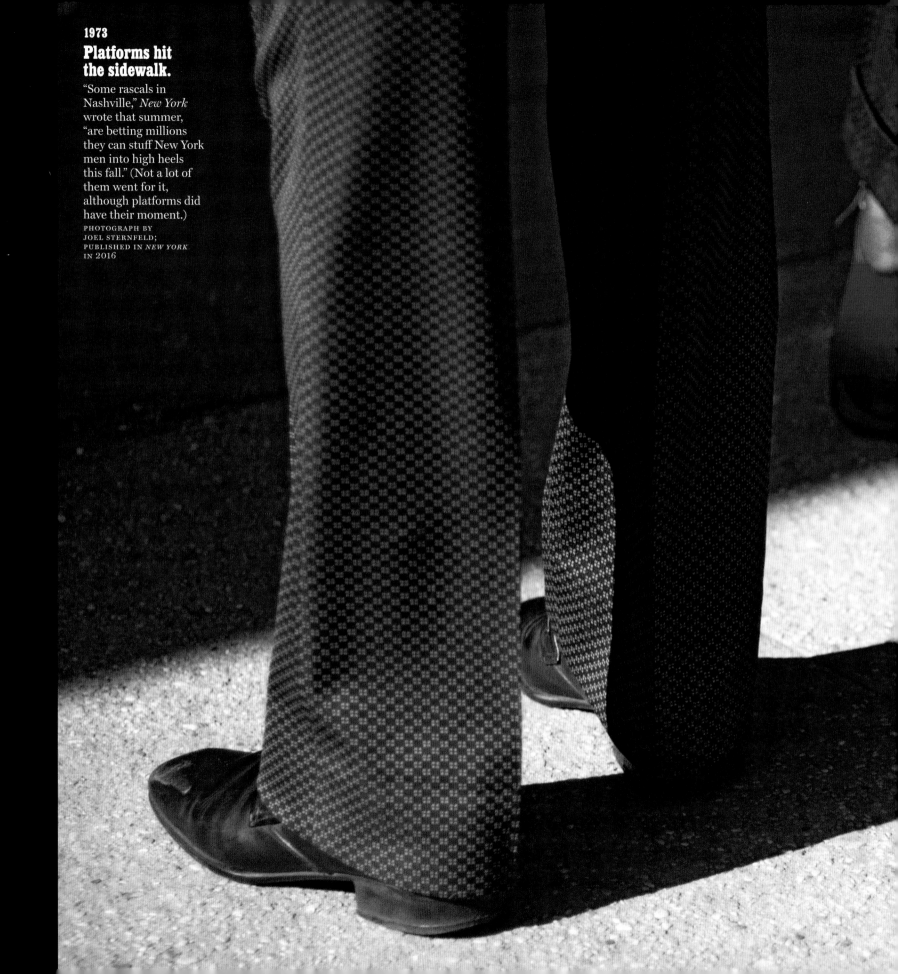

1973

Platforms hit the sidewalk.

"Some rascals in Nashville," *New York* wrote that summer, "are betting millions they can stuff New York men into high heels this fall." (Not a lot of them went for it, although platforms did have their moment.)

PHOTOGRAPH BY JOEL STERNFELD; PUBLISHED IN *NEW YORK* IN 2016

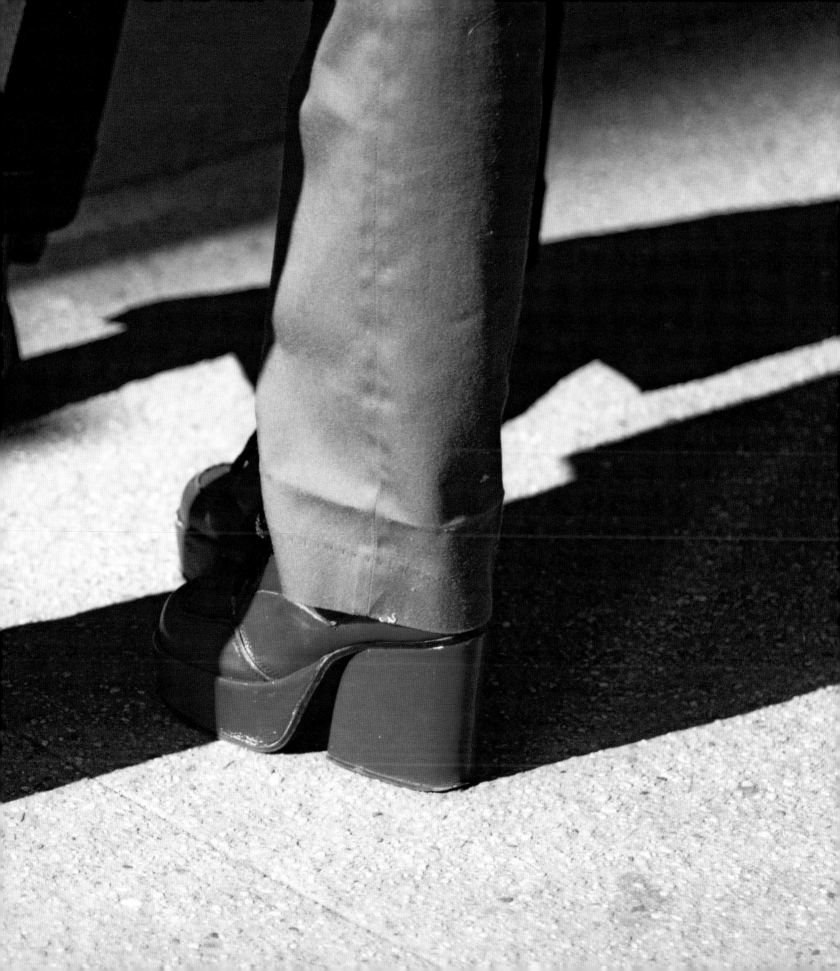

1976
**Grooming
trends came from
everywhere.**
Even the academy.

Outlaw and Order

By Stanley P. Friedman

"...Out of a recent class of 29 graduates from the New Yor
Authority Police Academy, 22 had given the outlaw lip ser

It took more than a half century, but the outlaw look is finally in—with cops, of all people! The fine mustachioed faces you see on these pages belong to members of the New York Port Authority police force. Two of them are medal winners; the rest are recent graduates of the Port Authority Police Academy. When photographer Don Brewster took their traditional graduation portraits, he discovered that 22 out of a class of 29 had given the outlaw lip service. It's all strictly within departmental regulations, of course; the rule

says that mustaches must be trimmed, neat, and kept at lip line. But the way this fashion has caught on with the new members of the force, it may become *the* rule. "It's definitely been gaining for the past five years," says photographer Brewster. Why? "They want to be in style with the public," explains police historian Detective Alfred Young. Well, that's one way of looking at it. But could it possibly be a reflection of the cops' inner fantasies? Maybe they really want to be outlaws—or at least Robert Redford! ■

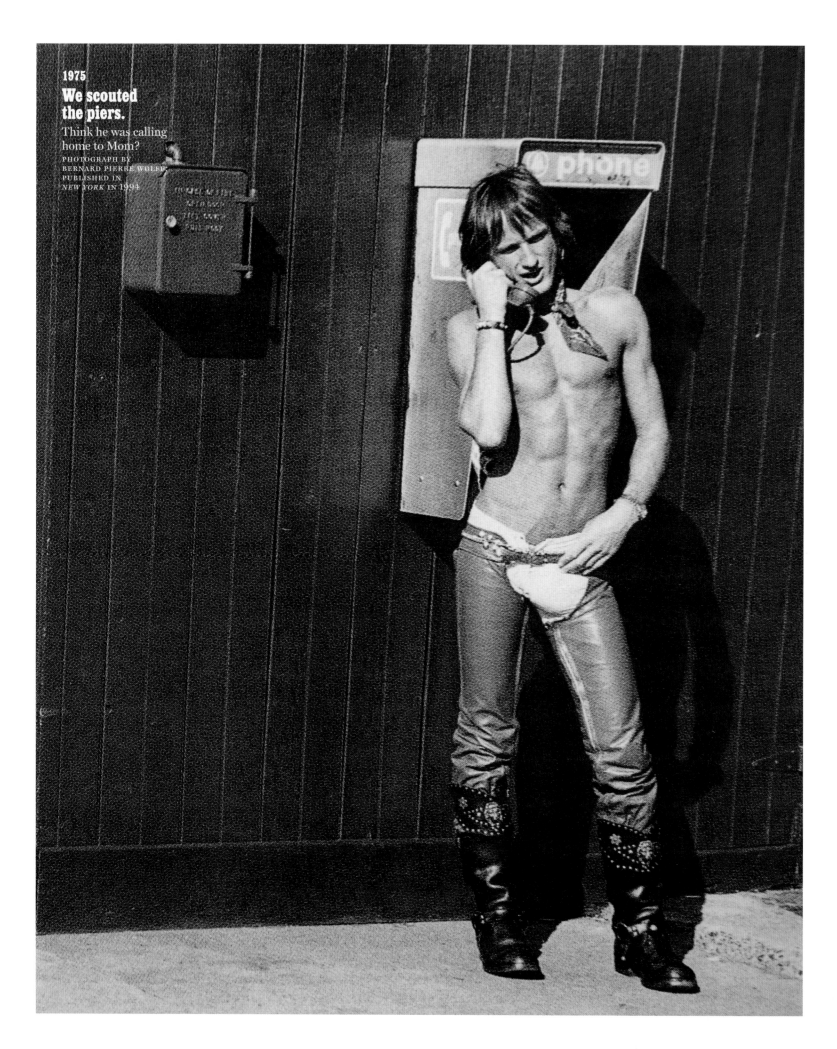

1975

We scouted the piers.

Think he was calling home to Mom?

PHOTOGRAPH BY
BERNARD PIERRE WOLFF
PUBLISHED IN
NEW YORK IN 1994

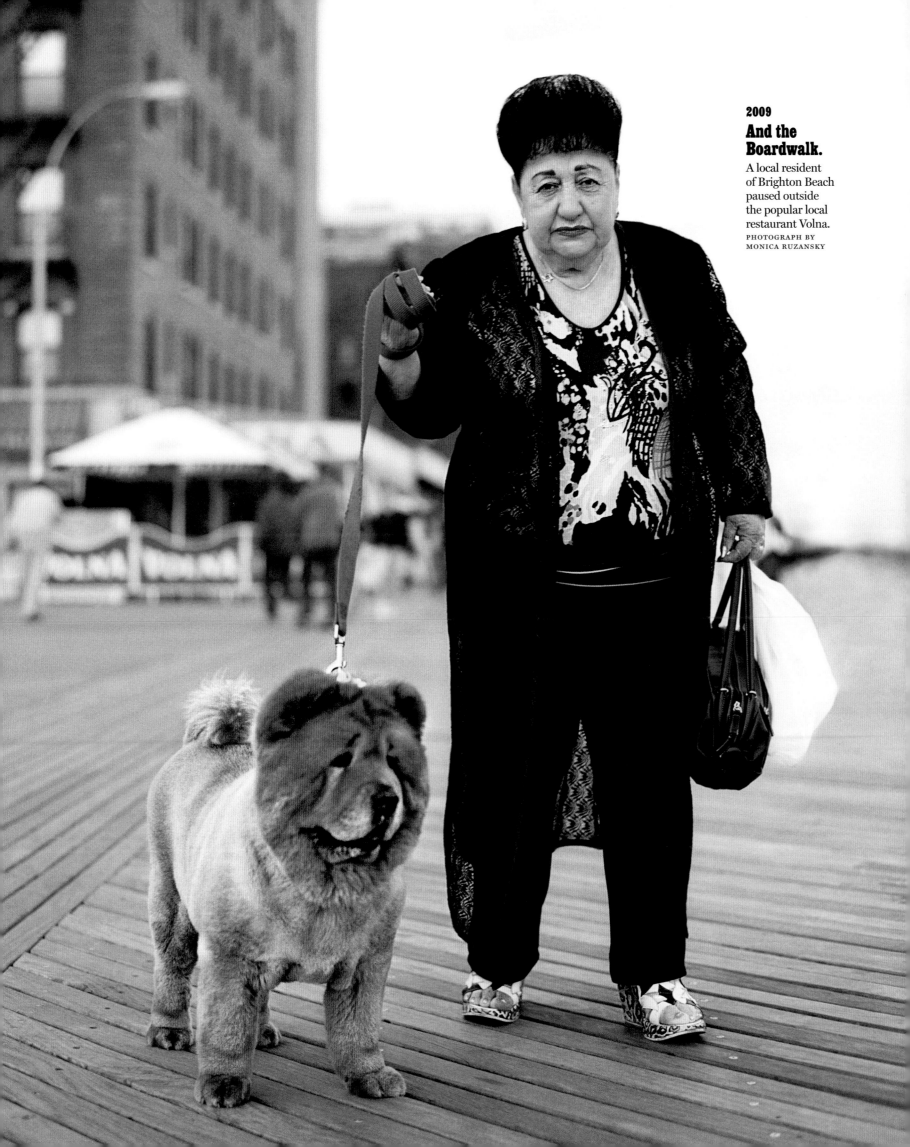

2009

And the Boardwalk.

A local resident of Brighton Beach paused outside the popular local restaurant Volna.

PHOTOGRAPH BY
MONICA RUZANSKY

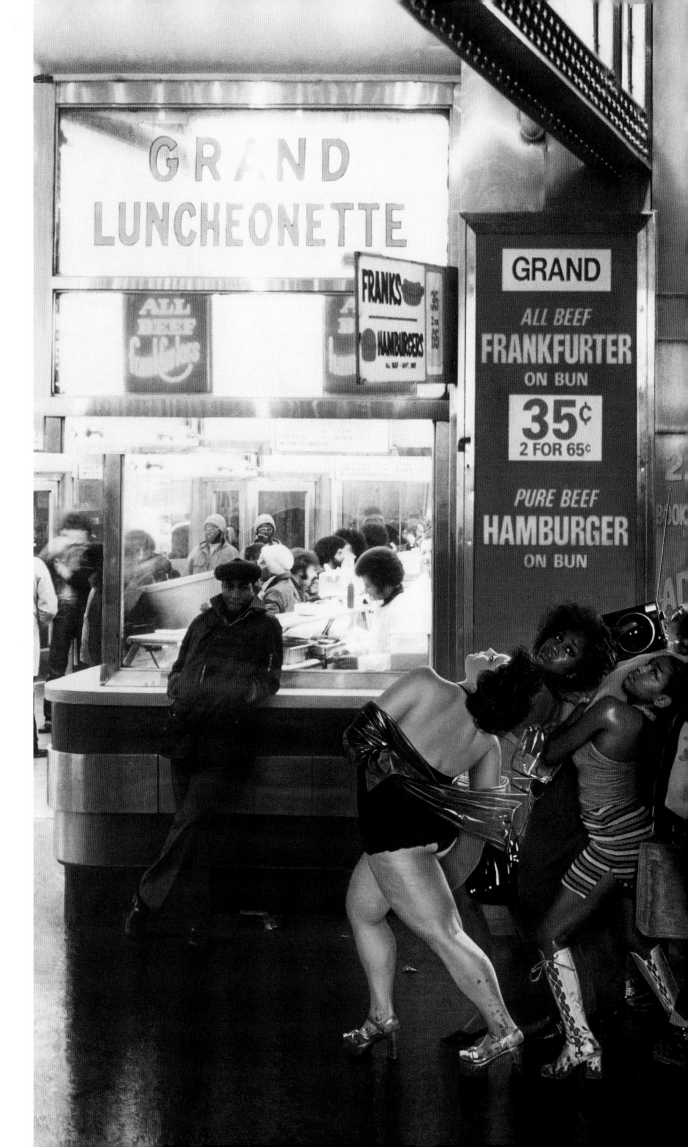

1978

Even at 42nd Street's nadir, it still looked cool.

What Nik Cohn encountered during 24 hours spent around Times Square: "Black hookers in hot pants and lacquered wigs; body builders and midnight cowboys; tattooed sailors in leather; evangelists with pamphlets or sandwich boards; Polaroid photographers, two bucks a shot; pubescent Puerto Ricans; Superflies in fancy hats, murmuring promises of cocaine, mescaline, speed; children who stared without blinking; all-Americans with blue eyes, bulging biceps, and Man-Tan golden flesh; furtive men in overcoats...defectives, derelicts, and scattered tourists, gawking."

PAINTED PHOTOGRAPH BY
JEAN-PAUL GOUDE

374

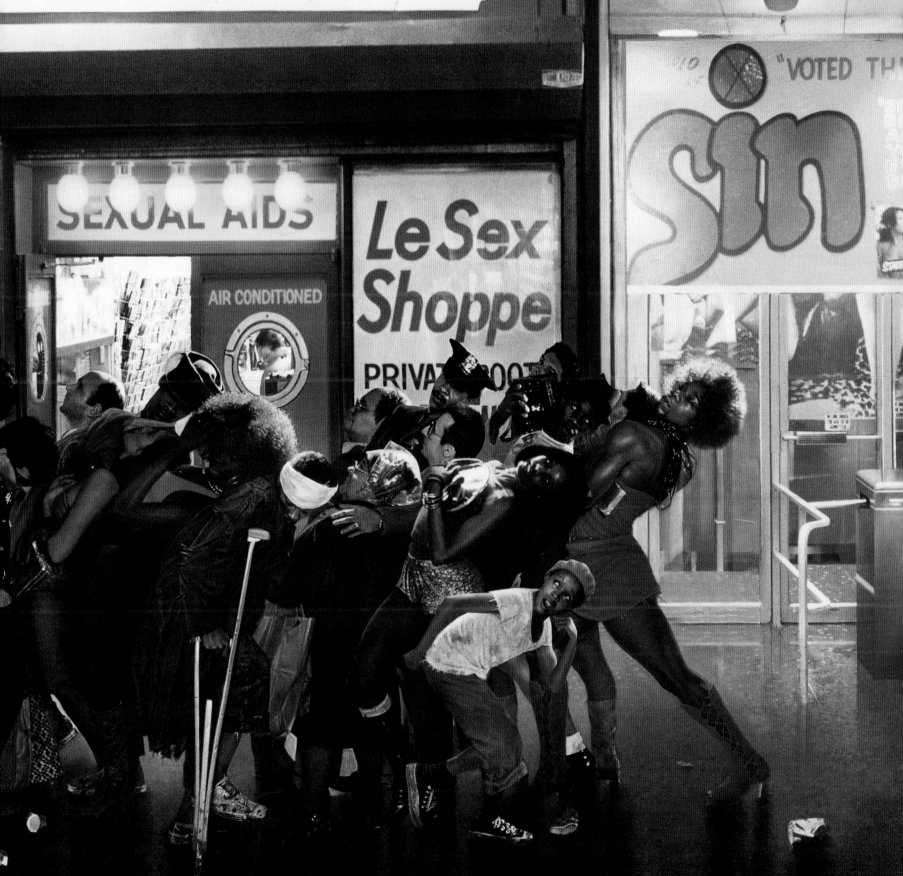

The tee was just making its way from underwear to outerwear. For baby-boomers, it was coming to mean much more.

Inside the T-Shirt

By Richard Goldstein

SOME PEOPLE THINK the T-shirt was invented by Fabian in 1954 and is thereby assured a place in the Bloomingdale's Hall of Kitsch. It is mentioned in the Sears, Roebuck catalogue of 1941 as the "T-shirt style," made of "light, airy, full-combed cotton yarn." The National Knitwear Manufacturers' Association (formerly known as the Underwear Institute) traces the origin to the Navy during World War II, when white T-shirts, called "skivvies," were the telltale mark of a sailor. Finally, there is a common notion that the T-shirt first appeared in the mid-twenties, when it was copied from the underwear of Basque fishermen and became known as the polo shirt.

Well, we all remember polo shirts, and they are not the same as T-shirts. Polo shirts are what your parents sent you out to play in. They were as soilable as diapers. T-shirts are what you wear to the Schaefer Music Festival to pick up other people (also wearing T-shirts), and they are chosen with all the care once lavished on automobiles. One selects them with an eye toward customizing one's appearance, as well as projecting a message,

either inviting or arcane. The T-shirt is deliberate. You can use it to tell people a great deal about your class, your city of origin, and what you like in bed.

The code of the T-shirt is difficult to crack. The thing to remember is that not just the logo communicates; one should also consider the shape, tone, and age of the shirt in sizing up its wearer's scene. Even more crucial is the factor of attitude; three people can appear in the same shirt to utterly different effect. A Zabar's T-shirt says one thing on upper Broadway (I love it here) and another on Kissena Boulevard (I hate it here). The young woman in the New York City T-shirt and magenta nails may be flaunting her proximity to dime-store flash. The young man in the striped tank top and culled jeans may be vamping on the traditional street-waif look, giving a middle finger to the Dead End Kids. One way of looking at costumes like these is to consider the swipes people are taking at the posturing of class. Another way is to see the yearning which such parody masks.

My personal approach to the selection of T-shirts emphasizes whimsical incongruity. The idea is to appear in the least appropriate slogan or design. If I were advising a hulking six-foot adolescent on his wardrobe, I might select T-shirts with dancing mice or chunky airplanes. For a languid type, I'd choose a prominent S, for Superman. In both cases, what underlies the comic effect is a desire to contradict the body's image and thereby invite attention and maybe a little tenderness. My own Superman T-shirt is an invitation to interact, and I wear it when I'm feeling open and benign. My collection of biking shirts, usually worn with a silver bracelet and a dash of sandalwood oil, is supposed to camp the Hell's Angels/macho effect. When I wear my NGK Spark Plugs shirt, people call me "Sparky" and give me extra ice cream. In a sense, I regard my approach to T-shirts as an application of Jewish humor to fashion, the idea being that a little self-deprecation generally lessens hostility and encourages warmth.

Even if the content of T-shirts were not so rich, there would still be justification for their sudden fashionability. The shirt itself is part of a much broader search for the perfect street uniform. The T-shirt is the upper equivalent of blue jeans. It is soft and clinging, seamless to the touch, the way blue jeans get when they are broken in. With wear and tear, it takes on the shape of the body, but not so faithfully that the flabs and crevices of flesh are likely to show. Both jeans and T-shirts give the illusion that a natural body is on display, when, in fact, one is seeing an idealized body, with flattering emphasis placed on genitals and other landmarks of gender. In a time when garments themselves are unisex, the shape of the body in this uniform is accentuated beyond the point where any mistake is possible. Blue jeans emphasize a woman's thighs and a man's crotch to such advantage that they are perhaps the most sensuous garment you can wear. The T-shirt shapes a woman's breasts without the aid of a bra. It horizontalizes a man's pectorals so that any wimp can feel like Marlon Brando. And it creates the most ingenious possibilities for holes, a crucial art in the Zen of street dress, since T-shirts, like jeans and sneakers, are worn long after they are frayed.

The T-shirt is a perfect fashion metaphor for the seventies. It seems spontaneous, but it is really premeditated. It seems democratic, but it is really chic. At a time when style demands a studied exuberance, an informality which is prearranged, people turn to garments which project the harmlessness of children at play. But it's a futile gesture, like going to war in lace. A T-shirt can make you sexy, but no fashion can make you feel innocent again.

∎

Thirty-three years later, members of Generation X (and the millennials who followed) still dressed exactly like the children they were now raising.

Up With Grups

By Adam Sternbergh

MY FATHER DID not wear T-shirts. He did not own sneakers. He may have had one pair of jeans, stiff and store-bought blue, to wear on the weekends when we'd do things like go apple-picking. At all other times, he wore suits.

So I wonder what he would make of the offices of Rogan, a very hot, very hip fashion label that operates out of the third floor of a building just off Broadway, north of Canal. The office is cluttered with large cardboard boxes and long tables, where twentysomething staffers fulfill orders by hand, among rolling racks of carefully crafted vintage-style shirts and down ski vests. Paper patterns for future clothes hang from a bar overhead like thought bubbles suspended in midair.

Rogan is run by Rogan Gregory, a 33-year-old designer who, when I meet him, is wearing a faded pink vintage surf-shop T-shirt, dirty white Vans slip-ons with seagull silhouettes, and a pair of his famous jeans. Famous, at least, within certain circles: namely, denim hounds who will pay $450 for a pair of jeans that are so distressed—so tattered, so frayed, so worked over and beaten down—that they will likely fall apart within two years.

Rogan is tall and slim, with a trim beard and jaw-length hair that's tucked back behind one ear. He specializes in clothes that are handcrafted to look like you exhumed them from a rack at the back of a dusty vintage store when, in fact, you bought them at Barneys for several hundred dollars each. He understands that this market did not always exist. "I've been wearing the same thing my entire life," he says. "But ten years ago, people gave me a hard time. If I was checking into a hotel, they wouldn't believe that I was actually staying there. Now it's accepted that just because that dude doesn't look like some fancy-pants—well, you never know." It used to be, he explains, that each stage of life had its uniform. Now, though, that fashion progression has flattened out, and everyone just wears the uniform of his choice. "It's absolutely not a hierarchical thing," he says. "It's just about how you like to be perceived."

A number of trends have nudged us in this direction. During the dot-com boom, businesses not only allowed people to come to work in clothes they might usually wear to clean out the attic but encouraged this as a celebration of youthful vivacity and an upheaval of the fusty corporate order. The dot-com bubble burst, but the aesthetic remained, as part of the ongoing rock-star-ification of America. Three-day stubble and shredded jeans are the now-familiar symbols of the most desirable kind of affluence and freedom. A suit says, *My mother made me wear this to go to a bar mitzvah.* The Grup outfit says, *I'm so cool, and so damned good at what I do, I can wear whatever the hell I want. At least when I go out to brunch.*

So now, for many people—many grown-up people—the uniform of choice is rock tees and sneakers and artfully destroyed denim. Of course, when you're 40, with a regular paycheck, yet still want to resemble a rock star who resembles a garage mechanic, well, what's a guy to do? Status symbols still have their uses, especially in the world of clothes. And this is where the $200 ripped jeans come in. Or $450. Or $600.

"One thing happened that I thought was funny," says Rogan. "I made a run of a hundred jeans, and I made them as perfectly as I could. Which for me means essentially destroying the fabric, to the point where if you wear them for a month, they'll disintegrate. And I literally sold them out in a week. And they'll completely disintegrate. You wear them for a couple of weeks and go out one night and there'll be a giant tear. I mean, it's embarrassing. I was surprised that people would pay that amount of money for something that literally falls apart."

At one point, I spoke to a 39-year-old musician who had lived briefly in Park Slope and then fled, largely because of the prevalence of exactly the kind of person who would buy jeans designed to fall apart in a month. This musician is old school in his fashion tastes—which is to say, one day he came to a point where he pulled that old concert T-shirt from his dresser and thought, *Yeah, I just can't pull this off anymore.* (For me, this moment came with a thrift-store T-shirt with QUALITY PLASTIC SUPPLIES decaled across the chest.) These days, though, there just aren't many people saying *I just can't pull this off anymore.*

"If really hard-pressed, I would admit that I actually own a Clash T-shirt that I got from that last Clash tour," the musician told me. "But I don't wear it! And I'm certainly not going to wear it under an Armani black blazer. I even remember meeting this guy who was around my age, who was wearing an expensive blazer, and on the lapel was a London Calling button. Who the fuck wears that? That's what I wore when I was 18 in art school! And you're the same age as me? And you're wearing it again?" He pauses, then adds, "And you know what? Giving your kid a mohawk is fucked up, too." ∎

He owns *eleven pairs of sneakers,* hasn't worn anything but *jeans* in a year, and won't shut up about *the latest Death Cab for Cutie CD.* But he is no kid. He is among the ascendant breed of grown-up who has *redefined adulthood* as we once knew it and *killed off the generation gap.*

Up With Grups*

BY ADAM STERNBERGH

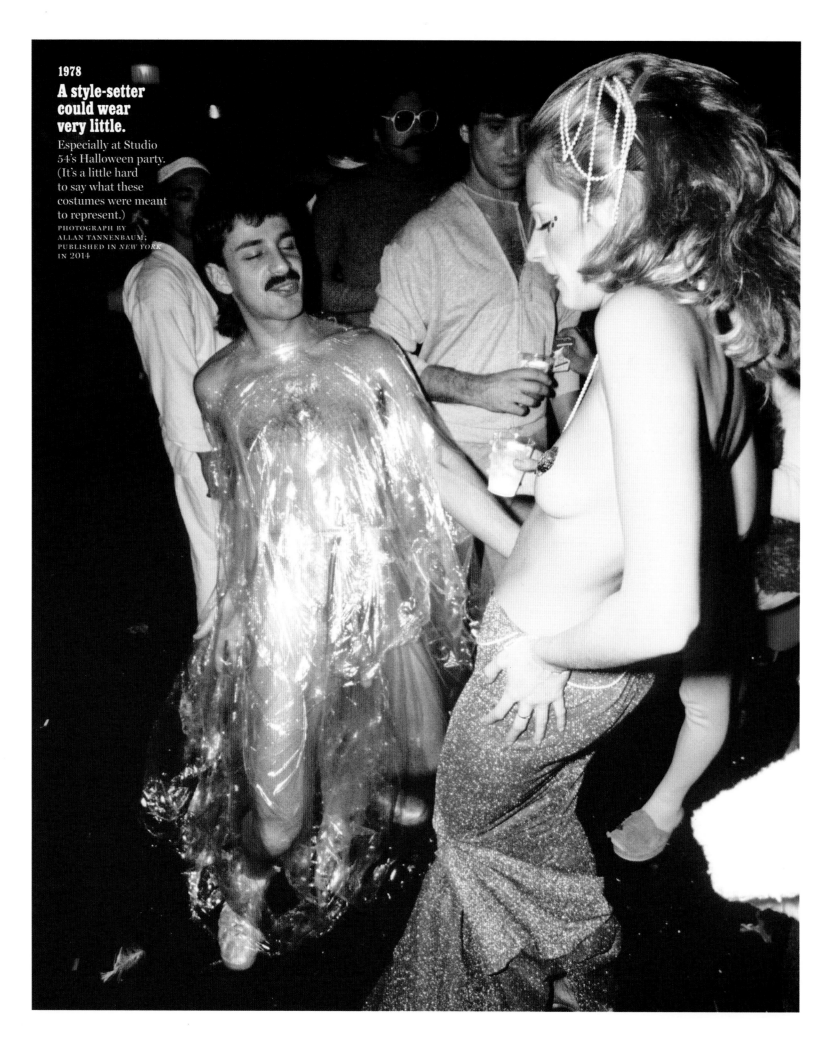

1978

A style-setter could wear very little.

Especially at Studio 54's Halloween party. (It's a little hard to say what these costumes were meant to represent.)

PHOTOGRAPH BY ALLAN TANNENBAUM; PUBLISHED IN *NEW YORK* IN 2014

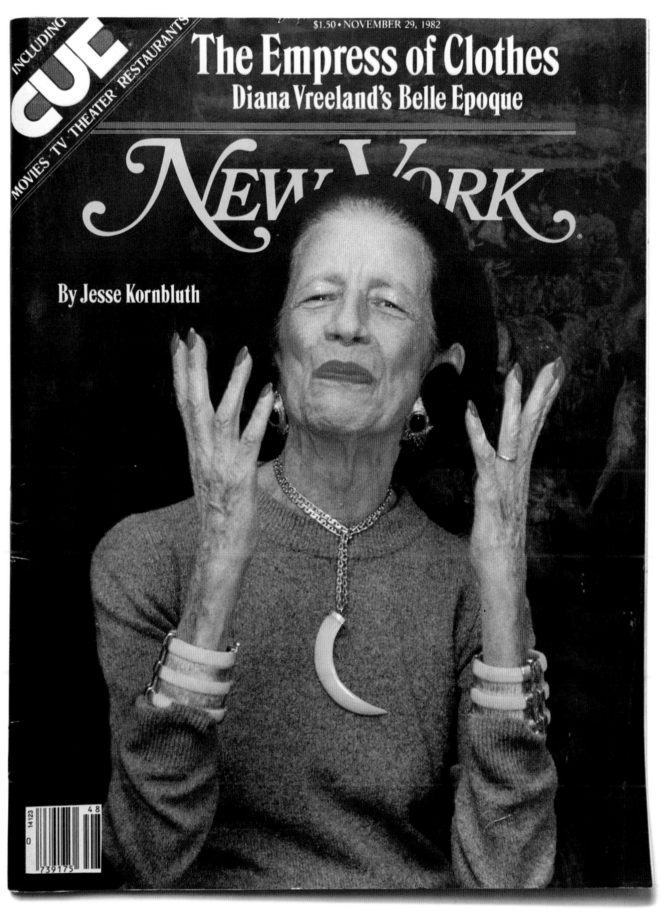

The Empress of Clothes
Diana Vreeland's Belle Epoque

New York

By Jesse Kornbluth

INCLUDING CUE

MOVIES · TV · THEATER · RESTAURANTS

1982
Diana Vreeland had a comeback.

In a feature about the former *Vogue* editor's late-life second act at the Metropolitan Museum of Art's Costume Institute,
she remarked that "I've changed my ways; for the last two years, I come home by midnight."

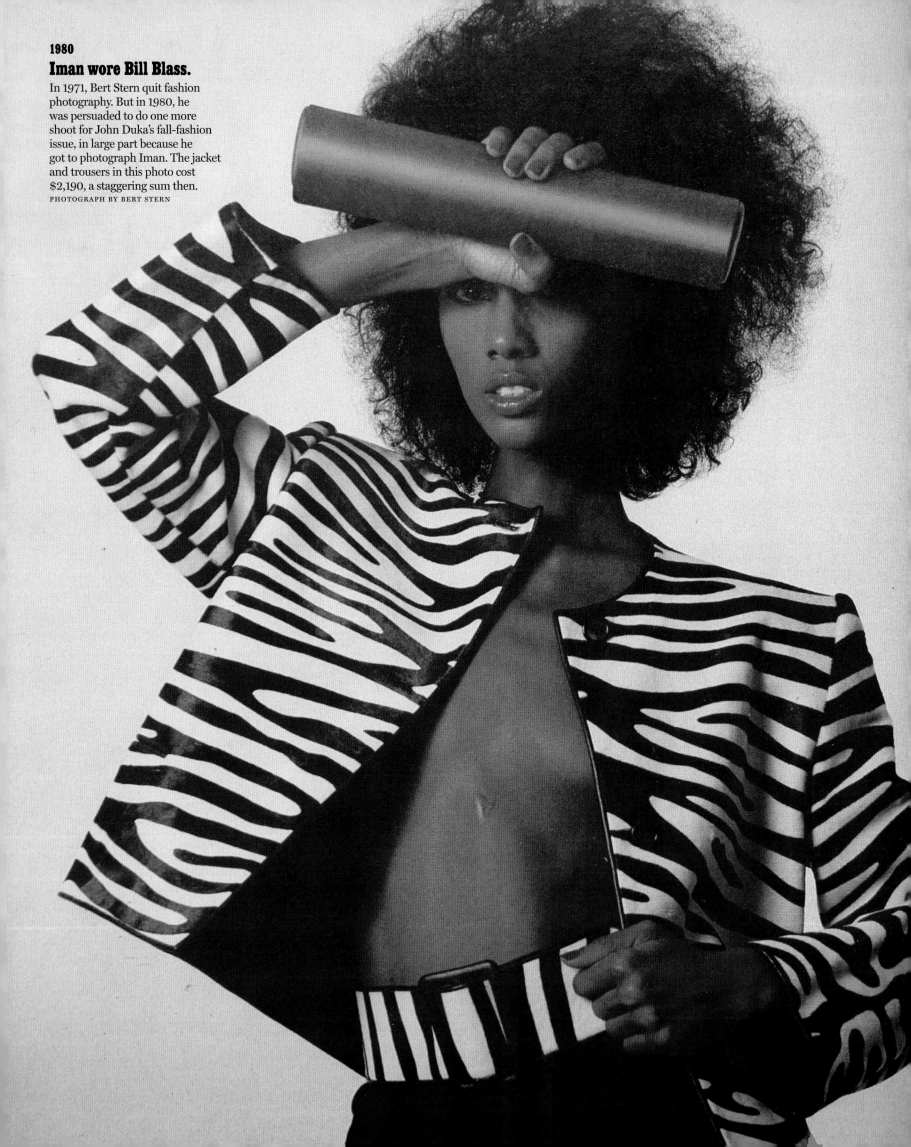

1980

Iman wore Bill Blass.

In 1971, Bert Stern quit fashion photography. But in 1980, he was persuaded to do one more shoot for John Duka's fall-fashion issue, in large part because he got to photograph Iman. The jacket and trousers in this photo cost $2,190, a staggering sum then.

PHOTOGRAPH BY BERT STERN

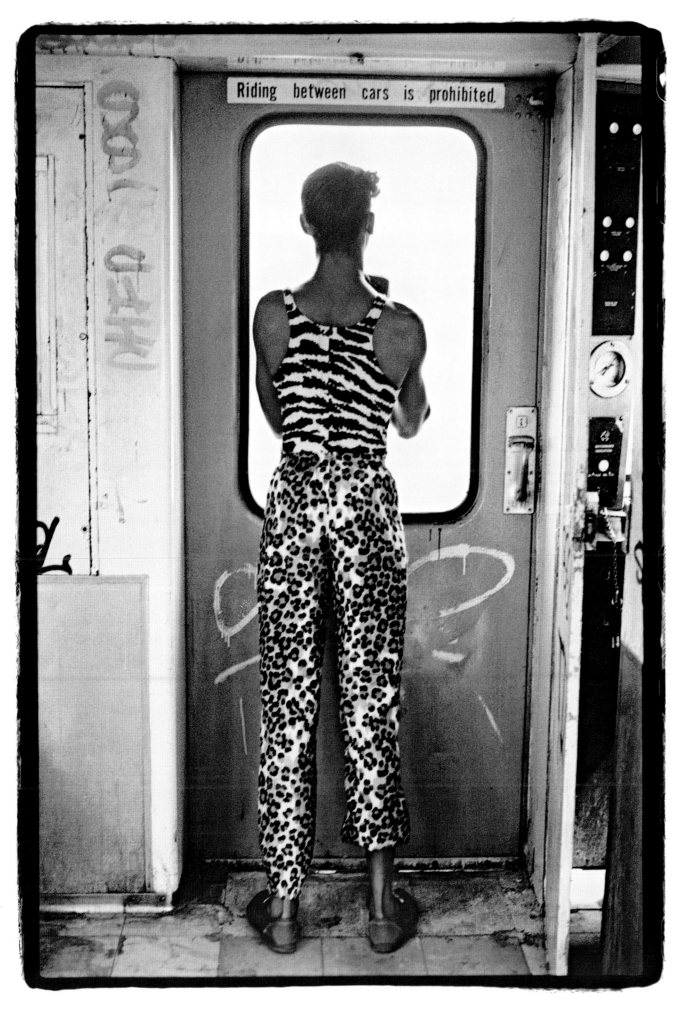

Riding between cars is prohibited.

1983

Three years later, those zebra stripes turned up on the D train.

Somehow, it kind of worked.

PHOTOGRAPH BY
AMY ARBUS; PUBLISHED
IN *NEW YORK* IN 2016

The most American of designers were also the New Yorkiest.

Donna Karan, daughter of Forest Hills, designed functional, stylish pieces for actual women with actual hips and actual jobs; Calvin Klein, born in the Bronx, brought minimalism (not to mention Brooke Shields and her jeans) into the mainstream.

PHOTOGRAPH BY
ROSE HARTMAN;
OPPOSITE, PHOTOGRAPH BY
JOHN MCDONNELL

1982

Halston was at the top of the world.
One of the most visible designers of his era, he operated from an atelier in Olympic Tower, high above Fifth Avenue; that's the model Karen Bjornson wearing an outfit from his fall 1982 collection.
PHOTOGRAPH BY
THOMAS IANNACCONE

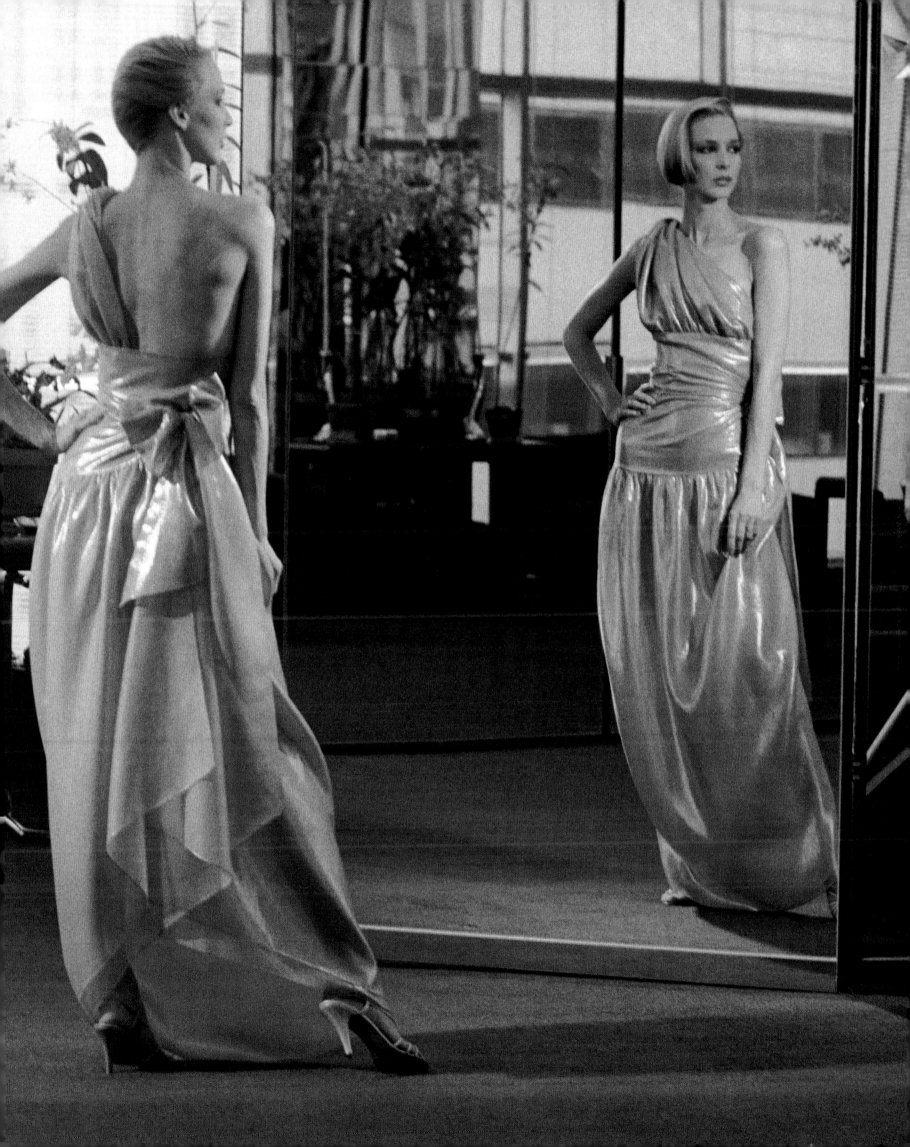

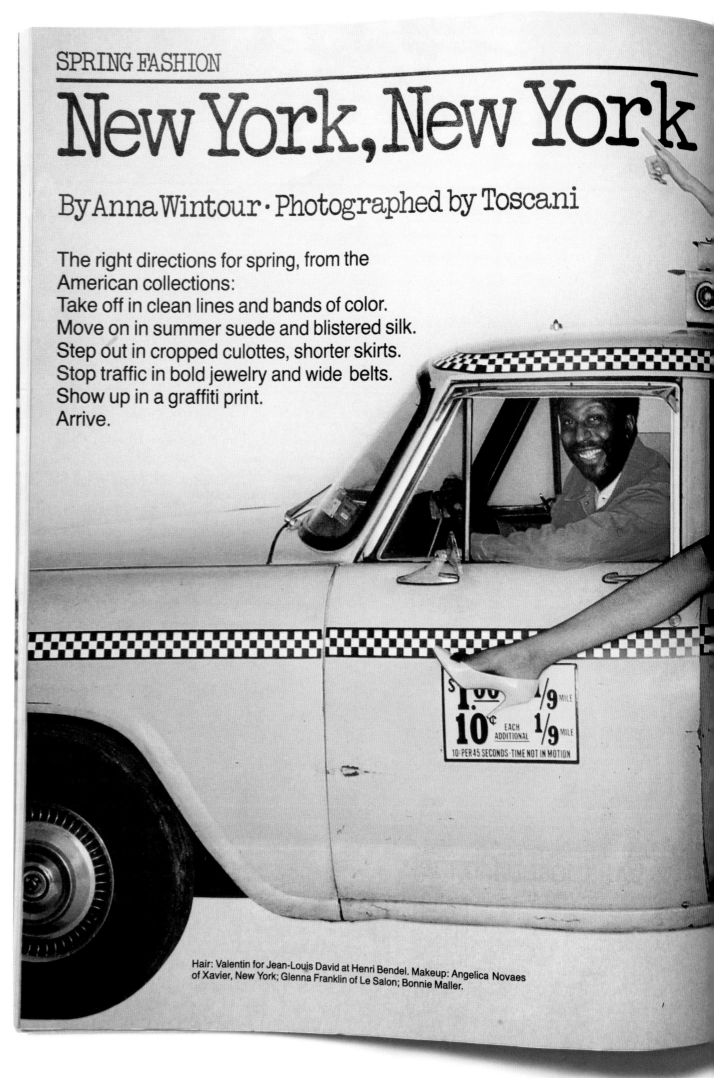

SPRING FASHION

New York, New York

By Anna Wintour · Photographed by Toscani

The right directions for spring, from the
American collections:
Take off in clean lines and bands of color.
Move on in summer suede and blistered silk.
Step out in cropped culottes, shorter skirts.
Stop traffic in bold jewelry and wide belts.
Show up in a graffiti print.
Arrive.

Hair: Valentin for Jean-Louis David at Henri Bendel. Makeup: Angelica Novaes of Xavier, New York; Glenna Franklin of Le Salon; Bonnie Maller.

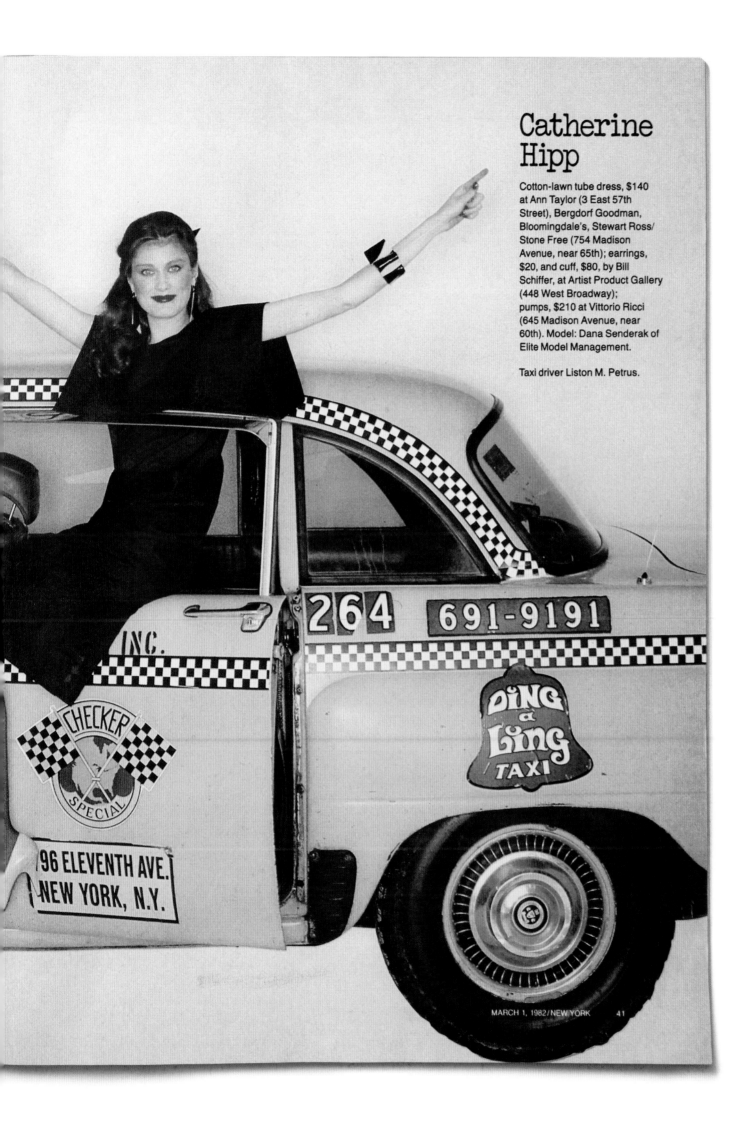

Catherine Hipp

Cotton-lawn tube dress, $140 at Ann Taylor (3 East 57th Street), Bergdorf Goodman, Bloomingdale's, Stewart Ross/ Stone Free (754 Madison Avenue, near 65th); earrings, $20, and cuff, $80, by Bill Schiffer, at Artist Product Gallery (448 West Broadway); pumps, $210 at Vittorio Ricci (645 Madison Avenue, near 60th). Model: Dana Senderak of Elite Model Management.

Taxi driver Liston M. Petrus.

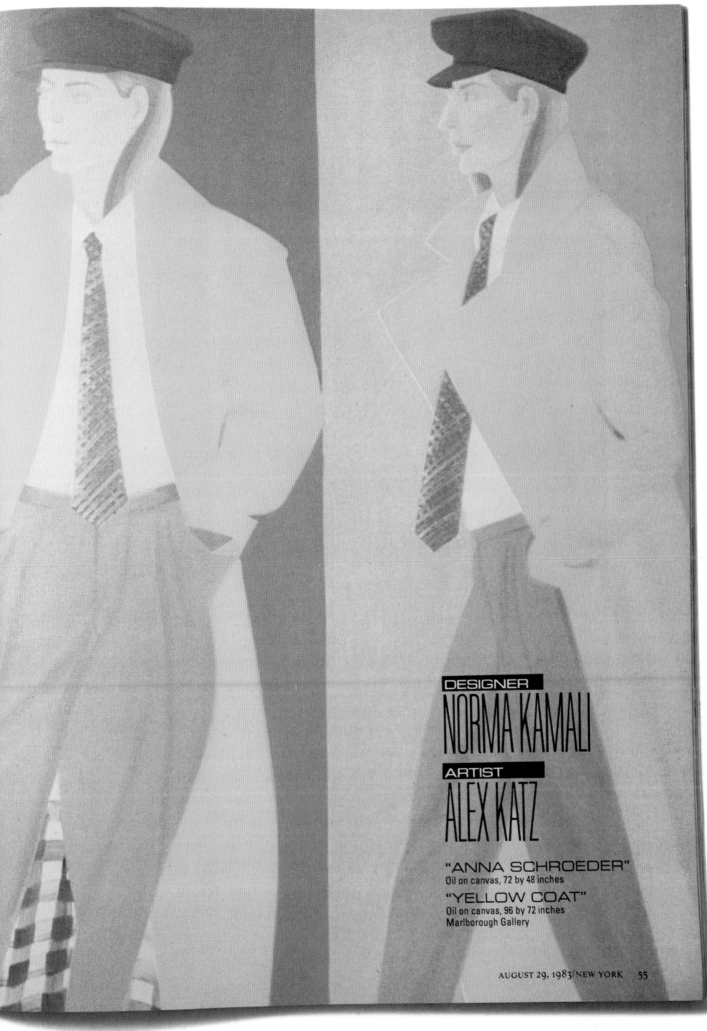

AUGUST 29, 1983/NEW YORK 55

DESIGNER
NORMA KAMALI
ARTIST
ALEX KATZ

"ANNA SCHROEDER"
Oil on canvas, 72 by 48 inches

"YELLOW COAT"
Oil on canvas, 96 by 72 inches
Marlborough Gallery

1983

Fashion and art hooked up.

For her most ambitious feature, Wintour commissioned Alex Katz, Jean-Michel Basquiat, and ten other artists to create paintings that harmonized with that year's clothes.

389

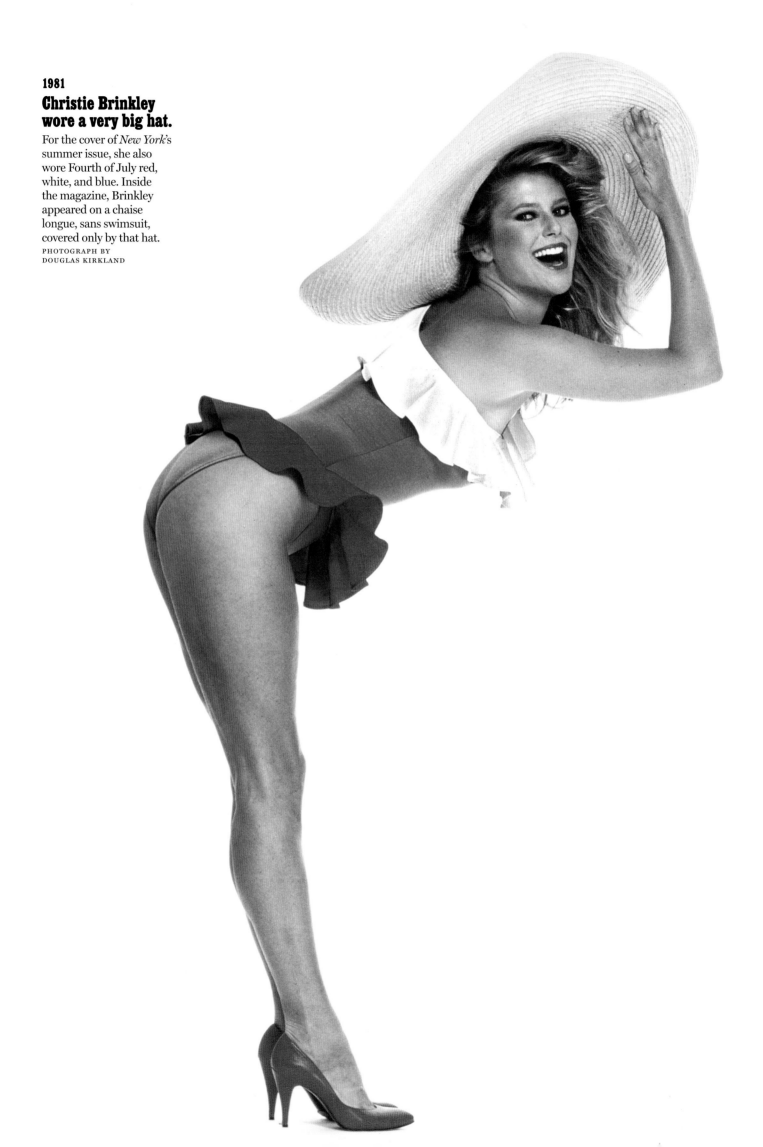

1981

Christie Brinkley wore a very big hat.

For the cover of *New York's* summer issue, she also wore Fourth of July red, white, and blue. Inside the magazine, Brinkley appeared on a chaise longue, sans swimsuit, covered only by that hat.

PHOTOGRAPH BY
DOUGLAS KIRKLAND

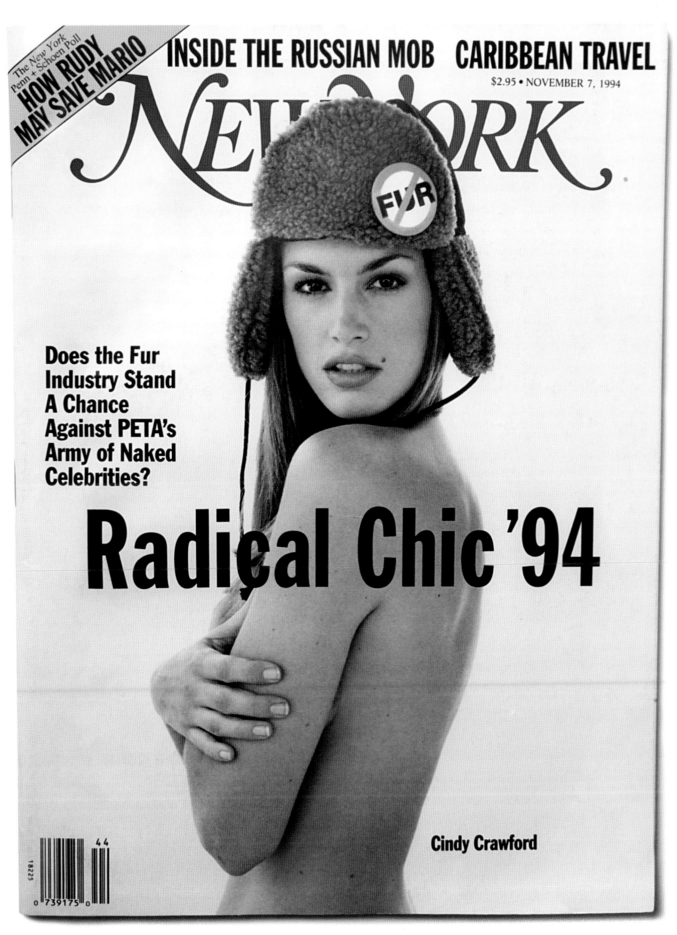

1994
Cindy Crawford did not wear fur.
For a feature about the brash tactics of PETA, Crawford did her own hat-only photo shoot
(wearing *faux* fur made from recycled soda bottles).

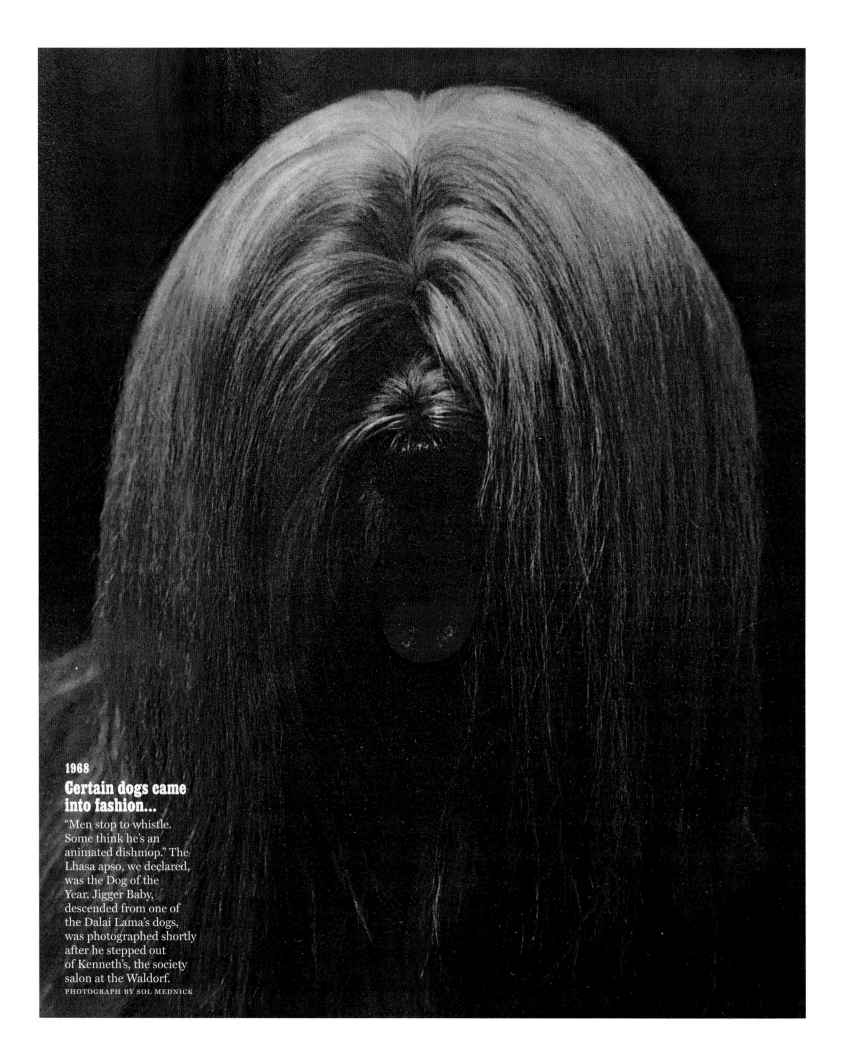

1968

Certain dogs came into fashion...

"Men stop to whistle. Some think he's an animated dishmop." The Lhasa apso, we declared, was the Dog of the Year. Jigger Baby, descended from one of the Dalai Lama's dogs, was photographed shortly after he stepped out of Kenneth's, the society salon at the Waldorf.

PHOTOGRAPH BY SOL MEDNICK

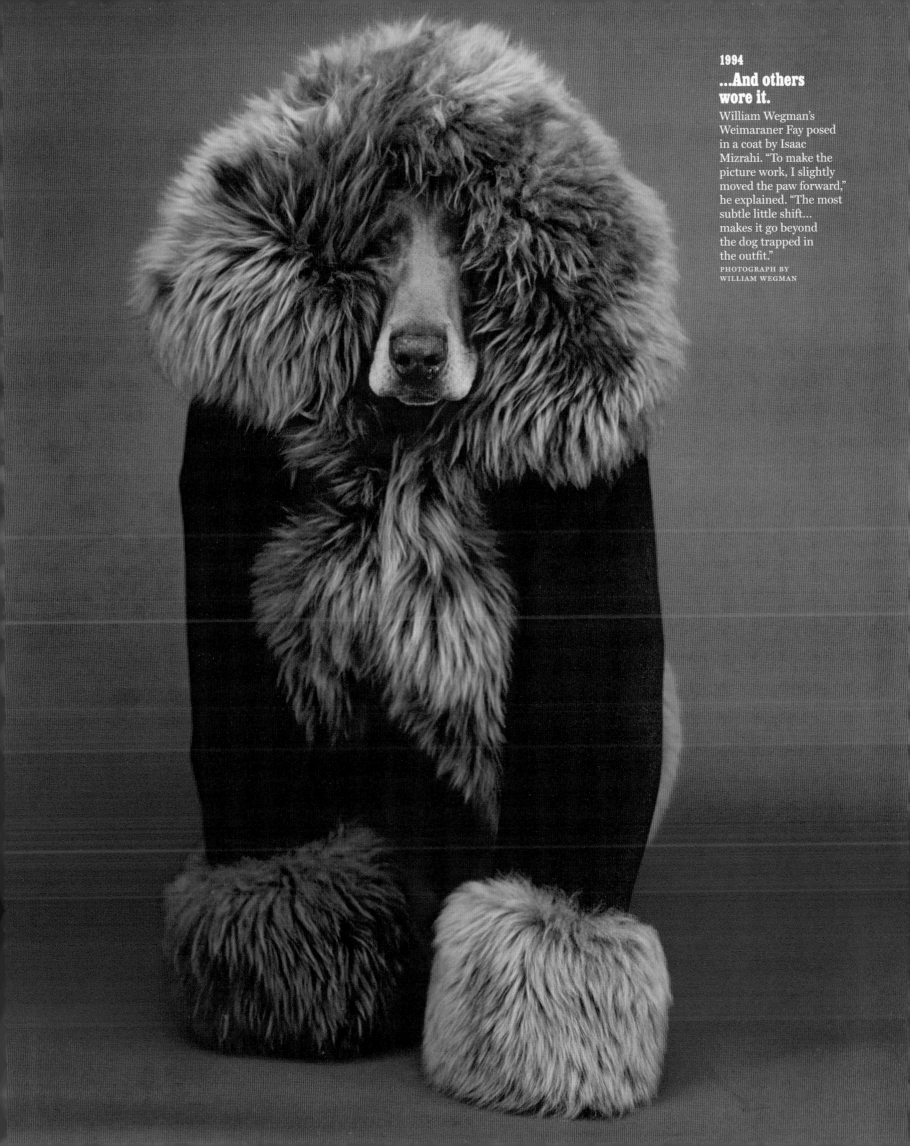

2004

By the new millennium, fashion and art had been knitted together for good.

The fine artist Marilyn Minter created tableaux for *New York*'s Holiday Gifts issue that were doused in her signature goo and glitter.

PHOTOGRAPH BY
MARILYN MINTER

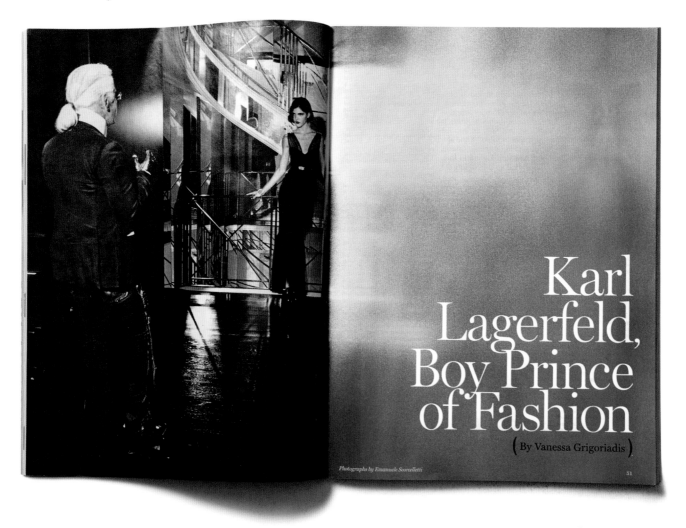

Karl
Lagerfeld,
Boy Prince
of Fashion

(By Vanessa Grigoriadis)

Photographs by Emanuele Scorcelletti

51

How to explain the fan-wielding, slightly mad designer? Just watch him in action.

**Karl Lagerfeld,
Boy Prince of Fashion**

By Vanessa Grigoriadis

DOWN FIFTH AVENUE they come, the fragrant and bejeweled hordes, having said their bons mots at Derek Lam's cocktail party at Barneys and a Tom Ford perfume launch at Saks, and now clippity-clopping their way ever closer to the opening of the exquisite new Fendi boutique on 53rd Street. It is 8 p.m., still early enough for tourists to stroll about and city buses to zoom by, and also too early for the arrival of Karl Lagerfeld, designer of Chanel, Fendi, Lagerfeld Collection, a new Karl Lagerfeld line, and "the reason we are all here!" Half an hour before the event is supposed to end, Lagerfeld remains at his suite at the Mercer, and it's whispered that he will not leave because he cannot find a thing to wear. Soon, Silvia Fendi, the handsome blonde daughter of the LVMH-owned house, is packed in a Town Car and sent downtown to work some magic, or at least appeal to Lagerfeld's nobler side, because Lagerfeld is nothing if not noble.

What can one talk about while waiting for Lagerfeld? Lagerfeld, of course. "Karl has the energy of...what? Twenty-five thousand Turkish elephants!" says socialite Anne Slater, wearing her big blue glasses and grinning up a storm. "He's magnetic and powerful. I think he's absolutely, devastatingly attractive."

"At our dinner for Karl at Schiller's, firemen had to stand at the door to stop people from coming in because everyone wanted to see him," says Robert Burke, the recently departed Bergdorf Goodman head of fashion. "Karl said the firemen were the best-dressed people from the whole evening!"

"Karl is a genius!" exclaims Lindsay Lohan, whose name has been lobbed recently as the new face of Chanel ("I prefer Nicole

Kidman and that generation at the moment," Lagerfeld later tells me drily). "I want to have everything that he makes. Everything! I go into stores and grab all his things."

"Karl is the one person that makes me shy," says throaty Bungalow 8 owner Amy Sacco. "I think I've conquered—I've run the gamut on people that I speak to, and very few times have I been shy. But Karl is beyond, and I'm afraid I'd bore him to tears."

Giorgio Armani, André Leon Talley, Anna Wintour with her pretty daughter, Bee. "A conversation with Karl is not a fashion conversation—it's a conversation, a conversation that embraces the culture of life," says Talley. Amanda Cutter Brooks, Celerie Kemble, Anh Duong. "Karl defended me once. He said, 'Do not forget that Anh is not only a beautiful woman but also an artist!'" exclaims Duong. Sophie Dahl, Cecilia Dean, Liv Tyler. "I'm starting to feel a little tired and overwhelmed, and I wonder if I slip out if anyone would notice," lisps Tyler, with one of her coy half-smiles. An emissary from Planet Not Obsessed With Karl: Chuck Close plants his wheelchair two inches from the exit door. "I'm not very interested in fashion," says Close, surveying the crowd. He sighs. "This event is making me want to start smoking again."

But then there he is—Karl! His stiff silver tie glitters like a saber. His black leather gloves are good for murder. He poses for the cameras wearing a ghastly grimace, an entourage of twenty Frenchmen and foxes waiting behind. Guests with fingers curled around champagne glasses jostle to catch a glimpse, not quite crying the way they did in Tokyo last year at the opening of the biggest Chanel store in the world, but certainly eager to be entertained. "I think his hair is powdered, like from the 1800s," says one socialite. "In fact, it is from the 1800s," titters her friend. Paparazzi are yelling "Karl!" and bystanders are yelling "Karl!" and PETA is yelling "Karl!" the loudest. A dreadlocked white guy with Rollerblades slung over his shoulder streaks down the sidewalk and snarls, "Blood for money, that's what Karl Lagerfeld wants. Karl is greedy! Karl is evil! Karl is wicked! Karl is...the devil!"

Lagerfeld stops in the doorway, puckering his bulbous German lips, which is what he does when he is mad—well, not mad, exactly, but frustrated with other people, who, he has found, are frequently idiots. "You eat meat and wear leather, so shut up," he says to a German reporter. "I have no time for zis foolishness."

Lagerfeld is too busy, too smart, and too old to be brought into any foolishness, at least not that which is not of his own making. At 67—or 72, if the 1933 birth date on a baptismal record unearthed by German tabloids is to be believed—he is one of the most professionally self-realized people alive, keeping busy with an incredible twelve or so collections each year, an extensive photography career, a Paris-based bookshop, personal museum-quality furniture collections, the management of six homes, and staying skinny. Lagerfeld lost 90 pounds four years ago on a low-calorie diet—his book on the subject was a best seller in Europe—and has put on ten or so since. The new, skinny Karl is an improved Karl. The creepy fat guy hiding behind a fan has been replaced by a boogying hipster who hangs out with Stephen Gan and Hedi Slimane. "My people are zee cool ones, the rockers," says Lagerfeld. "I get along with everyone except for men my age, who are bourgeois or retired or boring, and cannot follow the evolution of time and mood."

As much as Lagerfeld would like to ignore his association with such men—and aging and death in general—his role as a vital elder statesman has much to do with his importance in the world of fashion. He is the King of Fashion, if you will, though he would prefer to be called its eternal Prince. Lagerfeld is the last

of the old-world couturiers, with Valentino his only remaining contemporary, and the last of the big high-fashion names, with Yves Saint Laurent in retirement, Tom Ford in transition, and Helmut Lang disappeared. He is also a terrific pop cartoon—a scolding great-uncle, Dave Navarro the elder, the S&M George Washington. His look is an extremely conscious metaphor for his philosophy of fashion and life: Here, watch as I bring together the old, in my tall eighteenth-century collar and bizarre powdered hair, with the new, as seen in my ponytail and $2,500 Agatha leather pants, "the most expensive leather pants in the world," he declares, with a laugh exactly like Count Chocula's in its length and ridiculousness. Without the indecipherable French-German accent, he would be made for reality TV, although one would think he'd resist on grounds that philistines should not even be aware that he exists. His iconography grows and grows: first, menacing larger-than-life portraits at H&M; then, Los Angeles's Museum of Contemporary Art gift shop, where one could buy a pin with his face on it.

"In the whole world, there is nowhere I can go," says Lagerfeld, in a tone that should have him fluttering that old fan. "Everybody has a camera, and it is flash-flash-flash, and I am a puppet, a marionette, Mickey at Disneyland for children to play with. In Japan, they touch me. I have Japanese women pinch my ass, so now I must say, 'You can have the photo, but please don't touch me.' You cannot pinch the ass of a man my age! And I cannot go out without something for my eyes, because someone might throw chemicals in my face, and I would be like my childhood French teacher whose wife burnt him with acid, Mr. Pommes-Frites, can you believe the name. I can cross the street nowhere in the world, I can never go into a shop. Oh, it's horrible, horrible." Lagerfeld, the master of the contrapuntal, grins a bit and then whispers, "In fact, I do like it. It's very flattering, and very fun."

The place where Lagerfeld will likely be fending off excitable fans next is New York, though he will not say so directly. "I can tell you all sort of bullshit, but I work only from feelings and motivations and creations and needs and opportunities," he declares. Nevertheless, last year, while working on the show of Chanel couture at the Met, he bought one of the John Pawson–designed apartments in Ian Schrager's updated Gramercy Park Hotel, which he will decorate only with German design from 1905 to 1915 and move into in April. "I must have a key to the park, because you know I cannot walk in the street," he says. (Of the Met show, Lagerfeld says, "I do not care if they say I was a Fascist and all this—if you did not like it, you could have walked out.") Lagerfeld has been spending a lot of time here these days, making a trip about every six weeks, to stay at the Mercer, dine at diet-friendly restaurants like Omen, and occasionally go to nightclubs where young people ask him to sign their clothes with Sharpies. "I like New York these days," he says. "At least the way I see it, it is perfect, though I am not down in the streets, so don't ask me about that. I like how the people don't call me by Monsieur here. It's always just the first name—Karl!" ∎

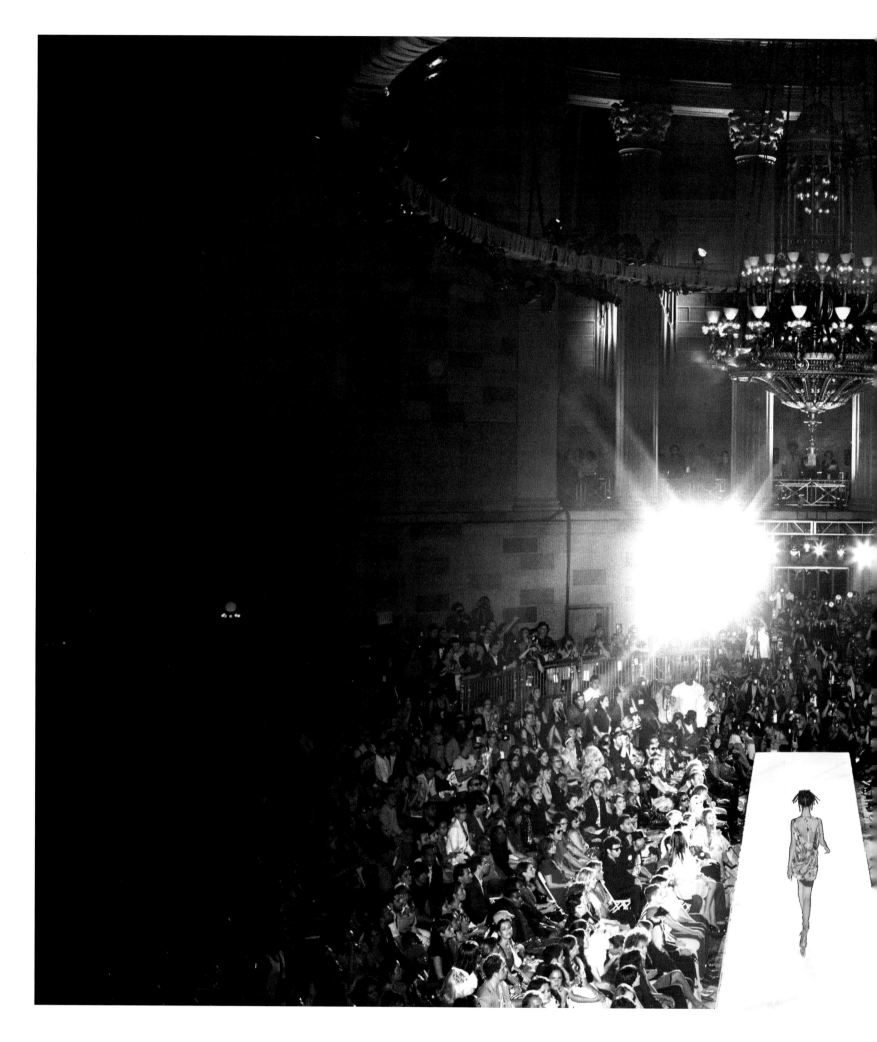

New York City's Fashion Week, once a little trade show, found a global audience.

The model Iekeliene Stange paused before making her entrance at Rodarte's New York show on February 5, 2008.

PHOTOGRAPH BY CHRISTOPHER ANDERSON

After the beatnik, the hippie, and the yuppie, a new species emerged.

What Was the Hipster?

By Mark Greif

WHEN WE TALK about the contemporary hipster, we're talking about a subcultural figure who emerged by 1999, enjoyed a narrow but robust first phase until 2003, and then seemed about to dissipate into the primordial subcultural soup, only to undergo a reorganization and creeping spread from 2004 to the present.

The matrix from which the hipster emerged included the dimension of nineties youth culture, often called alternative or indie, that defined itself by its rejection of consumerism. Yet in an ethnography of Wicker Park, Chicago, in the nineties, the sociologist Richard Lloyd documented how what he called "neo-bohemia" unwittingly turned into something else: the seedbed for post-1999 hipsterism. Lloyd showed how a culture of aspiring artists who worked day jobs in bars and coffee shops could unintentionally provide a milieu for new, late-capitalist commerce in design, marketing, and web development. The neo-bohemian neighborhoods, near to the explosion of new wealth in city financial centers, became amusement districts for a new class of rich young people. The indie bohemians (denigrated as slackers) encountered the flannel-clad proto-businessmen and dot-com paper millionaires (denigrated as yuppies), and something unanticipated came of this friction.

The Lower East Side and Williamsburg in New York, Capitol Hill in Seattle, Silver Lake in L.A., the Inner Mission in San Francisco: This is where the contemporary hipster first flourished. Over the years, there developed such a thing as a hipster style and range of art and finally, by extension, something like a characteristic attitude and Weltanschauung. Fundamentally, however, the hipster continues to be defined by the same tension faced by those early colonizers of Wicker Park. The hipster is that person, overlapping with the intentional dropout or the unintentionally declassed individual—the neo-bohemian, the vegan or bicyclist or skatepunk, the would-be blue-collar or postracial twentysomething, the starving artist or graduate student—who in fact aligns himself both with rebel subculture and with the dominant class, and thus opens up a poisonous conduit between the two.

The question arises: What was it about the turn-of-the-century moment that made it so clear—as it was immediately clear—that the character had to have this name, the hipster, which was so fraught with historical meaning? Subculture has never had a problem with neologism or exploitation of slang, from emo to punk to hippie. The hipster, however, was someone else already. Specifically, he was a black subcultural figure of the late forties, best anatomized by Anatole Broyard in an essay for the *Partisan Review* called "A Portrait of the Hipster." A decade later, the hipster had evolved into a white subcultural figure. This hipster—and the reference here is to Norman Mailer's "The White Negro" essay for *Dissent* in 1957—was explicitly defined by the desire of a white avant-garde to disaffiliate itself from whiteness, with its stain of Eisenhower, the bomb, and the corporation, and achieve the "cool" knowledge and exoticized energy, lust, and violence of black Americans. (*Hippie* itself was originally an insulting diminutive of hipster, a jab at the sloppy kids who hung around North Beach or Greenwich Village after 1960 and didn't care about jazz or poetry, only drugs and fun.)

The hipster, in both black and white incarnations, in his essence had been about superior knowledge—what Broyard called "a priorism." He insisted that hipsterism was developed from a sense that minorities in America were subject to decisions made about their lives by conspiracies of power they could never possibly know. The hip reaction was to insist, purely symbolically, on forms of knowledge that they possessed before anyone else.

The return of the term after 1999 reframed the knowledge question. Hipster, in its revival, referred to an air of knowing about exclusive things before anyone else. The new young strangers acted, as people said then, "hipper than thou." At first their look may also have overlapped enough with a short-lived moment of neo-Beat and fifties nostalgia (goatees, fedoras, *Swingers*-style duds) to help call up the term. But these hipsters were white, and singularly unmoved by race and racial integration.

Indeed, the White Hipster—the style that suddenly emerged in 1999—inverted Broyard's model to particularly unpleasant effect. Let me recall a string of keywords: trucker hats; undershirts called "wifebeaters," worn alone; the aesthetic of basement recroom pornography, flash-lit Polaroids, and fake-wood paneling; Pabst Blue Ribbon; "porno" or "pedophile" mustaches; aviator glasses; Americana T-shirts from church socials and pig roasts; tube socks; the late albums of Johnny Cash; tattoos.

> ## "Hipster, in its revival, referred to an air of knowing about exclusive things before anyone else."

Key institutions were the fashion magazine *Vice*, which moved to New York from Montreal in 1999 and drew on casual racism and porn to refresh traditional women's-magazine features ("It Happened," "Dos and Don'ts") and overcome the stigma of boys looking at photos of clothes; Alife, the hipster-branding consultancy-cum-sneaker store, also launched in 1999, staffed by employees who claimed a rebel background in punk/skateboarding/graffiti to justify why they were now in retail sportswear; and American Apparel, which launched in L.A. in 1997 as an anti-sweatshop T-shirt manufacturer and gradually changed its advertising focus from progressive labor practices to amateur soft-core porn.

These were the most visible emblems of a small and surprising subculture, where the source of a priori knowledge seemed to be nostalgia for suburban whiteness. As the White Negro had once fetishized blackness, the White Hipster fetishized the violence, instinctiveness, and rebelliousness of lower-middle-class "white trash." "I love being white, and I think it's something to be proud of," *Vice* founder Gavin McInnes told the *Times* in 2003. ■

EYES UP HERE!

Last summer, they were minuscule. This summer, they'll be microscopic. Are New Yorkers growing taller, or are their shorts getting shorter?

BY HARRIET MAYS POWELL

Shorts, $910 at
Chanel, 15 E. 57th St.

54

404

FASHIONABLES

MARKET EDITOR: DORIA SANTLOFER. FASHION ASSISTANT: EVE BERTIN-LANG. MODEL: RAQUEL LOHMANN/PARTS MODELS NY. STREET PHOTOGRAPHS BY JACKIE LADHER

Photographs by Hannah Whitaker

2010

We covered every trend, no matter how brief.

Before this issue went to press, there was a spirited discussion among *New York*'s editors about whether it was a little too much for a two-page spread. The bum—which, for the record, belongs to a model named Raquel Lohmann—won.

2014

We recognized a new fashion icon when we saw one.

Tavi Gevinson was 17, already the creator of *Rookie*—first a fashion blog, then a full-on digital magazine—and soon to co-star in a Broadway play when she posed (in Dolce & Gabbana and Saint Laurent) for *New York*'s fall fashion issue. She had graduated from high school just weeks before this portrait was made.

PHOTOGRAPH BY
MARTIN SCHOELLER

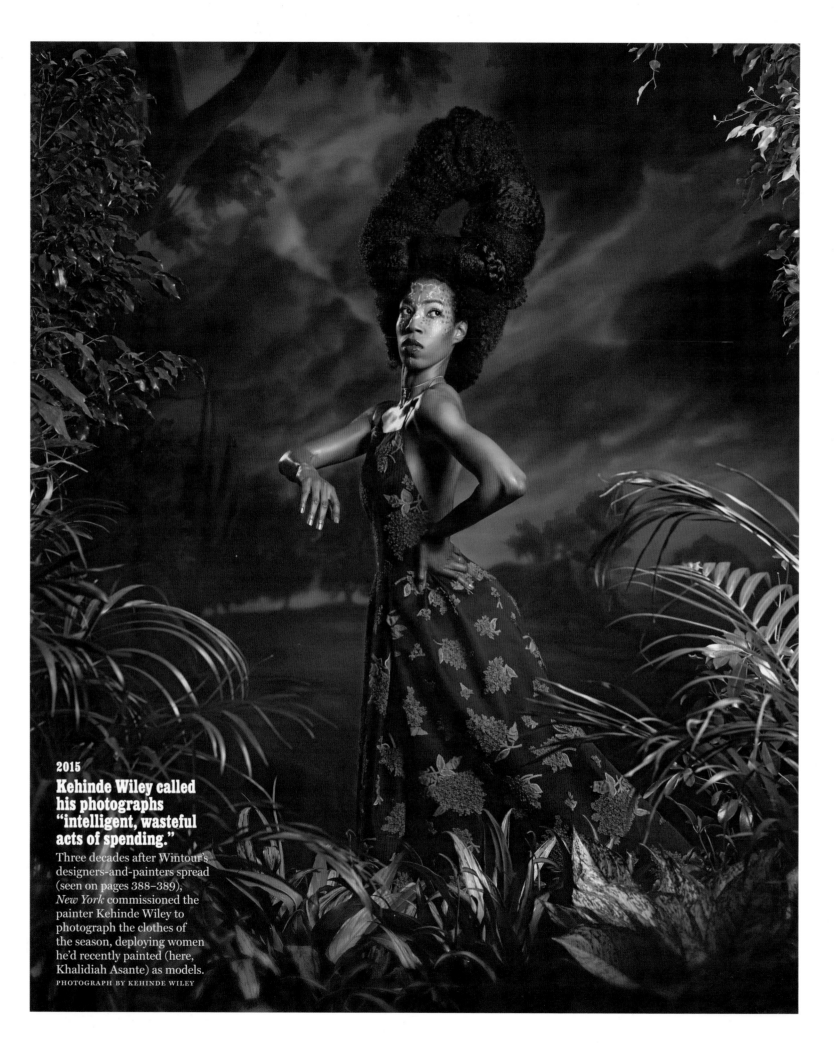

2015

Kehinde Wiley called his photographs "intelligent, wasteful acts of spending."

Three decades after Wintour's designers-and-painters spread (seen on pages 388–389), *New York* commissioned the painter Kehinde Wiley to photograph the clothes of the season, deploying women he'd recently painted (here, Khalidiah Asante) as models.

PHOTOGRAPH BY KEHINDE WILEY

2016
Laurie Simmons made accessories dance.

The artist, known for her portraits of dollhouses and cakes poised atop female legs, made an antic video to accompany the multimedia version of *New York*'s spring-fashion issue. The legs themselves were borrowed from the Broadway production of *Chicago*. "These Fosse movements," Simmons said, were "really amazing. I would ask the choreographer, *Get two lemons, get two girls*, and they would just make a dance on the spot."

PHOTOGRAPH BY LAURIE SIMMONS

Back of the Book

Over five decades, *New York*'s editors have filled the last few pages of the magazine with all kinds of standing departments: cryptic crosswords, standard crosswords, Mary Ann Madden's beloved Competition, a shopping column, a variety of oddball recurring features (like the "New York Page of Lists"), and the Strictly Personals matchmaking advertisements. Most recently, the last page of each issue has been held down by "The Approval Matrix," which moved out of "The Culture Pages" in 2009. (To see the poster-size 50th-anniversary Mega-Matrix, unfold the dust jacket of this book.)

Our puzzle constructor won a Pulitzer Prize for drama.

In Vol. 1., No. 1, Stephen Sondheim—who was hardly some unknown; he'd already co-written *West Side Story* and *Gypsy* and was becoming one of the great artists of the past 50 years—contributed both the magazine's first puzzle and a manifesto called "How to Do a Real Crossword Puzzle, Or What's a Four-letter Word for 'East Indian Betel Nut' and Who Cares?" In it, he made the case for the British-style cryptic, in which the clues are deliberately misleading bits of wordplay, incorporating double meanings and rearranged portions of the answer. (If you are a cryptic-puzzle enthusiast yourself, you will appreciate that SONDHEIM anagrams to HEDONISM.) For the next 40 issues, he created a hyper-complex cryptic puzzle each week; since then, *New York* has run thousands of crosswords of both types.

Answers appear on page 417.

New York Magazine Puzzle

By Stephen Sondheim

Clues

ACROSS

1 *Theme-word A* (8). *Variations:* 13 (4) and 36 (4)
11 Entertain and wind again? (6)
14 "Foremen Do" —poem in Old English (7)
18 Is it unnecessary to want fewer things? (8)
19 The straight prefix bit—ha! (5)
21 What's gone by sounds like it went by (4)
22 "Tramp, tramp, tramp"—a catchphrase (6)
24 *Theme-word B* (6). *Variations:* 28 (5) and 8 Ac.(4)
26 Heavy wig they messed up (7)
27 Uproot the house plant at the station? (5)
29 This Unit is still part of the Resistance (3)
31 *Theme-word C* (9). *Variations:* 31 Dn. (5) and 17 (4)
34 State housing South American Men's Club (3)
37 Hydrogen weapon can cause injury . . . (4)
39 . . . or about the opposite (5)
41 Take back the bet—I may explode (4)

42 All ten ruined with anger (6)
43 To carve with hesitation is more dainty (5)
45 Purge from the East—so be it, from the East (5)
46 *Theme-word D* (8). *Variations:* 16 (5) and 5 (3)
47 What goes from the center to the edge in the Strad I use (6)
48 Considers an affront almost all the gifts (7)

DOWN

1 *Theme-word E* (5). *Variations:*
30 (5) and 12 Ac. (3)
2 Concerning the district income (7)
3 Oh, gosh, the moulding's like an S (4)
4 Water propeller sounds like the alternative (3)
6 Drinks all around might cause song (4)
7 Negative printed in brown-orange (3)
8 One with a lot of gossip (3)
9 Is unable to talk hypocritically (4)
10 Carol is to sing just as Morris is

to dance (7)
12 The last letter is in French relish (4)
15 Lean out of a gas-lantern (5)
19 Members of the ruling class use rash logic, being spoiled (9)
20 Left the role in the middle of the Act (8)
21 Laborer with nothing in prison (4)
22 This is a prison term. This is another. (8)
23 Write for someone else with spirit (5)
25 Ice gliders from

Sark, set in motion (7)
26 Half this is an idiot—all this is quite the reverse (3)
32 Dance from "The Spanish Hour" (4)
33 Hesitation in French-born musicin's note (5)
35 Concerning part of a permanent wave (5)
38 Does she stick on one note in "La Boheme"? (4)
40 Successor to "The Sound of Music" (4)
44 Heavy French fashion (3)

Instructions. The heavy bars in the diagram indicate the beginnings and ends of words, just as black squares do in the usual crossword puzzle. The numbers in parentheses at the end of each clue denote the number of letters in the "light" (the answer to be filled in).

In this puzzle, fifteen of the lights have no written clues: there are five Theme-words, A, B, C, D, and E, which form a familiar group with something in common. Each Theme-word has its own pair of "variations" with a certain relationship to it. The relationship is somewhat different in each case.

E.g., if Theme-word A were SALT, its variations might be SAILOR and TAR; and if Theme-word B were PEPPER, its variations might be VIM and THROUGH (pep = vim, per = through).

Ignore punctuation, which is designed to confuse.

NEW YORK MAGAZINE COMPETITION

COMPETITION NUMBER 369

BY MARY ANN MADDEN

Your child's picture (from snapshot) done in sand. Write: SANDPIX Box 35M.

Lonely? Wishing to meet new friends? Western Thought & Agronomical Philately Ctr. invites members for Meditation & Lively Conversing. Write for App't. Baba Rabbitswanda, Box 36M.

Your name, printed on 10,000 fishing lures. Send $2.00 to LUREPIX, Box 35M.

Widower, mid-60s, retired podiatrist, seeks female companionship. Age no object. Interests: the Arts (chiefly Mozart, Beethoven, Paul Klee); nature walks (member, Audubon Society); reading (Jane Austen a favourite) and light bondage (no leather). Replies confidential. Box 36M.

Above, uninviting want ads. Competitors are asked to contribute one example of same.

Results of Competition 366, in which we asked for 1. What you should have said, and, 2. What you did say.

Report: 1. See, we've set this one before, so the repeats were plentiful, and really too numerous to list, so . . . 2. The repeats: 1. Yes. 2. No. 1. Carter. 2. Ford. 1. A clean shirt. 2. What do you think is in here, a bomb? 1. Yes, mother, I'm living with him. 2. I've smoked a pipe for months. 1. I loved last night, Jane. 2. I loved last night, Joan. 1. No, thanks. 2. Maybe just one for the road. 1. It's an old family recipe. 2. Heinz soup and Kraft dip. 1. Buy. 2. Sell. 1. I'll just clean this up and get the other turkey from the kitchen. 2. Oh, God, it slipped off the platter and I've ruined everything. 1. It takes some skill. 2. Just lucky, I guess. 1. Who cares? She never picks the really good ones, anyway. 2. Enclosed, my entry to Competition 366.

First Prizes of two-year subscriptions to "New York" to:

1. Look, there's a lot of traffic, and he's probably been stuck in a meeting all day and didn't get your message, or he'd have called. I'm sure there's nothing to worry about.
2. Maybe he's dead.
Cynthia Harrison, Rockville, Md.

1. Last Sunday.
2. They say it in *English*?
Ida Campbell, White Plains, N.Y.

1. Broken left upper window.
2. Eight ball, side pocket.
Alan Levine, Massapequa, N.Y.

Runner-up Prizes of one-year subscriptions to "New York" to:

1. Oh, God, I don't believe I'm talking to you. My friends will just die when I tell them. I mean, *The Godfather* is one of the all-time great movies.
2. Oh, God, I don't believe I'm talking to you. My friends will just die when I tell them. I mean, *The Graduate* is one of the all-time great movies.
Philip Jerry, NYC

1. We both have good taste.
2. When you took your coat off, I almost died . . . nothing like this has ever happened to me before . . . do you mind if I ask you how much you paid for yours?
Joan Corr, NYC

1. No, thanks, I'm trying to quit.
2. Hey wait! Don't shoot yet! The blindfold's too tight. Stop! Help!!!
Tommy Wino, NYC

And Honorable Mention to:

1. A hat.
2. When it's this cold I like something I can pull down over my ears. I mean, they just kill me when it's cold like this. When I put it on I didn't realize one side was . . .
Lee Bailey, NYC

1. Some tuna, some shrimp, a little yellowtail, and maybe some of that pink stuff.
2. Two uchimatas and an uke goshi, kudasai.
Stephen Pearlman, Los Angeles, Calif.

1. How do you do?
2. How do you do, your Highness. Excellency? Worship. No, Grace. Uh . . .
Andrew Mezzetti, Flushing Meadows, N.Y.

1. Thank you.
2. It's really a mousy brown, but I use Stardust Blonde #4 and a henna for body.
Anne Scott, Solon, Ohio

1. Excuse me; excuse me. Miss?/Is that the way you look?/Dip, dip, dip, ah-oom?/ Is that the way you look?/ Dip, dip, dip, ah-oom?/Is that really your shoe?/ Dip, dip, dip, ah-oom?
2. Don't I know you from someplace?
Sigrid Trumpy, Annapolis, Md.

1. If you'll forgive me for not answering that question, I'll forgive you for asking it.
2. Forty-two.
N. Schaaf, NYC
sp. ment.: *Elizabeth Bawn Hufford, NYC; Judith A. Berke, Miami, Fla.*

1. Salaam!
2. Shalom!
Carol Falcetti, Whitestone, N.Y.

1. You're having a baby! How wonderful!
2. Who's the father?
Brenda Lindberg, Little Silver, N.J.

1. We hereby declare that we are King for the rest of our natural life.
2. I am not a crook.
Mimi Kahn, Oakland, Calif.

1. Some look at the future and ask why. I look at the future and ask why not.
2. Some look at the future and ask what. I look at the future and ask what not.
Robert M. Hunt, Cambridge, Mass.

1. He's dead, Doctor.
2. Is he dead, Doctor?
Anne Fruchtbaum R.N., Gaithersburg, Md.

1. *The Journal of Critical Analysis.*
2. *TV Guide.*
A. Shulman, Villanova, Pa.
sp. ment.: *Jas. Penha, Jackson Hts., N.Y.*

1. That's really none of your business.
2. Because nobody ever asked me.
Ellyn Polansky, NYC

1. Of course I have Perrier in the fridge.
2. Will Grand Union seltzer do?
Marsha La Greca, NYC

1. No, it's too expensive.
2. Oh, I'm sorry. I misread the price tag. I'll—uh, of course I'll take it.
Bill Anthony, N. Hollywood, Calif.

1. Honk.
2. Hi, I'm Harpo Marx. Welcome to the costume party.
Louis B. Raffel, Skokie, Ill.
similarly: *Grace Katz, Rutland, Vt.*

1. How can I ever thank you for pulling my grandson from that icy river?
2. Where are his mittens?
Paul A. Zurkuhlen, Alexandria, Va.

1. The relationship between the discussion in your introduction and the assigned subject is unclear. Similarly, your reasoning. . . .
2. Stay off the grass when you're writing a term paper.
Page Collier, Thibodaux, La.

1. You have quite an attractive mother.
2. Who is that incredibly large and vulgar looking woman?
Scott L. Haskell, Stockton, Calif.

1979

"I do this thing in the back of the magazine…"

Starting at the beginning of 1969, the *New York* Magazine Competition appeared in two issues out of every three. The brilliant Mary Ann Madden would set an idea—requesting silly sequel names, or warped titles, or double-dactyl poems. Entries came in by mail ("postcards only, please") and, much later, by e-mail. Readers, and for that matter Madden herself, found it hard to explain but easy to love, and it remained in the magazine for 973 installments, until she retired in 2000. The record number of entries, which occurred twice, was 9,000 in a week. The winner of this one (sent by Cynthia Harrison, of Rockville, Maryland) was, arguably, the funniest ever submitted, and *Maybe He's Dead* became the title of one of Madden's three books compiling the best entries.

413

Please photocopy this page to solve.

The enormously popular crosswords of Maura Jacobson (running from 1980 through 2011) and Cathy Allis (since then) have entertained hundreds of thousands of readers through train rides and lunch breaks. This one, custom-created by Allis for this book, draws on the magazine's own history as its theme.

Answers appear on page 417.

The 50th-Anniversary Crossword

By Cathy Allis

Across

1 Shaggy dos
5 Rockefeller Center statue
10 Brits' bye-byes
15 Crescent segment
18 Elton John–Tim Rice musical
19 Hosiery shade
20 Sicilia, e.g.
21 Shrinking Asian sea
22 1968 co-founder of *New York* with designer Milton Glaser
24 It began as an insert to a 1971 *New York* issue
26 Weasel's dark-furred cousin
27 Sports legends, e.g.
29 Declare
30 1984 Olympics slalom champ Phil
32 Kook
33 Cara and Castle
34 Subject of a 1970 *New York* cover story by Tom Wolfe
37 "The __ ," subject of another Tom Wolfe *New York* story
39 Thornton Wilder's "__ Town"
40 "Milk" actor Hirsch
41 Ember, eventually
44 Lawn base
45 Spawned
47 *Sex and the City* actor Handler
48 Parasites' benefactors
50 Targets of crunches
53 Flavorful
55 Business-ltr. abbr.
56 Retro photo effect
57 Mount in a noted New York hospital name
59 Team owner urged to "Get Out of Town!" in a 1977 *New York* title
63 Degraded
66 Danseur's step
67 Mystery-writing awards
68 A *New York* cover story by Nik Cohn became the basis for this 1977 film
75 Tie the knot on the lam
76 Victorious Gettysburg general
77 Dated
78 Some become zests
82 Intention
83 Milk in one's caffe
84 *Friends* role for David
86 Air for a pair
87 Bro's counterpart
88 Prohibition, e.g.
90 Beatles song "Eight Days __ "
92 30 Rock tenant, once
93 Longest-serving editor of *New York*
98 Mayor during *New York*'s launch, whom Jimmy Breslin called "too tall" for the job
101 Territory
102 Prized statuettes
105 Stairway post
106 Make into law
107 North African expanse
108 Biathlon weapon
110 *New York* writer who penned a famed Katz's Deli film scene
112 *New York* published an encyclopedia of it in 2011
117 Hertz alternative
118 Fashion designer Geoffrey
119 Contort
120 Steady guy
121 Pt. of ASCAP or ASPCA
122 World-weary
123 Let up
124 Knock for a loop

Down

1 Rock's Fleetwood __
2 Many a hanging at the Met
3 Behavior prompting "Get a room!": abbr.
4 Utters a casual greeting
5 5'2"-tall successor of 98-Across
6 Divulge
7 Simile preposition
8 Basis for some discounts
9 Composer Prokofiev
10 Boggle-game need
11 Name in Syrian dictatorship
12 Hand drum
13 "Sad to say"
14 Droop
15 "Problem" singer Grande
16 Went on a tirade
17 He voiced God for *Spamalot*
21 Ancient Mexican
23 Absurd comedy
25 Comparable to a beet
28 Costa __
30 Jacobson who created *New York*'s crossword for 30 years
31 Madison Ave. figure
32 From what place
33 Wedding promises
34 Mugs, maybe
35 Dietary iron source
36 Anvil-striking sound
38 Cornerstone abbr.
42 "This is so exasperating!"
43 Pueblo dweller
46 Unearths
49 Confession subject
50 Sui for whom a "Boho" Barbie is named
51 1930s boxing champ Max
52 Galahad, Gawain, etc.
54 Big name in tractors
56 Former New York landmark the __ Deli
57 Pesach feast
58 Actress Bergman
60 Quirky
61 Web expert?
62 Title for M.L.K.
63 On the briny
64 Java neighbor
65 A bit smashed?
69 Stockpile
70 Thus far
71 Election analyst Silver
72 Sacred scrolls
73 Taken wing
74 1950s Ford flop
79 Health care professional
80 Sticker in a model kit
81 Stick around
83 Columbia University athlete
85 TV show in which Larry David voiced 59-Across
87 Belted, in the Bible
89 Not quite shut
91 Mournful peal
93 Madison Square Garden et al.
94 Anew, to Nero
95 Mushroom type (Garcia anagram)
96 Flaky minerals
97 Zoomed aloft
99 Creamsicle flavoring
100 Uncool types
103 Excelled
104 Wove a rattan seat, say
107 Citi Field predecessor
108 Messenger molecules, briefly
109 "Able was __ ..." (palindrome start)
111 Lunch-box sandwich, familiarly
113 Cookbook author Garten
114 Lab's doc
115 Perrier, par exemple
116 *Sister Act* extra

Acknowledgments

THIS BOOK IS AN EXHUMATION of 50 years' worth of decisions, ambitions, interpretations, and inventions by a series of superb magazine-makers facing relentless time pressure, occasional financial anxiety, and the exhilarating confusion of a constantly changing city. The editorial staff members of *New York* since 1968 effectively created these pages, and we owe an enormous debt of gratitude to all of them, past and present, and to all the previous editors-in-chief: Clay Felker, James Brady, Joseph Gravitt Armstrong, Edward Kosner, Kurt Andersen, and Caroline Miller. The lush and thrilling look of *New York* that Milton Glaser and Walter Bernard invented many years ago has been evolving under the guidance of subsequent designers and photography editors—all of whom have their fingerprints all over these pages.

In particular, we appreciate the many editors, writers, photographers, and graphic designers who contributed their time to the making of this book. In addition to the editors-in-chief and those credited on the last page, we would like to thank the following:

Sam Anderson, Julie Baumgold, David Blum, James Brady, Marie Brenner, Jimmy Breslin, David Brock, Jonathan Chait, Nik Cohn, Justin Davidson, David Denby, Edwin Diamond, David Edelstein, Nora Ephron, Steve Fishman, Barbara Goldsmith, Richard Goldstein, Jennifer Gonnerman, Meryl Gordon, Herb Goro, Jesse Green, Gael Greene, Mark Greif, Vanessa Grigoriadis, Michael Gross, John Hallowell, Pete Hamill, Molly Haskell, John Heilemann, Craig Horowitz, Doug Ireland, Mark Jacobson, Bernice Kanner, Joe Klein, Jesse Kornbluth, Michael Kramer, Dan Lee, Spike Lee, John Leonard, Elizabeth Lesly, Mary Ann Madden, Jonathan Mahler, Norman Mailer, Rebecca Mead, Lisa Miller, Emily Nussbaum, Nicholas Pileggi, Henry Post, Jessica Pressler, Frank Rich, Jennifer Rogers, Nancy Jo Sales, Jerry Saltz, Doria Santlofer, Kathryn Schulz, Jennifer Senior, Irwin Shaw, Gail Sheehy, Mimi Sheraton, Gabriel Sherman, Choire Sicha, John Simon, Chris Smith, Gloria Steinem, Peter Stone, Andrew Sullivan, Judy (Syfers) Brady, Gay Talese, Michael Tomasky, Rebecca Traister, Richard Turner, Jonathan Van Meter, Michael VerMeulen, Judith Viorst, Amy Virshup, Benjamin Wallace, Kat Ward, Tom Wolfe, and Wesley Yang wrote the memorable stories that fill these pages.

John Ashbery, John Berendt, Stella Bugbee, Nicholas Gage, Deborah Harkins, Luke Hayman, Michael Hirschorn, John Homans, Noreen Malone, Kelly Maloni, Adam Pasick, Willa Paskin, Alan Patricof, Rob Patronite, Corky Pollan, Robin Raisfeld, Richard Reeves, Jordan Schaps, Rita-Sue Siegel, Stephen Sondheim, Viva, Jean-Georges Vongerichten, Ben Williams, Anna Wintour, and Michael Wolff also spoke graciously and candidly with Christopher Bonanos to help shape our oral history and captions.

Editors Ann Clarke, Wendy Goodman, Jared Hohlt, Lauren Kern, Amy Larocca, Genevieve Smith, Alexis Swerdloff, and David Wallace-Wells all provided wise and helpful counsel.

Carl Swanson and Adam Sternbergh captained the assembly of our 408-item "Approval Matrix."

Alexa Tsoulis-Reay, Alan Sytsma, and Eric Benson contributed reporting and research.

Cathy Allis created our 50th-anniversary crossword puzzle.

Charles Denson graciously shared his archive of photographs from the early years of the magazine.

Staff photographer Bobby Doherty's images appear throughout the pages of this book.

Joy Crane, Morgan Kinney, Jordan Larson, Julia Mead, Amelia Schonbek, Nick Tabor, and James D. Walsh provided expert fact-checking; Mary Jane Weedman lent her expert eyes to copy-editing.

Thanks to Lisa Abreu, Larry Burstein, Brian Carney, Lisa Goren, Mona Houck (of Miller Korzenick Sommers LLP), Julie Jamerson, Abby Kallgren, Ruth Monsanto, Adelina Pepenella, Steve Remsberg, Lauren Starke, and Kit Taylor at *New York* for their support throughout this project.

Special thanks to David Kuhn, who, along with William LoTurco and their colleagues at Aevitas Creative Management helped conceive this project and convince us magazine editors that we could also make books. David introduced us to Jonathan Karp, who has demonstrated such warm enthusiasm for this project—the beginning of what we expect will be a terrific relationship between *New York* and Simon & Schuster. We extend our gratitude to our many friends at Simon & Schuster, including Stephen Bedford, Susan Bishansky, Raymond Chokov, Paul Dippolito, Lisa Erwin, Jonathan Evans, Erica Ferguson, Elizabeth Gay, Cary Goldstein, Julianna Haubner, Kayley Hoffman, Al Imperato, Kristen Lemire, Amanda Mulholland, Julia Prosser, Richard Rhorer, Emily Remes, Elisa Rivlin, Jackie Seow, and Alex Su. And in particular, we are grateful for the wisdom and imagination of Jofie Ferrari-Adler, who carried this extremely complex project to its finish.

And finally, thank you to Bruce Wasserstein, who bought the magazine in 2004; Pam Wasserstein, who runs it now; and their family, whose stewardship of *New York* would have made Clay Felker proud.

The (Un)Index

Impressionistic, incomplete, entirely unhelpful.

1968
Richard Nixon
Martin Luther King Jr.
SDS
Hair
Hair
Bobby Kennedy
The Society for
 Cutting Up Men
"Mrs. Robinson"
Mister Rogers' Neighborhood
Al Goldstein's *Screw*
Garbage strike
The Factory
The *Heidi* game
Madison Square Garden
John and Yoko

1969
John Lindsay
Cosa Nostra
Stonewall
Chappaquiddick
Portnoy's Complaint
Charles Manson
Sesame Street
Midnight Cowboy
Joe Namath
The Mets

1970
Legal abortion
The 30-cent subway fare
The New York City Marathon
Earth Day
Janis and Jimi
Women at McSorley's
Black Panthers
Hare Krishna
Maxwell's Plum
The Knicks
Weathermen
Company

1971
The Pentagon Papers
All in the Family
The Jewish American
 Princess
The Modern
 Corporation Man
Attica
Serpico
Ali vs. Frazier
Fillmore East
"Imus in the Morning"
The French Connection
King Cocaine
Shaft

1972
Sichuan cuisine
The Joy of Sex
Leonard Bernstein

The New York Dolls
The Godfather
"Walk on the Wild Side"
Grey Gardens
George McGovern
Juice bars
Crazy Joe Gallo

1973
Watergate
Egon and Diane
Abe Beame
CBGB
Julius Erving
Hip-hop in the Bronx
Robert Moses
Henry Kissinger
Billie Jean King
Yom Kippur War
The Rockefeller drug laws
Catch a Rising Star
Margaret Mead
World Trade Center

1974
Joe Namath
Gerald Ford
The Citicorp Center
Philippe Petit
Death Wish
Nautilus machines
Le Cirque
Arab oil
Gold bugs
Bisexuals
"Whip Inflation Now"
Dick Cavett
The Secret Life of Plants

1975
FORD TO CITY: DROP DEAD
Saturday Night Live
Bruce Springsteen
Jaws
Blaxploitation
A Chorus Line
Talking Heads
Horses
Fraunces Tavern bombing

1976
Truman Capote
Taxi Driver
Korean groceries
Patty Hearst
Bicentennial
Renata Adler
Rupert Murdoch
Rocky
Fiorucci
Sleeping pills
Daniel Patrick Moynihan

1977
Blackout
Saturday Night Fever
Studio 54
"Reggie, Reggie, Reggie"
Annie Hall
Jimmy Carter
Concorde
Son of Sam
The Robin Byrd Show
Barnes & Noble
Pelé
Dean & DeLuca
Roots
I ❤ New York

1978
Newspaper strike
Ed Koch
"Treasures of Tutankhamun"
Pooper-scoopers
Love Canal
The Mudd Club
The Lufthansa heist
Roller disco
Westway
Grete Waitz
Mommie Dearest
Sid Vicious and
 Nancy Spungen
The Wiz

1979
Oil shortage
John McEnroe
"Rapper's Delight"
Apocalypse Now
Three Mile Island
Danceteria
Iran hostage crisis
The Warriors
Etan Patz
Thurman Munson
Evita
The Quilted Giraffe
Christian Bob Dylan
Cruising

1980
Beta-blockers
Beaujolais Nouveau
The Ugly George Hour
*The Official Preppy
 Handbook*
The Guardian Angels
The Scarsdale Diet
Thy Neighbor's Wife
Brooke Shields
Woody Allen
Debbie Harry
South Street Seaport
Ronald Reagan

1981
MTV
Food stamps
George Steinbrenner
Julian Schnabel
The Odeon
Jane Fonda's Workout
Little Odessa
The '21' Club
Nancy Reagan

1982
AIDS
Barbiturates
John Belushi
Thriller

Money-market funds
Israel
Sandinistas
DDL Foodshow
Falklands
Crack
Atari
USA Today
Claus von Bülow
David Letterman
E.T.
Cats

1983
Money laundering
Breakdancing
Mountain bikes
Compact discs
Trump Tower
Vanity Fair
Def Jam
Matthew Broderick
Elaine's
Foie gras
Mario Cuomo
HEADLESS BODY IN
 TOPLESS BAR

1984
Aerobics
Bernie Goetz
Malcolm Forbes
Bright Lights, Big City
Hard Rock Cafe
"Hymietown"
Liposuction
Gary Hart
Glengarry Glen Ross
"Roxanne, Roxanne"
Air Jordans
Kate & Allie
The Mayflower Madam
The Cosby Show
Answering machines

1985
Ed Koch
Dwight Gooden
Carl Andre and
 Ana Mendieta
Tipper Gore
Palladium
Patrick Ewing
Hurricane Gloria
The Normal Heart
I.V.F.
Marla Hanson
Ecstasy
"We Are the World"

1986
Ivan Boesky
Perry Ellis
Nell's
Mortimer's
Bike messengers
Challenger
Battery Park City
Licensed to Ill
Howard Beach
Acid rain
Al Sharpton
Spy
Oliver North
The Preppie Killer
The Mets

1987
ACT UP
Bess Myerson
Black Monday
The Art of the Deal
The Giants
Tawana Brawley
Gordon Gekko
Fatal Attraction
Guerrilla Girls
Andy Warhol
Robert Bork
The Bonfire of the Vanities
Monkey Business

1988
The Phantom of the Opera
George H. W. Bush
Willie Horton
Kitty Dukakis
Jean-Michel Basquiat
Phil Donahue at the
 Rainbow Room
Eric Bogosian
Tyson vs. Spinks

1989
David Dinkins
Angelika Film Center
Japanese invasion
The Central Park jogger
Seinfeld
The War on Drugs
Junk bonds
The Rushdie fatwa
Do the Right Thing
Tiananmen Square
The Berlin Wall
Prozac

1990
Bouley
Ray's Pizza
2,245 murders
Drexel Burnham Lambert
Denzel Washington
American Psycho
Naomi Wolf
The Happy Land fire
Six Degrees of Separation
Ivana Trump
Vanilla Ice

1991
Political correctness
David Barton Gym
Madonna
CNN
Crown Heights riots
Darryl Strawberry
Operation Desert Storm
The World Wide Web
Baby Hope
Jimmy Connors
Camille Paglia
Lollapalooza

1992
Bill Clinton
Joey Buttafuoco
Mark Wahlberg's Calvins
Williamsburg
Donna Tartt
Christy Turlington
The Real World
Sister Souljah
Tina Brown

L.A. riots
Woody Allen and Soon-Yi
Guggenheim Soho
Lycra
Arthur Ochs Sulzberger Jr.

1993

World Trade Center bombing
Rudy Giuliani
Broken windows
Waco
The Menendez Brothers
Nobu
Grunge
Private Parts
NYPD Blue
Arthur Ashe
Golden Venture
Heroin chic
Angels in America

1994

Friends
Disney in Times Square
George Pataki
Salt-N-Pepa
Jackie Onassis
NAFTA
PETA
Ready to Die
The MetroCard
Starbucks
Pulp Fiction
The Rangers
Donna Hanover
Email

1995

O. J. Simpson
Kids
Silicon Alley
George
The Unabomber
Louis Farrakhan
Luna Lounge
eBay
Christopher Reeve
CompStat
Elisa Izquierdo

1996

TWA Flight 800
Rent
Michael Alig
Tupac
Joe Torre
Magnolia Bakery
Infinite Jest
Ultimate Fighting
Pop Up Video
6,000 Dow
Dress-down Fridays
Whitewater
Prep-school gangsters

1997

"Sensation"
The Lion King
Biggie Smalls
Titanic
Legal tattoos
Netflix
Rollerblading
Garbage barge
Doctor-assisted suicide

Abner Louima
South Park
Derek Jeter
Gianni Versace
Beanie Babies
Underworld

1998

Monica Lewinsky
Sex and the City
Mark versus Sammy
Total Request Live
Eleven Madison Park
Harry Potter
Cell phones
Lizzie Grubman
EZ-Pass
Will & Grace

1999

Serena Williams
The Matrix
JFK Jr. and Carolyn Bessette
Amadou Diallo
The Sopranos
Columbine
Asian fusion
*The Daily Show With
 Jon Stewart*
Talk magazine
Y2K bug

2000

George W. Bush
Hanging chads
Kabbalah
Survivor
Jennifer Lopez's
 Versace dress
The human genome
AOL and Time Warner
Subway Series
Napster
Gilmore Girls

2001

Space tourism
Senator Hillary Clinton
Bill Clinton in Harlem
The Producers
Mike Bloomberg
9/11
Aaliyah
A Beautiful Mind
Anthrax
Britney Spears's python
The Corrections
Tora Bora

2002

American Idol
Martha Stewart
Halle Berry
Bubble tea
Botox
Bennifer
Enron
Gawker
Axis of Evil
Coalition of the willing
TiVo
Crystal meth

2003

Blackout
Andy Roddick
Concorde
Columbia
Jayson Blair
Smoking ban
Rainbow parties
Avenue Q
Freedom fries
*Queer Eye for the
 Straight Guy*
Dave Chappelle
Al Jazeera
"Mission Accomplished"
The O.C.

2004

Facebook
Momofuku
The Apprentice
Nipplegate
Project Runway
Shake Shack
Per Se
Super Size Me
Lost
Abu Ghraib
Bernie Kerik
Isiah Thomas
Swiftboating
The Dean scream

2005

The Gates
Joan Didion
Bobby Short
Tom Cruise
Larry Silverstein
James Dolan
Live 8
Carrie Underwood
Trapped in the Closet
Brokeback Mountain
Hurricane Katrina
JT LeRoy
Truthiness

2006

Sean Bell
John Bolton
Brooke Astor
The Real Housewives
Twitter
Borat
The 9/11 memorial
Pinkberry
A Million Little Pieces
Brangelina
The Strokes
The cuddle puddle
Donald Rumsfeld
YouTube

2007

Joe Girardi
iPhones
Sterling Cooper
*Keeping Up With
 the Kardashians*
Al Gore
Fitbit
Urban farming
Viral marketing
Gossip Girl
Katie Couric
If I Did It

2008

Barack Obama
Bernie Madoff
Bear Stearns
Dick Fuld
David Paterson
Lady Gaga
Client Number Nine
Airbnb
Sarah Palin
Tina Fey as Sarah Palin
Goop
Rachel Maddow
The wedding of Bey and Jay
TARP

2009

Tim Geithner
The High Line
Times Square lawn chairs
Miracle on the Hudson
"David After Dentist"
RuPaul
Glee
Beer summit
Bedbugs
The Yankees
"You lie!"
Grindr
Kanye and Taylor
Snooki
Swine flu

2010

Tea party
Artisanal-food trucks
Governors Island
LeBron James
Eataly
Andrew Cuomo
Citizens United
WikiLeaks
Uber
Deepwater Horizon
"Ground Zero mosque"

2011

Anthony Weiner
Debt ceiling
Occupy Wall Street
Steve Jobs
Dominique Strauss-Kahn
Arab Spring
Game of Thrones
Spotify
Emoji
Bridesmaids
Tiger moms

2012

Hurricane Sandy
Mitt Romney
Sandy Hook Elementary
Barclays Center
Brooklyn Nets
Nora Ephron
Pink slime
Jonah Lehrer
Girls
Aurora
Tinder
Tim Tebow
Linsanity
Horace Mann

2013

Edie Windsor
Bill de Blasio
The Cronut
The Paleo Diet
Citi Bike
Twerking
Bridgegate
Bitcoin
Alex Rodriguez
Sheryl Sandberg
Edward Snowden
Pope Francis
Sharknado
E-cigarettes
Miley

2014

Michael Brown
Eric Garner
Steve Cohen
Normcore
Derek Jeter
Emma Sulkowicz
"Conscious uncoupling"
Gamergate
Ebola doctor
Serial
Uber
Truvada
Drones
One World Trade Center

2015

Hamilton
Stephen Colbert
Ta-Nehisi Coates
Pizza Rat
Plastic bags
Thinx
Marie Kondo
Primates of Park Avenue
Bill Cosby
Caitlyn Jenner
Deflategate
Desnudas

2016

Hillary Clinton
Donald Trump
Pulse
The Oculus
Peter Thiel
Pepe the Frog
Millennial pink
Poké bowls
#OscarsSoWhite
Brexit
Lemonade
Sad!

2017

Women's March
Kleptocracy
Get Out
The Second Avenue Subway
Cucks
The Handmaid's Tale
Samantha Bee
Moonlight
#DeleteUber
The resistance

50 YEARS OF NEW YORK

EDITOR-IN-CHIEF
Adam Moss

EDITOR
David Haskell

WRITER & HISTORIAN
Christopher Bonanos

DESIGN DIRECTOR
Thomas Alberty

PHOTOGRAPHY DIRECTOR
Jody Quon

DESIGNERS
Chris Cristiano, Aaron Garza, Randy Minor

PHOTO EDITORS
Roxanne Behr, Sofia de Guzman, Marvin Orellana

PROJECT MANAGER
David Bressler

CONTRIBUTING DESIGNERS
Alyce Jones, Abby Kuster-Prokell,
Jamie Prokell, Mallory Roynon

PRODUCTION DESIGNER
Robyn Boehler

ART & PHOTO COORDINATORS
Jemma Hinkly, Julia Jones,
Surya Patel, Meagan Wholey

PERMISSIONS COORDINATOR
Katherine Barner

COPY MANAGER
Carl Rosen

RESEARCH MANAGER
Edward Hart

PREPRESS IMAGING
Gary Hagen, Kevin Kanach, Matthew Kersh

COVER LETTERING
Ed Benguiat

SIMON & SCHUSTER

PUBLISHER
Jonathan Karp

EDITORS
Jofie Ferrari-Adler, Julianna Haubner

MANAGING EDITOR
Kristen Lemire

PRODUCTION MANAGER
Lisa Erwin

PRODUCTION EDITOR
Kayley Hoffman

Simon & Schuster
1230 Avenue of the Americas
New York, NY 10020

First Simon & Schuster hardcover edition November 2017

Simon & Schuster and colophon are registered trademarks
of Simon & Schuster, Inc.

For information about special discounts for bulk purchases,
please contact Simon & Schuster Special Sales at 1-866-506-1949
or business@simonandschuster.com

The Simon & Schuster Speakers Bureau can bring authors to
your live event. For more information or to book an event contact
the Simon & Schuster Speakers Bureau at 1-866-248-3049 or
visit our website at www.simonspeakers.com.

Excerpt from "Radical Chic" from RADICAL CHIC &
MAU-MAUING THE FLAK CATCHERS by Tom Wolfe.
Copyright © 1970, renewed 1999 by Tom Wolfe. Reprinted by
permission of Farrar, Straus and Giroux.

"Tribal Rites of the New Saturday Night" by Nik Cohn. Copyright
© 1976 by Nik Cohn. Used by Permission. All rights reserved.

Manufactured in China

10 9 8 7 6 5 4 3 2 1

Library of Congress Cataloging-in-Publication Data is available.

ISBN 978-1-5011-6684-6
ISBN 978-1-5011-6685-3 (ebook)